Cézanne—his Life and Art

Jack Lindsay

CEZANNE

his Life and Art

New York Graphic Society Ltd.

To Josef Herman

For what is vivid in your eyes
of something lost forever found
again at break or death of day
the truth of man the truth of earth
which still with stubborn warmth of heart
and clarities of involving art
you follow through our desperate age
with its deliberate confusions
and hell's dull round
seeking the rhythms of rebirth
and satisfied with nothing less
than man and earth

JACK LINDSAY

© 1969 Jack Lindsay

*First published 1969 by Evelyn, Adams & Mackay Ltd, 9 Fitzroy Square, London, W1
and in the U.S.A. by New York Graphic Society, Greenwich, Connecticut
SBN 8212-0340-1 Library of Congress Catalog Card No. 76-77230
Printed in Great Britain*

Contents

List of Illustrations

Foreword

I N many ways this book follows on and complements my Life of Turner, but it was not conceived as that; it arose out of interest in Cézanne for his own sake. However, in writing it, I have felt more and more the extent to which Cézanne was the culmination of the revolution in art inaugurated by Turner, even though there is no evidence that he ever saw one of Turner's pictures or even heard his name. (As Pissarro became enthusiastic about Turner during his visits to England and studied his small colour-washed sketches as well as his large oils, it is likely that Paul did at least hear something about those works.)

There has been a multitude of books and essays on Cézanne since his death in 1906; but it can hardly be claimed that any satisfactory Life exists. Gerstle Mack's book in 1935 was a worthy attempt for that date; and Rewald in particular has added considerably and valuably to the biographical material. But there is no single book which gathers the available facts and sets them in a critical perspective, with regard to both the ceaseless struggle inside the art and the personal tensions brought out by writers like Reff. It has been in the hope of producing such a book that I have laboured.

On account of the close links with Zola, a large portion of any Life of Cézanne must deal with that relationship; and I think that I have shown more fully than before how strongly and intimately bound up were the developments of the two men, despite all the diversities in their expression. I have quoted extensively from the letters between them, or their letters to others, since only thus can we thoroughly grasp the vital closeness, the rich texture, of their relationship. The result is somewhat massive; but for a work such as this which seeks to establish convincingly all that the union meant, there is no other course. To generalize from the documents would at this stage of the inquiry into Cézanne's make-up have an effect of superficiality, as can be seen well enough by glancing at several other books on the subject. For the same reason I have felt it necessary to make a complete translation of Cézanne's poetry, the first made in English. The more lyrical poems I have given in the same rhyme-scheme as in the originals; the alexandrines I have done mostly in blank verse.

One grave problem for a biographer who seeks to link Cézanne's life and art is the difficulty in dating precisely so many of his pictures. In a general way it is clear that the development of the art is bound up in an extremely close way with the emotions of the artist and his experiences. But there is an inner zigzag of anguish and exaltation in the movement of the art which does not coincide in any simple way with the more direct patterns of Cézanne's life, so that it is dangerous to devise any scheme of datings on purely stylistic factors. However, by taking as fixed marks the few works which can be dated securely on external

evidence, we can begin to work outwards and use stylistic analysis to group the others. Even if we still remain dubious before many particular points, something of a reliable pattern can be evolved. The recent work of Gowing and Cooper has been very useful in this crucial matter. Badt's error in basing arguments on the *Old Woman with a Rosary*, which he dated 1900–4 and which was certainly done in the 1896 summer, is the sort of pitfall that a biographer must beware of.

Another problem appears with the accounts of meetings with Cézanne published by many persons, especially younger artists or writers after his death. We have the odd position that his last few years, when he was beginning to attract a wider attention, are precisely those with the most treacherous snares. The writers almost all had definite views to propagate and tended to put their own ideas in Cézanne's mouth, directly or indirectly; and Gasquet was a proficient liar. A biographer cannot ignore these accounts and yet must treat them with every critical caution. A further difficulty arises in the fact that the Cézanne who thus came into the distorting limelight was in any event different in certain important respects from the friend of Zola and Pissarro. As a result there has been a tendency to view Cézanne's earlier years in terms of the later developments, which has meant that even those developments themselves have been obscured. The evidence in his letters for earlier standpoints has been ignored. No one has even noticed that he expressed hatred of the Minister responsible for the execution of the Communards, or has bothered to look at Vallès' writings, for which he declared such a strong sympathy.

The legends and misinterpretations built up round Cézanne in his last years have not only been unfortunate for the unravelling of his life and its events. They decisively oriented the approach to his work along lines of which he would have passionately disapproved, and which indeed he did his utmost to avert in his letters to Bernard. As a result the impact of his work on artists in the earlier decades of the century was in terms of abstracted aspects of his works, not in terms of the struggle for full integration which was the core of his creativity. The misinterpretations could not have had such an effect if the whole trend of the times had not been in their favour; but in the circumstances they played their important part in turning artists away from the road that Cézanne had followed. I have not attempted to enter at any length into this controversial field, but have limited myself to what seem to me the plain facts of the extraordinary divergence between Cézanne's aims and his influence.

Picasso once said, 'What interests us is the disquiet of Cézanne. That is, the man's drama.' I have done my utmost to explore that drama; but at the same time I hope that I have brought out the full circumstances of the conflicts. Those conflicts have their significance only if we understand what all the suffering and aspiration were about: what was the resolution of the tragic anguish. To admire the drama as a sort of abstracted spectacle of creative pangs is to deny the whole meaning of Cézanne's life and art; it is indeed the final and worst insult of all the many insults that he had to endure.

PART ONE

Early Years

I *The Family and Aix*

THE Cézannes came from the small mountainous town of Cesana now in West Piedmont, and it has been assumed that they were ultimately of Italian origin. However, in the seventeenth century, if we may judge by the names, the place seems to have been populated by families of French stock; and it was only in 1713, by the Treaty of Utrecht, that the Briançonnais valley on the eastern slopes was exchanged by the French for the valley of the Barcelonnette. The town of Cézanne-Cesana thus became Italian. The Cézannes had already emigrated, about 1650, to Besançon some fifteen miles away by road. The registers tell of a master shoemaker, Blaise Cézanne, who had five or six children by two wives. Some time before 1700 a branch of the family appeared further west, at Aix en Provençe. In the parish of Sainte Madeleine there, Jacques Joseph was born in August 1702, son of Denis Cézanne and Catherine Marguerit. Denis may have been an elder son of Blaise. A third son, André, born in April 1712, was a perruquier, wigmaker or hairdresser—probably both. His wife Marie Bougarel had several children, one of whom, born 14 November 1756, was Thomas François Xavier Cézanne, a tailor. He married Rose Rebuffat, and moved to a small place, St Zacharie, some fifteen miles from Aix. His son Louis Auguste was the father of the artist.

One point of interest in this pedigree is that it shows Paul as coming from a hard-working line of handicraftsmen. Perhaps too, in the movements of the family, which suggest a sense of being intruders on the Provençal scene, we touch something of a restless family tradition that took a deeply internalized form in Paul.

Louis Auguste was the one Cézanne who rose from the lowly craft level. Born on 28 July 1798, he was a sickly child, but grew up all the stronger and more aggressive for his frail start. As he became older, he had a heavy clean-shaven face with high forehead, re-treating hair, and deep lines cut between thick brows; we sense a mixture of hardness and shrewd irony. He wore boots of untanned leather to save money and to obviate the bother of polishing. A keen hard-headed bargainer, he was dedicated all his life to money-making and could conceive no other sensible or worthwhile way of living—except perhaps for a certain interest in women. Not that such a frugal and tightfisted fellow could ever have wasted any cash on lovemaking. In his early teens he realized that St Zacharie was no place for a man determined to make his way in the world. He returned on the family tracks and settled at Aix, one of the main centres for making felt hats. Farmers in the neighbourhood bred rabbits; at workshops in Aix the felt was manufactured into hats; and Louis Auguste inevitably turned to the hat industry as the main source of local wealth. First he worked for a firm of wool merchants, then decided to learn all he could of the hat trade. Shrewdly

he left for Paris about 1821, and stayed for three to four years as common worker with a felt hat maker, then as salesman. A handsome lad, he was said to have charmed his employer's wife; but we may be sure he threw himself whole-heartedly into his job, eager to learn everything useful from the metropolis, while avoiding its temptations. Back in Aix about 1825, he set up shop with Martin, hatter. Probably needing more ready cash, they soon brought in Coupin. They were concerned with the sale and export of hats, not the manufacturing. Their shop was at 55 the Cours (in 1876 the Cours Mirabeau) under the name of Martin, Coupin and Cézanne; and the townsfolk made a joke about Martin and Coupin and the Seize Anes—eighteen animals in all. The joke perhaps expressed a suspicion in highly conservative Aix of all newcomers; if it carried a hope of seeing the Asses fail, it was soon to be belied. The trio did well. There may however have been a certain strain among three such astute money-makers; about 1845 the firm was dissolved. Louis Auguste went on for a couple of years dealing in hats on his own; then he boldly seized the chance to become a banker in the revolutionary year of 1848. The only Aix bank, the Banque Bargès, had failed in the growing crisis. Characteristically, Louis Auguste, on closing shop, put aside a store of top hats for important occasions, and caps with peaks and flaps for daily use, which lasted him for the rest of his life. 'Have you seen old Cézanne's Spade?' the jeerers used to say of his cap.

Apart from *la haute banque* based on rich families in Paris with international links, banking in France was backward in comparison with that in England. Textiles drew on their own funds for expansion; but the spread of a market-economy in the countryside, with the growth of the towns, was accompanied by a shortage of money and credit. Especially after 1833 the building and financing of railways became a matter of public debate and interest— though France was slow in recognizing that the railway age had arrived. The few provincial banks were like the merchant banks of Paris on a smaller scale, giving a limited range of services for a narrow local clientèle; they transmitted funds, discounted bills, acted as intermediaries for wholesale deals in internal trade. Now however they began to branch out and meet the needs of local industries, adding deposits from the middle class to their own resources. But in many areas there was still a blank distrust of banks, and credits were gained through notaries using their clients' funds in mortgages and usurious loans. Between 1842 and 1848 railways began to exert a stronger influence. There was a larger demand for capital; textiles and machine-making expanded, as also markets for coal and iron; but there was no adequate system for the flow of investment, no established habit of long-term investment. Then the agricultural crises worsened things; bad harvests in 1845–6 produced a food shortage and higher prices, with a contraction of the commodity market, especially for textiles. Investments fell off. The decline of income hit all sorts of industries; emergency imports of food-grains depressed the Bank of France's reserves and weakened the supply of money, while lack of transport obstructed the movements of grain. Hoarding and specula-

tion by big producers or dealers drove prices up yet further and angered the hungry folk. Many provincial banks had to suspend payment; the Caisse du Commerce et de l' Industrie failed. These were some of the factors leading to the paralysis of credit and the crisis in State finances that helped to bring about the February and June Revolutions of 1848.

We can be sure that Louis Auguste was watching things closely, from the angle of the credit problems of Aix and its manufactories; and the energy and self-confidence of his character appears in the fact that he chose this difficult moment to enter banking. Rightly enough, he calculated that the 1848 crisis would somehow be overcome and that it would not be long before the farmers and manufacturers would need funds more than ever. The situation was one that could be securely exploited by a money-lender who kept out of deep investment waters and used his close expert knowledge of the Aixois in making loans. At any time the rabbit farmers worked on a small margin of profit and needed ready cash to tide things over till they got in the payments for the skins. Louis Auguste indeed seems to have been making loans for some time on the side at high though legal interest; he now felt that he could take the risk and become a full-time banker at a moment when others were shrinking from the credit field. The primitive system of financing which still served for a provincial town like Aix was exactly that for which his talents, methods and knowledge fitted him.

He took in as partner F.R.M. Cabassol, who had been cashier of the Banque Bargès, to deal with the technical procedures of which he knew little. He himself put up the capital of 100,000 francs, with Cabassol contributing only his expertise; each man was to draw 2,000 francs yearly, with Louis Auguste getting 5% interest on his capital. The agreement was for five years three months. As all went well, it was renewed in 1853; and the system carried on till 1870, when both men were old and another violent crisis was coming upon their world. The offices were at 24 Rue des Cordeliers, then in a house belonging to the Cabassols, at 13 Rue Boulegon.

Cabassol was as sharp and hard as his partner. The pair had their way of working together. If Louis Auguste thought a client had insufficient security, he'd ask, 'What do *you* say, Cabassol?' and Cabassol would shake his head. They made few mistakes. Louis Auguste was ruthless to debtors, whom he rated as lazy, negligent, prodigal or incapable, but he was ready to give time to those whom he knew to be thrifty and hard-working. A tale runs that he once erred in lending to a man of Marseille who was near bankruptcy; on learning the facts he moved in and ran the household in every detail for two years, till he restored the man's solvency and regained his loan with full interest. The account may be somewhat exaggerated, but doubtless reflects truly enough his remorseless grip on any situation involving money.

While still dealing in hats, he had met another young man, Louis Aubert, and may have employed him for a while. He persuaded Louis' sister, Anne Elisabeth Honorine, a tall comely woman, to live with him. The Auberts had been craftsmen at Aix for generations,

and Elisabeth was born there on 24 September 1814, her father a chairmaker, her mother a Girard of Marseille. The latter family seems to have had a romanticizing trend, making some claim to be linked with the Napoleonic General Girard, who, after playing his part in subduing the West Indian island of San Domingo, was said to have returned with a Negro wife. In fact the mother of Elisabeth had been born in 1779 to a labourer in the saltpetre works; and the tradition must have been sheer fantasy.

Elisabeth bore Paul and Marie to Louis Auguste before they were married on 29 January 1844; in 1854 she bore a second girl, Rose. Paul was born at one o'clock on 19 January 1839 at 28 Rue de l'Opéra. His father was living in the old building where he began as hat-dealer, a site separated from the rest of the Cours by the Rue des Grands-Carmes on the west and a narrow alley, the Passage Agard, on the east. In the alley a small door under the entrance arch led to the apartment upstairs; the alley itself was a short cut from the Cours to the Palais de Justice. Elisabeth however soon moved to join Louis Auguste; perhaps she had gone temporarily to the other house to minimize gossip. On February 22nd Paul was baptized in the parish church, with Auberts as godparents: his grandmother and uncle Louis. Marie was born in the alley apartment on 4 July 1841. Paul spent his first years in the Cours, the main street of Aix, a wide boulevard with a double row of elms (later planes) and ancient mansions, many already mouldering. Before they married, the Cézannes moved to a house in the Rue de la Glacière, a quiet, dim, winding street.

Aix had been at its most flourishing in the seventeenth and eighteenth centuries when the great families of the region built their houses on the Cours. The descendants of those families, some 700 names, were still living there a vegetative life amid their fine but shabbying furniture. Still in 1850 the Marquise de la Garde, who had been presented to Marie Antoinette at Versailles, liked to go out in a sedan chair on Sundays; but the only bearers she could muster were undertakers' men, whom she dressed up in her livery. But offices of the stage-coach and of carriers had intruded; plebeians held the north side of the Cours; and under Louis Philippe a Faculty of Letters and a School of Arts and Crafts, as well as secondary schools, were brought into the town, with gas lamps and a cattle market. But the families with great faded names had no wish to enter industry and compete at making hats and sweets. In any event Marseille had far outstripped Aix in trade and manufacture. In compensation Aix tried to keep up a leading role as an academic town, as the seat of an Archbishop and a Court of Appeal. The town was demonstratively devout, crowded with Franciscans and Jesuits. Priests and canons paraded in the Cours as well as professors and magistrates. Churches intruded their towers or belfries over the roofs, with red or yellow tiles, of houses crowded together for coolness; fountains were plentiful; and there was little sign of life behind the shuttered windows, charming ironwork, and stone caryatids. At night the paraffin lamps cast a soft glow over the streets, where in the poorer quarters grass grew among the cobbles.

Aix played a pervasively important part in the lives of Paul Cézanne and his friend Zola, who described it in his novels under the name of Plassans. Especially *The Fortune of the Rougons* and *The Conquest of Plassans* depicted in thorough detail the social situation there. The conservative elements much outnumbered the radical, but were divided into the old nobility, 'dead men finding life tedious', and the middle class smarting under their disdain. 'No town', wrote Zola, 'kept more fully the devout and aristocratic character that distinguished the old Provençal cities.' Class-distinction 'was long preserved by the separation of its various districts. Plassans has three of them, each forming, as it were, a distinct and complete borough, with its own churches, promenades, customs, and horizons.' In the one quarter with 'the straight streets overgrown with grass, the large square houses that hide extensive gardens at the rear', the nobility are 'hermetically immured. Since the fall of Charles X they scarcely ever go out, and when they do they hasten back to their big dismal mansions, walking along furtively as if in hostile country. They do not visit anyone, nor even receive one another. Their drawing-rooms are frequented only by a few priests.' The well-to-do traders and professions (lawyers, notaries) 'eagerly seek popularity, call a worker my good man, chat with the peasants on the harvest, read the papers, and walk out with their wives on Sundays.' But all the while they dream of an invitation to one of the noble houses. The awareness that this is impossible 'makes them proclaim all the louder that they are freethinkers; but they are freethinkers in words only, firm friends of the authorities, ready to rush into the arms of the first deliverer on the least sign of popular discontent.' The poorer class are composed of labourers, craftsmen, retail traders, even a few wholesalers, making up a fifth of the population. 'On Sunday after Vespers all three strands appear on the Cours.' Three quite separate currents 'move along this sort of boulevard planted with two rows of trees. The middle class merely pass through it; the nobility stroll on the south side with its mansions; the lower class frequent the cafés, inns, and tobacconists on the north'. Thus 'the nobility and the people promenade the whole afternoon, walking up and down the Cours without any one of either party thinking of changing sides. They are divided by six or eight yards, yet keep a thousand leagues apart.' Even in the revolutionary epochs they kept their distances.

The picture that Zola paints is one that must have sunk as deeply into Paul's mind during the long years they shared at Aix and in Paris. Zola's great series is based on the account of an Aix-Plassans family (though in turn Paris is taken into the panorama). The Rougons represent the unscrupulous middle class who play a key part in gathering the conservative opposition to crush the people; and in *The Conquest*, where the main family is based on the Cézannes, we see how a Bonapartist clerical agent brings about the effective union of the reactionary classes. Zola makes a powerful effort to grasp the inner meaning of 1848 and the following Bonapartist coup as the necessary prelude to an understanding of the world which he and Paul were seeking to penetrate. We glimpse 'for a moment, as in a flash of lightning, the future of the Rougon-Macquarts, a pack of ravening beasts unleashed and

gorged, in a blaze of blood and gold.' The society of the Second Empire has been founded. Louis Auguste, who as banker cashed in on 1848 and its aftermath, must have stood strongly in Zola's mind, and also in Paul's, as an emblem of the vocally-staunch freethinking Republican who was ready, at the first flicker of social upheaval, to rush to the arms of the authorities he criticized.

II *Childhood and Youth*

As a child of three or four Paul showed signs of an ungovernable temper; but as soon as the brief fits passed he became amenable, affectionate, cheerful enough. From the outset he was devoted to his sister Marie; and she in turn, almost as soon as she could walk, took to looking after and protecting him. But in the process of shielding she learned to manage, direct, and even bully; and this childhood relationship persisted to the end. In 1911 Marie wrote to Paul's son:

My earliest memory is this (perhaps you have heard the story from your grandmother): your father must have been about five years, he had drawn on the wall with a bit of charcoal a drawing that represented a bridge, and M. Perron, Th. Valentin's grandfather, exclaimed on seeing it: 'Why, it's the Pont de Mirabeau [over the Durance].' The future painter was already discernible.

Such stories could be told of countless children; it was in fact a long time before 'the future painter' could have been discernible to even the most prescient. Paul and Marie went to a primary school in the Rue des Épinaux, that of Tata Rébory. Paul stayed there for five years, till he was ten. Marie records:

Your father looked after me carefully; he was always very gentle and probably had a sweeter disposition than I, who, it seems, was not very nice to him; doubtless I provoked him, but as I was the weaker, he was satisfied with saying, 'Shut up, child. If I slapped you, I'd hurt you.'

At the primary school he met Philippe Solari, son of a stonemason, a gentle boy with whom he got on well. They played and wandered about the town, loitering at the fountains. The Cours was busy when coaches rattled in from Marseille, Avignon and the Var; and on market days the town saw the big wagons of red, yellow and green, and the blue-smocked herdsmen with cows and sheep from the slopes of the Trévaresse. Amid smells of pepper, garlic, olives, tomatoes and aubergines, men smoked clay pipes on the café terraces over their Palette wine. Then,

when he was about ten, he was sent as a halfboarder to the School of St Joseph conducted by a priest, the Abbé Savournin, and his lay brother. It was while he was there, I think, your father made his first communion at the church of Ste Madeleine. A quiet and docile student, he worked hard; he had a good mind, but did not reveal any remarkable qualities. He was criticized for his weakness of character; probably he allowed himself to be influenced too easily. St Joseph's School was soon closed; the directors, I believe, did not make a success of it.

Now to Solari as a companion was added Henri Gasquet, son of a baker in the Rue de Lapécède. A Spanish monk was said to have taught art at the school. Marie adds:

I remember hearing Mamma mention the names of Paul Rembrandt [?Veronese] and Paul Rubens, calling our attention to the similarity between the Christian names of these great artists and that of your father. She must have been aware of your father's ambitions; he loved her dearly and was no doubt less afraid of her than of our father, who was not a tyrant but was unable to understand anyone except persons who worked in order to get rich.

She gives no date for the anecdote; but it shows that at some fairly early date Paul's mother did not oppose, and even encouraged, a leaning to art. Mme Cézanne seems to have been the parent from whom he inherited something of his art sensibilities; he remained in close sympathy with her until her death. Through her the family subscribed to the *Magasin Pittoresque*, which must have been the first source of art images for the boy; we can be sure that Louis Auguste had no interest in such a periodical. Important clues to the character of the Cézanne household are given by Zola in his novels. He knew the family inside out and must have heard countless little stories and anecdotes about Paul's parents; in the manuscript notes for *L'Oeuvre*, he wrote of Claude Lantier (Paul): 'Born in 1842—mixture, fusion;—moral and physical preponderance of the mother; heredity of a neurosis turning into genius. Painter.' Marie wrote to her nephew: 'You are much better able than I to appreciate the artistic side of his [Paul's] nature and his art, which I confess is a riddle to me because of my ignorance', and no doubt her mother would have said much the same. She has been described as illiterate at marriage and unable to sign her name properly for some years afterwards; but in a book found in Paul's Lauves studio when he died—J. J. Marmontel's romance, *Les Incas, ou La Destruction de l'Empire du Pérou* (1850, first published 1777)—we find the inscription *H[onorine] Aubert 1850*. (It is hard to see why at this date she still used her maiden name.) But if little cultivated at the outset, she seems to have had a fine sensibility, an impulsive and intelligent mind, a lively imagination, in her tall, thin, strongly-built body with brownish colouring. She was interested in art magazines, encouraged Marie to acquire the accomplishments of a young lady, and then supported her son in courses that she must have known were anathema to her husband. She had probably given Paul *Les Incas*.

That there was a deep conflict between her and Louis Auguste, of the sort we should expect, is stressed by Zola in his sketches for *The Conquest*. For François Mouret, he says: 'Take the type of C.'s father, banterer [*goguenard*], republican, bourgeois, cold, meticulous, avaricious; picture of the interior; he refuses luxuries [*la luxe*] to his wife, etc. He is further a chatterbox, supported by fortune, and jeers at everyone.' We catch his very tones in the opening pages of the novel, where Mouret tells his wife how he has decided to make some money by letting the upper floor to a priest. His wife is unhappy at the intrusion.

He took his stand in front of her and interrupted her with a sharp motion of the hand. 'There, there, that will do,' he said. 'I've let the rooms, don't let's say anything more about the matter.' Then in the bantering tones of a bourgeois who thinks he has done a good stroke of business, he added, 'At any rate one thing is certain, and that is that I'm to get a hundred and fifty francs rent; and we shall have those extra hundred and fifty francs to spend on the house every year.'

Martha bent her head and made no further protests except by vaguely wringing her hands and gently closing her eyes as if to prevent the escape of the tears already swelling beneath her eyelids. Then she cast a furtive glance at her children, who hadn't appeared to hear anything of her discussion with their father. They were indeed accustomed to scenes of this sort in which Mouret, with his bantering nature, delighted to indulge. 'You can come in now if you'd like something to eat,' said [the servant] Rose in her crabby voice as she came up the steps.

'Ah, that's right, come along, children, to your soup!' called Mouret gaily, without appearing to retain any trace of temper.

It seems clear that Mme Cézanne saw and cherished elements in Paul which she felt to be callously thwarted in herself; and the boy's strong sympathy for her worked out as something of a self-identification with her predicament, contributing powerfully to his father-antagonism and his omnipresent anxieties. The mixture of good humour and severity in Louis Auguste is brought out by Coquiot: 'For some, Old Cézanne was a sort of Père Goriot, authoritarian, very shrewd, and miserly. . . . For others he was on the contrary a human specimen of the rarest kind.'

As a child Paul managed to get hold of an old paintbox. Vollard, the art dealer, says his father found it in an assorted lot from a pedlar, and, considering it of no value, gave it as a plaything to his son. Rivière, a writer who knew the impressionists, says a family friend made the gift. In any event Paul used it to colour anything he could lay hands on, especially the illustrations in the *Magasin*.

The in-turned strength of family relations must have been increased by isolation from the social life of Aix, such as it was. Louis Auguste had lived unmarried for some years with Elisabeth and had begotten two illegitimate children. He was an upstart, a plebeian who rapidly forced his way into the front ranks of the bourgeois of the town; his ready tongue, with its often keen mockery, and his republican views, cannot have endeared him to many of his fellow citizens. He himself found all the outlet he wanted for his energies, first in the shop, then in the bank; the family itself was for him a place of secure retirement, which he did not want connected with the life outside. Thus both the antagonisms and the alliances among its inmates were intensified. Though the union of Louis Auguste and Elisabeth was legitimized in 1844, soon after Paul's fifth birthday, the latter must have been aware of the situation, which would have deepened his sense of difference from the other boys. In a provincial town like Aix, with a strong closed hothouse atmosphere of scandal, and with sharply marked social differentiation, everything was known. The sneers of the better-born boys would not have been softened by the raillery or abuse they must have heard at home about the rising well-off Louis Auguste, who cared nothing at trampling on the feelings of a class or group not engrossed with money-making, the more lethargic sections of the bourgeois, the dowagers in silk dresses and the aristocrats with starched shirts.

Zola stresses the isolated nature of the Mouret-Cézanne household. Mouret keeps up his teasing and bantering all the while; he is extremely inquisitive about any gossip and wants to know as much as possible about all the people around. But at home he cuts himself

off from his outside interests; he dislikes his wife going out at all from the house and plays piquet with her, though she has no taste for the game; he gives her no money and she is driven to borrow from the servant.

In view of the importance of Louis Auguste in overshadowing the whole of Paul's life, the glimpses given us by Zola are of much interest. The following passage seems a direct transcript from the life of the Cézanne household:

Martha loved her husband with a sober unimpassioned love, but with her affection was mingled considerable fear of his jokes and pleasantries, his perpetual teasing. She was hurt too, by his selfishness, and the loneliness in which he left her; she felt a vague grudge against him for the quietude in which she lived—that very manner of life which she said made her happy. When she spoke of him, she said, 'He is very good to us. You've heard him, I daresay, get angry at times, but that arises from his passion for seeing everything in order, which he often carries to an almost ridiculous extent. He gets quite vexed if he sees a flowerpot a little out of place in the garden or a plaything lying about on the floor; but in other matters he does quite right in pleasing himself. I know he is not very popular, because he has managed to accumulate some money and still goes on doing a good stroke of business now and then; but he only laughs at what people say of him. They say nasty things too of him in connection with me. They say he's a miser and won't let me go out anywhere, even deprives me of boots. But all that is quite untrue. I'm entirely free. He certainly prefers to see me here when he comes home instead of finding me always off somewhere paying calls and walking on the promenade. But he knows quite well what my tastes are. What indeed should I go out for?'

As she defended Mouret against the gossip of Plassans, Martha's voice assumed a sudden animation, as though she felt the need of defending him quite as much from the secret accusations that arose within her own mind; and she kept reverting with nervous uneasiness to the subject of social life.

Paul's almost compulsive untidiness throughout life must be seen against the background of the stern father demanding that everything should be in its right place. It is significant that in what seems the earliest drawing we have of his, on the back cover of *Les Incas*, which his mother had probably given him, he drew the bust of a scowling heavily-shaded man and two delicate female figures, one of them merely a smiling face. He seems certainly to be expressing the conflict which hung over his whole life.

In 1852, at the age of thirteen, he became a resident boarder at the Collège Bourbon (now Lycée Mignet) as befitted the son of a solid citizen. The school, a big dull unfriendly structure with grey dilapidated front along the Rue Cardinale, had once been a convent. It was gloomy and damp inside; the plaster of the classrooms on the ground floor sweated; the refectory smelt of fat and dishwater; and the dim chapel (said to be built after Puget's design) mingled incense and the smell of mould. But there were two courts shaded by planes and a big mossy pool for swimming; and from the first floor the boys could look out on neighbouring gardens. Nuns were in charge of the sanatorium and of laundering. Here Paul stayed for six years (till 1858), though in the last two years he was a day scholar. Here apparently happened the accident to which he later attributed such importance in causing his fear of physical contact: he was kicked from behind by a boy sliding on the bannisters

and almost fell down the stairs. The occurrence, a common enough one, could not by itself have brought about his phobias; but the fact that it thus stuck in his mind suggests that already in those schooldays he felt himself deeply vulnerable, with some dizzying source of attack liable to come up from behind. Why he was made a full boarder at a school so close to his home is not clear. Did Louis Auguste hope to save money on domestic expenses, or did he want the boy in these first years of puberty out of his way?

However, the Collège had its compensations. Paul was freed from the bantering authoritative presence of his father—cut away also perhaps from the sense of security he found in that overbearing presence; and though he does not seem to have been able to find any ease in the collective life of the scholars, he gained a few friends, above all Emile Zola. Joachim Gasquet thus describes him standing before the building in his last years and descanting:

The pigs! Look what they've done to our old school. We are living under the thumb of the bureaucrats. It's the kingdom of the engineers, the republic of straight lines. Tell me, is there a single straight line in nature? They make everything conform to rule, city as well as countryside. Where is Aix, my old Aix of Zola and Baille, the fine streetlamps in the old suburbs, the grass between the cobblestones, the oil lamps? Yes, oil lamps instead of your crude electricity that destroys mystery, while our old lamps gilded it, warmed it, brought it to life *à la Rembrandt*.

The idiom is Gasquet's, and Cézanne was no favourer of mystery; but the general emotion of the outcry is certainly true.

Paul was a studious pupil, with a good all-round performance, and he gained many of the book-prizes with their stamped blue covers. In art he was not considered any good; all he managed was a first mention in painting in his second year, while Zola took several art prizes as well as being better at religion. The courses of which Paul seems to have been most fond were Latin and Greek; in Latin he excelled. Music was one of the subjects, but while Zola got first prize for wind instruments, Cézanne achieved no mentions. Marie tells us, 'he took no interest whatever in the music taught by a professor at home and often the descent of a violin bow on his fingers bore witness to M. Poncet's displeasure'. Poncet was organist and precentor of the Cathedral of St Sauveur; and Marie herself learned the piano as a genteel accomplishment. However, both Paul and Zola were in the school band organized by a classmate, Marguery. It played in the streets for festivals and processions, when 'the rain-bringing saints or the cholera-curing Virgin' were brought out; also, at the station, it gave 'the aubade to more than one functionary returning from Paris with the blue ribbon'. For their trouble they were fed on cakes. Marguery played the first cornet, Cézanne the second, Zola the clarinet. Henri Gasquet tells us that 'Zola and he [Paul] had the custom of performing a serenade for a pretty girl of the quarter, who owned as her sole fortune a green parrot. The parrot, driven crazy by the cacophony, made an unimaginable hubbub'. A postscript to the earliest letter we have by Paul (to Zola, April 1858) ends, 'I received your letter in which were the tender doggerels we had the honour of singing with the bass Boyer and the light tenor Baille'. Later, Cézanne developed a feeling for music, especially for Wagner,

but never drew from it the sustenance he drew from literature. His niece, Marie Conil, later recorded a family tradition of his flute playing, even if she got the chronology somewhat mixed-up. She said that after the house, the Jas de Bouffan, was bought (in 1859), Louis Auguste rented a country house for the family on the Route des Alpes, in the Quarter of the Planes. 'Paul goes down every morning to town by the old Roman road—and so the way may seem less long, he plays the flute—as he walks to the Collège Bourbon (now Lycée Mignet); in the evening he went back home with his father to the Planes.' The week's festival of Corpus Christi was one of the main events for band-playing. Citizens set out chairs on the pavement to watch the processions passing and draped their windows with bright hangings; monks and nuns escorted the red velvet canopy, followed by young girls in white and a crowd of penitents in blue hooded robes with eye-slits; children strewed the streets with broom-blossom and rose-petals.

Zola was in the eighth class at the age of twelve. Though small for his age, he stood out there, a head taller than the little boys. Shortsighted, he blushed when spoken to, and was in general what the others would pick out as a mother's-boy; indeed things were made worse by his mother and grandmother coming daily to see him. Among the Aixois he talked with a foreign (French) accent and lisp, and worst of all, was obviously very poor. He had been living in the poverty-stricken district near the Pont-de-Beraud; and when his mother had moved to the Rue Bellegard the situation was not much better. Though the family had kept changing houses and been hard up, he himself had lived a sheltered life, playing on the banks of the Torse amid happy dreams of animals and flowers. At the age of seven-and-a-half he had still hardly known the alphabet; but now he began a historical novel based on Michaud's *History of the Crusades*, and Paul, becoming his friend, discovered a new world of interests and fantasies. On half-holidays they went to the places where Zola had played as a child. Clearly town-children, they had stones thrown at them but did not care. (Zola had had his own traumatic experience of attack: when he was aged five, in 1845, his parents had dismissed an Arab servant, aged twelve, for sexual assault upon him.)

His father, whose ancestors had come from Zara in Dalmatia and who was himself a Venetian, was a romantic with a great zest for life. Once he saw a girl of nineteen coming out of Church, fell in love, pursued and married her. She was a Greek from Corfu. After the Austrians conquered Venice he went to Austria, Holland, England. At twenty-six he laid out in Austria one of the first European railways; later he served as an officer in the Foreign Legion in Algeria, but had to leave in haste through a disastrous love-affair. Arriving in Marseille in 1833 he settled nearby and worked on numerous large-scale projects, among which his grand-daughter listed:

a plan for fortifying Paris; the invention of various machines for scooping up earth, forerunners of our modern steam-shovels; the construction of a new port for Marseille; and finally the scheme, which was actually carried out, of a canal for supplying the city of Aix with drinking water in periods of drought.

Emile had been born in Paris in April 1840, but he was brought to Aix in 1843 when his father settled there with his wife (who chanced to have the same family name as Paul's mother: Aubert). Next year a royal decree authorized the canal, and at last in February 1847 the scheme in all its details was approved. A company with a capital of 600,000 francs was formed. But the improvident engineer, worn out by the protracted struggle, caught pneumonia and died at Marseille on 27 March 1847 at fifty-two. Zola never forgot the hotel room in the Rue de l'Arbre where he saw the body laid out, and for years the very word *death* crushed him. The canal was executed, and still operates with the dam, or Barrage Zola, at its head; Aix named a boulevard François Zola. But the widow inherited little more than a mass of debts and lawsuits. She stoutly fought to retrieve the situation with the aid of her parents, who came to join her at Aix.

After attending a primary school and the boarding-school of Notre-Dame, Emile entered the Collège Bourbon in October 1852 at the same time as Paul.

Gasquet tells us that Paul later said:

At school Zola and I were considered phenomenal. I used to knock off a hundred Latin verses just like that, for two sous. I was a businessman all right when I was young. Zola didn't give a damn about anything. He dreamed. He was stubbornly unsociable, a melancholy young beggar. You know, the kind that kids detest. For no reason at all they ostracized him. And indeed that was the way our friendship started. The whole school, big boys and little, gave me a thrashing because I ignored their blackballing. I defied them. I went and talked to him just the same. A fine fellow. Next day he brought me a big basket of apples. There you are. Cézanne's apples! they date back a long time.

As usual, Gasquet's citations do not ring quite true; but the substance of this passage is doubtless correct enough. The Aix boys did jeer at Zola as Towny, *Marseillais*, and Frenchie, *Franciot;* and he records in his *Confession of Claude* how miserable he was among his schoolfellows:

who were merciless, soulless, like all children. I must be a strange creature, capable only of loving and weeping, for I looked for affection, I suffered, from the very first steps I took. My years at school were years of tears. I had in me the pride of loving natures. I was not loved, for I was not known, and I refused to let myself be known.

He and Paul, as two hopeless outsiders, came together. And they found a few others with whom they could agree: Marguery, the bandleader, a boisterously gay fellow who as a lawyer later killed himself; Boyer who sang bass; and especially Baptistin Baille, two years younger than Paul but in the same class. In 1860 Zola described himself, Paul and Baille as 'all three rich in hopes, all equal in our youth, our dreams' (to Paul), and declared (to Baille), 'what we sought was wealth of heart and spirit, it was above all the future that our youth made us glimpse as so brilliant'. The trio jeered at the vice-principal with his long nose, nicknamed Pifard, at the never-laughing Rhadamante, at the cuckold You've-deceived-me-Adèle, at Spontini the Corsican usher always ready to show a dagger stained with the blood of three vendetta-slain cousins, at Paraboulemenos the scullion, and Paralleluca the

dish-washer. Baille was a capable plodder; Paul worked hard, 'almost painfully' (Gasquet), unsure of results through his emotional instability; Zola worked methodically and con-scientiously, but only just enough to get the needed results. He was the leading spirit, writing and declaiming verses, drawing up plans for the great future they all had as poets. The Cézannes had now moved to 14 Rue Matheron, close to the bank; and Paul must have gained his first intimations of a future other than that laid down for him by Louis Auguste. Through Zola the spirit of revolt and resolution was being born in him.

In *L'Oeuvre* Zola described the expeditions and exploits of the trio in a passage that preserves the spirit of those young days. For both him and Paul the memories of their summer wanderings were of incomparable importance; in them they found a touchstone of happy union and imaginative liberation by which they tested and judged all later experiences; to them they returned as to a source of pure freedom and inspiration. They felt that in those days they had known truly a communion of spirits which was also a communion with the earth.

While still children, in the sixth form, the three inseparables had a passion for long excursions. They took advantage of every holiday, they discovered new spots, they grew bolder in growing older, till at last they rambled over the whole countryside in expeditions that finally lasted several days. They slept wherever night happened to catch the sun's heat, where the beaten straw made them a soft bed, in some deserted hut with a floor which they covered with a pile of thyme and lavender. These were escapes from the world, the unconscious love of children for trees, streams, mountains, for the boundless joy of being alone and free.

Debuche [Baille], who lodged at school, joined the others only during holidays. . . But Claude [Cézanne] and Sandoz [Zola] never grew tired, and one would wake the other every Sunday at 4 a.m. by throwing stones at the shutters. Most of all in summer they longed for the Viorne [Arc], the river whose slight trickle waters the meadows round Plassans [Aix]. When hardly twelve, they learned to swim; and they loved to dabble in pools with deep waters, to pass whole days naked, drying themselves in the hot sand, only to plunge back again, to live in the water, on their backs, on their bellies, exploring the grasses along the river banks, submerging themselves ear-deep, and watching for long hours the lairs of the eels. This trickle of pure water which kept them moist under the hot sun prolonged their childhood, gave them the merry laughter of truant kids when as young men they returned to town in the oppressive heat of July evenings.

Later they took up hunting, but hunting as it is carried on in that gameless land, six leagues of stalking to get half a dozen warblers, tremendous expeditions from which they often came back with empty pouches or with an imprudent bat brought down when they unloaded their guns on the town outskirts.

Paul was an even less enthusiastic hunter than Zola's Claude. But he was getting the landscape burned into his system; and the memories of the river bathes were to drive him in time to his unending attempt to paint male and female bathers. The emotions of happi-ness, freedom, uncorrupted union, were all indissolubly merged with the forms of Provençal nature, with its vital elements of light, colour, heat, smell, texture, with its flowing inter-relations, its stark structures. The pictorial or plastic aspects were one with the sense of poetic liberation and pure human contact. Paul's life, from one angle, was a long struggle to recapture these experiences in terms of a highly complex organization of art imagery, and

once we see only the complex organization and forget the dynamic experiences behind it we falsify his aims and achievements at their root.

Tears came into their eyes at the recollection of these orgies of walking. They saw once more the white roads, interminable, covered with a layer of dust like a thick fall of snow. They followed these roads, happy to hear the scuffling of their heavy boots; then they cut across the fields, over the red earth tinged with iron, where they tramped on and on; and a blazing sky, not a speck of shade, nothing but olive and almond trees with meagre foliage; and each time they came home, the delicious relaxation of weariness, the triumphant boast of having walked further than the last time, the joy of being at last unaware of their steps, of plodding mechanically on, driven by blood-curdling marching-songs, which they found as soothing as dreams.

Already Claude carried, between powder-horn and cartridge-box, a sketchbook in which he drew bits of landscape, while Sandoz had a book of poetry in his pocket. It was a romantic frenzy, winged verses alternating with barrack-room bawdries, odes tossed to the luminous vibrations of the burning air. And when they chanced on a spring, four willows making a blotch of grey against the intense colour of the earth, they let go to the limit, they acted plays which they knew by heart.

In this remote country district, in the somnolent dullness of a small town, they had thus from the age of fourteen lived in isolation, swept by a fervent passion for literature and art. At first the gigantic conceptions that appear on the huge stage of Hugo in the midst of·the eternal strife of opposites enchanted them, drove them to make grand gestures, to watch the sun set behind ruins, to see life pass by under the false and superb illumination of the fifth act. Then Musset came to overwhelm them with his passion and his tears. They could hear their own hearts beating in him; a more human world was opened, overcoming them by pity, by the eternal cry of distress that they would always thereafter hear mounting on all sides. They were not really hard to please, they showed youth's voracity, a prodigious appetite for reading, swallowing impartially the best and the worst, so anxious to admire that often the most execrable works threw them into the same exaltation as a true masterpiece.

This love of nature and poetry, Zola insists, saved them from being caught and crushed by the town's philistinism. In his notes he states, 'No cafés, no women, life in the open air: that saved them from the provincial stupor [*bêtise*].' *L'Oeuvre* expands the idea:

And as Sandoz said, it was the love of long tramps, it was this hunger for literature, which saved them from the deadening influence of their surroundings. They never went into a café, they professed a loathing for streets, asserting that in them they pined away like eagles in a cage, while their comrades were already soiling their schoolboy sleeves on little marble tables and playing cards for drinks. This provincial life that took hold of children while they were still young, the local club, newspapers spelt laboriously out to the last advertisement, the everlasting game of dominoes, the same stroll at the same hour in the same street, the final degeneration under the millstone that ground one's brain flat, infuriated them, pushed them to revolt, to clamber up the near hill-slopes as to find some hidden refuge, to shout verses under the driving rain without seeking shelter, because of their hatred of towns.

They planned to camp out on the Viorne's banks, to live like savages, to do nothing but swim, taking along some five or six books, not more, which suffice for their needs. No woman would be allowed there; they suffered from timidities, awkwardnesses, which they idealized in their own minds as the chastity of superior young men. For two years Claude [Paul] had been consumed with love for a milliner's apprentice, whom he followed daily at a distance; but he never plucked up courage to speak to her. Sandoz had visions of ladies he would meet on his travels, lovely damsels who'd suddenly appear in some unknown forest, give themselves to him for a day, then vanish like ghosts at twilight. Their one gallant exploit still made them laugh, it seemed so silly:

serenades played to two young girls when they were members of the school band; nights spent in playing clarinet and cornet under a window; horrible discords that scared the neighbours until the memorable evening when the exasperated parents emptied all the chamberpots in the house on their heads.

These days left an indelible imprint on both Paul and Emile. The latter never tired of recalling them. He did so in *The Confession* and also in occasional writings like the essay on de Musset. With Paul, a painter, the Provençal earth, soaked as it was with the emotions which Zola sets out, had a yet more direct force and significance for his work. But we must note that the lads, though they did not know it, were thoroughly contemporary in their attitudes. In the summer of 1847 Flaubert and Maxime Du Camp had wandered in the wilds of Britanny with staff and knapsack, and found 'true freedom' in their tramping; in 1849 the De Goncourts, dressed as poor art students, went walking across France; in 1850 Courbet declared, 'In our over-civilized society, I must lead the life of a savage; I must free myself from governments . . . I have therefore just started out on the great wandering and independent life of the gypsies'; in 1854 his friend Pierre Dupont published a hymn to the joys of the open road; he also wrote *Chants Rustiques* and a novel *Les Paysans*. Another friend, Max Buchon, collected rural poems in France and translated those of Germany. Sue published his *Wandering Jew* in 1844–5; here the homeless wanderer embodied working-class protest against oppression. Dupont tried to point the moral yet more sharply in a verse-exposition ending with a utopian vision of liberated earth. Courbet in 1850, in a lithograph with verses, devised the image of the wandering *Apostle Jean Journet Setting out for the Conquest of Universal Harmony*. However, the most powerful definition of the wanderer as the hero turning from the dehumanizing life of the cities, as the true independent, as the disseminator of the message of a fraternal earth, appeared in Courbet's large canvas, *Bonjour M. Courbet*, where the theme, ostensibly that of the painter welcomed with the utmost respect by a patron with servant, was iconographically that of the Wandering Jew met by Two Burghers—as shown in popular prints. (His friend and supporter Champfleury made an important study, *Popular Imagery*, published in 1869; he had been working on the section about the Wandering Jew at least twenty years earlier. Balzac, it is worth noting, had called himself the Wandering Jew of Thought, 'always afoot, forever on the move, with no rest, no emotional satisfaction', and Shelley had a lifelong obsession with the image of the Jew.) Amiel in his *Journal*, 13 August 1865, related hiking to the whole complex of attitudes introduced by Rousseau. 'He it was who founded travelling on foot before Töpffer, reverie before *René*, literary botany before George Sand, the worship of nature before Bernardin de St Pierre, democratic theory before the Revolution of 1789. . . .'

The Dam was naturally a place of pilgrimage for Zola. The trio also often trod the road running east from Aix to Le Tholonet, a village with a few cottages and a church like an abandoned farm. To the south lay the red lands: still bloody, according to legend, from the

slaughter of the barbarians by Marius' legions. To the north was the Infernets Gorge and the Dam amid the thorny scrub and aromatic herbs of the stony hills. The lads climbed the pine-slopes loud with cicada past the Gothic-windowed Château Noir—the Château of the Devil, since an alchemist had once dwelt there—on to the Bibémus quarry overlooking the Dam. (The quarry, exploited since Roman days, supplied the soft warm-hued stone that composed most of the Aix houses and gave them their hint of sunglow.) From the hills they gained vistas of the red-land vineyards, the meadows of the Arc, and a lake covering 400 acres, stretches of sterile hills, with the far grey shapes of the Ste Baume and the Étoile chains. And, rising high, towered the blue cone of the Mont Ste Victoire. Perhaps it was the way they saw it from the hilltops which gave Paul the liking for a high view of the motif in his later paintings—an angle which draws up the background and brings the planes of distance together. At Aix they had their laboratory in Baille's house, in a big room on the third floor, 'full of old journals, engravings trampled underfoot, chairs with bottoms out, tottering easels,' and raisins hanging to dry from the roof. They were much impressed by the passage of troops through the town on the way to Marseille for embarkation in the Crimean War. The Aixois billeted the troops with reluctance; the authorities had to coerce them. The boys turned out on to the Cours at 4 a.m. to watch the departures and accompany the soldiers for a while, admiring the uniforms and the cuirasses in the rising sun. This year Baille got the first prize for excellence; Paul the second, plus a first for Latin prose and a second for Greek, a second mention for history and for arithmetic, and a first for painting; Zola got a second mention for excellence in his class. The latter had recently gained a bursary, to his mother's relief; his family had now moved to the Rue Roux-Alphéran.

In 1856, as we saw, Paul and Emile ceased to be boarders. They each got a prize for excellence in their respective classes; Paul got first class for classics, Baille first class for drawing and Zola second. When Baille could not join the other two on their walks, they took Solari, Marius Roux, or Baille's young brother Isidore, who was permitted to carry the knapsack. But mostly Paul and Emile were content to wander on their own. One night they tried to sleep in a cave on beds of herbs; but as soon as they went to sleep the wind came up and whistled into the cave. Awoken, they saw bats flitting overhead and longed for home; by 2 a.m. they gave up and went off. Among the haunts they found was the road to the Château de Galice with its lovely garden, or that to Gardennes with its houses on a mound, the church highest of all.

There were many differences between the ardent Zola and the diffident Paul with his veering moods; but as Zola wrote in *L'Oeuvre*, 'Opposed in nature, they were bound together at one blow and forever, drawn by secret affinities, the still vague torment of a shared ambition, the awakening of a superior intelligence, in the midst of the brutal mob of abominable dunces against whom they fought'. Zola himself was the leader of the fervent forays into the free earth of poetry; Paul followed, now and then outdoing him in reckless-ness and the intoxication of the moment; Baille played an accommodating role as well as he

could. When Zola painted the bright future of three youths of genius, Paul was liable to react with gloom. 'It is indeed black, the sky of the future.' And when he had any cash, 'he hurried to get rid of it before going to bed'. When asked by Zola the reason for this prodigality, he replied, '*Pardieu*, if I were to die tonight, would you want my parents to inherit?' Something of the obsessive fear that was to dog him seems already to unnerve his hands at the touch of coins; a father-antagonism speaks in the retort he made: a growing opposition to his father on the crucial money question as well as a linking of money anxiety and death-fears, which was to remain constant with him all his years. It seems that about this time Louis Auguste realized that there was little hope of drawing him into the bank, and began to urge a legal career as the next best step.

He began going to the free Drawing School which had existed at Aix, thanks to a Duc de Villars, since 1766. In 1825, when the town took over the old Priory of the Knights of St John of Malta and turned it into a Museum, the School was transferred there. Classes were under the Museum's director, Joseph Gibert, who, born at Aix in 1808, was a strictly academic artist painting portraits of prelates, generals, ministers, even Spanish infantas. Solari, that amiable fellow, aspiring to be a sculptor, attended; and Paul began to come in the evenings from November 1858. Louis Auguste, apparently thinking that Paul would learn drawing as a mere genteel accomplishment, made no objection; Marie was turning out her little watercolours. The classes, Louis Auguste no doubt thought, would keep Paul from lounging in cafés and chasing girls.

At the School he met others besides Solari who looked forward to making a career of art: Numa Coste, son of a poor cobbler, three-and-a-half years his junior, who, employed at the free school of the Brothers of the Christian Doctrine, was struggling to educate himself— he became a lawyer's clerk; Auguste Truphème, brother of a sculptor; Joseph Villevielle, ten years Paul's senior, who had been a pupil of Ingres' friend, Granet, and who was now a hard-working conventional painter; Chaillan, another mediocre painter; Joseph Huot, whose father, beginning as a cameo-engraver, had become town architect at Aix. Huot had many interests: the theatre as well as drawing and architecture. We may assume that, as a result of attending the School, Paul began looking seriously at the pictures and sculptures in the Museum. There was nothing outstanding, but the items included several works of seventeenth-century Baroque painters of France and Italy. One work, *The Card Players*, attributed in the catalogue to Louis Le Nain and probably of his school, seems to have attracted him; there were also works by Granet, an Aixois, *The Prisoner of Chillon* by Dubufe, and Frillie's *Kiss of the Muse*.

Zola was a keen attendant at the performances, thrice a week, of the Repertory Company at Aix; it is likely that Paul accompanied him to the old-fashioned melodramas. Zola at times went without his dinner so as to be at the head of the box-office queue; at school he wrote a farce, *Enfoncez le Pion*, as well as two verse-plays, each in one act: *Perrette* and *Il faut hurler avec les loups*. He was reading Montaigne and Rabelais.

In October 1857 Paul and Baille moved up to the first class, Zola to the second. Paul had first prize for excellence; Zola likewise in his class, with firsts also for religious instruction and drawing. Zola did very well at French Composition and his new master, impressed by an exercise carried out in verse, said, 'You'll be a writer, Zola'. Meanwhile his family was moving round: in the Cours des Minimes, on the town-outskirts, then in the Rue Mazarine with two rooms opening on an alley, of which one end abutted on to the old town ramparts. Nearly all the furniture had been sold; and in November Mme Zola's mother, a tireless old lady without a single grey hair, died. Mme Zola left for Paris, her father looking after Emile. Then in February 1858 she wrote: 'Life in Aix is no longer possible. Sell the four pieces of furniture we still own. The money will suffice to buy third-class tickets for you and your grandfather. Hurry. I'm waiting for you.' After a farewell visit to Le Tholonet and the Dam, Emile dashed off with many fervent promises of reunion.

III *Parting (1858)*

MME Zola was hoping to get help from some of her husband's friends; and Labot, attorney to the Council of State, gained Emile a scholarship at the Lycée St Louis, in the science department. The lad, now eighteen, entered there on March 1st. Paul wrote on April 9th a letter which serves to show how truly Zola caught the essence of their youth in *L'Oeuvre*, *Confession*, and other writings.

Good day, dear Zola:

> So I take up my pen,
> Following my habit, then
> I tell you first of all
> As local news the town
> Had rain come pouring down
> Out of an ardent squall.
> This fertilising stream
> Makes the Arc's banks now teem
> Gaily as showers fall.
> And while the slopes are seen,
> Our countryside of green
> Rich with the Spring's own clusters,
> Sprouting the place is found
> And leafily is crowned
> Green hawthorn with its whitening lustres.

I've just seen Baille, this evening I'm going to his country house (it's Baille senior I mean), so I'm writing to you.

> Misty the days arise
> In sombre and rainy wise,
> And now the sun expires.
> No longer from the skies
> He scatters for our eyes
> His ruby and opal fires.

Since you left Aix, my dear chap, a dulling regret has overwhelmed me; I'm not lying, my faith. I don't recognise myself any more, I'm heavy, stupid, and slow. By the way, Baille told me that in a fortnight he'd have the pleasure of putting into the hands of your most eminent greatness a sheet of paper expressing his regrets and griefs at being cut off from you. Truly I'd love to see you and I think I will see you, I and Baille (of course) in the holidays, and then we'll perform, we'll put into action the projects we've planned, but meanwhile I lament your absence.

> So Emile dear, goodbye.
> Not now, where waves rush by,

So gaily follow I
As once in the warm weather
Our quick arms would we ply
Snakily and defy
The docile waves, and try
Our swimming games together.
Goodbye, you happy days
Tasting of wine, I praise
Our lucky fishing-ways
When monster fish we took.
Now when to fish I go
And drop my line below
Where the cool waters flow,
No frightful thing I hook.

Do you recall that pine, planted on the Arc's banks, that stuck out its comose head over the gulf extending at its feet? That pine which shielded our bodies by its foliage from the sun's ardour, ah may the gods preserve it from the deadly stroke of the woodman's axe!

We thought you'd come to Aix for the holidays, and that then, *nom d'un chien*, then what joy! We have planned monstrous hunts, as hideous as our fishings. Soon, dear chap, we're off after fish again if the weather keeps up, it's magnificent today, for I'm finishing my letter on the 13th.

Phoebus pursues his course, a splendid sight,
And bathes the whole of Aix with waves of light.

Unpublished Poem

There in a wood's retreat
I heard her splendid voice
Sing and three times repeat
A song that made me rejoice
 On the air of a pipe etc.

A maiden I beheld,
And a fine pipe had she.
With her charms I was so spelled
A shiver ran over me
 For a pipe etc.

Wonderful grace she shows
And a gait of majesty.
On her amorous lips there goes
A gracious smile O see,
 Gentle pipe etc.

I resolve then to be bold,
I accost her, swaggering.
This tender chat I hold
With the delightful thing,
 Gentle pipe etc.

Have you not come, I sigh,
O beauty that I bless,
From cloudlands up on high
To bring me happiness,
 Pretty pipe etc.

Your goddess-shape, your arms,
Your arms, your brow—each sign—
The delicacy of your charms,
All seem in you divine,
 Pretty pipe etc.

Your step is light and clear
As when a butterfly goes
Outstripping far, my dear,
The northwind as it blows,
 Pretty pipe etc.

With the imperial crown
Your brow should now be crowned,
Your calf (as I glance down)
Seems finely filled and round,
 Pretty pipe etc.

Thanks to my flattery, pat,
She swoons on the forest floor,
And while she's lying flat
Her pipe I well explore,
 O sweet pipe etc.

Then she's revived at last
By all my strenuous love,
Surprised but not aghast
To find me stretched above,
 O sweet pipe etc.

She blushes and sighs away,
Lifts languid eyes again,
Which seems indeed to say:
She doesn't much complain,
 Gentle pipe etc.

And when our pleasure dies,
It's not 'enough' she cries.
Feeling me re-begin,
She says, 'Go deeper in'.
 Gentle pipe etc.

Ten or twelve times I come,
Then my rapier out I take;
But waggling still her bum,
'Why stop, for heaven's sake?'
 Says this pipe etc.

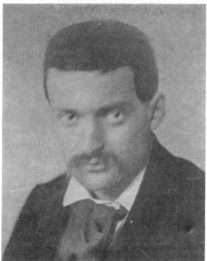

1 (above) Cézanne in 1861
3 (below) Portrait of Fortuné Marion, *c* 1866

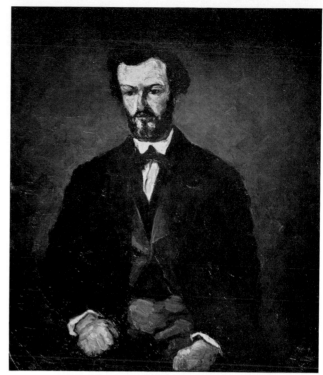

2 Portrait of Antony Valabrègue, *c* 1866

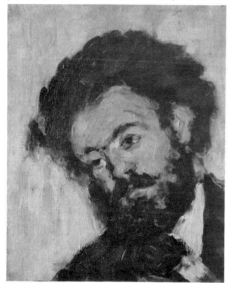

5 A Corner of Cézanne's studio, *c* 1866

4 The Conversation,
1866–68

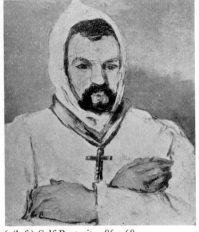

6 (left) Self Portrait, 1865–68
7 (above) Uncle Dominique, 1866

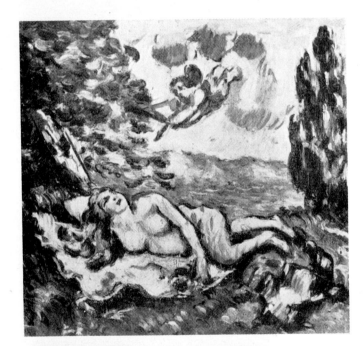

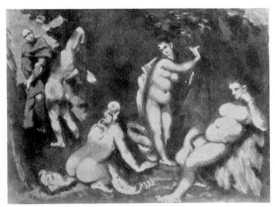

8 (left) Venus and Cupid, *c* 1873
9 (above) The Temptation of St Antony, *c* 1869
11 (below) A Modern Olympia, 1870

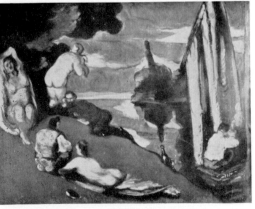

10
Pastoral,
1870

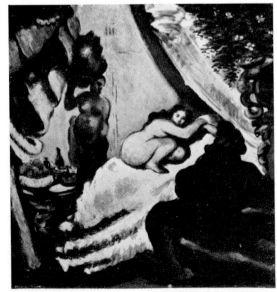

Mirliton, pipe, had a slang use for the nose; but here Paul employed it for another part of the anatomy. He added a postscript about some other Aix schoolfellows who had gone to Paris; and in acknowledging verses from Zola he repeated the term *mirlitons*, now meaning doggerel or idle ditties.

Zola's answers to Paul in this period are lost; but on May 3rd the latter wrote again in the same high spirits. He began with a drawing and a rebus, then went on:

Are you well? I'm very busy, *morbleu* very busy. This will explain the absence of the poem you asked for. Believe me, I'm most extremely contrite being unable to reply with a verve, a warmth, an animation equalling yours. I love the savage phiz of the principal. (The one in your letter I mean, there must be no confusion.) By the way, if you guess my famous rebus you'll write to me what I wanted to say. Do one for me too *si tempus habes*.

I gave Baille your letter. I also gave Marguery his. Marguery is as dull as ever. And now the weather has suddenly grown colder. Goodbye to swimming.

> Goodbye, fine swims, no more
> We'll try the laughing shore
> And by the currents bask
> As on the strand the stream
> Brings up the wave—my dream
> No better wave could ask.
> The water, muddy and red,
> On sloshy earth outspread,
> Is driving, dragging still
> The plants uptorn and reft,
> The broken branches left
> To the wild current's will.
> And then the hail comes pelting!
> Soon we see it melting
> And mingling in its play
> With waters black and grey.
> Torrents of endless rain
> Which earth dries out again
> Make streams that gush away.
> Here's rhyming with no reason.

My friend, you know, or else you do not know,
A sudden love has burned me up, I'm done.
You know whose charms it is I cherish so.
A pretty woman is the one.
Brown is her skin and gracious are her ways,
Quite small her foot, her hand, in form so fine, For she was
Is doubtless white, as in my loving daze wearing gloves.
I trust, inspecting her full length divine.
Of supple alabaster her lovely breasts
Have been well turned by love. The wind in raising
Her robe of splendid-coloured gauze attests
A richly rounded calf. We guess the pleasing
Contour . . .

At the moment I am opposite Boyer on the second floor in my own room. I am writing in his presence and I command him to write a few words in this letter with his own hands:

> [Boyer writes] May your health be sound and true,
> And love still bring you happiness.
> Nothing like being in love can bless,
> And that is all I wish for you.

I warn you that when on your return you come to visit Cézanne, you'll find against the tapestry of his room a large selection of maxims culled from Horace, Victor Hugo, etc. Boyer, Gustave.

[Paul resumes] My dear chap, I'm studying for matriculation. Ah, if I had matric, if you had matric, if Baille had matric, if we all had matric. Baille at least will have it; but I—sunk, submerged, done-for, petrified, extinguished, annihilated, that's what I shall be. My dear chap, it's 5th May today, and it's raining hard. The cataracts of the sky are open.

> Lightning has furrowed deep the cloud.
> And in the inane rrrols thunderrr grrrowling loud.

There's more than two feet of water in the streets. God, irritated by the crimes of the human species, has doubtless decided to wash away their numerous iniquities with this fresh deluge. For two days this horrible weather has lasted. My thermometer is 5° above zero and my barometer indicates heavy rain, tempest, and storm for today and all the rest of the quarter. All the town's inhabitants are plunged in deepest gloom. Consternation can be read on every face. Everyone has contracted features, haggard eyes, a scared look, and presses his arms to his sides as if afraid of knocking someone in a crowd. Everyone goes about reciting prayers; at the corners of every street, despite the beating rain, groups of young maidens can be seen, who, no longer dreaming of their crinolines, strain their voices by hurling litanies heaven-high. The town echoes with their inexpressible *brouhaha*. I am deafened by it. I hear nothing but *ora pro nobis* resounding on all sides. I myself have made some pious *pater noster* or even *mea culpa*, ter, quater, quinter, *mea culpa*, follow on the impudent *mirlitons* and the atrocious hallelujahs, thinking by a happy return to make the very august Trio who reign above forget all our past iniquities.

But I note that a change, forever sincere, has just appeased the anger of the Gods. The clouds are breaking up. The radiant rainbow shines in the celestial vault. Goodbye, goodbye, P. Cézanne.

The playful semi-blasphemous tone, with perhaps an undercurrent of genuine fear, makes the Trinity itself a reflection of the earthly Trio. As for the dreaded exams, Paul did fail at first, but later in the year managed to pass. In a letter of the 29th of an unstated month, he returns to the theme of unrequited love.

My dear chap, It was not only pleasure your letter gave me, its receipt brought me a further sense of wellbeing. A certain inner sadness fills me, and dear God, I do nothing but dream of the woman I spoke to you about. I don't know who she is. I see her sometimes passing in the street when on my way to my monotonous college. I have reached the stage of heaving sighs, but sighs that do not externally betray themselves. They are mental sighs.

The poetic piece you sent delighted me. I greatly appreciated finding that you recalled the pine tree that shades the outskirts of Palette [a small village on the Arc near the Nice highway]. How I should like, cruel fate that separates us, how I should like to see you coming. If I didn't hold myself back, I'd hurl some litanies of God's Name, God's Brothel, Holy Whore, etc., up to heaven. But what's the use of getting angry? That wouldn't get me any forrader, so I resign myself.

Yes, as you say in another piece no less poetic (though I prefer your one about swimming), you are happy, yes *you* are happy, but I, miserable wretch, I wither in silence, my love (for it is love I feel) cannot find an outer expression. A certain dejection goes with me everywhere, and it's only for moments I forget my sorrow: when I've had a drop. And so I used to love wine, I love it even more now. I used to get drunk, I'll get drunk even more now, unless by some unexpected stroke of luck—hey ho, I might succeed, *nom d'un Dieu*! But now, I'm in despair, in despair, so I'm trying to besot myself.

Then he mentions his artwork. He has made a sketch which is a parody of the grand manner, and which he grandiloquently expounds.

> *Cicero*
> *blasting Catalina*
> *after having exposed the conspiracy*
> *of that citizen lost to honour.*
> Admire the force of language, my dear friend,
> Wielded by Cicero blasting this bad person.
> Admire too Cicero, whose burning eyes
> Throw out those glances venomous with hate
> Which bear down Statius hatching out his plots
> And stupefy his foul accomplices.
> Consider, friend. Look well at Catilina
> Who falls to earth exclaiming loud, 'Ah! Ah!'
> See the bloody dagger that this man of arson
> Wears at his side with sanguinary blade.
> See the spectators upset and terrified
> At being so very nearly sacrificed.
> And do you note the Standard which of old
> Broke African Carthage with its Roman purple?
> Though I'm the one who made this famous picture
> I shudder at such an excellent spectacle,
> At every word that bursts from Cicero
> (I'm scared, I tremble) all my blood's on fever,
> And I foresee, I'm thoroughly convinced,
> You too will quail at such a striking sight.
> Impossible otherwise. The Roman Empire
> Never produced another thing so imposing.
> Behold the floating plumes of cuirassiers
> Tosst up into the air by the wind's breath.
> See too O see the big display of pikes
> That the Philippics' Author here has set,
> And you will find I think a novel vision
> In thus revealing how the Signpost looks:
> *Senatus, Curia*. Ingenious notion
> For the first time arrived at by Cézanne,
> O sublime spectacle that astounds all eyes
> And whelms the gazer with extreme surprise!

But enough of revealing to you the incomparable beauties contained in this admirable watercolour.

The weather improves, though I'm not sure if it will keep up. What is certain is that I am burning to go

> And be a swimmer brave
> Cleaving the easy wave
> Here of the Arc,
> Or, as the ripples lave,
> Catch every fish that offers me a mark.
> Amen amen, these stupid lines I waive.
> They don't show much of taste,
> Stupidly they behave,
> In fact they're just a waste.
> Goodbye, Zola, goodbye.

I see that after my brush my pen can say nothing worthwhile and today I'll attempt in vain:

> To sing some woodland nymph would be my choice,
> But I don't own the right melodious voice.
> The beauties of the rustic scene I find
> Prompt in my songs the aspects least refined.

I'm stopping at last, for I only heap imbecilities on stupidities.

> As one sees rise to heaven up-piled absurdities
> On top of more stupidities.
> Now that's enough.

The drawing makes no attempt to depict a Roman scene. The setting is roughly medieval with the senators as French judges, Cicero and Catalina in modern types of uniform; and Cicero's eloquence is shown as a blast of wind actually knocking Catalina down flat. Paul must have been reading at school the speeches of Cicero against Catalina; he puts in one corner the Latin text of the opening sentence of the first oration: 'When, Catalina, do you mean to cease abusing our patience?' When we recall that his father was now trying to drive him into a legal career, we see that the figure of authority (Cicero, the great man-of-law, Louis Auguste) is rebuking the rebel (Catalina, Paul) for his backsliding, his failure to grapple with his career and vindicate himself respectably in the eyes of the world. The rebel is the son who in his previous letter to Zola had expressed his despairing resolve to besot or brutalize himself (*m'abrutir*) and who in his innermost being was rejecting the Law with all his might. The drawing however is clumsy and much less expressive than the mocking verses; we can understand why, when this was the best that Paul could produce at the age of nineteen, he found it hard to convince himself he was an artistic genius.

The next letter, of July 9th, is a rambling mixture of doggerel, confused revolt, and day-dreams about girls. It opens with a challenge to Zola to compose a poem out of a number of offered rhymes; and we may note that the first word which comes at random to his mind is *révolte*.

Carissime Zola, Salve.

> *Accepi tuam litteram, inqua milis dicebas*
> *te cupere ut tibi rimas mitterem ad bout-rimas*
> *faciendas, gaude ; ecce enim pulcherrmias rimas.*
> *Lege igitur, lege, et miraberis!*

révolte	*Zola*	*métaphore*	*brun*	*vert*	*bachique*	*boeuf*
récolte	*voilà*	*phosphore*	*rhum*	*découvert*	*chique*	*veuf*
	aveugle	*chimie*	*uni*	*borne*		
	beugle	*infamie*	*bruni*	*corne*		

As to the above-cited rhymes you have permission to put them in the plural, if your serenissimo majesty thus decides: *secundo*, you can put them in any order you like; but *tertio*, I demand alexandrines from you, and finally *quarto*, I want, no I don't want but I beg you, to rhyme the whole lot, even Zola.

Here are some little verses of mine I find admirable, because they are mine, and the excellent reason is that I am their author.

Little Verses

> I see Leydet
> Going his gay way
> Gripping his donkey
> Galumphing along
> He goes with a song
> Under a planetree.
>
> The hungry beast
> Seeking a feast
> Lifts to the branches
> Glad mad and strong
> A neck rather long
> And happily munches
>
> Boyer brave boy
> Goes hunting in joy,
> In his pocket he slips
> A blackfeathered snipe:
> For the spit it is ripe
> As down its blood drips.
>
> Zola goes swimming
> Courageously skimming
> Where the waters gleam,
> With arms of vigour
> He cuts a fine figure
> On the pleasant stream.

Very misty weather today. O, here you are, I've just made up a couplet, listen:

> Let's praise now the sweetness
> of the divine bottle.
> Its goodness and greatness
> warm me up down the throttle.

That must be sung to the tune of Let's praise now the sweetness of a cherished mother etc. Dear lad, I do truly believe you must be sweating when you tell me in your letter:

> Your brow indeed was wet with sweat and burning,
> Enveloped by the vapour born of learning
> Breathed right to me by foul geometry
> (Don't take to heart this cruel infamy)
> If thus I qualify
> Geometry
> As hopelessly I struggle on to study,
> Dissolving into water steams my body.

Dear lad, when you have sent me your bout-rimé,

> In them adorable, I think, are you:
> Incomparable in other verses too.

I'll set about questing out further rhymes, richer and more disconnected (*difformes*) ones. I prepare them, I elaborate them, I distil them in my alembic brain. They will be new rhymes, ahem, rhymes such as one scarcely ever sees, *morbleu*, in short, accomplished rhymes.

Dear chap, after starting this letter on July 9th, it's only right to finish it off today the 14th, but alas in my arid wits I don't turn up the least little idea, and yet how many themes would I find to discuss with you in person, hunting, fishing, swimming, there you are, you, the variety of themes, and love (*Infandum*, let's not touch on that corrupting theme).

> Our soul, ingenuous yet,
> Is timid, has not set
> Its feet against the edge
> Of the steep cliff: we sway
> And slip as oft we stray
> In this corrupting age.
> I have not raised in pledge
> To my still-innocent lips
> The deep voluptuous bowl
> Which to satiety grips
> The drinking lover's soul.

There you are for a mystical tirade, ahem, well now, it seems to me that I can spy you reading these soporific verses, I can see you (though you're rather far away) shaking your head and remarking, 'Poetry doesn't quite chime with him'. Letter finished, the 15th in the evening.

Song in your Honour

> (I sing here as if we were together dedicated
> to all the joys of human life,
> it's an elegy, as you might say,
> a vaporous breath, as you will see.)
> Seated at eve upon the mountainside,
> With eyes that searched the country far and wide,
> I asked: Why is a girlfriend then denied?
> When will she come, great Gods, to soothe away
> The griefs, the misery, crushing me today?

> O, she'd appear to me in my distress
> As dainty and pretty as a shepherdess:
> Alluring charms, a round fresh chin,
> Plump arms and calves well shaped to see,
> With a trim crinoline
> And goddess-form within
> And carmine lips for me,
> Digue dinguedi dindigue dindin
> O ho, the charming chin.

I halt at last, for I know I'm not really in the mood, alas.

> Weep for your fosterchild who can't for long
> Compose, O Muses, even the briefest song.
> Matric, matric, how terrible alas,
> Horrible faces of the examiner-throng.
> But indescribable joy, if I should pass.

Great gods, I don't know what I'd do. Alas, my dear Zola, I keep on meandering, Paul Cézanne.

I have conceived the idea of a drama in 5 acts, which we (you and I) will entitle: Henry VIII of England. We'll do it together in the holidays.

The postscript is no doubt not to be taken seriously, as it has been done; at most Paul may mean that he and Emile will enact the part of the many-wived Henry in one of the improvisations that the trio seem to have liked. The remark merely carries on the theme of girls. Important is the proof these letters give of how deeply the joys of swimming and running about naked had sunk into Paul's being. Here lies the root of the emotion he put into his many later paintings and drawings of bathers.

The next letter, of July 26th, brings to a head his fear of the examination, which is also his fear of his father, whom he has to satisfy. Under the strain he breaks into a religious idiom jestingly blasphemous but expressive of a genuinely deep terror and sense of martyrdom:

Mein lieber Freund, It's Cézanne writing, but Baille dictating. Muses, descend from Helicon into our veins to celebrate the matriculating triumph of mine. (It's Baille speaking, it won't be my turn till next week.)

[*In Baille's hand*:] This bizarre originality agrees well enough with our characters: we were going to give you a crowd of riddles to guess, but the fates have decided otherwise. I came to visit the poetic, fantastic, bacchic, erotic, antique, physical geometrical friend of ours, he had already written down the date and was waiting for an inspiration. I gave him one. I wrote the address in German; he was going to write at my dictation and sow in profusion, together with the figures of his rhetoric, the flowers of my geometry (allow me this transposition, otherwise you might have thought we were going to send you triangles and such things). But my dear chap, love that destroyed Troy still wreaks enough damage: I have grave grounds for believing that he's in love. (He won't admit it.)

[*Paul*:] My dear chap, it's Baille who with a rash hand (O vain spirit) has just traced those perfidious lines, his wit has never produced any other sort. You know him well enough, you know his follies even before he was subjected to the terrible exam, so what is he like now? What burlesque and distorted [*difformes*] notions aren't born from his malignly mocking wits. You know Baille is B.Sc. and on the 14th next he sits for his B.A. As for me I sit on August 4th; may the omnipotent

Gods ensure that I don't break my nose in my fall alas approaching. I swot, great Gods, I break my head over this abominable toil.

> I tremble, seeing how Geography,
> History, Latin, Greek, Geometry all,
> Conspire against me. I see them menacing,
> These curst examiners with piercing stares
> That stir deep trouble in my innermost heart.
> My fear each moment terribly increases
> And I cry out: O Lord, please scatter them all,
> Those foes now shamelessly confederate
> To wreck me. O confound the dreadful host,
> My prayer, it's true, is lacking charity,
> But hear me, pity me, O Lord, I call,
> A pious servant here before your altars.
>
> Your images with daily incense I honour.
> Lay low these wicked characters, O Lord.
> Don't you behold them already eager to gather,
> Rubbing their hands, prepared to sink us all.
> Don't you behold them in their cruel joy
> Already count the eyes they'll claim as prey.
> O look, Lord, look, how on their writing tables
> They group the fatal numbers with such care.
> No, no, don't suffer me an innocent victim
> To fall beneath their blows of rising rage,
> Send down your sanctifying Holy Ghost
> To spread forthwith upon your servant here
> The dazzling light of its tremendous knowledge.
> And if you answer me, at my last hour
> You'll hear me bellowing still oremus out,
> At which, Saints of both sexes, you'll be numbed.
> Pity me then, be willing, Lord, to hear me,
> Deign also, Lord, not to be slow about it
> (In sending your graces, be it understood),
> Let my prayers mount right up to the heavenly Eden.
> In saecula, saeculorum, amen!

There's a ridiculous digression for you. What do you say to it? Isn't it ugly [*difforme*]? Ah, if I had the time, you'd swallow lots of others. By the way, in a short while I'll send you your bout-rimés. Address a prayer to the Highest [*Altissimo*] that the faculty will decorate me with the much desired title.

[Baille:] My turn to carry on: I'm not going to make you swallow verses. I have almost nothing to tell you except that we're all waiting for you: Cézanne and I, I and Cézanne. We swot while we wait. So come. Only I shan't go hunting, but I'll accompany—though what of that! We'll still be able to make some fine excursions. I'll carry the bottle, I, though it's the heaviest item. This letter has already bored you: it's written for that. I don't mean we wrote it with that aim in mind. Give our regard to your mother (I say our for a good reason: the Trinity isn't a single person). We shake your hand: this letter is from two persons. *Becézanlle*.

[Paul:] You see in this letter the work of two originals. Dear chap, when you come, I'll let my

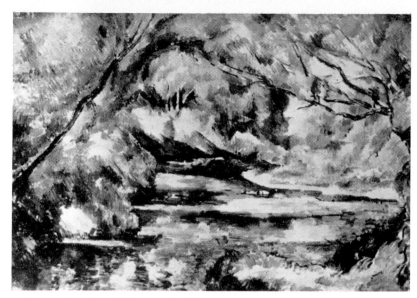

12 Stream through the Undergrowth, 1898–1900

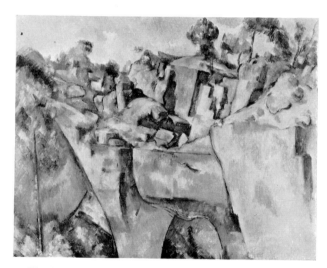

13 The Quarry at Bibémus, 1898–1900

14 (below) Bathers, *c* 1895
15 (right) In the Park of the Château Noir, *c* 1900

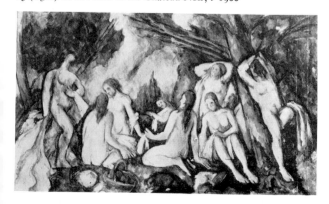

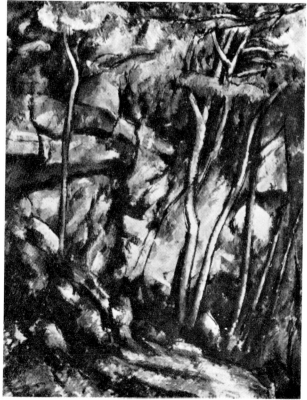

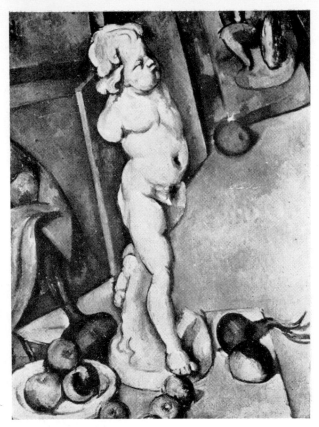

16 Still Life with plaster Cupid, *c* 1892–95

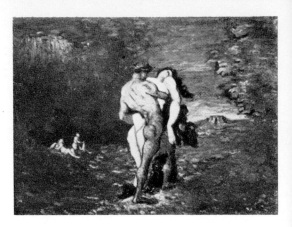

17 The Rape, 1867

18 Letter to Zola, 3rd May 1858

19 Letter to Zola, 17th January 1859

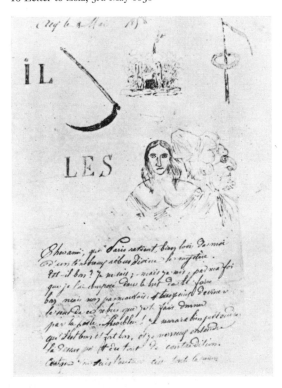

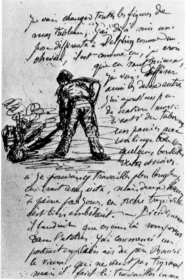

24 Letter to Zola, 19th October 1866

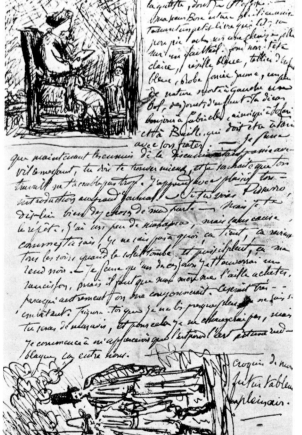

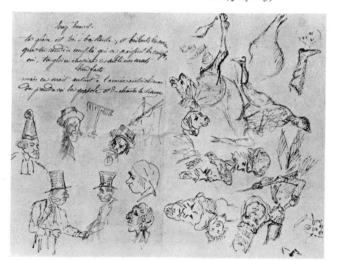

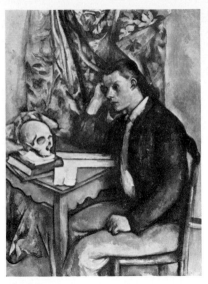
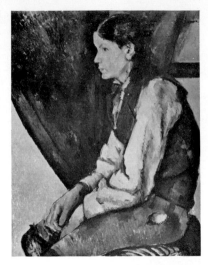
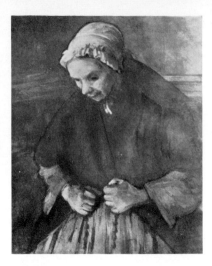

25 (above) Youth with a Skull, 1894–96

26 (above centre) Boy in a Red Waistcoat, 1890–95

27 (above right) Old Woman with Rosary, 1896

28 (right) Sainte Victoire, Beaurecueil, 1885–86

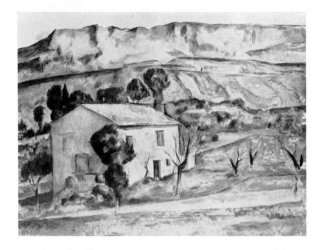

29 (below left) Woman with Coffee-pot, 1890–94

30 (below right) The Pine Tree, 1892–96

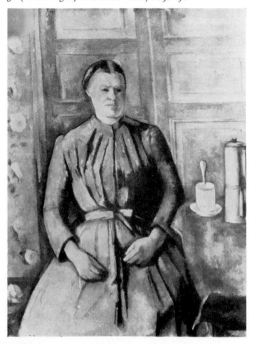
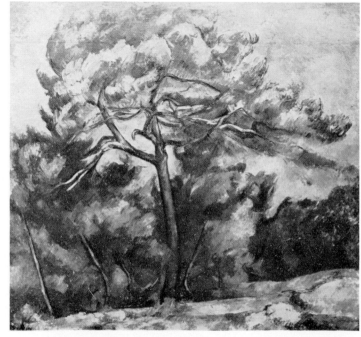

beard and moustache grow. I expect you *ad hoc*. Tell me, have you got a beard and moustache? Goodbye, old chap, I don't understand how I can be so stupid.

Baille's taking-up the jest of the Trio as the Trinity shows that verbal play on this point must have been common among them. The jest is given force by the way in which their contributions are tangled up in this letter and the two friends become one person, Bécézanlle. Zola did come for the holidays, and once again the trio were together, 'wrestling, throwing stones at pots, catching frogs in their hands'. On October 1st Zola returned to Paris and his Lycée, and Paul and Baille got ready for the exams. On November 12th Baille had passed his two matriculations and gone off to study at Marseille; Paul passed his examination on November 12th: *assez bien*. A letter to Zola on November 14th seems lost; Paul refers to it in a letter three days later, saying that letters have crossed. He adds that in the lost letter he described 'a longish poem' he wanted to compose, and he now asked for a title. As usual he tries to joke his fears away, saying that he will die young through his plethora of *esprit* (both wit and spirit):

> *Sacré nom, sacré nom* of 600,000 bombs.
> I cannot rhyme, knocked dumb, and you succumb
> To 600,000 bursts of 600,000 bombs.
> That's too much wit at a single blow, I agree.
> I feel it (twice), I must die young of it.
> How can I hold inside me so much wit?
> I don't suffice, not vast enough am I
> To enclose it all, and therefore young I die.

He continues with further revelatory verses:

> Yes, friend, O yes, I feel enormous joy
> At this new title in my heart deploy.
> No more of Greek and Latin I'm the prey.
> O blessed day, O more than blessed day
> This pompous title came my honoured way.
> For I'm a Bachelor, a great thing, I say.
> The person made a Bachelor, in my notion,
> Has drunk of Latin and Greek a mighty potion.

Theme of Latin Verses given in rhetoric and translated into French by us, poet:

> *Dream of Hannibal*
> *Annibalis Somnium*

> The hero of Carthage, going from a feast,
> At which there had been rather much recourse
> To rum and cognac, tottered, stumbled, tumbled.
> Already the famous victor of Cannae went
> To sleep beneath the table. Strange miracle.
> Awful disaster of the repast's remains,
> For through the mighty swipe the hero gave
> The tablecloth, the wine spread pouring round.

The plates and dishes the empty salad-bowls
Rolled sadly about amid the limpid streams
Of punch still warm, a most regrettable waste.
Sir, can it be that Hannibal thus squandered
Infandum, infandum, the rum of his fatherland?
Liquor so cherished by the old French trooper.
O Zola, could he commit such sacrilege
And Jove still not avenge the foul black deed?
Could Hannibal so badly lose his head
As to forget you in such thorough fashion,
O rum? Avert your eyes from the sad picture.
O punch, you merit some quite different tomb.
Has not this wild fierce victor granted you
A proper passport for entry to his mouth
And straight descent into his stomach's depths?
He left you lying, cognac, on the floor.
But by four lacqueys, what indelible shame,
Saguntum's conqueror soon is lifted up
And laid abed. Then Morpheus and his poppies
Upon his stupefied eyes bring down repose.
He yawns, outstretches, sleeps on his left side.
Our hero snoozes after his debauch.
The formidable swarm of airy dreams
At once come pouncing down about the bolster.
Hannibal sleeps. The oldest of the troop
Is dressed as Hamilcar and owns his shape.
His hair is bristling, prominent his nose,
And his moustache is most remarkably bushy.
Add an enormous slash across his jaw
Giving his phiz a quite distorted look.
Then, sirs, you have the portrait of Hamilcar.
And four great horses harnessed to his car
Draw him along. He comes, grips Hannibal's ear,
Gives him a shaking. Hannibal awakes.
Already wrath . . . But then he quiets down,
Seeing it's Hamilcar whom rage, restrained,
Makes ghastly pale. 'Unworthy son, unworthy,
You see in what a state the wine's pure juice
Has thrown you, son—yes, you. Blush, *corbleu*, blush,
Up to the whites of your eyes. You, thoughtless, lead
A shameless life instead of going to war,
Instead of guarding all your homeland's walls,
Instead of driving back the ruthless Roman,
Instead of preparing, you victor at Tesine,
At Trasimene, at Cannae, a campaign
By which the Town, that foe of Hamilcar's,
That most inveterate of our enemies,
May find its citizens brought low by Carthage.
Degenerate son, you've had a drinking-bout,
See, your new doublet's spotted all with sauce,

With good Madeira wine and rum. It's dreadful.
Son, rather follow your ancestors' example.
Banish this cognac, these lascivious women,
That hold our souls too captive in their yoke.
Abjure the liquors. It's all most pernicious.
Drink only water and you'll benefit.'
Hannibal at these words leaned on the bed
His head, and most profoundly slept once more.
Have you ever struck a style more admirable?
If you're not satisfied, you're unreasonable.

Here the denouncing authority is directly defined as the father. Whether Paul had been rebuked by Louis Auguste for drinking, or had merely been afraid of some such rebuke, he expresses here strongly his sense of guilt. It is possible indeed that during the months of strain he had made a fool of himself through drinking too much; but the guilt fears go much deeper than any such episode. The Hamilcar–Hannibal image ties up with the Cicero–Catalina one, expressing the crisis of choice that Paul is finding inescapable as schooldays come near their end. (He is drawing on Livy, while also remembering de Musset's poems; but unlike the Cicero-verses, his fantasy here has no historical basis. There is no suggestion of any backslidings by Hannibal, though Paul is doubtless recalling how Capuan dissipations helped to weaken his army.) The picture of the 'degenerate son', a prey of women as of wine, brings in Paul's sexual fears, and the spilling of the wine over the floor suggests a dream-orgasm or an onanistic sense of loss. The classical passages that Paul seems to have in mind were that of Livy in his 23rd Book (18) on the Capuan debauches and that of Virgil at the end of the *Aeneid's* 1st Book on the feast at Dido's court. In the latter scene Dido sits fondling Cupid disguised as Ascanius, Aeneas' son; and this point is recalled by Paul's repeated *infandum*, which as we saw in the letter of July 9th was linked for him with *amor*, love. He had been strongly affected by the passage (iv, 85) in which Dido fondles the actual boy, seeing in him his father, in the hope 'of being able to cheat *infandus amor*'. The 'unspeakable love', then, that stirs Paul's mind and senses, belongs to the fondled boy who finds himself willynilly in his father's place. Ascanius-Paul then becomes the scared boy who *wants* to take the father's place but is terrified of the role, and collapses, overcome, amid the warm limpid streams, 'a most regrettable waste'.

We have one more letter from this year, which further valuably clarifies the complicated state of hope and fear in which Paul found himself. Here the problem of choice that agitates the previous letters comes right out into the open. Zola in Paris, torn by his own fears and despairs, had fallen gravely ill. For six weeks he lay feverish and delirious. When he did get up, his mouth was ulcerated and his teeth loose; he could not speak and had to write on a slate. Looking at advertisements on the wall opposite, he realized that he could not read them. On December 7th Paul wrote to him on a theme that was to play an important part in his art; he does not seem to realize how bad had been Zola's illness.

You didn't tell me that your illness was serious, very serious—you should have. M. Leclerc has instead informed me, but as you've recovered, best wishes!

After hesitating for some time—for I must admit that to start off with this *pitot* [Provençal for young lad] didn't suit me at first—I finally decided to treat him as unmercifully as possible. So I'm setting to work, but, faith, I don't know my mythology. However I'm taking myself in hand to learn the exploits of Master Hercules and will convert them into the high deeds of the *pitot* as far as it can be done. I declare to you that my work—if work rather than mess is the deserved term— will be worked out, digested, perfected by me for a long time, as I have little time to consecrate to the adventurous recital of the Herculean Pitot.

> Alas, I've taken the tortuous road of Law,
> But choice is not the term, I was forced to take it.
> Law, horrible law, with entangled equivocations
> Will make my life a nightmare for three years.
> Muses of Helicon, Pindus, and Parnassus,
> Come down, I pray, and sweeten my disgrace.
> O pity me, a most unfortunate mortal
> Snatcht in his own despite from your dear altar.
> The arid problems of the Mathematician,
> His pallid wrinkled brow, his lips as pale
> As the pale shroud of some cadaverous ghost:
> I know, Nine Sisters, frightful to you they seem.
> But he who takes on himself a Law Career
> Quite loses all your trust, and all Apollo's.
> Ah, do not cast on me a scornful eye.
> I am less guilty alas than miserable.
> Rush at my call and succour my disgrace
> And in eternity I'll render thanks.

Wouldn't you say on hearing, not reading, these insipid lines that the muse of poetry has forever abandoned me. You see what this wretched Law has done.

> O Law, who bore you, what misshapen brain
> Created, for my pain, the deformed Digest? [*difforme*]
> And this incongruous Code, has it not lasted
> For a whole century unknown in France?
> O what strange fury, what stupidity,
> What dottiness troubled and disturbed your brain
> Paltry Justinian, Author of the Pandects,
> And impudent redactor of the Corpus Juris.
> But is it not enough that Horace and Virgil,
> Tacitus and Lucan, come to bring upon us
> For eight long years a difficult text's dismay,
> Without thus augmenting the causes of my sorrow?
> If there's a Hell, with a single place unfilled,
> Whelm there, God of Heaven, the Digest's Begetter.

Get the facts about the competition at the Académie, for I stick to the decision we made to compete at any price [apparently at the Paris Beaux Arts]—provided of course that it costs nothing.

> I know that Boileau's broken shoulderblade
> Was found last year deep down inside a ditch,

And masons, digging deeper, found as well
His hardened bones and carried them to Paris.

In a Museum there this King of Beasts
Was classed in the ranks of old Rhinoceroses
And under his carcass were engraved these words:
Here lies Boileau, the Rector of Parnassus.
This tale of mine, so very very true,
Brings out for you the fate that he deserved
For overpraising with injudicious verve
The Fourteenth Louis, the most stupid of kings.
A hundred francs were given in reward
To the keen workers, who, for their discovery,
Wear a fine medal with this legend stampt:
'Deep down inside a ditch they found Boileau'.

One day, snug in a wood, was Hercules
Deeply asleep. For the fresh air was good.
If he'd not kept inside a charming thicket,
If he'd exposed himself to the sun's rage,
Where the hot summer-rays were darting down,
Maybe he'd have incurred a dreadful headache.
So, well he slept. And there a youthful dryad
Passing quite close to him . . .

But I see that I was going to say something foolish, so I shut up. Let me end this letter, as stupidly finished as begun. I wish you a thousand and one good things, joys and delights; goodbye, dear chap, best wishes to M. Aubert, to your parents, goodbye, I salute you, your friend, Paul Cézanne.

In a postscript which shows already his thrift, he asks Zola to use thinner paper for his letters, as he has had to pay 8 sous surcharge on the one just received. (Compare his remark about entering the art-competition as long as it costs nothing.) Recurrent words in his missives are *bêtises* or *bête, difforme, informe;* he is aware all the while of mockery and mistrust, and seeks to get in first with declarations of weakness and impotence; he has a pervasive sense of something unformed, confused, distorted; he uses almost the same tone of irony in addressing the Muses as the Trinity. In the last letter he glances at two aspects of the myths of Hercules; that of the Choice at the Crossroads and another of more local provenance. First, the Choice. This appears in the verses, 'Alas, I've taken the tortuous road of Law'—*Droit*, which in French means both Law and Right. Paul has been hesitating like Herakles in the allegory of Prodikos at the Crossroads, uncertain whether to take the road of Duty or Pleasure (Art). He had doubtless met the theme in Xenophon's *Memorabilia*, Loukianos' *Dream*, and Cicero's *De Officiis*—works of which school-editions were easily available. The version in Silius Italicus, which stressed the roads as Right and Left, and the road of the Right as tortuous, was not thus at hand, and we may assume he did not know it. The version in the *Dream* would have specially affected him, for the youth there is torn between Education and Sculpture. He doubtless also knew the motive from de

Musset's *Rolla* and Hugo's *1851—Choix entre Deux Passants*, where the theme of Death and Shame is influenced by Dürer's *Knight, Death, and Devil;* and he must further have known the motive in its art forms. Annibale Carracci's version he could have seen in reproduction: it showed Virtue on the Right, Vice on the Left. In the nineteenth century there were versions by Rude, G. Moreau, Fantin-Latour, as well as by Delacroix in his murals at the Hôtel de Ville—though Paul could not yet have seen these. He may, however, have seen the painting by Caspard de Crayer in the style of Rubens (at Marseille, with Vice on the Right); and he more than likely knew G. de Lairesse's version, which appeared in the *Magasin Pittoresque* of 1844, a volume in which there were two essays on the Musée of Aix. For the association of the Left with Pleasure, Vice, Revolt, we may note that Hannibal in the poem is described as sleeping on his left side.

The importance of the image of the Hero at the Crossroads will appear as we go on, since it underlies Paul's fascination with, and treatment of, the themes of the Judgment of Paris and the Temptation of St Antony, and leads on into the early conception of the Bathers. Further, from 1880, through Paul's deep interest in Pugin's statue *Hercule Gaulois*, Hercules became for him the emblem of the indomitable and powerfully thewed artist driving on despite all obstacles and difficulties.

Paul's comments on the *Pitot* show that the theme of Hercules was well known to the Trio; it seems to have made up part of their personal mythology. Hercules was said to have passed through Provence on his way to Spain and the cattle of Geryon; he founded cities there and slew a brigand Tauriskos (whose name suggests a bull-cult connection); the classical legend became entangled with local tales of giant-fights and hurled boulders, as on the plain La Crau. Mistral used these traditions; and Hercules became a part of the region's folklore. People wrote up over their doors: 'The conqueror Hercules dwells within. Let nothing evil enter here.' There was thus good reason for the Trio to be much interested in the Hero. Zola took the theme up about 1858; and in his letter Paul was clearly dealing with the tale of a nymph who seduced Hercules by promising to reveal what has happened to the horses stolen during his sleep. Again, then, we have the theme of the hero who fails in his duty: as with Hannibal the disgrace is connected with sleep, but here it leads on to a second fall, into *infandum amorem*. Paul thus identifies himself in a complicated way: with the hero choosing the *Droit* and with the *pitot* waylaid by a nymph among the trees and the streams of his beloved countryside.

This year Solari, aged eighteen, won the Prix Granet of 1,200 francs and was able to go to Paris. His departure must have increased Paul's agitation and sense of loss. As examples of how deeply Zola felt his roots in Aix, we may note that he used his experiences of fever for the account he gave later of Serge in *The Fault of Abbé Mouret*, where the garden Le Paradou, a paradise of sexual liberation and sin, was based on Le Gallice; and that Souvarine, the anarchist of *Germinal*, though partly drawn from a tale told to Zola by Turgenev, was also based on a Russian at the Aix Faculty of Law, who had in his room a grey-covered

pamphlet—a treatise on the best way to blow up Paris written by a Russian officer domiciled in France in the late eighteenth century.

Probably to the end of 1858 belong three quatrains by Paul on the back of an early drawing:

> Ah, my gracious Marie,
> I love you and I pray
> You'll keep the words of writing
> Sent by your friends today.
>
> On your lovely rosy lips
> This *bonbon* will slip clear.
> Over many things it passes
> And the red takes no smear.
>
> This pretty rosy *bonbon*
> So nicely turned, as it goes,
> Will be happy to enter in
> Those lovely lips of rose.

This poem, probably to go with a New Year's gift, has a very sensuous feeling of contact; it is more the kind of thing we would expect a lover to write. Paul's almost total inability to achieve a normal relationship with women seems to have as its obverse side an extremely close emotional bond with his mother and his sister Marie; and this poem thus confirms what we would imagine on general grounds.

IV *A Lonely Year (1859)*

Throughout 1859 Paul continued to pour out his emotions in verse. A letter of January 17th expressed an even deeper perturbation than the previous ones. It opened with a burlesque sketch of Virgil and Dante (Paul and Emile) entering a room in Hell where five persons sit round a table with a skull in the middle. Its title runs: 'Death reigns in these places.' Once again the fear of death and the fear of money entwine; the image of family-life with its need of earned sustenance is that of cannibalism in an infernal prison.

Dante: Tell me, my friend, what are they gnawing there?
Virgil: A skull, *parbleu*.
Dante: My God, it's frightening.
 But why do they nibble this detestable skull?
Virgil: Listen and you'll learn why.
Father: O, tear to pieces this inhuman mortal
 Who's made us suffer for so long from famine.
Eldest: Let's eat.
Junior: I'm hungry. Give that ear to me.
Third: And me the nose.
Grandson: And me that eye.
Eldest: The teeth.
Father: Ho, ho, if you go eating at this pace,
 What will remain for us tomorrow, children?

I have resolved, my friend, to scare your heart
By casting in it a vast atrocious fright
In the monstrous aspect of this dreadful drama
Well framed to shake the hardest soul alive.
I thought your heart responsive to these evils
Would cry out: What a marvellous picture there.
I thought that a great cry of horror would burst
Out of your breast, to see what one imagines
As hell where the sinner, dead in impunity,
Terribly suffers for all eternity.

But I note, dear chap, that now for fifteen days
Our correspondence slackens in its pace.
Is it, by chance, that you're consumed with boredom?
Has some vexatious cold now seized your brain
And stretched you despitefully abed, while coughs
Keep worrying you? Alas, it isn't pleasant
But there are other evils yet far worse.
Perhaps it's love that's slowly eating up
Your heart? yes? no? My faith, I'm ignorant of it,

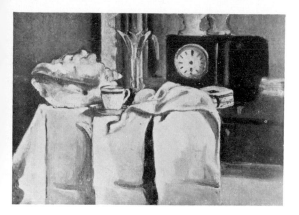

31 (right) Still Life with
Glass and Apples, 1879-82

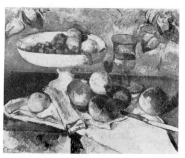

32 (below) At the Lakeside,
1873–75

33 (above) The Black Pendulum Clock, 1869–71
34 (below) The Wine-Market, 1871–72
35 (bottom) The Picnic, 1869–70

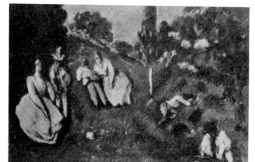

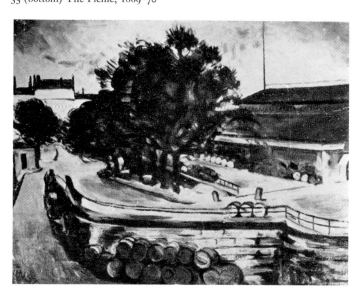

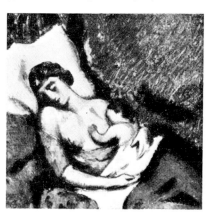

36 The Conversation, *c* 1869–70

37 Woman suckling her child, 1872

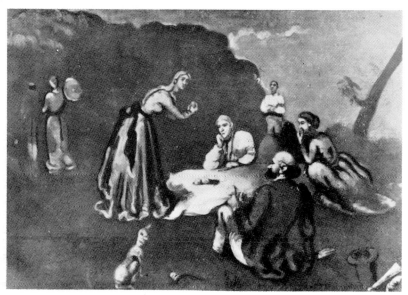

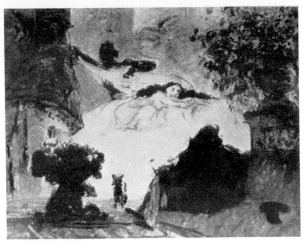

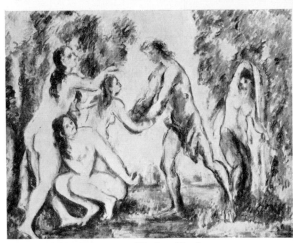

38 (above) A Modern Olympia, 1872–73
39 (below) Five Bathers, 1885–87

40 (above) The Judgement of Paris, 1883–85
41 (below) Bathers, 1883–85

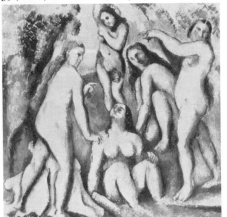

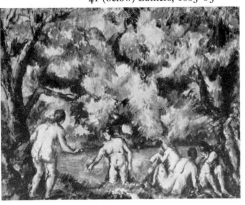

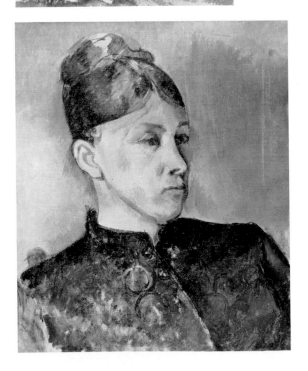

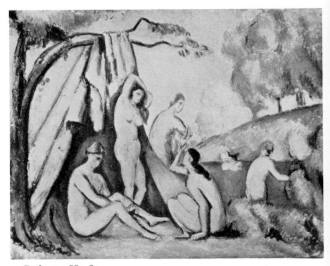

42 Bathers, 1883–85

43 Portrait of Madame Cézanne, c 1885

But if it's love, I'd say, then things go well.
For love, I strongly suspect, has killed no man.
Perhaps at times it gives us all the same
A pinch of torment and a pinch of sorrow;
But if it's come today, it's gone tomorrow.
If, grievously, you're grieved, let's hear the news,
If now some horrible malady destroys you.
Still I can't credit the malevolent gods
Have given you, *sacrebleu*, terrific toothache
Or something else that's just as horribly stupid
To suffer, for instance an enormous headache
Which, circling round from head to feet in torment,
Makes me address atrocious oaths to heaven.
That would be silly. Being ill's a thing,
Whatever sort it is, extremely gloomy.
We lose our appetite, we cannot eat,
Vainly before our eyes pass endless dishes,
Delicious, alluring. Still our stomach rejects
The nicest, the best of grub, the most attractive
Of sauces.
 Ah, good wine, I love it, though
At Baille's, true, it knocked us on the nuts.
But I forgive it. Wine's then excellent,
Able to attack at the root most various ills.
So drink, dear friend, drink up. For wine is good
And soon the cure of all your ill will come.
For wine is very good, *bis* good, and *ter*.
Could you by chance have overeaten *bonbons*
On New Year's Day? why not? Too strong a dose
Might have condemned you to remain, mouth closed,
While giving you a fit of indigestion.
But, faith, enough! This shameless self-surrender
To stupid things. Unceasingly time gnaws
Our life; our days decline; the tomb is there,
Voracious abyss, ghastly, insatiable,
With ever open jaws. Deflowered, but chaste,
When our day comes, then innocent or guilty,
We'll pay the tribute to inescapable fate.

It's now several days since I wrote the above. I said to myself like that, I don't know what fine thing to say to him, so I must wait a bit before sending my letter, but now I'm troubled, seeing I haven't received news of you. In my faith, *sacrebleu*, I have invented hypotheses, even the most idiotic ones, as to this continuation of silence. Perhaps, thought I, he is taken up with some *immensisime* work, perhaps he lucubrates some vast poem, perhaps he devises some truly insoluble riddle for me, perhaps he has even become the editor of some feeble journal. But all these suppositions don't tell me in fact *quod agis, quod bibis, quod cantas, quomodo te ipsum portas,* etc. I could bore you much longer and you could in your annoyance exclaim with Cicero: *Quosque, tandem, Cézasine abuteris patientia nostra?* To which I should reply that in order to stop being bored, you must write me as soon as possible—unless there's some serious impediment. *Salut omnibus parentibus tuis, salut tibi quoque, salve, salve, Paulus Cézasinus.*

Once again Paul identifies himself with Catalina denounced by Cicero. The *bonbon* which slid between Marie's lips in delicious sensuous union becomes the source of illness and malaise; and the opening mouth becomes the jaws of death. The pervasive sense of fear and horror crystallizes in the burlesqued vision of Ugolino. Cantos 32–3 of Dante's *Inferno* depicted Ugolino desperately gnawing at the skull of his foe, who, on the earth, had shut him up with his four sons in a tower; as the sons died, the starving father ate their corpses. Paul seeks to increase the horror of the motive by merging the two episodes, that of earth and that of hell, in the domestic banality of the family group dining on the skull, with the thrifty father giving the sort of advice that Louis Auguste must often have given in less melo-dramatic surroundings. The father ceases to be the panged sufferer; he becomes the com-placent paterfamilias, the good father-of-a-family who (in Voltaire's phrase) is *capable de tout*, presiding over the infamous feast which symbolizes the everyday meal of the bourge-oisie. Paul is asking himself if he must choose the *Droit* and become accomplice. In his grim jests he fuses his fears of money, the family, the authoritative father, death, starvation. He stands in the midst of his imagery as a sort of paralysed rebel; he falls flat like Catalina before the blast-power of the authoritative world, like Hannibal rolls in the spew and wastage of his life-energies. No way can he escape; he submits and yet totally refuses to submit.

The theme of Ugolino had become popular with the rise of Romanticism and many ex-amples of its treatment in painting and sculpture could be cited from the eighteenth and nineteenth centuries. Delacroix used it; and not long after Paul's letter, in 1861, Carpeaux worked in Rome at a large Ugolino group that attracted much attention and was shown in the 1867 Salon. The climax came with Rodin's Hell-Gate (which was probably influenced by Carpeaux). Paul however shows no awareness of the art treatments in his crude little sketch, and was probably inspired simply by Dante. He several times later used the skull in his art, no doubt in part because of the interesting problems in volume that it raised. Vollard describes him many years later in his studio reading *Athalie*, with a still-life of skulls (started some years before) on the easel. 'What a fine thing to paint, a skull,' he said. But the skull, especially the skull on a table, held for him the complex of emotions revealed in this letter of his: not merely a *memento mori*, a variation of the *Vanitas* theme of the seven-teenth century, but rather an emblem of inner death, of total dehumanization and surrender to the values of Louis Auguste. We know that as a money-lender the latter used the term *mangé*, eaten-up, for someone who lost his money. 'Paul will let himself be *mangé* by painting, Marie by the Jesuits.' The struggle to make money is thus seen as a struggle to save oneself from being eaten up. In his transference of the image Paul sees himself as liable to be eaten up by the father with his cannibalistic money values. The skull became for him the emblem of surrender to the world, the loss of spiritual life as well as physical. In a letter of 1868 Paul uses the phrase 'some money mortgaged on the paternal skull'. (*See* Fig. 19).

Cézanne's verses are rough, often deliberately prosaic as part of their mocking function,

their refusal to accept the romantic attitudes they conjure up. But, taken altogether, they are very effective; they evoke his character and express sensitively the rapid turns and twists of his mind and senses—his deep aspirations and his recoils of fear. Oddly, if we compare them with the sort of things that Zola was writing at the same time, we feel that the latter were feebly derivative and quite lack the distinctive energy of Paul's coarser lines. Thus, Emile's *To my friend Paul*, written at the Lycée, attempts to answer Paul's pictures of girls by setting friendship above love. It ends:

> But if my feeble hands, sweet-smelling wreath,
> Have not for a loved one woven here your flowers,
> If I've not mingled my capricious verses
> To gain a passing smile from two bright eyes,
> My humble bouquet, it's that I prefer
> One heart before the dear heart of a blonde.
> A noble and tender heart, on which today
> I set you, a moment's solace for his tedium.
> Go then and find my friend. His masculine chest
> I rate above the breasts of a childish front.
> You will gleam better on his coat of black
> Than in the jewels of a charming corsage.

The effect is highly embarrassing; and only less so is *To my friends*:

> . . . And long, my demon, my sylph with rosy wings,
> Prattled and stirred these ancient things anew;
> And, though in tears, I long still smiled at him,
> Because, my two old friends, he spoke of you.

We cannot blame his fellow-pupils in Paris for failing to admire when he read such things out. But, unaware as yet how out-of-date and weak his verses were, he was still planning his *Chain of Being* (based on Chénier and Hugo) and making up long poems like *L'Aerienne* and *Paolo*. There was a strong feminine streak in his composition. He had been brought up by mother and grandmother; and the theme of an orphan, usually a girl, recurs in his novels. The heroines of *Thérèse Raquin* and *Madeleine Férat* both lack fathers; in *The Joy of Living* Pauline has lost the parents that still survived in *The Belly of Paris*; Sandoz' wife in *L'Oeuvre* is an orphan, as is also the whore Irma. Further examples are Angelique in *The Dream* and Christine in *A Page of Love*, as well as Jeanne the tyrannical child. Jeanne's father dies like Zola's in a hotel in a big city, 'in a large bare room, filled with medicine bottles, the trunks yet unpacked.' When the boy Pierre Froment, hero of *The Three Cities*, loses his father (in an explosion), he becomes a priest—that is, renounces his virility. There is no doubt that in his orphan motive Zola shows his wish to keep on identifying himself with the protective female sphere, and his fear of being torn away and thrown out into the world. In the letters of the years we are considering, he appears as the indefatigable reconciler, humouring Paul and Baille, doing his best to cover up every rent in their friendship.

On June 20th Paul has fallen once more into a hopeless and distant love-affair, and uses some English terms to express his admiration of the girl:

My dear chap, yes my dear chap, it's really true what I said in my previous letter. I tried to deceive myself, by the tithe of the Pope and his cardinals, I felt a keen love for a certain Justine who is truly *very fine*; but as I have not the honour of being of *a great beautiful*, she has always turned her head the other way. When I directed peepers towards her, she used to lower her eyes and blush. Now I think I've noted that when we were in the same street, she made what you'd call a halfturn and dodged off without looking back. *Quanto à della donna*, I'm not happy, and yet I run the risk of meeting her three or four times a day. Better still, dear chap, one fine day a young man came up to me, a first-year student like myself, indeed it was Seymard whom you know. 'My dear fellow', he said, taking my hand, then hanging on my arm and continuing to stroll towards the Rue d'Italie. 'I'm going', he went on, 'to show you a pretty little girl whom I love and who loves me'.

I confess that at once a cloud seemed to pass before my eyes. I had as it were a presentiment that luck was against me, and I wasn't wrong, for midday struck just then and Justine came out of her dressmaking workshop. And by my faith, as soon as I could make her out, Seymard signed to me. 'There she is', he said. At this point I saw nothing more, my head was in a whirl, but Seymard dragging me along, I brushed against the young girl's frock . . .

This passage, which he himself ends with dots, reminds us how later in life he was so much upset by physical contact, even by the brushing of a woman's skirts against him, that he ordered his housekeeper to take special care when serving his meals.

Since then I've seen her almost daily, and often Seymard was trailing her . . . Ah, what dreams I've reared, the maddest dreams at that, but you see that's how things go, I was telling myself, if she didn't detest me, we'd go to Paris together, there I'll make myself an artist, we'd be happy. I was telling myself, like that, we'd be happy, I was dreaming of pictures, a studio on the 4th floor, you with me, how we'd have laughed then. I wasn't asking to be rich, you know what I'm like, with a few hundred francs I thought we'd live in contentment, but by my faith it was a great dream, all that; and now I who am so idle, I'm only satisfied when I'm drunk. I can hardly do anything more, I'm an inert body, good for nothing.

By my faith, old chap, your cigars are excellent, I'm smoking one while I'm writing. They have the taste of caramel and barleysugar. Ah, but look, look, there she is, how she glides and hovers, yes it's my young girl, how she laughs at me, she floats in the eddies of smoke, look, look, she goes up, sinks, frolicks, spins round, but laughs at me. O Justine, tell me at least that you don't hate me. She laughs. Cruel girl, you enjoy making me suffer. Justine, listen. But she is fading out, she goes up, up, always up, then, see, at last she vanishes. The cigar falls from my mouth, and at that I go to sleep. I thought for a moment I was going crazy, but thanks to your cigar, my mind is fortified, then more days and I'll get her out of my mind, or else I'll only see her on the horizon of the past as a shadow I've dreamed of.

Ah, what ineffable pleasure it would give me to shake your hand. You see, your maman told me you'd be coming to Aix towards the end of July. You know, if I'd been a good jumper, I'd have hit the ceiling, so high I jumped. Really for a moment I thought I was going mad, night was coming on and I thought I was going mad, but it was nothing, you understand. Only I'd drunk too much so I saw before my eyes spirits hovering at the tip of my nose, dancing, laughing, springing wildly about. Goodbye, my dear chap, goodbye, P. Cézanne.

On the back of the final sheet he drew a big tree and the Trio bathing and sporting under it: the scene that haunted him all his life as the expression of freedom and happy communion

with the earth. In a letter probably of early July, he generalized his dreams of Justine:

> You'll say to me perhaps: My poor Cézanne,
> What female demon has nonplussed your skull?
> You whom I once watched walking firm of step,
> Doing nothing good and saying nothing bad?
> In what blurred chaos of fantastic dreams
> As in an Ocean do you stray today?
> Can you by chance have seen the Polka danced
> By some young Nymph, an artist at the Opera?
> You'd have written surely, sunk beneath the table
> And snoring as drunk as a deacon of the Pope,
> Or else, my friend, filled with rococo love,
> Has your coconut been given a knock by vermouth?

The ideas of love and drink once more produce the Hannibal image of being laid out flat. The female demon has *demonté* his skull—a term which carries the idea of disorder and confusion, but also of having the head taken off—like a rider from a horse or a rudder from a ship. The woman-itch thus removes his skull from his body and we are reminded of the Ugolino skull; the idea returns in the last line where the head is hit by vermouth like a coconut knocked off at a fair-sideshow. We shall see later how this feeling of a dislocated body, at odds with itself, affected Paul in his art.

> Not love nor wine has touched here my Sorbonne
> And I've never held that only water's good.
> This reasoning alone should prove, my friend,
> Though somewhat dreamy, yet my mind is clear.
> Ah, have you never seen in dreamy hours
> As in a mist a drift of gracious forms,
> Indefinite beauties there, whose fervent charms,
> Dreamed in the night, have fled before the day?
> As in the morning, vaporous haze is seen
> When the sun rising with a thousand fires
> Lights up the greening sides where forests rustle,
> The waters sparkling with most rich reflections
> Of azure; then a gentle breeze comes up,
> Chases and whirls away the fugitive mist:
> Thus to my eyes are now and then presented
> Ravishing beings with angelic voices
> During the night. My friend, it seems the dawn
> With fresh pure light in emulation paints them.
> I feel them smile at me, I stretch my hand
> But vainly near them, suddenly they are gone.
> They climb the heavens, carried by the zephyr,
> Casting a tender glance that seems to say
> Goodbye. Again I strive to approach. In vain,
> It's all in vain, my hope of touching them.
> They are no more. The transparent gauze already
> No more depicts the ravishing form of their bodies.

> My dream is faded, reality returns
> And finds me lying there with saddened heart,
> And I behold a phantom loom before me,
> Horrible, monstrous. LAW is what it's called.

Again after the onanistic vision we find him stretched flat, with Cicero, Hamilcar-Law-Father threatening above him. He goes on:

I think I did more than dream. I fell asleep and I must have frozen you with my platitudes, but I dreamed I held in my arms my *lorette*, my *grisette*, my *mignonne*, my *friponne*, that I smack on the buttocks and many another place too. . .

> Lycéen filth, you ignobilissimi scabs,
> O you who flounder still along old ways
> And scorn all those whose smallest spark of warmth
> Stirs in their heart some sally that's sublime,
> What idiot mania makes you criticise
> A man who laughs at such a feeble assault,
> Lycéen Myrmidons, you forced admirers
> Of sad flat verses Virgil has bequeathed,
> True herd of swine that march beneath the aegis
> Of a rotten pedant who's your stupid guide
> Compelling you to admire, not knowing why,
> Verses considered good on his sole word,
> When in your midst there rises up like lava
> An uncurbed poet breaking every fetter
> As round an eagle we hear clamouring
> A thousand paltry birds, good but for whipping,
> Pitiful detractors, priests of cavilling,
> On him you vomit your profane foul slaver.
> I hear you already, true concert-band of toads,
> You strain your voices, on a false tone singing.
> No, one has never in this world seen frogs
> That splutter, sirs, so foolishly as you.
> But fill the air with all your sottish noises,
> The verses of my friend will conquer still,
> And your low nastiness they'll still defy,
> Marked as they are with genius' genuine stamp.

Baille has told me that the Lycéens, your fellow-students, seem to have set up, absurdly by my faith, as critics of your piece to the Empress. That stirred my bile, and though a bit belatedly I've hurled at them this apostrophe, the terms of which are all too weak to characterize such abortive blocks, literary penguins, asthmatic quizzers at your sincere rhymes.

If you think it worthwhile, pass on my compliment to them and add that if they have anything to say, they'll find me waiting here as long as they are ready, to punch the first who comes within reach of my fist.

This morning, July 9th, 8 a.m., I have seen M. Leclerc, who tells me that the youngest Miss M., once the prettiest, was ulcerous from head to foot and on the point of giving up the ghost on the hospital bedsteads. Her mother who has also too much taken the arse-viewpoint, moans over her last lapses. Finally the elder of the two girls, that is, the one who was once the ugliest and who is so still at the moment, wears a bandage as a result of overmuch banding. Your friend, who has drunk vermouth to your health, Paul Cézanne. Goodbye to all, your parents and equally to Houchard.

Now an undated letter, written late in July. It shows considerable distraction, no doubt largely due to the impending examination in law and all the involved anxieties.

> Baille's not writing. He fears that from his spirit
> You remain, dear Zola, abruptly turned away.
> In dread that you won't understand him then,
> Today he yields me up free rein to write.
> So in his room am I, and at his desk
> I scrawl these verses, children of my brain.
> No one will claim them, friend, in my belief:
> Unique's the fashion of their genuine flatness.
> But still, below, I'm going to set you out
> Some verses that we've carefully composed
> In your honour. *Tallow*'s the title of the Ode
> Which scorns the code of the poetic art.

> *Ode*
>
> O Tallow, whose good works, truly incomparable,
> Deserve an honour that will be remarkable,
> To you that drive the black of the night away
> Honour we pay.
> Nothing is finer than a fine candle at night.
> Nothing is better than a candle for its light.
> O sing it at all times through the universe
> In verse.
> That's why with so much zeal this theme I handle,
> Seeking to celebrate the immortal Candle.
> No words I know to immortalise your stuff
> Are fine enough.
> Brilliant your glory, brilliant the services too
> You give to all who grease their thighs, it's true,
> Your glory will inspire this small sublime poem
> So well composed.
> But the Austrian Army, now as the main thing,
> Must take up the word and yours they must sing.

Yours may refer to *glory* or to *la parole* of the Candle. The Candle seems to have a sexual meaning as well as symbolizing the light of study and poetry, if we may judge from the reference to those who *se graissent les cuisses*. The Ode is followed by two pages of sketches: heads of people, a labourer with a rake, a French legal character, a soldier with a gun, a man doing something to a woman: he seems to be punching her, but is perhaps preparing to copulate. Paul has been stirred confusedly by the war with Austria; this year on May 3rd Napoleon had proclaimed a free Italy. Baille now adds a passage:

Come, come quick, my dear chap! Cézanne has the cheek to go to [illegible]. He wants to spend eight days there. He has left this letter on my table and I send it on. Come quick, quick! There are monstrous projects: you don't even suspect them. Write to us about the examination, your departure, your arrival, Baille.

The examination was that for the baccalauréat. Zola passed the written test, but failed in the oral (German, history, literature). He came to Aix; and though he needed both rest and leisure to prepare for a second test at Marseille, he rushed around on the usual excursions. If they went shooting, young Baille carried things; and Zola's weak eyes made him more than ever a 'detestable shot.' Paul took his paints, and his friends posed as Brigands, a theme vainly attempted several times. Zola, the Parisian, was more than ever the dominating figure, ardently reciting de Musset's *Rolla* or *Les Nuits*.

Brothers, do you remember days when life was a song for us? We had friendship, we dreamed of love and glory. . . All three, we let our lips say what our hearts thought, and, naively, we loved queens, we crowned ourselves with laurel. You related your dreams to me, I related mine to you. Then we deigned to come back to earth. I confided my rule of life, wholly consecrated to work and struggle; I told you of my great courage. Feeling the riches of the soul within, I took pleasure in the idea of poverty, you climbed like me the staircase of mansard roofs, you hoped to nourish yourselves on great thoughts. Thanks to your ignorance of real life, you seemed to believe that the artist, in the insomnia of his vigil, earned the morrow's bread. (*Confession*)

Paul accepted the creed of 'work and struggle'; he accepted 'the idea of poverty' and in his life he lived it out in the sense that he lived frugally and crudely—but he was terrified, now and always, of the fact of poverty: that is, of being left without a regular unearned income which would ensure his frugal system.

Zola's attitude was however much more realistic than the *Confession* suggests. In Paris he had been struggling to understand what was happening socially, and how the Aix-cult of Hugo and de Musset stood in the literary world. Not much later (2 June 1860) we find him writing to Baille:

Our century is a century of transition; emerging from an abhorred past, we move towards an unknown future. . . What characterizes our time is this impetuosity, this devouring activity; activity in the sciences, activity in commerce, in the arts, everywhere; railways, electricity applied to telegraphy, steam driving ships, the aerostat rising up aloft. In the political domain, it's much worse: the peoples are rising up, the empires tend to unity. In religion, everything is unsettled: for the new world that is going to come up, a young and lively religion is needed. . . What then will the poet do? Will he be the romancer of the sixteenth century flagellating without pity the vices of his time, drinking fresh wine and making a mock of God and Satan? Will he be the tragedian of the seventeenth century, wearing a wig and mathematically arranging his alexandrines, two by two? Will he be last of all the philosophers of the eighteenth century, denying everything, so as to deny the divine right invoked by kings, shaking the old society so as to make a new one germinate on its debris? No, what was done in these past times had its reason for existence; but we would be perfectly ridiculous to rise up like mummies from their tomb and come to declaim to the gaping crowd that it wouldn't understand. And even if we should want to deny the date of our birth, we couldn't do it.

He was finding that the poetic trends were towards what was to be called in 1866 the Parnassian: an attempt at the marmoreal and the serenely detached, in the name of art for art's sake. And both he and Paul could find no kinship with such a trend. Romanticism was at its last gasp, in the novels of George Sand, the verse and prose of Hugo; and the problem

for the young men who had responded so fervently to the romantic pang and aspiration was how to carry on with the revolt which had sunk deep into their being, while remaining true to the contemporary situation. For Paul, who had not yet seen the work of Delacroix, the question as to what should be done must have been even more obscure than for Zola. But both had become to some extent aware of the problem of originality, of breaking from dead traditions and methods.

Zola failed even in his written test when examined at Marseille; he gave up all hope of scholastic success. On November 30th Paul had better news about himself:

> Dear chap, if I am slow
> To give, in rhymes on O,
> What final results now show
> Of the grim test, a blow
> That made my worries grow:

it's because (I'm not in a good mood) my exam was postponed from Friday to Monday the 28th; however I have been admitted.

> The facts you may easily credit,
> Two reds, one black I got:
> Soon as possible, to reassure you, I've said it,
> In the doubt floating on my indefinite lot.

He went on with a quatrain and a dialogue making fun of the story *Ludovico* by Marguery which was to be serialized in *La Provence*; Marguery was on the periodical's staff. The dialogue was between Gaut, editor of the weekly *Mémorial d'Aix*, and various Spirits; and Gaut was given pedantic words dealt with in a Dictionary Explicatory of the Gautique Language:

Verbology: Sublime art invented by Gaut; this art consists in making new words out of Latin and Greek. *Gunogene*: from the Greek *gune* (woman) and the Latin *gignere* (engendered). The *gunogene* is then he who is engendered by woman, that is to say, man. *Carmines*: from the Latin *carmina* (green [*sic*: should be songs]). *Excelse*: from *excelsus* (lofty). *Virid*: from the Latin *virides* (verdant). *Domine*: *dominus* (master). *Sideres*: *sidera* (stars). *Philonovostyle*: from *philos*, friendly, *novus*, new, and *style* (friend of the new style).

From a letter apparently of December 29th, as the year drew near its end, we get another burst of verses, which elaborate further Paul's dreams and anxieties:

> When wanting to write verses, my dear friend,
> One can't omit the rhyme at the line's end.
> Then in this letter if some words you find
> Come in skew-whiff, just to round off the verse,
> Don't blink annoyed at sterile rhymes and curse.
> Only through trying to be of use they jar.
> So you're forewarned. I start and first declare:
> It's now December, 29th the day;

And, friend, my self-esteem is very strong:
I'm saying easily what I want to say.
But not too soon must I thus cheer my song.
The rhyme, in my despite, may send me wrong.
Baille, our friend has visited me. I'm glad.
To let you know, I write without delay.
But far too lofty I feel this tone I take.
On Pindus heights I must pursue my way.
I sense the heaven's secret influence.
My poet's wings I'll then unfold and rise
Quickly aloft in an impetuous race.
I'm going to touch the high vault of the skies.
But lest my voice-blast now should daze you badly,
A bit of liquorice in my mouth I'll place,
Which, filling up the passage of my voice,
Won't deafen you with all-too-Chinese cries.

A Terrible Tale

It happened at night. Note well the sky was black,
And not a star lit up the heavenly rack.
Extremely night it was, the blackest night
As setting fit for this lugubrious tale.
An unknown drama, monstrous and unheard-of,
The sort of thing no person's ever heard.
Satan, of course, must play a part in it.
The thing's incredible, and yet my word
That's always gained belief is there to prove
The truth of these events that I'll relate.
So listen. It was midnight, when each couple
Labours away abed without a candle,
But not without some heat. And it was warm,
A night of summer. In the sky was spread,
From north to south, announcing a big storm,
Like a white winding-sheet, a cloud immense.
The moon at moments, breaking through this shroud,
Lighted the path where, lost, I strayed alone.
Some raindrops falling at short intervals
Spotted the ground. The usual precursor
Of terrible squalls, a fast impetuous wind
Blowing from north to south rose up in fury.
The simoon that in Africa is fearfully seen
Burying whole cities under waves of sand
Bowed down spontaneously the audacious front
Of trees that raised their boughs towards the skies.
The voice of tempest followed on the calm,
The roar of winds repeated by the forest
Perturbed my heart. The lightning, with a blurt,
Terribly streaked the veil of night with flashes.
Vividly outlined by the livid glow

I saw the sprites and gnomes, O God preserve me,
Who fluttered chuckling on the soughing trees.
Satan commanded them. I saw him there.
My senses froze with fright. His burning eyeball
Shone with a fierce bright red. At times a spark,
Detached, cast off a terrifying reflection.
The round-dance of the demons whirled about him.
I fell. My body, icy, almost lifeless,
Trembled at contact of an enemy hand.
All over me I felt a chilly sweat.
I strove in vain to rise and flee away.
I saw the diabolic band of Satan
Approaching, dancing its fantastic dance,
The dread sprites there, and there the hideous vampires,
To get at me, were tumbling, tripping, pressing.
Up towards heaven they flung their eyes of menace,
Competing which could make the worst grimaces.
'Earth, swallow me up! Rocks, pulverise my body!'
I wanted to cry. 'O, dwelling of the dead,
Receive me living.' But the infernal troop
Swung closer, tighter, its revolting spiral.
The ghouls and demons already ground their teeth,
Preparing for the horrid feast. Delighted,
They cast their glances bright with gluttony.
No hope for me. And then, O sweet surprise,
Suddenly, faraway, there rang the gallop
Of neighing horses coming at full speed.
Slight at the first, the pounding of their movement
Clanged nearer still. Ah, the intrepid coachman
Whipped at his team, arousing with his voice
The fiery quadriga that crossed the woods.
The demon troop, dumbfounded at the noise,
Vanished like clouds before the sweeping zephyr.
I, I rejoice, and then, more dead than living,
I hail the coachman. The attentive carriage
Halts on the spot; and out of the barouche
Comes simpering a fresh and gentle voice.
'Climb up,' she told me, 'climb.' I make a leap.
The carriage-door shuts. I find myself confronting
A woman. O, I swear upon my soul
I've never seen so beautiful a woman.
Fair-haired. Eyes gleaming with bewitching fire
That in a single flash subdue my heart.
I drop at her feet, her small adorable feet,
Her rounded leg. Emboldened, with guilty lip,
I set a kiss upon her heaving breast.
Immediately the cold of death engulfs me.
The woman I hold, the rosy-tinted woman,
Is suddenly gone, is metamorphosed there
To a wan corpse with angular sharp contours.

Its bones all knock together, its eyes are hollow.
It clasps me tight, O horror. A ghastly shock
Wakes me. I see the hearse go turning over,
The hearse toppling. I go, I don't know where,
But very probably I'll break my neck.

There follows a charade of ten lines with the answer: *Chat-Riz-Thé* (Cat-Rice-Tea), meaning *Charity*.

Again we have the cannibal feast, and now Paul himself is explicitly the victim. The dancing sprites seen in the cigar-smoke, the playful nymph waylaid in the forest, have now become nightmare figures; and even the yielding woman, who has been the daydream-liberator, turns into one of death's minions. The embrace, betraying the lover into the snare, flings him out to loss and destruction. The poem thus belongs to the sequence of Catalina and Hannibal, and brings out the rending persistence of the complex of anxieties we have been tracing. The fancy of strange encounters in the woods, of girls or of faery bands, was common property of the Trio. In a letter of 25 July 1860 to Baille, Zola cites a quatrain from 'an epistle addressed to Cézanne':

Go, go, my verses, good or bad, what matters,
If the door of the ideal world you open wide,
If your burning bells recall to me sometimes
The mysterious silence of the wood's sylphides.

But what is a weak dream-formula with Zola becomes a genuine nightmare with Paul.

On December 30th, just about the time Paul was composing his poem, Zola was writing him a letter which helps us to understand those anxieties. 'Since you have translated the 2nd Eclogue of Virgil, why haven't you sent it? Thank God, I'm not a young girl and I won't be scandalized.' The Eclogue deals with the homosexual passion of the shepherd Corydon for the minion Alexis, and depicts the forest as the haunt 'of Trojan Paris and the holy gods', where lioness follows wolf in desire, wolf follows goat, and goat the lucerne-bloom: a very different place from the forest of Paul's nightmare. Why had Paul chosen to translate it? and did it play any part in provoking the nightmare? Perhaps the attraction had lain in its pastoral picture of the summering earth and its delights. Paul may well have felt some link with the earth of the Trio's summer rambles; and the homosexual nexus may have helped to deepen the sense of guilt he already felt strongly enough about sex in general. We may recall the complex of emotions we traced around *infantus amor*. Zola brings out in his letter how racked Paul was by the need to stand up against his father:

What shall I say to end this letter cheerfully? shall I give you courage to advance to the assault of the rampart? or shall I talk to you of painting and drawing? Cursed rampart, cursed painting. One is yet to be tested by the cannon, the other is crushed by the paternal veto. When you hurl yourself at the wall, timidity cries: Go on further! When you take up your brushes: Child, child, says your father, think of the future; with genius one dies and with money one eats. Alas, alas, my poor Cézanne, life is a ball which does not always roll where the hand would like to send it.

In 1859 Louis Auguste had bought for 80,000 francs the Louis-XIV mansion *Jas de Bouffan*, which had been the residence of the governor of Provence. The place was now getting into a bad way. It lay about half a mile to the west of Aix, amid fields, farms, and smaller estates; its value for the banker lay in its profitable acres of vineyard. The name was Provençal for *Habitation of the Winds*; and even in summer, when the town was heavy with heat, a breeze cooled the Jas. The grounds, farmland, and vineyard covered some 15 hectares (37 acres); but Louis Auguste was not the man to spend good money in restoring the layout of the garden, which was mostly let run wild. Low walls surrounded the property. In the house the big hall on the ground level and several rooms above were at first left closed up; the family still used 14 Rue Matheron for the town and went out to the Jas for weekends or for the summer. They could bathe in the fair-sized pool with its stone dolphins and limes; indeed the mansion had no other bath. At the rear stretched a fine avenue of chestnuts, much loved by Paul. Large, square and plain in structure, the house had once been stuccoed yellow; now it was faced with a tawny grey cement; red tiles covered the low-pitched roof. A drive led to the main entry, on the north; a broad terrace flanked the south wall. On the ground floor a hall ran across the house, with stairway near the front door; to the west a big salon with rounded end ran the full length of the house; across from the hall lay dining-room and kitchen. The next floor held the bedrooms, apart from Paul's, which was yet higher up. At some date (probably after his first trip to Paris) Paul had another room on the same floor as his bedroom fitted out as a studio. A big window, put in for north light, cut into the cornice and spoiled the roof-line on that side.

The removal to the big house with its shuttered windows and high ceilings must have pleased Louis Auguste as a sign that he could outdo the snobs with their long pedigrees; but he made no attempt to use the place socially. Oddly, we find no mention of it in Paul's letters to Emile. Perhaps he didn't want to vaunt his family's wealth in the face of the poverty-stricken Zolas; perhaps he was averse at first from thinking of the Jas as his home since such a mansion would seem to bind him yet more closely into the respectable world of his father. However, he came to love the house and its grounds; and for the next forty years it was the one stable point in his restless existence. Though he chafed at anything that seemed to tie him down, any family or social routine, he loved the old house for itself. Generally he did not care where he was, as long as he could work.

Now in 1859–60 his struggle with his father was coming to a head. We can guess how the sharp bantering tongue of Louis Auguste was used to make him writhe and lapse into despair. Though he must have gained some comfort from his mother, she was too dependent on her husband in all senses of the term to give him any steady support in his mute obstinacy. Paul was torn between moods of ambitious self-confidence and hopeless self-distrust. What had he done to prove that he had any future as an artist? Nothing. And yet he could conceive no other kind of life.

PART TWO

Paris and Art: the 1860s

I Zola in Paris (1860)

PAUL's letters to Zola for 1860–1 have not been found; but now we can turn to letters from Zola to him and to Baille. After failing at Marseille, Zola did not go back to the Lycée. As he soon wrote to Paul, 'I didn't complete my studies; I can't even speak good French; I'm a complete ignoramus. The education I got at school is useless: a little theory, no practical experience. What am I to do?' For a few months he wrote verses in a wretched room in a furnished hotel; his mother's apartment was too small to take him in. In December 1859 he had written to Baille, 'I've very little to tell. I can scarcely go out, I live in Paris as if in the country. I'm in a back room, can hardly hear the noises of the traffic; and if it weren't for the spire of Val-de-Grâce in the distance, could easily believe myself to be still at Aix'. Marguery's success in getting a novel printed made him send to *La Provence* a work of his own, *La Fée Amoureuse*. He told Baille:

This is my position: to earn my living no matter how, and if I don't want to bid goodbye to my dreams, busy myself at night with my future. It'll be a long struggle but it doesn't scare me. I feel something latent in me, and, if that something really exists, it will sooner or later see the light of day. So, no castles in Spain; a logical caution, first to make sure of enough to eat, and then to find out what there is in me, which may be much or little, and if I'm wrong, at least I'll be able to eat in my obscure job, and, as so many others have to do, get through this wretched world with my tears and my dreams.

But at moments he lost heart and found his work 'puerile and detestable.'

I am totally downcast, incapable of writing a word, incapable even of walking. I think of the future and it seems so appallingly black I recoil in horror. No money, no job, nothing but discouragement. No one to lean on, no wife, no friend at my side. Indifference and contempt all round. These are what I see when I raise my eyes to the horizon.

Paul, with his terror of finding himself in just the situation into which Zola had landed, must have followed every detail of the latter's struggle with a fascinated interest. Zola's position must have both strengthened him in his resolve to cling to art, and yet terrified him. Early in 1860 Labot found Emile a menial sort of clerk's job at the Docks Napoléon in the Rue de la Douane at 60 francs a month. He started work in April, surrounded by dusty files and clerks 'who were mostly stupid.'

Naturally Zola in libertine Paris was imagined to have plunged into love-affairs. On 5 January 1860 he wrote, 'You ask me to tell you about my mistress; my loves are only dreams.' There had been much discussion on whether one should restrain oneself or not, and under Michelet's influence the Trio had a creed of pure love which didn't much interfere with

bawdy talk. 'The love of Michelet, pure noble love,' Zola wrote to Baille, 'can exist, but it is very rare, admit it.' But, 'far from turning him away from this platonic love,' he urges perseverance with it. This sort of talk went on for some time. The serenaded girl at Aix seems to have stuck in Zola's mind as an ideal love. The lads called her *l'Aerienne*. Zola mentions her in his letters to Baille. On 3 December 1859 he says he isn't missing her, but not long after he asks Baille to 'give her a smile from me if you see her.' Next summer he saw in the Jardin des Plantes a girl who reminded him of her; and this set him off on a trail of reminiscences. He blamed himself for backwardness; he should have written to her, offering his friendship. Baille replied that she had taken a lover. Zola was unmoved. 'It wasn't with S. I was in love, and still perhaps am. It was with *l'Aerienne*, an ideal being whom I did not so much see as dream of.' (He wrote an early, lost work, *Les Grisettes de Provence*.) The vague distant romances of Aix were repeated in Paris. From the window in his lodgings in the Rue St Victor he exchanged smiles with a florist's assistant passing in the morning and evening. 'It's far less tiring to love like that. I wait for her, the girl I worship, puffing at my pipe. Then what fine dreams I have. Not knowing her, I can endow her with any number of qualities, invent endless mad adventures, watch her and hear her talk through the prism of my imagination.' A deep fear of experience as pollution underlay these attitudes. 'I turn my eyes away from the dungheap to rest them on the roses . . . because I prefer roses, useless as they are.' And the daydream of union had as its obverse side a crushing sense of loneliness, that of the city-desert of Baudelaire.

In the crowds that surround me I do not see a single soul, only prisons of clay, and my soul is smitten with despair at its immense solitude and grows more and more sombre. . . Jostling among its fellows, but never knowing them save by the commonplace exchange of commonplace conversation: is that not how man's life is passed?. . . Man is alone, alone on the earth, I repeat shapes pass before our eyes, but every day shows me the vast desert in which each one of us lives.

He, like Paul, had been much affected by Michelet's *Love* and *Women*, with their denunciations of promiscuity; he also took in, with those books' general respect for science, a belief in certain pseudo-scientific propositions such as the indelible effect made on a woman by the first man who mated with her.

Meanwhile, to return to early 1860, Paul had written with some commission about passepartout that he wanted handed on to Villeveille, now in Paris; Zola replied that he hadn't yet met the latter. On February 9th he wrote in extreme depression. 'I doubt everything, myself the first. I don't know where I'm going and cannot put my foot down without fear, knowing that the road I have to traverse is bordered by precipices.' What kept him spiritually alive was the memory of his days in Aix.

Since I came to Paris, I've not had a moment of happiness. I see nobody and I sit in my chimney-corner with my sad thoughts, at times with my fine dreams. Still, now and then I'm cheerful: that is when I think of you and Baille. I rate myself lucky to have found among the mob two hearts that understand mine. I tell myself that, whatever our situations may be, we'll hold fast to the same sentiments, and that consoles me. I find myself surrounded by such insignificant prosaic

people that I rejoice in knowing you, you who are not of this century, you who would invent love if it were not already a very old invention, not yet revised and perfected. I feel a certain pride in having understood you, in having appreciated your true value. Let's have done with the wicked and the jealous; as the majority of human beings are stupid, the scoffers won't be on our side, but what matter! if it gives you as much joy to clasp my hand as it does me to clasp yours.

A few days later on March 3rd, he wrote a long letter again to Paul, encouraging him in his efforts to break with Aix. He made the most of his sophisticated knowledge of Paris, but used it to soothe the fears and vacillations which he knew were agitating his friend. Louis Auguste had weakened in his oppositions; perhaps Paul's evident unhappiness had given his mother courage to champion his cause. Perhaps also Louis Auguste, while afraid of his son succumbing to the lures of wicked Paris, was hoping that the problems of living on his own would soon drive him back home; with his shrewd power of estimating character, he must have had a low opinion of Paul's competence in almost every direction. Whether any conditions were attached to his acceptance of a Paris visit, we do not know.

I don't know. I have uneasy forebodings about your visit, I mean as to the more or less imminent dates of your arrival. To have you near, to chat together, as in the old days, pipe in mouth and glass in hand, seems to me something so wonderful, so incredible, that there are moments when I ask if I'm not fooling myself and if this fine dream is really coming true. One is so often cheated in one's hopes that the realization of one of them takes one by surprise, and one doesn't admit it as possible till the facts are certain.

I don't know from what point the blow will fall, but I feel a sort of storm around my head. You have fought for two years to reach your present position; it seems to me that after so much effort the victory can't be complete without some more battles. Here is M. Gibert trying to sound out your intentions, who advises you to stay on at Aix: a teacher who doubtless sees with regret a pupil escape him. On the other hand your father talks of making inquiries, of consulting this Gibert, a consultation that will inevitably result in your visit being postponed till August.

All this gives me shivers. I tremble at receiving a letter in which with many lamentations you announce a change of date. I'm so used to thinking of the last week of March as the end of my boredom that it'd be very hard for me, after storing up only enough patience to last till then, to find myself alone when the time comes. Well, we must follow the great maxim: Let the water flow, and we'll see what of good or ill the course of events will bring us. If it's dangerous to hope for too much, nothing is so stupid as total despair. In the first case one risks only one's future happiness, while in the second one is sad without even a reason.

You ask me an odd question. Of course one can work here, as anywhere else, if one has the will. Paris offers, further, an advantage you can't find elsewhere: the museums in which you can study the old masters from 11 to 4. This is how you must divide your time. From 6 to 11 you go to a studio to paint from the live model; you have lunch, then from 12 to 4 you copy, in the Louvre or the Luxembourg, whatever masterpiece you like. That will make up nine hours of work. I think that ought to be enough, and you can't but do well with such a routine. You see, we'll have the whole evening free and we can use it as we think fit, without interfering in the least with our studies. Then on Sundays we'll dodge off and travel a few leagues outside Paris. The places are delightful, and if your heart desires, you can sketch on a piece of canvas the trees under which we eat our lunch.

Daily I have charming dreams I want to realize when you're here: poetic work such as we love. I am lazy when it comes to crude work, work that keeps the body busy and stifles the intelligence. But art, which occupies the mind enchants me; and it's often when I'm carelessly lying down that

I work the hardest. Many people don't understand that, and I'm not the one to bother about making them understand. Besides, we're no longer kids, we must think of the future. Work, work: it's the only way to get ahead.

As for the money-question, it's true that 125 francs a month won't leave much room for luxury. I'll reckon out for you what you should spend. A room at 20 francs a month; lunch at 18 sous and dinner at 22, which makes 2 francs a day, or 60 francs a month. Add 20 francs for your room, the total is 80 francs a month. Then you have the studio to pay for: the Atelier Suisse, one of the least expensive, charges, I think, 10 francs. Add 10 francs for canvas, brushes, colours: that makes 100. So you'll have 25 francs left for laundry, light, the thousand little needs that turn up, tobacco, amusements. You see you'll have enough to live on, and I assure you I'm not at all exaggerating; rather I'm underestimating.

Incidentally, it'd be a valuable experience. You'd learn the value of money and how a chap with his wits about him can always extricate himself from a predicament. I repeat, so as not to discourage you, you can manage. I advise you to show your father the above reckoning. Perhaps the hard fact of the figures will make him loosen his purse strings a little. On the other hand you could earn some cash yourself. Studies made in the studios, above all copies made in the Louvre, sell very well. And if you only did one a month, that would add very nicely to the budget for your amusements. It all depends on finding a dealer: simply a question of looking round. Come without fear. Once your bread and wine are assured, you can, without danger, devote yourself to the arts.

Here you have plenty of prose, plenty of material details. As they're for your sake and useful as well, I hope you'll forgive them. This devil of a body is sometimes a nuisance, one has to drag it everywhere, and everywhere it makes terrible demands. It's hungry, it's cold, and so on, and there's always the soul wanting to put its word in and forced in turn to keep silent and behave as if it didn't exist, so that the tyrant may be satisfied. Luckily one finds a certain pleasure in the satisfaction of one's appetites.

Answer this at least before the 15th, to reassure me and tell me of any new developments cropping up. Anyhow, I expect you to write, just before you leave, the day and hour of your arrival. I'll go to the station to meet you and take you at once to lunch in my erudite company. I'll write again before that. Baille has written. If you see him before leaving, make him promise to join us in September. Greetings to you, my respects to your family, your friend. Emile Zola.

We see how thoroughly aware he was of Paul's timid character and how tactfully he tried to remove the grounds of his fears. Sure enough, an impediment came up. On March 17th Zola wrote to Baille, 'Recently I got a letter from Cézanne in which he tells me his little sister is ill and that he scarcely counts on arriving in Paris before the first day of next month.' (Rose was now in her sixteenth year.) Gibert had in fact advised against the trip; and Paul seems to have agreed not to press further till he had finished his legal studies. On March 25th Zola wrote another long letter, which brings out how immature still were the art ideas held by both the youths. It has often been cited to show Zola's views, but Zola, who knew Paul thoroughly, is quite confident in appealing to him; and as we shall see, a letter from Paul to Huot, in June 1860, proves that he too had at this phase a complete acceptance of academic values.

We often talk about poetry in our letters, but the words sculpture and painting are seldom, not to say never, mentioned. It's a serious omission, almost a crime; and I'll try to remedy it today. I don't know if you're acquainted with Ary Scheffer, that painter of genius who died last year. In Paris to answer no would be a crime, but in the provinces it's only gross ignorance. Scheffer was a

passionate lover of the ideal, all his types are pure, ethereal, almost diaphanous. He was a poet in every sense of the word, almost never painting actual things, treating the most sublime, the most thrilling subjects. Can you ask for anything more poetic, of a stranger and more heart-rending poetry than his *Françoise de Rimini*. You know the episode in the *Divine Comedy*. Françoise and her lover Paolo are punished in hell for their lust by a terrible wind that bears them eternally along, locked together—that eternally drives them to whirl in gloomy space. What a magnificent theme. But also what a difficult one. How to render this supreme embrace? These two souls that remain united even when enduring eternal punishment: what expression to give to their countenances in which suffering has not effaced love? Try to get hold of an engraving and you'll see how the painter has come victorious out of the struggle. I won't try to describe it. I'd only waste paper without imparting any idea of it.

Scheffer was a feeble and sentimental romantic, into whose thin conceptions Zola or Paul could throw their strained and hectic emotions at this moment. But Zola was not alone in his estimation of Scheffer. It is instructive to read how the de Goncourts in *Manette Salomon* defined that artist's place in the post-romantic phase as the leader of poet-painters:

He painted souls, white and luminous souls created by poems. He modelled angels of the human imagination. The tears of masterpieces, the influence of Goethe, the prayer of St Augustine, the Canticle of moral sufferings, the chant of the Passion of the Sistine Chapel: he tried to put all that on his canvas with the materiality of design and colours. Sentimentalism: that was the means used by the weeper of woman's tendernesses in his effort to rejuvenate, renew, and impassion the spiritualism of art.

They mention also the artists who attempted a vague Dantesque symbolism or sought the Muses in the Walpurgis Night, 'in the melancholy of the fantastic.' Literary influences in the art world are seen as at the extreme end away from Scheffer, in the work of Delaroche. (Note how Zola assumes that Paul knows Dante's work.)

Zola goes on to address a lecture to a 'realist', assured that Paul will agree with it. *Realism* was in fact a new word of the critical vocabulary, used to define the achievement of Courbet. Duranty had founded in 1857 a review *Le Réalisme*. The realist school proposed to set out and describe 'the things that touch life in the greatest number,' to depict the most trivial persons and facts, to oppose to romantic effusions and hyperboles the everyday truth, rendered with minute exactitude. Zola, who was soon to use the term Naturalism for his art in an effort to outdo Realism, has picked up the chatter of the day without any deep grasp yet of what was at stake.

Scheffer the spiritual makes me think of the realists. I have never understood these gentry very well. I take the most realistic subject in the world, a farmyard. A dungheap, ducks waddling in a puddle, a figtree to the right, etc. etc. There you have a picture that seems stript of all poetry. But let a beam of sunshine enter to make the golden straw sparkle, the pools of water glitter, to glide among the leaves of the tree, break up and come out in shining rays; in addition let a graceful girl enter the background, one of those peasant girls of Greuze, throwing grain to her little world of poultry. From that moment will not this picture too have its poetry? Will not one pause enchanted, thinking of the farm where one drank such good milk one day when the heat was overpowering?

Then what do you mean by this term realist? You pride yourself on painting only subjects denuded of poetry! But everything has it, manure as well as flowers. Is it because you claim to make

a servile imitation of nature? But then since you rail so against poetry, you must say that nature is prosaic. And that is a lie. It is for you I say this, monsieur my friend, monsieur the greater painter of the future. It is to tell you that art is single, that spirituality is only words, that poetry is a great thing, and that except in poetry there is no salvation.

Though he weakens his case by the references to Scheffer, Greuze, and the importance of personal associations roused by a picture, what he says has its great truth, a truth that remained at the heart of both his own and Paul's work throughout their lives: art implies the penetrative and transformative force which we may call poetry, at work on the actual world of experience.

I had a dream the other day. I had written a beautiful book, a sublime book, which you had illustrated with beautiful, sublime drawings. Our names shone in golden letters, united on the first page, and in this brotherhood of genius went down inseparably to posterity. Unfortunately it is still only a dream.

 Moral and summing-up of these four pages. You should satisfy your father by studying law as assiduously as possible. But you should also work at strong and firm drawings—*unguibus et rostro*—in order to become a Jean Goujon, an Ary Scheffer, to avoid becoming a realist, and finally to be able to illustrate a certain volume that is running in my mind.

Their names have gone down inseparably to posterity, but not in the form of text and illustration which both of them in these early years must have hoped for.

As for the excuses you make, either with regard to sending me engravings or as to the pretending boredom your letters cause me, I make so bold as to declare they're in the worst possible taste. You don't believe what you set out. . . . Next, you write that you are very sad. I'll reply that I too am sad, very sad. It's the breath of the century that has passed over our heads. We should not blame anyone, even ourselves; it's the fault of the times in which we live. Then you add: even if I have understood you, you do not understand yourself. I do not know what you mean by the term "understood." For my part, this is how it stands. I have recognized in you a great kindness of heart, a great imagination: the two main qualities before which I bow. And that has been enough for me. From that moment I have understood you, I have judged you. Whatever your weakness, whatever path you follow, you will always be the same to me. It is only stone that does not change, that does not deviate from its stony nature. But man is a whole world. He who would try to analyse the feelings of only one for a single day would perish in the attempt. Man is incomprehensible, if one should wish to know him down to his slightest thoughts. But what do your apparent contradictions matter to me? I have judged you to be good and a poet, and I shall always repeat to you: I have understood you.

He himself had begun a work and given it up. On April 16th he could not resist giving Paul another dose of advice. We learn that Paul was still sending poems in his letters.

You are right to not grouse too much at fate. After all, as you say, with two loves in your heart, one for woman and one for the beautiful, it would be wrong to despair. You sent me some verses exhaling a sombre sadness. . . You say that sometimes you lack the courage to write to me. Don't be an egoist. Your joys as well as your sorrows belong to me. Another phrase in your letter also left a depressing impression on me. It's this: 'Painting that I love, even though I don't succeed, etc.' You, never succeed! I think you're mistaken about yourself. But I've already told you: In the artist there are two men, the poet and the craftsman. One is born a poet, one becomes a crafts-

man. And you, who have the spark, who possess what one can never acquire, complain: when, for success, you only need to train your fingers, to become a craftsman.

We know little of Paul's early works; but he was clearly finding it very hard to find a personal style or to put down on canvas even a fraction of the emotions and ideas that stirred him. His first paintings of any sort of competence seem to have been done in an anaemic and sentimental academic vein, and were mostly copies of works in the Museum or engravings from periodicals. This style came to its head in the panels of the Seasons done for the Jas and ironically signed Ingres—not out of scorn for that painter, but as a piece of self-mockery. Other examples were his copy of *The Kiss of the Muse*, which his mother hung on her wall, or *The Girl with Parrot*, which he painted for her.

I shall not leave this subject without adding a couple of words. Recently I warned you against realism; today I want to point out another danger, commercialism. The realists do after all create art—in their own way—they work conscientiously. But the commercial artists, those who paint in the morning for their evening's bread, they grovel in the dust. I don't tell you this without some reason. You are going to work with —[? Villevielle]; you copy his pictures, perhaps you admire him. I'm afraid for your sake about this path you're taking, all the more because he whom you are perhaps trying to imitate has some fine qualities, which he shamelessly exploits, but which all the same make his pictures seem better than they are. His work is pretty, it's fresh, the brushwork good; but all that's just a trick of the trade, and you'd be wrong to halt at that point.

Art is more sublime than that. Art is not limited to the folds of a drapery, to the rosy tints of a virgin. Look at Rembrandt: with one ray of light all his figures, even the ugliest, become poetic. So, I repeat,——is a good instructor to teach you the trade; but I doubt if you could learn anything more from his pictures. Being rich, you no doubt expect to follow art and not business. . . So beware of an exaggerated admiration for your compatriot. Put your dreams, those lovely golden dreams, on to your canvas, and try to bring out the ideal love you have in you. Above all, and here is the abyss, do not admire a picture because it is painted quickly. In a word, and in conclusion, don't admire and don't imitate a commercial painter.

Zola has been ridiculed for his comment on quick painting, since later Cézanne became so slow at the easel. However, Paul may well have been already attempting works in which his emotions were deeply implicated, like the nudes and rapes that he was soon to depict; and in such works he would have used a wild and agitated method—the sort of thing we see in his fantasy works of the 1860s, but in a cruder, even more violently slashing style. We may recall that he had written to Zola arguing against reworking a picture. Of himself Zola remarked:

My new life is monotonous enough. At 9 a.m. I go to the office; until 4 I make a record of customs declarations; I copy correspondence etc. etc.; or rather I read the paper, yawn, pace up and down, etc. etc. Very sad indeed. But as soon as I go out, I shake myself like a wet bird, light my pipe, breathe, live. I turn over in my head long poems, long dramas, long novels. I am waiting for summer to find an outlet for my creative spirit. *Vertu Dieu*, I want to publish a book of poems and dedicate it to you.

On April 26th, at '7 o'clock in the morning,' he wrote again. Clearly Paul had not replied and Zola was worried. 'I am afraid of the slightest cloud between us.' He asks Paul to assure

him that he hasn't been angered at comments with which he disagreed. He begs to be told that he is still

the gay friend, the dreamer, who stretches himself out so gladly on the grass at your side, pipe in mouth and glass in hand. Friendship alone dictates my words; I feel closer to you when I tangle myself up a little in your affairs; I chat, I fill out my letters, I build castles in Spain. But for God's sake don't think I'm trying to lay down a line of conduct for you. Take from my words only what suits you, what you find good, and throw the rest away without even bothering to argue the matter.

He knows how easy it was to discourage or repel Paul with the least effect of dictation; and regrets that he has been carried away by the impulse to show off his newfound sophistications (or what he thinks are such). He hastens to admit his own ignorance of art, saying that he 'can no more than distinguish white from black,' and thus cannot 'judge the brushstrokes' —a reference to his bad sight.

I content myself with saying whether the subject pleases me, whether the whole makes me think of something fine and great, whether the love of beauty is expressed in the composition. In a word, without troubling about the craftsmanship, I speak of the art, of the thought dominating the work. And I believe I do wisely. Nothing seems to me so pitiful as the exclamations of dabblers who learn a few technical terms in the studios, and then repeat them confidently like parrots. . .

On the other hand, I can understand that when you look at a picture, you who have learned how hard it is to put colours on to canvas according to your wish, you are very interested in the technique, you go into ecstasies over this or that brushstroke, over a particular colour etc. etc. That is natural. The idea, the spark in you, you are seeking for the form you haven't acquired, and in good faith you admire it wherever you find it.

But take care. This form isn't everything, and whatever the excuse you have, you should put the idea ahead of it. I'll explain. A picture should not be to you only grand colours set on a canvas; you must not all the while search for the mechanical procedure by which the effect has been got, what colour used—but look at the whole, ask yourself if the work is really what it ought to be, if the artist is really an artist.

There is little difference, to the vulgar eye, between a daub and a masterpiece. In both there are white, red, etc., brushstrokes, canvas, a frame. The difference is only in that something which has no name, which is revealed only by intelligence and taste. It is this something, this artistic feeling for possibilities, that you must discover, and above all admire. After that you may try to understand how it's done, you may think of the technique.

He goes on to admit that form is important; to despise it is stupid.

Without form one can be a great painter for oneself, but not for others. It is form that establishes the idea, and the better the idea, the better the form should be as well. . . That is, the technique is everything and nothing. One absolutely must know it, but one must not forget that the artistic feeling is equally essential. In a word, they are two elements that cancel each other out separately, and which when united make a magnificent whole.

Apart from the conception of form as a mere means, something external to the idea or image, which is used to 'establish' them, these comments are not so foolish or wide of the mark as they are often described. Indeed, at the end Zola moves towards the notion of form and idea as inseparable opposites which, in action, create the unity of a work of art. But in any case he is largely talking to himself of his own problems. At Aix Paul had no temptation to

become a realist or a commercialist or a technique-deifier. He was struggling along, still rather blindly, unable to find out how to achieve any sort of satisfactory whole.

Before Zola had posted his letter of advice he received a letter from Paul, who for once was in a hopeful mood, for a Postscript said: 'I have just got your letter this moment. It gives me a sweet hope. Your father is relenting. Be firm, without being disrespectful. Remember that it is your future at stake and that your whole happiness depends on it.' But soon Paul was in despair again. During the Easter holidays Baille was at Aix and called at the Jas. Paul in his touchy frustrated mood would hardly speak to him, and he came away depressed. He had written to Zola, 'When you realize I'm incapable of giving expression to art in painting or poetry, don't you feel I'm unworthy of you?' Kindhearted Zola replied, 'When you see us, art-student and scribbler, incapable of gaining a position for ourselves in life, don't you think we're unworthy of you, poor Bohemians that we are?' He set himself to bring Paul and Baille together again. On May 2nd he wrote, 'Cézanne spoke to me about you, he admits his fault and assures me that he's going to change his character. Since he's opened up the subject, I mean to let him have my opinion on his way of behaviour. I shouldn't have begun it, but I feel it's useless at present to wait till August before attempting your reconciliation.'

But in his amiable way, afraid of giving offence, he could not speak in such an outright tone. He approached the issue of reconciliation more deviously. 'You mention Baille in both your letters. For a long time I've been wanting to discuss this *garçon* with you.'

He is not like ourselves, his mind is not cast in the same mould. He has many fine qualities we lack, and many faults too. I won't try to paint his character to you, to tell where he sins, where he excels; nor will I call him wise any more than I'll call him fool. All that is only relative and depends on the angle from which one looks at life. More, what does it matter to us, his friends? Is it not enough that we've rated him a good fellow, devoted, superior to the rabble, or at least better qualified to understand our hearts and our minds? Shouldn't we judge him by the same tolerance we expect for ourselves, and if anything in his conduct annoys us, by what right shall we find evil in what he finds good? Believe me, we don't know what life holds for us. We're at the beginning, all three of us, rich in hope, all three equal because of our youth and our dreams. Let us clasp hands: not the embrace of a moment, but an embrace that will keep us from failing someday, or console us if we should fail.

What the devil is he mumbling about? you'll say. My poor old chap, I thought I noticed that the tie binding you to Baille was getting weaker, that one link in our chain was about to break. And trembling I beg to think of our happy gatherings, of the vow we made, glasses in hand, to walk all our lives along the same path, arm in arm; to remember that Baille is my friend, that he is yours, and that if his character is not wholly sympathetic to ours, he is nonetheless devoted to us, loves us—in short, that he understands me, he understands you, he deserves our confidence, our friendship. If you have anything to reproach him with, tell me. I'll try to excuse him. Nothing is so much to be feared as these misunderstandings that aren't freely discussed between friends.

Zola further goes into the relations of himself and Paul, and tries tactfully to encourage his friend.

'When I've finished my law studies,' you say, 'perhaps I'll be free to do what I think right;

perhaps I'll be able to go and join you.' I hope to God it isn't just a momentary joy, but that your father is opening his eyes to your true interest. Perhaps in his eyes I am a rattlebrained fellow, even a bad friend to encourage you in your dream, in your love of the ideal. Perhaps if he read my letters, he'd judge me severely; but though it meant the loss of his esteem, I'd say boldly to his face what I say to you: 'Long have I pondered on the future, on the happiness of your son, and for a thousand reasons it would be tedious to list I believe you should allow him to go in the direction his inclination leads him.'

Mon vieux, it's a question of a little effort, a little hard work. Come, what the devil, are we wholly devoid of courage? After the night comes the dawn. So try to make it pass as well as may be, this night, and when the dawn comes, you can say: I've slept long enough, Father. I feel strong and courageous, have pity, do not cage me in an office, let me take wing, I am suffocating. Be kind, Father.

We have the feeling that Zola knew quite well how Louis Auguste took on himself the right to open all letters addressed to any member of the family, and that at such a juncture as the present he would keep a sharp eye on the post. He was making an indirect appeal to him and hoping to say for Paul what Paul didn't dare to say for himself. But he certainly over-estimated his own powers of eloquence. However, he went on trying to reconcile Paul and Baille, probably stretching a point here and there to make things look better than they were. He declared that Paul had replied:

You're afraid, according to your last letter, that our friendship with Baille is weakening. O no, for, *morbleu*, he's a *bon garçon*, but you know that with my character as it is, I don't know too well what I do, and so if I've behaved badly to him at times, please let him forgive me; but apart from that you know we get on very well together, but I approve of what you say, because you're right. And so we are still the best of friends.

In his letter, of May 14th, he gave a pacifying version of Paul's character to Baille, as he had given of Baille's character to Paul. He was relying on the unlikelihood of either of his correspondents showing his letters to the other.

So, you see, my dear Baille, I was right in thinking it was only a slight cloud that would blow away at the first puff of wind. I told you the poor chap doesn't always know what he's doing, as he himself admits readily enough; and that, when he hurts your feelings, you mustn't blame his heart, but the evil demon that clouds his thoughts. He has a heart of gold, I repeat, he is a friend who can understand us, he is made as we are, a visionary. I don't agree with you he should know anything about the letters we've exchanged concerning your reconciliation. Let him think rather I've butted in at your suggestion. In a word, he mustn't realize you've complained of him, that you were on bad terms for a moment.

As for your behaviour towards him till August, when our happy reunion will take place, it should be as follows (that is, in my opinion, of course): you are to write to him regularly, without grumbling too much if his replies are delayed; your letters should be as affectionate as in the past, and in particular should avoid any allusion, any reference that might recall our little quarrel. In a word, everything should be as if nothing had happened between you. We are treating a convalescent, and if we don't want a relapse, let us avoid any imprudence. You understand what makes me write like this, the fear of seeing our friendly triumvirate broken up. And you must forgive my pedantic tone, my exaggerated fears, my perhaps unnecessary precautions, setting them all down to the friendship I bear towards both of you.

With all his care and tact he found that it was hard to bring the two old friends together again. On June 2nd he wrote to Baille:

Old Cézanne tells me in each of his letters to remember him to you. He asks for your address, so as to write to you very often. I'm surprised he doesn't know it, and that proves, not only he hasn't written to you, but also you keep the same silence towards him. Still, as it's a request that shows his good intentions, I'll satisfy him. And so a little upset fades out and becomes a legend.

He added, 'In the meanwhile, Cézanne says, run off and have a good time'.

Baille, no longer subjected to the ardent presence of his two friends, was drawing away from their ideas as he sought to get at grips with his career. He blamed Zola 'for not facing reality bravely, for not trying to gain a position in life' of which he might be proud. Zola replied, 'My poor dear chap, you talk like a child. Reality seems no more than a word to you.' He objected: 'You talk of the false fame of poets; you call them mad, you assert you won't be such a fool as to go and die in an attic just for applause as they do.' By June he was growing somewhat irritated, despite all his efforts to take Baille for what he was. 'The word *position* occurs several times in your letter and makes me angry. Those eight letters have something of the well-to-do grocer about them and they annoy me . . . The letter you've written is not that of a young man of twenty, not that of the Baille I know Are you really being sincere? do you really no longer dream of liberty? . . . Are all your aspirations limited by material success? If that's so, my poor chap, I'm sorry for you; for then all I've written to you will seem, as you say, lacking in reason, composure, and commonsense.'

On June 13th he was writing to Paul, 'Why don't you say anything more of the Law? What are you doing about it? Are you always on bad terms with it?' And he made a comment which showed how much both he and Paul lived in the happy summers of their youth that now seemed fast receding. 'You sometimes re-read my old letters, you say. It's a pleasure I too give myself often.' He means that he re-reads Paul's letters. On June 25th he wrote again:

You seem discouraged in your last letter; you speak of nothing less than throwing your brushes at the ceiling. You moan about the solitude surrounding you. You are bored. Isn't that a malady we all suffer from, this terrible boredom? isn't it the sore spot of our century? and isn't discouragement one of the results of this spleen that constricts our throats? As you say, if I were at your side, I'd try to console you, encourage you. I spent yesterday with Chaillan. As you remarked, he's a lad with a certain basis of poetry. What he lacks is direction. I know how you hate the crowd, so speak only of yourself, and above all never be afraid of boring me.

Paul must have been suffering at the way in which others known at the art school had left for Paris—Solari, Villevielle, Chaillan (now at the Suisse), with Truphème due to go. Zola returned to the task of cheering him up, pretending that the need for their friendship was mainly on his side.

God help me if I'm your evil genius, if I'm creating unhappiness for you by glorifying art and

dreams. But I can't believe it. The devil can't be lurking under our friendship and leading us both to our destruction. So take courage again. Pick up your brushes once more, let your imagination rove as it will. I have faith in you; and if I'm urging you in the direction of ruin, may the ruin fall on my own head. Above all have courage and think seriously, before you bind yourself to this career, of the thorns you may come up against. Be a man, leave dreams aside for a moment, and act. . . .

Like a shipwrecked man who clings to a floating plank, I've been clinging to you, dear old Paul. You have understood me, your character has been sympathetic to me. I have found a friend and given thanks to heaven. At various times I've been scared of losing you, but now that seems impossible. We know each other too well ever to drift apart.

On July 4th he was once more trying to placate Baille and work out schemes for bringing him and Paul together. 'As for Cézanne's continued silence, we'll have to take thought. I've told him to send you my poem. On your side you might write to tell him I've informed you he has it, and ask him how he can send it to you. Such a letter could do no harm. You would keep in the background, speaking only of me or something else, and that would no doubt revive your friendship.' He sought to interest Baille in his quest for the new way in literature which he sensed but which still eluded him.

I would rather not follow in anyone's footsteps. Not because I'm ambitious for the name of head-of-a-school—normally such a man is always systematic—but I'd like to find some unexplored pathway and get away from the crowd of scribblers of our time. . . It's an evident thing, each society has its own particular poetry; well, our society is not that of 1830, so our society does not yet have its poetry and he who found it would be rightly famous. The aspirations towards the future, the breath of liberty that rises up on all sides, the religion that purifies itself: there indeed are powerful sources of inspiration. The problem comes down to that of finding a new form, of singing worthily the future peoples, of showing with grandeur humanity climbing the steps of the sanctuary. You cannot deny that there's something sublime to be found. What? I still don't know. I feel confusedly that a great figure is agitated in the shadow, but I can't grasp its features.

Sometime in July he also returned at length to the task of instructing and encouraging the despairing Paul.

Let me explain myself yet again frankly and clearly. All your affairs seem to be going so badly I'm upset. Is painting with you only a caprice that came into your head one day when you were bored? Is it only a pastime, a mere theme for conversation, a pretext for slacking at the Law? If that's the case, I can understand your behaviour. You do well in not driving things to an extreme and bringing about more family ructions. But if painting is your vocation—and that's how I've always looked on it—if you believe yourself able to make good at it after working hard, then you become an enigma to me, a sphinx, and heaven knows what of the impossible and the mysterious. One thing or the other. You don't want to—and in that case you're gaining your end admirably—or you do want to, and then I don't understand what it's all about.

Sometimes your letters give me lots of hope, sometimes they take away even more. Of such is your last, in which you seem almost to bid farewell to your dreams, which you could so well change into reality. In this letter there's a phrase I've tried vainly to understand. 'I am talking in order to say nothing, as my conduct contradicts my words.'

I've built up hypotheses in order to explain the meaning of this statement. None of them satisfies me. What is your conduct then? Certainly that of a lazy man. But what is surprising in that? You are being forced to do work repugnant to you. You want to ask your father to let you

come to Paris and become an artist. I see no contradiction between that and your actions. You neglect the Law, you attend the Museum, painting is the one work you care about. There you have an admirable agreement between your desires and your actions.

Shall I tell you something?—above all don't get angry—you lack character. You have a horror of fatigue of any sort, in thought or in deed. Your great principle is to let things slide and pick them up again at random. I don't say you are wholly wrong; everyone sees things in his own way and has his own beliefs. Only, you have already tried out this system of conduct in love; you were waiting, you said, for the right time and circumstance; you know better than I that neither the one nor the other ever came. The water never stops flowing by, and one day the swimmer is astounded to find nothing left but burning sand.

I've thought it my duty to repeat to you once again what I've often said: my position as friend excuses my frankness. In many respects our characters are alike. But *par la croix-dieu*, if I were in your place, I'd have the thing out, risk all for the sake of all, not drift vaguely between two such different futures, the studio and the bar. I pity you. You must be suffering from this vacillation. For me that would be yet another reason for rending the veil. One thing or the other. Be a real lawyer or else be a real artist, but don't linger on as a being without a name, wearing a paint-soiled toga.

You're a bit careless—let me say it without annoying you—and no doubt my letters lie about and your parents read them. I don't think I give you bad advice. I believe I speak as a friend and reasonably. But perhaps everyone doesn't think as I do; and if what I surmise is correct, I can't be in high favour with your family. No doubt they look on me as a dangerous influence, the stones cast in your path to make you stumble. All this distresses me greatly. But, as I've already told you, I have so often found myself misjudged that one false judgment more doesn't surprise me. Remain my friend. That's all I ask.

Another passage in your letter grieved me. You say you sometimes throw your brushes at the ceiling when the form doesn't follow your idea. Why this discouragement, this impatience? I might be able to comprehend them after years of study, after thousands of vain attempts. Then, realizing your incapacity, your inability to produce good work, you'd be wise to trample palette, canvas, and brushes underfoot. But you who have so far had only the desire to work, you who haven't yet taken up your task seriously and regularly, you have no right to rate yourself incapable. So take courage. All you have done so far is nothing. Courage, and remember that, to reach your goal, you'll need years of study and perseverance.

Am I not in the same position as you? is not form equally rebellious in my hands? We have the idea. Let us march frankly and gallantly on our way, and may God guide us! All the same I like this lack of confidence in oneself. Look at Chaillan. He finds all he does excellent. That's because he has nothing finer in his mind, no ideal he is striving to attain. And he'll never be great, because he thinks he is great already; because he's satisfied with himself.

Then before he had finished the letter more news came—another false hope. No doubt what was holding Paul back now was not only the opposition of his father; as his departure for Paris became more possible, his self-doubts increased. He was both afraid of the unknown in general and afraid that he'd feel a fool with a petty provincial sensibility, a set of hopes based on the lack of any criteria, before the metropolitan situation in art. Zola wrote:

I've just had a letter from Baille. I don't understand it at all. Here's a phrase I read in this epistle: 'It's almost sure that Cézanne will go to Paris—what joy!' Is it of you he writes? have you really given him this hope recently when he was in Aix? or has he just been dreaming? he has taken your desire for fact? I repeat, I don't understand. I urge you to tell me frankly in your next letter how things stand. For three months I have been saying to myself, according to the letters I get: He's

coming, he isn't coming. Try, for God's sake, not to imitate the weathercock. The question is too important to go from white to black. Frankly, what is the position?

But that was just what Paul could not tell him; for he didn't know, torn between the struggle against his father and the struggle against his own indecisions. On July 25th Zola wrote to Baille, saying that in his last letter he had asked several questions: 'news of Aix about which Cézanne obstinately declines to write.' In another letter of this month he mentions: 'a charming expression found in one of Cézanne's letters: I am a nursling of the Illusions (*je suis en norrice chez les Illusions*).' This may have been said in connection with the projected visit to Paris, recalling the theme of Lost Illusions in the Balzacian characters who seek to conquer that city. On August 1st, Zola was still trying to find out what Paul really had in mind. He had just received a letter from Aix and discusses whether an artist should work afresh over something done, *remanier*; he agrees with Paul that he shouldn't. 'So I am wholly of your opinion. Work conscientiously, do the best you can, fill in the shape a little so as to adjust the parts to form a proper whole, then leave your work to its good or bad fortune.' Baille, Cézanne has said, looks on art as sacred. 'That means thinking like a poet.' Zola remarks, 'While reading over your letters of last year I struck the little poem on Hercules between Vice and Virtue.' This must have been the poem on the *Pitot*. We see then that Paul actually completed it; and now Zola brings it up in connection with his inability to make a choice at the crossroads of his life. He himself continues with the metaphor of the two pleaders, who represent different ways of life; but in Paul's mind Right or *Droit* is inextricably entangled with paternal authority, and Vice or the Left with Art, which in turn is hard for him to distinguish from sex. That is, Authority (Father-Cicero-Hamilcar-Law-Money and the rest of it) is felt as equally cutting him off from the liberation of his impulses in artistic expression and sexual experiences. That is why for so long many of his paintings, when he lets himself go, deal with orgies, rapes, temptations. Zola goes on:

As to the matter you know of, I can only repeat myself, only give you the same advice already given. As long as both advocates haven't made their pleas, the cause doesn't advance; discussion dominates everything. So if you stay silent, how can you expect to get ahead and come to an end? It's a sheer impossibility. And remember that it's not the loudest shouter who's in the right. Speak quite softly and wisely; but by the devil's horns, feet, tail, and navel, speak, but speak!

In the same letter he makes a comparison between his own verse and Paul's; and despite his ideal of 'purity' in style, he correctly recognizes the much greater vigour of Paul's poems, which, however dashed off, do spring genuinely from his inner struggle.

Singing for singing's sake, and rather careless, you use the most bizarre expressions, the most droll provincial turns. Far from me to take that as a crime, especially in our letters; on the contrary I'm delighted. You write for me and I thank you for it; but the crowd, *mon bon vieux*, is indeed otherwise exigent. It's not enough to speak; one must speak well. . . What is there lacking, I've asked myself, to turn this brave Cézanne into a great poet? Purity? He has the idea, his form is nervous, original, but what spoils him, what spoils everything, are the provincialisms, the barbarisms, etc. Yes, old chap, you are more a poet than I. My verse is perhaps purer than yours, but certainly yours is more poetic, more true. You write with the heart, I with the *esprit*. . .

But what Zola took for provincialisms were in the last resort rooted in Paul's whole artistic outlook: a respect for the particular, for the unique moment of experience in all its strains and stresses. And this aspect he was to carry forward one way or another into all phases of his art. Zola, struggling to achieve a refined literary style, ended by coming round in essence to Paul's standpoint. By the time he wrote *L'Assomoir* he had achieved realistic dialogue (in both the social and the psychological sense), and he realized that he could not embed such a dialogue without falsity in a narrative of literary refinement. So he gained a new kind of unity for a novel by writing the whole thing in a style keyed to the realism of the dialogue. Here is one of the many points in which we see the close kinship, artistically as well as emotionally, of Zola and Cézanne.

The hope of summer holidays together in Aix fell through. Zola had been so worn-out at the docks that after June he didn't return there. He was too poor, and wrote regretting that he couldn't come south to the place where 'he had so many things to see: the panels of Paul, the moustache of Baille.' We see that Paul had already started on the panels at the Jas, and may assume that the works in question were the pictures of the Seasons. Zola was in a bad way. 'I am consumed by boredom. I am not leading an active enough life for my strong constitution, and my nerves are so shattered and fretted that I'm in a continuous state of moral and physical excitement. I can't get down to anything.' He was beginning to suffer from the hypochondria that long oppressed him. On September 21st he asked Baille to 'tell dear old Cézanne that I'm sad and can't answer his last letter.' He no longer had the strength to keep up his encouragements. 'It's almost useless for him to write to me till the question of his journey is settled.'

However on October 24th, in a letter to both Paul and Baille, he wrote, 'This morning I got a letter from Paul,' and went on to tantalize Paul with an account of art-models.

The account of your model amused me a lot. Chaillan claims that the models here are approachable, thought not of the freshest quality. One draws them by day and by night caresses them—though the term caress is a trifle mild. So much money for the pose by day, so much for the pose by night. As for the figleaf, it's unknown in the studios. The models undress there as they do at home, and the love of art veils what might otherwise be too exciting in their nakedness. Come and see.

His own condition was deteriorating. He grew lethargic, with poor meals of bread and cheese or of bread dipped in oil, pawning his few possessions. Alexis later described him in the period as 'abandoned on the Paris pavement without position, without resources, nothing to do, no future before him.' At the same time he felt that he had the problems of Baille and Paul on his hands.

II *Paul in Paris (1861)*

PAUL was working, not only in Gibert's studio, but also in the open, even in midwinter, seated 'on the frozen earth, taking no thought of the cold.' Zola approved. 'This news has charmed me, since I deduce from such constancy your love of the arts and the fervour you put into your work.' (February 6th) The earlier section of *The Confession of Claude*, for all its link with de Musset, gives us the spiritual history of Zola at this period. 'The whole book,' says the preface, 'consists in the conflict between dreams and reality.' Claude, a country lad who has taken Murger's *Vie de Bohème* too seriously, is struggling to find his place in Paris. With his literary approach he naturally attempts to raise fallen women (remembering the *Marion Delorme* of Hugo and the *Dame aux Camélias* of Dumas). He fails with his chosen mistress Laurence, but unexpectedly succeeds with Marie, the mistress of a neighbouring student. Claude's experiences seem to have been based on fact, on what happened to Zola in the winter of 1860–61. He told the story to Baille without putting himself into the picture; to Paul he was more explicit. 'I am emerging from a hard school, that of real love,' and promised to tell more when they met. 'I am doubtful even whether I'll be able to communicate by the spoken word all the painful and joyous sensations I've had. One result is that I now have the benefit of experience, and that, knowing the road, I can guide my friend with assurance. Another result is that I've gained a new outlook on love that will be of much help for the work I'm planning to write.'

Presumably to this period belongs the anecdote (recorded by both Alexis and E. de Goncourt) that one cold night he was so hard up that he took off his coat and gave it to his mistress to pawn; then two days later he gave her his trousers and had to stay in bed, wrapped in a sheet. The girl remarked that he was 'got up like a sheikh of Araby.' The *Confession* tells the tale, without that remark. De Goncourt records that Zola claimed to have been scarcely aware of his problems at the time. 'He had never been happier than in those days, destitute as he was.'

Claude's failure with Laurence was the death-blow to his idealism; and no doubt a similar change occured about this time to Zola. He grew up out of the high-faluting talk, the overstrained romantic ideas of Aix, with which Paul also was struggling in these years. 'I fear greatly that our dreams are merely lies,' says Claude. 'I feel petty and puerile in the face of a reality of which I am dimly aware. There are certain days when, beyond the sunbeams and the scents, and those shimmering visions I can never attain to, I glimpse the hard outlines of things as they are. And I realize that there only are to be found life, action and truth; whereas in the world I devise for myself there move figures alien to man,

72

vain shades whose eyes do not see me, whose lips do not speak to me.' He looks outside himself and sees the couple in the near apartment, Jacques and Marie; he is fascinated by the issues that their calm and ordinary existence raises. 'Here is a world that you have no knowledge of, this world is poignant. I long to unlock every heart and soul; I am drawn towards these men who live round me.' And he adds, 'They live so strange a life that in watching them I feel myself always on the point of bringing new truths to light.'

These passages give us the key to the essential element in Zola's creative drive. Precisely to the degree that he has been enclosed in his dreamworld (shared by Paul), he feels a force propelling him out of it, into the strange outer world, which he fascinatedly explores as if it were the system of some other planet. But the tension between the familiar romantic dream and the strangeness of actuality is never lost; from first to last it provides the creative drive of exploration, to which he gave the deceptive name of Naturalism. What he needs, in order to defeat the shimmering visions (and also to absorb them), is a desperate search for 'the hard outline of things as they are.' Similarly, Paul, tormented by seeing 'in dreamy hours, as in a mist, a drift of gracious forms,' has to fight at all costs for an artistic method that will discard mystery and give him precise control of 'the hard outline of things as they are,' an outline realized with a new fullness and sense of inter-relationships. Once again if we go down deep enough, we find an extreme closeness in the problems that Paul and Zola faced, and in the solutions they found—whatever differences came up in the working-out.

On 22 April 1861 Zola wrote one of his long letters to Baille, who had told him that Louis Auguste suspected him (Zola) of being the bad influence that had led Paul astray from the respectable path of money-making. Much disturbed, Zola replied:

Thanks for your letter. It's heartbreaking, but useful and necessary. The sad impression it made on me was somewhat lessened by the vague knowledge I already had of the suspicions floating round me. I felt myself an adversary, almost an enemy, of Paul's family. Our different ways of seeing, of understanding life, warned me secretly of the lack of sympathy that M. Cézanne must have felt for me. What shall I say? All you've told me I already know, but didn't dare to admit to myself. Above all, I didn't believe they could accuse me of such infamy and see in my brotherly friendship only cold-blooded calculation.

I am frank, I must admit that such an accusation coming from such a source saddens rather than surprises me. I'm beginning to get so used to this mean and jealous world that an insult seems to me a normal thing, not worth feeling annoyed about, only more or less able to astonish me, according to who throws it in my face. Generally I'm my own judge, and, secure in my conscience, I smile at the judgment of others. I have constructed a whole philosophy so as not to suffer a thousand vexations in dealing with other persons, I go on, free and proud, bothering little about the tumult, sometimes making use of it with an artist's eye for the study of the human heart.

That, I think, is the highest wisdom: to be virtuous, gentle, loving the good, the beautiful, and the just, without trying to prove to all the world one's virtue, one's gentleness, without protesting when one is accused of evil and wickedness.

But in the present case it's hard to follow the path I've marked out. As Paul's friend, I'd like to be, if not loved by his family, at least respected. If somebody quite indifferent to me, whom I'd met casually and shouldn't see again, were to hear calumnies about me and believe them, I'd let him do so without even trying to alter his opinion. But this is not the same thing. Wanting at any

cost to remain Paul's brother, I often find myself compelled to be in touch with his father. I am forced to appear before the eyes of a man who scorns me and whom I can only repay with scorn for scorn.

On the other hand, I don't want under any circumstances to cause trouble in that family. As long as M. Cézanne considers me a vile intriguer, and as long as he sees his son associate with me, he'll grow angry at his son. I don't want that to happen; I can't keep silent. If Paul isn't ready to open his father's eyes himself, I must try to do it. My superb disdain would be misplaced here. I must not let any doubts remain in the mind of my old friend's father. It would mean, I repeat, the end of our friendship or the end of all affection between father and son.

Louis Auguste, with his view of the world in which money determined all interests and attitudes, could only interpret Zola's efforts to encourage Paul into visiting Paris as the efforts of a poor ambitious youth to get hold of a rich friend and make use of him; Zola was an immoral character who made dereliction and idleness seem exciting with a spate of fine words. Deeply hurt, Zola continued his endless analysis and self-justification. He had been having trouble with Baille in recent months and perhaps suspected that even his old friend, with his newly acquired worldly-wisdom and desire for success, sympathized more with Louis Auguste than he admitted.

There's another detail I think I can guess at and you're doubtless hiding through affection. You include us both in the Cézanne family's disapproval; and I don't know what it is that tells me I'm the more accused of us two, perhaps even the only one. If that is so—and I don't think I err—I thank you for taking on yourself half of the heavy burden and thus trying to lessen your letter's painful impression. There are a thousand details, a thousand arguments, that have led me to this belief.

In the first place, my poverty, then my almost declared profession of writing, my sojourn in Paris, etc. Finally, as a last reason, the decisive one: whenever a blow is to fall, it's always on my head it alights. Whenever there's an obstacle higher than the other, it's the one I meet. I shall end by believing in fate.

The question seems to me this. M. Cézanne has seen his plans thwarted by his son. The future banker has discovered that he's a painter. He feels the eagle-wings on his shoulders and wants to leave the nest. Astounded at this transformation and this desire for liberty, and quite unable to believe that anyone could prefer painting to banking and the air of heaven to his dusty office, M. Cézanne has gone questing for an answer to the riddle. He doesn't want to admit it's happened because God willed it so, because God, having created him a banker, has created his son a painter.

Having probed the matter thoroughly, he decided at last I was responsible, that it was I who changed Paul into what he is at present, that it was I who robbed the bank of its dearest hope. No doubt evil associations were mentioned, and that's how Emile Zola, man of letters, turned into an intriguer, a false friend, and I don't know what else. It's just as sad as it's ridiculous. If done in good faith, it's stupid; if deliberate, it's the worst kind of wickedness.

Fortunately Paul has no doubt kept my letters. By reading them one could see what my advice has been and if I've ever urged him to do wrong. On the contrary I've often pointed out the disadvantages of a visit to Paris and counselled him above all to conciliate his father. But there's no call for me to justify myself to you. If a shadow of the suspicion hanging over my head existed in your mind, you couldn't have the least affection for me. I can be accused of nothing worse than thoughtlessness. In the advice I gave Paul I always restrained myself. Knowing his character wouldn't easily accept any definite opinion, I spoke to him of art, of poetry, not so much from any set plan on account of my own nature.

I wanted to have him near me, but in suggesting this idea I never urged him to revolt. In a word, my letters have had nothing but friendship for motive, and for contents only such words as were dictated by my nature. The effect of those words on Paul's career cannot be held against me as a crime. Without trying, I stimulated his love for the arts. No doubt I merely developed the germs already there, an effect that any other external cause might have brought about. I examine myself and find I'm guilty of nothing. My conduct has always been frank and blameless. I loved Paul like a brother, thinking always of his welfare, without egotism, without any selfish motive, reviving his courage when I saw it weaken, always speaking to him of the beautiful, the true, and the good, always seeking to raise his spirit and make him above all a man.

Indeed when we realize what a tremendous fight Paul had to put up—against both his father's strong opposition and his own entrenched fears—we may well ask if he would ever have made the break from Aix (the bank and the law) and gone off to Paris to study art, if it had not been for Zola. No doubt nothing would have stopped him pottering about with paints; but without the Paris visits and the friendship with Pissarro and Monet it is hard to see how he could have effectively developed as a painter.

Such have been my relations with him. I'd show my letters with pride and still write them if they weren't already written. That is what I want the world to know, and you in particular, if you didn't know it already. It's true that I never spoke of money in my letters; that I didn't suggest such and such a deal by which one could make enormous sums. It's true my letters only spoke of friendship, of my dreams, and I don't know how many fine thoughts: coins without value in any business in the world. That's why, no doubt, I'm an intriguer in M. Cézanne's eyes.

I'm joking and don't feel like it. Whatever comes of it, this is my plan. After consulting Paul, I propose to see M. Cézanne in private and come to a frank understanding. Have no fear as to my moderation and the propriety of the words I'll utter. Here I can breathe out in irony my wounded self-esteem; but in the presence of our friend's father I'll be only as I ought to be, strictly logical and with a frankness based on facts. Indeed you yourself seem to advise such an interview. I may be wrong but certain vague phrases in your letter seem to urge me to bring these calumnies to an end by an explanation.

I say all this and I don't yet know what I'll do. I'm waiting for Cézanne and I want to see him before I decide on anything. His father will have to grant me his esteem sooner or later. If he doesn't know the facts of the past, the facts of the future will convince him. Perhaps I've dwelt on this matter a little too long, and I admit I leave it with regret. I'm so anxious to demonstrate my lack of guilt and the ridiculous side of these accusations.

Then Zola was interrupted in his zealous scribbling. The unexpected news made nonsense of all his worried protestations and showed that Paul's vacillations had played as important a part, at least in these recent months, as had his father's obstructions, in keeping him away from the dreaded and desired metropolis.

I interrupt this over-rapid and unworthy analysis to shout: I've seen Paul!!! I've seen Paul. Do you understand that? do you understand the melody in these three words? He came this morning, Sunday, and shouted at me several times up the stairs. I was half asleep. I opened my door trembling with joy and we embraced furiously. Then he reassured me as to his father's antipathy towards me. He claimed that you had exaggerated a bit, doubtless because of your warm feelings. Finally he announced that his father had asked for me. I am to go and see him today or tomorrow. Then we went out together to lunch and to smoke a quantity of pipes in a quantity of public

gardens, and I left him. As long as his father is here, we'll be able to see each other only rarely, but in a month we expect to take lodgings together.

Why hadn't Paul written? No doubt he had been uncertain till the last moment, worried about his father's assent and rent by his own doubts. But now the barriers were at last down. He had come to join Zola in seeking 'the wreath and the lover that God keeps for our twenty years.' He, who had never been far from Aix before, must have found the thirty-hour train journey painfully exciting, with its new vistas of the Rhone valley, the stretches of fields and vineyards. At that time it took some twenty hours to go by express from Marseille to Paris.

Louis Auguste, who had brought his daughter Marie along with Paul, stayed a few weeks, then departed, promising Paul an allowance of 250 francs a month, much more than Zola's computation of the minimum needed by a young artist. The sum was soon raised to 300 francs, paid by Le Hideux, the Paris correspondent of the Aix bank. Paul seems first to have lodged in a small hotel in the Rue Coquillière, near Les Halles Centrales, where he had been with his father. Then he did not move to join Zola. Perhaps his father had frowned on too close an association; more likely he himself did not want to be hemmed in. He took a furnished room in the Rue des Feuillantines on the Left Bank. There he was not far away from Zola near the Panthéon; after moving from lodging to lodging Zola had ended in the Rue Soufflot in a house frequented by whores and often raided by the police.

Zola promptly took him to see works by Scheffer and the fountain of Jean Goujon. The pair visited the museums and exhibitions. They planned to spend Sundays in excursions to the Paris environs. At first all went smoothly. Paul painted or drew in the morning at the Atelier Suisse on the Île de la Cité (at the corner of the Boulevard du Palais and the Quai des Orfèvres). In the afternoons he made copies in the Louvre or went to Villevielle's studio. Anyone could join the Atelier Suisse by paying a fixed sum monthly for the models and the costs of upkeep. Paul worked as he liked, at pastel, watercolour, oil, using the model or working on his own inventions. There was complete freedom of method, with a tacit understanding that arguments should not grow violent. Père Suisse, the founder, had once been a model; and many important artists had used the place because of the freedom they had there: Delacroix, Bonington, Isabey, Courbet and others. Only five or six years earlier Manet had attended, and, a few months before Paul looked timidly in, Monet—now doing military service in Algiers. The atelier was on the second storey, reached by a dirty old wooden staircase spotted with bloodstains left by clients of the dentist on the first floor. The latter's sign could be seen from afar along the quai: *Sabra Dentiste du Peuple*. Three weeks a month the model was a male, one week a female. The studio opened at 6 a.m., and there were evening classes from 7 to 10 p.m. Sometimes people with toothache opened the studio door in mistake and stared at the nude models.

At first Paul clung to Zola and to Villevielle, who had a pleasant wife and house; but after a few weeks he shrank back into himself and began to shun them. On May 1st, ten days

after Paul's arrival, Zola wrote to Baille that he'd gone on Sunday to an art show with Paul.

I see Paul very often. He's working very hard, which at times keeps us apart, but I don't complain of that sort of obstacle to our meetings. We have made no excursions yet, or rather such as we've attempted aren't worthy of being dignified by the pen. Tomorrow, Sunday, we mean to go to Neuilly to pass the day on the banks of the Seine, bathing, drinking, smoking etc., etc. But now the sky is overcast, the wind howls, it's cold. Goodbye to our fine day. I don't know how we'll spend it. Paul is going to paint my portrait.

Paul had lived a narrow but easy life. Poverty was an idea to him, not something he understood. He must have been shocked when he saw how Zola lived in a disreputable house with a faded old overcoat and worn-out trousers. Left to himself, he must however have felt something of the aimless unhappiness that Millet felt on coming from Normandy to 'black muddy smoky Paris' in January 1837, finding the country around as fabricated as 'stage scenery'. Millet wrote: 'The light of the streetlamps, half quenched by the fog, the vast number of horses and carriages, jostling and crossing one another, the narrow streets, the smell and the atmosphere of Paris affected my head and my heart as if they would suffocate me. I was overtaken by a burst of sobs which I couldn't check. I wished to be stronger than my feelings but they overcame me with their whole power. I only succeeded in keeping my tears back by throwing in my face handfulls of water scooped up from a street fountain.' Vallès too, in the autobiographical novel in which Paul was to rejoice, described the lonely effect of Paris on a provincial lad.

Paris, 5 a.m. We've arrived.
What silence! Everything looks pallid under the sad glimmer of morning, and there is the solitude of villages in this sleeping Paris. It's as melancholy as abandonment. It's cold with dawn-cold and the last star blinks stupidly in the dull blue of the sky.
I'm scared like a Robinson disembarked on a deserted shore, in a country without trees and red fruit. The houses are tall, mournful, and like blind men with their closed shutters, their lowered curtains.
The porters hustle the luggage. Here's mine.

But Paul must also have caught glimpses of a luxurious Paris that exacerbated his daydreams. The Second Empire was at the height of its splendour and elegance, gorgeous demi-mondaines passing with tantalizingly flaunted charms or strolling with magnificent bosoms in the avenues. The great courtesans had their photographs sold in the shops with those of royalty and statesmen; their doings were eagerly told in the newspapers; they regally welcomed admirers in their boxes at the opera. In 1860 they showed themselves at the races of Satory and were taken by the ladies as models of dress and deportment. Princesses and duchesses attended a ball at the house of the coarse courtesan Cora Pearl, whose minimum price for the night was 50 louis; in 1868 at the Baden races princesses and the rest could not drive into the Enclosure, that honour being reserved for Cora and the actress Hortense Schneider. The fashionable ladies and gentlemen could be seen going into Tortoni's or the Café Anglais, while the art student jingled his sous in his pocket. There

was a feverish air of rapid change and reckless extravagance, deeply unsettling for a provincial lad with vast but vague ambitions. There was a gambling mania and a railway craze. Baron Haussmann was tearing Paris to pieces, building the boulevards that were meant to prevent a recurrence of the 1848 barricades by providing broad straight lines for cannon-fire. The Boulevard de Sébastopol (now St Michel) had just been cut out; the Rue de Rennes and other thoroughfares were being laid down. With such a multiplicity of impressions, and with the problem of finding his place in the friendly but rowdy Suisse, Paul had a recrudescence of his fears and uncertainties. A letter which he wrote on June 4th to a boyhood friend, Joseph Huot, who in 1864 was to come to Paris for the Beaux Arts, is very valuable in showing how unclear his ideas still were and how he accepted all the academic values:

Ah, my brave Joseph, so I'm forgetting you, *morbleu*, and the friends and the bastion where Huot's friends and brothers gathered, and your brother and the good wine of Provence. You know the wine here is detestable. I don't want to write elegies in these few lines, but *I must confess* I don't feel so very gay. I fritter away my little existence left and right. Suisse occupies me from 6 a.m. to 11. I eat at the rate of 15 sous per meal. It's not big, but what would you have? I still don't die of hunger.

I thought that, by leaving Aix, I'd leave far behind me the boredom that pursues me. All I've done is to change place, and the boredom has followed me. I've left my parents, friends, some of my habits: that's all. And yet to think I wander round almost all the day. I've seen, it's naive to mention, the Louvre and the Luxembourg and Versailles. You know them, the rigmaroles [*tartines*] housed in those admirable monuments, it's upsetting, swankily impressive [*esbrouffant*], shattering. Don't think I'm becoming Parisian.

I've also been at the Salon. For a young heart, for a child born for art who says what he thinks, I believe that is what is really better; for there all tastes, all genres come together and clash. I could launch into some fine descriptions and put you to sleep. Thank me for sparing you.

> I've seen the glittering battle of Yvon,
> Pils whose stylish crayon traces the memory
> Of a moving scene in his lively picture,
> And the portraits of those who lead us on a leash:
> Large, small, middling, short, lovely or worse.
> Here there's a river. There the sun is burning.
> Phoebus is rising and the moon is setting.
> A day is sparkling and the dusk is deepening,
> The climate of Russia or the African heaven.
> The bestial face, here, of a brutal Turk,
> And there, contrary, I see a childish smile.
> A pretty girl on cushions of rich purple
> Spreads out her breasts of lustre and of freshness.
> Fresh little loves are fluttering in space.
> The fresh-faced coquette admires herself in the mirror.
> Gérôme and Hamon, Glaise and Cabanel,
> Müller, Courbet, Gubin, dispute the honour
> Of Victory. . .

The inclusion of Courbet amid the names of the worst academics is only the final proof of how totally confused Paul's values were at this phase. He was still looking quite superficially

at paintings. The old masters had left him feeling crushed, and he had not been able to sort out contemporary tendencies; at most he saw that there was a clash of different styles. There is no sign that he was aware of the significance of Courbet; he did not seem yet to have discovered Delacroix; and he was unaware of Corot, Daubigny and the others with fresh qualities. He continued the letter with praise for Meissonier with his meticulously moribund concoctions.

(I've run out of rhymes, so I'd best shut up; the enterprise of giving you an idea, even the most meagre, of this show, would be too bold on my part.) There are some magnificent Meisonniers. I have looked at nearly everything and mean to go back. For me it's all very worthwhile. As my regrets are superfluous, I won't tell you how sorry I am at not having you with me to see all this together, but, the devil, that's how it is.

M. Villevielle, at whose place I daily work, sends you a thousand friendly wishes, as does friend Bourck, whom I see from time to time. Chaillan sends you his most cordial greetings. My best wishes to Solari, Félicien, Rambert, Lelé, Fortis. A thousand *bombes* to all of them. I'd never stop if I wanted to name them all. Let me know if you can the results of the lottery for the army call-up in its effect on any friends. Kindest regards from me to your parents. For yourself, courage, good vermouth, not too much boredom and au revoir. Goodbye, dear Huot, your friend, Paul Cézanne.

PS. Combes with whom I've just had supper sends his greetings. Villevielle has just made a sketch for a picture, a monster in size, 14 feet high, persons of 2 metres or more. The great G. Doré has a wonderful [*mirobolant*] picture. Goodbye again, dear chap. Hoping to empty a divine bottle. P. Cézanne. Rue d'Enfer 39.

There is no word there of Zola. Certainly things were not working out in the charming way that he had foreseen. Paul, in his confusion, his sense of being lost and flattened between the unattainable old masters and the flashy academics who still filled for him the contemporary horizon, must have found it impossible to discuss the situation with his old friend, whose kindly words of encouragement would infuriate him and whose daydreams of success would merely beget in him shame and repudiation. In his disappointment, Zola too was thrown back on himself and felt the need to see Paul in a more critical focus. He now realized more sharply the elements of contrariness in Paul's character, the sheer obstinacy in the midst of obscure unceasing vacillations. Naturally it was to Baille he unburdened himself, on June 10th:

I rarely see Cézanne. Alas, it's no longer as it was at Aix, when we were 18, when we were free and had no worries about the future. How the conditions of life, of work, separate us, alienate us. In the morning Paul goes to the Suisse, I stay in my room to write. At 11 we lunch, each by himself. Sometimes at noon I go to his room, then he works at my portrait. Then he goes to Villevielle to work for the rest of the day. He has supper, goes to bed early, and I see no more of him. Is this what I'd hoped for?

Paul is still the same excellent fantastic fellow I used to know at school. As proof of his having lost nothing of his eccentricity, I have only to tell you that no sooner had he arrived here than he was talking of a return to Aix. To have fought for three years to make this trip and then to throw it away like a straw! Before such a character, such unforeseen and irrational veerings of conduct, I admit that I stay dumb and put away my logic.

To convince Cézanne of anything is like wanting to persuade the towers of Notre Dame to dance a quadrille. He might say yes, but he wouldn't budge a fraction. And note that age has developed his obstinacy, without giving him rational bases on which to be obstinate. He is made in one piece, rigid and hard under the hand. Nothing bends him, nothing can draw a concession out of him. He won't even discuss what he's thinking; he has a horror of argument. Firstly, because talk is tiring, and also because he may have to change his mind if his adversary is proved right.

So there he is, thrown into life, bringing to it certain ideas, unwilling to change them except on his own judgment; at the same time remaining the best chap in the world, always saying what you say—the result of his horror of arguments, but just as firmly thinking his own thoughts. While his lips say yes, most of the time his judgment says no. If by chance he advances a contrary opinion and you take this up, he flares out without wanting to examine the matter, shouts that you don't understand anything about it, and jumps on to something else. Go on then arguing—what am I saying? no use even in conversing with a chap of this temper, you don't gain an inch of ground, and all you get out of it is the fact of having observed a very odd character.

I had hoped the years would modify him to some extent, but I find him just as I left him. So my plan of conduct is very simple. Never to hinder his fantasy. At most to insinuate advice very indirectly. To leave entirely to his good nature the survival of our friendship; never to force his hand to clasp mine; in short, to efface myself completely, always welcoming him gaily, seeking him out without importuning him, and handing over to his good pleasure the decision of how much or how little intimacy he wants between us.

Perhaps my language surprises you, but all the same it's logical. Paul is always for me a chap with a good heart, a friend who can understand and appreciate me. Only, as each of us has his own nature, the only sensible way is for me to conform to his moods, if I don't want to lose his friendship. Perhaps, to keep yours, I'd use reasoning; with him that would mean a total loss. Don't think there's any cloud between us. We are still very close, and all I've just said doesn't take into account the fortuitous circumstances that separate us more than I'd wish.

Remarkably, Zola seems to have been able to maintain the programme he had laid down here, to humour Paul and fit into his moods, until the publication of *L'Oeuvre* in 1886. He did not altogether understand Paul's inability or refusal to argue. It wasn't that he brought along 'certain ideas, unwilling to change them'. At this period Cézanne had no clear ideas; only the need and the resolve to be an artist. What he did have was a plethora of emotions; and he suffered because he could not find an idea, a method, which would enable him to discipline and express those emotions. He couldn't argue, because, as soon as he tried to, he was faced with the heaving inner void; and whatever was said seemed an attempt to impose order from outside—which could only work out as the dissipation or flattening-out of all the intuitions and emotions which he rightly felt as his one truly personal and creative property. Zola was right in saying that only indirect advice—or in the sphere of art, indications of method which he observed but which were not being in any way pushed upon him—could be accepted and absorbed. At such moments the guardian fear was lulled and did not spring up to repel the intrusion. To a considerable extent this attitude of Paul to his inner world, a powerful chaos which he wanted to resolve by his own magical power alone into a cosmos, had been determined by his attitude to his father. For years he had been opposing the blind faith of his conviction that he was or could be an artist, to his father's harsh scathing denial. Any intrusion, any attempt by someone else to impose ideas, however

well-intentioned, was felt and interpreted as the alien will seeking to destroy him. Zola was perfectly correct in grasping that these reactions were immune to any rational protest or analysis; they sprang from too deep a fear. The intrusions were felt at once, blindly, as a blow aimed at the root of his identity.

Paul, kindly enough when he could get outside his fears and see someone as existing in his own right, seems to have been unaware of the precarious situation of Zola and his need for sympathetic aid. In the letter just cited Zola tells Baille that he is suffering from 'some physical ailment or other, of which no doctor can give me a satisfactory account. My digestive system is thoroughly upset. I am always feeling a heaviness in my stomach and bowels; sometimes I could eat a horse, at other times food fills me with loathing.' He had the queasiness of undernourishment, living on 'bread and coffee, or bread and a penny-worth of Italian cheese, sometimes nothing but bread, sometimes no bread at all' (Alexis). But with his changing moods Paul was not consistent in his withdrawals and despairs. He had been contemplating a stay at Marcoussis on the Seine-et-Oise; and not long after the letter of complaints Zola was writing again to Baille:

I find nothing so repugnant as to pass a definite judgment on anyone. If I'm shown a work of art, a picture, a poem, I'll examine it with care and won't be afraid to express my opinion; if I err, my good faith excuses me. This picture, this poem, are things one shouldn't change one's mind about. They have but one quality. If good, they'll be good for ever; if bad, eternally bad. If I'm told of a single act of a man, even, I'll judge unhesitatingly whether he did well or ill in that separate act of his life.

But if I'm then asked the general question: What do I think of the man? I try to be politely evasive so as to avoid answering. And indeed what judgment can be passed on a human being who isn't brute matter like a picture, nor something abstract like an action? How can you come to a decision about the mixture of good and evil making up a life? What scales can you use to weigh exactly what you're to praise, and what to condemn? And above all, how are you going to collect the totality of a man's actions? If you omit a single one, your judgment will be unjust. Finally, if a man isn't dead, what favourable or unfavourable judgment can you make about a life that may still produce evil or good?

This is what I've been saying to myself, meditating over my last letter in which I spoke about Cézanne. I was trying to judge him, and, despite my good faith, I repented having arrived at a conclusion which after all wasn't correct. Scarcely arrived from Marcoussis, Paul has come to find me, more affectionate than ever. Our place of reunion is his little room. There he works at my portrait; while that goes on, I read or we babble, both of us; then when we're deep immersed in work, we usually go and smoke a pipe in the Luxembourg.

Our chats meander a bit over everything, especially painting. Our recollections also take up a large part of the time. As for the future, we skim over it with a word, in passing, either to hope for our complete reunion or perhaps to pose the terrible question of our success. Sometimes Cézanne gives me a lecture on economy, and to round it off, forces me to drink a bottle of beer with him. At other times he recites silly verses with words and music, by the hour. Then I say emphatically that I prefer the lectures on economy.

We are seldom disturbed. From time to time a few intruders come in to disturb us. Paul takes up his painting again furiously; I pose like an Egyptian sphinx; and the intruder, quite disconcerted by so much work, sits down a moment, dares not stir, and takes himself off with a murmured goodbye, shutting the door softly behind him.

I'd like to give you still more details. Cézanne has many accesses of discouragement. Despite the somewhat affected scorn that he expresses for glory, I see that he desires to succeed. When he does badly, he speaks of nothing less than of returning to Aix and making himself a clerk in a commercial house. I then have to embark on vast discourses to prove to him the folly of such a return; he gladly agrees and sets himself again to work. However the idea gnaws at him. Twice already he has been on the point of going off. I fear from one instant to the other that he'll escape me. If you write to him, try to speak of our forthcoming reunion, and in the most seductive colours. It's the only way to hold him.

We have made no excursions yet. Money prevents us. He isn't rich, and I still less so. However, one of these days we hope to get away and go somewhere to dream. To sum up all this up: I'll say that despite the monotony the life we lead is not the most tedious. Work prevents us from yawning; then an exchange of memories gilds the whole thing with sunbeams—Come and we'll be even less bored.

I take up this letter again to support what I've written above with an account of what happened yesterday, Sunday. Some time ago I'd gone to Paul's and heard him declare calmly that he was packing his trunk to leave next day. Then we went to a café. I didn't lecture, I'd been so astounded, so firmly convinced that my arguments would be futile, I didn't raise the least objection. Still, I quested round for a pretext to hold him up. At last I thought I'd found one and asked him to paint my portrait. He enthusiastically took up the idea, and for a while there was no more talk of departure.

But yesterday this cursed portrait, which I'd expected would keep him in Paris, came close to driving him away. After starting it twice, always dissatisfied, Paul wanted to finish it and asked for a last sitting for yesterday morning. So, yesterday, I went to his place. When I entered, I saw the trunk open, the drawers half-empty. Paul, with a sombre face, huddled things together and heaped them anyhow into the trunk. Then he said to me tranquilly: 'Tomorrow, I'm off.'

'And my portrait?' I asked.

'Your portrait,' he replied, 'I've just torn it up. I wanted to retouch it this morning, and as it got worse and worse, I demolished it. And now I'm off.'

I held myself back from any comment. We went out to lunch together and I didn't leave him till evening. During the day he came back to more sensible sentiments, and at last, when leaving, he promised to stay on. But it's only a bad bit of patching-up. If he doesn't go this week, he'll go the next. You can expect to see him go off from one moment to the next. I even believe he'd be doing the right thing. Paul may have the genius of a great painter, but he'll never have the genius to become one. The least obstacle throws him into despair. I repeat, let him go off, if he wants to save himself from many vexations.

Zola with his own many vexations had at last grown tired of nursing Paul. In a postscript he added, 'Paul will surely stay on in Paris till September; but is that his final decision? Yet I have hopes he won't change it'. He was already arriving reluctantly at the conclusion he drove home in *L'Oeuvre*, that Cézanne had the sensibility but not the stamina of a great artist. 'Though owning an excellent nature and full of natural gifts, he cannot accept a remonstrance however gentle it may be.' Already Paul was arriving at his semi-paranoic fear of any close contact: 'They might get their grappling-hook (*grappin*) into me.' His extreme difficulty in completing portraits came from his discomfort in being forced into familiar terms with another person as much as from his inability to realize his aesthetic intentions; indeed the two problems were indissolubly connected for him. Probably from this period comes the study for a self-portrait based on a photograph. The head is lowered,

and in the painting he makes several alterations to stress character. He sharpens the lighting, draws out the chin, enlarges the white colour, models the jaws more strongly, and adds a wild suspicious look to the eyes; altogether the forms are drawn forward. There is something haunted, bitterly aggressive, about the face; and the handling is crude, yet somehow suggestive of breadths which the painter cannot yet compass. The work seems to sum up the desperate, insecure, thwarted mood of this first visit to Paris.

In September he returned to Aix. Whatever the friends said together in the last days, to keep their spirits up, there must have been a deep feeling of frustration in both their hearts. Paul must have felt that his visit had been a total failure and that he had no future as an artist; Zola must have suffered at his intense egoism and his inability to join him frankly in a common struggle of art and literature against the blankly uninterested world of Paris. In Aix Louis Auguste must have been cock-a-hoop when the chastened Paul told him that he was ready after all to enter the bank.

Setbacks and physical disabilities had made Zola only more determined to grapple with the contemporary world and master its problems. In July he had hinted to Baille that he was already busy on an essay to be called, 'On Science and Civilization in their Relations with Poetry'. He was arguing, 'Let us take over from the sciences their wide horizons, their hypotheses so admirable that it is hard not to believe them true'. Though he felt that he was 'losing not only the present, but the future too', he was in the last resort happy at the gains he was making. 'My mind is awake and functioning wonderfully well. I believe I am even growing through suffering. I see, I understand better. New senses, which I lacked for certain things, have been granted me.' An Aix friend put him in touch with a group of students publishing a satirical review, *Le Travail*, which was hostile to the Empire. They wanted a poet. So Zola sent some verses in, and they were accepted, even if their religious-tinged idealism was not altogether to the taste of the editor, Georges Clemenceau, a twenty-year-old student from the Vendée. 'If the review keeps on being published', thought Zola, 'I may start making something of a name.' But the police were watchful and ready to pounce. At the same time he was hoping daily for a letter from the firm of Hachette; Boudet, an old friend of his father, a member of the Académie de Médicine, had given him an introduction; but the letter still did not come. On the first day of 1862 Boudet asked Zola to deliver New Year Cards around Paris, and paid him a louis—an act of disguised charity.

III *A New Start (1862–5)*

PAUL was hopelessly bored in the bank and found that he could not relinquish his dreams of art. He scribbled drawings and verses in the margins of ledgers. One couplet must have been much recited in the family, for his sister Marie quoted it in 1911:

> My bankerfather can't help shuddering to see
> Born in his counting-house depths a painter-to-be.

He was still only a painter in the future; but in fact he could not stop painting. He wrote to Zola in January 1862. The letter is lost, as are all his letters to Zola until 1877; but we have the reply:

It's a long time since I wrote to you, I don't know why. Paris hasn't done our friendship any good. . . Some unfortunate *quiproquo* has put a chill into our relations, some badly-judged circumstance, or again some sorry [*méchante*] word entertained with too much favour. It doesn't matter. I believe you to be always my friend . . . but I don't want to write you a letter of explanations. I want only to answer your letter as a friend. . . You advise me to work and you do it so insistently anyone might think work repels me.

Perhaps Paul was himself trying to regain his own impetus in work. He seems to have overcome his sense of failure enough to propose another visit to Paris. For Zola, after verifying Baille's news that he was to get a job with the Librairie Hachette, added, 'If you come as you promise in March, if I have a job, if fortune smiles on us, then perhaps we'll be able to live a little in the present'. Baille had come to Paris to study in the Polytechnic School, and he and Zola were meeting on Sundays and Wednesdays. 'We don't laugh much.'

Zola apparently was able to go this summer with Baille to Aix, and something of the old accord was established for the Trio, in the Provençal setting that meant so much for their brave dreams and light-hearted rambles. Zola began his *Confession of Claude*, a novel in the form of a tale told to his two friends. He was attempting to recreate the romantic idealistic mood of a few years back, and to show what happened to it at the bitter test of everyday experience in the dehumanized city-world. 'Faith has returned. I believe and hope.' Paul too began to believe and hope afresh. From Zola we learn that he was painting landscapes and trying to work out a system which would save him from the disasters of his first visit to Paris. On September 29th Zola wrote:

As for the View of the Dam, I much regret that the rain has kept you from carrying on with it. As soon as the sun comes out, take the path by the cliffs again and try to finish it as soon as possible. . .
There's one hope that has doubtless helped to cure my gloom: that of soon being able to clasp your hand. I know it's not quite settled yet, but you allow me to hope: that's something. I com-

pletely approve of your idea of coming to work at Paris and then retiring to Provence. I believe this is a way to withdraw oneself from the influence of the schools and to develop some originality if one has it.

Zola tried also to overcome his romantic dream of a life rapturously shared by the two of them in all its details, and suggested: 'We shall organize our lives, spending two evenings together a week, and working on the others.' In a deliberately sober and sensible vein, he added, 'The hours we spend together will not be wasted. Nothing encourages me so much as a chat with a friend for a while. So I'll expect you.'

At Aix Paul was going to evening classes with Numa Coste, now a solicitor's clerk, Solari, and Huot, who had founded an amateur dramatic company, Théâtre Impérial du Pont de l'Arc, for which he wrote the plays. Then in November he returned to Paris. Louis Auguste seems to have been ruefully convinced by his behaviour in the counting-house that he would never make a banker or a businessman; and it was probably about this time that the studio was installed in the Jas. Paul lodged in the Latin Quarter, in the Rue de l'Est near the Luxembourg Gardens, and went once more to the Suisse, for both morning and evening classes. Now that he had come with less extravagant hopes and knew better what he was up against, he was able to adapt himself better. As Villevielle was out of Paris, he asked another mediocre academic, Chautard, to correct his studies. This time he was to stay in Paris about a year and a half.

Zola was bored at Hachette's, the bookshop and publishing house. (It had been founded by Louis Hachette, now 63. His father had been ruined; his mother became linen-maid at the Lycée Impériale to get her son taken as boarder; he became the best pupil at the Normale Supérieur, then founded his firm in the Rue Pierre-Sarras in 1826. There he rapidly expanded.) Zola tried to interest Hachette by putting a manuscript book of verse on his table, but he was merely advised to write prose. However, his salary was raised to 200 francs a month. He had kept on changing his lodgings, and by July was in a three-roomed flat at 7 Rue des Feuillantines, where he began his Thursday dinners for friends. At Hachette's he was coming into contact with well-known writers such as Duranty, the unrecognized apostle of literary Realism, a saddened and rather bitter man to whom he listened with interest.

Paul was seeing him now and then as well as other friends from Aix such as the confident dauber Chaillan and Auguste Truphème, brother of a sculptor, who had won first prize at Aix in 1861 (when Coste got *accesit* in design and painting). Truphème was now at the Beaux Arts in Paris. A letter from Paul to Coste, dated 5 January 1863, shows that he was still happy in academic circles, though he is rude about the arch-reactionary Signol. However a crucial thing had happened: he had discovered Delacroix. Colour-sense had always been his own one strong point, and he gained a stimulus from Delacroix that he never forgot. The academic world was dominated by the aged Ingres and his disciples; Delacroix was

now 63, ill and near his end; he was generally compared unfavourably with Ingres and his works were hung with reluctance. The romantic trend thus seemed at its last gasp; the anti-academic struggle was being carried on by Courbet, with his Realism: he had been gaining some recognition, but was still viciously attacked. More quietly, Corot and the Barbizon group were at work in the field of landscape. But it was natural that Delacroix should be the first of the dissident artists to have a strong impact on Paul and make him sharply aware of new possibilities in art, in which he could play his part. Late 1862 and early 1863, then, mark the moment when Paul made the first significant stride towards a liberation of his art faculty.

This letter, sent to you, is meant for both you and M. Villevielle. To start with, I could have written to you a long time back, for it's already two months since I left Aix. Shall I tell you of the fine weather? No. Only the sun, so far hidden by clouds, has just today put its head in at the garret-window, and, wanting to finish off gloriously this last day, is throwing a few rays on us as it departs. I trust this letter finds you all in good health. Courage, and let's try to get together in the near future. As in the past (it's right for me to let you know what I'm doing) I go to the Suisse in the morning from 8 to 1 o'clock, and the evening from 7 to 10. I work calmly, I eat and sleep likewise. I go fairly often to see M. Chautard, who is good enough to correct my studies. The day after Christmas I had supper at his place and tasted the old wine you sent them. O, M. Villevielle, and your little girls, Fanny and Thérése, are they well? I hope so. And the rest of you too. By the way, is the picture of which I saw you making the sketch, on its way? I spoke to M. Chautard on the subject, he praised the idea, and said you ought to be able to make something of it.

O Coste, Coste junior, are you still enraging the reverendissime Coste senior? Do you still paint? And the academic evenings at the school, how are they going? Tell me who's the wretched person who takes the X-poses for you and holds himself by the belly? Have you still got the two louts [*magots*] of last year?

Lombard has been back in Paris nearly a month now. I learned, not without grief, that he attends the Signol studio. That worthy gentleman instructs after a certain pattern [*poncif*] that leads to an exact copy of his own practice. It's very fine, but it isn't admirable. To think it was necessary for an intelligent young man to come to Paris in order to lose himself. Moreover, the novice [*apprenti*] has made a lot of progress.

I also love Félicien, the boarder of Truphémus.

The dear boy sees everything in relation to his illustrissime friend and trims his views to match the latter's colours. According to him, Truphème dethrones Delacroix, he alone can produce colour, and so, according to a certain letter, he goes to the Beaux-Arts. *Do not think I envy him.*

This instant I've got a letter from my father announcing his near visit on the 13th of this month. Tell M. Villevielle to give him any commission he may like, and that as for M. Lambert (my address for the moment is St Dominque d'Enfer) he should write some instructions, or have them written, about the object, the place where it's to be bought, and the best way of sending it. I'm at his service. On top of that I recall regretfully

> The days we went along the Torse's meadows
> To eat a good lunch, palette in our hand
> To trace on canvases a rocky scene:
> Those places where you almost sprained your back
> And rolled right down the damp ravine below,
> And Black, he'll spring to mind! The yellow leaves
> Have lost their freshness at the winter's breath.

On the stream's bank the plants now withered show,
The tree that's shaken by the furious winds
Now agitates aloft like a huge corpse
Its bare stript branches that the mistral swings.

I hope this letter, which wasn't finished all in one go, finds you all in the best of health, my regards to your parents, greetings to friends. I clasp your hand, your friend and brother in painting, Paul Cézanne. Go and see young Penot and remember me to him.

Paul seems to have applied for admission to the Beaux-Arts and to have failed in the tests; an examiner is said to have remarked, 'He paints riotously'. If this anecdote is true and not antedated, he had already developed the wild style of attack which he called *couillarde* (painting with one's balls); but that is more than unlikely. At the Suisse, despite his academic connexions with men like Villevielle, Chautard, Chaillan and Truphème, he was coming to know some of the young painters with rebellious ideas or outlooks. Among his friends were Antoine Guillemet, handsome, easy-living, good-natured, Rabelaisian, pupil of Corot and Oudinot, with a good allowance from his wine-merchant father of Bercy; he and Paul later went painting together in the Paris environs. (Zola used him for the vain dandified Fagerolles in *L'Oeuvre ;* but there was more in the man, with his robust joviality, than that.) There was also a Spaniard, Francisco Oller, of St Germain, where Paul was to go painting with him. Neither of these two was an original or advanced painter but, probably through Oller, who had been born in 1837 in Puerto Rico, Paul met Camille Pissarro, whose influence was crucial for his development.

Pissarro was born in 1830 on St Thomas, one of the Virgin Islands; his parents were Jews of Spanish descent. Sent as a boy to be educated in France, he was called back home at seventeen to take up a business career. But he resisted, and when twenty-two travelled with a Danish painter, Fritz Melbye, to Caracas in Venezuela, then next year to France, where he gave himself up wholly to painting. He met Corot and was influenced by him, but was never anyone's pupil. In the Antigues he had acquired the habit of working out of doors, and was the first artist in France to carry on this practice systematically. Though he had a landscape in the 1859 Salon, he was rejected in 1861 and 1863; however, still painting in a fairly low key, he succeeded in getting works into most of the Salons between 1864 and 1870. A magnificently generous and well balanced character, he had a wide influence, and in effect initiated Impressionism. Up to his appearance the fight against Salon-art had been waged by Courbet, who introduced new themes from common or working-class life and refused to idealize them—a socialist of the Proudhon school. At the same time a stream of dissent, of direct vision, had been coming into landscape through Corot and the Barbizons; but their work had not yet detached itself enough from the ruling conventions for its full consequences to be realized. With Pissarro the logic of the innovations made by Courbet and Corot was made fully implicit: the fact that the new Realism, in its full development, must involve new methods of work which in turn involved a new relationship to nature—above

all a new penetration into colour-relationships. Later, in 1895, he said, 'Was I not right in 1861 when Oller and I went to see that odd Provençal Cézanne, in the atelier Suisse, making studies which were then derided by all the untalented in the school, among them the celebrated Jacquet, who declined ages ago into the pretty-pretty, and whose works fetched their weight in gold'? If he was right in his dating (1861 and not 1862–3), Paul had met him during his first visit to Paris. But in any event he was too worried at that time to take full advantage of the meeting. Pissarro may have then noted that there was something striking about the odd young Provençal's work; but it was certainly not till 1863 and thereafter that Paul began to profit from the encounter.

The turn to the actual lighting of a scene or figure in the open air, in its own natural situation, as opposed to the reconstitution of scene or figure in the studio, was slowly awakening the eyes of artists to the actual colour of things, the true nature of shadows and reflected lights. Here the influence of English art—through Constable and Bonington (whose teacher had been influenced by both Turner and Constable)—combined with a general trend towards Realism and immediate truth, as contrasted with the generalized canons of academic beauty: canons in effect born weakly out of earlier art, and divorced from the conditions which had at the time made that art valid.

David had painted his picture of the Luxembourg Gardens straight out of his prison-window; Turner had driven the colour-key up towards the intensity of daylight; and he and Constable in various ways had introduced all kinds of directly observed aspects of nature into their art. The 1860s saw decisive new applications of such principles, linked from different angles with the work of both Delacroix and Courbet. Jongkind, like Constable, realized that local colour changed with the seasons or the time of the day; he painted two pictures of Notre Dame from the same angle—one in the cold morning, the other in a warm sunset. He was one of the first to do open-air watercolours. Monet in 1865–6 depicted the same Norman road when under a heavy sky and when covered with snow. He painted his *Lunch on the Grass* as much as possible in the open, a tribute to Manet, but also an effort to show what was lacking in the latter's picnic (where studio-lighting had affected the figures). The same sort of lack had for some time affected the 'realistic' representation of figures in such scenes, for example, as Courbet's *Demoiselles on the Banks of the Seine* or his *Baigneuses*, where Delacroix noted the disharmony between figures and background. In Switzerland Frank Buckser painted a young Englishwoman actually in a wood.

In 1860 Pissarro was still close to Corot, though more interested in spatial organization; by 1863–4 he was showing Courbet's influence, for example in his use of the palette-knife and his strong contrasts of light and dark masses. By 1865 his colour-key was lightening, growing more atmospheric; by 1866 he was working consistently in the open. He was living, under conditions of much hardship, with his mother's maid, who bore him a son in 1863 and a daughter in 1865. Married in 1870, they were to have seven children in all. The critic Jean Rousseau called Pissarro's *Banks of the Marne* in 1866 'an ugly vulgar motif', and

thought the artist 'used a robust exuberant talent to show the vulgarities of the contemporary world, perhaps with satirical intention'. Zola wrote in rebuttal, 'You must realize that you won't please anyone and your picture will be found bare, too dark. Then why the devil do you have the arrant clumsiness to paint solidly and to study nature frankly'?

This year, 1863, a highly reactionary jury (perhaps dominated by Signol, the master who warned Renoir against becoming another Delacroix) rejected any works in the least original: those by Fantin-Latour, Legros, Manet, Whistler, Jongkind, Bracquemond, Laurens, Vollon, Cazin, Harpignies. The painters and their supporters protested. Napoleon III paid a surprise visit to the Salon, asked to see the rejected works, and declared them as good as those on the walls. A decree established the Salon of the Rejected on April 24th. It was to open on May 15th, in the same range of buildings as the official Salon, the Palais de l'Industrie built for the Universal Exhibition of 1855 (and pulled down in 1900 when the Avenue Alexandre III was laid across it). Many of the rejected felt that it would be un-dignified to contribute; but some 600 canvases by more than 300 painters were hung, plus several roomfuls of drawings, engravings and sculptures. Zola gives a long and lively account of the occasion in *L'Oeuvre*. Claude and Sandoz turn from the monumental stair-cases. 'What, are we going to trudge through all the rubbish in *their* Salon'? They take a short cut, pass scornfully the little tables of the catalogue-sellers, go between the red velvet curtains, through a porch full of shadows and the glass-roofed garden, on up the western stairs to the Rejected.

It was all very well arranged. The setting was quite as luxurious as that provided for the accepted pictures: tall antique tapestry-hangings in the doorways, exhibition panels covered with green serge, red velvet cushions on the benches, white cotton screens stretched under the skylights. At first glance down the long succession of rooms it looked very much the same as the official Salon, with the same gold frames, the same patches of colour for the pictures. But what was not immediately obvious was the predominant liveliness of the atmosphere, the feeling of youth and brightness. The crowd, already dense, was growing every minute; for visitors away from the official Salon, goaded by curiosity, were eager to judge the judges, convinced from the outset that they were going to enjoy themselves and see some extremely amusing things. It was hot; there was fine dust rising from the floor; by four o'clock the place would be stifling.

Soon through the mighty voice of the crowd that had dazed him at first, he detected laughter, restrained still and drowned by the trampling of feet and the hubbub of conversation. Visitors were cracking jokes in front of some of the pictures. That disturbed him, for beneath his rugged-revolutionary's exterior he was as credulous and sensitive as a woman, always expecting martyrdom, always suffering tortures, always amazed to find himself refused or ridiculed. 'They seem to be having fun in there,' he said, half to himself.

The critics had told the public to laugh, and they laughed. Caricaturists drew the *Exposition des Comiques*; the Variétés parodied the show as the Club des Refusés. The centre of argu-ment and ridicule was Manet's *Déjeuner sur l'Herbe*, with the men in contemporary dress and the girls nude. Zola depicts at length the wild hilarity and fierce disgust it excited, and the particular mockery of the term *Open Air*. Technically the work broke the conventions

which insisted that patches of light should be separated by patches of dark, that strong colours should be connected by graduated semitones, and that shadows should be defined always in browns, blacks and greys. The idea of mixed clothed and nude figures came from Giorgione; the composition was based on an engraving of Raphael. Zola recognized 'a sensation of unity and force', 'free and strange aspects.' No doubt it was through Paul's comments that he noted 'the very delicate justness in the relation of tones to one another'. Later in his notes for *L'Oeuvre* he jotted down in connexion with Paul, 'The Salon of the Rejected. Great discussions with me.' Paul was stirred by Manet's work and awoke Zola's enthusiasm. The discovery of Delacroix and the discussions at the Suisse (such as no doubt underlay his critique of Signol's teaching-methods) had prepared him for a break with the Salon and the Beaux-Arts; but it was the Salon of the Rejected that was decisive. The need to discard all conventional approaches and to look at life with fresh un-opinionated eyes became explicit, and was adopted as a principle that must be applied all the time, in all instances. Zola sums up the effect of the dissident Salon:

Superficially it was an incoherent jumble, but there was truth and sincereity about the landscapes and sufficient points of technical interest in most of the portraits to give it a healthy atmosphere of youthful passion and vigour. There may have been fewer frankly bad paintings in the official Salon, but the general level of interest and attainment was certainly lower. Here there was a scent of battle in the air, a spirited battle fought with zest at crack of dawn, when the bugles sound and you face the foe convinced you will defeat him before nightfall. The warlike atmosphere put new life into Claude [Cézanne] and roused him to such anger that he listened to the swelling laughter of the crowd with a look on his face as defiant as if he were listening to the whistle of bullets.

Manet remained for Paul a symbol of liberation. Long afterwards he commented appreciatively on the 'kick in the arse that Manet gave to the Institute' (Rivière). He paid him several tributes in his art, significantly not imitating his style in any sense, but using his works as the springboard for his own fantasy—the *Lunch* and *Olympia*. Zola too, championing Manet, found in his paintings certain affinities with the struggle he himself was making to overcome romanticism and get down to earth. But, soon after the impact of Manet, Paul found himself drawn to Pissarro with his patient quest for a fuller truth in colour-definitions, and the importance of Manet for him lessened. He later called Manet 'poor in colour-sensations' (Gasquet), while Manet in turn found him 'not much more than an interesting colourist.'

 Manet, about this time, was in close association with Baudelaire, Paul's favourite poet, whose *Painter of Modern Life* appeared in 1863, written at the time Manet was working on *Music at the Tuileries*. In *Flowers of Evil* Baudelaire had declared, 'The man who does not accept the conditions of ordinary life sells his soul'—by which he did not mean that the conditions should be passively accepted as good. He meant that any rebellion must come from within their framework, on the basis of a complete realization of what they were. The romantic revolt-by-flight was no longer valid. The poet or artist must look fully and un-flinchingly at what was happening to men. Zola later put the point in his own way, 'Fatally,

the novelist kills heroes if he does not accept the ordinary course of common existence.'
Courbet and Daumier had brought art down to the sphere of actuality, to the specific forms
and textures of the nineteenth century; the problem now was to free it thoroughly, in all
aspects, inside the new dimensions. Manet, Paul recognized, had made one of the important
steps in this liberation. His example was also affecting Monet, Bazille, and their friends,
who in 1865 began to paint figure-compositions in open-air settings.

In the spring of this year Paul and Zola made many Sunday expeditions. Taking an early
train, they got out at Fontenay-aux-Roses and walked through the fields to the woods of
Verrières. 'We used to leave on the first Sunday train', said Zola later, 'to be past the
fortifications by early morning. Paul carried a complete artist's outfit, I had only a book in
my pocket.' They walked through big strawberry-fields to Aulnay, where the Loups valley
started. Once they were lost in the forest; Paul climbed a tree to find the way, but only
scratched his legs and saw treetops.

One morning, wandering in the forest, we encountered a pond, far from any path. It was a pond
filled with rushes and slimy water that we called the Green Pond, not knowing its real name; I've
since heard it's called the Chalot Pond. The Green Pond finally became the goal of all our walks;
we felt for it the affection of a poet and a painter. We loved it dearly and spent our Sundays on the
thin grass around it. Paul had begun a sketch, the water in the foreground with big floating reeds,
with the trees receding like theatre-wings, drawing their branch-curtains as in a chapel, with blue
holes that disappeared in an eddy when the wind blew. The sun's thin rays crossed the shadows
like balls of gold and threw on the lawns shining quoits, the round discs of which travelled slowly. I
stayed there for hours without boredom, exchanging an occasional word with my companion,
sometimes closing my eyelids and dreaming in the vague rosy light that bathed me. We camped
there, we lunched, we dined, and only the twilight chased us away.

On the evening way home they sometimes went by Le Plessis-Robinson to enjoy its noisy
holiday atmosphere. There, in the mild air, the tavern was overhung by an old chestnut,
and the two young men listened to the barrel-organ waltzes and watched the women's
dresses floating under the lamplight. The laughter sounded 'like shivers in the night.'

There is no record of a return by Paul to Aix in 1863. If he made any visits, they were
brief. More likely he stayed the whole year in Paris, pleased at the way in which he was
adapting himself and afraid of breaking the spell. He was getting to know more of the young
painters. For the first time he had the experience of talking and working with men of his
own craft, whom he could respect and whose interest in his work was genuinely encouraging.
Zola went round with him to many studios, and linked himself with Béliard, Pissarro,
Monet, Degas, Fantin-Latour. Largely through Paul he was thus well acquainted with
many important artists before he had many connexions with the literary world. Soon,
through Duranty and Guillemet, he met Manet too, and had his portrait painted by him
in 1868.

Guillemet seems to have taken Paul to Frédéric Bazille of Montpellier, a tall lanky fellow

now about twenty-one, with blond beard and long moustache. Born in a rich family of Protestant winegrowers, he had come to Paris to study medicine, but attended the studio of Gleyre (a teacher at the Beaux-Arts). He too had found the Salon of the Rejected a revelation. He shared his studio in the Rue de la Condamine, in the Batignolles, with another young artist, also at Gleyre's, Auguste Renoir, who had been born at Limoges in 1841. Bazille took Pissarro and Paul in to see Renoir: 'I'm bringing two capital recruits.' Renoir, son of a poor tailor, had earned his own living from the age of thirteen; he decorated porcelain, fans, blinds, cafés, at low fees, but saved enough money to attend art-classes for a year. He was there reproached for not understanding that 'the big toe of Germanicus must have greater majesty than that of the coal-merchant at the corner.' Once Gleyre said, 'I suppose you simply paint for pleasure.' And Renoir answered, 'Of course, and if it wasn't pleasure, I assure you I wouldn't do it.' Also in the new group was the Englishman, Sisley, born 1839; and Armand Guillaumin, two years younger, born in Paris but brought up at Moulins-sur-Allier, who returned to Paris at sixteen to be apprenticed to an uncle with a linen shop. The family objected to his turning to art and he carried on without an allowance; needing to keep a wife and family he took a wearying job, till late in life a windfall enabled him to paint full-time. Paul liked to paint on the quais or in the suburbs with him. He also, Duret says, 'made personally the acquaintance of Courbet.'

We have only one letter written by Paul in 1864—to Numa Coste on February 27th. Coste had drawn an unlucky number in the conscription lottery, and was not rich enough to buy a substitute as Paul did when passed for military service. Paul now advised Coste to come to Paris and enlist in a corps there; Baille would then be able to recommend him to his company-lieutenant, as he knew a lot 'who came from the same school as he did, and also from the school of St Cyr.' This would mean more leave facilities and easier duties.

And now, mon brave, as for myself, my hair and beard are longer than my talent. Still, no discouragement for painting, one can easily make one's small bit of road-end even as a soldier. I see some who come here to attend the anatomy-courses at the School of Bozards [Beaux-Arts] (which, as you should know, has been *bougrement* changed and the Institute swept away). Lombard draws, paints, and pirouettes more than ever. I haven't yet been able to go and see his drawings, with which he tells me he's satisfied. For two months I haven't been able to touch my [illegible, perhaps *Boat of Dante*] after Delacroix. I shall however retouch it before leaving for Aix, which won't be before mid-month, I think, unless my father recalls me. In two months there'll be an exhibition like last year's. If you were here, we could visit it together.

However there was no second Salon of the Rejected. 'I'll soon be seeing Villevielle', Paul added to Coste, who took his advice, enlisted in Paris, and spent seven years there.

On April 21st Zola wrote to Valabrègue, 'Cézanne has cut his beard and sacrificed the tufts on the altar of victorious Venus.' He had shaved, it appears, in the hopes of attracting some girl. With such a shy person it seems unlikely that a girl, wooed, had told him to shave. It was perhaps about this time that he adopted various Bohemian habits, at least in Paris, wearing a red waistcoat and lying down to sleep on public benches with his shoes as

pillow. His baldness must have set in early; there is no sign of it in the photo and self-portrait about 1861, but in the 1870s it was well advanced.

In July he went back with Baille to Aix. He now had his studio in the Jas, into which he allowed no one; and he went painting round Aix and perhaps already at l'Estaque near Marseille, where he loved the strong contrasts of the red-tiled roofs and factory-chimneys with the expanse of rich blue sea and distant hills. His mother rented there a small fisherman's cottage on the Place de l'Église. On July 6th Zola had written to Antony Valabrègue, 'Has Baille made a furious swipe at you with his good Toledo blade, and has Paul dressed the wound with his benevolent lint of indifference'? Valabrègue thought Paul much changed. The dumb fellow had found his tongue and used it to talk radical politics. 'He produces theories and develops doctrines. Worst crime of all, he even allows you to discuss politics with him (theoretically of course), and says the most terrible things about the Tyrant' [Napoleon III].

Valabrègue and Abram were two Aixois Jews who several times appeared in his work. Of the first Paul painted a number of portraits; and the pair appeared in both *The Conversation* and *The Promenaders*. Zola, it has been noted, was for some years still surrounded by Aixois: Paul, Baille, Solari, Chaillan, Coste, then Alexis and 'the great Valabrègue' (as Paul called him). With other Aixois he corresponded: A. F. Marion at Marseille, Marguery with his novels in the local press, Marius Roux writing criticism. Only G. Pajot of his circle came from the Parisian Lycée. The Aixois grouping kept together till 1870. This year, 1864, taking Hachette's advice, he turned to prose and published—with Lacroix, not Hachette—a collection of short stories, *Contes à Ninon*, a slight work. It was composed of three tales printed in provincial periodicals, a better story that had been rejected by *Le Figaro*, three trifles, and a would-be *conte philosophique*. (A mild tale of his had been refused by the chief at Hachette's for a children's magazine: 'You are a rebel'!)

On August 18th Zola had written to Valabrègue an elaborate exposition under the title of *L'Ecran* (screen, filter, film). Paul must have read this letter, and he no doubt had heard Zola expound his screen-thesis, which certainly helped him to clarify in his thoughts the part played by the creative mind in the study and representation of nature. Zola opens: 'Every art work is a window opening out on to creation: stretched taut in the window-frame is a sort of transparent screen, through which one can see objects that appear more or less distorted (*déformés*) because they undergo more or less palpable alterations in their lines and colours. These alterations have their origin in the nature of the screen.' The fact that Zola, a literary man, writing to another literary man, Valabrègue, uses a metaphor wholly drawn from the sphere of art in order to explain creative activity shows how much they were all absorbed in arguments about art at this time.

Zola discusses screens of genius, which produce pictures of great intensity; school-screens develop from the need of lesser artists to use the vision created by the genius. He differentiates three main types of screen: the classical, the romantic, and the realist.

The classical screen is a beautiful sheet of very pure talc, of fine dense grain and a milky white. On it the shapes of things are clearly drawn with simple black strokes. The colours of things are veiled by passing through the veiled limpidity, often they are wholly extinguished by the passage. The lines undergo a perceptible distortion, all tend to become curved or straight lines, to flatten out, stretch into length, with much extended undulations. In this cold and scarcely permeable crystal, Creation loses all its hardness, all its life and glowing force; only its shadows are retained and they appear in relief on the smooth surface. In a word, the classical filter is a magnifying glass which promotes lines and makes it difficult for colours to pass through.

The romantic screen is a sheet of unsilvered mirrorglass, pure, yet a little dull in certain areas and tinted with the seven colours of the rainbow. It not only lets colours through, but gives them extra strength; often it transforms and mixes them. Outlines too undergo alterations; the straight lines bend to breaking point, the circles turn into triangles. Nature shown to us through this screen is restless and exciting. Shapes are strongly marked, by means of great patches of shadow and light. The illusion of naturalness is strong here, more seductive; there is no peace, but life itself, a life more intense than ours; no pure development of lines, but instead the whole passion of movement and the whole sparkling lustre of imaginary suns. In brief the romantic screen is a prism with immense refraction, which bends every ray of light and splits it up into a dazzling spectrum of sunlight.

The latter portion of this account suggests impressionism in a general way, though that art creed had not been worked out. It follows however that Zola, in these terms, would class it as a romantic expression of delight in nature rather than a realism. He goes on:

The realistic screen is a simple windowpane, very thin, very clear, which is claimed to be so wholly transparent that things seem to pass right through, are thus present with complete realism. So there is no alteration here in lines or colours, but an exact, free and artless reproduction. The realistic screen denies its own existence. But that is too conceited. Whatever is said, it exists and so cannot boast of giving us Creation in the radiant beauty of truth. However pure and thin, even if it's only window-glass, it still has its own colour and a certain thickness; it tints things, it reflects their shapes like every other [screen]. For the rest I willingly admit the pictures it gives are more real; it attains a high degree of exact reproduction. It's certainly hard to describe a screen of which the main quality is a near non-existence; I think however that I judge it fairly in saying that a fine grey dust lessens its limpidity. Everything that penetrates this material loses its splendour, or, rather, is slightly dimmed. On the other hand lines grow more voluptuous, to some degree exaggerated in breadth. Life is unfolded with greater opulence, a material life, slightly ponderous. To sum up, the realistic screen, the latest to appear in contemporary art, is a smooth windowglass, very transparent without being quite limpid, which gives pictures as true as any screen ever can.

He and Paul at this time would have considered themselves as of the realist school (Courbet as compared with Ingres and Delacroix); but it is of interest to note that in the end Paul took over elements from each of the groups—the shadow-line giving relief (for him in terms of colour), the spectrum of sunlight, the direct opulent vision. Zola's screen-analogy has its virtues, but it leaves the relation of 'temperament' or mind to the external world too much a fixed and unvarying matter. The dialectic of a full aesthetic comprehension of nature is lost.

Early in 1865 Paul was back in Paris and lodging in the Marais, on the right bank near the Bastille, at 2 Rue Beautrellis, in a seventeenth-century house, the Hôtel de Charny, mostly

inhabited by clerks and folk of modest means, but still showing an elegant façade. Handsome green doors opened into an arched vault where wainscotting survived. Paul had an attic on the fourth floor, to which he climbed by a staircase at the further end of the courtyard. He knew no doubt that Baudelaire had lived in the Hôtel six or seven years earlier; but the cause of his going there seems to be Oller, who may have had a room in the place (at least this was Oller's address in the catalogue of the 1865 Salon). Paul stayed in his attic for two years. On March 15th he wrote to Pissarro, and the letter shows they were now on good but not yet close terms.

M. Pissarro, Forgive me for not coming to see you, but I'm off for St Germain this evening and won't be back till Saturday with Oller to take his pictures to the Salon. As he writes, he has painted a Biblical battle scene, I think, and the big picture you know. The big one is very beautiful; as for the other, I haven't seen it.

I'd have liked to know if, in spite of the misfortune that happened to you, you've done some pictures for the Salon. If you should want to see me any time, I go every morning to the Suisse and am at home in the evenings; but give a rendezvous that suits you and I'll come to clasp your hand when I return from Oller's. Saturday we are going to the barracks of the Champs Elysées to take our pictures, which will make the Institute redden with rage and despair. I hope you've done some fine landscapes, and give you a cordial handclasp.

The Salon was more tolerant this year. The jury accepted two works by Pissarro, and one by Oller, *Ténèbres*. Everything that Paul put in was rejected. Manet's *Olympia* was shown, and since it affected Paul so strongly it needs some attention here. He was not attracted by Manet's liking for clear flat colours, his way of painting with the light behind his head so that shadows were driven out of the form and the object flattened—a method which made Courbet remark that Olympia looked like the Queen of Spades on a playing-card. Rather, Paul was drawn by the theme and the elements of symbolism in the treatment. The basis was Titian's *Venus of Urbino* (of which Manet made a copy); but in effect Manet was bringing the loose wench down from the academic glamourizing of a Couture or the romantic distance of the odalisques of Delacroix and Ingres to the soiled bed of Parisian fact, and was thus pointing the way to Zola's *Nana*. He put in a cat instead of Titian's white lap dog, a piece of sexual symbolism linked with Baudelaire's *Le Chat* and with a version of his own lithograph, *Le Rendez-vous des Chats*; the orchid was brought in to emblematize the girl's genitals. She herself is made deliberately cold, rather undeveloped; we are reminded of de Goncourt's phrase, 'meagre women, emaciated, flat, bony, thin enough to hold in your hand, with hardly a body at all' (*Journal* 11 April 1864). But this element of perversity was not likely to appeal to Paul, who, as far as we can tell from his art, loved big Rubensesque bodies. What he did like in the painting was its note of impertinence, the way in which the whore appears as challenging the spectator, not as secluded in some disguised *voyeur's* nook. To the passage in the *Journal* we may add that in *Manette* when we are told how the artist 'followed these unexpected apparitions, these charmingly irregular and radiant faces', and tried to analyse the charm of these skinny young girls with reflection of workshop lamps

on their temples, pale with lack of sleep and as if vaguely tormented with a nostalgia of idleness and luxury.' Paul may even have known the model of Olympia, Victoire, at least by sight. Vollard has an account of a long talk between himself, Guillemet, and Paul in front of the picture (after it had gone to the Luxembourg). Paul has remarked, 'That would please me well enough: to pose nudes on the Arc's banks! Only understand, women are cows, calculating, and they'd put the *grappin* into me'—and Guillemet talks about Victoire, who once remarked that she had the young daughter of a colonel ready to pose for him, but he must curb his tongue and use only refined language before her. Next day she brought the girl in and said at once, 'Come on, my lovely, show your *casimir* to the monsieur.' (*Casmir*, *cachemire*, literally 'your bit of kersey', was a slang-term for her genitals.)

There is also the tale of Vollard, imprecise, unreliable and gossipy as he was, that Paul was at first impressed by Manet. '*Il crache le ton*' (*crache*: spits out, comes right out with), but later added, 'Yes, but he lacked harmony, and temperament as well'. Then, when Vollard mentioned Manet's value in breaking through academic conventions, Paul replied, 'You know Daumier's phrase: I don't entirely love Manet's painting, but I find in it this enormous quality: it brings us back to the figures of playing-cards.'

Paul seems to have developed what we may call his black-contour style after his second visit to Paris. The sight of works by painters like Manet and Courbet, as well as experiences at the Suisse, jolted all the conventional ideas he had accepted at Aix. He wanted at all costs to escape from the thin laboured academic method, which was totally ineffective for the expression of the turbulent emotions now flooding him. His letters show that these emotions had been present for some time, but he had not been able to imagine any form able to express and contain them, apart from the rough joking sketches of the letters. He now sought above all for a strong system, trying to find a way of both free brushwork and forceful patterning. For some time his draughtsmanship and his control of volume was woefully inadequate to master this system. At its extreme the black contours were not at all absorbed into the modelling, as in the painting of two young women with a small girl between them. Here the black shadows on the dresses compose a hard grille over the surface and give an effect of clumsy marquetry. On the other hand there are odd works like that on which he wrote, *The Mother of the Seven Sorrows and Belzébuth*, in which he attempts to show figures in a more conventional spatial scene, but which is expressively weak despite the black hair and red flames of the devil (the theme is perhaps stimulated by the conflict between the suffering mother and the mocking father.) In the *Judgment of Paris* the treatment grows more free; but Paul is still far from knowing what he is after or how to gain it. However he keeps on struggling, gaining more sense of volume and liberating his brushwork into his full *couillarde* style, probably in 1866. In his first portrait of his father (perhaps done after his second Paris visit) he appears more settled in his new line of attack, though still in a rudimentary way. Something of the heavily-modelled style he had come to admire in Paris as the true contemporary vision is coming through.

Gleyre, with failing eyes, had closed his studio, and Monet, Renoir, Bazille and Sisley were now without a master. Monet had been with Bazille in Normandy and had brought back two seascapes he meant to send to the Salon; the two artists shared a studio in the Rue de Furstembourg (close to one that had been occupied by Delacroix), where Paul and Pissarro often visited them. Bazille was happy at having at last persuaded his family to let him drop medicine. Zola was working very hard, now living in a sixth-floor flat with balcony at 278 Rue St Jacques, where he still kept up his Thursdays. Louis Hachette had died, but Zola still worked ten hours a day for the firm, at the same time writing weekly for the *Petit Journal* and fortnightly for *Le Salut Public* of Lyon. 'Finally I have my novel on which I must work and which so far has slept quietly in the bottom of a drawer.' In October *The Confession of Claude* appeared; and critics, who had been ready to give a passing smile at the *Contes*, hated the 'hideous realism' of this highly romantic work, and the authorities pondered whether to prosecute Zola for indecency. The police made investigations and reported. The public prosecutor decided, 'He has no definite political opinions and his ambitions seem to be chiefly literary.' His aim had been to disillusion the young who 'let themselves be carried away by poets idealizing the love-affairs of Bohème.' That sounds very much like the sort of thing that Zola would have told the police in his own defence. However, inquiries had been made at Hachette's and Zola's lodgings at 142 Boulevard Montparnasse were searched. He resigned his job as head of publicity at Hachette's, at 2,400 francs a year. Perhaps the firm showed their disapproval of his book, or he may have decided to take the chance of breaking away and trusting to his writing. He was resolved, he said, to 'consecrate himself wholly to literature.' The experience must have shaken him; but his inner strength showed in the way he refused to be deflected from his course.

He was thus forced further into journalism, a course no doubt useful for him in the long run. A revolution was going on in newspapers. *Le Petit Journal*, with which he began in 1865, was the first of the new cheap journals, founded in 1863 and already reaching a circulation of 200,000 copies—huge for those days. In 1867 rotary presses were installed. Zola enjoyed the sense of contact with the hurlyburly of everyday life, of participation in the forces directly if crudely forming a new kind of society. In 1866 *L'Evénement* was launched and he was put in charge of book-reviewing, introducing a special feature of excerpts from books still in proof form. After a year *L'Evénement* was swallowed up in *Le Figaro* when it changed from a bi-weekly to a daily. Furthermore, for four years after leaving Hachette Zola wrote sub-literary serial tales for periodicals, which helped to free his narrative style. As he wrote to Valabrègue, 'You must realize I don't write all this stuff simply for love of the public. . . . The question of money has a great deal to do with it, but I also think journalism has a powerful effect and I am not at all sorry to be able to appear on fixed days before a considerable number of readers.' He had been able to double his income, and by his criticisms to gain links with the literary world. 'Every day I take a step forward.'

On November 19th Pajot wrote to him of *The Confession*, 'I felt shame at this misery

that neighbours on infamy,' and added, 'My regards to Gabrielle, who, if she inspires you with a novel, will make it less gloomy than this.' Zola was already living with Alexandrine Gabrielle Meley. (A photograph that Zola took of her in 1901 is inscribed, 'To the Companion of 37 Years': which would put their union back to 1864.) One tale ran that Paul had introduced her to Zola; but this seems unlikely—unless she happened to do some spare-time work as a model and Paul had thus met her. On her birth certificate her father appeared as a hosier; later we find him as a letterpress printer: so Zola may have met him at Hachette's or some newspaper office. Rémy de Gourmont, however, calls Gabrielle the daughter of a suburban café proprietor, and elsewhere she is called a shop-assistant. Zola had written to Coste on July 26th, 'I am now with my *femme*, Rue de Vaugirard no 10 . . . Alexandrine is getting plumper.' She was a year older than he, 'Tall, dark, distinguished, with black eyes, the astonishing deep black eyes of certain of Velasquez' infantas' (Huysmans); and E. de Goncourt, after she had been ill, on 6 February 1878, speaks of her 'rare beauty, made up of the softness of her two very dark eyes in the almost radiant pallor of her face.' Under the heavy lids and high fine brows, the eyes are what dominate in Manet's portrait. She was a good housekeeper, and what Zola seems to have sought was a sensible and enduring attachment rather than any strong romantic feeling. He was afraid of love-affairs, and he rationalized his fear as a need to conserve energy for work. Sandoz-Zola sets out marriage as the 'very prerequisite of a sound working life, of the regular solid output of the great modern productive writers.' Gabrielle seems to have been coldly ambitious; she suited Zola, protecting him and building up his secure and comfortable home life. Now she presided over his Thursdays and, however well she controlled herself, she cannot have cared for the unpredictable Paul, who in one of his bad moods could become a social liability.

Marius Roux was to review *The Confession* at Aix. Zola asked him to bring Baille and above all Cézanne into his notice: 'which will give pleasure to their families.' Perhaps he felt he would be taking a harmless revenge on Louis Auguste with his suspicions, in showing that the despised hanger-on had been the first one to attain to some sort of fame. Roux obliged, and wrote at some length on Paul:

We are a group of Aixois, all of us old schoolmates, all of us linked in good and genuine friendship. We do not know what the future has in store for us; but meanwhile we work and struggle . . . If we are all linked in friendship's bonds, we're not always united in our conception of the beautiful, the true, and the good. In such a matter, some of us vote for Plato, others for Aristotle; some admire Raphael, others Courbet. M. Zola, who prefers the *Spinning-Girl* [by Millet] to the *Virgin of the Chair* [by Raphael], dedicates his book to two devotees of his school.

M. Cézanne is one of the good students which our Aix school has contributed to Paris. He has left us with the memory of an intrepid worker and a conscientious student. There he will establish himself, thanks to his perseverance, as an excellent artist. Though a great admirer of the Riberas and the Zurburáns, our artist is original and gives his works a character of his own. One thing is sure: his work will never be mediocre. Mediocrity is the worst thing in the arts. Better be a mason if that is your profession; but if you are a painter, be a complete one or perish in the attempt.

M. Cézanne will not perish. He has taken from the Aix school principles that are too good; he

has found here examples which are too excellent, he has too much courage, too much perseverance in work, to fail in reaching his objective. If we were not afraid of indiscretion, I'd give you my opinion of some of his canvases. But his modesty forbids him to believe that what he produces is adequate, and I do not wish to hurt his fine feelings as an artist. I am waiting till he shows his work in broad daylight. That day I won't be the only one to speak. He belongs to a school which has the privilege of provoking criticism.

Marguery followed this lead in *L'Echo des Bouches-du-Rhône*. Of Paul and Baille he wrote, 'They are making names for themselves respectively in the arts and sciences.' Such notices in the local press must have gone far to pacify Louis Auguste for the moment, as no doubt Zola intended.

Paul had returned to Aix, probably in the autumn. He added a postscript to a letter which Marion wrote on December 23rd to a German, Morstatt, at Marseille, asking the latter to come to Aix and play Wagner for them. Paul's lines spoke of 'the noble accents of Richard Wagner.' He must have gone with other students to hear Wagnerian music played in Paris; certainly Wagner's work left a strong impression on him.

IV *A Crucial Year (1866)*

Paul was in Paris early this year, probably in February. From *L'Oeuvre* and its notes we can build up a picture of him as he appeared to Zola in these years: 'thin, with knotty articulations, a strong bearded face. Very fine nose, lost in the bristly hair of the lips, eyes narrow and clear. In the depth of his eyes a great tenderness. His voice was strong.' *The Belly of Paris* tells us that he wore 'a felt hat of rusty black, shapeless, and buttoned himself up in the depths of a huge overcoat, once mild chestnut brown, which rain had given big greenish streaks. Slightly bent, agitated with a shiver of nervous disquiet that must have become habitual, he stood there planted in his big laced shoes.' He wore blue socks and trousers too short (*L'Oeuvre*): a note adds 'according to portrait of C.,' while another note mentions his 'long form, accentuated brow, Arab visage.' The notes for *L'Oeuvre* emphasize: 'he distrusted women . . . Never did he take girls into his place, he treated them all as a lad who ignored them, with a suffering timidity that he hid under a fanfarronade of brutality . . . "I don't need women," he used to say, "that would derange me too much. I don't know what's the use of it all, I've always been afraid of trying." ' In the margin of this last comment: 'Very important.' Coquiot says (perhaps of later years) that, overcome by a model undressing in his presence, he would stare till he couldn't bear it any longer and then push the woman out, half-naked, on to the landing. Then, returning to his easel, he'd lay her 'on the bed of his pictures.' His speech was rough, deliberately coarse. 'He swore, sought for excremental words (*mots orduriers*); sank himself right down into the mud with the cold rage of a tender and exquisite spirit that doubts itself and dreams of sullying itself.' He was 'gay in the morning, unhappy in the evening,' called painting 'a dog's trade.' 'When I paint I feel as if I'm tickling myself.' Then came despair. 'I've never finished anything, never, never' (notes). Later J. Gasquet wrote, 'Those who saw him at that time have depicted him to me as terrible, full of hallucinations, almost bestial in a sort of suffering divinity. He changed his model weekly. He was in despair at ever being able to satisfy himself. He suffered from those combinations of violence and timidity, humility and pride, doubts and dogmatic affirmations, that shook him throughout life. He went to earth, for weeks refusing to let a living soul into his studio, fleeing every new acquaintance.' Though Gasquet overdramatizes, Paul was certainly already suffering from the desperate alternations of mood which provided the basis for the characterization of Claude in *L'Oeuvre*.

Thus his studio is described in that novel:

Last winter's ashes were still heaped up in front of the stove. Apart from the bed, the little wash-stand and the divan, the only big pieces of furniture in the place were a dilapidated oak wardrobe

and a huge deal table littered with brushes, tubes of paint, unwashed crockery, and a spirit stove crowned with a saucepan still dirty after being used for cooking vermicelli. The rest was a staggering collection of battered old chairs and broken-down easels. Near the divan, on the floor, in a corner that was probably swept out less than once a month, was the candle he had used last night, and the only thing that looked neat and cheerful was the cuckoo-clock.

Addresses of models were scribbled on the walls in chalk, straggling in all directions. With all his fear of women, he was obsessed by them.

Chaste as he was, he had a passion for the physical beauty of women, an insane love for nudity desired but never possessed, but was powerless to satisfy himself or to create enough of the beauty he dreamed of enfolding in an ecstatic embrace. The women he hustled out of his studio he adored in his pictures. He caressed them, outraged them even, and shed tears over his failures to make them sufficiently beautiful or sufficiently alive.

His attitude to women was closely linked with his attitude to his art: devotion and rejection, hope and doubt, a moment of hopeful outgoing followed by a retreat into despair. A passage from *Thérèse Raquin* (published in 1867) on Laurent's studio gives us Zola's idea of Paul's art at this phase—though otherwise there is no link between him and Laurent:

There were five studies, painted with veritable energy. The method of painting was thick and solid, each passage rose up in magnificent splotches [*taches*] . . . Certainly these studies were clumsy, but they had a strangeness, a character so powerful that they announced an artistic sense of the most developed kind. One would have spoken of lived painting [*peinture vécue*]. Never had he seen sketches so full of high promise.

Paul could now feel himself a part of the advanced Parisian movement of art. Probably through Guillemet, he met Manet early this spring. Valabrègue sent the news to Marion, who passed it on to Morstatt in a letter of April 12th. Paul had visited Manet, who in turn went to see Paul's still-lifes at Guillemet's studio. Manet was said to have found them 'boldly handled', and Paul, delighted, hid his pleasure as usual. Valabrègue concluded that the two artists would understand one another as they had 'parallel temperaments'—hardly an accurate prognostication. Paul was not likely to feel at ease with such an elegant Parisian as Manet with his top hat, gloves, cane and sophisticated wit, his liking to expand magisterially amid a group of disciples in places like the Café Tortoni.

By 1866 it seems that Paul had met all the painters who were to become famous impressionists except Berthe Morisot, who belonged to Manet's polished world and who in 1874 married his brother Eugène. The rebellious painters, needing to talk out their theories, their likes and dislikes, used to meet at Fantin-Latour's house in Rue des Beaux-Arts, where Renoir and Bazille also lived. But from 1866 to 1870 their favourite haunt was the Café Guerbois, at 11 Grande Rue des Batignolles, near the restaurant of Père Lathuile. Manet and his friends had two tables reserved on the left of the entry; and besides the painters there were writers like Zola, Duranty, and Duret, or the novelist Léon Cladel. Monet declared, 'Nothing could have been more interesting than those causeries with their perpetual

clash of opinions. They kept our wits sharpened. . . From them we emerged with a firmer will, with our thoughts clearer and more distinct.' Elegants like Degas were ready to discourse on the error of making art available to the lower classes, while Duranty, though of humble origin, studiously made clear that, whilst a realist, he wasn't a muddy or declassed one—doubtless aiming shafts at the Courbet enthusiasts in the Brasserie Andler. But he may already have been thinking of Paul. Monet mentions that Manet never appeared 'save as a gentleman.' He, Pissarro, and the other strong democrats must have had their smiles; but Paul felt the fine clothes and fine manners a sort of personal affront to his self-conscious provincial gaucherie. He said to Guillemet, 'They're a lot of bastards, they dress as smartly as solicitors'—note the reference to men of the law from which he had fled. Monet recalled with pleasure that Paul no sooner arrived at the Café than he threw on all the assembly a scornful (*méfiant*) eye; then, drawing his jacket aside, with a quick movement of his hips, he hitched up his trousers and ostentatiously readjusted his red waistband. After that he shook hands all round. But in Manet's presence he took off his hat and said through his nose, with a grin, 'I won't offer you my hand, M. Manet. I haven't washed for a week.' He then sat in a corner, appearing to take no interest in the talk going on around him. At times, however, when he heard something that irritated him too much, he rose brusquely, and instead of replying went out without saying goodbye to anyone. At most he might blaze out and then stalk away. He detested the clever speakers. '*L'esprit m'emmerde*': 'Wit shits on me.'

He was painting hard and kept on sending works to the Salon, though he had called it the 'Salon des Bozards' and the 'Salon de Bouguereau'. *L'Oeuvre* states, 'After swearing he would never try to get into the Salon again, he now contended that on principle one should always put something before the Jury if only to prove it was in the wrong. Besides, he acknowledged the usefulness of the Salon as the only battlefield on which an artist could assert himself at one blow.' No doubt all that was true; but Paul badly wanted some official success. Above all it would justify him at Aix and at home; and perhaps he felt that his uncertainty would wane if he could ever gain this one solid basis of acceptance. After all, Delacroix, Courbet, Manet, had forced their way into the Salon and used it. We hear of him bringing pictures to the Salon on the last day fixed for reception, and at the last hour. The pictures were in a handcart, dragged and pushed by his friends. On arrival he slowly took them out and showed them to the crowd of students forming up each side of the door. This scene was repeated several times by Paul and Guillaumin together. Once when Manet at the Guerbois asked him what he was sending in, he is said to have replied, 'A pot of shit.' Certainly the retort is in character; and indeed his addiction to excremental terms suggests an infantile fixation which would harmonize with his obsessional fears about money.

This year he sent two works, *An Afternoon at Naples, or the Wine-Grog* and *Woman with Flea*. For the first he used as model (says Vollard) an old nightsoil-remover whose wife kept a little creamery where she served a beef soup much appreciated by her hungry young customers. Paul, who had won the old man's confidence, asked him to pose and was

reminded of his job. 'But you work by night, you've got nothing to do in the day'. The nightman replied that in the day he slept. 'All right then, I'll paint you in bed'. The old man was put under bedclothes with a cotton nightcap; but as he felt there was no need for ceremony among friends, he took off his cap, then threw off the sheets, and ended posing naked. His wife was introduced into the picture, handing him a bowl of wine. Guillemet suggested the pseudo-romantic title. Paul's faecal style of humour would have enjoyed making the nightman his amorous hero.

The study that has been taken as nearest to the lost painting shows the man sprawling on his stomach, with a woman sprawled the other way round against the small of his back; a servant in green brings in a tray behind them. Why the old man would be needed as model for such a rough work, it is hard to see. In a variant (done it seems in the early 1870s) we do however find an old man smoking a pipe, though he is again largely hidden, this time by the girl sprawled flat in front of him. She is extended in an odd set of gestures, which Paul was to exploit in an emotionally charged way for bathers and which were more natural for a standing than a lying figure. One arm, the right, is held straight up above her head; the other goes down, the two arms thus forming a kind of diagonal with the head in the middle. But here the left arm can hardly just stick out in a functionless way, so Paul makes the girl lift her right knee and clasp it with her left hand. Behind, the woman holds out a plate, on which is a single apple; drinks stand on a table. In other studies a Negress is attendant. (The raised-lowered diagonal arms must have early had a deep meaning indeed for Paul. The gesture appears already in the *Spring* panel at the Jas, though there the raised arm is bent over and drops flowers that descend to the lowered hand; the gesture is innocent and suggests harmony between head and loins.)

There are a number of works of the 1860s in which the heavy black edges and shadows cut the forms up, and others in which the violent attack dominates. The more static conception of form appears when he is dealing with the family, for instance in the picture with his two sisters at the front and Valabrègue and Abram at the back on the right— though here the lines breaking up the skirts are not at all as heavy as in the picture showing two girls with a young girl between: *Interior Scene*.

The question of Choice, first brought to a head in the image of Hercules at the Cross-roads, was now finding a purely sexual idiom. Faced with the possibility of easily actualizing his daydreams, he was more undecided than ever. Even if he could not bring himself to pick up a shopgirl, he had the venal models at his disposal; and it was no doubt the strong association of accessibility with the female models that made it increasingly difficult for him to use them for his art. His fears and uncertainties found a direct allegory in the theme of the Judgment of Paris. Departing from accepted forms, he saw the shepherd as choosing a woman for himself or immediately gaining her embrace as the result of his choice. In his painting the two defeated goddesses still reach out their arms while Venus snuggles down against Paris, who rests his hand on her shoulder. And here a further identification intruded.

Though the shepherd Paris in the myth was the judge, Paris was also for Paul the name of the city of temptations. Venus, the venal model, the city-Paris were merged in his mind, and Art itself merged with the Trio as the supreme temptress and seducer:

The arts, painting is for them the great Corruptor, the Courtesan always hungry for new flesh, who will drink the blood of the children and strangle them, heaving and gasping, on her insatiable breast. (Zola on Manet, 1867.)

This philistine conception was one that haunted the provincial lad with fear and desire, and was one of the reasons for his vacillating fears, his revulsions of despair, in the face of a canvas with which he was struggling. He identified the act of creation with the act of copulation and felt himself torn between the woman-art and the woman-lover.

Here Paris, the youth faced with sexual choice, is set against Paris the courtesan-city, the whore-model. (Paul had a weakness for puns. Lucien Pissarro, who had a schoolmaster Rouleau, told how Paul called to him, 'Hé, Lucien, have you had yourself rolled-over [roulé] today?') Paris the Temptress was a common image, aptly expressed in Offenbach's *La Belle Hélène*. Zola with great insight expressed all this tangle of ideas and emotions in Paul's mind when he described Claude-Cézanne's painting that symbolized Paris:

[a boat] filling the whole centre of the composition and occupied by three women. One of them, wearing a bathing costume, was rowing, another was sitting on the edge with her legs in the water and her bathing dress slipped halfway off one shoulder. The third was standing at the prow, completely naked, her nudity so radiant that it dazzled like the sun.

Claude tries to defend the theme, saying the women have 'come from the swimming-bath, you see, and that provides a nude motif. Quite a discovery, don't you think?' Zola-Sandoz argues that such an explanation could hardly justify 'a woman naked like that in the middle of Paris.' But—

Claude refused to give way and offered unsatisfactory and violent reasons for his choice, since he didn't want to admit the real reason for it. It was an idea he had had, but an idea that he would have been unable to express clearly, the old streak of romanticism in him that made him think of his nude figure as the incarnation of Paris, the city of passion seen as the resplendent beauty of a naked woman. Into it he poured all his own great passion, his love of beautiful bodies and thighs and fruitful bosoms, the kind of bodies he was burning to create in boundless profusion so that they might bring forth all the numberless offspring of his prolific art.

And so the apple, indeed any rounded fruit, became of great emotional importance to him. Of course there were many other reasons why he liked painting apples. They lasted a fairly long time—even though with his slow meditative methods they often did decay before he had got all he wanted out of them; they presented problems in volume and modelling that fascinated him—just as did breasts and buttocks, which however were less at his disposal and raised disquieting emotions that he could partially pacify before fruit. But in the last resort he was deeply concerned with apples because the apple was the emblem of love, whether Paris put it in the hands of Venus or Eve put it in the hands of Adam. (The mother-goddess

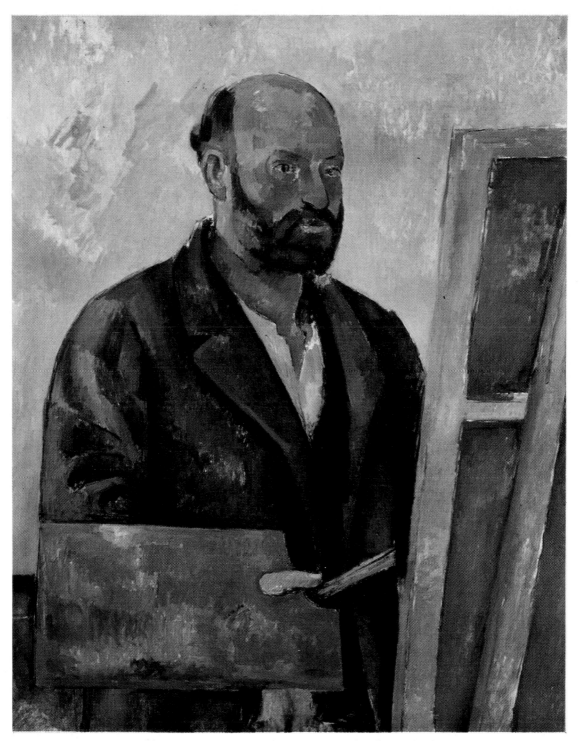

I Self Portrait with Pallette, *c* 1885–87 *E. G. Bührle Collection, Zurich*

with apple or pomegranate was an ancient symbol.) The apple thus represented for him both the moment of sexual choice and the sexual object itself, the rounded curves of Venus. We noted above the rounded fruit in the bowl offered by the woman in *Le Grog au Vin*; there are both early and late paintings of peaches that use the cleft in the rounded shape to suggest buttocks or the vaginal cleft; and it is only if we grasp the symbolism of the rounded fruit for Paul that we can understand such a strange work as *The Picnic*, derived from Manet's *Déjeuner sur l'Herbe*, of which it is a fantasy-variant without nudes. (The extremely long figure of the girl with the fruit suggests the early *Spring*; but the baldness of Paul could hardly be dated before 1869.)

The ordinary meanings of a picnic are overlaid here by a strange, dreamlike atmosphere. Above a tablecloth spread out on the grass, on which is nothing but two oranges—the apparent object of the meditations of the figures—hovers a tall, bent woman with loosened golden hair, a sibyl who holds a third orange in her extended hands, as if performing a sacramental rite or pronouncing an incantation. She turns her gaze to the frock-coated, gesturing man in the foreground; he resembles the young, prematurely bald Cézanne. In the distance stands a solemn rigid figure, smoking a pipe, with folded arms like a guard or the celebrant of a ritual; on the left, a man and woman, dressed like Cézanne and the sibyl, go off into the dark woods arm in arm (as in a picture by Watteau, *L'Accord Parfait*). [Schapiro.]

The three oranges or red-golden apples represent the three sexual choices: one for each couple, leaving Paul as odd-man-out. The mystery of the picnickers intensely preoccupied with the three fruits (the only eatables) is thus explained. The sibyl is both offering the love-apple to Paul and taking it away; she belongs to the smoking man, whose head is in a line with hers and who is regarding her. The top hat and parasol-end in the corner of the picture provide another set of sexual symbols, as does the dog who watches the sibyl's fruit. Paul, we may note, has raised his left forefinger as if in a tentative bid for the fruit which he knows is forbidden to him—the fruit which, by the woman's bending gesture, is brought on a level with her emphasized breast. (Fig. 35.)

Paul liked to introduce himself into his fantasies. Here he is the man left out in the game of sexual choice; he appears later as the woman-fancier of the *New Olympias*; in the *Autopsy* he is the man apparently plunging his bare arms into the corpse's loins; he lolls in the *Pastoral*. And we may note that as master of the apple he is after all the master of the situation of choice. He, the Paris of the apple, offers the prize to Paris the lovely and corrupting woman. He told Geffroy, 'With an apple I want to astonish Paris.'

This year both the works he sent in to the Salon were rejected. Whereas other rebels tried their mildest works on the Jury, Paul tried his most violent. Marion had written to Morstatt in March, 'I've just had a letter from my Paris friends: Cézanne hopes to be rejected at the exhibition and the painters of his acquaintance are preparing an ovation in his honour'. Soon afterwards Valabrègue wrote to Marion from Paris. 'Paul will be rejected without doubt. A philistine on the Jury exclaimed on seeing my portrait that it was painted not only with a knife but with a pistol as well. Many discussions have broken out. Daubigny

said some words defending my portrait. He declared that he preferred pictures over-brimming with boldness to the nullities that appear in every Salon. He didn't succeed in convincing.' Marion sent this letter on to Morstatt. He himself remarked:

Since then I've had more news. The whole realist school has been refused, Cézanne, Guillemet, and the others. The only accepted pictures are Courbet's things—it seems he is growing weak—and a Fife-player by Manet, one of the youthful glories who decidedly occupies the front rank [an error; it was rejected] . . . In reality we win and this mass-rejection, this vast exile, is in itself a victory. All we have to do is to plan a show of our own and put up a deadly competition with those bleary-eyed idiots. We are in a fighting period: you against old age . . . the present, laden with promise of the future, against the past, *that black pirate*. Talk of posterity. Well, we are posterity. And we're told it's posterity that judges. We trust in the future. Our adversaries can *at best trust in death*. We are confident. All we want is to produce. If we work, our success is certain.

Paul, as the spokesman of the indigent and dissident young, wrote an indignant letter to the superintendent of the Beaux-Arts, Comte de Nieuwerkerke. There was no reply. He wrote again, saying that he refused to

accept the illegitimate judgment of colleagues to whom I have not myself given the authority to appraise me. I write to you then to stress my demand. I wish to appeal to the public and have my pictures exhibited in spite of the Jury. My desire does not seem to me extravagant; and if you ask any of the painters who find themselves in my position, they will all reply that they disown the Jury and want to take part, one way or another, in an exhibition which will be open as a matter of course to every serious worker. Therefore let the Salon of the Rejected be re-established. Should I find myself alone in my demand, I sincerely wish that the public at least should know that I no longer desire to have anything more to do with these Gentlemen of the Jury than they seem to desire to have to do with me.

He says, unfortunately, that 'I need not here repeat the arguments I thought it necessary to put before you in the first letter'. On the margin a curt reply is written: 'What he asks is impossible. We have come to realize how inconsistent with the dignity of art the Exhibition of the Rejected was, and it will not be re-established.'

Paul's letters were probably composed by Zola, with the agreement of other artists, to find out if the authorities could be goaded into another Salon of the Rejected. The idea was certainly being discussed. Renoir went to wait for the Jury to emerge from the Palais. He saw Corot and Daubigny; but, too shy to address them in his own name, he said that he was a friend of Renoir. Daubigny remembered the name and described Renoir's work: 'We were very annoyed on your friend's behalf, but his picture is rejected. We did all we could to prevent it. We recalled the picture ten times without managing to get it accepted, but what would you have? We were six for it against all the others. Tell your friend not to be discouraged and that there are great qualities in his picture. He should make a petition and ask for an Exhibition of the Rejected'. Daubigny seems also to have been alone in defending Paul's portrait of Valabrègue; and he did succeed in getting a Pissarro landscape in. The Comte considered the rejected artists as so many Millets, whose work 'disgusted him'; they were democrats.

Solari however was accepted. As he had long used up all the money from his prize, Paul was sharing his resources with him. He had been working on a larger-than-life bust of Zola, with which Zola and Paul helped when it was being cast. Solari was thin, sallow, rather ugly, with bright eyes that held a childish charm, prodigal, full of grandiose ideas, but incapable of dealing with ordinary life. 'Marvellously indifferent, sober, distracted, always equably calm, he was a Bohemian free of all self-interest, and also a shy fellow' (Bernex). Zola based Silvère—the hero of *The Fortune of the Rougons*—on him, making him there a noble and naive revolutionary; Silvère was 'a Philippe Solari in aspect, but less furrowed' (notes); Miette, the heroine, Silvère's lover, was based on his sister Louise. Pajot met a Russian count who wanted a statuette for his garden, a clay figure of Ingres' *Source*, and suggested Solari; but we don't know if the commission came off.

The noise of a shooting-gallery had made Zola move from Montparnasse to a five-roomed flat with balcony at 10 Rue de Vaugirard, close to the Odéon and the Luxembourg Gardens, 'a veritable palace.' He had his mother with him. The Thursday dinners went on, 'awaited like a love-rendezvous' (notes to *L'Oeuvre*), swollen by some new Aix friends; Valabrègue since March had been at a hotel in the Rue Vavin. What increased the likelihood that Zola had both instigated and written Paul's letters about another Exhibition of the Rejected was the fact that he had persuaded *L'Evénement* to put him in charge of the Salon reviews and had launched his series by serving a Notice on the Jury. 'I'll no doubt make many malcontents, having resolved to tell rough and terrible truths, but I'll experience a deeply felt pleasure at discharging from my heart all the accumulated angers.' Paul's second letter, dated April 19th, was penned on the day when Zola opened his attack with this declaration of a 'ruthless investigation' of the Jury. The attack proper began on the 27th and went on to May 7th.

Zola had learned a great deal about the members of the Jury, especially from Guillemet: how they were chosen and did their work. And he had material also on the events of 1863. He set out to attack 'those who amputate art and present to the crowd only a mutilated corpse.' *L'Evénement* was a good medium, widely read by men of letters and the theatre, and by *gens du monde*. He pointed out that 'the Salon of our days is not the work of artists; it is the work of a Jury,' and 'only those nominate the Jury who precisely have no need of the Jury.' Three-quarters of the works shown were chosen by exhibiting and already-decorated artists; the last quarter were chosen by the administration. The artists in question had the right to put pictures in unchallenged, though this fact was not mentioned in the Catalogue. As for the Jury:

They are good fellows who reject and accept with indifference; they are established persons, outside the struggles; they are artists of the past who hold to their outlooks, who deny all new endeavours; they are finally artists of the present, whose little manner has had a little success and who grip this success between their teeth, growling and threatening any colleague who comes near.

He cites the case of an artist known as a student of Courbet's, who sent in two pictures, one

under his own name, one under a pseudonym; the first was rejected, the second accepted. He gives his own criterion; 'A work of art is a corner of creation seen through a temperament.' 'A work of art is a personality, an individuality.' And he declares, 'M. Manet's place is marked in the Louvre like that of Courbet.' The result was a great scandal; there were so many letters of protest and threats to cancel subscriptions that the paper's director brought in a conventional critic, Pelloquet, to write three articles contradicting all Zola's remarks. Zola, who had already written five articles and meant to write sixteen to eighteen, had to content himself with three more.

Here are some more passages from his articles, which he would certainly have discussed with Paul and which we may therefore take as setting out positions close to those which the latter had been evolving:

Yes, I constitute myself the defender of reality. I avow calmly that I am going to admire M. Manet. I declare that I take little account of all the rice-powder of M. Cabanel [whom Paul had admired in 1861] and that I prefer the harsh and healthy smells of true nature. Besides, each of my judgments will duly come true. I content myself with stating here, and nobody will dare to contradict me, that the movement described under the name of Realism will not be represented in the Salon . . .

Art has had its face washed, has been carefully combed. It's a brave bourgeois in slippers and a white shirt . . .

This year the jury has had need of a sharper propriety. It has found that last year the broom of the ideal had missed some bits of straw on the parquet. It wanted to make a clean sweep and it has shown the realists the door: folk accused of not washing their hands. The fine ladies will visit the Salon *en grandes toilettes*. Everything will be proper and clear there as a mirror. They could do their hair in the canvases . . .

What I ask of the artist is not to give me tender visions or terrifying nightmares. It is to deliver himself up heart and flesh. It's to make a lofty affirmation of a powerful and particular spirit, a nature that can seize nature liberally in its hand and set it standing upright before us, such as it is. In a word, I have the profoundest disdain for small clevernesses, for interested flatteries, for what study has been able to learn and a tenacious labour has made familiar, for all the historical *coups de théâtre* of this gentleman and for all the perfumed reveries of that other. But I have the profoundest admiration for individual works, for those that come from the stroke of a vigorous and unique hand . . .

I am not for any school, because I am for human truth, which excludes all coterie and all system. The word *art* displeases me. It holds I-don't-know-what ideas of necessary arrangements, of absolute ideal. To produce art: isn't it due to something that's outside man and nature? I, I want artists to make life, I want them to be alive, to create anew, outside everything else, according to their own eyes and temperament. What I seek before everything else in a picture, is a man and not a picture. I consider there are two elements in a work: the real element, which is nature, and individual elements, which are the man.

We have already noted his praise of Pissarro. When he came to publish the articles as a pamphlet, *Mon Salon*, he dedicated the work to Paul under the date 20 May 1866. His words bring out the extreme closeness of their outlook at this moment and the extent to which in fact *Mon Salon* was something of a collaboration.

I feel a profound joy, my friend, in conversing alone with you. You cannot believe how I have suffered during this quarrel I have just had with the crowd, with unknown people. I feel myself so

little understood. I divine such a hatred around me that often discouragement had made me drop the pen.

Today I can give myself the close pleasure of one of those good causeries we have had for ten whole years. It is for you alone I write these few pages. I know you will read them with your heart and that tomorrow you will love me more affectionately . . .

For ten years now we have talked of the arts and literature. We have often lived together—do you remember?—and often the day has surprised us, still discussing, digging into the past, questioning the present, trying to find the truth and create an infallible and complete creed [*religion*]. We have turned up some terrifying heaps of ideas, we have examined and rejected all the systems, and, after such a rough labour, we have told one another that outside potent and individual life there was only lie and folly.

Happy those with memories. I see you in my life like the pale young man of whom Musset speaks. You are all my youth. I find you mingled with each of my joys, in each of my sufferings. Our spirits, in their fraternity, have developed side by side. Today, in the day of our first appearance, we have faith in ourselves, because we have penetrated our hearts and our bodies . . .

And so on in this vein. He uses the name Claude for himself as the signatory of the articles, for himself as the hero of *The Confession*, for Paul as the artist of *The Belly of Paris* and *L'Oeuvre*. Paul too could say as sincerely, 'You are all my youth': meaning, as Zola did, 'we have shared the same essential formative process.' One interesting point is that Zola clearly includes Paul in the statement that he has rejected all the creeds and systems, and holds that 'outside potent and individual life there is only lie and folly.' These words embody both an aesthetic and a philosophical position, which Zola attributes in an unqualified way to Paul as well as to himself. Together they have sought for a satisfying way of life, an acceptable world-view. In a letter written when he was twenty Zola shows that he has dropped all institutional religion, though he still holds to a vague deism; he is uncompromisingly anti-clerical, considering that faith has been weakened by the commentators who undermine religious authority, and by the priesthood, 'a new race of deceivers, creatures on the margin of society, impossible and contrary to the divine spirit.' The tone of Paul's early letters is in the key of such an attitude. As Zola's Rougon-Macquart series developed, it expresses a strong anti-clericalism, which is especially brought out in *The Conquest of Plassans*, set at Aix and dealing with the Mouret-Cézanne family. Mouret is a republican vigorously opposed to the Church and religion; his house lies between the Bonapartists and the Legitimists, and its destruction symbolizes the destruction of the radical and republican party as the climax of an intriguing abbé's work. (Louis Auguste stood in 1848 for the town council; he was twenty-second on a list of twenty-seven candidates, advocating a 'fusion of classes and parties'; he gained only a few votes and was defeated.) But the wider political theme is narrowed down in the Mouret family as a clash between the free-thinking republican and his wife who, previously docile, becomes intensely religious under the abbé's influence and breaks up the home, getting her husband locked up while he is still sane, and thus driving him really mad. The unhinged Mouret burns the house down, killing himself and the abbé, as the wife dies. Zola here, as often, starts off from a situation he has personally known, and proceeds to drive it to its desperate extreme

of conflict. (He does the same with Paul himself in *L'Oeuvre*.) The given facts are the non-believing republican husband and the tamed yet obstinate wife who clings to religion; and we may safely assume that here Zola is drawing directly on what he knew of the tensions in the Cézanne household at Aix. In such a divided family situation, Paul, with his anxious but persistent questioning of authority, had certainly gone the way of his father, giving his attitude an intellectual and moral passion, however, that was quite foreign to Louis Auguste. It is a great pity that we lack the letters he wrote to Zola about those early novels, and so do not know what he said of *The Conquest*. But we do know that at the time he was still in perfectly amiable and assured harmony with Zola.

This year saw something of a crisis in fashions. The couturier Worth challenged the reign of the crinoline with the princess-dress gathered at the back of the waist and falling into a train, and the *fourreau* or sheath-dress, resembling a cassock, though also widened out behind. The crinoline-makers reacted by a campaign trying to prove that their article had nothing to do with fashion, but was a modern scientific device essential as long as skirts were worn. Women found it hard to imagine life without crinolines. Colours tended to get political names. Princess Pauline, shocked at the defeat of the Austrian army, helped Worth to launch a *Metternich green*; and a vow by a rich Mexican woman, a dream of Worth's, and a conversation with Princess de Metternich mingled to beget *Bismarck brown*. Soon every smart woman had her Bismarck dress for walking, with bronze shoes and Bismarck hat and sunshade. Variations of the colour were called *Bismarck malade*, *Bismarck content*, *Bismarck en colère*, *Bismarck glacé*. Paris became a sea of brown, and some women had their hair dyed to match the shade they wore. The undermining of the scheme for a Mexican Empire and a growing financial crisis affected the scene. Princess Charlotte, returned from Mexico, remembered Dürer's engravings of the Apocalypse; she decided in anguish that she was in Babylon, the Emperor Napoleon was the Devil, and the idle well-dressed crowds of Paris were the doomed worshippers of evil. The artists could not but have been aware of much that was happening; but Pissarro, Monet and Renoir were lightening their palette as the political arena darkened.

On June 14th Zola wrote to Coste that he was leaving with Baille for a week in the country, where he would meet Cézanne. 'Paul has been rejected, as was to be expected, also Solari and everyone else you know. They've gone back to work, sure they'll have another ten years to wait for acceptance.' The trio does not seem to have met at once, for on June 30th Paul wrote to Zola:

I got the two letters you sent enclosing the 60 francs, for which I thank you since I'm more unhappy than ever when I haven't a sou. So nothing amusing happens of which you don't speak at length in your last letter. Impossible to get rid of the *patron*. I don't know for sure which day I leave, but it'll be Monday or Tuesday. I've done little work, Gloton's birthday was last Sunday 24th, and the *patron*'s brother-in-law came, then a pack of idiots. Dumot will leave with me.

The picture doesn't go badly, but the day takes a long time to pass. I must buy a box of water-colours, so I can work when I can't get on with my picture. I'm going to change all the figures in it.

I've already given Delphin a different pose, like a hair: he's like that, I think it's better. [Drawing of a man digging.] I'm going to alter the other two as well. I've added a bit of still life at the side of the stool, a basket with some blue linen and green and black bottles. If I could work longer at it, it'd go quickly enough, but hardly two hours a day, it dries too quickly, it's infuriating. Decidedly these people should pose for you in the studio. I've begun in the open air a portrait of father Roussel the elder, which is coming on not too badly, but I need to work more on it, especially on background and clothes: on a canvas of 40, a bit bigger than one of 25 cm.

I fished yesterday with Delphin and yesterday evening with my hands in the holes. I caught at least more than a score yesterday in a single hole. I took six, one after the other, and once I caught three at the same time, one in the right, two in the left; they were rather fine. It's easier all that than painting, but doesn't get a man far. My dear friend, see you soon. My regards to Gabrielle as well as to yourself, Paul Cézanne.

Thank Baille from me, he's saving me from needing money. The food here becomes too mean and trichinous, they'll end by giving me food only as a favour. And greetings to your mother whom I was forgetting, *mille pipes*.

Where Paul was is not clear; none of the names occurs elsewhere. But he does not seem to have been at Aix. For July, however, he and his friends were together at Bennencourt: the trio with Solari, Valabrègue, Roux, swimming, fishing, canoeing, walking. They enjoyed something like the blessed release of their earlier Aix days; and Zola depicted the scene later in *L'Oeuvre*, using it for Claude's honeymoon—though in fact the honeymoon was rather his own, for Gabrielle was with them. Bennencourt, on the Seine between Paris and Rouen, consisted of a scatter of yellow-washed houses set along some kilometres of the riverside behind poplars; around were fields and wooded hills; and in the river were reedy isles. An old ferry broke the quiet with its clanking chains. 'Intoxicated with the hope of soon being able to overthrow everything that exists' (as Zola wrote in *Une Farce, ou Bohèmes en Villègiature*), the young men went after dinner to lie on bales of straw in the yard of Mère Gigoux's inn, smoke, and talk. 'It was the hour of theories, of furious discontents, that lasted till midnight and kept the trembling peasants awake. We smoked pipes while contemplating the moon. We called each other idiot and halfwit for the least difference of opinion.' (The poets advocated romanticism; the painters, realism.) On July 26th Zola wrote to Coste:

Three days ago I was still at Bennecourt with Cézanne and Valabrègue. They are both staying on and won't be back till the start of next month. The place, as I've told you, is a regular colony. We've taken Baille and Chaillan there; we'll take you too . . . Baille left for Aix last Saturday. He'll return the 2nd or 3rd of October. He has finished a book on physics for Hachette, the publishers, about which I think I wrote to you. It will appear before the year's end . . . Cézanne is working. He grows more and more firmly set in the original course into which his nature forces him. I have great hopes for him. At the same time we expect he'll be rejected for the next ten years. At present he's trying to paint huge canvases of 4 or 5 metres. He's going soon to Aix, perhaps in August, perhaps not till the end of September. He'll stay there at most two months.

In August Paul went home, and walked the Cours with 'his scarce and immensely long' hair, as Marion wrote, and a 'revolutionary beard'; but 'people are really beginning to notice us.

They wish us good morning.' Among the group there was now Paul Alexis, son of a rich solicitor, who was bored, studying law and dreaming of an escape to Paris and literature. As for Paul, he did seem to be making some headway at Aix; there was talk, perhaps only among the band of the faithful, that he might be offered the directorship of the Museum. A minor poet dedicated some verses to him in *L'Echo des Bouches-du-Rhône*. 'Some idiot dedicates a poem to Paul Cézanne,' commented Marion, 'in the local newspaper. What a bunch of clods.' Paul, after feeling that he'd failed in a picture of Rose reading to her doll, tried to paint Valabrègue and Marion out of doors, and again was dissatisfied. 'We are arm-in-arm and look hideous,' declared Valabrègue. 'Paul is a horrible painter as regards the poses he gives people in the midst of his riot of colour. Every time he paints one of his friends, it seems as if he were taking revenge on him for some hidden injury' (October 2nd). The breaking-up of the weather further depressed him. The lively Guillemet, with his wife Alphonsine, arrived. (He had spent a month at Aix earlier this year and liked the place. Probably it was then that he tackled Louis Auguste on behalf of Paul, trying to get his allowance raised—if we may trust the story of his intervention.) He and Paul went to paint in the hills near the Dam, accompanied by the geologizing Marion.

A letter from Paul to Zola, dated October 19th, gives his account of these events:

For some days it's been raining in a pertinacious way. Guillemet arrived Saturday evening. He spent some days with me, and yesterday, Tuesday, went to a small lodging, not bad, at 50 francs a month, linen included. Despite driving rain, the countryside is superb and we've made a few sketches. When the weather clears, he'll get down seriously to work. As for me, I'm overwhelmed with idleness; for 4 or 5 days I've done nothing. I've just completed a little picture which is I think my best as yet; it represents my sister Rose reading to her doll. It's only one metre. If you like, I'll give it to you. It's the same as the frame of the Valabrègue. I'll send it to the Salon.

Guillemet's apartment consists of a kitchen on the ground floor, with salon opening on to a garden which surrounds the country house. He has taken two more rooms on the first floor with a small washroom. He has only the right wing of the house. It's at the start of the Route d'Italie, just opposite the little house where you've lived and where a pine tree grows, you must recall it. It's next door to Mère Constalin who keeps a pub.

But, you know, all pictures done indoors, in the studio, will never be as good as those done in the open. In representing out-of-door scenes, the contrast of the figures with the groundsites is astounding, and the landscape is magnificent. I see some superb things, and I must make up my mind only to do things in the open.

So it was in October 1866 that Paul definitely reached his conviction of the value of work in the open air; he had spent July with Zola, but he now sets out his views on this matter as if it were something new, or at least something on which a final decision had only now been taken.

I've already mentioned a canvas I mean to try. It'll show Marion and Valabrègue setting out for the motif (I mean the landscape). The sketch, which Guillemet has pronounced good and I've done after nature, makes everything else seem bad. I think indeed that all the pictures of the old masters representing things out of doors haven't been done with a sure touch, for they don't seem to me to have the true and above all original aspect provided by nature. Père Gibert of the Museum invited

me to visit the Musée Bourguignon [the collection of Bourguignon de Fabregoules, acquired by Aix], and I went with Baille, Marion, Valabrègue. I thought everything was bad. It was very consoling. I'm rather bored, only work occupies me a bit. I'm less dull with someone else. I see only Valabrègue, Marion, and now Guillemet.

[*Sketch of seated sister.*] That will give you a slight idea of the morsel I offer you. My sister Rose in the centre holding a little book she reads, her doll is on a chair, she in an armchair. Black background, light head, blue head-dress, blue pinafore, dark-yellow frock, a bit of still-life on left: a bowl and children's toys. (Fig. 24.)

We have a sketch of the Valabrègue-Marion painting, which is close to the little drawing in the letter. It is a slight thing, but shows an advance towards the clear fresh rendering of a moment, with the forms well grasped.

Remember me to Gabrielle, also to Solari and to Baille who must be in Paris with his *frater*. I suppose that now the nuisances of the argument with Villemessant are over, you'll be feeling better and I hope your work isn't getting you down. I hear with pleasure of your introduction to the great paper. If you see Pissarro, tell him lots of things from me. But I repeat, I have an attack of apathy [*marasme*], for no reason. As you know, I don't know what's the cause. It comes back every evening when the sun sets and there's rain. It makes me gloomy. I think that one of these days I'll send you a sausage, only my mother must go and buy it, as otherwise I'd be cozened. That'd be very . . . annoying.

Just imagine, I hardly read now. I don't know if you'll be of my opinion, and I won't change for that, but I begin to discover that art for art's sake is a hell of a humbug [*rude blague*]: this between ourselves. Sketch of my future picture out of doors [*Sketch of Marion and Valabrègue*]. For four days I've had the letter in my pocket and I feel the need to send it on to you. Goodbye, my dear chap, Paul Cézanne.

There seems to have been some strain with Villemessant after Zola had been checked in his outpourings in *Mon Salon*; the 'great paper' was probably *Le Figaro*, which was swallowing up *L'Evénement*. The comments on open-air painting were linked with his growing friendship with Pissarro, and the greetings he sent through Zola led him to write directly as soon as he had posted the letter. It was a sign of the trust and sympathy he already felt that he opened this second letter with an unmitigated denunciation of his whole family, mother and sisters as well as father.

My dear friend, here I am in my family, with the dirtiest beings in the world, those who compose my family, a supreme lot of shitters [*emmerdants*]. But no more of that.

Daily I see Guillemet and his wife, who are fairly well lodged, Cours Ste Anne 43. He hasn't yet started big pictures; he has preluded by some small canvases that are very good. You're perfectly right to speak of grey, for grey alone reigns in nature, but it's a terrifying hard job to catch it. The landscape here is very beautiful, much character, and Guillemet made a study of it yesterday and today in grey weather, which was most beautiful. His studies seem to me to stand out much more than those he brought back from Yport last year. I am much struck by them. Anyhow, you'll judge them better when you see them. I add nothing more except that he's soon to start a big picture, as soon as possible, the moment the weather recovers. In the next letter you get, there'll probably be good news about it.

He still shows much respect for a mediocre painter like Guillemet. Between his own varying

reactions to Delacroix, Courbet and Pissarro, he could not be at all clear as to what he was after beyond a strong impulse to paint, to liberate his colour-sense, and to build broadly-grasped powerful forms.

I've just put a letter in the post for Zola.

I keep on working a bit, but paints are rare here and very expensive, *marasme, marasme*! Let's hope, let's hope that there'll be sales. We'll sacrifice a golden calf for that. You aren't sending anything to Marseille, ah well, neither am I. I don't want to send again, all the more because I lack frames and that means expense it'd be better to consecrate to painting. I'm saying this for myself, and then shit for the Jury.

The sun will I think still give us some fine days. I'm very sorry that Oller, Guillemet tells me, can't return to Paris, as he might be very fed up with Porto Rico, and then too, with no colours available, it must be very difficult to paint. And so he told me it'd be a good thing to take a job on a merchant ship coming straight to France. If you write to us again any time, please tell me how to write to him, I mean the address to put on the letter and the correct way of stamping so as to avoid unnecessary charges for him.

Guillemet enclosed a note in which he said, 'Cézanne has done some very fine paintings. He is working in light tones again and I'm sure you'll be very pleased with three or four canvases he'll bring. I'm not quite sure when I'll return, probably when my pictures are finished. So you are back in Paris, and I expect your wife is better there than at Pontoise. The babies are well, I suppose.' And on November 2nd he wrote to Zola an interesting letter about Paul:

For a month now I've been in Aix, this Athens of the Midi, and I assure you the time hasn't dragged. Fine weather, lovely country, people with whom to talk painting and build up theories that are knocked down next day, have all helped to make my stay here pleasant. In his two letters Paul told you more about me than himself, and I'll do the same thing, that is the opposite, and tell you a lot about the master.

His physiognomy has rather improved [*embelli*], his hair is long, his frame exhales health, and his very appearance causes a sensation on the Cours. So reassure yourself on that score. His spirits, though always in ebullition, leave him moments of calm [*embellies*]; and painting, encouraged by some serious commissions, promises to reward his efforts. In a word, 'the sky of the future seems at moments less black'. On his return to Paris you'll see some pictures you'll like a lot: among others a *Tannhäuser Overture* that could be dedicated to Robert, for there's a successful piano in it. Then a portrait of his father in a big armchair, which looks very good. The painting is light in colour and the whole look [*allure*] very fine. The father would suggest a pope on his throne if it wasn't that he's reading the *Siècle*. In a word, it goes well, and from now on we'll see some very fine things, be sure.

The Aixois keep jangling his nerves. They ask to come and see his painting, so as to abuse it afterwards. '*I shit on you*', he says to them, and those who lack temperament flee in horror. Despite, or perhaps through, this, there is a turn to him, and the time is near, I think, when the museum's direction will be offered to him. I strongly hope for that, since either I know him very little or we'll be able to see there some pretty successful landscapes done with the knife, which have no other chance of getting into any other museum anywhere . . .

The cholera, as you know has left the Midi, but we still have Valabrègue, who with astonishing fecundity, daily brings to light one or more corpses (in verse, it goes without saying). He'll show you quite a fine collection on his return to Paris. The verses you're familiar with as *The Two Corpses* are now entitled *The Eleven Corpses* . . . A very nice chap, giving the impression of having swallowed a lightning-conductor, making it difficult for him to walk. As for young Marion whom you know by reputation, he cherishes the hope of being called to a chair of geology. He excavates

hard and tries to prove to us that God never existed and belief in him is a put-up job. In which we take little interest, as it's nothing to do with *painting*.

The *Tannhäuser* painting was a homage to Wagner, in memory of his meetings with Morstatt. He made a sketch in a single morning, and Marion thought it superb: 'It is as much of the future as is Wagner's music.' The portrait of Louis Auguste must be that in which he reads *L'Evénement*; it is odd that Guillemet says the paper is the *Siècle*. Perhaps Paul made it first the *Siècle*, or said he was going to, then changed the title to that of the paper in which Zola had published *Mon Salon* (Renoir put the same paper prominently into his *Lunch with Father Lathuile*).

We now meet several definitely dated pictures and can see that by 1866 Paul had made big advances in control of the oil-medium. There is a solidity of form and a clear grasp of character in the portrait of his father, which shows a tremendous development on the portrait of him seated almost in profile, which must have been after the second Paris visit. (If Paul did come home in the summer of 1863, he may well have painted it then.) A work dated 1864, a portrait, shows expressive attack, an attempt at unified modelling; and a still life that includes loaves, knife, eggs, glass, cloth and a jar shows a growing mastery of brushwork and modelling. In 1866 he seems to have brought to a head the turmoil of influences and ideas that had been seething inside him since his first visit to Paris. He has broken right away from his early Aixois academicism and its laborious thin handling. He knew something of Pissarro's ideas, but was hardly as yet much affected by them. He was still in an emotional and aesthetic turmoil, valuable in its fertilizing effects, but which prevented him from settling to any steady line of growth. Indeed for several years he was to swing rather widely between the different methods or styles he was acquiring, every now and then roused to attempt a triumph over his difficulties by a furious attack on his canvases. But the confidence that he and his group were on the whole feeling at this phase is shown by a remark Marion made to Zola: 'Paul has been an epidemic germ at Aix. Now all the painters, even the glassmakers, have begun to impaste.' Guillemet had mentioned that a letter had come from Pissarro and that he and Paul often went to the Dam; they meant to return to Paris in December. Paul added a brief note saying that he hadn't done his big picture of Vala(brègue) and Marion and that a *Family Evening* had failed to come out. Still, with the new controls he was achieving, he now painted many works rapidly and with considerable success. He got Valabrègue to sit for a head—'Flesh: fire-red with scrapings of white; the painting of a mason.' Valabrègue thought of the statue of the Curé de Champfleury when it was covered with squashed mulberries. But, 'I luckily had to sit only for one day.' On the other hand the docile Uncle Dominique sat day after day, a new image emerging each time, while Guillemet 'made appalling jokes at his expense' (wrote Valabrègue to Zola in November). All these portraits are slashed in with much fury and skill, the palette-knife often building up the paint in thick relief. The method of constructing by separate areas, which in the black-contoured works had produced disarticulations, is here used to gain a

broad system of design, with effective placing of masses. The most effective example is that of Dominique as a Dominican Monk in a white robe, with crossed arms. This is perhaps the first work in which Paul manages to express his inner conflict with adequate artistic means. The form fills the canvas with a taut solid structure; and inside it there is a powerful tension in design between the flesh-areas (head and two hands) and the white robe, reinforced by the colour-contrasts between the warm earthy flesh and the white of religious dedication. The dark hair framing the face gives a valid reason for a black marking-off, and the cold blue neckband with its crucifix cuts apart and yet connects the three separated flesh-areas. Paul has succeeded in expressing the conflict he feels between his strong sensuality and the anxious fears that cut him off from any easy satisfactions and at the same time enwrap him in a clear dedication (to art). He has projected his own problems on to the sitter. *Dominique* as *Dominicain* is a pun of the kind that pleased Paul and stirred his imagination, both poetically and plastically; and he was no doubt aware that the Order had been revived by the preacher Lacordaire with the aim of instilling republican ideals in the Church. (Lacordaire had opposed the Bonapartist coup; he also founded a society for the revival of religious art; and he and his Order were well known to poets and artists. It seems likely then that Paul is infusing the image with meanings on several levels of his mind. The Dominican, retiring inside himself, is also a fighter in the sphere of both politics and art.)

The de Goncourts in *Manette Saloman* (1867) bring out well what Delacroix meant for a post-Romantic dissident:

[Ingres is] the inventor in the 19th century of colour-photography for reproducing Peruginos and Raphaels, that's all. Delacroix is the other pole. Another man. The image of the decadence of these times, the mess, the confusion, the literature in painting, the painting in literature, the prose in verse, the verse in prose, the passions, the nerves, the feebleness of our times, the modern torment. Lightnings of the sublime in it all. At bottom the greatest of failures . . . His pictures, fetuses of masterpieces . . . For movement, a feverish life in what he does, an agitation of tumult, but a mad design, in advance on movement, pushing out on the muscle, losing itself in seeking the *boulette* of the sculptor, the modelling of triangles and lozenges, which isn't the contour of a body's line, but the expression, the thickness of the relief of its form. Colorist? A discordant harmony, no generality of harmony, hard pitiless colours cruel to the eye that have to come up out of tragic tonalities, tempestuous depths of crucifixion, vapours of hell as in his *Dante*.

And a lack of sunlight, of transparency. A great deal of this aptly defines what Cézanne was doing; he alone of his generation was carrying to an extreme the tendencies that artists of advanced sensibility most responded to in Delacroix.

On December 10th Zola wrote to Valabrègue, 'Tell Paul to come back as soon as possible. He'll inject a little courage into my life. I wait for him as a saviour. If he isn't to arrive in a few days, beg him to write. Above all, let him bring all his studies and prove to me I should work.' He was thinking hard about the Novel, but was still far from finding what to do as a true follow-on for *The Confession*. During the year, in his reviews, he had

been seeking out and praising works that grappled with what he felt was real life—not with 'dolls stuffed with sawdust, but beings of flesh and bone, whose blood and tears really flow.' He had been preparing himself with a thorough study of the historical development of the novel-form. At the end of 1866 he was invited to attend the Congrès Scientifique de France meeting at Aix; unable to go in person, he sent his contribution by post—a survey of the novel from the Greek romances down to the works of the nineteenth century, which ended with an acclaim of Balzac, whom he had been studying and whose influence on him was decisive for the Rougon-Macquart series.

V *Vacillations and Consolidations (1867–9)*

FROM the accounts of Paul's swaggering both in Paris and at Aix we find him, in these first years of his assumption of the artist's character, as a rebellious and resolute Bohemian. The nineteenth century had seen the advent of the artist as a respectable and rich businessman, sloughing the status of mere craftsman which had previously haunted him even at the height of success. David, with his career as politician, organizer and town-planner, had marked the break with the old attitudes; and as things settled down in the nineteenth century the academic artist who could sell his works for big prices was as good as any other successful man of the money-market. But such a role could hardly satisfy those who were carrying on the glorification of genius that had come up with the romantic movement, or those who like Courbet wanted to link art with the struggles to change society. Under the smug money-making academic world there grew up the Bohemian protest, in which romantic dreams and social revolt were often merged. How high the status of the academician became under the Empire is illustrated by the story of how Monet painted his picture of Gare St Lazare. Desperately hard up at the time, he put on his best clothes and boldly went to call on the Superintendent of the Chemins de Fer de l'Ouest, introducing himself as 'the painter Claude Monet.' The official, unable to conceive such a visitor as anything but a famous Salon exhibitor, told Monet that he could do exactly as he wished. The trains were all halted, the platforms cleared, the engines packed with coal to produce as much smoke as the painter wanted. Afterwards, he was bowed out by uniformed officials. Many dissidents, like Manet and Degas, refused to surrender the artist's gentlemanly status, and acted the parts of fashionable *flâneurs*. The artists in the pictures of the studios by Latour and Bazille are all extremely smart in appearance. Manet, despite his dissidence, was able to get soldiers sent to be used as models for one of his versions of the Execution of Maximilian. The men of the Beaux-Arts, ending their training in the Ecole de Rome, were convinced, says Zola, that 'the State owes them everything, the lessons to teach them, the Salons to display their works, the medals and money to reward them.'

Works like Murger's *Vie de Bohème* set out the anti-respectable side, the careless life of art, love and wine among the poor artists who had not yet achieved success or who were totally opposed to the ruling trends. Paul, who had doubtless with Zola read Murger in his early Aix days, had thrown in his lot with these latter. Now he was able to admire the more realistic picture of life in the studios in the de Goncourts' novel (1867), which also has its idealization of the rebel, who is however dragged down by a woman, the model Manette. Here is an account from that novel of the anti-bourgeois attitude of the artists with all its confused mixture of motivations:

Each threw in his anecdote, his word, his touch; and each new recital was saluted by hurrahs, derisions, groans, enraged laughs, a savagery of joy that had an effect of wanting to eat up the Bourgeoisie. One would have thought one heard all art's instinctive hates, all the scorns, all the rancours, all the revolts of the studio-people's blood and race, all its deep-seated and national antipathies rise up in a furious *hue-and-cry* against this comic monster, the bourgeois, fallen into the Ditch of the artists who'd destroy its ridiculous representatives. And always came back the refrain: No, no, they are too stupid, the bourgeois!

Underlying the tangle of emotions and attitudes of the Bohemians there were strong social antagonisms. The Barbizon school benefited from the revolution of 1848 and was anti-aristocratic in basis. 'I will never have the art of the Parisian drawing-rooms forced upon me,' said Millet; 'a peasant I was born, a peasant I will die.' Louis Blanc and the Fourierists took their stand on an art of the actual world, not one which deviously idealized the values of the ruling class. After Charles Blanc became Director of Fine Arts, state commissions were given to Millet, Rousseau, Daubigny, Dupré. No one could forget that the socialist Proudhon, champion of Courbet, had laid down the programme for realists:

To paint men in the sincerity of their nature and their habits, at their work, accomplishing their social and domestic duties, with their actual countenances, above all without posturing; to surprise them in the undress of their consciousness, as an aim of general education: such seems to me the real starting-point of modern art.

Above all the defenders of academic art against realism were well aware that they were defending the art of the privileged classes. Count Nieuwerkerke, Superintendent of Fine Arts, who directed official patronage under the Empire, said of the Barbizon painters and the like, 'This is the painting of democrats, of those who don't change their linen and who want to put themselves above men of the world. This art displeases and disquiets me.' The effect of such attitudes was to make rebellious characters like Paul feel there was a virtue in not changing their linen . . .

Though the personal attitudes of the Impressionists varied from the strong socialist outlook of Pissarro to the élite-position of Degas, the movement as a whole had behind it a clear social basis, partly of protest against the aristocratic values of the Empire and the pseudo-elegances of the *haute bourgeoisie*, partly of democratic affirmation. The democratic element again had its variations and contradictions, ranging from an elevation of the worker or the peasant to a simple delight in the plebeian forms of enjoyment. It has been well said:

The fact that their accord concerned the totality of the human spirit is shown by the fact that the moral and social content of their art is new. The faces of Renoir don't belong to the boulevards but to the suburbs; the peasant-women of Pissarro are 'vulgar'—links between them and the characters of *Les Misérables* have been noted; the locomotives of Monet puff with his revolutionary force, and Cézanne's spirit during his ten impressionist years is clearly anarchic, parallel to that of Zola. In short, impressionism introduced into painting something like what has been called in French political life *la fin des notables*, the end of elegances and splendours, the beginning of a new dignity

for the humiliated masses. Rivière has been able to say that they 'treat a subject for the tones and not for the subject itself, that is what distinguishes the impressionists from other painters.' But the tone was nothing other than their way of moral and social feeling; it was the catharsis, the moment of serenity, of a new world in gestation. (Venturi)

The spring of 1867 was in fact one to stimulate the dissident mood. A huge international exhibition had been opened in Paris to dazzle the world, raise the Empire's prestige, and cover up the growing rifts in its social system. Paris became more than ever a centre of the pleasure industry; the Princess de Metternich called the occasion the Grand Tra-la-la. Military bands played in the Gardens of the Tuileries; balls and receptions of all kinds proliferated; the people danced in the public gardens. Bismarck was present. Everyone chattered about the dawning of the age of international co-operation, with railways and telegraphs as the saviours of the human race. The Champs de Mars, it was continually said, where so many foreign tradesmen now gathered, should be renamed the Champ de la Paix; no one paid attention to the mighty guns from Krupp of Essen displayed there amid plush curtains and aspidistras. Photographs of Alexandre Dumas *père* clasping Ada Mencken to his vast pot-belly were sold on the boulevards. Three Emperors—of France, Prussia, Russia—attended the parade at Longchamps on June 6th. But as Napoleon drove home with the Tsar, a shot from the crowd was aimed at the latter, who was saved by a prompt equerry. And then on the day of the great festival at the exhibition came a telegram from Mexico: 'Emperor Maximilian condemned and shot.'

Paul returned to Paris with Guillemet early in 1867. Before leaving, he sent a picture to a Marseille dealer who was organizing a show. Valabrègue, who stayed on at Aix, wrote to Zola, 'There has been a great deal of fuss; crowds gathered in the street outside; they were astounded. People wanted to know who Paul was; from that viewpoint there has undoubtedly been a certain excitement and success due to curiosity. However, I think that if the picture had been exhibited any longer, in the end the window would have been broken and the canvas destroyed.'

Zola wanted a group all working and struggling together. On February 10th he wrote to Valabrègue, 'I won't hide that I'd have preferred to see you in the midst of us, struggling like us, daily renewing your endeavours, striking out to right, striking out to left, marching always ahead.' Nine days later he wrote, 'Paul works very hard, he has already completed several canvases and dreams of immense pictures; I greet you in his name.' He adds, 'I am surrounded only by painters; I haven't a single writer here to chat with.' On April 4th Zola wrote, 'Paul is rejected, Guillemet is rejected. The Jury, irritated by *My Salon*, has thrown out everyone who follows the new road.' Then on May 29th we learn, 'Cézanne is going back with his mother in about ten days. He says he'll spend three months in the depths of the country and return in September. He is greatly in need of work and courage.' His mother's presence in Paris around the time he was sending pictures in to the Salon, and having to report failure, must have specially depressed him.

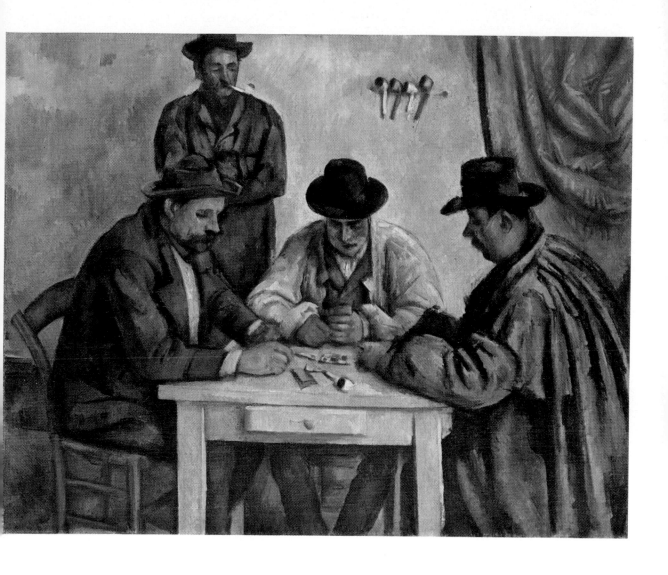

II The Card Players, 1890–92 *The Metropolitan Museum of Art, Bequest of Stephen C. Clark, 1960*

He had been jeered at by critics in *L'Europe* and *Le Figaro*. Zola, lacking a *Salon* this year, had written a reply in *Le Figaro* on April 12th:

This concerns one of my childhood friends, a young painter whose vigorous and individual talent I must admire. You have cited from *L'Europe* a paragraph in which is mentioned a M. Sésame, who exhibited at the Salon of the Rejected in 1863 'two pig's trotters in the form of a cross' and who this year had another canvas called *Le Grog au Vin* rejected. I must admit I had some difficulty in recognizing under this disguise one of my old schoolfriends, M. Paul Cézanne, who has no pig's trotters in his artistic baggage, at least so far. I make this qualification as I see no reason why one should not paint pig's trotters as one paints melons or carrots.

M. Paul Cézanne, in excellent and numerous company, has indeed had two canvases rejected this year: *The Wine Grog* and *Intoxication* . . . But I have never been able to understand this particular brand of criticism, which consists of ridiculing and condemning what one has not even seen. I insist at least on saying that M. Arnold Mortier's descriptions are inaccurate.

Even so, my dear colleague, add your opinion: you are 'convinced that the artist may have put a philosophical idea into his paintings.' That is an inappropriate conviction. If you want to find philosophical artists, look for them among the Germans, or even among our pretty French dreamers; but the analytical painters, the young school whose cause I have the honour to defend, are satisfied with the great realities of nature.

He adds that a number of painters have petitioned for another Salon of the Rejected, so that Mortier may some day see the works he so glibly judges.

Philosophical painting is here identified with the Scheffer type of idealization, now all the more repudiated because Zola and Paul once admired it. But in a deeper sense to enter into the 'great realities of nature' is to be philosophical; and in that sense Paul was always trying, with varying degrees of success, to be a philosophical painter. In the same way, Zola, proclaiming Naturalism, was seeking to find a new philosophy of the Novel; 'Art' was being rejected, in both art and literature, in the name of Nature, so that a new kind of vital art might be achieved.

Zola, with his expenses now doubled as a married man, had moved to the Batignolles. Only some 1,500 copies of *The Confession* had sold, and he was forced to rely on journalism. While working on a novel, *A Marriage of Love* (later called *Thérèse Raquin*), he wrote a cheap serial, at two sous a line, for *Le Messager de Provence*. This work, *The Mysteries of Marseille*, bored him, but with Roux' help he adapted it for the stage. To Valabrègue, who reproached him for such potboilers, he replied that he needed money and publicity; the serial meant nothing to him, but 'I know what I'm doing.' Valabrègue thanked him for the defence of Paul. 'Paul is a child and ignorant of life; you are his guardian and guide. You watch over him. He walks beside you and is always sure of being defended. An alliance between you to defend him has been signed, an alliance which will even be an offensive one if necessary. You are his thinking soul. His destiny is to paint pictures, yours to organize his life.' About the time Paul was leaving Paris, Valabrègue arrived, going to a job on Arsène Houssaye's *L'Artiste*.

By August Zola had had no news of Paul for a month. Roux was in Marseille negotiating

with the local theatre Gymnase about their play; so Zola asked him to go and see Paul. Roux went, but was baffled:

I promised to write at once on arriving at Aix. That would have been too soon, as I couldn't have answered your questions. Even now is too soon. Paul is for me a veritable Sphinx. In the first few days of my stay here I went to see him. I saw him at his house and we talked quite a long time. A few days ago we went together to the country and slept there one night; we had a lot of time to chat. Well, all I can tell you is that he's in good health. Not however that I've forgotten our conversations. I'll report them verbally to you and you'll translate them. As for me, I'm not capable of that. You understand what I mean. I haven't had a deep enough intimacy with Paul to catch the exact significance of his words. Still (I can hazard a guess) I believe he has retained a holy enthusiasm for painting. He is not yet beaten; but without having the same enthusiasm for Aix as for painting, I believe that henceforth he'll prefer the life he leads here to that he leads in Paris. He is vanquished by this Gomard-like [?] existence and he has a devoted respect for the paternal vermicelli. Does he deceive himself, and does he believe himself beaten by Gomard [?] instead of by Nieuwerkerke? That is what I can't tell you and what you must decide for yourself when I describe our conversations at greater length.

Clearly Roux felt that for all his obsession with painting Paul was being beaten down by the philistine Aixois and by his father in particular. (*Vermicelles* had a slang-meaning of hair, also, in thieves' argot, of blood-vessels; here it seems to mean merely the food or livelihood provided by the father.) Paul however was impressing some of his friends with his work. About this time Marion was writing to Morstatt: 'Paul is here, painting, more Paul than ever, but imbued this year with a firm resolve to succeed as quickly as possible. Lately he has painted some really beautiful portraits, no longer with the knife, but just as vigorous and much more skilful and pleasing in technique . . . His watercolours are especially remarkable, their colour amazing, and they produce a strange effect of which I did not think watercolours capable.' A little later he wrote again:

I wish you could see the canvas he is doing now. He has taken up again the subject you already know, *The Tannhäuser Overture*, but in entirely different tones, in very clear colours, and all the figures are very finished. There is a head of a blonde girl, both pretty and amazingly powerful, and my profile is a very good likeness; it's carefully done without harshness of colour and that somewhat repellent ferocity. The piano is wonderful, as in the other painting, and the draperies, as always, astonishingly real. Probably it will be refused at the exhibition, but it will certainly be shown somewhere; a canvas like this is enough to make a reputation.

Zola was to attend the first night of *The Mysteries*, and Paul arranged to return to Paris with him. On September 6th he went with Marion to the performance. Zola thought the play foul, and so did the audience; the curtain went down amid whistles and boos. On September 11th he and Paul went off for Paris. Paul did not now stay at the Rue Beautrellis, but kept on moving for some time: from the Rue de Chevreuse to the Rue de Vaugirard and on to Rue Notre-Dame-des-Champs.

It was probably in the later months of 1867 that he painted *L'Enlèvement*, working at Zola's house. For once he signed and dated a picture. Here we find a new branching-out in technique. He has dropped his palette-knife and painted in long strokes of the brush; in a

way he is developing on the style of 1865, but with a new sensuousness, making the strokes curl and embrace the forms with loving vehemence. Out of a plain of sombre green, rendered with cross-hatching that gives it something of the effect of a troubled sea, there rises up a tall naked man, whose bronze hues contrast with the white of the woman borne in his arms. Her hair is black and a deep blue drape falls from her hips. In the distance, under a white cloud, appears a mountain vaguely suggesting Mont Ste Victoire; and on the left are some small warm-bodied girls. The tree on the right has the same choppiness as the ground. Paul gave the canvas to Zola, who had doubtless praised it as expressing their youthful dreams. Probably a little later (in early 1868) he painted the fine nude of *The Negro Scipio*, who had been the model for Solari's *Sleeping Negro*; in any event the ravisher of *L'Enlèvement* and *Scipio* are closely connected.

In *L'Oeuvre* Zola depicts Claude pacing the streets and thinking of the useless walls of churches, stations, markets, which he would like to cover with his paintings; tiring out models with his demands and crying, 'When I think of this damned business of parents, I could kill my father and mother'—words in accord with those he wrote in October 1866 to Pissarro.

In December Zola published *Thérèse Raquin*, in which we find at last signs of his maturing talent. The main theme concerns two guilty lovers who murder the woman's husband and miserably perish. Zola used the 'laws of physiology', crudely formulated, as a fate-mechanism in his desperate effort to find something hard and objective, a system of definite laws, which would release him from his dream-world and enable him to enter the mysterious otherness of the world outside himself.

The letters of Marion in this year give us further insights into what Paul was thinking and how his friends responded. After discussing the merits of Courbet and Manet he decides that 'Paul is really much stronger than they. He is convinced of being able, by a more skilful execution and perception, to admit details while retaining breadth. Thus he would achieve his aims, and his works would become more complete. I think the moment of his success isn't distant. It's merely a question of producing.' But soon afterwards he modified the optimism as to recognition:

Realist painting, my dear fellow, is further off than ever from official success, and it's quite certain Cézanne has no chance of showing his work in officially sanctioned exhibitions for a long time to come. His name is already too well known; too many revolutionary ideas in art are connected with it; the painters on the jury will not weaken for an instant. And I admire the persistence and nerve with which Paul writes to me: 'Well, they'll be blasted to eternity with even greater persistence.' All that considered, he ought to think about finding another and greater means of getting publicity. He has now reached an astonishing perfection of technique. All his exaggerated fierceness has been modulated, and I think it's time that circumstances offer him the means and opportunity to produce a great deal.

We catch a glimpse of Paul's ideal at this phase: to admit details while retaining breadth; to carry on the work of Courbet and Manet with greater subtlety and richness.

What of the family background, the world of paternal vermicelli, the bank that gave Paul his perpetually-threatened independence? A conservative attitude to savings and investments was still strong. But in 1863 the State gave up control of joint-stock companies; the Crédit Lyonnais was formed; a credit network had been growing and at least the well-off were acquiring the banking habit. The Empire encouraged a speculative temper, which showed itself above all in the railway boom. The Société Genérale, authorized in 1864, was an investment bank after the style of the Crédit Mobilier rather than a deposit bank. Indeed banks of this later and more modern type still hardly existed. The whole investment drive, encouraged by the State, was insecurely based; a financial crisis resulted in 1857, and in 1867 a widespread depression began, heralding the Empire's breakdown. Already in the 1860s a drift from the land was attracting attention. The world of Louis Auguste was thus steadily disintegrating; and Paul, however much he tried to close his ears to the disquieting theme of money, could hardly have been ignorant of his father's pessimistic comments. The economic factor must have increased his anxieties and played its part in his antagonism to the Empire.

Sometime during these years he had met the colour-merchant, Père Tanguy. Julien Tanguy had been born at Plédran in Brittany in 1825, of a family of small weavers. A plasterer, he moved to St Brieuc, married a woman with a pork-butcher's shop, and for a while sold sausages; then he became a railway employee. In 1860 the family moved to Paris, where he took a job as colour-grinder in the shop of Edouard, in rue Clauzel. Finally he set up himself as a colour-merchant, while his wife worked as a Montmartre concierge. Too poor to hire a shop, he ground his excellent colours at home and peddled them to the *plein-airistes* around Paris. The new painters needed lots of paint. Tanguy took an interest in the pictures made out of his wares, looked on the artists as his friends, and was always ready to allow them credit. An ardent socialist, he disliked money dealings. As his clients were generally hard up, payment was often commuted by his taking one of their canvases. He liked the works, but never thought of them becoming valuable. Paul and he were on very friendly terms and he acquired in the end a fine collection of Cézannes. A typical remark of his was: 'A man who lives on more than fifty centimes is a blackguard.'

Early in January 1868 Zola wrote an essay on Valabrègue, who had literary ambitions, in the anti-bonapartist *Tribune*, and passed off a poem by Alexis as one by the recently-dead Baudelaire. After the poem was admired, he revealed the facts. Paul Alexis, eight years younger than Cézanne, had entered the Collège Bourbon in 1857 as the latter started his last term; influenced by Valabrègue, he became an ardent admirer of Zola. Also connected with the *Tribune* was Theodore Duret, whom, perhaps through an introduction by Manet, Zola was now coming to know. On January 23rd *Le Figaro* published an attack on *Thérèse Raquin* by Ferragus (L. Ulbach) entitled *Putrid Literature*, which described the novel as 'a mass of blood and mud.' Zola was accused of seeing woman 'as M. Manet paints her,

mud-coloured with rosy make-up.' The critic admitted, however, that 'some parts of this analysis of the sensations of two murderers are well observed . . . I don't systematically reproach the shrill notes, the violent and violet brushstrokes; I complain at their being the only thing, and unrelieved.' Much the same terms of attack might have been used on Cézanne's work at this time.

Paul was seeing much of Solari, that amiable fellow who never tried to impose anything on him. They pooled resources and usually managed to spend them all early in the month, then lived hand-to-mouth. Once Paul had a large jar of olive-oil sent from Aix. They dipped their bread in it and declared the result 'sumptuous' as they 'licked themselves from fingers to elbow' (Gasquet). Solari was working on his big statue of the Negro struggling with Dogs: clearly a symbol of sympathy for the slaves in the American Civil War still much in men's minds. Zola brought Manet along to see it. The weather was cold and Solari lit a fire in honour of the visitor. The clay of the statue was built up on a frame of broomhandles and chairboards, which warped in the heat and collapsed. So the statue had to be reorganized as a fallen Negro worried by Dogs. Paul used to say that 'this is typical of the Realists,' and Zola elaborated the episode in *L'Oeuvre*. This year the Salon Jury was more tolerant, and the statue was accepted, as were works by Manet, Monet, Pissarro, Bazille, Renoir, Sisley; but Paul was again rejected. Solari, who had gone along to the Palais de l'Industrie to hear the latest about the verdicts, 'met there Pissarro, Guillemet, in short all the Batignolles,' he told Zola. 'They consider Cézanne's painting very good. Since then I've seen Cézanne, who told me the last is even better.' The critic Castagnary, one of the Guerbois set, declared, 'The doors have been opened to nearly everyone who presented himself,' and the Comte de Nieuwerkerke disliked a 'Salon of Upstarts.' Manet exhibited his portrait of Zola.

The success of the dissidents led to *L'Evénement Illustré* (which had succeeded *L'Evénement*, without de Villemessant in charge) asking Zola to cover the Salon, while reserving the right to follow with a more conventional critic. Zola was requested to deal with the official school only in a general way, so that he avoided 'naming a single one of the painters whose pictures annoyed him'. He claimed that Manet's success was now complete, and introduced a eulogy of Solari.

The classic landscape is dead, killed by life and truth. No one would say today that nature needs to be idealized, that skies and water are vulgar, and that it's necessary to make horizons harmonious and correct if one wants to produce beautiful works . . . Our landscapists set out from dawn, box on back, happily like hunters who love the open air. They go and sit anywhere, down there in the forest clearing, here at the water's edge, hardly choosing their motives, finding everywhere a living horizon, with a human interest, so to say.

Certain landscapists have created a nature in the taste of their day, which has a sufficing aspect of truth and which at the same time possesses piquant graces of the lie . . . What I accuse them of is a lack of personality . . . They have created a nature of convention . . . Naturalists of talent on the contrary are personal interpreters; they translate truths in original languages; they remain profoundly true while preserving their individuality. They are above all human and mix their humanity in the least tuft of foliage they paint. That is what will make their works live.

There are several gaps in the argument there. He seems to be advocating a direct copy of whatever happens to present itself, but he also insists on the dynamic union of artist and nature, on the humanization of the transcribed scene. And he talks as if all the admired artists had long been painting wholly in the open, though Delacroix, Daubigny, Rousseau, Courbet and Corot completed their works in the studio. He notes, however, that Corot's open-air studies have a 'more sincere and brilliant' note than his studio-works with their 'heavy and dreamy scale.' (By 1866 Paul had theoretically come over to the Pissarro viewpoint, but he still lagged in practice. Zola was no doubt drawing on discussions, not only with him but also with Pissarro, Monet, Boudin, even Renoir.) Pissarro's Hermitage landscape, painted in the open, stirred him to cry, 'A fine picture by this artist is like an act of an honest man.'

Zola's effect was soon spoiled by the articles that followed by Paul Delmas, in which a list was given of the remarkable works in the Salon 'from an impersonal viewpoint': beginning with Cabanel and Bouguereau, the leading academics.

On May 15th Paul wrote a note to Coste, now at his military service in Paris as *sergeant élève d'administration*, and suggested a meeting and farewell dinner, as he himself was soon going back to Aix. He shows his vagueness about the world of fact and act. 'I imagine that if I send this note to the Place Dupleix, in spite of the inaccuracy of the address, I'll be lucky enough to find it reaching you'. He makes an appointment for '2½ minutes past 5 or roundabouts, at the Pont Royal, I think at the point where it goes into the Place de la Concorde.' After seven years of Paris his topography is quite muddled. 'If you can't come tomorrow, make it Friday any time if you like.' He was leaving on Saturday, May 16th.

He must have gone sometime about that date, for on May 24th he wrote from Aix to Morstatt, saying he had had the good fortune to listen to Wagner overtures. Early in July he wrote again to Coste in a letter that once more brings out his sociability and his shyness, his warmth and his isolation:

Several days have passed since your letter came and I'll be very hard put to tell you anything new about your far-off homeland. Since my return I'm here in the green, in the country, I've cast myself loose a few times. One evening, then another, I ventured on your father, whom I didn't find in, but one of these days, at full noon, I think, I'll catch him at home.

As for Alexis, he was kind enough to come and see me, learning from the great Valabrègue of my return from Paris. He has even lent me a little 1840 revue by Balzac. He asked me if you went on with your painting etc.—you know, everything one says when chatting. He has promised to come back and see me; I haven't seen him for more than a month. On my part, and especially after getting your letter, I've been turning my steps in the evening to the Cours, which is somewhat contrary to my solitary habits. Impossible to meet him. However, urged by a great desire to fulfill my duty, I'll try a descent on his house. But on that day I'll first change my shoes and shirt. I've no more news of Rochefort and yet *Lanterne* has made a noise even down here.

We see that Paul was keenly interested in politics and staunch in his republicanism. Rochefort was an extreme and fearless advocate of the Republic; *La Lanterne* was his paper. He was launching out on a strong campaign against Napoleon. By 1869 *La Lanterne*

had set a new standard in vituperation; it was suppressed and had to be smuggled in from Belgium—according to one tale, inside plaster busts of the emperor. Paul goes on:

I did see a bit of Aufan, but the others seem in hiding, and a great gulf seems to yawn about someone who's been away from home for some time. I won't speak of him. I don't know if I'm living or only remembering, but everything makes me think. I wandered off alone as far as the Dam and St Antonin [at the foot of Ste Victoire]. I slept there in a straw-pallet among the miller's family, good wine, good hospitality. I recalled our attempts at climbing there. Shall we ever make them again? Bizarrerie of life, what a diversion, and how difficult it would be right now for the three of us and the dog, at the moment I mention, to be together in the place where we were only a few years ago.

I have no distraction outside the family and a few copies of the *Siècle* where I gather anodyne news. Being alone, I venture with difficulty into the cafe. But behind it all I'm still hoping.

Did you know Penot is at Marseille, I was unlucky and so was he. I was at St Antonin when he came to see me at Aix. I'll try to go to Marseille one day and we'll speak of absent friends and drink to their health. In a letter he remarked, 'and the beers will go down.'

PS. I left the letter unfinished when at midday Dethès [a descendent of the wool merchant in whose firm Louis Auguste was early employed] and Alexis tumbled in to see me. You can imagine we talked literature and took refreshment, for it was very hot that day. Alexis was good enough to read me a piece of poetry that I found truly very fine, then he recited from memory some strophes of another entitled *Symphony in A Minor*. I thought these verses more unusual, more original, and complimented him. I also read him part of your letter; he said he'd write to you. Meanwhile I send you his love, also my family's: I read them your letter, for which I heartily thank you, it's like dewdrops in burning sunshine. I've also seen Combes, who's come to the country. I vigorously clasp your hands, yours with all my heart, Paul Cézanne.

Now as always Paul turned his thoughts back to the youthful days with Zola for a contrast with the increasing isolation and loneliness he felt. The landscape he sought was the lost landscape of those earlier days; the mountain he wanted to climb was that of his youth. His emotions were so strong that his problem was to control and canalize them, to find forms which they wouldn't confuse and burst with an overplus of their rebellious energies. In the autumn Marion wrote to Morstatt, 'Cézanne is working with all his might to control his temperament, to impose the rules of a cool temperament on it. If he succeeds, my dear chap, we'll soon have powerful works of great achievement to admire.' But the imposition was not so easy.

Marion gave some further glimpses of Paul. 'Cézanne is planning a picture, for which he'll use some portraits. One of us, the middle of the landscape, will be speaking, while the others listen. I've got your photo, and you'll be in it.' He 'intends to make a gift of the canvas, nicely framed, if it's welcome, to the Marseille Museum, which will thus be compelled to display realist painting and our glory.' We know nothing more of this project. Perhaps it disappeared in one of Paul's depressions. 'What a generation of sufferers, my poor old friend Zola, the pair of us, and so many others. There are sufferers among us who're just as unhappy with fewer troubles: Cézanne with his secure livelihood and his black despairs of morale and temperament. One must resign oneself to all that.' Marion worked at geology in the morning and spent his evenings with Paul. 'We dine. We take a little stroll. We don't get drunk. It's all very sad.'

Near the end of November Paul wrote again to Coste on a Monday evening. He expected to leave in December, about the fifteenth. As he wanted to make sure of going to Coste senior, with whom he had visited Villevielle, he said that he would write it down on a bit of paper with all the things he had to do and the people he had to see—'and cross them out as I get them done, and that way I won't forget anything.' Coste's letter had roused him from 'the lethargy into which one finally sinks.' The heat prevented a desired visit to Ste Victoire; then the rain came. Despite his contempt for the Gibert circle—*L'Oeuvre* says Claude was hard on bad painters: 'They're goitrous'—he was interested in the art-school gossip.

You see then how slack begins to grow the willpower of our boyhood comrades. But what would you, things are like that, it seems one isn't always vibrant, or as one would say in Latin *semper virens*, always vigorous, or better still, willing.

I won't give you any news from here, as, apart from the creation of Galoubet at Marseille, I know nothing new. And yet Gibert *Pater*, a bad *pictor*, has refused to let Lambert photograph some canvases of the Musée Bourguignon, and thus prevents him from working. Refusal to let Victor Combes copy etc. Nore is a great dunce. They say he's doing a picture for the Salon. All this is goitrous [imbecile]. Papa Livé has been sculpting for 58 months a relief of one metre; he's still on the eye of Saint XXX. It seems that the Sieur d'Agay, the young Fashionable that you know, comes one day into the Musée, and there Maman Combes says to him, 'Give me your cane, Papa Gibert won't allow that.'

'I don't give a damn,' says the other. He keeps his cane. Gibert pater arrives; he wants to make a scene. 'I shit on you,' cries d'Agay. Authentic.

M. Paul Alexis, a chap who's a superior sort and one might say not at all stuck-up, lives on poetry and other things. I saw him a few times in the fine weather; quite recently again I met him and acquainted him with your letter. He burns to set off for Paris, with paternal consent; he wants to borrow some money mortgaged on the paternal skull and flee under other skies, whither as well the great Valab., who gives hardly any sign of life, is drawing him. Alexis then thanks you for remembering him and sends his regards in return. I told him off for being a bit lazy; he told me that if you knew his botherations (a poet should always be pregnant with some Iliad or rather with a personal Odyssey) you'd forgive him. Why don't you give him the price of a coach-seat or something equivalent? but I conclude by asking you to pardon him, for he read me some pieces of verse that give proof of no mediocre talent. He has already what goes to make up his trade.

We may pause here to consider Paul and his reactions to music. We have seen him at music lessons and in the band of his schooldays; we have seen his interest in Wagner, expressed in his paintings and in his notes to Morstatt. In May this year he had written to the latter:

We'll then have the pleasure of seeing you again without the need of waiting for a better world, as according to your last letter you have come into your money. I'm very happy about this bit of good fortune for you, because all of us together are striving after all art, without material difficulties coming to trouble the work that is so necessary for the artist. I press with warm sympathy the hand that is no longer defiled in philistine industries. I had the good fortune to hear the Overture of *Tannhäuser*, of *Lohengrin*, and of *The Flying Dutchman*. Greetings, always yours.

Morstatt had escaped from the money worries that were to press in on Paul for many more years.

Probably in 1865 Paul had gone with Renoir to hear and applaud Wagner's music at the

Pasdeloup concerts. He and his group knew how *Tannhäuser* had been hissed off the stage after three performances; and so Wagner became for them one of the comradely band of the Rejected.

They jeered at Dalacroix and they jeered at Courbet. Philistines, that's what they are. A race of inhuman stupid brutes. It's the same lot who hiss at Wagner, I know their faces . . . Look, that fat one over there . . .
 O Wagner, the god, the incarnation of centuries of music. His work, the mighty firmament, where all the arts are blended in one, characters portrayed in all their true humanity, and the orchestra itself lives through every phase of the acted drama. Think what a massacre of the conventions, what wholesale destruction of ineffectual theories it stands for, the revolution, the breaking-down of barriers to infinity . . . The Overtures to *Tannhäuser*, what is it but the mighty hallelujah of the new century? First, the pilgrim's chorus, the calm slow beat of the religious motif, gradually giving way to the Siren song, the voluptuous pleasures of Venus, their rapturous delights and fascinating languors imposing themselves more and more, to the point of complete abandon; then, bit by bit, the sacred theme comes back, takes all the other themes and welds them in one supreme harmony and carries them away on the wings of a great triumphal anthem. (*L'Oeuvre*)

That was the way in which Wagner was welcomed in the group of Paul and Zola; and music, thus interpreted, could not but have strengthened the violent ecstatic elements in Paul's painting and Zola's writing. What Paul gained from Wagner was rather a general example of the liberated and liberating creator than any particular ideas of method. The notion of an art which drew in as many elements as possible from life and from the other arts, and which thus attempted a more far-reaching synthesis or fusion of elements, was also something that sank deeply in. But though it was certainly as a general stimulus of emotion, fullness of colour, and bold unifications, that Paul looked on Wagner's music, we cannot ignore the possibility that his response to the chromatic subtleties and the shelving semitones helped to deepen his colour-sense, or rather to encourage his already fine sense to let itself go and seek ever-new harmonies of complex relationships. Gauguin remarked of Paul's developed art, 'We may be quite sure that colour painting has entered a musical phase. Cézanne, to mention a veteran, seems a pupil of César Franck's. He constantly plays the great organ.'

 From some much later reminiscences we learn that Paul kept his interest in operatic music till the end. Marie Gasquet said that at times he asked her to play the piano, preferring selections from Weber's *Oberon* or *Der Freischutz*. However, he always went to sleep, and she played the last few chords fortissimo to wake him up and spare him the embarrassment of admitting his doze. (We must remember that at this time he was aging, ill, and very exhausted after his work at the easel.) Aurench tells us:

Once when he recounted the early days of his Parisian life, a little after 1860, exhilarated by his too excellent wine, he recalled the operas he had heard—for he had a great love of music—and began to sing the cantilena of *La Folle*: 'Tra la la la—Tra la la la.' 'What then is that air'?
 What was his surprise to hear me hum with him, for I had often heard my dear mother sing it in my childhood. So now we took up the couplets together. At that moment, penetrating into the

dining-room, our harmony intrigued Mme Brémond with its sound and indeed bewildered her. Often we sang the well-known airs of old operas that we knew by heart: *La Dame Blanche*, *Le Pré aux Clercs*, *Robert le Diable*. I must add that these digressions of song took place only between us two. The evening when Leo Larguier in particular dined there, the master lost his voice. The tall stature and gravity of the soldier impressed him; and then Cézanne had a holy respect for poets and much admired the Hugo-like poems that Leo composed. He wouldn't have liked the poet to get a wrong impression of this childish play [*enfantillage*].

Paul arrived in Paris about mid-December 1868. He found Zola still worried about money despite the publication of his second serious novel, *Madeleine Férat*. The story had been based on the phoney thesis, set out by Michelet, of a permanent organic imprint left on a woman by her first lover. Zola was still struggling clumsily with his anxieties over sex, and it has been suggested that the novel was a fantasy-construction of the relations between Paul, Zola, and Gabrielle. That might be so if it were a fact that Paul had introduced Gabrielle to Zola and the latter suspected a liaison between the two in their first days of contact. All that however is very doubtful; but the novel certainly shows Zola's fears of a woman's sexual character: fears focussed on the experiences darkly hidden in her pre-marital years. Once again the work caused a scandal during its serialization, which was halted by the public prosecutor.

Zola was, however, already outgrowing the crude physiological fate-mechanisms of these first two novels. In the preface to the second edition of *Thérèse Raquin* (dated 15 April 1868) we see him approaching a fuller perspective. 'What is now needed in short for the writer to compose a new novel is that he should view society with a wider vision, that he should paint it in its multiple and varied aspects, and especially that he should write clearly and naturally.' He was moving towards the conception that was suddenly to become concrete in the plan for the Rougon-Macquart series.

1869 is not well documented for Paul, though it was probably an eventful year for him, that in which he met Marie Hortense Fiquet. She had been born in the village of Saligny in the Jura on 22 April 1850. Her mother had been dead for some time, and her father had worked in a bank, perhaps as a clerk; she later exaggerated his importance, being much addicted to cheap romantic novels. As a child she was brought to Paris by the family and grew up in a household with a small income, though towards 1866 her father owned a property at Lantenne (Doubs). She earned a little by sewing handmade books, and seems to have posed as a model. Doubtless it was in this latter role that she encountered Paul, who lived wholly in the art world. She was a big handsome girl, a brunette with big dark eyes that gleamed against her rather coarse skin; as she aged, her chin grew heavy. She seems to have been lively and quick-spirited, a volatile chatterbox, interested superficially in people and things, but with no sense of art values, no hint of intellect. In view of what we know of Paul, we may assume that in a light-hearted way she took charge of him, somehow broke down his fears of women and his shrinking-away from touch, and played the active role in the courtship. By some desperate act of submission Paul allowed himself to be

seduced. It says much for the easy warmth of Hortense, at least in these years of her youth, that she could get through his prickly defences. Whether she knew that he came of a rich family, we have no knowledge. (Duret states that Paul was 'married' in 1867; but whether it is a wild guess or based on information from young Paul we do not know.)

One of the best writers on Cézanne says that the relationship between the two 'had no influence at all on his art, or on his relations with his friends' (Rewald). No statement could be more at variance with the truth. The fact that Paul had now at last managed to embrace and lie with a woman, as he had so long despairingly desired, released a great deal of his fear or, perhaps we should rather say, lifted those fears on to a new level and made a decisive change in his reactions, his powers of organizing his sensations. (It may be argued that we have no proof of a lack of previous connexions with women; and that is true. But any such connexions must have been brief, involving painful reactions and disgusts, in such a person as Paul. His art does not suggest that in fact such relationships ever did exist. Though the link of art and life in Paul is complex, it is passionately and subtly present.) Though now in one sense he had gained a new balance and self-confidence, the failure of the relationship to live up to his daydreams or to beget a lyrical and idyllic love had the effect of driving him back once more on himself and his art, intensifying his loneliness, his irritability, his sense of failure and impotence, and thus affecting his contacts with everyone else. Not that these results happened overnight. But his union with Hortense, unsatisfactory and partial as it was, was of the utmost importance in helping to change him and enable him to set out on the new courses of the 1870s and the succeeding decades.

We do not know if there is any shred of fact in the account in *L'Oeuvre* of Claude-Cézanne encountering Christine-Hortense in a thunder-storm and taking her home to his studio. In the earlier pictures she appears as a young girl with a fine oval face; with the years she became solid and matronly in build, her jaw squarer and uglier. She hated posing in unmoving and mute positions, but drilled herself, or was drilled, into accepting the role for her slow-painting husband. So she is seen in his works as dull, grave and stolid, but this appearance was not that of her normal self. She stares out at us, not so much in hostility as in a sort of implacable reserve and distance, a stunned stupidity; there is no sense of connexion. At most, in one of the portraits of her made in the 1880s, he lends her some of his own shyness and there is a certain abstracted sadness on her face which may link with a subdued mood of pity for her in the artist; but even there we feel he is refusing to accept the element of submissive weakness as anything, in the last resort, but an expression of the distance between them both: an impassable barrier.

Hortense had nothing clinging in her disposition. She became a burden in social and economic terms, but she seems not to have asserted her claims, at least in the early years, in ways that would paralyse Paul with his fear of *grappins*. Perhaps her very lack of any deep response, her inability to stimulate such a response in him, was what enabled their relationship to continue. The dull and unexciting quality was what enabled Paul to sustain it.

Still, especially in the period before his son was born, he must have been extremely agitated at the new problems that living with a woman thrust upon him. The difficulty of dating his works prevents us from working out with any precision the way in which his emotional veerings, blockages, releases, found their expression in paint; but we can get some general idea. It was probably in 1868, before Hortense was on the scene, that he painted his portrait of Achille Emperaire seated in the same armchair as his father, reading *L'Evéne-ment*. The odd little dwarf, born in 1829, remained ambitiously devoted to art despite his poverty; in 1857 he left Aix for Paris, but he must have been back in Aix when Paul did the portrait. In Paris they visited galleries together, sharing an enthusiasm for the masters of colour, Rubens and the Venetians. They disagreed only over Delacroix, whom Paul deeply admired, while Achille inclined to Tintoretto. 'A dwarf,' Gasquet described Achille, 'but with a magnificent cavalier's head, like a Van Dyck, a burning soul, nerves of steel, an iron pride in a deformed body, a flame of genius on a warped hearth, a mixture of Don Quixote and Prometheus.' The portrait shows him in a bathrobe, with big head and shrunken legs, a mane of hair and a small beard. The style is brutal and yet sympathetic, with thick paint rapidly laid on in broad strokes, but with a fine feeling for the different textures. We might call it the climax of Paul's early work. Following, there seems to come the finer passionate style of *L'Enlèvement* and *Scipio* though with reversions to a harsh tonality and strong contrasts. But we do not know if a work like *The Autopsy* was done before or after the portrait of Achille, or what part it plays in relation to the *Scipio* style. If we have safe landmarks in the still lifes painted in these years, Cézanne seems to be broadening his treatment and his sense of design, of solidity and the interrelationship of things. From Courbet and Daumier he was learning to strengthen his feeling for weight and mass, from Delacroix to deepen his colour-sense and make subtler his treatment of edges.

Zola thus describes the experimentations of Claude:

He had carefully hidden secret methods too, such as amber solution, liquid coal, and other types of resin which dried quickly and kept the paint from cracking. And so he found himself engaged in a terrible struggle against flat and streaky effects, since his absorbent canvases soaked up the modicum of oil there was in the paint. Brushes were another of his problems; he insisted on having them made to order and preferred oven-dried horsehair to sable. Perhaps the most important thing was the palette-knife; like Courbet he used it for his groundwork and had quite a collection of long flexible knives, broad stubby ones, and in particular a specially made triangular one, like that used by glaziers and just like the knife used by Delacroix. To employ a scraper or a razor he considered discreditable, though on the other hand he indulged in all sorts of mysterious practices when it came to applying the colours. He concocted his own recipes and changed them at least once a month.

A work we can definitely date is the sketch of Alexis reading to Zola (September 1869 and July 1870). The characters of the men are well brought out; but as an organized work of art the canvas falls far below *Emperaire*, *L'Enlèvement*, or *Scipio*. It shows an effort to continue the broad style.

Zola was now grappling with his Rougon-Macquart idea, studying psychology and history at the Bibliothèque Impériale and turning his thoughts back to Aix in a new way. He was trying to understand what had happened there in 1848 and the following years, to fuse his memories with a clear social pattern of development. No doubt a sense of the worsening crisis of the Empire, soon to issue in the Franco-Prussian war, helped thus to drive his thoughts deeper down into the social foundations. Though he clung to notions of heredity or physical fate in working out the development of the various members of the family, in effect he was concerned with the dialectics of individual and society. He consulted Paul on matters of detail, as well as no doubt discussing with him his general ideas. On 5 April 1869 Marie wrote to her brother a letter with information about the dress of peasant women, which has come down to us among the Notes for *The Conquest*.

My dear Paul, Peasant women when working in the fields have a skirt, usually blue, darker when the stuff is cotton and then called *cotonnade*, paler when the stuff is *en fil* and the peasants then call it a *cotillon* made on a *toile*. For corsage they have a *cosaque*, which is simply a *corsage à fond*, to which is added a flap [*basque*] straight at the lower end and of equal length all round the belt, and the *basque* is called *lou pendis* or the parasol. When heat obliges them to remove this corsage, only the braces [*bretelles*] are seen—they're made with cotton attachments a little longer than a finger-breadth. They are sewed on to the *jupon*; behind they start off both from the same point, in the middle of the waist, passing over the shoulders and in front remaining a little apart from each side of the waist and not joining up as at the back. When they take off the *casque*, their corsage is then visible, usually blue or white; they are *en bras de chemise*, sleeves drawn up and folded to the elbow, a coloured *fichu* round the neck with the ends stuck in front in the corset. For head-dress, a felt hat of blue wool with big brim: that is the old way, nowadays one rather sees straw hats. I've forced myself to be as clear and lucid as possible while avoiding all the while being etc. . . . I don't know if you'll be satisfied.

 We are all in good health. Maman and Rose have spent some days in the country [at the Jas] . . . Write to us soon and often, you know what pleasure we feel at getting your letters. We are going to miss you for the celebrations of the regional agricultural show. Adieu, I'm off to eat my soup that's getting cold. I embrace you for us all, your sister Marie.

In September Alexis at last got away to Paris. Valabrègue took him to Zola, who welcomed him; and Paul painted his conversation piece of the two men.

 Alexis has left an account of his call on Zola in the Rue de la Condamine. 'In the little *pavillon* [outhouse] he inhabited at the foot of the garden, in the narrow dining-room, so narrow that when he later bought a piano he had to have a niche hollowed in the wall to take it, I see myself seated before a round table from which the novelist's mother and wife had just removed the cloth. . . . Then when tea was served . . . Unforgettable evening. Evening such as I have passed often again, during which I saw springing up close to me that vegetation of the Rougon-Macquart which then was hardly emerging from the earth.' He adds, 'The entry wasn't handsome. The *pavillon*, poky as it was, was scarcely habitable, but the garden, with one big tree and several small ones, was conscientiously dug, sown, planted, watered by him. . . Sometimes, in the fine summer eves, the table was set on the narrow terrace and the family dined out of doors. Then some intimates, M. Roux,

Duranty, the painters Beliard and Coste, or myself, came along. We talked till midnight under the stars.'

We may now pause to glance at the work of the past three or four years. Landscapes of the Arc banks or the Jas garden show that Paul had begun to some extent to work out of doors with a range of colours such as white, blue, green-black, which he liked to oppose—e.g. green-black leaves against blue-white sky. Pissarro had talked to him of greys, but he had no idea yet how to use them. In figure compositions he was still lost for a satisfactory method, uncertain between his black-contour grilles and his attempts to gain rhythmic force by means of *couillarde* attack. Depth in any serious sense evaded him, and at times his compositions were built up as if viewed from above so as to minimize the need for depth at the back. From Courbet he was still taking many aspects of his approach to the model, particularly a sense of largeness; from Manet, something of his way of organizing the areas of the canvas-surface; from Delacroix, a nervous energy and a strengthening of his innate colour-sense—the use of Veronese green, purple, Prussian blue. With his impasted trowel-ling method there was a danger of forms becoming quite immobilized; hence his need to infuse certain rhythms and *couillarde*-impulsions. Not till he had learned enough from Pissarro would he be able to progress from a balancing of forms on the surface. In *The Descent to Limbo*, though he was copying from S. del Piombo, he could not achieve any sense of depth. He had to get some life into the work by making Christ's head a pivot, crossed by a pair of diagonals, and he tried to escape the imprisoning surface by stressing the shadow of Christ's leg and the forward movement of his arm; but he could not get rid of the single enclosing plane. The curtain's voluminous folds and the entanglement of bodies in the *Grog au Rhum* similarly failed to break through.

Consider further the *Reading in Zola's House* (related to *Alexis Reading*). Here he has the two men in a closed space and should have been able to define each body as definite and homogeneous in its volume, which at the same time should be open to influences from outside, sharing in the atmospheric play. 'The volume should *turn* in the space of which the reflections hem it in; should enter into struggle, by the affirmation of its presence, against those reflections, and thus should enlarge the space and suggest its depth' (Guerry). But all that was beyond Paul's power. So he used what has been termed the play-of-screens:

a succession of oscillations, an incessant coming-and-going of values which cancel one another only after giving the spectator a feeling of depth. The picture is run-through as by a series of vague shoves, one on top of another, to bring about this fictive course to the third dimension. (A. Lhote)

So here Paul multiplies the screens:

Sombre screen of the big curtain on the chamber's clear back; even on this back an opposition between the luminous glass and its darkish frame, between the black clock and its white orb. Violent contrast between the dark red mass of Zola's person, thickened in the shadow, and the

clear blue-grey clothes of the reader (perhaps Alexis), treated in full light. The floor even is violently striped with transverse shadows intended to excite the eye and force it to run through, like the notes of scale, the distance that separates it from the back of the room . . . The room where Alexis and Zola are found is effectively a volume in space. But in the bosom of this volume the persons and the objects themselves are not volumes. Certainly they are not on the same plane, for the points of the depth have been differentiated by the screens, but they do not turn in space. The persons seem silhouettes cut out in cardboard that have been set, one behind the other, in a square box. Pulling a string could make them slide more to the right or more to the left, in the groove of the same plane, but it would be impossible to bring them on forward or send them back. For they're surfaces, not volumes. (Guerry)

This point is worth making in some detail. We must realize what an abnormal difficulty Paul had in making volumes *move* inside a volume. For long he strove to gain an effect of reality by overstressing values in their contrasts; but transitions defeated him. He realized that he was liable to bring about a fragmentation of volumes by the use of reflections, and sought to avoid it by affirming form. In *Alexis Reading*, unlike *The Reading*, he managed to show each man closed in himself as a volume, but at the same time he cut them off from the atmosphere in which they moved. No reflections or colour-conflicts play over the surfaces. Even more in a work like *The Young Girl at the Piano* (*Tannhäuser*) do the figures fail to occupy space, despite all the use of screens (Fig. 54).

He must have been vehement against interruptions in early 1870. In May, Duret wrote to Zola: 'I've heard talk of a painter named, I think, Cézanne or something like that, who'd be at Aix and whose pictures have been rejected by the Jury. I seem to recall that sometime you spoke to me of an Aixois painter who's totally eccentric. Wouldn't he be the rejected one of this year? If so, please, if you will, give me his address and a word of introduction so that I can go and make acquaintance with the painter and his painting.' On the thirtieth, Zola replied, 'I can't give you the address of the painter you mention. He keeps himself too shut away; he's going through a phase of gropings; and in my opinion he's right in not wanting anyone to penetrate into his studio. Wait till he himself turns up.' Next day Zola and Gabrielle were married, with four Aixois as witnesses; Paul, Solari, Roux, Alexis.

The works rejected by the Jury had been the *Emperaire* and a nude. They had been delivered on the last day, March 20th. A journalist who was present interviewed him, and Paul declared, 'Yes, my dear M. Stock, I paint as I see, as I feel—and I have very strong feelings. Those others feel and see as I do, but they daren't do it. They go in for Salon painting. But I dare, M. Stock, I dare. I have the courage of my convictions, and he laughs longest who laughs last.' Or so he was reported as saying. Perhaps it was this account which had aroused Duret.

On June 7th he wrote a note to Justin Gabet, a cabinet-maker and joiner, whose workshop was near the Rue de Boulegon where the Cézannes lived at Aix. We see how tender he always felt towards his boyhood friends. He apologized for slowness in replying and said that Emperaire and Uncle Dominique would have given Gabet any news.

Well, I've been rejected as in the past, but I'm none the worse for it. Unnecessary to add that I paint all the time and for the moment am well. I'll mention there are some very nice things in the exhibition and some ugly ones too. There's the picture of M. Honoré [Gibert's son] which has a very good effect and is well placed. Solari also had done a very nice statue. Please give my regards to Mme Gabet and kiss little Titin for me. Greetings also to your father and father-in-law. And don't forget our friend the streetlamp-extinguisher Gautier, and Antoine Roche. My dear friend, I embrace you with all my heart, and good courage, all yours, your old friend P.C. Does he walk straight or still on one side, and the great Saint Y?

In July Zola asked Guillemet for news of Paul. 'Has he succeeded in finishing his picture? It's time for him to create according to his own conceptions and I'm anxious to see him occupy the position he ought to have. What a strange thing is painting. It's not enough to be intelligent to do it well. Still, in time he'll get there, I'm sure.' Zola must have been asking himself the same questions. True, he himself had not 'got there', but he had made a definite start, was coherently developing his powers of expression, and felt himself on the verge of a large-scale expansion; while Paul, despite brilliant moments, seemed ever more unstable and unclear as to what he wanted, and how he was to set about it. Zola must have said something along these lines, for Guillemet's reply stated, 'What you tell me about Paul makes me very sad; the good fellow must suffer like a damned soul because of all the attempts at painting into which he throws himself headlong and which only rarely succeed, alas! Where there is good material, one can't despair. Myself, I always expect him to produce beautiful things which will give pleasure to us, his friends who love him and which will confound the sceptics and denigrators.'

A few days later war between France and Germany was declared.

PART THREE

Breakthrough

I *End of the Empire (1870–3)*

IN January 1870, at the funeral of the journalist Victor Noire, assassinated by Pierre Bonaparte, people on the boulevards shouted, 'Vive la République!' Napoleon, drawn on by the wily Bismarck, rushed into the war which was to consolidate his throne; but despite the official pronouncements nothing was organized nor were food, uniforms or munitions ready. In the confusion many soldiers did not even find their units; the *garde mobile*, called up, had to drill with broom-handles. If Paul was in Paris, at 53 Rue Notre-Dame-des-Champs, he went south at once. He must have been already living with Hortense; perhaps the reason why Zola had put Duret off visiting him had some connexion with the new union resulting in an intensified shyness of Paul's part; and the amiability of the letter to Gabet may have reflected a temporary relaxation in domestic happiness. Cézanne seems to have stowed Hortense away at l'Estaque, while going himself to paint at the Jas. The first troops called up included only reserves who had done their military service or very young men liable to a coming draft; Paul belonged to neither category and he had no intention of fighting in a war which, if won, would strengthen the State he hated. Zola in Paris began the serialization of *The Fortune of the Rougon's* in June, in *Le Siècle*, and was working on its sequel, *The Quarry*, when the invasion put an end to all such matters. On August 5th he had boldly published in *La Tribune* an article *Vive la France* in which he declared his extreme disenchantment with the Empire; and the public prosecutor was proceeding against him. The rout of the imperial forces saved him; and Gabrielle was terrified of the advancing Prussian armies. He therefore took her south and joined Paul at l'Estaque. His intention was to leave her and himself return to Paris; but on September 17th Paris was invested. He then went to Marseille, to 15 Rue Haxo, and made plans with Roux, also now in the south, to start a daily paper, *La Marseillaise*. Arnaud, editor of the *Messager de Provence*, was to lend the editors the necessary facilities; and Valabrègue, who was another refugee from Paris, was to help.

At Aix a telegram announcing the Empire's fall came from Paris about 10 p.m. on Sunday, September 4th. The republicans at once invaded the Town Hall; the mayor and an assistant, who had rushed along, were forced to withdraw; the city councillors were tumultuously dismissed and a new body, elected by acclamation, was composed of the democrats who had been defeated in the last elections, and some co-opted friends. After the election the cast-iron bust of Napoleon was knocked off its pedestal, kicked out of the room and thrown into the fountain outside; a painting of him was torn to pieces. On September 5th, at 10 a.m., the Republic was proclaimed. A chemist Alexis was appointed

mayor; and among the councillors were Louis Auguste, Baille, Valabrègue, and Victor Leydet (now an oil-merchant). The fact that Louis Auguste, in his 72nd year, was elected, was a testimony to his reputation as a staunch republican. Fighting still went on round Paris, on the Loire, and elsewhere. The Aix Council issued a proclamation:

Let us arise, Citizens, and march as one man! The Municipal Council of Aix calls you to the Defence of your Country. It assumes the responsibility of providing for the needs of the families of all those who volunteer to bear arms to save France and gain respect for our glorious and pure Republic.

Rous wrote cynically of the enthusiasts, Baille and Valabrègue. 'I'm bored stiff here. I watch the revolution pass by. In the gang are our admirable friends, Baille and Valabrègue. They give me a tremendous laugh. Can you see these slackers from Paris, who come here to stick their noses into the local government and vote resistance. Let's march like one man, say the proclamations. March! They're a fine pair.' In fact the two slackers seem to have taken their new roles with genuine seriousness. Baille was on the committee of public works; Valabrègue, with Leydet, on that dealing with miscellaneous matters. Both men were concerned with the census for the organization of the National Guard. (The provisional council was ended in the spring of 1871.) Louis Auguste was on the committee for finance. In the Council's minutes he usually appeared 'absent for reasons unknown,' no doubt on account of his age—though caution may also have played a part. His wife was patroness of the International Society for Aid to the Wounded. On November 18th Paul was notified that the Aix municipality had elected him to a Committee for the Drawing School by 15 out of 20 votes—the largest majority that anyone gained; but he neglected to attend the meetings.

No doubt he was afraid of being made to fight. At Marseille Zola was doing badly with his paper and had thoughts of getting an administrative job to tide things over, and perhaps with a certain ambitious wish to see how he would shape in such a role. He tried to become Sub-Prefect of Aix, but found the system in such a chaos that no one seemed to know who had named the present holder of the office. As his lack of money grew more acute, on December 12th he left his wife and mother in Marseille and went to Bordeaux where the Government of National Defence was now situated. Finally, in desperation, he took the position of secretary to a minister, Glais-Bizoin, whom he had known on *La Tribune*. He wrote on December 22nd to Roux, 'If we are clever about it, we'll make a triumphant return.' Five days later the Prussians began the bombardment of Paris. The mobilization went on and call-up papers were served on Paul. He ignored them. The police went to the Jas in search of him, and his mother said, 'He left two or three days ago. When I hear where he is, I'll let you know.' (According to Conil, who later married Rose, he was in the house, but knew its nooks and crannies well enough to evade discovery.) Informers had denounced Zola as well, not knowing that he had left l'Estaque some time back; on January

2nd Roux's father heard in a café that four Guards and a corporal had been ordered to nose out absentees. Roux wrote at once to Zola on hearing the news:

With regard to the mobilized Guard I have two bits of news for you, a vexatious bit and an astonishing bit.

The vexatious bit is that Paul C. is being actively searched for and I'm much afraid that he won't escape from the searches if, as his mother has said, it's true that he'll stay all the while at l'Estaque. Paul, who in the early stages didn't foresee enough what could happen, has shown himself a lot at Aix. He went there often enough and stayed there one, two, even three or more days. It's said also that he was getting properly drunk together with gentlemen of his acquaintance. He must have, it's even certain, made known the place of his residence, since the gentlemen in question (who, in short, must be jealous of him for living without having to do a stroke of work for his livelihood) have lost no time in denouncing him and giving all the necessary information for getting him found.

These same gentlemen (here is the astonishing bit of news), to whom Paul remarked that he was staying at l'Estaque with you—not knowing that you have been able to quit this hole—ignorant whether precisely you are bachelor or married man—have denounced you at the same time as a defaulter. On the evening of 2nd January my father took me aside and told me, 'I've just heard a conscript [*un moblot*] making this remark: There are four of us, with the corporal Untel, who are to go to Marseille to bring back defaulters.' Among the names cited, my father said, 'I noted those of Paul Cézanne and Zola. These two, the *moblot* added, are hiding at Saint Henri [village near l'Estaque].'

I told my father to lend a deaf ear and not get mixed in any conversation of this sort whatever; I myself would make it my business. And next morning I ran to the Mairie. There I had free scope and had the list of defaulters shown to me. Your name wasn't there. I related to Ferand, a serious man who's devoted to me, what had been said. He replied: 'Zola must have come up in the matter only because of Cézanne, who is being diligently looked for; but if your friend's name has been mentioned, that must have happened before investigation was made, as Zola isn't of Aix and besides is married.'

It was probably after this that the search at the Jas occurred. It seems unlikely that any inquiry was made at l'Estaque, since there Paul would easily have been discovered. According to Vollard, he said later, 'During the war, I did a lot of work on the motif at l'Estaque . . . I divided my time between the countryside and the studio.' This statement has been taken at its face value, and it has been assumed that he painted on, blandly and blindly unaffected by the shattering events all round. That he painted doggedly is correct enough, but in order to shut out as much as possible the fears and uncertainties he was feeling. Such an anxiety-ridden mind as his could not but be continually shaken by a situation which was liable to affect his life in all sorts of ways and perhaps even remove his source of income. About this time Louis Auguste, feeling his age and disturbed by the course of events, had retired from banking. In fact the paintings that we can assign to this period show considerable inner perturbation.

Black dominates, and dull red and brown ochres create a sad and impressive harmony. There is always the same defiant handling and the same determination to crush the spectator by the vehemence of the imaginative attack and to impose upon him at once the artist's own emotional attitude. In the *Toits Rouges* the mood is one of melancholy and brooding, and the summary

treatment, the almost melodramatic reality of the scene is in harmony with a sombre poetical mood. (Fry)

L'Estaque, Melting Snow further reveals his mood. Here:

Colour and brushwork sustain the hurricane violence of the scene. A blackish tint permeates the landscape, and even the snow, which in places is a pure unmixed tone, seems a partner of black. Painted in stark contrasts, with an overwhelming, almost monotonous fury—less to capture the essence of a changing scene than to express a gloomy, desperate mood—the picture has some subtle tones: the varying whites of the snow and the many greys, including the warm tones of the middle ground set between the red roofs. The taste for cold black, cold white and grey, seems natural to Cézanne's mood; but this taste presupposes Manet's elegant and impassive art of which the tones and the directness of vision have here been put to emotional use and strangely transformed. (Schapiro)

The winter of 1870–1 was a bad one, and this picture was painted during January and February 1871.

It is of interest to cite here a description of l'Estaque by Zola, which shows how responsive he was to the same landscapes as Paul:

The arms of rock stretch out either side of the gulf, while the islands, extending in width, seem to bar the horizon and the sea is only a huge basin, a lake of brilliant blue when the weather is fine. At the foot of the mountains the houses of Marseille are visible on different levels of the low hills; when the air is clear one can see, from l'Estaque, the grey Joliette breakwater and the thin masts of the vessels in the port. Behind this may be seen, high on a hill, surrounded by trees, the white chapel of Notre-Dame de la Garge. The coastline becomes rounded near Marseille and is scooped out in wide indentations before reaching l'Estaque; it is bordered by factories that at times let out high plumes of smoke. When the sun falls level to the horizon, the sea, almost black, seems to sleep between the two promontories of rocks whose whiteness is relieved by yellow and brown. The pines dot the red earth with green. It is a vast panorama, a corner of the Orient rising up in the blinding vibration of the day.

But l'Estaque does not only offer an outlet to the sea. The village, its back against the mountains, is traversed by roads that disappear in the midst of a chaos of jagged rocks . . . Nothing equals the wild majesty of these gorges hollowed out between the hills, narrow paths twisting at the bottom of an abyss, arid slopes covered with pines and with walls the colour of rust and blood. Sometimes the defiles widen, a thin field of olive trees occupies the hollow of a valley, a hidden house shows its painted façade with closed shutters. Then, again, paths full of brambles, impenetrable thickets, piles of stones, dried-up streams, all the surprises of a walk in the desert. High up, above the black border of the pines, is placed the endless band of the blue silk of the sky.

And there is also the narrow coast between the rocks and the sea, the red earth where the tile-works, the district's big industry, have excavated large holes to extract clay . . . One would think one were walking on roads made of plaster, for one sinks in ankle deep; and, at the slightest gust of wind, great clouds of dust powder the hedges . . . When this dried-out country gets thoroughly wet, it takes on colours . . . of great violence; the red earth bleeds, the pines have an emerald reflection, the rocks are bright with the whiteness of fresh laundry.

Paul's development was often a matter of swings, not of simple returns, but of picking up a past method in forms determined by the intervening experiments. Already in 1869 he seems to have sought a harsh simplification of colour and form in a reaction from his baffled

attempts to define volumes in depth. *The Cutting*, based on a point of the railway running near the Jas, and *The Black Pendulum Clock*, with their stark clear forms, may date from that year—though *The Clock* with its monumental character may come on into 1870. The drive for clarity was strengthening. (Comparison of his landscapes with photographs of the motifs show how he eliminated what he could not express clearly and completely.) He did not want to use for his transitions the vague indeterminate elements that proliferate in almost any landscape; and as part of his unrelenting quest for fullness without any confusion or indeterminacy, he rejected the use of a constantly changing focus, which deals with various levels of distance in separation. He could not as a consequence use a blurring of objects to define distance or depth. In one sense he was carrying the focus of the eye dealing with foreground-objects into the distance; in another he was treating the foreground as if it had no greater claim to sharpness of focus than the various distances. But at the same time he had somehow to create a feeling of distance as definite as his sense of the mass and volume of the objects he was considering. Here, finally, his colour-sense, related directly to the scenes before him by the impact of impressionism, came to his rescue. He achieved his aim by means of edges and planes realized in terms of colour: what we may call a complete plasticity of space. Thus his final solution was the result of his inability and his refusal to accept the conventional solutions of the problem. The weaknesses, the overstrains, of his earlier phases lead into the strengths of his later work. He has been described as having ended scientific perspective in terms of colour-plasticity: but that only means he found a different kind of science. To say then that the space he defined was 'not a space in which objects can *live*' (Novotny), not 'an illusory space' offering a false picture of the everyday world to man, is mere nonsense. An exponent of this viewpoint (Badt) describes his space as that 'in which things have their being, in which they exist together, which they themselves actually create in the first instance merely by their being together: it is both the possibility and the result of their existing together. Thus it is no longer something special in itself but is inextricably a part of the objects depicted in the picture.' How can such a space be 'not one in which objects can live?' It is one in which they can live with special strength and fullness of life; it has transcended the mechanistic limitations of perspective-rules deduced from Renascence mathematics and geometry, and for this reason belongs to a realm of genuinely organic conceptions, in which space and time are not abstractions, but are the very essence of life.

But in these considerations we are pushing too far ahead. In 1870–1 Paul was still far from solving his difficulties; though the new attempt to achieve a solidification of objects was a landmark on his journey to the solution.

The figure compositions of these years also indicate a deep spiritual disturbance. Lack of precise dating makes any close correlation between paintings and events difficult, as usual; but it seems that his affair with Hortense was heralded by, or accompanied, the advent of the Temptation motif in his work. Interestingly, his first attempt to deal with his motive

seems dated 1869–70 and is still only half-detached from the scene of Paris' Judgment. The main part of the picture, painted with sweeping strokes in his black manner, is taken up by three heavy nudes in a pyramidal arrangement that anticipates similar kinds of organization in his unending series of *Baigneuses*. In the left upper corner a fourth nude confronts the saint who is intruding on the scene; she raises her left arm in a gesture of much importance to Paul, which we shall discuss later. The theme of the choice of a mistress has abruptly been given a new angle. The man does not choose the woman, but is assaulted by her charms, is tempted out of his role of lonely self-dedication. That this change in approach to the question of scenes of nude women seems to occur about the time of Hortense's irruption into Paul's life can hardly be an accident.

The popularity of the Temptation arose with the attempt to revive religious art in the mid-century; artists read the Lives of the Saints, which were finding a wide audience. Baudelaire used the Temptation theme in his *Fleurs*. Egyptian settings also had some vogue—going back to the days of Napoleon's invasion of Egypt. And oddly there was a strong element of popular art behind Flaubert's book. His first version owed much to the puppet-shows at the yearly Rouen Fair, with dialogue based in part on old songs about the hypocrisy and double-tricks of monks. Some of these latter were arranged in a suite by Sédaine and reprinted in the 1840s with lithographs by Daubigny. Thus in Flaubert's work were mingled popular satire and phantasmagoria with perverse romantic sensibility. The artists had already taken up the theme since 1840; there were many versions by Delaroche, Corot and others. Millet painted a *Temptation of St Jerome* in 1846 to express his sense of the evil glitter of Paris.

In the 1869 Salon there were three paintings on the theme: by E. Isabey, A. L. Leloir and A. Vély. Isabey's version was based on the Queen of Sheba episode from Flaubert (2nd version, 1856), as was the scene of Verlaine's *Cortège* in *Fêtes Galantes*, written about this time. Gautier criticized Isabey's work for its abundance of female devils, nymphs, bacchantes, angels: 'The whole essence of the Temptation is loneliness.' In *Madeleine Férat*, 1868, the old housekeeper Geneviève owns an engraving of the Temptation; she imagines that a figure in it resembles the heroine, who is thus linked with the Fatal Woman. Zola may not be drawing on the Flaubertian tradition; but Paul would have read his novel. Flaubert, like Paul, used the theme for self-revelation. 'In St Antony I was myself the saint.' The first version has the cry: 'O fancy, carry me off on your wings that my grief may be dissipated.' Louis Bertrand even says of Flaubert, 'The hallucinations he ascribes to the hermit are the apparitions he himself used to see, which bewitched him and brought him to despair.' He declares, 'He sought for consolation and a strange sort of voluptuousness, to surrender in imagination to those temptations which he himself condemned as deceptions and as culpable'. Writer and artist were close in these matters.

The 1869 *Temptation* has slight reminiscences of Giorgione's *Fête Champêtre* in the two central figures; Paul had no doubt had his thoughts drawn to that work through its link

with Manet's *Déjeuner sur l'Herbe*. The two left-hand figures show some affinities with Spanish painting; perhaps Oller had interested him in the Spanish school, though we may note that Roux in 1865 had called him an admirer of the Riberas and Zurburáns, and he found his interest quickened by his turning to the Temptation theme and its harsh dark tensions. The extent to which he had been studying the old masters can be seen by the way in which the fourth nude was based on Minerva in Raphael's *Judgment of Paris*, which had also inspired Carracci's Vice in his *Choice of Hercules*. Further, the big meditative female in the right corner derives from the seated artist in Delacroix's *Michelangelo in his Studio* (shown in 1864) which Paul had before him, it seems, in Laurens' lithograph: he shows the figure in reverse like the reproduction. The pose—one hand propping the head, the clenched fist of the other lying in the lap—goes back to a Renascence type of Melancholia (used sometimes in versions of the Temptation), but Paul is certainly importing it direct from Delacroix. Survivals of the male form show in the short hair, heavy limbs, angular facial plane. This female, sunk in serious brooding, is thus a surrogate of the artist pondering the scene, torn between desire for, and revulsion from, the amorous encounter; her head suggests the head of Zola painted early by Paul. The hand in the lap gains a new significance, which we will understand when we come to the series of diagonal-armed bathers. We may note also that Paul's later skull-picture, *Youth with a Skull*, was based on Delacroix's *Tasso in the Madhouse*: the artist finally driven to madness and complete alienation. (The skull continued to be for Paul an emblem of mortality, of family-cannibalism, of total dehumanization, as well as providing an excellent model for treating volumes.) Baudelaire, we may note, wrote a sonnet on Delacroix's *Tasso* about this time: '. . . Vertigo's stairway where his soul goes down. . . . Horror surrounds him, and ridiculous Fear, hideous, many-shaped, is circling round.' (He also saw that Flaubert had embodied himself in Mme Bovary, 'that bizarre man-woman.')

Thus in the *Temptation*'s upper left corner we have the direct confrontation, the inescapable challenge of women; in the lower right, the in-turned anguish of meditation on the theme, liable to lead to madness. The artist in the process is feminized; the uplifted hand, linked with the head, is opposed to the downthrust one, where the closed fist is linked with the genitals. This way of symbolizing inner division, the conflict between mind and feeling (centred in the genitals), persists throughout Cézanne's work (Fig. 9).

He seems however to have been veering in his moods. Linked in style with the *Temptation* is the *Pastoral*, in which, as well as hints of Tintoretto and the Spaniards, we find the Giorgione-Manet inspiration. Here all is calm, preparing the way for bathing scenes. The men are dressed, the women nude; and one of the men is Paul himself, deeply pondering the moment, in a pose reminiscent of Delacroix's *Death of Sardanapalús*: once again the image of the obsessed artist is linked with Delacroix. The composition is strongly circular. The main point is the island in the distance with its reflections in the water. Round this swerve two circling zones: one moving through the Paul-figure and the woman above him,

the other through the three nearer figures. Both zones converge on the man in the boat, and then the upswinging lines of the sail gather the movements together, checking the flow and giving it a fresh start. The mood of the *Pastoral* is thus seen as an acceptance of the life of the flesh, which is questioned in the *Temptation*.

The monk in the *Temptation* seems in a way irrelevant to the sphere of bodily exuberance on which he intrudes. But in other works we feel a deep-rooted revulsion. *The Strangled Woman*, with its extremely violent rape-murder attack on a woman, probably belongs to Paul's early period with Hortense. He may have painted it while waiting for the moment of childbirth in late 1871. The work is done with a fury that exactly matches the theme. On the other hand *A Modern Olympia* has been given the same date, though 1872 seems more likely. Here Paul records with a mixture of irony and satisfaction his role as an enjoyer of female flesh. He sits like a sort of libertine pasha contemplating the naked woman offered to his embrace, a Negress in attendance; with flowers, wine, and a basket of fruit to complete the debauch. He sits in shadow, and the huddled girl is shown in sheer light so that, though in the background, he moves forward and we get the effect of suddenly opened curtains dramatically presenting her to the view. The work is a parody and an adaption of Manet's *Olympia*; but whereas in that work the naked girl is shown brazenly and coldly exposing herself to all the world, here the gesture has coyness as well as abandonment, and the prey is for Cézanne alone. (We are told that Paul had been discussing Manet with Dr Gachet and had remarked, 'What, the *Olympia*, I too could do that sort of thing.' Gachet replied, 'Do it then.' What Paul did was something very crude and rough compared with Manet's control of tone and design, but with a ferocious energy that might mean a new set of artistic potences or might mean a mere dispersal of forces.) (Fig. 11.)

The artist-friends of Paul were scattered. Renoir, a trooper in the Cuirassiers, groomed horses in Bordeaux, then Tarbes. Bazille enlisted in the Zouaves and was killed in action in November. Guillaumin escaped service, but Manet like Degas enlisted as a gunner, and became a staff-officer. At Paris he served under Meissonnier, who ignobly sent him on the most dangerous missions. Monet fled from the occupied zone at Argenteuil to Amsterdam where he painted canals and windmills, then early in 1871 he went to England; there he met the dealer Durand-Ruel. Pissarro, at Louveciennes near Paris, fled from the invaders leaving all the pictures accumulated in the last three to four years; his house was turned into a slaughter-house, his canvases were used as aprons, then burned. Two were found later, covered with blood. Meanwhile he went to the Department of Mayenne, then to England where he settled at Norwood till 1872. Daubigny too was in England. Courbet, remaining in Paris, took a prominent part in the Commune; he was supported by Corot, Daumier and Manet, who were elected to the Federation of Artists of Paris. Manet's barricade-scenes depicted the cruelties of the army destroying the Commune; he also dealt with the escape of the Communard Rochefort from a penal colony by boat. Alexis was a corporal in the army.

At l'Estaque Paul must have been in close contact with events in Marseille, where there was a strong revolutionary temper, stimulated by Bakunin and Esquiros the Prefect. There had been trouble in October 1870, when Esquiros on the 31st declared the city to be under the rule of the Commune; two days later a nominee of Gambetta arrived to put down the outbreak. (Zola's *La Marseillaise* is said to have sided with Gambetta; but as no copies survive we cannot check the statement.) On 19 February 1871 Zola returned to journalism, and was later much ashamed of his venture into the political sphere. 'I imagined the world was coming to an end, no more books would ever be written,' he told Alexis, claiming that at the time he could see no other way of supporting his wife and mother, so he plunged 'blindly into the political life I had despised so heartily a few months earlier, and for which, as it happened, I developed a renewed contempt immediately after'. (If at that time he felt a total collapse of the world he had known, what must the much less politically-sophisticated Paul have felt?)

Paris surrendered to the Prussians on January 28th. On February 9th Manet wrote to Zola:

I'm very pleased to get good news from you. You haven't wasted your time. Recently we've suffered a good deal in Paris. Only yesterday I learned of poor Bazille's death. I'm overcome: alas, we've seen many people here die in many ways. At one time your house was inhabited by a family of refugees. Only the ground floor; all the furniture was moved upstairs. I think no damage was done to your things. I'm leaving soon to join my wife and my mother in Oloron in the Basses-Pyrenées. I'm anxious to see them again. I'll pass through Bordeaux and will perhaps come to see you. I'll tell you then what can't be put on paper.

By March 14th Zola had returned to his house in the Batignolles; four days later the serialization of *La Fortune* was resumed and the Commune was established. He had a difficult time, being arrested first by the insurgents, then by the government-supporters; threatened with a third arrest, he slipped off to Bonnières. On May 28th the Commune was bloodily suppressed and he went back to Paris. At Marseille the reactionaries had tried a manifestation through the National Guard in favour of Thiers; but the rank-and-file of the Guard joined the populace in taking over the Prefecture. Crémieux, a radical, set up the Commune. But the regular troops, with a general and the town authorities, had withdrawn to Aubagne; one morning they attacked Marseille, bombarding the Prefecture from the heights. The general's sailors then assaulted the empty building. A brutal repression resulted; some 150 people were killed and 500 arrested. The general entered the town, cheered by the upper classes and hooted by the people. The National Guard was disarmed and three leaders of the Commune were condemned to death, though Crémieux was not shot till six months later. The sympathy that Paul later showed for the Communards was perhaps aroused even more by these events, close at hand, than by the similar events on a much larger scale at Paris.

Zola had been wondering what had happened to him. On March 2nd he wrote to Alexis,

'I have no news of Cézanne; he must be in some corner of the Aix countryside.' Some time in May or June Alexis replied, 'No Cézanne. I have had a long talk with M. Giraud, called Longus,' who owned the house that the Cézannes rented at l'Estaque. 'The two birds have flown . . . a month ago. The nest is empty and locked. They've left for Lyon, M. Longus told me: Wait till Paris stops smoking. I'm surprised that for a month we haven't seen him in Paris.' But Zola knew Paul better than Alexis. On June 30th he replied:

What you say of Cézanne's flight to Lyon is an old wives' tale. Our friend has simply wanted to put the sieur Giraud off the track. He is hidden in Marseille or in the hollow of some valley. And it's up to me to find him again as soon as possible, for I'm worried. Imagine. I wrote to him the day after you went. My letter, addressed to l'Estaque, must have been lost—not a great loss; but I fear that through an unforeseen set of circumstances it may have gone on to Aix, where it will fall into his father's hands. It contains certain details compromising for the son. You follow my reasoning, eh. I'd like to find Paul so as to make him reclaim this letter. So, I count on you for the following commission. Go to the Jas de Bouffan where you'll have the air of seeking news of Cézanne. Arrange things so you have a chance of speaking a moment with the mother in particular. Ask her for the precise address of her son for me.

Zola had written something about Hortense. He knew how Paul was terrified of his father and how the latter opened his son's letters. He knew also that the mother, far more sympathetic, was her son's confidante. Alexis seems to have made further inquiries, whether or not at the Jas, and to have found Paul, a few days before the latter set out for Paris. On July 4th Zola wrote in relief:

My dear Paul, your letter gave me great pleasure as I was beginning to feel worried about you. It's four months since we had news of one another. About the middle of last month I wrote to you at l'Estaque. Since then I learned you'd gone and my letter had strayed. I was really at a loss how to find you again, when you solved the problem for me.

You ask for my news. Here's my story in a few words. I wrote to you, I think, a short time before leaving Bordeaux, with a promise of another letter after my return to Paris. I arrived here March 14th; four days later, March 18th, the insurrection broke out, the postal services were held up, I no longer thought of getting in touch with you. For two months I lived in a furnace, night and day the cannon, and near the end shells as well, whistling overhead in my garden. Finally, on May 10th, threatened with arrest as a hostage, I took flight with the aid of a Prussian passport and went to Bonnières to spend the most critical days. Now I find myself quietly at home again in the Batignolles Quarter as if I'd just woken up from a bad dream. My little garden-house is the same as ever, my garden is untouched, not a stick of furniture, not a plant has been damaged, and I could almost believe the two sieges were bad jokes invented to scare children.

He felt optimistic. 'As I've often told you, our reign is at hand.' *La Fortune* was in the press and he enjoyed correcting the proofs. 'I feel rather sorry that all the imbeciles aren't dead, but it consoles me that we are still alive. We can take up the struggle again.' (Vollard says that later Paul, on being told by Zola of a dinner with a coarse [*gros*] person introduced by F. Jourdain, retorted, 'All the same if all the imbeciles had disappeared, you'd have been forced to eat the leftovers of your stew at home, alone with your *bourgeoise*.' It is unlikely that Paul ever made such a rude remark to Zola, though he may have recalled Zola's phrase

in some sarcastic way in talking with Vollard, who recast his words in a dramatized form.)

Gradually the artists were reassembling in Paris or nearby. Paul on his return in late 1871 found Solari, Valabrègue, Roux there. Monet came back to Argenteuil; Sisley was at Voisins, Pissarro at Pontoise. The old meetings at the Guerbois were not resumed; instead the discussions took place at the Nouvelle Athènes. At first the artists hoped that the Republic would break the grip of the academic conservatives; but they were soon disillusioned. The old system of money still ruled in society, the same system of patronage in art. Cézanne, absorbed in personal problems, did not attempt the Salon in 1872; nor did Monet, Pissarro, or Sisley, whose pictures Durand-Ruel was buying. Zola was learning that the same pressures of censorship were at work. The Prosecutor warned him to stop serializing *The Quarry* in *Le Cloche* as it was being accused of immorality; if he did not stop, the paper would be prosecuted. The Salon Juries were if anything more reactionary than before; advanced work was liable to raise the bogey of Courbet, who, as President of the Federation of Artists under the Commune, had shut up the School and the Academy of the Beaux-Arts. An appeal for another Salon of the Rejected was refused.

Meanwhile Paul had gone to live at 5 Rue de Chevreuse, where Solari was. On 14 December 1871 Solari wrote to Zola, 'Greetings to Paul Cézanne, who has vanished. I heard the furniture rolling on the staircase, but I didn't show myself for fear of troubling the removalists.' Paul must have been in a highly exasperated state of nerves if so amiable a fellow as Solari felt it best to ignore the removal. He went to a little flat on the second floor of 45 Rue de Jussieu, overlooking the wine-market. He painted that view in greys and browns, in a harsh expressive style that is reminiscent of the snow-scene at l'Estaque, but without its drama. Here the hard solid literalness is married to a sweeping clarity of design: as if he were staring out of his window, gaining inner balance by his secure grasp of the scene, but insisting that it keep its distance.

On 4 January 1872 Hortense bore a son, who was named Paul and registered at the Mairie of the 5th arrondissement. On February 18th Emperaire arrived from Aix; he wanted to make another attack on Paris, and Paul agreed to put him up at his 'hovel.' The arrangement was not a success. Emperaire thought Paul 'very ill lodged,' and the noise from the barrels rolled about the wine-market 'a clatter to raise the dead.' We can imagine Paul's irritation, torn between a wife and yelling baby that needed attention, and a lodger who wanted to chatter in the old careless way. Emperaire was loud with his plans to conquer that 'monster', bourgeois art, and to triumph over 'the great ones of the earth.' He was ready to challenge anyone in his campaign, to wait in the ante-rooms of ministers, and to call on Victor Hugo, 'the great poet of the Revolution,' show him sketches, and ask his advice on subjects for the Salon. 'Seeing the Giant doesn't scare me.' By the end of a month the situation had become impossible. 'I'm leaving Cézanne's flat,' Emperaire announced. 'I must. The way things are, I can't evade the others' fate. I've found him forsaken by everyone. He no longer has a single intelligent or affectionate friend. Zola, Solari, all the rest

never see him now.' Paul, he noted, was 'the most extraordinary creature imaginable,' he was 'a real monster if ever there was one (in the scientific sense of the word).'

Paul was not forsaken; he was the one who had done the forsaking, unable to face his friends in the new situation. However, there was one equable man to whom his thoughts turned. He went with his wife and child to Pontoise, to be near Pissarro, and stayed at the Hôtel du Grand Cerf, near the old bridge of St Ouen-l'Aumône; Pissarro was in the Hermitage Quarter. Thus Paul found a place where he could calm down and turn again to art.

The next three years were decisive for Paul's development. They enabled him to build on his previous gains, while learning from Pissarro what the open-air approach fully implied. He was able to learn what lessons he needed from impressionism, absorb certain important aspects of its method, and then proceed to the full creation of his own style and outlook. He could not have done all that without the stability gained from Pissarro—with his genial warmth and easy-going tolerance, his nobility of character and comment, his deeply stimulating sympathy.

Pissarro was now over forty, while Paul, though thirty-three, was in many ways extremely immature as a man. Pissarro understood him and knew how to undermine and banish his fears and doubts. Others who came to the house in the Rue de l'Hermitage were Béliard, Victor Vignon, and Guillaumin who, unable to carry on further with his extreme penury, had become again a civil servant. The company and the fresh quiet landscape of the Vexin pleased Paul. He worked at Pissarro's side and listened to his suggestion that he should lighten his palette. 'Never paint except with the three primary colours and their immediate derivatives'. (For some time Daubigny had been saying, 'We never paint light enough'.) Pissarro worked with little touches to gain the effect of vibrating light and air, and to give his colours their full value. Paul copied his view of Louveciennes, so as to enter into his technique; but it wasn't easy to move all at once from his habits of passionate attack. Pissarro however was pleased with him and wrote that he would 'astonish many painters who had been far too hasty in condemning him'.

Paul later said that Camille was 'like the Good God', and he once signed himself a 'pupil of Pissarro'. He said, 'He was a father to me'. One of the citations by Gasquet we can surely trust is that in which he makes Paul remark, 'We perhaps all come out of Pissarro. In 1865 he already eliminated black, bitumen, raw Siena, and the ochres. It's a fact.' Bernard reports Paul as saying that he had wasted his time up to the age of forty when he met Pissarro. If he made some such remark he must have meant that he began to find himself in his forties through Pissarro; he had met him several years earlier.

Another person who helped him in a lesser degree at this time through his sympathy was Dr Paul Ferdinand Gachet, one of the Batignolles group, who now had a house at Auvers-sur-Oise, near Pontoise: a large house that stood alone with a terraced garden, dominating the countryside around, in the Rue des Vessinots. Gachet had been born at

Lille in July 1828. He still had a practice in Paris, in the Rue du Faubourg, St Denis. In 1868 he had married a young woman who suffered from consumption and who soon became pregnant, so Gachet bought the Auvers house (once a girls' school), and divided his time between Paris and Auvers. He had early been drawn to art, claiming descent from Jean Mabuse; he admired Courbet, frequented art cafés, and came to know Manet, Monet, Renoir, Degas, Pissarro. He was always ready to defend young and dissident artists on aesthetic, psychological or sociological grounds. An eccentric, he could be seen wearing a blue army-surgeon's overcoat of 1870; in summer a white cap, in winter a cap of fur. He dyed his hair yellow, gaining the name of Dr Saffron, and carried a white sunshade. A socialist and homeopathist, he was interested in palmistry and phrenology. He became friendly with Daubigny, who also lived at Auvers, and with Daumier, now half blind and retired to Valmondois, not far off. Warm of heart, energetic, full of enthusiams, Gachet treated the poor of the district gratis without letting it be known, and couldn't resist stray animals: his house was full of lost cats and dogs. Paul, on meeting him, felt that here was another person whom he could wholly trust. He decided to rent a small house in Auvers and moved there in the autumn. The site was close to the Gachet's. Gachet even bought a couple of Paul's canvases at modest sums, and thus may have been his first buyer. As a result Paul sold some works also to a local collector Rouleau, a schoolmaster, while Rondès, grocer of the Rue de la Roche, Pontoise, accepted a canvas in payment of a bill. Pissarro no doubt encouraged the grocer in the transaction.

Others were coming into the area. Besides Guillaumin, there were Cordey and Vignon. Paul, under Pissarro's guidance, was beginning to understand and like the Ile de France with its wet greens, its misty blues. The only letter of the period, written on 11 December 1872, shows how much he felt at home with the easy-going Pissarro household. He had missed the train to Auvers:

I take up Lucien's pen, at an hour when the railway should be transporting me to my penates. It's to tell you in a roundabout way that I missed the train. Useless to add I'm your guest till tomorrow Wednesday. Well then, Mme Pissarro asks you to bring back from Paris some flour for little Georges, also Lucien's chemises from his aunt Felicie's. Good evening, Paul Cézanne.

The little Lucien has added with some odd spellings:

My dear papa, Mamman wants you know the door is broken so come quick because robbers could come, I prey you if you like please bring me a paintbox, Minette preys you bring a bathing suit. I is not written well as I were not inclined, Lucien Pissarro 1872.

As we see from later letters to Zola, the missing of trains was not unusual for Paul. To this year, or else to 1873 or 1874, belongs a draft of a letter on the back of a sketch of two peasants. It might have been written any time during his three years' absence from the south, though we would expect the pressure for his return to Aix to have increased during the later part of his stay in the Pontoise-Auvers area. No doubt he stayed away so long

because he was engrossed in the advances he was making through Pissarro, but also because his position as a family-man was easier to maintain at a distance from his dreaded father.

You ask me in your last letter why I'm not yet coming back to Aix. With reference to this matter, I've already told you it's more pleasant than you think for me to be with you, but once I'm at Aix I'm no longer free there, and when I want to return to Paris, it always means a struggle for me; and although your opposition to my return is not absolute, I'm very much affected by the resistance I find on your part. I'd deeply desire my liberty of action not to be fettered, and I'd then only have much more joy in hastening my return. I ask Papa to give me 200 francs a month, which will allow me to make a long stay at Aix, and I'll be very happy to work in the south where there's such a wide range of views for my painting. Believe me I do really beg Papa to grant me this request and then, I think, I'll be able to continue the studies I want to make. Here are the last two receipts.

Dr Gachet was interested in etching and had installed a studio in his barn. Paul was drawn into trying the medium; he copied a picture by Guillaumin which Gachet had, drew a *Hamlet* scene after Delacroix (but failed to etch it), and etched the head of a girl (? Hortense). Pissarro drew Paul, etched, and painted him. Paul used for his painting the long flat supple knives that Pissarro used. He began to understand how objects reflected one another and how the depth of air in its varying levels could only be expressed by a close study of edges and planes. While he found it hard to abjure altogether his sombre range of colours, he began to feel the fascination of bright clear colours, painting gaily the flowers that Mme Gachet grew in her garden. He subdued his impetuous force and learned to use small strokes that finally loaded a vanvas with a thick layer of colour. Later, Denis asked why he had turned to these separate touches, and he said, 'Because I can't render my sensation at a blow [*du premier coup*]. So I lay on colour, I keep laying it on as best I can. But when I begin, I seek always to paint sweepingly [*en pleine pâte*] like Manet, bringing out the form with the brush'. As always, he had his moments of intense despair, and he was liable to drive on desperately in the quest for a fuller realization than he was yet capable of. Gachet would cry, 'Come on, Cézanne, leave this picture, it's just right [*à point*], don't touch it any more'. Paul, cursing and grumbling, would obey. (Doiteau)

In the *Maison du Pendu* (1872–3) we see him coming through into his new style. He has got rid of his black outlines and his harsh isolation of objects or areas; yet with all the increased finesse of touch and of clear diversity of colour there is a link with the past in the continued use of a thick granular patching. This helps him towards the expression of a massive solidity in forms, a tactual richness, that already separates him from his impressionist colleagues. He draws from Pissarro a liking for the view of buildings seen close and therefore presenting big plain forms, which are diversified by the patterns of branches in front of them; but all his own is the structure, the strong expanses of ground sloping up on each side, drawing the eye down between them and then up and out over the middle-roofs into the distance. The jutting-out rocky ground on the right, in particular, sets a sort of obstinate obstruction round which the eye dodges in and out in a complex yet irresistible movement into open space. We feel that there is both an identity and an opposition be-

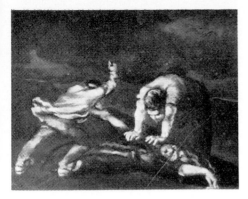

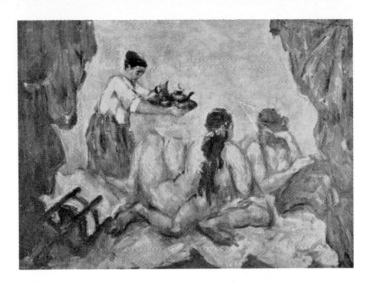

44 (above) The Murder, 1867–70

45 (right) Afternoon at Naples, 1872–75

46 (below) Maison du Pendu, at Auvers, 1872–73

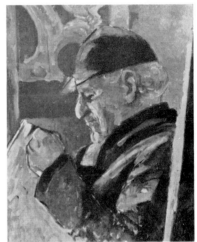

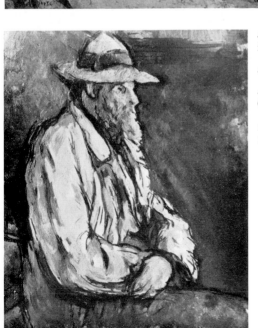

47 (above right) Portrait of his father, *c* 1865–66

48 (left) Portrait of Vallier, 1906

49 (right) Still Life with Apples and Oranges, 1895–1900

50 (below right) Still Life with Skull, 1895–1900

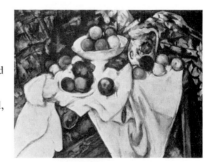

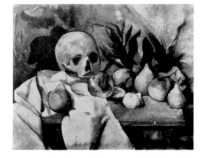

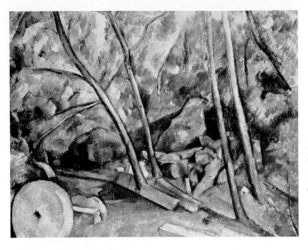

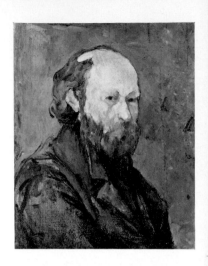

51 (left) Woods with
Millstone, 1898–1900

52 (right) Self Portrait,
c 1877

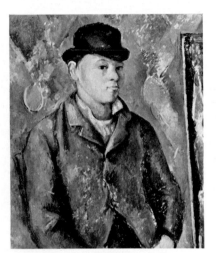

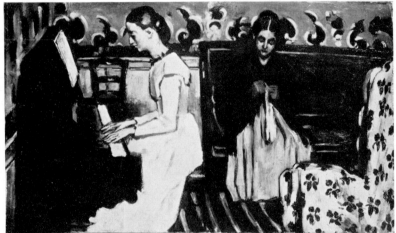

53 Portrait of his son, Paul, *c* 1890

54 Overture to Tannhäuser, *c* 1866

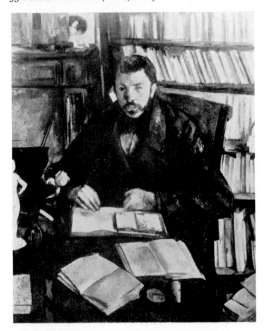

55 (left) Portrait of Gustave Geffroy, 1895

56 (below) Mont Sainte Victoire, 1904–06

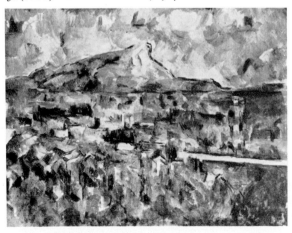

tween rock and house, echoed in the interplay of obstacle and free movement, and linked emotionally with the title: *The Suicide's House.*

Paul seems now to have made his second shot at the Olympia theme, able to discard his cruder violence of approach and to build on colour-harmonies, with a note of lyrical irony. The girl, unveiled by the Negress, floats in a cloud of fine faint greens, with the Cézanne-spectator elegantly dressed as an upper-class roué. Pissarro perhaps mentioned this work to Duret, who wrote on 6 December 1872, 'If it were possible, I wouldn't be put out if I could see something by Cézanne at your place. In painting I seek more than ever the five-footed sheep'. Pissarro at once replied, 'If it's five-footed sheep you're after, Cézanne will be able to satisfy you; he has some very strange studies, seen in a unique way'. Things were looking brighter. In early 1873 Pissarro sold some works in Paris, one at 950 francs. He wrote to Duret on February 3rd: 'We begin to make our breach. We are strongly opposed by certain masters, but there's no need to wait on these divergent viewpoints when one arrives as intruder to plant one's little flag in the midst of the mellay. Durand-Ruel holds fast; we hope to move ahead without bothering about opinions'. They were thinking of holding their own show.

Early this year Paul moved to Auvers, where Daubigny also lived. He lodged near Gachet. Auvers, with its thatched cottages, was much more of a village than Pontoise, and Paul was able to work there at more ease. Daubigny once watched him paint. 'I've just seen on the banks of the Oise an extraordinary piece of work. It's by a young and unknown man, a certain Cézanne'.

Paul was going round in thick boots, a waggoner's cloak, an old cap or a yellow straw hat; he held his head high and walked with a light step; his beard was ragged and his eyes bright. Once as he was working with Pissarro, some gentlemanly riders came up and gave a supercilious look at the untidy painters; Paul said loudly, 'What a turn-out! [*tournure*]'. A peasant, who had watched him and Pissarro at work, remarked, 'M. Pissarro in painting dabbed [*piquait*], and M. Cézanne smeared [*plaquait*]'. Paul never adopted any of the more precise systems of impressionist painting, let alone the formulas of *pointillisme*; but as he gave up knife-trowelling or broad brush-curls, he moved towards a method of fine long parallel strokes, which were painted in layer on layer of transparent colour. At first he made the strokes run in more or less the same direction over the whole surface (especially from the upper right to the lower left corner); then, mastering the definition of planes, he gained variety of levels by treating various areas individually—the strokes in each area being parallel, but at different angles from those in other areas. Hence his capacity to represent a rich diversity of planes and movements in space without the loss of brilliancy in colour and its reflections. The full achievement was far ahead; but he had already set out on the journey towards it.

He had now spent a considerable time without any contacts with Zola. True, if we had his letters of this period, we might find that he still kept in touch with him; but it seems

likely that in the absorption of his new breakthrough in landscape and his deepened friendship with Pissarro, he had put Zola out of his thoughts for the first time. Zola on his side also had a set of new interests. In 1871 *The Fortune of the Rougons* launched his great series. The part played by the Cézannes in the seminal ideas of the project is shown by his Notes to *The Fortune*. 'Exhaustion of intelligence by the rapidity of the élan towards the heights of sensation and thought. Return to brutalization. Influence of the feverish modern milieu on the ambitious impatience of the persons. The milieux properly so-called, milieux of place and milieux of society determining the person's class (worker, artist, bourgeois— I and my uncles, Paul and his father)'. In 1872 came *The Quarry* continuing the story of the speculations and mad quest for money under the Empire. The two books failed to achieve even a *succès d'estime*, and the publisher went bankrupt. In 1873 a new publisher, Charpentier, issued *The Belly of Paris*, with its magnificent picture of the markets, in which Zola discovered his deep poetic power to animate a scene and to draw broad unified sweeps in which individual and social setting were fused in a new way. But again nobody was impressed. As he sent all his books to Paul up to 1886, and as Paul clearly wrote each time in thanks, it is a great loss that we do not possess his comments on Zola's picture of Aix-Plassans and on the vivid imagery of *The Belly*. But it is of interest that at the same time as Paul was coming down securely to earth in such subtly realized definitions as *La Maison du Pendu*, Zola was achieving in *The Belly* a power to vitalize and humanize such scenes as those of the markets with their fruits, vegetables and fish.

Zola indeed declared that he meant to make of this novel 'an immense still life'. He directly links the fruits and girls:

In the display the lovely fruits, daintily set off in baskets, had the roundnesses of cheeks that hide themselves, faces of lovely children half glimpsed under a curtain of leaves. Above all the peaches, the reddening Montreuil, with skins as fine and clear as girls of the North, and the peaches of the Midi, yellow and burnt, owning the tan of the girls of Provence . . .

And he goes on to bring out the analogies in all sorts of glancing and suggestive ways. There existed the same sort of correspondences in Paul's mind with his fruits, sometimes coming into the open, but, by the nature of his medium, less explicit or obtrusive than Zola's imagery.

The painter L. Le Bail has given us a clear account of Pissarro's attitudes and the sort of advice he offered. Le Bail was writing in 1866–7, but Pissarro was a singularly consistent man and his conceptions were highly stable, even when he briefly joined the pointillists.

Seek out for yourself a type of nature which suits your temperament. One should observe forms and colours in a motif rather than drawing. It's not necessary to accentuate the forms. They can be realized without that. Accurate drawing is dry and destroys the impression of the whole, it annihilates all sensation. Do not make the bounding line of things too definite; the brushstroke, the right shade of colour, and the right degree of brightness should create the drawing. With a mass the main difficulty is not to give it an accurate outline, but to paint what is to be found within it. Paint

the essential character of things, try to express it with any sort of means you like, and don't worry about technique.

When painting, look for a clear object, see what lies to right and left of it, and work at all sections simultaneously. Don't work bit by bit but rather paint everything at once, applying paint all over, with brushstrokes of the right colour and brightness, and observe in each case which colours are near the object. Use small brushstrokes and try to set down your observations directly. The eye should not be fixed on one point but should note everything, and in so doing observe the reflections which colours throw on their surroundings. Work at the same time on sky, water, twigs and ground, bring on everything evenly and go on tackling everything without stopping again and again, till you've got what you want. Cover the canvas in one sitting and work at this till you can find nothing more to add. Observe accurately the aerial perspective, from foreground to horizon, the reflection of sky and foliage. Don't be afraid of applying paint, make your work gradually more perfect.

Don't proceed in accordance with rules and principles, but paint what you see and feel. Paint strongly and unhesitatingly. For it's best not to lose the first impression . . . One must have only one master: nature. One must always ask her counsel.

Though Paul developed these sorts of ideas in his own way, they had an essential liberating value for him, especially the question of an over-all unity dynamically apprehended and tackled, and the part that colour played in the relationships and in the creation of depth. For a period he came close to the actual methods being used by Pissarro. In a letter of 22 November 1895, Pissarro, dealing with the incorrect approach by Camille Mauclair to Paul's work (in connexion with Vollard's show), remarked, 'There is no doubt that Cézanne was at first influenced by Delacroix, Courbet, Manet, and even by Legros, as we all were; in Pontoise he was influenced by me and I by him'. In the show were 'certain landscapes of Auvers and Pontoise, whose similarities with mine are striking. Of course we were always together; but of this you can be certain: each of us preserved the one thing that really mattered: his own sensation'. Zola and Béliard had noted the closeness of the two men's work. Pissarro commented that it was an error to assume 'artists are the sole inventors of their styles and to be like someone else is to lack originality'.

When Paul began to paint at Pontoise, he was still unclear as to what he wanted to get out of landscape. His first approach had been through near views, in which he felt impelled to use his violent methods of attack in the treatment of detail. Then, with a sudden leap that seems connected with the sense of crisis in 1870, he grasped a scene as a unity. He was able to see in a broad way, organizing the composition in terms of masses of volumes related and balanced, but still failing to define depth or spatial openness. Pissarro was grappling with this problem in terms of the Corot tradition, affected at the same time by photography. The camera had revealed a new way of looking at distances, in which near and distant views were brought together, starting at the painter's feet. Such scenes, previously unknown,

embrace a section of space such as a camera would take in one exposure, but which the human eye on the contrary could only put together by combining two views, that is, by being first cast down and then raised to the level of the horizon. The relevant extract shows the vanishing lines of perspective (which link the depth of the scene to the standpoint of the spectator) rapidly diverging and falling away in the foreground, i.e. close at hand. (Badt)

When photographs of this sort were first taken, artists thought they were fakes. Delacroix was cited in a book of 1865 as saying that even 'the most stubborn realist will improve the rigid perspectives produced by the camera, which by reason of its correctness actually falsifies the appearance of things'. But by 1870 painters had accepted this new camera-view. Paul, however, could not adopt the Pissarro system of Corot-plus-camera. So when, following Pissarro, he painted from the standpoint of the artist standing in a road and looking into the distance, he thrust the motif away, into the distance, suppressed the foreground and painted a smaller extract. He was seeking for ways of opening up the Corot-Pissarro world, with its camera-modifications, into a new sort of freedom and unity; and though he did not yet quite know it, he had found the clue in learning from Pissarro to drive up his scale of colours in ever richer brightness, ever purer light-permeation, but at the same time to define the sheer materiality of objects. Gradually the masses of volumes lose their opacity (still dominant in 1870–1) and yield to the subtle interrelations of colour (which also define the planes of deepening space), but do not become vague, ambiguous, or soft. Indeed their character, their identity becomes intensified, while playing its part in the modulated whole.

In this development Paul was taking up what was in fact the most truly original and creative element in Pissarro. Lucien noted that 'exploration of values of closely adjacent colours' was 'the outstanding characteristic of my father's art'. But by his insistence on linking this exploration with both the strengthening of form and the deepening of space, Paul carried it into yet further spheres and achieved a new unity of definition all his own.

Now we may consider a few general points about impressionism. Scientific curiosity, in the areas relevant to art expression, has always been characteristic of a large number of artists. The aspects of contemporary science which linked with impressionism went back indeed to the early eighteenth century—to the work of Newton and others in optics and in the analysis of light. Newton inaugurated a cultural crisis, apparently revealing a mechanistic universe and at the same time stimulating interest in light and colour. The resulting conflicts in the world of thought and art led to the elevation of colour and light as active principles opposed to the realm of mechanism. The poets first took up this theme, which appears strongly already in Thomson; with Turner the tradition of romantic poetry burst into art. The impressionists therefore belonged to the Turnerian line, even if his influence reached them only indirectly—except, after 1871, in Monet's later work. We may say that, in a very rough way, the tradition of the romantic colour-image was dissident, opposed to a mechanistic interpretation of the universe and of experience, even if its stimulation on the scientific side came from Newtonian mechanics. By the mid-nineteenth century the analysis of light had gone much further than in Turner's earlier days, though he tried to keep up with its developments, as well as those connected with the camera, till his death in 1851. Charles Blanc wrote articles on colour in the *Gazette des Beaux-Arts* in 1865, when Paul's mother and sister were subscribers. Bunsen and Kirchoff had been working on the spectrum.

Already in 1828 James Nicol devised his prism, and the polarization of light by refraction became known; Arago and de Fresnel, between 1854 and 1862, published work on the polariscope, which was based on the use of apparatus such as revolving mirrors. The chemist E. Chevreul, appointed director of the dyeing department in the Gobelins tapestry factory in Paris, had worked on colour-harmonies and in 1839 published *The Principles of Harmony and Contrast of Colours, and their Application to the Arts*. He showed how neighbouring colours influenced and modified one another, and noted that any colour, considered on its own, was seen to be surrounded by a faint aureole of its còmplementary colour: for example, red on white is felt to tint its background green (the negative 'after-image'). He also found that two threads dyed differently seemed to be of a single colour when viewed from a distance. Delacroix was certainly much affected, even if he made no systematic application of such ideas; Monet, Pissarro and, later Seurat, knew Chevreul's work well. The impressionists tinged shadows with colours complementary to the colour of the shadow-casting object; they juxtaposed colours which the eye fused at a distance. Pissarro, followed by Seurat, also studied the physicists Helmholtz, Clerk Maxwell, O. N. Rood. He was how the brilliance of light could be achieved on a canvas by giving the spectator's eye the function of making it up out of its component prismatic colours.

At the same time artists could not but be much interested in the effects gained by the camera, as was Turner in his last years. The camera itself grew out of these optical experiments. Photographers working at Arras and in the forest of Fontainebleau were in contact with the Barbizon painters; and Corot's art in the late 1840s was much influenced by photography—especially by the light-effect called halation, which blurs contours, gives an impression of light-impact and penetration, and creates a sensation of movement. Many impressionists used photographs in their work: Paul, for instance, in his *Melting Snow in Fontainebleau*. The generalizing effect of photography on distant figures appeared in works like Monet's *Boulevard des Capucines*.

The invention and development of the camera was accompanied by the elaboration of all sorts of trick-devices connected with effects of light and vision. The idea of working in the open must have been stimulated by the very name given to photographs: sun-pictures. Sun and light were conceived as the begetters of the view. Baudelaire, revolted at the way 'the whole foul lot rushed at it [the camera] like one Narcissus, to look at their trivial likenesses', remarked that 'a craze, a sensation of fantaticism took hold of these sun-worshippers'. Clear light was needed; the first man to take a misty scene seems to have been W. M'Leish, who exhibited *Misty Morning on the Wear* in 1882 and created a sensation. The first man to use artificial light was Nadar, who took an electric-lighting set into the Paris Catacombs about 1860. This Nadar (W. G. F. Tournachon) was a friend of Baudelaire and wrote a book on him; he took part in the 1848 revolution, found himself impoverished, and turned to the camera. Flaubert travelled in 1849 in Egypt with his photographer friend Maxime du Camps, and ended by being interested in daguerreotyping: 'the mill, the

camels, the bushes, the rippling water, the foreground and the distance—an accomplished composition at the right moment'. Manageable colour-photography, which Ruskin had said he hoped he wouldn't live to see, arrived only in 1907. The effects of light on certain chemicals had, however, been investigated for some time (e.g. by Clerk Maxwell in 1855), as the necessary prelude to this development.

Paul was much affected by all these developments, perhaps more through the work of other artists, especially Pissarro, than by any direct study of the scientists. He must, however, have heard things like Chevreul's theories discussed in the cafés and other gathering-places. With his dogged persistence at the easel, he could be influenced by what he saw others doing, above all if he were working at their side; while general theories tended to leave no mark or to muddle him. And so there was an aspect of impressionism, which we may say developed decisively in 1869 in the work of Monet and Renoir at La Grenouillère, that struck home with him—its effect of a world of actual and potential joy. G. Geffroy wrote that impressionism was born from an 'exaltation' of the senses. The conviction of a quite new form of free and yet precise comprehension of nature, of a release into light and infinitely rich and subtle colour, had a liberating quality: the final ratification of that impulse to deny and defy the world of drab and restrictive conventions, and to get away untramelled into the free tracks of nature, which we discussed in connexion with the Trio's wanderings in the 1850s. As an artist, Paul had set out in the main as a romantic, driven by a sense of doom and tragic conflicts: a disciple of Delacroix, of whom Baudelaire sang in *The Beacons*:

> Delacroix, lake of blood haunted by evil angels,
> Shadowed by a wood where evergreen fir-trees rise,
> Where under a sky of gloom, mysterious fanfares
> Pass by like one of Weber's choking sighs.

Impressionism, by giving him the technical possibility of mastering his medium, also gave him the power of resolving his deepest conflicts. He took over its essentially harmonious or idyllic world, but carried on from his earlier phases the need to solidify the earth, which impressionism in its logical extremes threatened to dissolve in a sweep of reflected lights or to reduce to a schematic system of colour-divisions. Hence he could say in his later days to Jourdain, 'Impressionism, it's no longer necessary, it's nonsense'—and without any feeling of contradiction launch into a eulogy of Pissarro. The harmony that he required in his innermost being was not a lyrical cry of praise to certain aspects of landscape; it was a harmony that emerged from as full a grasp of all the elements as possible, one that included permanence as well as impermanence, stable structure as well as the oscillations, asymmetries and tensions of change.

II *Forward with Pissarro (1873-6)*

IN the 1860s the dissident artists had now and then got canvases into the Salon. There was much oscillation: a tolerant Jury caused a scandal and the following one would be strongly conservative. But in any event a few more original works, scattered about among the vast number of mediocre paintings, went unnoticed unless some special notoriety was attached to them; as yet they were not painted in challengingly bright colours. Only Paul and Guillaumin never got in at all. After the founding of the Republic, the academics grew more determined than ever to crush anything new; and no reputable dealer was ready to fall out with the great men. So now in 1874 the advanced painters decided to organize their own show with the aid of a few critics and sympathizers. The economic situation was bad. A brief expansion after the war had been followed by something of a crisis, and more than ever the dissident artists were feeling the pinch. There were discussions as to the best tactics, and fears were expressed. Degas suggested as a name for the show *La Capucine*, because Nadar the photographer had promised them his premises at 35 Boulevard des Capucines; but Renoir objected. So a colourless name was chosen: *Société Anonyme Co-operative des Artistes, Peintres, Sculpteurs, Graveurs*, etc.

All the men who were to make a name in the impressionist movement took part, and Cézanne and Guillaumin appeared for the first time before the Parisian public. Manet did not show anything. He had now forced a sort of reluctant official acceptance, though the dissidents thought that this year he had 'watered his beer' by the weak imitation of Hals (*Le Bon Bock*) in the Salon. Moreover he was known to dislike many of the new painters; he called Renoir 'a good man gone astray' (Vollard) and was said to have announced his refusal ever to appear with such a troweller as Paul. The exhibitors at their own risk addressed themselves 'simply to the public that judges, disapproves, or supports. This procedure does not lack a certain boldness [*crâneries*]; it proves in addition a great good faith' said *Le Petit Parisien* on April 17th. The 29 artists with 169 works included Pissarro, Monet, Renoir, Sisley, Morisot, Guillaumin, Cézanne, Degas, De Nittis, Boudin, Bracquemond, Cals, Levert and Rouart. Ottin was the only sculptor. Many exhibitors seem to have objected to Paul as likely to attract too much obloquy, but Pissarro overbore them. Guillemet refused to participate; he had won honourable mention in the Salon in 1872.

The show was open from ten in the morning to six, then from eight to ten, in a busy thoroughfare; the entry fee was a franc. Huge crowds came to jeer, laugh or grow angry; the scene at the Salon of the Rejected was repeated. Paul had put in his *New Olympia* and a couple of recent landscapes; his choice of the first work shows how much he was still

wedded to his role as a sort of post-Courbet Delacroix. On Pissarro's suggestion 'once the works had been arranged according to size, chance must decide where they hang'. The pessimistic Degas was proved right in his estimate of the reception the show would get. The artists were equated with the Communards. They 'squint with their minds'; they saw 'hairdresser's blue in all nature'; 'this painting lacks all sense'. Of Paul, Jean Prouvaire of the *Rappel* remarked: 'Shall we speak of M. Cézanne? Of all known juries, none ever imagined, even in a dream, the possibility of accepting any work by this painter, who used to present himself at the Salon carrying his canvases on his back like Jesus his cross. A too exclusive love of yellow has up to now compromised the future of M. Cézanne'. In *L'Artiste* Marc de Montifaud (who was, in fact, a woman) wrote:

On Sunday the public found material for laughter in the fantastic figure who exhibits herself [in the *New Olympia*], surrounded by a sickly sky, to an opium-smoker. This apparition of pink naked flesh thrust forward by a sort of demon into the smoky heavens, a corner of artificial paradise in which this nightmare appears like a voluptuous vision, was too much for the most courageous spectators, it must be admitted, and M. Cézanne can only be a bit of a madman, afflicted while painting with *delirium tremens* . . . In truth it is only one of the weird shapes generated by hashish, borrowed from a swarm of absurd dreams . . . No audacity can surprise us. But when it comes to landscapes, M. Cézanne will allow us to pass in silence over his *Maison du Pendu* and his *Etude á Anvers* [*sic*]; we confess that they are more than we can swallow.

Yet this was a fairly liberal critic, who treated Degas, Renoir and Monet amiably, did not guy Guillaumin, and saw hopes even for Sisley and Pissarro. (We may note, however, that the linking of Cézanne's outlook with Baudelaire and his artificial paradises was correct enough.) A few young radical writers gave some words of praise to the show, but had no effect. Paul, however, had some reason to be pleased: Comte Doria bought the *Maison du Pendu*, and Pissarro wrote cheerfully on May 5th to Duret, 'Our show goes well; it's a success. Criticism overwhelms us and accuses us of not studying. I'm off back to my studies; that's worth more than reading [the critics]. One learns nothing from them'.

The movement now had a name. L. Leroy in *Charivari* entitled his notice 'The Show of the Impressionists', and hammered the term home in his long account. He tells how he went in with a much-decorated landscapist, Joseph Vincent (his own invention):

Gently, with my most naïve air, I led him before the *Ploughed Field* of M. Pissarro. At the sight of this formidable landscape, the bonhomme thought the glass of his spectacles was smudged. He carefully wiped them, then put them back on his nose. 'By Michalon,' he cried, 'what on earth is that?' 'You see, a white frost on deeply-cut furrows.' 'What, that is furrows, that frost? But they're palette-knife scratches made regularly on a dirty canvas.' 'Perhaps, but the impression is there.' 'Ah well, it's a funny thing, that impression.'

Monet's *Boulevard des Capucines* excites his wrath by its summarily indicated pedestrians. 'What are those countless black squiggles at the bottom of the picture? . . . Then that's what I look like when I walk on the boulevard?' The *Maison du Pendu* with its 'prodigious impasto' completes the effects of Monet's work. After the *New Olympia* Vincent's brain is

totally disordered. He finally totters out, muttering, 'Ho, so I'm a walking impression, the avenging palette-knife, the *Boulevard des Capucines* of Monet and the *Maison du Pendu* and the *Modern Olympia* of M. Cézanne! Ho, ho, ho!'

This wasn't the first use of the term *impression*. Gautier had written of Daubigny that it was a great pity he 'contents himself with an *impression* and so much neglects details'. Castagnary wrote of Jongkind in 1863 that 'everything lies in the impression'; he also used the term of Corot. The catalogue preface of an exhibition of Manet's work in 1867 stated that 'the painter had thought only of rendering his impression' (Dimier). Redon said of Daubigny the next year that he was 'the painter of a moment, of an impression', and someone had even called him 'the leader of the impressionist school'. Monet showed a picture entitled *Impression* in 1874. But it was only now that the critics took the term up strongly in order to abuse the new painters, who in turn adopted it in defiance. Similarly Realism had been devised as a term of abuse against Courbet, but in the 1850s he and his friends took it up and turned it back on their denigrators. Champfleury applied it to literature in his manifesto, *Le Réalisme*, of 1857. Zola developed Naturalism as a term for extreme Realism, partly because he wanted to give a note of science to his outlook and partly because he wanted a new term for his extended use of Balzacian methods. Taine had compared the work of social historians and historians of ideas with that of naturalists, natural scientists, in a book that Zola reviewed on 25 July 1866; in his preface to the second edition of *Thérèse Raquin*, April 1868, he referred to 'the group of naturalist writers to which I have the honour of belonging'. We may compare the way in which scientific work on light and optics was affecting art and making possible the impressionist approach.

While the Capucines show was being organized, Paul had returned to Paris, to a two-storied house at 120 Rue de Vaugirard. Perhaps about this time he sent off that draft-letter of protest we considered earlier. He had promised to go to Pontoise to say goodbye to Pissarro; but the abusive notices of his work in the show seem to have shaken him. He slipped off to Aix, leaving Hortense and the boy behind. Scared of letters from her being opened by his father, he depended on friends for news about his family. Perhaps he went home out of fear that any further prolongation of his absence might lead to trouble over his allowance, and he may have hoped to get it increased. What had sufficed for himself was not enough for a family. On June 24th he wrote from Aix to Pissarro, saying that he had arrived back on a Saturday evening in May and had begun at once to paint. Little Georges Pissarro had been ill; Paul suggests that the Midi might be more healthful than the north and better suited for Pissarro's art. The countryside 'recalls in a most amazing way your study of the railway barrier painted in full sunlight in midsummer'. For some weeks he had been without news of his little boy (no mention of Hortense), but Valabrègue had come from Paris, '. . . Yesterday, Tuesday, he brought me a letter from Hortense telling me he's not doing badly.' In the next sentences of his note he refers to the image of Hercules at the Crossroads:

I'd learned from the papers of Guillemet's great success and of the happy event for Groseillez in having his picture bought by the administration after his medal. There, that proves by following the way of Virtue one is rewarded by men, though not by painting. I'd be pleased if you could give me news of Mme Pissarro after her delivery, and if you could notify me of any new recruits to the Co-op Society. But of course you mustn't let this in any way interfere with your work.

The Co-operative was the new organization of artists, in which the impressionists had a large but not exclusive part.

When the time nears, I'll let you know of my return, and what I've been able to get out of my father, but he'll let me return to Paris. That's already a lot. In these last days I've seen the director of the Aix Museum, who, driven by a curiosity that's fed by the Parisian journals mentioning the Co-operative, wanted to see with his own eyes how far the peril to Painting actually went. But, on my protesting that by the sight of my productions he'd not gain a correct enough idea of the evil's progress and he must see the works of the great criminals of Paris, he replied, 'I'll be able to get a good idea of the dangers run by Painting if I see your attempts.' Whereupon he came, and when I told him for example that you replace modelling by the study of tones, and tried to make him understand by reference to nature [*sur nature*], he closed his eyes and turned his back. Still, he said he understood and we parted, each satisfied with the other. But he's a good chap who has urged me to persevere, because patience is the mother of genius etc.

I almost forgot to add that Maman and Papa ask me to send on their affectionate greetings. A little word for Lucien and Georges, whom I kiss. Regards and thanks to Mme Pissarro for all the kindnesses to me during our stay in Auvers. A good fistful of handslaps for you, and if wishes could make things go well, be sure I wouldn't fail to make them. Wholly yours, Paul Cézanne.

By September he returned to Paris. The teasing authoritative manner of Louis Auguste seems to have hidden a great deal of forbearance for his son, though no doubt he yielded to pleas only at the last possible moment. He wanted to keep Paul on tenterhooks, and succeeded in doing so; Paul was never sure how secure were the gains he had made. But the fact that so completely bourgeois a character, with money-making his sole interest and criterion of worth, did give Paul so much headway in his erratic career, with no signs of a cash return, shows that he was kinder and more affectionate under his show of intolerance than Paul ever grasped. On September 24th the latter wrote from Paris to his mother, in very cheerful terms; but we cannot estimate how stable the mood was and how much he assumed it for the occasion. The last person he could afford to frighten was his mother, his one stay in the family.

My dear Mother, First I must thank you much for thinking of me. For several days the weather has been bad and very chilly. But I'm not suffering and I've got a good fire. I'll be glad to get the box you're sending, you can always address it Rue de Vaugirard 120. I expect to stay there till January. Pissarro hasn't been in Paris for a month and a half. He's in Britanny, but I know he has a good opinion of me, who have a good opinion of myself. I begin to find myself stronger than all those who surround me, and you know the good opinion I have of myself hasn't come without clear thought [*à bon escient*]. I must always keep working, not to arrive at some high finish, which begets the admiration of imbeciles. And this effect that is commonly so much appreciated is only a result of a skilled craftsman and makes inartistic and vulgar any work born of it. I mustn't seek to finish anything except for the pleasure of making truer and more full of knowledge (*plus savant*).

And you may be sure there always comes an hour when one imposes oneself and one has admirers far more fervent, more convinced than those who are pleased only by an empty appearance.

This is a bad time to sell pictures, all the bourgeois are grumbling at letting their pennies go, but that will stop. My dear Mother, greetings to my sisters. Best wishes from M. and Mme Girard, and my thanks. Wholly yours, your son Paul Cézanne.

No message to his father. We get the impression that he had the habit of unbosoming himself to his mother, rambling on about his ambitions and his attitudes in an uninhibited way—'You know the good opinion I have of myself . . .'

As he says, conditions were difficult, and the artists were hard up. They welcomed into their circle Caillebotte, a rich man through his inheritance from a commercial father. Recently, entering the Beaux-Arts, he had become a pupil in Bonnet's studio, but was soon disillusioned by the academic way of teaching; he met Monet and Renoir, and through them the rest of the impressionist group. Pale, slender, with fine features and mournful grey eyes, he was modest and loyal, and often bought pictures just to help the struggling artists.

On 24 March 1875 Monet, Renoir, Sisley, Pissarro and Morisot tried out an auction of their work at the Hôtel Drouot. Though some journals made a friendly announcement, they gained very little money and much more mockery. Albert Wolff in *Le Figaro* wrote, 'The impression made by the impressionists is that of a cat walking over the keyboard of a piano or of a monkey that has laid hands on a paintbox'. The spectators yelled with laughter as each picture was put up, till the jostling and arguing reached such a height that the auctioneer sent for the police. However, the event brought into the impressionist orbit an intelligent collector, Victor Choquet, an enthusiast for Delacroix. A customs administrator, not at all rich like Caillebotte, he was a tall middle-aged man, with silvered hair, a rather ascetic face, and small beard. At the sale he spoke in the impressionists' favour, but in an equable way. He had meant to visit the Capucines show, but had been dissuaded by friends. Now, the day after the show, he wrote to Renoir in praise of his work and asked him to paint a portrait of Mme Choquet. He had filled his flat in the Rue de Rivoli with art-treasures; he had twenty oils by Delacroix as well as many watercolours and drawings, Courbets: Manets, a fine Corot, together with rare porcelain and antique furniture. He could have risen in his department if he had been ready to leave Paris; but he could not part from its bookshops, antique shops and the like. To build up his collection, he saved on food and clothing. Renoir soon felt that here was a man who would understand Cézanne, and took him along to Père Tanguy's place. There Choquet bought a *Baigneuses*. 'How splendid it will look between a Delacroix and a Courbet!' But on his doorstep he halted and wondered if his wife would approve. 'Listen, Renoir, do me a good turn. Tell my wife the Cézanne belongs to you, and then forget to take it away. Like that, Marie will have time to get used to it before I admit it's mine'. Renoir introduced him to Paul, and they got on well together.

Sharing a great love for Delacroix, they soon had the master's works spread out all over the carpet, while they got down on their knees to look; suddenly, in a moment of rapturous agreement, they both burst into tears. After that Paul often dined with the Choquets, and he put Victor into his sketch for the *Apotheosis of Delacroix*, together with Pissarro, Monet and himself. (Fig. 67.)

The details of Paul's life in 1875 are lost. We are told that he vainly sent in a watercolour of the Jas to the Salon. He left the Rue de Vaugirard for the Ile-St-Louis, where Guillaumin had Daubigny's old studio at 13 Quai d'Anjou. The two artists painted together on the quays. Little Paul, now about three, played with his father's canvases and tore them. Cézanne was amused. 'My son tears open the windows and chimneys; the little beast knows perfectly well it's a house'. In general it seems he was living like a recluse, occasionally visiting Tanguy and more rarely letting a friend take him to the Nouvelle Athènes, where he seldom stayed for long.

Tanguy had had a hard time since 1870. A passionate Communard, he fought in the defence of Paris and was captured by the government troops with arms in his hands. Treated as a deserter, he was condemned to the galleys. His wife was threatened with dismissal from her job, but finally was allowed to keep it. After two years an influential friend gained Tanguy's release, but at the cost of two more years' exile from Paris. Tanguy stayed with a brother at St Brieuc till he was able to rejoin his wife and daughter in 1875. The household where his wife was concierge would not tolerate him; so he and his family had to move to a tiny lodging in the Rue Cortot. But soon the closing of Edouard's workshop enabled him to open a small place in the same street, no. 14. Renoir's visit with Choquet shows that his old customers returned to him as soon as he was back in Paris.

This year Zola published *The Fault of l'Abbé Mouret*, in which Paradou is the Domaine de Galice, well known to the Trio in their excursions. It would have been instructive to know what Paul wrote to Zola about this book, which may be said to play the same part in the latter's world of poetic inventions as the series of male and female *Bathers* did in Paul's world of art. Here the earth of their youthful ramblings was given a fierce vivid life, on the one hand of harsh barren rocky hills, and on the other of concentrated lush vigorous growth. Zola underlined the point of a direct communion with the earth as with a creature feeling the same pangs and ecstasies of conception and birth as men; both he and Paul were penetrated with a Hugo-type of pantheism, which made an object, a scene, at once an extension of human life, a symbolic image of it, and a form pregnant with an inexhaustible series of vital correspondences, merging and separating the object or scene and the human sphere. Paul had refined the orgiastic tumult of Hugo's pantheism with the subtler *symbolisme* of Baudelaire; with Zola the orgiastic element remained stronger, though he too had learned from Baudelaire. The following passage from *The Fault* draws on a sonnet by the poet:

There were large patches of shadow, wooded ridges, pools of blood-red earth where the red stars

seemed to seek their image, and there were chalky whitenesses like the garments of rejected women, revealing bodies drowned in obscurities, engulfed in the hollows of the countryside. By night this land assumed the strange arching spasm of lust. It slept, but with coverlets torn aside, hips naked, limbs contorted, legs straddled, while from its bosom rose heavy tepid sighs and the pungent odour of women's bodies moist with sweat as they slept. One might have said it was some tremendous Cybele fallen on her back, bosom upthrust, belly bare to the moonlight, intoxicated still from the sunshine of the past day and crazed in expectation of new impregnation. In the far distance, following that vast body, Mouret's eyes followed the Olivette road, thin pale ribbon outstretched like the disengaged cord of a corset.

The flowers are described in terms of girls: '. . . exposing beauties that modesty had hid, crevices of the body not usually shown, of silky softness, with faint blue transparency of minute capillaries'. All nature is given this entanglement with human life, in a vast sustained vision which encloses, submerges, exalts the lovers.

The planes reared their straight torsos, their satiny red-tattooed skin releasing its large flakes of enamel painting. The larch came streaming down the slope like a troop of young savages, draped in their long waistcoats of woven greenery, all fragrant with their balsam of resin and incense. And the oaks were the kings, huge oaks, square set on paunchy bodies, dominating arms widespread, assuming all the sunlight for themselves, titanic trees, some struck by lightning and recoiling in postures of invincible wrestlers whose wide-apart legs were a forest to themselves. . . .

In 1876 Paul's work was again rejected by the Salon and he took no part in the show organized by his friends in April at the Galeries Durand-Ruel, 11 Rue Peletier. Perhaps he felt depressed by the reception at last year's show and did not want to embarrass his colleagues. In this exhibition only nineteen artists were represented; and on the whole the impressionist outlook was more fully evident—though the contributors included Degas, Ottin, and others. Caillebotte also exhibited. Albert Wolff of *Le Figaro* had his say:

The Rue St Peletier has bad luck. After the burning-down of the Opera [on 28 October 1873], a new disaster has fallen on the district. Five or six lunatics, of whom one is a woman, a group of unfortunates obsessed with ambitious folly, are showing their work there. There are people who will roar with laughter at them. For my part I find it sad . . . It is an appalling spectacle of demented human vanity.

Paul wrote about it to Pissarro, from Aix, showing how carefully he followed the critics:

Two days ago I got a large number of catalogues and newspapers relating to your show at Durand-Ruel. You must have read them. Among other things I saw a long attack by the sieur Wolff. It was M. Choquet who obtained for me the pleasure of thus having some news. From him too I learned that Monet's *La Japonaise* has been sold for 2000 francs. According to the papers it seems Manet's rejection at the Salon has caused a sensation and he is exhibiting his works at his own house.

Before leaving Paris I met a certain Authier [?], I've sometimes mentioned him to you; he's the lad who signs articles on painting as Jean-Lubin. I told him what you'd shown me about yourself, Monet etc. But (as you've doubtless since heard) the word he meant to put was initiator, not imitator: which totally changes the article's meaning. For the rest, he told me felt obliged, or at least thought it proper, not to belittle the other painters at Durand's too badly. You understand why.

Blémont's article in *Rappel* shows a much better sense of things despite too many reservations and a long preamble in which he gets lost a little too much. It seems to me your blue is condemned because of your mist-effect.

The weather had been rainy for a fortnight—and a bad frost had spoiled the fruit and vine crops. 'I almost forgot to mention I received a certain letter of rejection. That's neither new nor surprising'. He gives no clue as to his reasons for not joining the other artists in their show. Though Degas and Paul did not like each other, the explanation cannot lie in any objections raised by such of the exhibitors as thought him too extreme; and the suggestion that he wanted to show only with the Salon or some independent organization is unconvincing.

The opening of the exhibition coincided with the publication of Zola's *His Excellency Eugène Rougon*. Though his novels were still selling badly and little critical attention being paid to them, Wolff, who damned the painters, remarked that he was a born writer, 'who lacks tact, I agree, but his work is of very great interest and incontrovertible value'. Why Zola did not write in support of the shows of 1875 and 1876 is uncertain. He may have felt too absorbed in his novels, which he was doing his utmost to develop powerfully; he may have felt that he was not art-critic enough. He had set out his broad principles of judgment in *Mon Salon* and elsewhere; and he might well have found it difficult to discover a periodical of any standing that would accept him as a critic for such occasions. Further, it seems that during these years of close union with Pissarro, Paul had drawn to some extent away from him. Zola was living increasingly in a purely literary world, Paul in a specifically artistic world. So Zola may have thought it more sensible to leave the defence of the new painters to professionals like Duranty and Duret. It has been asked why, when he championed Manet so strongly, he did not do the same for Paul; but it must be remembered that Manet was already a matured painter whose work and name were well known to the public, while Paul was known by practically nothing except the three derided works of 1874.

Duranty issued a pamphlet, *The New Painting*, in which he described the new men as having 'recognized that full strong light changes the colour of tones, that the sun reflected by objects tends by force of its lustre to bring them to that luminous unity which bases its seven prismatic rays on a single colourless burst, which is light'. (Some years earlier Duranty had been drawn into a duel with Manet, for whom Zola acted as second. Zola too was once challenged to a duel, apparently through his art criticisms; but Guillemet and Paul, his seconds, succeeded in bringing about a peaceful settlement.) In May 1878 Duret also published a pamphlet, *The Impressionist Painters*, in which Paul was mentioned as one of the painters 'who were most closely attached to the first impressionists or who were their pupils'.

Paul went in early June to l'Estaque and spent the summer there; and on July 2nd he wrote again to Pissarro. He was giving much thought to the problems of exhibition; the

comments on Monet revolve round the fact that that painter had managed to get into the 1875 Salon. We see also that Paul hadn't given up hope of drawing Pissarro south.

I'm forced to reply to the fellow-feeling [*sympathie*] of your magic crayon with an iron point [pen]. If I dared, I'd say your letter has the imprint of depression. Pictorial matters don't go well. I'm afraid that you are morally influenced somewhat in grey; but I'm convinced it's only a passing thing. I'd rather not talk of impossible matters, yet I always make plans quite impossible to realize. I'd imagine the country where I am would suit you wonderfully. There are some famous bother-ations, but I think they're purely accidental. This year it's rained weekly two out of seven days. Which is astounding in the south. Such a thing has never been seen.

I must mention that your letter came to catch me at l'Estaque on the seashore. I'm no longer at Aix, which I left a month ago. I've started two little motifs with a view of the sea: they're for M. Choquet who spoke to me about them. It's like a playing-card, red roofs over the blue sea. If the weather turns propitious, I may carry them through to the end. So far I've done nothing. But motifs could be found which would need three or four months work, as the vegetation doesn't change. Olives and pines are the trees that always keep their leaves. The sun is so frightening here that it seems to me as if objects were silhouetted not only in black and white but in blue, red, brown, and violet. I may be mistaken but this seems to me the antipodes of modelling. How happy our gentle landscapists of Auvers would be here and that arse of a Guillemet. As soon as I'm able, I'll spend at least a month in these parts, as it's necessary to do paintings of at least two metres in size, like the one you sold at Faure.

It appears from these statements that he is looking at the Provençal landscape with fresh eyes after his period with Pissarro round Auvers, and is making the decisive change in his outlook which supplants *couillarde* modelling with colour-modulation. In his previous work, under the influence of Courbet and Daumier, he had tended to make strong oppositions, without gradations, between light and shadow. Shadow had been for him not space of a lessened light-penetration or even the absence of light, but a positive force expressed by blacks. At Auvers he learned to define volume by modelling through tone; he began to work on a system that was based not on the shadow-light opposition, or even on a gradation of shadow-penumbra-light, but on a modulation of colour itself. The study of the Provençal scene in terms of these emerging principles was confirming him in his new approach to colour. His letter to Pissarro continues:

If we have to exhibit with Monet, I hope the Exhibition of our Co-operative will be a flop. You'll consider me a low dog (*canaille*), possibly, but one's own affairs come first before all else. Meyer, who hasn't got in hand the elements of success with the co-operative, seems to me to be turning into a shitty stick and trying, by advancing the date of the impressionist show, to damage it. He may tire out public opinion and produce confusion. First, too many shows seem bad to me; secondly, people who may think they're going to see impressionists will see only co-operatives. Cooling off.— But Meyer must be all out to harm Monet. Did Meyer make a few sous? Another question: if Monet's making money, then why, since this exhibition succeeded, would he fall into the trap of the other one? Once he's successful, he's quite justified. I said: Monet—meaning: Impressionists.

Meanwhile I rather like the gentlemanly behaviour of M. Guérin, ninny, who goes about to degrade himself among the rejected co-operatives. I give you those ideas, perhaps somewhat crudely, but I haven't a lot of subtlety at my disposal. Don't mind that, and then on my return to

Paris we can discuss the matters, and run with the hare and hunt with the hounds. So if the impressionists serve as a useful set-off for me, I'll exhibit with them the best works I have, and something neutral with the others.

Paul's notion of the correct tactics for himself and the other artists is not altogether clear, but there seems to be an ignoble notion that one's aim in all shows and the like is to make enough reputation to force one's way into the supreme glory of the (despised) Salon; and once this goal has been achieved, an artist is released from any ties of loyalty to his colleagues.

My dear friend, I'll end by saying that as some of us have a common tendency, let's hope that necessity will force us to act in concert and that self-interest and success will strengthen the ties that goodwill too often wasn't able to consolidate. Lastly, I'm very glad M. [Ludovic] Piette [landscapist] is on our side. Remember me to him. Regards to Mme Piette and Mme Pissarro, love to all the family, a firm handclasp, and fine weather for you.

Just imagine, I'm reading the *Lanterne de Marseille*, and I must subscribe to *Religion Laique*. How's that? I'm waiting for Dufaure to be knocked out; but from now on to the partial renewal of the Senate, there's lots of time and how many dirty tricks [*embûches*]. Wholly yours, Paul Cézanne.

If the eyes of the folk here could emit murderous glances, I'd have been done for long past. My head doesn't suit them. P.C.

I may return to Paris at the month-end. If you write sooner, address: Paul Cézanne, Maison Girard (called Belle), Place de l'Eglise at l'Estaque, Banlieue of Marseille.

We have here another clear indication of Paul's strong radical position in politics during these years. He knows that Pissarro with his deeply-rooted socialist views will be glad to hear that he is subscribing to radical and anti-clerical papers; and he expresses his support of the Commune by his unforgiving attitude to Dufaure, who had been Minister of Justice under Thiers and thus directly responsible for the murderous treatment of the Communards after the storming of Paris. Between 17,000 and 25,000 people were shot offhand, and the problem of what to do with the masses of corpses was acute; the Seine was stained with long streams of blood. Some 38,568 prisoners (of whom 1,858 were women) were held at Versailles; and prosecutions and transportations went on until 1874. Dufaure issued on 23 April 1871 a circular to all district attorneys commanding them to prosecute 'the apostles of conciliation who set on a level the Assembly elected by universal suffrage and the self-styled Commune of Paris.' Paul, at l'Estaque, close to insurgent Marseille, must have had Dufaure's name imprinted on his mind as especially infamous. Commentators have uniformly turned a blind eye to this letter as to the other statements of Paul's political interests.

In August he returned to Paris. Zola had again been having trouble with his work. His novel *Son Excellence* was ignored; but when in April *Le Bien Public* started serializing *L'Assommoir* (the dramshop, low tavern or drinking den, but with a root-meaning of poleaxe, loaded bludgeon, fall-trap), there was an uproar and many readers cancelled their subscriptions. By June 6th publication had to stop. However, on July 9th *La République des Lettres*,

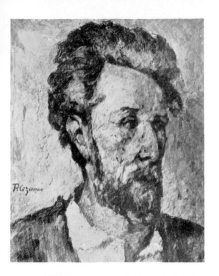

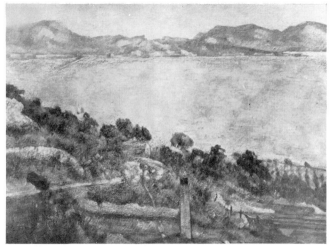

57 (above left) Portrait of Victor Chocquet, 1876–77

58 (above) The Gulf of Marseilles seen from l'Estaque, 1883–85

59 (left) Bathsheba, 1875–77

60 (below) Houses at l'Estaque, 1882–85

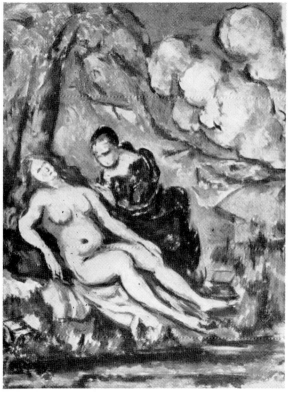

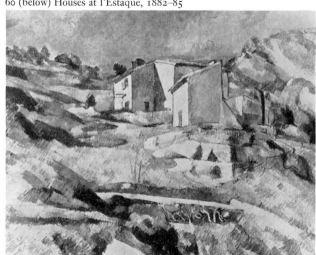

61 (right) Gardanne, 1885–86

62 (left) L'Estaque, Melting Snow 1870

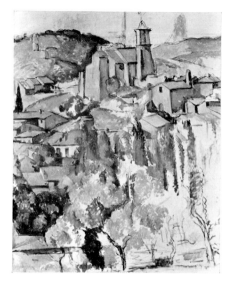

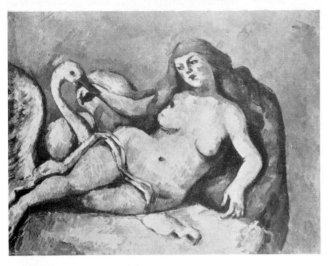

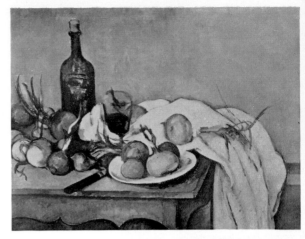

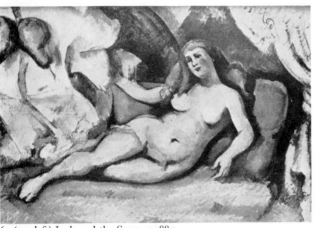

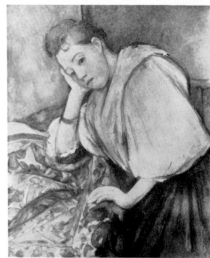

63 (top left) Leda and the Swan, *c* 1885
64 (top right) Still Life with Onions and Bottle, 1895–1900
65 (above left) Naked Woman, *c* 1885
66 (above right) Italian Girl Leaning on Her Elbow, *c* 1896
67 (below left) The Apotheosis of Delacroix, 1873–77
68 (below right) Maison Lézardée, 1892–94

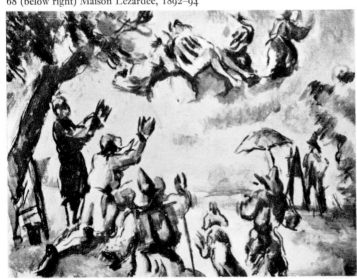

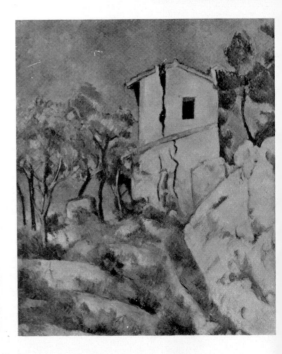

edited by Catulle Mendès, took the serial over. As it is not till next year that any of Paul's letters to Zola survive, we do not have any statement of his reactions, but he must have been confirmed in his antagonism to the bourgeois public.

In the 1870s Paul, though being drawn more and more through Pissarro into landscape-painting, had in no way relinquished his hopes of achieving figure compositions in which he could express his ideas and emotions. Works like *The Autopsy, The Strangled Woman, The New Olympia* and its many associated studies (shading off into variants of the *The Wine-Grog (Punch), The Eternal Feminine*, as well as *The Temptation*, revealed the turmoil of emotions into which the war and the civil war, his liaison with Hortense and the birth of a son, had cast him. The sadistic fury of *The Strangled Woman* shows a sense of bottled-up terror and fury, a conviction of being cornered and fettered for life by the event of child-birth; his close contact with that event would also in itself stir all the buried traumatic anxieties connected with his own mother. Rape-murder is done in a wild swirl of *couillarde* brushwork. *The Autopsy* on the other hand has clearly demarked areas in strong agitated rhythm, but with a disarticulation of parts which derives, in the last resort, not from any weakness of drawing but from an intense inner conflict about his own body and its urges. In the black space without air or depth the bald man, suggestive of himself, seems at first glance to be plunging his arms into the dead body. The dead body provides three long curves (made up by the arms, legs and shadow cutting the thorax and continuing between the legs), with contrary curves coming in from the woman's sleeve and the bald man's arms; the pivotal point is given by the right forearm of that man in the middle—a sort of spheroid that determines the rest of the pattern. Since the other curves swing or branch out from this point, we feel action is concentrated there: hence the effect of the hand and arm plunging into the genital area of the corpse. Above the plunging arm hangs the bald skull; and the oscillation of the curves about the line of skull-arm gives life to the hard disarticulated system of airless forms. It is as if the detached head (mind) is bearing the burden of a dead but compulsive sex-life (the emotional conflict of this picture will become clearer when we consider soon the series of bathers with diagonal arms). This work, though often dated in the early 1870s, may well be earlier—though Paul's very bald cranium suggests at least 1869–70.

In the two direct fantasy-variants on Manet's *Olympia* Paul made a quite different approach to the matter of sex. Here he is the spectator, who apparently controls the situation. He sits in the foreground with his back to the audience; and the presentation of the naked girl is dramatized, frankly turned into a daydream of luxurious vice. The bouquet becomes a great burst of flowers and the negress-attendant unveils the girl with a lavish gesture. The earlier version is much cruder, though with the same general system; in the second, the colours have also grown clearer, with blacks reserved for Paul and the little dog. But in both works, as in the series of the *Grog au Rhum* (where we meet both a negress and

an ordinary *bonne* bringing in refreshments), there is a mixture of amused irony, satire, and sexual excitement.

In *The Eternal Feminine* (or *Woman*) a few years later we meet the same mixture. A naked woman with open legs is enthroned on her canopied bed and surrounded by a throng of admirers, who include the artist himself, musicians, and a bishop in canonicals. There is a hint of Delacroix's *Sardanapalus* in the composition, suggesting the link of love and death. Lack of depth is again compensated for by a sort of swinging movement: the woman lies under the angled canopy, with the ring of worshippers curved round below, so that she oscillates as if at the pull of their competing adorations. Her arms and legs repeat the rhythms. (Fig. 82.)

Paul seems to have been in an excited physical state during this period. There are many other works with nudes where the treatment shows an agitated condition, such as the studies of a naked woman with dressed servant, a nude at her toilet (inspired by *The Rising* of Delacroix), *Venus and Cupid*, various *baigneuses*. As Pissarro's influence grows, the dark airless space breaks open; the black contours fade out, a new treatment of edges appears (as Paul attempts the free handling of Delacroix in a lyrical vein). The climax of this phase appears, perhaps, in *The Struggle of Love*. Here we have four pairs of wrestling naked lovers, with a wildly leaping dog. Behind the image lies, not Poussin's *St John Baptizing* (as has been suggested), but Delacroix's *Jacob Wrestling with the Angel*, where we find the same sort of correspondences (crossed trees and an entangled pair). The interlacing forms of the lovers are dynamically repeated everywhere in the landscape—in the swirl of clouds and trees, in the rippling energies that animate every inch of the scene; they are expressed by the rich entanglement and fusion of colours as much as by the twining interweaving forms. All is connexion, interchange, a ceaselessly shifting and reasserted balance of unbalanced forces. Once again a version, only briefly earlier, shows how carefully Paul studied his work, pulling it to pieces and quickly re-creating it on a far more secure level. The date was probably the later 1870s.

But before he reached the release of *The Struggle of Love* Cézanne had returned to the Temptation theme. The darkish colour, dominated by blue and neighbouring tones, with only the devil's red cloak as a striking contrast, suggests the same period as *Woman*. Unlike the first *Temptation*, the picture makes the confrontation of saint and naked woman the central theme. A study, rather rough in treatment, shows the saint veiling his eyes with one hand and turning away. The developed work draws him into the composition and links him with the nude through his outstretched arm; and the whole design is far more drawn together. The devil takes the part of the procuress in early representations of seduction; indeed, a procuress actually figures in some seventeenth-century *Temptations*, e.g. that of Teniers. In the painting there is also a monkey with a staff and a big bird in the sky, as well as a row of cupids. The inspiration has been Flaubert's *Temptation* with its Queen of Sheba episode, where at the Queen's whistle a big bird comes down and settles on her hair, while

twelve small Negroes bear her train and a monkey at the end lifts it up from time to time.

Paul changes the proud and elegant Queen into a lewd wench. The devil here is his addition—though in Flaubert he is incarnated in the Queen and appears in other episodes in his own person. On one sheet of a sketchbook is a draft of the whole picture, two nude studies, and the scribbled start of a poem that seems to read

> to my seduction
> From my body bursting . . . the fleshtint [*carnation*]
> Licenses and doesn't resist seduction

We are reminded of the poem in the letter to Zola of December 1859 where Satan commands the diabolic dance. 'My senses froze with fright . . .'

The Temptress has one arm raised, the other stretched down in a variation of the diagonal-arm tension that had such a great emotional significance for Paul, expressing joyous surrender or terrified conflict according to the way it was defined. Here the direct inspiration was an engraving by Marcantonio, *Incense-burner*, in which Caryatids in the same pose as the Temptress form the stand. Thus is explained the odd way in which the latter has her left hand reversed. In the engraving this hand would be joined with the lowered hand of the next Caryatid; here it turns away from the saint. The Caryatids no doubt reminded Paul of his first Temptress; but they had their strong impact because of the appeal of their pose in itself.

As for the saint's gesture, Paul had earlier made a drawing for Molière's *Tartuffe* in which outstretched arms have the same significance. He was illustrating:

> Cover that breast I don't know how to look at.
> For souls are wounded by such things to sin.
> They make our guilty thoughts rise up within.

But he was probably also recalling baroque paintings. The date of his second return to the *Temptation* was around 1875.

In landscape, during these years, he was learning much in his own way from Pissarro, learning how to use a quick broken touch and develop atmospheric effects. As we saw from *The Suicide's House*, he was at the same time struggling towards a new solidity; and this latter quality appears in his studies of bathers. He seems to have made an important turn about 1875. Probably he then painted *The Alley at the Jas*, in which he returns in some ways to his earlier use of paint.

In the foreground there is a bank of grass rendered in vertical streaky touches which have no parallel in anything painted during the time of close contact with Pissarro. . . The solid and deep colour of *L'Allée* differ greatly from the broken touch and silvery tone of these pictures. . . Perhaps the passage on the right of the picture in which the mass of foliage breaks up and begins to form into separate, delicately drawn leaves, pointing towards the style of 1875–6, is indicative. *L'Allée* seems to belong to the immediately preceding phase: it may have been painted in 1874. (Gowing)

In portrait we see him moving from that *au fond rose* with its broad treatment and subdued colour (found also in the landscapes of the 1873–4 winter, with their Venetian reds) to the *Choquet* with its small squarish strokes and impressionist colour-analysis.

We may say, then, that by 1875–6 he was still close to Pissarro, but structure, rhythm and spacing were reasserting themselves now in a much more sensitive way than in his earlier work; they were more related to direct observation and had an intimate sense of natural process.

III *Secure Achievement (1877–9)*

ON 4 April 1877 the impressionists opened their third show in tall rooms at 6 Rue Le Peletier, which they had rented on the second floor of an empty house in the throes of reconstruction. The exhibition had been made possible by Caillebotte. Though only twenty-eight, he felt sure he would soon die ('All my family die young') so he had drawn up his will stipulating that the sum of 30–40,000 francs needed for a show should be available if necessary. Convinced that the new men would make their way in 'twenty years or more', he bequeathed his collection of their work to the Luxembourg (so that they might go later to the Louvre) at that length of time, adding that, if he died meanwhile, his brother would look after the pictures. Much work was put into the preparation for the show in the autumn and winter of 1876. Durand-Ruel had leased his gallery for a year: hence the search for premises. Caillebotte overcame all difficulties, and the show was ready for the spring 1877. This time it was far more homogeneous than before, and at Renoir's suggestion it was called *The Impressionist Exhibition*. The name would tell the public: 'You will find here a kind of painting you don't like; if you come, it's your own fault you won't get your entry-fee of ten sous back'. The hanging committee of Renoir, Monet, Pissarro and Caillebotte, gave Paul the best place for 16 of his works: five still lifes, portraits of Choquet and a woman, a study of Bathers, a Tiger (after Delacroix), three watercolours (one of flowers, two land-scapes). The catalogue gives his address as 67 Rue de l'Ouest. He was now thirty-eight, and it was time he made some mark. Monet showed his *Gare St Lazare* and *Dindons Blancs*; Renoir, *La Balançoire* and *Bal au Moulin de la Galette*. These works with Paul's and Berthe Morisot's held the place of honour; further on were works by Guillaumin, Sisley, Pissarro, Caillebotte, with more Monets.

The first visitors were not unsympathetic. 'Even those who had come to criticize halted before more than one picture in admiration', said the *Siècle*. The *Courrier de France* remarked that, 'One might think the hostility that the impressionists stirred up by their early works was perhaps due to the clumsy and maybe brutal expression of a profound astonish-ment'. But then the general press came in with the same sort of attacks as before. On Renoir's advice, G. Rivière published for the show's duration a periodical, *L'Impressioniste*, the first issue appearing April 6th. But this, sold by hawkers outside, was read only by a few intellectuals. The press attack was decisive in changing the mood of spectators into one of ribald mockery. Crowds thronged the rooms in rowdy disapproval. It was impossible, said Barbouilotte in *Le Sportsman*, 'to stand for more than ten minutes before some of the more sensational canvases without feeling seasick'. Choquet was present all the time arguing in

defence of the pictures in his calm polite way, and people thought he was a harmless lunatic. Paul went sometimes to see his friends there and sat listening in silence, while Choquet insisted it was only a matter of time for the blind to see. Choquet indeed managed to persuade a few collectors to buy works by Renoir, Monet, Pissarro, but failed with Cézanne; some critics might weaken in denouncing Monet, Renoir and the others, but they blanched before Paul's work. He was a madman, a monster, a Communard.

Messieurs Claude Monnet [*sic*] and Cézanne, happy to find themselves in the limelight, have shown the former 30 canvases, the latter 14 [*sic*]. You must see them to imagine what they're like. They show the most profound ignorance of drawing, composition, colour. When children amuse themselves with paper and colours, they do better. MM. Levert, Guillaumin, Pisarro, Cordey, etc. do not deserve to have anyone pause before their works. (R. Ballu, *La Chronique des Arts et de la Curiosité*, 14 April 1877)

If you visit the exhibition with a woman in an interesting condition, pass quickly before the portrait of a man by M. Cézanne. . . That head, colour of boot-tops, with so strange an aspect, might impress her too sharply and give yellow fever to her fruit before its entry into the world. (Leroy, *Charivari*, 11 April)

A real intransigent, hotheaded and fantastical. When we look at his bathers, his head of a man, his female figure, we must admit that the impression nature makes on him is not *that* which the painter feels. (*Le Petit Parisien*)

The Choquet portrait was nicknamed 'Billoir in Chocolate'—Billoir being a murderer who had cut a woman into small pieces. Paul Mantz in *Le Temps* wrote, 'They have closed eyes, a heavy hand, and superb contempt for technique. There is no need to concern oneself with these chimerical minds who imagine that their casualness will be taken for grace and their impotence for candour'. He was reassuring the academics and the connoisseurs who had bought their pictures. 'One need not fear that ignorance will ever again become a virtue'. When the director of *L'Artiste* asked Rivière for an article, he 'begged him not to speak of Pissarro and Cézanne, so as not to scare off the review's readers'. But in *L'Impressioniste* Rivière had freedom to speak his mind:

M. Cézanne is a painter and a great painter. Those who have never held a brush or pencil claim that he does not know how to draw, and have criticized him for imperfections which are actually a refinement gained through tremendous knowledge. His beautiful still lifes, so exact in tonal relationships, have a solemn quality of truth. In all his painting the artist produces emotions because he himself experiences in the face of nature a violent emotion which his craftsmanship transmits to his canvas. . .

His canvases have the calm, the heroic serenity of ancient paintings and terracottas, and the ignoramuses who laugh before the *Bathers*, for example, have on me the effect of barbarians criticizing the Parthenon.

Though the leading impressionists were slowly gaining some recognition, they still had few buyers. Morisot and Paul were well off; but Monet, Pissarro and Renoir, almost wholly dependent on sales, were often very hard up, and Sisley at times faced starvation; Guillaumin had a small wage. This year another auction was tried, Renoir, Pissarro, Sisley and Caillebotte contributing 45 works and getting on an average only some 170 francs per

picture—not to mention that many paintings had been bought by the artists themselves. The only dealer buying their work was Durand-Ruel; and though he got the canvases cheaply, he still lost money on them. The group went on holding shows (1879, 1880, 1881, 1882, 1886), though in no case did all the original members come together; and Paul never sent anything in again. Only a few weeks before his death he recalled these years to his son:

I am deeply touched by the kind of memories of me that Forain and Léon Dierx have been good enough to retain: my acquaintance with them goes back quite a long way. With Forain, to '75 at the Louvre, and with Léon Dierx to '77 at Nina de Villars' in the Rue des Moines. I must have told you that when I dined at the Rue des Moines there were present at the table Paul Alexis, Franck Lami [Lamy], Marast, Ernest d'Hervilly, L'Isle Adam, and many others, and the lamented Cabaner. Alas, how many memories have been swallowed up in the abyss of the years.

It may seem surprising to find Paul at dinner parties; but Nina de Villars, young and pretty, a good pianist, was 'a princess of Bohemia' (Larguier). Liking the society of painters, she kept no formality; guests sat down on arrival, and latecomers had warmed-up dishes. We are told that Paul turned up on the appointed day, rang, and got no answer; rang again and still got no answer. Suddenly the door was opened by a maid in a *negligée*, with un-buttoned corsage and splendid golden hair hanging to her knees. She asked what he wanted, and told him he was too early. He ran off, but came back later. Cabaner, whom he met there, became one of his enthusiastic supporters. Imaginative and talented, he lacked application, and was better known for his wit than his music. A Catalan from Perpignan, he was short, thin, and sickly in appearance, but had a mocking tongue. 'My father was much the same sort of man as Napoleon, but less stupid'. Once, Paul, who had set out with the canvas of *Baigneurs au Repos* to find a buyer, met him in the street, unwrapped the picture, and set it against a wall. 'It's come off fairly well, hasn't it?' Cabaner admired it so much that Paul gave it to him, 'very happy' that it was going 'to someone who likes it'. (It is hard to imagine Paul in search of a buyer; perhaps he was taking the work to Tanguy or to some friend.)

This year Zola at last achieved success and matured his method as a novelist in *L'Assomoir*, a picture of working-class demoralization. This work may be called the first important novel based on the working-class: *Germinie Lacerteux* by the Goncourts came later. And in any event *L'Assomoir* was differentiated from the latter work by its different approach, its underlying scope, its passion. Here the workers are shown as going downhill. We must recall that the 1870s were a period of repression. The Communards were not amnestied till 1879; and only in 1880 did the workers regain enough cohesion to form a political party. But while dealing with the way in which bourgeois greeds and corruptions sink downwards and affect the whole of society, Zola conveys a sense of great energies and powers deflected into decay. In his novel are types like Goujet, the smith who symbolically forges modern civilization. (Incidentally we may note that here is Zola's version of the *Hercule Gaulois* that interested Paul. Probably he and Paul had halted before Puget's

statue in the Louvre while Paul expatiated on its merits. Goujet's 'shoulders and arms seem sculpted, as if copied from those of a giant, in a museum'.) In *L'Assomoir*, also, as we noted above, Zola achieved a new sort of style, in which, taking the idiom of the characters in speech as the criterion, the narrative loses its effect of a literary frame and is assimilated to speech-forms. Thus a new sort of unity is gained, in which the whole texture of the work reflects the central idea as embodied in the people of the action. The author disappears into the work, not to become a neutral and objective God's-Eye as in the Flaubertian system, but to share the lives of his characters at their own level, contributing only the deepened consciousness of relationships that makes up the aesthetic unity. This development of what we may call a new sort of textural unity, with varying planes of vision, is Zola's counterpart of the new concepts of space and objects in interrelation which Paul was working out in his colour-modulations.

L'Assomoir had a great success. By the end of 1877 the 38th impression had appeared, and by 1881 a hundred thousand copies had been sold. At the same time a lift was given to the sales of earlier works. Zola had broken through the boycott; but Paul was still as far as ever from such a breakthrough.

In 1877 it was Zola who spent the summer in the south. He had got 18,500 francs as royalties for the first 35 printings of *L'Assomoir*, and could take his ease. He went to l'Estaque, working on *A Page of Love* and eating vast quantities of bouillabaisse, shellfish and spiced dishes, 'a mass of delicious filth'. He called on Mme Cézanne at her l'Estaque house; he had always been friendly with her. On June 29th he wrote to a friend, 'The country is superb. You'd perhaps find it arid and desolate, but I've been reared in these rocks and in these stript wastes, so that I'm brought to tears on seeing it all again. The very smell of the pines evokes all my youth.' Paul was working at Pontoise beside Pissarro in his huge kitchen-garden at Auvers, where Gachet noted his movements in his journal; and, wandering towards Chantilly and Fontainebleau, on the banks of the Seine and the Marne. He also joined Guillemet at Parc d'Issy-les-Moulineaux. In Paris, Duranty wrote to Zola, he 'appeared a short while ago at the little Café on the Place Pigalle in one of the costumes of olden times: blue jacket, vest of white linen covered with the strokes of brushes and other instruments, battered old hat. He made quite an impression'. Pissarro had introduced him to a young stockbroker, Gauguin, working in the Banque Bertin, Rue Lafitte, who had taken lessons in the Académie Calarossi and had a canvas accepted at the last year's Salon, but had turned to the dissidents. Gauguin disliked Paul's slovenly dress and his faecal language, not to mention his arrogant assumption of humility, but he admired his work and bought some of his paintings as well as Pissarro's.

On August 24th Paul wrote to Zola from Paris. The tone of his letter proves that his relations with Zola over the recent years had been as close as ever; otherwise he would overflow with apologies and excuses for suddenly asking a favour from him. We see else-

where how humbly and protestingly he writes in such a situation; here he assumes that Zola will be ready to do as he asks—just as next year he has no compunction about landing on him for money.

I thank you warmly for your kindnesses to me. I'll ask you to let my mother know I want nothing, as I mean to pass the winter at Marseille. If, when December comes, she'll take on the job of finding me a quite small lodging at Marseille with two rooms, not dear, in a quarter however with not too many murders, she'll do me a great favour. She could have a bed brought there and what's needed for sleeping, two chairs, which she can take from her house at l'Estaque to save too many heavy expenses. Here the weather, I must inform you, the temperature, is very often refreshed by munificent showers (Style of Gaut of Aix).

I go daily to the Parc d'Issy where I make studies. And I'm not too badly satisfied, but it appears a profound desolation reigns in the impressionist camp. Pactolus [gold] doesn't exactly flow into their pocket, and studies dry out on the spot. We live in a very troubled period, and I don't know when poor painting will regain a little of its lustre. Was Marguery less desolate on this last excursion to Tholonet? And have you seen Houchard, Aurélien? Apart from two or three painters, I've seen absolutely nobody. Will you go to the agapes of Cigale [society of writers and artists of the Midi, founded in Paris, 1876, with a yearly banquet]? For a month and a half Daudet's new novel has been appearing in the *Temps*, yellow posters, stuck up even at Issy, have informed me. I also know that Alexis will be played at the Gymnase [theatre]. Are the seabaths doing Mme Zola good, and you, do you cleave the salty waves? My regards to everyone and a cordial handclasp for you. Au revoir then when you return from the sunny shores. I am the painter thankful for your kindness.

A little later he wrote again, asking Zola to tell Mme Cézanne not to worry as he had changed his plans in view of various difficulties. However he still meant to come south to Aix 'in December, or rather in early January'. The night before he had encountered 'dear Emperaire' at Père Tanguy's.

The younger artists soon to come up were to follow the older *plein-airistes* in going to Tanguy—Gauguin, Van Gogh, Signac, Toulouse-Lautrec. Somehow Tanguy linked the clear bright colours of the new painters with the free society he hoped for, just as he identified tobacco-juice colours with the bourgeoisie. Pissarro would have agreed, seeing clarity and truth in art as anti-bourgeois: 'England, like France, is corrupt to the very marrow of its bones, and the only art it has left is the art of throwing dust in people's eyes'. Tanguy not only accepted pictures in place of cash, but also fed the artists when hungry, together with whores and beggars. His loving wife protested, but somehow managed to provide food. After this year, 1877, it was Tanguy who kept Paul's work from being forgotten; for he was always pleased to show his Cézannes. Vollard owed his introduction to Paul's paintings to Tanguy's collection, and thus Tanguy was in fact the begetter of the 1895 show which at last brought Paul effectively before the art world.

1878 is better documented for Paul. His correspondence with Zola is well preserved: this year we have 18 letters to him as well as one to Caillebotte and perhaps one to Roux. In early March Paul had gone south. This time he stayed there a year, and with his meagre allowance had no choice but to take Hortense with him. He stowed her away at 183 Rue de

Rome in Marseille, ten kilometres from l'Estaque (which was 30 from Aix). Terrified all the while of being found out by his father, he fretted over the problem of money and the possibility of now at last, at the age of thirty-nine, being forced to earn his own livelihood. So he turned to the man on whom he knew he could always rely for help, Zola, and on March 3rd wrote to him:

My dear Emile, I'll soon find myself forced to gain some resources by myself, if however I'm capable of it. The situation between my father and me grows badly strained, and I'm threatened with losing all my allowance. A letter written to me by M. Choquet, in which he spoke of Madame Cézanne and the little Paul, has definitely given my position away to my father who was anyhow on the lookout, full of suspicions, and who has had nothing more urgent to do than to unseal the first letter addressed to me, though it bore the superscription: Mons. Paul Cézanne, artist painter.

So I appeal to your benevolence towards me to ask you to look round in your circle and use your influence to arrange something, if you consider it possible. The break between me and my father isn't yet complete, but I don't think I'll spend another fortnight without my position being fully settled. Write (addressing your letter to M. Paul Cézanne, *poste restante*) and tell me what decision you've reached as to my request. Kindest greeting to Mme Zola and a firm handclasp to you. I write from l'Estaque, but return to Aix this evening.

Paul was expected back to dinner at Aix, and such was his dread of his father that he feared to miss a meal; he must have spent much of this period in tramping between Marseille, l'Estaque, and Aix. He was crushed by his father's threat to reduce his allowance by half, to 100 francs a month. Besides the problem of keeping himself, Hortense and the boy, he was badly in debt. He had kept on getting materials from Père Tanguy without paying him, and before he left Paris he had handed over an IOU for 2,174 francs, 80 centimes. Yet it seems that he was already in possession of his inheritance, as his father, to escape death duties, had divided his estate among his children. Such was Paul's abject fear of Louis Auguste, however, that he was quite incapable of urging even his clear legal claims; perhaps he feared that his astute father had left some loophole in the settlement and, if upset, would reclaim the money. Yet it is obvious that Louis Auguste now knew perfectly well that Paul had a woman and a son. He had read Choquet's letter. Numa Coste in a letter to Zola remarked that old Cézanne knew that 'Paul has a brat. He said to someone who questioned him: It seems I have some grandchildren in Paris; I'll have to go and see them some day'. Also we have a story of his meeting Villevielle one day and saying abruptly, 'You know, I'm a grandfather'. 'What do you mean? Paul isn't married'. 'He was seen coming out of a shop with a rocking horse and other toys. You're not going to tell me they were for himself'. 'So much the better', Villevielle commented. 'It's about time you found out'. The only interpretation of the situation that makes sense is that Louis Auguste wanted to force Paul into admitting the truth, but Paul was so paralysed by fear in his presence that he could only lie blindly and miserably. His mother and sisters knew the facts. After the birth of the boy they must have urged Paul to confess to his father and to marry Hortense. Marie, intensely respectable and pious, is said to have told him again and again, 'Marry her,

why don't you marry her?' But Paul could not act in any direct way. He could only make hopeless efforts to cover up things, while appealing to Zola for help.

By March 28th he was feeling a little better. He had kept on lying and felt that he had worn his father down.

I think as you do that I shouldn't renounce too impulsively the paternal allowance. But judging by the snares laid for me, and from which I've so far escaped, I foresee that the great argument will be about money and the use I should make of it. It's more than likely I'll not get more than 100 francs from my father, though he promised 200 when I was in Paris. I'll then have recourse to your kindness, all the more because my little boy has been ill for the last fortnight from an attack of typhoid fever. I'm taking all precautions to stop my father from gaining abolute proofs.

Excuse me for the following comment. The paper of your envelopes and notepaper must be heavy: at the post I had to pay 25 cmes for insufficient stamping—and your letter held only one double sheet. When you write, would you please only enclose a single sheet folded in two. If as a result my father doesn't give me enough, I'll turn to you in the first week of next month, and I'll give you the address of Hortense, to whom you'll be kind enough to send it. Remember me to Mme Zola. I clasp your hand, Paul Cézanne.

He thought there would soon be another impressionist show; he had had an invitation to a preliminary meeting at the Rue Lafitte on the 25th, but 'naturally I didn't go'. He asked Zola to send for the show the still life with the black marble clock in it, and asked if *A Page of Love* had come out in book form. However, soon afterwards he heard that the show had been given up. In his next (undated) letter he discussed the novel, which Zola had sent him with an inscription; and his comments bring out the insight and understanding with which he read his friend's work.

I haven't yet got far in reading it. My mother is extremely ill, she's been in bed ten days, her condition is most serious. I stopped my reading at the end of the description of the sun setting over Paris, and of the growth of reciprocal passion between Hélène and Henri. It's not for me to praise your book; for you can reply like Courbet that the conscious artist awards himself just praises in another manner than those coming from outside. So what I say is only to make you understand what I can perceive of the work. It seems to me a picture more gently painted than in the previous work [*L'Assomoir*], but the temperament or creative force is always the same. And then, if I don't commit a heresy, the progress of the passion between the heroes is more consistently graded. Another observation, which seems to me correct, is that the places, by their way of painting, are impregnated with the passion that agitates the persons, and thus make more a body with the actors and are less dissociated from the whole. They seem to be animated, so to speak, and to share in the sufferings of the living beings. Further, according to indications in the papers, this book will be at least a literary success.

He states clearly his grasp of Zola's poetic method, with its dynamic unity of man and nature, and he realizes that in *A Page* the writer has attempted a more restrained and psychological presentation of character and conflict ('I must make a study of passion, which is something I have not hitherto done'). Zola told Goncourt that he wanted to provide a striking contrast with *L'Assomoir*. The theme is the love-affair between a young widow and a married doctor; the widow has a fiercely possessive daughter, who dies as a result of

the affair and sunders the lovers. Hélène's fall is linked with the middle-class hypocrisy and promiscuity of Paris; and the work is largely an exterioization of Zola's fear of sex. In a postscript Paul mentions that he cannot go regularly to the post, and slips in a 'last-minute reflection. You observe the precept of Horace for your characters. *Qualis ab incepto processerit, et subi constet.* But you doubtless mock at it, so here again is one of the returns we get for things here below'. Why, after congratulating Zola on character-consistency, he adds his odd comment, it is hard to say—unless it is that he feels self-conscious after pedantically citing Latin.

On April 4th he wrote a letter which brings out well the ignominious position he was in.

Please send 60 francs to Hortense at the address below: Mme Cézanne, Rue de Rome 183, Marseille. In spite of the faith of treaties I've been able to get only 100 francs out of my father. Worse, I was scared he'd give me nothing at all. From various persons he gathers I have a child, and tries to catch me out by all possible means. He wants to disencumber me of him, he says. I add nothing further. It'd take too long to explain the bonhomme to you, but with him appearances are deceptive, you can take my word for it. When you can, please if possible write, you'll give me great pleasure, I'm going to try to get to Marseille. I dodged off Tuesday week ago to go and see my boy. He's better, and I was obliged to tramp back [30 km.] to Aix, as the train in my timetable was wrong and I had to be home for dinner. I was an hour late.

Louis Auguste's talk of ridding Paul of his encumbrances may have been a try-on to see how Paul would respond. He probably wanted to estimate how strongly Paul was entangled, and, knowing his fear of any claims or pressures, thought that he might reveal a wish after all to be helped. 'With him appearances are deceptive'. No doubt, now in his eightieth year, he was anxious to see his grandson. Ten days after the last letter Paul wrote again. He was just back from Marseille: hence his delay in answering Zola's letter, which he hadn't managed to get hold of till last Thursday. 'Thanks for sending twice. I write under the paternal eye'. He says that Villevielle's pupils insult him as he passes. 'I'll have my hair cut, it's perhaps too long. I am working: small in result and too far removed from general understanding'. (Villevielle had left Paris and was now settled at Aix, where, with some students, he painted religious pictures for colonial missions.) He adds an anecdote:

On my way to Marseille I was accompanied by M. Gibert. These people see all right, but own professors' eyes. As the train runs close to Alexis' country-house, a stupendous motif unfolds on the eastern side: Ste Victoire and the rocks dominating Beaurecueil. I said, 'What a fine motif.' He replied, 'The lines are too well balanced.' With regard to *L'Assomoir*, about which by the way he spoke first, he said some very sensible and eulogistic things, but always from the angle of technique. Then, after a long interval, 'It would have been good to have studied well,' he went on, 'to have passed the Ecole Normale.' I mentioned Richepin. He said, 'He has no future.' What a deduction: that chap did pass. And yet in a town of 20,000 souls he is beyond doubt the one who most and best devotes himself to art. I'll be very wise, I don't know how to be clever.

In May he wrote again, once more begging 60 francs for Hortense at the same address. 'I understand that just now you must be absorbed in your new book [*Nana*]; but, later when

you may, you'd give me great pleasure if you spoke of the artistic and literary situation'. On May 8th he completed his comments on *A Page of Love*:

My mother is now out of danger. She's been getting up for the last two days and that comforts her a lot, and she has better nights. For a week she was very worn out. But now I hope the fine weather and good care will put her quite on her feet again. I only fetched your letter yesterday evening, Wednesday: which explains the long gap between your despatch of it and my reply. I thank you for the news of my little canvas. I understand very well that it can't be accepted, because of my point of departure, which is too distant from the end to be attained, that is, the representation of nature.

I've just finished *A Page of Love*. You were indeed right to tell me it couldn't be read as *feuilletons*. I hadn't at all grasped the links, it all seemed cut up, while on the contrary, the working-out of the novel is done with a very great skill. There is a great dramatic sense in it. It's really regrettable that art matters aren't better appreciated and that it's necessary to attract the public by retouching, which doesn't belong exclusively [?] without harming it, it's true. I read your letter to my mother. She joins me in sending greetings.

The difference between Paul's relationship to his mother and that to his father could hardly be greater. At the moment his mother's illness had increased his problems. On May 1st, as in the previous month, Louis Auguste had paid over only 100 francs. Clearly he hoped, by providing insufficient cash for Paul to keep a family, to force him into confessing. But Paul's fears were even more stubborn than his father's determination to get at the facts of the situation. On June 1st he was again begging for 60 francs in a slightly shamefaced tone. 'My good family, otherwise excellent, is perhaps a bit hard over money for a wretched painter who has never known how to do anything. It's a slight failing, doubtless excusable enough in a province'. He has bought the illustrated edition of *L'Assomoir* 'at Lambert, the democratic bookshop', and notes the work is being serialized in *l'Egalité* of Marseille. 'I keep working a bit. Politicians hold a terrifying position. And how is Alexis?' Again in July he wanted 60 francs; Hortense was now at 12, Vieux Chemin de Rome; in ten days he thought of going to l'Estaque. Girard the landlord had been in an asylum, but had now come out. The weather was very hot; and Paul watched the papers to see if Zola would be awarded the order of the Legion of Honour. In an obscure anti-clerical gibe he remarks, 'It seems there has been not a bad knock-about at Marseille. A certain Coste junior, municipal councillor, distinguished himself by flourishing his stick over clerical shoulders'.

Hortense's move was no doubt to cheaper lodgings. Paul's mother, though tolerant and sympathetic to his sufferings, did not like Hortense; she was soon, however, devoted to her grandson. On July 16th Paul had been at l'Estaque a week, where Girard told him that his father-in-law was to visit Paris and would call on Zola (no reason is given). 'We've had notice at our house here; at the moment I'm at Isnard's, quite near Girard's place'. He still wonders about the order, says the days of great heat have come, gives thanks for the francs, and regrets the end of *Le Bien Public*, where Zola had been writing on the theatre (as he did later in *Le Voltaire*). 'I saw Guillaumin the gardener back from Cannes where his boss is going to set up a nursery'. On July 29th he recorded a fresh mishap. He had left the key of

his Paris flat with a cobbler, Guillaume, who used it to put up some of the people thronging from the provinces for the Exhibition. The landlord, annoyed at this unauthorized act, 'sent with last quarter's receipt a starched sort of letter, letting me know that my apartment is occupied by strangers. My father read this letter and concluded I am concealing women at Paris. The whole thing begins to look like a *Vaudeville à la Clairville* [a musical comedy]. Otherwise all goes well'. He was trying to arrange for a winter at Marseille, then a return to Paris in the spring, in March. 'At that time the atmosphere [here] gets overcast and I think I'll be able to make much less good use of my time in the open air. Besides, I should be in Paris at the time of the exhibition of painting'. (He still can't ignore the Salon.) He was pleased to hear of Zola's house at Médan, now bought; he could stay there and get to know the country around—or, 'if existence isn't possible there for me', at La Roche (Guyon) or Bennencourt, or 'a little here, a little there. I'll try to spend a year or two there as I did at Auvers'. He gave thanks for another 60 francs and thought he might spend a month in Paris in the autumn. 'I gave your kind messages to my mother and she was very glad to get them, yes, I'm with her here'. He was having 'pleasant trips on the water'.

On August 27th he again appealed for 60 francs. He couldn't find cheap enough lodgings at Marseille, where he'd like to winter, carrying on instead at a studio in l'Estaque. Then sometime during the summer he wrote with further demands on Zola's good nature, though not this time for himself:

Hortense on a visit to Aix called on Achille Emperaire. His family is in a state of dire want, three children, winter, no money, etc., you can guess it all. So I beg you (1) as Achille's brother is in the bad books of his ex-superiors of the tobacco administration, to do your best to get back the documents relative to his petition—if there's nothing for him to get in the near future (2) to see if you can find or help him to get a job of any sort whatever, e.g. in the docks (3) Achille also appeals to you for a job, no matter how slight it might be. If you can do anything for him, please do. You know how much he deserves it, being such a decent chap, undergoing such a crushing treatment by people and abandoned by all the clever ones. There it is.

We do not know what happened, but can be sure that Zola did what he could. He was much taken up at the time with his Médan house, originally built for a waiter at the Café Américain. On August 9th he had written to Flaubert, 'I've bought a house, a rabbit-hutch, between Poissy and Triel, in a charming spot on the Seine banks: 9,000 francs. I tell you the price so that you won't be too much impressed. Literature has paid for this modest rustic retreat, which owns the merit of being far from a station and without a single bourgeois neighbour'. At the outset it was indeed a small cottage, *pavillon*; but Zola soon added two big wings: that on the right with his huge study two storeys high. As soon as he settled in there was a steady flow of guests. Henceforth he spent some eight months a year in the country. The village of about 200 folk nestled among trees by the Seine, and the railway ran through the ground of his house. There were water-meadows and orchards, with rows of willows and poplars along the river. In his study was a great desk, a Louis XIII armchair, a monumental chimneypiece with *Nulla Dies Sine Linea* inscribed in gold

letters. Maupassant has described the overloaded and pretentious house, hung with ancient tapestries and lit by church-glass which threw chequered lights on a thousand whimsical gimcracks; the workroom 'spread with immense tapestries, encumbered with furniture of all times and all lands, medieval armour, authentic or not, side by side with surprising Japanese furnishings and gracious objects of the eighteenth century'. All sorts of styles were mixed together, Turkish and Gothic, Japanese and Venetian, genuine and fake; an alcove had a rood screen, a ceiling an ivory angel; fine porcelain stood by tasteless pots. When Paul saw it later, he doubtless smiled and shrugged, but it was not likely to have bothered him while he felt Zola was his friend.

Early in September a third compromising letter was read by Louis Auguste. On the 14th Paul said he was writing in a very composed frame of mind; but he had a fresh mishap to recount. Hortense's father had written to her as Mme Cézanne, and the Paris landlord sent the letter on to the Jas, where Louis Auguste promptly opened it. 'You can guess the result. I violently deny; and as happily the name Hortense doesn't occur in the letter, I insist it's addressed to some woman or other'. How he thought to divert his father by such feeble arguments, it is hard to say. He goes on to say that if he has weathered his troubles, it's through the 'good and solid plank you have held out to me'. His reputation with the architect Huot had gone up through his being able to claim acquaintance with Zola; and a reading of the book of Zola's plays has made him feel in the *Rabourdin Heirs* 'a note of kinship with Molière'. He hadn't imagined 'the dialogue would be so good and spirited'. He sends his mother's thanks. 'Pelouse is back from Paris; nothing is good. Remember me to Alexis and tell him that business-houses and artistic reputations are built up on hard work'. Then a postscript: '*Nota-Bene*: Father gave me 300 francs this month. Unheard of. I think he's making eyes at a charming little maid we have at Aix; I and Maman are at l'Estaque. What effects things have!' Perhaps Louis Auguste had felt a tinge of conscience; perhaps he was merely being worn down by Paul. In any event Paul's comment is an interesting sidelight on his father's character; he and his mother don't seem to object or find anything unusual in the amorous behaviour of the man of eighty.

Ten days later Paul was alone at l'Estaque. His mother had gone off eight days before for the vintage, the jam, and the removal. 'They're going to live in town, behind Marguery, or more or less'. Paul was himself going to Marseille in the evening to sleep—now at a flat, 32 Rue Ferrari near the Central Market—returning in the morning to work. He meant to carry on the whole winter thus. Zola's letter arrived, he says, as he was making *soupe au vermicelli à l'huile*, so much appreciated by Lantier in *L'Assomoir*. He again discussed the plays; said the *Heirs* reminded him of Regnard as well as Molière; and stressed 'the power and the links of the characters and the flow of the thing inferred' [*le coulant de la chose déduite*]—a rather odd phrase: presumably he praises the unity of character-definition with the analytic narrative. He had seen Marion—now professor of geology at the age of thirty-two—at a distance, and wondered if he should call on him. 'That will take a long

time to settle. He can't be sincere on art, perhaps in his own despite'. Then he made some remarks about Marseille which are of the greatest importance in showing how clearly he linked the standardizing and fragmenting trends of his world with the bourgeois cash-nexus, and how he saw the quest for beauty, the struggle to achieve an expressive and individual utterance, as a form of protest against the dehumanizing and flattening forces.

France's oil capital, just as Paris is the butter capital. You have no idea of the overweening conceit of this ferocious population; they have but one instinct, that of money; it's said they earn a lot, but they're very ugly. From the viewpoint of external life, the means of communication efface the salient sides of the types. In a few centuries it will be perfectly futile to live, everything will be flattened. But the little that survives is still very dear to the heart and the eye.

Though Paul did not often speak of his social convictions, he clearly thought hard about what was going on. Conversations with Zola and Pissarro, not to mention humbler persons like Tanguy and Gachet, must have helped him towards his matured views.

On November 4th he wrote to say that Hortense was alone in Paris; he asked Zola to lend her 100 francs. Why she had left him with the child at this difficult financial juncture, we have no clue. 'I'm in the kneading-trough', a mess, he declared. 'If you write, tell me a bit about art. I think always of returning to Paris for some months next year, about February or March'. A week later he wrote to Caillebotte about the death of his mother: 'I know well the painful void caused by the disappearance of people we love'. What experiences he refers to, we do not know. On the 20th he thanked Zola for lending (giving) Hortense the 100 francs. 'My little boy is with me at l'Estaque; but for some days the weather has been frightful'. Held up from work, he had been reading Stendhal's *History of Painting in Italy*: 'a tissue of observations of a subtlety that often escapes me, I feel, but what anecdotes and true facts. And the people *comme il faut* call the author paradoxical'. He had read the book in 1869, but carelessly; now he read it for the third time. He also read the illustrated *L'Assomoir*, 'Better illustrations would doubtless have served the publisher less well. Next time I chat with you, I'll ask if your opinion on painting as a means of expressing sensation is the same as mine'. The term *sensation* in relation to painting was not new, though Cézanne was to give it a new fullness and precision. This letter seems to contain his first use of it; the tentative way he puts his statement suggests that the idea was recent. The illustrated *L'Assomoir* had doubtless reminded him of the youthful dreams of a book by Zola illustrated by him. That is why he makes the rueful remark that better drawings would probably be less useful in gaining the novel a popular audience; and this side-glance at bad art leads him to express the new ideas he was forming of what really constitutes good art.

On December 19th he wrote to say he was still at l'Estaque, though Hortense had come back four days earlier and was again at Rue Ferrière. Her return was a great relief, for the child was still with him and his mother, 'and my father might have surprised us'.

It's as if there were a conspiracy to give my position away to my father. My Jeanfoutre [blasted fool] of a landlord is mixed up in it too. It was more than a month ago Hortense got the money I

begged you to send; and I thank you, she needed it badly. In Paris she had a little adventure. I won't confide it to paper; I'll tell you when I come back—besides it isn't important. Finally I think I'll stay here some months and leave for Paris near the start of March. I expected to taste the completest tranquillity here, and a lack of entente between me and paternal authority makes me on the contrary more tormented. The author of my days is obsessed with the idea of freeing me. There's only one good means for that, to stick another 2 or 3,000 francs a year on to me, and not make me wait till I'm dead to become his heir. For I'll finish before him, that's certain.

As you say, there are some very beautiful views here. The point is to render them. It's hardly my line. I've begun to see nature a bit late, though that doesn't prevent it from being full of interest for me.

We see that he still doesn't think of himself as at all primarily a landscape painter. That can only mean he is still more interested in his figure compositions. Next Tuesday, he adds, he was going to Aix for two days, and he begs Zola not to forget to send letters to l'Estaque.

By the end of the year his father gave up trying to probe into Paul's obvious liaison. No fool, he must have known that his wife was in the secret and was helping Paul; and this fact may have helped to quiet his suspicions that such a weakling as he considered Paul had become the victim of some unscrupulous woman of low character. What makes Paul's cowardly behaviour so hard to fathom is the fact, as we noted, that Louis Auguste, soon after his retirement in 1870, divided the bulk of his fortune among his three children. Paul junior and Maxime Conil could not name the exact date of the transfer, but were sure it happened several years before 1878. Even if Paul feared that the deed of gift had some clauses giving his father the right of revocation, it is odd he never refers to the facts of the situation. Perhaps he feared that if he let Zola know, he would be urged to stand up for his rights, which he was totally incapable of doing.

To this year of extreme strain we may allot Paul's final version of St Antony. Here the Temptress and her host have quite gone. The hermit is shown with his hut in a bare clear scene, accepting his crucifixion. Flaubert similarly moved in his revisions of his text further away from the perverse and the sensual aspects. It is interesting that Monet compared the two men and called Paul 'a Flaubert of painting, somewhat heavy, tenacious, assiduous . . . resting in the gropings of a genius that struggles pathetically to get a grip on itself'. After imaging himself as the hermit content to drudge in his desert-lair, Paul dropped the theme, his acceptance finding its expression in the Bathers, the Pastoral of the Earthly Paradise, where bodily release and union with nature have banished all conflicts. It is typical that one drawing of a nude in the Sheba pose (with reversed right hand) shows also a bather seated against a tree, and it is uncertain if the Sheba nude is a study for the *Temptation* or a transformation of Sheba into a carefree swimmer.

It was probably some time during this year that he wrote introducing Cabaner to Marius Roux. He expressed himself modestly. 'Though our friendly relations haven't been kept up, in the sense that I haven't often knocked at your hospitable door, I don't today hesitate to write. I hope you can well distinguish between my slight personality as impressionist painter and myself as a man, and I'd like you to recall only the comrade. Then

it's not the author of *The Shadow and the Prey* I invoke, but the Aquasixtain under the same sun whose light of day I have seen.' He mentions the day 'when the Salon will dawn for me'. He calls himself an impressionist, and earlier this year had been ready to exhibit with his colleagues, so it was not the bad reception he met in 1877 which made him fail to exhibit in 1879 and thereafter.

Possibly this year he came to know at Marseille the painter Adolphe Monticelli, who in 1870 had made a permanent return from Paris. To reach his place, Paul went behind the church of the Reformes, up the slope of the Cours Devilliers, then up the stairs of an old house to an untidy attic. Monticelli, some fifteen years older, was still a fine-looking man with a red beard and a dignity that his short legs could not mar. Once a dandy, he had grown negligent; but, poor as he was, he still clung to his dream of luxurious elegance embodied in an art of Venetian opulence and Watteau-esque gallantry, of shadowy gardens enclosing lovely women in a glow of gems, a drift of golden brocades. Delighting in operas and gypsy bands, he listened to the music, then hastened home to light all his candles and paint the dream as long as he could hold the brush. Unconcerned about recognition, he sold works only to gain a livelihood and ignored the critics who belittled or misrepresented his art; he scorned any bargaining about prices. He and Paul shared a love of Delacroix and could mock at the mocking world together. They roamed at times round Marseille; once, with haversacks, they are said to have spent a whole month in the hills, with Paul declaiming Virgil (Gasquet). Monticelli was reputed to be an expert in the matter of paint-preparations, with 'private secrets of trituration'.

On 28 January 1879 Paul was still at l'Estaque, writing to Choquet. He asked how a rejected artist of the provinces could get a picture sent back at his own charge from the Salon, and added that if Choquet didn't know, he could ask Tanguy. He himself was going to Paris with his 'little caravan' in early March, and had asked for the information on behalf of a compatriot (probably Monticelli). As Choquet knew of Hortense, he concluded, 'my wife and little boy send you their greetings'. On February 7th he thanked Choquet for answering his query. 'I think my pal will have every reason to be satisfied with the peremptory and imprinted way in which the higher administration acts towards its subordinates.' He expressed pleasure at some success of Renoir. 'My wife, charged with the cares of providing for our daily nourishment, knows the trouble and bother it gives, sympathizes with Mme Choquet's worries, and sends her kindest regards, as does your humble servant. As for the small boy, he is terrible all along the line and is preparing trouble for us in the future'.

The same month he wrote to Zola, congratulating him on *L'Assomoir*'s stage success (according to *Le Figaro*); in a fortnight he meant to go to Aix, then to Paris; 'Mother joins me in greetings'. On April 1st, in Paris, he gave an evasive and disingenuous reply to the suggestion of showing work with his friends. 'I think amid the difficulties raised by my sending to the Salon, it would be more proper [*convenable*] not to take part in the Exhibition

of Impressionists. As well I'll avoid the turmoil caused by the disturbances in transporting my few canvases. Also I'm leaving Paris in a few days.' He was still pinning all his hopes on getting into the Salon; and in fact he had a plan for getting in by the back door, as we shall see later.

On June 3rd he wrote to Zola from Melun, suggesting diffidently that he'd like to visit Médan. He had called in at Zola's Paris address in the Rue de Boulogne on May 10th and had been told that the master had left for the country; he had also paid an 'insinuating visit' to Guillemet, who declared that he had vainly championed him, Paul, at the Salon. (This year Paul wasn't the only dissident with hopes of being officially hung; Renoir and Sisley had decided to keep out of the forthcoming impressionist show, the fourth, in the Avenue de l'Opéra, and concentrate on the Salon.) Paul added that he was following Zola's career in the *Petit Journal* and *La Lanterne*, and thanked him for the pamphlet *La République et l'Art*; Cabaner had drawn a similar and even more gloomy picture of the situation. On June 5th Paul was still at Melun. He acknowledged an appointment on the 10th at the Rue de Boulogne.

He visited Médan; and on June 23rd was back again at Melun. He sent greetings for Alexis, if he'd arrived at Médan, and inquiries at what depth water was found in the wells—there must have been some trouble about it. 'I arrived unbespattered at Triel station, and my arm, swung about through the carriage-door as I passed before your house, must have revealed my presence in the train, which I didn't miss. Meanwhile I got, Friday I think, the letter addressed to me care of you, thanks, a letter from Hortense. In my absence your book *My Hates* arrived here, and today I've just bought *Le Voltaire* to read your article on Vallès. I've just read it and think it magnificent. The book *Jacques Vingtras* had roused much sympathy in me for the author. I hope he'll be pleased.'

This is an important letter, decisive on the question of Paul's political position in these years. Jules Vallès (1832–85) was a consistent revolutionary. Son of a professor, he was born at Le Puys and came in 1849 to Paris. Instead of continuing at school, he took to the politics and journalism of revolt. Involved in a plot against the Prince-President, he was a short while in Mazas Prison, then carried on with his freelance work, and published in 1857 his first book, *L'Argent*, directed against the financier Mires. What brought him fame was a series of articles in *Le Figaro*, 'Sunday of a Poor Young Man', in 1861. In 1866 came *Les Refractaires*. As a journalist on *L'Evénement* he must have come to know Zola. In 1867 he published *La Rue* and founded a weekly with the same title. After the first defeats of 1870, the government clapped him in Mazas jail. Freed on September 4th, he founded *Le Cri du Peuple*. He fought till the very last in defence of the Commune, of which he was a member, then escaped death by getting away to England, where he still was in 1879. After the amnesty, he returned in 1883 and restarted *Le Cri*. His main work was made up of three autobiographical novels depicting in detail the birth and growth of a revolutionary: this was the work that attracted Paul's deep sympathy. Zola had reviewed *La Rue* in 1866 as a

book 'notably characterized by verve and energy'. Now in 1879 he praised *Jacques Vingtras*
strongly. 'I want this book to be read. If I have any authority, I demand that it be read.
Works of such vigour are uncommon. When one appears, it must be placed in everyone's
hands'. At the same time he regretted that Vallès had spent so much time in political
agitation instead of keeping to the pen; and repeated the lament on 30 May 1881 in *Le
Figaro*. Vallès replied in two articles in *Le Reveil* (24 July and 1 August 1882); he claimed
that Flaubert, the Goncourts, Zola, even Dumas *fils*, were socialists without knowing it, as
their pictures of popular distress and bourgeois corruption merely underlined what the
socialists taught. When Alexis tried to reply, Vallès asseverated, 'The man who says he has
no political opinions confesses to one all the same. He is the collaborator and accomplice of
those who hold the whip-hand, who have their heel on the motherland's throat. It is his
indifference that supports the slayers of the poor and the butchers of thought'. This, then,
is the man for whom Paul expressed such entire sympathy and admiration, showing that at
this phase, under Pissarro's influence, he had become more politically rebellious than even
Zola at the time. Zola however was deeply affected by the 1882 controversy, which preluded
Germinal and in time led him to socialism, albeit of a utopian Fourrierist kind.

Jacques Vingtras is written in three parts, *L'Enfant, Le Bachelier, and L'Insurgé*. As there
is no other literary work for which Paul expressed such admiring sympathy, we need to get
some idea of its theme and method. It describes the birth and development of a revolutionary
out of a middle-class childhood and education, and ends with the hero's wholehearted
activity in support of the Commune. But the account is given without any preaching or
argumentative lessons—as if the career of Vingtras were the only logical way of thinking and
acting for a sane and humane man. The directness of the method in presenting the moral
and emotional growth of a rebel against the whole bourgeois system is reflected in the spare
kinematic style, in which brief episodes or snapshots follow one another without any
conventional transitions, explanations or connections. The effect is achieved solely by the
placing of the rapidly evolving and contrasted moments. The work is thus highly original
and breaks new ground in novel-technique; its system did not reappear in any way till the
film influenced literature many decades later. Vallès no doubt devised it because of the
need he felt to catch the actual movement of life, disconnected and yet with its own laws of
pattern, montage, and accumulative rhythms. Here are two complete episodes as they
follow one another. There has been a joyous day of demonstrations; then:

> 'Halt there!'
> Troops bar the road.
> Rochefort comes down:
> 'I'm a deputy and I have the right to pass.'
> 'You won't pass.'
> I look back. Along the whole stretch of the avenue the procession is straggling, breaking up.
> It's getting late, we're tired, we've sung.
> The day is finished.

A little old man jogtrots near me, alone, quite alone, but followed, I see, by the eyes of a band in which I recognize friends of Blanqui.

It's he, the man who skirts the ramparts, after having rambled all day along the flanks of the volcano, watching if, above the crowd, there doesn't jet out a flame that will be the first blaze of the red flag.

That solitary, that little old man, is Blanqui.

First there is the dramatic clipped scene in which the two powers, that of the people and that of the State, confront one another, and the latter triumphs. Then the switch to the isolated shambling figure of the old revolutionary, who seems quite out of things, but who represents the idea that is kindling the people and will one day reverse the situation when the two powers confront one another. The same sort of contrast can be powerfully and sharply expressed in a single episode.

I have just thrown myself down on camp plank-bed, between a beggar on stumps, who renews his ulcers with herbs, and a chap with a distinguished but lost look, who, seeing me a little bit better placed, squats down against me and tells me in a low voice, with teeth clenched and panting breath:

'I'm a sculptor. I haven't damped my clay. I haven't fed my cat. I was going to buy some lights. I was rounded up with the republicans.'

Breath fails him.

'And you?' he finishes painfully.

'I wasn't going to buy lights. I have no cat. I have opinions.'

The following two sections show his method of descriptive characterization, of expressing revolutionary emotion by evocation rather than explanation; thus he defines the transformation of religious ideas into revolutionary ones:

Briosne: a Christ with a squint—and the hat of Barrabas. But not at all resigned, tearing the lance from his side, and lacerating his hands to break the thorns that remain on his brow of an old victim of those Calvaries that are called Centrales [prisons]. Condemned for a secret society to five years, sent back some months earlier because he spat blood, returned penniless to Paris, not having been able to heal up his lungs but having the soul of the revolution nine-lived in his body.

Penetrating voice, coming from a murdered heart as from a cracked cello; tragic gesture; arm held out as if for an oath; shaken now and then from head to foot with an ancient pythoness's shudder; and with his eyes, which have the look of holes dug out with a knife, piercing the smoky depths of the club-halls, as a Christian preacher pierces with an ecstatic glance the vault of cathedrals and goes seeking heaven.

L'Insurgé was dedicated: 'To the Dead of 1871, to all those who, victims of total injustice, took arms against a badly made world and formed, under the Flag of the Commune, the great Federation of Sorrows'. But with all his absorbing fervours Vallès stresses the need to live life out to the fullest and to damn future Pantheons. Politics are never an end in themselves.

At last the fatigue duty is finished, the electoral period is over. I'm free.

Down there, by way of Chaville, there's a farm where I have spent calm and happy days in watching the wheat threshed, the ducks run to the pond—drinking white wine under a great shady oak and taking my siesta in the cut grass, near apple trees in blossom.

I'm thirsty for silence and peace. I've gone there, forgetting the vote of the Paris sections, rolling myself in the hay, listening to the tree-frogs that cry in the green reeds; and in the evening I've slept in brownish stiff linencloths like those in which my cousins in the village used to wrap me.

To the village!

Ah, I'd rather be made as a peasant than a politician—short of taking the pitchfork with the Jacques for a year of dearth, a winter of famine.

This then was the work into which Paul entered with full sympathy. The direct presentation gave him no fear of *grappins* being prepared by a propagandizing author; his natural fellow-feelings for the man of independent spirit, who came in the end to oppose with every fibre of his being the bourgeois world, were able to flow uninhibited. Vallès had had a difficult childhood, though his parents didn't play the same roles for him as did Paul's. 'My mother said that children mustn't be spoiled, and she whipped me every morning; when she hadn't time in the morning, she did it at midday, seldom later than four o'clock'. The spare bitter tone would have pleased Paul who, from his different angle, could read himself into Vallès' picture of childhood's hell. Vallès' way of gay or grim stoicism, taking things as they came, suffering but unflinching, and making a fuss about nothing, was the diametric opposite of Paul's way, and no doubt Paul felt attracted for this very reason. He would have liked to move through life like that, but couldn't. Vallès was a rebel pure and simple, instantly reacting to any injustice, oppression, or exploitation, but belonging to no school of politics, no revolutionary system. *Les Réfractaires* evokes all the pariahs and outcasts of Paris, failed artists as well as journalists out of a job, chimerical inventors, and odd-bodies of the fairs.

Hardship without a flag brings a man to hardship with one, and out of the dispersed rebels [*réfractaires*] it makes an army, an army that counts in its ranks less sons of the people than children of the bourgeoisie. Do you see them rush upon us, pallid, dumb, emaciated, sounding their charge with the bones of their martyrs on the drum of revolts and waving like a standard at sword-end the shirt stained with the blood of the last of their suicides?

Though quite ignored by all the histories of literature, Vallès affected—as well as Zola and Cézanne—Jean Richepin, Léon Cladel, Léon Bloy, Séverine, Huysmans, Descaves, Geffroy, Deffoux, Mirbeau, Jules Renard, young Maurice Barrès and others.

In passing we may note a passage from *L'Enfant* which must have reminded Paul of the staircase accident which he considered had caused his fear of touch. Jean has a dog which dies; he wants to bury it. 'I had to take and carry it [in a basket] before my mother, who giggled. Jostled by my father, I almost rolled with it down the stairs'. He goes out and drops it from the basket 'on to the heap of ordure before the door of this accursed house. I heard it fall with a wet plomp and I saved myself, calling out, "But as it can't be buried!"' For long he imagines the bitch's corpse, 'guillotined and disembowelled, instead of having a little place under the earth where I knew there was a being who had loved me'. We recall Paul's fascination with Baudelaire's *Carrion*, with its image of such an open-bellied corpse, a bed of ordures. The fear of a fall (first down the stairs, then into the ordures) appears in

the passage from *L'Enfant*; and when we consider how Paul extended his fear of the stair-fall into a fear of contact, especially with women, there seems here a strange complex of images and emotions, which, especially with Paul and Baudelaire, equates death, rotting flesh, faeces and sexual union. (The deep linkage of money and faeces in the unconscious is well known.)

Paul wrote letters from Melun in September, October and December. Three to Zola dealt with the play of *L'Assomoir*, for which he asked three seats; it had been showing at the Ambigu since January. As usual he was confused about arrangements, unsure whether it would be 'easy to harmonize the date of my arrival in Paris with the issuing of the tickets'. 'You must have been overwhelmed with similar requests', and so on. His comment on the play was not exactly flattering; but for someone used to early hours of retirement it may have been well meant.

I had the best possible seats and didn't sleep at all, though I'm accustomed to go to bed soon after 8 o'clock. The interest doesn't slacken for a moment. Still, after seeing the play, I dare to assert that the actors seemed to me so remarkable that they must bring success to a host of plays known only by name. Literary form doesn't appear to be necessary for them.

Nana had been advertised on the curtain. Of himself Paul said, 'I'm still straining every sinew to find my pictorial way ahead. Nature puts the greatest obstacles in my path. But I'm not getting on too badly, after a renewed attack of the bronchitis I had in '77, which racked me for a month'. His father's old partner had died some time ago, but his father and mother were well.

That winter was harsh; the snow was deep and frozen hard. On December 18th he discussed the cold and said that he couldn't obtain fuel; probably by Saturday he'd have to flee Paris. 'I have some difficulty in recalling the month of July; the cold brings one back too much to reality'. He left a record of the hard winter in his *Melting Snow* painted near Melun. He rarely painted snow, but this year it stayed on the ground long enough for even him to tackle it—though he seems also to have used a photograph.

It was probably during the 1870s that Paul's phobia about touch developed. For his later life this fear is well documented; but it was known earlier to the Pissarro children, who were warned against touching him. We have also some internal evidence from his art which suggests that it had come to a definite point around 1875. A series of drawings of a single bather in a particular position is here of extreme importance. The pose appears also in two of the paintings, and has links with gestures in many other works, going as far back as *Spring* in the Seasons (here a gesture of easy grace, which in due time became that of a woman offering herself). In the male bather-form we find one arm raised on high and the other stretched down, the two arms thus making a sort of diagonal. The head is averted from

the raised arm, and the lowered hand is more or less on a level with the genitals. The line of the two arms is one of tension, creating an intense conflict in the figure. The series would appear to date between 1875 and 1885. The source of the male figure in this pose was Millet's *End of the Day's Work*, where a peasant is pulling on his coat with one arm stuck out. The painting was engraved and also published as a woodcut in 1860. Van Gogh also knew the work and was attracted by it, but his copy introduced no fresh tensions: it carried over the simple effect of relief at the ending of the working day. Between 1875 and 1877 Paul twice depicted the peasant pulling his left arm through the jacket sleeve; here there is no upraised arm and the head is not twisted aside. Significantly, he was interested solely in the figure of the man in his struggle to dress—which could also be a struggle to undress. He omitted the broad field-scene and the signs of work. The scene becomes a private one, its enclosed nature stressed by a steep hillside and an inclined tree. And we can see from a third work how he used the pattern in a transition to the bather stripping himself naked, alone in his landscape.

Millet did not introduce Paul to the motif, but his painting stirred Paul and started him off on this series of variations. Two drawings dated 1873–5 show the posture without any connexion with dressing-undressing. An actor gesticulates furiously with raised-down-stretched arms; and a boy makes the same wild movement in a frenzy of fear as rats gather round him. The gesture is linked by him with moments of extreme excitement, of invitation or terror. (There seems to be a memory of Poussin's *Plague at Ashdod*, which would help us to realize the aspect of pollution, disease, castration, death, which the pattern suggests so strongly to Paul. We are reminded of his youthful nightmares set out in his poems.) A painting early in the series shows the anxious tension of the diagonal arms, with a knotting of the muscles in the upper part of the body and a dark wrenched-aside face; the preliminary drawings have the same rigours. The tension is centred in the neck, as if the head is trying to tear itself away and disown the rebellious energies of the body; the image expresses an extreme dislocation of impulses, especially a dissociation of cerebral and sexual elements. Paul made many sketches of the head and shoulders, realizing that there was the concentration of conflict. It is noteworthy, too, that the series seems to begin with a naked male; then Paul more and more covers up the loins, starting with a narrow band and ending with full trunks. Sexual revulsion dominates the whole image: the lowered hand, with its clenched and clawing gesture, is level with the genitals, to which it is drawn and from which it swings away in a fierce deadlock of frustration and fear; while the upper arm, raised above the head, out of the genital sphere, gains its freedom only by a rigidity that makes it a sort of phallic surrogate. In the drawings we at times find the emotional emphasis set in the lowered arm, in the elongated fingers that strain in anguish away from the genitals without being able to escape the attraction; but even more strongly appears the anxiety tightening in the raised arm with its opposition to the genital sphere. Once Paul draws it over and over again in lines that reveal a keen impulse to pull the arm up and away; but the skyward escape is

self-defeating and the energies of the arm are twisted and useless. He twice repeats the form in the margin. This arm of cerebral revolt and escape is drawn out with no concern for the anatomical proportion that rules in the rest of the body. The drama of the series thus lies in the sharp conflict of the two sections of the diagonal: below, a panged and uneasy oscillation between hand and genitals, and above, a violent tension between the head and the arm of revulsion. (*See* Figs. 71, 73, 80.)

The development has thus been well summed up:

He succeeds about 1878 in converting the first pathetically helpless figure (Venturi 262) into an image of energetic action appropriate to the inner struggle (V. 259) and this increase in affective power invades even the landscape, producing the sloping hillside and tree of V. 259 and the physiognomic cloud of V. 271. After an interval of about five years, perhaps sooner, he begins to modify the awkward intensity of this expression by increasing the spatial ambience and adopting a traditional pose of relaxation—at first in an exaggerated manner. (V. 544), later with more restraint and power of construction (V. 549). Here he achieves at last a clear, compact, objective form—not because it lacks a deeper significance, the purely formal 'motif' replacing an earlier 'subject' as Venturi states, but because the very objectivity is the result of a progressive refinement and repression in which the original meaning is almost totally concealed. (Reff)

Clearly in this series we have a very important personal revelation, which cannot but be linked with a breakdown of the physical aspects of his union with Hortense. In view of what we know in general of Paul's character, this breakdown no doubt began in the period of childbirth and suckling. With such a shy unsure person the problem of resuming relation- ships on the same level as in the pre-1872 years would have been acute; and we must add the fear that would have afflicted him, of increasing his family and his financial burdens. In such a situation there can be little doubt that marital relations with Hortense would wither; Paul was thrown back on himself, in a state of self-enforced continence which was in some ways even more unsettling than had been his pre-marital state. For now he had the memory of a period of more or less easy and continuous physical union, with a tantalizing inability to repeat it. As Reff says of the climacteric drawing, we trace 'almost certainly an expression of anxiety and guilt about masturbation'.

About 1878 he seems to gain a certain self-control. The helpless surrender to dislocation and disharmony gives way to something like a successful containment of energy in a less distorted body; the conflict is still there, but no longer in such a destructive form. At the same time—an important development—as a result of his clearer confrontation of his pang, he feels linked afresh with the world of nature. The tensions are not merely concentrated in a twisted and awkward body, expressing a hopeless antagonism of mind and body, thought and impulse: they flow out and affect the landscape. The tormented man is after all part of nature with its own entanglement of check and breakthrough, death and life. He is involved in a pattern of hill-slope and tree and cloud; and this discovery eases the tautness of his pain. His body starts coming together in a more unified form, and he breathes; there is an ambience of atmosphere and space.

The importance of this analysis does not lie merely in the revelation it gives of Paul's physical condition, his sufferings and the pressures of his isolation; it also gives us in a personal refraction the general pattern of his changing art:

In their gradual development towards a monumental form, compact and clear in construction but without overt expression, the successive versions of the bather with outstretched arms are typical of Cézanne's art as a whole in the period round 1880. If this process is observable in all subjects, however, it is only in images of exceptional human actions such as this one that we gain insight into its hidden causes, for here the radical stylistic change is accompanied by an equally profound change in the conception of the figure, and this in turn reflects, we must assume, a change in the artist's attitude towards his own body, its impulses and their means of expression. It has of course long been recognized that this extraordinary growth 'rests on a deliberate repression of a part of himself which breaks through from time to time' [Schapiro], but it has never been possible to link it with a specific theme in his own fantasy-life. (Reff)

Once again we can link what seems to be a purely personal theme with what was going on in the world of art. As part of the revolt against the academic nude existing in a classical setting that never was on sea or land, we find various devices used to give a natural explanation for a woman's nakedness. She is bathing in a stream or pool: as in works by Delacroix, Courbet, Millet and, later, Manet and Renoir. And in thus giving the nude a place in reality, not merely in a studio-fantasy, new problems of emotion and personal relationship come up; problems of narcissism, of the consciousness of one's body and its secret life, its contacts with external objects and other people. From one angle this new attitude was linked with the idea of the free wanderer, the tramp-pilgrim escaped from the trammels of an oppressive society into the bosom of nature: the idea which Paul and Zola had felt to be realized in their excursions and bathings. But here the stress was on the erotic aspects— the body liberating itself from the constricting clothes and corsets of a moribund society and discovering afresh its own essence, its potencies and its capacities for a new freedom of enjoyment. ('Our clothing depraves form', Diderot had long past written: 'Our legs are cut by garters; the bodies of our women are stifled by bodices, our feet are disfigured by narrow hard shoes'.) To throw off these distortions was one way of returning to 'nature', and thus the romantic and realist ideas merged in a fascination with the naked body as holding the secret of freedom and the revelation of the realities hidden under the falsifications of society. Delacroix entered in his Journal for 5 April 1863, concerning Courbet's *Bathers*, 'There is between these two figures an exchange of thoughts that one cannot understand'. The bather could be used to express both a deepened liberation of the senses in joyous union and a frustrated isolation of the body which found no responding mate. Paul uses the theme of Bathers in both these aspects; his struggle is to move from isolation to a realization of free and full contact.

In many of the earlier works of the series the stress is on failure to find freedom in nakedness. In one, the man presses an arm against his body and wraps the elongated other arm round his head; he seems afraid of both his hands; in another a seated female tightly

crosses her legs and locks her hands behind her head. There is fear of what the hands may do. Beyond a doubt we see expressed in such works a struggle against masturbation.

These revelations have much more than a merely personal aspect. The strains and stresses in the anguished body, divided against itself, give us important clues to the strains and stresses which distort or modify the shapes of inanimate objects in Paul's work as well as the bodies of men and women. He himself seems to have gone out of the way to express the relationship on several sheets of drawings connected with our series, on which he later drew rounded vessels (probably in the years 1880–5). In all cases he was careful to equate the object with the nude. He drew the object aligned with the figure or paired it off with the latter on the surface. Thus, opposite the excited actor is a wine-glass of equal height. Behind an early bather is a drinking-glass of equal width. Flanking another stands a large pitcher or funnel. Above the study with the upper arm broken into a wild series of out-stretching lines he puts a sugar bowl with handles and lids that suggest organic forms. (It is of interest that a Provençal proverb uses a pot and its cover as images for man and wife: 'Every pot finds its cover', *Chasque toupin trovo sa cabucello*.) He was particularly stirred by the correspondences between drinking vessels or hollow receptacles and the human form. (We noted how in one of the early adaptations of the *Lunch on the Grass* motif he used a tubular hat and a funnel as sexual emblems.) Thus, as his art matures, he transfers to nature the tensions and resolutions which he feels in his own body. Both in still life objects, and in the larger objects and fields of landscape, he finds a reflection of his own inner struggle. What he does is in no sense a mere imposition of an abstracted pattern; the pattern drawn from his own body is organically linked with the resistances and the rhythms of release which he observes and imaginatively recreates outside himself. He is simultaneously humanizing nature and naturalizing his human self—to use an early phrase of Karl Marx. Thus at every point his definition of objects and of natural forms—his realization of them, as he would put it—was linked with the inner turmoil of fear and desire, of frustration and release. Emotion always has its physical or organic pattern, its complex of tensions and satisfactions in the body; and art forms are always, when creatively potent, deeply based in this pattern or complex. From about 1875 Paul was driven sharply and powerfully back into himself; he might easily have cracked up under this strain; and indeed the struggle to overcome the dislocating and crushing burden of anxiety was extreme. But he gradually came up out of it, and was able to use the elements he had built up in his previous development—elements often drawn from Delacroix, Courbet, Daumier, Manet, Pissarro, Monet—for the expression of a truly personal vision.

How do these considerations correspond with what was going on in his landscapes and figure compositions at this time? As we have seen, in the two versions of *The Struggle of Love* (probably about 1877) he achieved his most successful works in which figures in action (lovers struggling and tumbling) are combined with landscape—as distinct from the quieter compositions of bathers. Here was the climax of his line of direct development out of

Delacroix; and certainly there are no inhibitions in his treatment of the theme—though one might argue that his own baffled sex-life comes out in the stress on violence in the embraces. He seems then to have been able to carry on his daydreams of contact with women in this comparatively free and lyrical vein, while in the bathers with diagonal-arms he found himself driven back to the facts of his physical frustration. But after *The Struggle* he gave up almost wholly the attempt to depict the love-embrace and contented himself with pictures of male and female bathers in segregation. The transition into the second half of the 1830s in general saw a switch from the 'apprenticeship' to Pissarro. He feared to fall into too facile an application of impressionist atmospherics, and began turning more to aspects of mass and rhythm. By 1877 his work was diverging significantly from that of Pissarro.

The essential development of 1877 was that the atmospheric tones of impressionism gave way to the intensity of local colour: colour, in fact, gained a sort of autonomy, and form, as if to serve it, became progressively simpler and more block-like. In the Louvre still life [*Still Life with Soup-tureen*] a cold yellow reverberates, seeming to press against the contours of the apples and modify their shapes: it evokes, through its apple-green halftones, correspondences everywhere—it is the apex of a chromatic progression which descends through blue-grey and dark blue to black. The picture is a tightly-knit structure of colour, a structure of the kind which was the distinctive discovery of 1877. The Louvre still life was perhaps among the first works of the phase: in succeeding pictures the separate touch characteristic of the impressionist method was also abandoned. The palette-knife handling of *L'Etang des Soeurs* may well have been a necessary stage in the process. In other pictures, worked by the brush, forms are similarly modelled by rectangular accents of positive colour placed against simplified, schematic contours. (Gowing)

1877, then, seems to have been the year in which Paul decisively brought together all his main objectives and achieved his unified personal style. The liberation of colour learned from the impressionists is put to the service of his own aims. Henceforth he needs no new lessons or influences. He may have gained something from his painting with Renoir, but it was not something essential.

 In 1878, spent in the South in continual struggle with his father, he made a fresh advance. He began his use of parallel strokes to define different areas; and for five years from 1879 he almost always kept to this system, which enabled him to approach the problem of depth and of planes receding or coming forward in terms of colour. Later we find many comments on planes attributed to him:

Planes in colour. Planes! the coloured area where shimmer the souls of the planes, in the blaze of the kindled prism, the meeting of planes in the sunlight. I construct my planes with the colours on my palette, do you understand? The planes must be seen. Clearly. . . But to join and weld them. They must revolve and interconnect at the same time. Only volumes matter. (Gasquet)
 I see planes bestriding one another and sometimes straight lines seem to me to fall. (Bernard)
 Planes! that is what Gauguin never understood.
 He did not understand me. Never did I want and never will I accept this lack of volume and gradation. It's nonsense. Gauguin was not a painter, he produced nothing but Chinese pictures. (Bernard)

Apart from some of Gasquet's idiom intruding into the first passage and attributing souls to

planes, these remarks do seem in general to express his obsession with the interrelation of planes realized dynamically in terms of colour. Form is not lost but is conceived simultaneously in terms of its own identity in mass, volume and shape, and of the strains and stresses created in space by its link with other objects. Space becomes a field of force, not a construction of separate geometrical objects; and what we might call the inner attractions and repulsions of the electro-magnetic field is defined by colour—colour as planes in movement.

This new conception and treatment of colour led in turn to a coherent system of form-modification, which is most apparent in the still lifes. There we see the curves and volumes of objects such as fruit, glasses, dishes and so on, subtly affected by the pulls of colour; distortion is too strong a word. In speaking of 'the pulls of colour' we are also speaking here of the movement and interaction of forms, of an over-all rhythm, in which form and colour are one and the same thing, and in which the set of balances and unbalances, symmetries and asymmetries, is connected both with the activity of the eye-plus-hand in defining scene in its totality, and with the organic 'becoming' of the forms themselves. This 'becoming' is difficult to express in words, yet it lies at the heart of Cézanne's aesthetic. We can perhaps begin to explain what it is by saying that he is not dealing with a finished world, put in its place once and for all; this world of his is full of secret vortices of growth and movement, of change and disintegration, of rich impulses towards new dynamic unities or balances. Each picture is a movement from symmetry to asymmetry, and from asymmetry to symmetry. Though Paul later resisted Geffroy's effort to relate impressionism to the fields of science in which new concepts of change and movement were coming up, we may note an important connexion between his struggles in art with ideas that were coming up embryonically in the science of his period. After the discovery of the Second Law of Thermodynamics Spencer recognized a widespread tendency to equilibrium; Fechner suggested that every system moves from unstable to stable states; Petzoldt put much emphasis on this principle; Mayer suggested that instability shows the existence of differences that he called forces; Mach drew attention to Mayer's ideas and held that 'without differences' nothing ever happens; he tried to show that certain classes of stable systems must necessarily possess elements of spatial symmetry; Mallard in 1880 noted that 'this tendency towards symmetry is one of the great laws of inorganic nature.' Then in 1884 Pierre Curie made a crucial advance on these formulations. 'What is necessary [for the presence of a particular physical phenomenon] is that a certain amount of symmetry should be absent. It is the asymmetry that creates the phenomenon.' We may add:

Apparently he did not take the further step and observe that just as the physical field represents a particular asymmetry, the process resulting from the field consists in the decrease of the asymmetry. The physical tension or force within any system can be regarded as a consequence of the tendency to establish its characteristic symmetry. (L. L. Whyte)

There is a profound sense in which Paul's work could be taken as illustrating these

principles. It is worth noting that just as Paul opened up a new world of colour-form which no one has yet been able to develop coherently, so the ideas of Curie are still not absorbed into twentieth-century physics.

Along these lines we can begin to understand Paul's system of colour-form, of interacting planes as a field of force in which the symmetry-asymmetry tensions operate. We have seen that he is working, not by some abstract notion of picture-making, but by a penetration into the actual colour-field before him, into a unifying grasp of its tensions, its inner attractions and repulsions. He is treating his motif as a living system.

A remark made later to Renoir dealt with the transition from his early phases to his mature use of colour: 'It took me forty years to find out that painting is not sculpture.' Renoir explained: 'That means that at first he thought he could force the effects of modelling with black and white, and load his canvases with paint, in order to equal, if he could, the effect of sculpture. Later, his study brought him to see that the painter's work is to use colour so that, even if laid on thickly, it gives the full result.' But there were certain links between the two attitudes. The wish to sculpt with paint was connected with a desire to grapple actively and concretely with reality in a short-circuited way. When Paul gave that up and turned to colour-form, he was still carrying on with his desire for a fully concrete universe, and so he was making out of the new colour-texture with changing interconnected planes a sensuous continuum. It would be going too far to see here a definition of space in terms of tactile values, but the definition does give space everywhere a sort of sensuous accessibility; we feel and enjoy it in a new way, it exists in complex depth and yet has an immediacy of contact.

We can better understand what is meant by this inner system of balances and unbalances in a complex rhythmic structure if we look, for instance, at a finely completed work of this period, the *View of Médan*. Here we find a general frontality of aspect in the banks, houses and trees, with a consequent stress on verticals and horizontals. As there was thus not much diagonal recession in space, the forms have somewhat the look of being packed and stacked on top of one another. In order, therefore, to achieve a feeling of space the artist was driven back upon atmospheric effect on local colours and on changes of scale. The paint is applied in his method of parallel diagonal strokes, thicker in some parts than others where stroke has been piled on stroke. The forms emerge from the network of strokes, and at the same time the vertical–horizontal pattern holds the composition together. We feel a profound tension between the structure and the elements composing it, the life of nature caught at a single moment and yet involving energies that move from past into present into future. The grid of pattern 'is never strong enough to transform the energy that causes the contours to buckle and swell under its constraint into a mere grid of an entirely abstract sort. It has the job of canalizing this energy rather than of destroying it.' (Fig. 79.) In developing the conflict and resolution of grid-structure and recession, Cézanne was helped by the colour he was using, blue:

for in his mind blue stood for space and air. Meanwhile his deep sympathy with nature, and his sense of the optical 'tug' between forms, helped to ensure that he was not merely ticking off a series of levels with straight lines. His marks were essentially rhythmic. While he was drawing one part he was constantly aware of others, so the series of divisions he made of his picture surface formed an effective recreation, or translation, of his whole experience. He must have been particularly aware of the shape of his canvas as he worked, for its corners were continually finding echoes at the places where the vertical and horizontal lines of his design met each other: he was constantly dividing his main rectangle into smaller rectangular units. But it's important to realize that these things came directly out of Cézanne's study of natural forms, and that he was continually stressing that an artist's only salvation lay in the study of nature. (Hoyland)

The conflict of structure and colour-recession, more than anything else, gave his work the quality of actual time-process, a quality which Turner, alone of artists, had also achieved in his own way. The life of nature is moving in, and moving out, and yet is held and contained. The present moment involves past and future; it defines them as much as the present by the totality of its tensions, rhythms, directions, and symmetry-asymmetry. The need to achieve this particular kind of totality led to Paul's method of working 'all over at once.' There could be no question of roughing out or blocking in, in the conventional way. Each stroke altered the colour-form tensions, and so he had to work all the while with the whole canvas in mind, rediscovering space-time and its pull of inner relations all the while. Hence the intense strain of his creative concentration. 'The plastic sequence must be felt throughout the whole surface of the canvas.'

Certainly the fact that he usually worked a good while in front of his model, and inevitably changed his standpoint slightly now and then, had something to do with the effects he got. We can speak of 'the intricate interrelationships of forms seen from shifting points in space at various times. In the introduction of change and process, through multiple sightings deposited upon its surface, the picture became a record of the continuous present, of the experience of space in the mode of time, and, in turn, an experience that requires time to unravel' (Hamilton). But we cannot bring the definition down to the mere fact of shifting focus, which in a sense was a by-product of Paul's way of working and re-working at a scene or model again and again: in practice he did his best to keep to the same viewpoint. The slight shifts aided a method which was based ultimately on his whole conception of volumes, planes, colour-relations, edges, depth. Out of all these factors came the changing pattern of in-and-out, of space-as-time.

Clearly we could trace similarities in Paul's outlook with the philosophy of Bergson which was emerging during his mature period, especially in its emphasis on the omnipresence of change and on the concrete nature of the intuitional grasp of reality in its immediate fullness, as opposed to the divisive attitude of the analytic intellect with its discrete time. But Bergson's system had its own illusory abstractions; and it seems better to stress the link with the crisis in physics and science in general, still unresolved, which emerges openly with Curie's comment on asymmetry.

PART FOUR

A New Crisis

I *Lull before the Storm (1880–3)*

FOR 1880 we have eight letters written to Zola. In February Paul was still at Melun. Zola had sent him *Nana*, and he had 'hurled himself' upon it. 'It's a magnificent book, but I fear that as the result of a conspiracy the papers haven't written about it. Indeed I saw no article or advertisement at all in any of the three little papers I take. Well, I was rather annoyed at this situation, as it would be the sign of a too great indifference to things of art or the deliberate shamefaced mark of an antipathy that one doesn't strike for certain subjects.' Paul is here reading his own position into that of Zola; for in fact the book created a vast uproar. Since its serialization began in *Le Voltaire* in the previous October, there had been great publicity, prospectuses, sandwich-men on the boulevards, advertisements, caricatures in the papers, even songs on the street: *Belle Nana, fais pas ta tata ; Nana, la Vestale de la Place Pigalle, La Femme à papa c'est Nana*. 'It's becoming an obsession, a nightmare' wrote Céard. When on February 15th the novel appeared in book form, some 55,000 copies were sold in 24 hours. (Manet later painted a *Nana*, and Paul made a rough painting in which the Olympia theme merges into that of Nana. He seems to have had Manet's work in mind; the top-hatted roué stands at the back and is not based on himself, but a naked woman is substituted for Manet's petticoated *cocotte*.)

On February 25th Paul sent thanks to Alexis, through Zola, for a book of his, probably *The End of Lucie Pellagrin*. Valabrègue had published his *Petits Poèmes Parisiens*; and the feminist Mlle Deraismes had attacked Zola. In March Paul returned to Paris. On April 1st he wrote from the Rue de l'Ouest (but now from the fifth-floor flat, no. 32). He was living a quiet life. Occasionally he saw a friend, Tanguy, Zola, Guillaumin, Cabaner (now a consumptive playing the piano in a café concert in the Arc de la Motte-Picquet); or he went to the Louvre. In the studio he painted a still life or a self-portrait. Scared of models, he used old studies, and resisted Zola's efforts to draw him out of himself, hating parties and strange faces. Zola got him once to the salon of his publisher Charpentier, where there were too many celebrities; Paul refused to go again, though Charpentier was friendly. Perhaps it was at this time that Zola also got Paul along to one of the parties at his own large apartment in the Rue de Boulogne. Paul went in his working-clothes and did his best to make things worse by remarking, 'Don't you think it's rather hot, Emile? Do you mind if I take my coat off?' and so taking it off, amid the guests in evening clothes. Such behaviour did not endear him to Mme Zola, but there is no evidence that Zola himself objected.

Paul heard from Guillaumin that the impressionist exhibition was open at a gallery in the Rue des Pyramides. 'I rushed there. Alexis fell into my arms. Dr Gachet invited us to

dinner. I stopped Alexis from paying you his respects. May we be permitted to invite ourselves to dinner Saturday night'? He signed himself, 'in gratitude your ancient college-comrade of 1854.' He had again been rejected at the Salon, and on May 10th he sent Zola a copy of the letter written by Renoir and Monet to the Minister of Fine Arts asking for a show next year of the true impressionists. They had had works accepted but badly hung. Now they wanted Zola to publish the text of their letter in *Le Voltaire*, with a comment. Paul had heard the day before of Flaubert's death; and in his usual way he hedged his request round with semi-apologies: whatever Zola did wouldn't affect their friendship, he knew he was liable to make disagreeable requests, anyway he was here only an intermediary. Zola agreed, and wrote some articles on *Naturalisme au Salon*, not exactly what the impressionists wanted, in *Le Voltaire* (June 18th to 22nd).

He denounced the Committee for its way of hanging Monet and Renoir, and declared that Pissarro, Sisley and Guillaumin had followed Monet's path, interpreting nature 'in real sunlight, undaunted by the most unexpected effects of colour. M. Paul Cézanne, with the temperament of a great painter who is still struggling with technical problems, is closer to Courbet and Delacroix.' But he considered that the group had in general failed to mature. 'Not a single artist of this group has powerfully and definitely applied the new formulas.' They were 'the forerunners; the man of genius is not yet born.' The impressionists were 'still unequal to the task they have set themselves, they stammer without being able to find the right word.' He admitted that 'their influence is immense, for theirs is the only possible evolution, they are adventuring into the future.'

This statement has been taken to show Zola's insensitivity; but in fact it has not been understood. Even if he had been writing with the later Monets before him, he would still have said the same. What he wanted was the impressionist clues to a new fullness and truth in the treatment of light and colour to be used for the expression of a complete vision of life: a vision capable of grappling with all the depths and complexity of human character, with the human scene in all its variety and richness of action and emotional experience. Looking back, he might have said that Delacroix and Courbet made an attempt at this breadth of theme, which in the last resort was also a mastery of technique; Manet seemed to be seeking for as wide-reaching a method, but lacked stamina and depth of understanding. Now the true artists were making many brilliant discoveries and breaking through into valuable new ground, but in the last resort the method was more important than the revealed images; a grasp of the real world in its human fullness was weakening; the eye of the artist was growing more significant than the thing seen and defined. Even Renoir, with his love of life, could not reach the breadth of theme that Zola wanted: an art as capable of embracing man and nature as thoroughly as the art of the great Venetians, of Rubens, Rembrandt, and other masters of the past. So, in the terms of Zola's critique, by far the highest compliment is paid to Paul, who is seen to be struggling to continue the grand tradition on the bases laid by the impressionists, though not yet quite capable of achieving his aim.

Zola had been arriving at this position for some time. In July 1879 an article of his had appeared in the *Messenger of Europe*, at St Petersburg; and a translation promptly appeared in the *Political and Literary Review* (taken up next day in *Le Figaro*). Manet was declared to have exhausted his talent with hasty work; and as for the impressionists, 'all these artists are too easily satisfied. They wrongly disdain the solidity of long-meditated works; that is why one may fear that all they can do is to indicate the road to the great artist of the future, awaited by all the world.' Zola at once wrote to Manet, saying that the version was forced and inexact, and that for thirty years, in Russia as in France, he had spoken of him with 'a solid sympathy.' But in view of his 1880 articles it is clear that the drift of his Russian essay was not misinterpreted. However in the former he did pay a considerable tribute to the impressionists:

They have been treated as practical jokers, charlatans making a mock of the public and beating the big drum round their works, when they on the contrary are austere and convinced observers. What seems to have been ignored is that most of these strugglers are poor men dying in hardship, poverty, and weariness. Singular jokers, these martyrs to their beliefs.

Paul in general agreed fully with what Zola had said; he twice thanked him for his essay; and he already felt what he later explained: 'the impressionist gang' lacked 'a leader and ideas.' However, at this time, though refusing to exhibit with his colleagues, he still thought of himself as a member of their group; he it was who used the term 'true impressionists.' On June 19th he thanked Zola for a letter dealing with his request, and Mme Zola for a large heap of rags, *chiffons*, to be used no doubt for wiping brushes and keeping himself as clean as possible during his painting bouts. 'I go to the country daily to do a little painting.' He'd like to visit Médan and bring a canvas along: 'if you're not alarmed at the length of time I risk taking,' and 'always providing you see no objection.' Monet had a fine show at M. Charpentier's. 'I saw that excellent man Solari. Tomorrow I'm going to visit him; he came three times to my house and I was always out.' As for him, 'nothing goes well. He can't make fate come round to his side. With less force, how many lucky buggers arrive. But there is the man, and for my part I thank God for having an eternal father. Please remember me to Mme Zola, also your mother.' He seems to be saying of Solari that despite disappointments the man remains unbroken, a true man; and the thought of a frustrated artist makes him think of himself and add the ironic comment about the heavenly father being better than the earthly one, who is equated with the world of heartless success and the authorities of that world.

On July 4th Paul was still in Paris, wondering why he hadn't heard from Zola. 'Naturally I didn't intend to be in the way.' He sent thanks in his own name and in the name of his colleagues for the articles. He has heard of Monet selling some pictures and Renoir gaining commissions. Sometime on a Saturday of this year he sent thanks for a copy of *Soirées de Médan*, a collection of six stories by the Médan group: Zola, Maupassant, Céard, Hennique, Alexis, Huysmans. 'Yours with affection, the Provençal in whom maturity did not precede

old age.' Knowing how he brooded over things, we can take this signature as expressing a certain resentment against Zola's comment in *Le Voltaire*. He is already old, he says: when is the maturity to which Zola looks ever going to come about? Resentment is mixed with despair.

On October 28th he acknowledged a letter brought by Solari. From a newspaper he had learned: 'You'd lost your mother and also that you were going to Aix, which is why I didn't go to Médan.' He added, 'I'm at your disposal for anything I can do. I well understand all the misery in your position and hope it will all the same affect your health as little as possible, also your wife's.' Still, in July-August he spent several weeks with Zola, who wrote to Guillemet on August 22nd, 'Paul is still here with me; he is working hard.' There is no evidence that he was ever anything but happy at Médan, where Zola welcomed him with affection and tact, and where, as at Zola's Paris apartment, he could see his pictures on the wall alongside works by Manet, Monet, Pissarro, Coste. Zola ignored the surprised comments of visitors at this collection. Paul no doubt disliked some of the people whom Zola tolerated because of their business value—Busnach for example, a gross and cynical man who poured out operettas and melodramas, and who adapted *Nana* and *L'Assomoir* for the stage. 'A great man arrived when I was there,' Paul is said to have recalled. 'Busnach! One is no longer anyone when such a great man is about.' Clearly he felt crushed in such company, which Zola could treat with a smile, but then such people were useful to Zola, now a leading writer, while Paul felt himself a nobody. On another occasion, we are told, Mme Zola posed in the garden serving tea; and as usual Paul found that things didn't come out as he wanted. She heard him cursing away to himself; then Guillemet came up and made a joke. Paul broke his brushes, tore the canvas, and went off shaking his fists. Once when Busnach was announced, Paul left Médan and went off to Giverny, where he told Monet of 'his flight without apparent bitterness:.

From an island in the Seine, reached by Zola's boat *Nana*, he painted a view of Médan, showing the dormer-windowed château (which in the following account Gauguin took to be Zola's house):

Cézanne paints a glittering landscape with an ultramarine background, and heavy greens and ochres of silken lustre; the trees are in a straight line and through the entwining branches may be seen the chromes sparkling on the limewash of the walls. Crackling Veronese greens indicate the garden's superb foliage, and the grave contrasting note of the violaceous nettles in the foreground orchestrates the simple poem.

The pretentious shocked passer-by looks at what he thinks is a lamentable daub by an amateur and, a smiling teacher, says to Cézanne, 'You are painting.'

'Certainly, but so little.'

'O, I can see that. Here, I'm a former pupil of Corot, and if you'll allow me, with a few deft touches I'll straighten all this out for you. Values, values—that is all that counts.'

And the vandal impudently puts some stupid strokes on the glittering canvas. Dirty greys cover the oriental silks. Cézanne exclaims, 'Sir, you are fortunate, and when you paint a portrait you probably put highlights on the nose-top as on the rungs of a chair.' He takes up his palette and

scratches out with his knife all the mess that the gentleman has made. Then after a silence he lets out a terrific fart and turning to the gentleman he says, 'What a relief.'

Gauguin had bought the picture, probably from Tanguy; the story he may have got from Pissarro or Cézanne himself.

Paul was back in Paris by the end of August. Nowadays he kept to himself and rarely visited the Nouvelle-Athènes. His few appearances in rough work-clothes brought from Duranty the comment: 'Those are dangerous manifestations.' As usual in such circumstances the legend that grew up was more picturesque than the facts. George Moore, who frequented the Café in 1879, records in his *Reminiscences*:

I do not remember ever having seen Cézanne at the Nouvelle-Athènes; he was too rough, too savage a creature, and appeared in Paris only rarely. We used to hear about him—he used to be met on the outskirts of Paris wandering about the hillsides in jack-boots. As no one took the least interest in his pictures, he left them in the fields. . . It would be untrue to say that he had no talent, but whereas the intention of Manet and of Monet and of Degas was always to paint, the intention of Cézanne was, I am afraid, never very clear to himself. His work may be described as the anarchy of painting, as art in delirium.

On 12 April 1881 Paul wrote to ask Zola to compose a preface for the sale of works being held by the hard-up Cabaner, 'as you did for Duranty's sale.' (Duranty, born 1833, had died in 1880.) Cabaner had works by Manet, Degas, and Pissarro as well as those by Paul; and Zola agreed to provide the preface, asking Paul in what terms he was to mention Cabaner's difficulties and struggles. Paul sent the letter on to Duret. On May 7th he had been at 31 Quai du Ponthuis, Pontoise, for two days, and wrote to tell Zola he had not been able to see Lamy, one of the sale's organizers; he had received books from Huysmans, Zola and Céard, and found the latter's work 'very amusing, not to mention the great qualities of perception and observation' it showed. He was grateful for having been introduced to 'these very remarkable people.' He added, 'I've just heard Mme Béliard is very ill; it's always painful to hear of fate weighing heavily on people one likes.' On May 16th he wrote to Choquet that 'the 40 [cm.] canvas which M. Tanguy should have let you have lacks a frame.' The day before he'd seen Pissarro; Hortense and the boy were with him. On May 20th he wrote again about the Cabaner preface and was planning to walk the ten miles across to Médan. 'I don't think the task is beyond me. I see Pissarro fairly often.' He had lent him Huysmans' book, probably *En Ménage*. 'A slight trial looms ahead. My sister [Rose] and my brother-in-law are coming to Paris, accompanied by their sister Marie Conil. You can see me piloting them through the Louvre and other places with pictures.' He asked to be remembered to his 'compatriot Alexis,' whose jolly manners seem always to have attracted him. (Rose had married Maxime Conil this spring and was coming to Paris to honeymoon.)

Pissarro was still very hard up. Now past fifty, with white head and beard, he had had no success to build on, but he quite lacked Paul's resentful bitterness—though he also

lacked his tormented struggle into deeper syntheses. The two men often painted together. Paul painted Cergy village, the mill of La Couleuve, Galet hill, and with his short thin strokes was working towards compact and rhythmical form. Dr Gachet at Auvers, still a close friend, had suffered misfortune. Six years earlier his wife had died, and a governess now cared for his children and the house. In 1879 he was involved in a railway accident at La Chapelle on the way to Paris, and, ignoring his own injuries, had been concerned only with the other passengers; in recognition, the railway company had appointed him their doctor for the Herblay-Auvers section, so that he was able to spend three days a week in the country.

In June Paul was working 'a little, but with much softening' (*ramollisement*). He was reading Zola's *Experimental Novel*. 'It seemed to me the piece on Stendhal is very fine.' On a visit to Paris he had found a book of Rod's sent by the author: 'easy reading'. He asked Zola for Rod's address. Rose's visit had eventuated; but 'Sunday morning, my sister being ill [Rose was a bad sufferer from rheumatism], I was forced to pack them off to Aix. The first Sunday of the month I went with them to Versailles', to see the fountains. In July he heard of Alexis' duel with Delpit, a journalist whom he thought had defamed him. Alexis was wounded. 'As usual, right was betrayed,' Paul commented. He wrote to Zola for news, and was interested in the critic Wolff's reactions to Zola's article on Maupassant and Alexis; he meant to go to Paris early in August. On the fifth of that month he told Zola that he had seen Alexis, and while with him 'on Tuesday morning your letter came to Pontoise.' He found his compatriot quite restored, 'and he showed me the articles leading up to and following the duel.' A man from Caserta had written for material about Zola's work. 'My visit to Médan has been held up by small obstacles, but I'll go for sure at October's end. At that time I must leave Pontoise and may perhaps spend some time at Aix.' Zola had gone to Grandcamp near Cherbourg for a month or two of sea-bathing, but returned in time to receive Paul, who wrote on October 15th about the coming of the bad weather. He expected to call in on the 24th or 25th. On November 5th Zola wrote to Coste, 'Paul has been with me for a week here; he has gone to Aix where he'll no doubt see you.' Baille, he said, was on his way to success with a rich wife; he was about to become an important manufacturer of spectacles and binoculars in the Rue Oberkampf; the firm supplied the War Ministry.

In the Midi Paul quietly left Aix for l'Estaque. His father had now given up pestering. This year a new recruit had come to the Pontoise-Auvers camp, the amateur painter Gauguin, now about thirty-three, who was so devoted to art that in a year when he earned 40,000 francs as a bank-agent he allotted 15,000 for buying pictures. Paul was suspicious of his caustic tongue, and would not have been pleased with the letter that Pissarro got after the rich young man's departure: 'Has M. Cézanne found the precise formula for a work that everyone will accept? If he should find the recipe for compressing the extravagant expression of all his sensations into a single and unique process, I pray you to make him talk in his sleep by administering one of those mysterious homoeopathic drugs [of Dr

Gachet], and come at once to Paris to tell me of it.' We see from this letter that Paul was now frequently using the term sensation to define what he was after; Gauguin is sceptical though fascinated. His reference to Gachet's homoeopathy suggests that Paul was an advocate of that method, especially as we find him, in his last days, trying a homoeopathic course.

This year saw the publication of Duranty's posthumous novel, *The Country of the Arts*, in which a young painter goes to visit various artists in their studios. Paul appears in it as Maillobert.

As I went to knock, I heard a parrot inside. I knocked. 'Come in,' someone cried with an almost extravagant accent. Hardly was I in when a cry burst out inside me: But I'm in a madman's house. I was quite flabbergasted at the place and the person . . . The painter, bald, with a huge beard, looking simultaneously old and young, was himself, like his studio's symbolic genius, indescribable and sordid. He gave me a lavish greeting, accompanied by a smile I couldn't define, sly and imbecile. At the same time my eyes were assaulted by so many vast canvases hung on all sides so terrible in colour that I stood petrified. 'Ah, ah,' said Maillobert with a nasal drawling accent, 'monsieur is an amateur of painting (painnnttting)? There are my little palette-scrapings [*rognures*],' he added, indicating his most gigantic canvases.

At this moment the parrot's voice rang out, 'Maillobert is a great painter.'

'He's my art critic,' the painter told me with a disturbing smile. . .

Then, as he saw me look curiously at a set of big pharmaceutical pots with abbreviated Latin inscriptions: *Juisqui. Aqu. Still. Ferrug. Rib. Sulf. Cup.*, 'That's my paintbox,' Maillobert told me. 'I make the others see that I arrive at true painting with drugs, while they, with fine paints, make nothing but drugs.'

My eyes were rivetted on an immense picture high up, which represented a coalheaver and a baker clinking glasses before a naked woman, above whose head was written CO-OPERATION. When I say a coalheaver and a baker, it's because Maillobert told me that such were these naked persons: the one slashed out in white, the other in brown, the three figures were colossal, twice lifesize, executed on a completely black background, in the mist of broad jostling strokes in which vermilion, Prussian blue and silver-white carried on a furious war. Big eyes with a glittering point struck up out of each head. Still, an arm here, a bit of hip there, a knee somewhere else, were treated with a certain power. 'It's the expression of civilization,' Maillobert told me. 'We have to satisfy the philosophers who are always crying after us.'

I was next drawn by a series of portraits, portraits without faces; the heads were a mass of strokes from which no feature emerged. But on each frame a name was written, often as strange as the painting: Cabladours, Ispara, Valadéguy, Apollin [Achille Emperaire, Valabrègue, etc.], all disciples of this master. 'He's a great painter,' cried the parrot, who seemed to sense the moment when he should intervene.

'He's right,' the painter said vehemently.

At this moment two of his friends turned up, bearded, black, dirty. I asked myself: Can he be the head of the school of mystifiers[*fumistes*]? They contemplated the master's works as if seeing them for the first time. How bold [*crâne*] it is! what energy!' they cried. 'Courbet and Manet are only small fry next to that.'

Maillobert smiled, brightening up. . . He dipped a spoon in one of the pharmaceutical pots and took out a real trowelful of green, which he applied to a canvas where some lines suggested a landscape. He turned the spoon round; and if hard-put one could make out a meadow in what he had just daubed on. I noted then that the paint on his canvases had a thickness of almost a centimetre and formed valleys and hills on a relief-map. Evidently he believed that a kilogram of green was greener than a gram of the same colour.

Perhaps recalling this last sentence, Gauguin later remarked, 'A kilo of green is greener than a half-kilo. You painter, you must meditate this truism.'

Paul had been away from Aix for some two-and-a-half years; and now he stayed in the Midi only a few months. No doubt he wanted both to keep away from his father and to be near Pissarro. Hortense and the boy remained in Paris. In February 1882 Renoir came on a visit to l'Estaque and fell ill with pneumonia. Paul attended to him with much care and Renoir's letters to Choquet are full of gratitude. 'I can't tell you how kind Cézanne has been to me. He mobilized his whole family to help me. We're having a big farewell dinner at his house with his mother; for he's returning to Paris and I'm forced to stay somewhere in the Midi on my doctor's strict instructions.' Mme Cézanne took such trouble over the food: 'At luncheon she gave me a ragout of cod. It think it must be the ambrosia of the gods rediscovered. One should eat it and die.' He brought back to Paris a magnificent water-colour of *Baigneuses*. 'I was with my friend Lauth one day when he was suddenly taken short. He said: "You don't happen to see any trees about, other than pines?" "Splendid," I cried, "there's some paper." It was a most exquisite watercolour that Cézanne had discarded among the rocks after spending twenty sessions on it.'

On February 15th Paul wrote from l'Estaque, 'homeland of the Sea-urchins', to thank Alexis for his book on Zola. The copy had gone to Aix and fallen into 'the impure hands of those related to me.' That is, his father had opened the parcel. 'They took good care not to let me know. They stripped it of its envelope, cut the pages, went through it in every sense, while I was waiting under the harmonious pine. But I got to know of it in the end.' No doubt his mother told him. He enjoyed the evoked memories of youth, especially the poems (printed in an appendix) of 'him who indeed wishes to continue as our friend,' Zola. He found in these verses a marvellous *pâte*. 'But you know how much it [Zola's friendship] means to me. Don't tell him. He'd say I've fallen into the treacle' [*mélasse*]. He sent his 'compatriotic' feelings. In fact the verses were very bad, but they meant for Paul the lost and marvellous days of pure comradeship.

In his book Alexis had written a passage on Zola's forthcoming work, which could not but stir Paul's hopes and fears, since he, Paul, knew that Claude would be based on himself. Perhaps the words with which Alexis ends show that Zola had expressed to him some doubt as to Paul's reactions:

His principal character is ready to hand. It is the painter, dedicated to modernity, who appears in *Le Ventre de Paris*, Claude Lantier. . . I know that in Claude Lantier he means to make a study of the terrifying psychology of artistic impotence. Around this central man of genius, the sublime genius whose production is paralysed by a flaw in his nature, will live other artists, painters, sculptors, musicians, writers, a whole band of ambitious young men who set out to conquer Paris. Some fail, some more or less succeed; but they are all case-histories of the sickness of art, variations of the present neurosis. Naturally Zola will be compelled in this book to lay friends under contribution and to record their most typical characteristics. As far as I'm concerned, if I find myself in it, and even if I'm not flattered by it, I promise not to sue him.

Indeed the picture of Alexis in *L'Oeuvre*, as the sensual and unscrupulous though high-spirited Jory, was not at all flattering.

On February 28th Paul thanked Zola for a critical work, *Une Campagne*, and said that after four months in the Midi he would return to Paris in about a week. He meant to call in at Zola's Paris address and go on to Médan if he were absent. By March he was in Paris, with hopes at last of getting into the Salon, not by any relenting of the Jury but with the aid of Guillemet. The latter was this year a juryman with the privilege of introducing, '*pour la charité*,' one picture that could not be challenged. Such a work was supposed to be by a pupil of the sponsor; but so far from being ashamed of such a subterfuge Paul seems to have been working for it for some time (at least since 1879); on 22 August 1880 Zola had written to Guillemet that Paul was 'still counting on you for you know what.' So his *Portrait de M. L. A.* [Louis Aubert, his godfather?] was exhibited, and he was described as the pupil of the mediocre Guillemet. The only notice taken of the work was by a journalist of the *Dictionnaire Véron*, who saw in it 'a beginner's work painted at great expense of colour: the shadow in the eye-socket and on the right cheek may give promise of a future colourist.' Soon afterwards the charity-privilege was abrogated and Paul had no second chance of by-passing the Jury.

On September 2nd in Paris he was hoping to arrange for a visit to Médan, where he soon spent some five weeks. On November 14th he wrote from the Jas, where he had been staying. He had met only Gibert and two schoolfellows, big Dauphin and little Baille, the younger brother of Baptiste. 'Both of them solicitors: the latter has the air of a nasty little legal blackguard. But nothing new here, not even the least little suicide.' He was recalling the suicide of Marguery, who, after practising as a solicitor, had thrown himself from an upper gallery of the Palais de Justice at Aix on to the floor of the Salle des Pas Perdus. Paul was doubtless thinking with a shudder of his own escape from a legal career. His mother sent good wishes to the Zolas, and he himself sent thanks for a book (*Pot Bouille*). On November 27th he wrote about a decision to make his will, and as usual the need to carry out any sort of action set him in a confused flurry.

It seems that I can make it; the title deeds of the stocks that fall to me are made out in my name. So I want to ask your advice. Could you tell me in what formula I ought to make this document out? I want to leave, in the event of my decease, half my income to my mother and the other half to my little boy. If you know anything about it, please let me know. If I were to die in the near future my sisters would inherit from me and I think my mother would be cut off, and the child (as he was recognized when I registered him at the *mairie*), would, I believe, have a right to half my estate, but perhaps with a lawsuit. If I can draw up the will in my own hand, I'd like to ask you, if it's not a trouble, to keep a duplicate. As long as you wouldn't be inconvenienced, as the paper in question might be removed from here.

He seems reluctant to admit to Zola that he actually had the stocks made out in his name, not as something he would inherit; and he clearly feared that his father, if he laid hand on the will, would tear it up. He also feared that any local solicitor would inform his father of what

he was doing. As his mother was already well provided for, his fears on her behalf were odd. It seems unlikely that she had agreed to act as a cover for Hortense; and his refusal to name Hortense as the boy's guardian must come from some antagonism towards her or from a blind terror of putting her name down anywhere where it might be seen by his father. Perhaps he hoped that by including his mother he made any lawsuit by Marie or Rose more unlikely and thus safeguarded his boy.

II *Desperate Setbacks (1883–6)*

O N 6 January 1883 Paul wrote to thank Coste for the periodical *L'Art Libre*. 'I appreci-
ated the generous impulse with which you take up the defence of a cause to which I am
far from being a stranger. I remain gratefully your compatriot and I'd dare to add confrère.'
On Saturday, March 10th, he thanked Zola for *Au Bonheur des Dames*, a novel which in-
augurated his series of economic or industrial studies. The omnipotence of women made up
what he called 'the *poem* side of the book,' but in the story itself the sex-conflict was less
important than the death-struggle of a doomed commercial order.

Paul had been painting at l'Estaque, renting a small house with garden, just above the
station, in the Quartier du Château. There, at the foot of a hill, he had rocks and pines
behind and the island-strewn bay before him, with the hills of the Marseilleveyre in the
distance. 'The whole, towards evening, had a very decorative effect,' he said. Renoir asked
him to send on two landscapes, left behind from his 1882 visit, which were needed for a show
to follow one held by Monet. Snow had fallen all day on Friday, Paul wrote, and the
countryside looked beautiful, though a thaw had begun. Rose had been at Aix since
October and had borne a girl. 'All this is not very amusing. I think my outcries will have
the effect of stopping them from coming out this summer to the country,' the Jas. 'This de-
lights my mother.' It is not clear if the birth of a granddaughter or the choking-off of the
Conils is what pleases Mme Cézanne; in any event Paul's attitude is selfish and un-
brotherly. Rose had as much right to the Jas as he had. Marie, his autocratic sister, who had
grown more sharp-tempered with the virginal years, abetted him. He told Zola that he
expected to stay on for five or six more months, and sent his regards to Alexis; as usual he
included his mother in his greetings to Mme Zola.

On May 19th, at l'Estaque, he took up again the matter of his will. He and his mother
had finally gone to a notary at Marseille, who told him to draw up the document in his own
hand and make his mother 'universal legatee.' This he did; but he distrusted the Marseille
man and on reaching Paris he wanted Zola to go with him to another notary for fresh advice
and a new will. 'Then I'll explain to you in conversation what drives me to this course.'
(Perhaps he did not like putting his mother in complete control, though the way they had
acted together suggested that she was ready to act as accomplice.) He wished Zola good
health; 'for some things that happen are not at all amusing. These last words are inspired by
Manet's catastrophe; otherwise I'm well.' Manet had just died after the amputation of a leg.

On May 24th he sent a duplicate of the will. 'I'm afraid all this won't help much as
these wills are very easily disputed and nullified. If the case came up, a proper protocol

made before the civil authorities would carry more weight.' Whom does he fear? Hardly his mother and Marie, who must have known all about Hortense and the boy; hardly the Conils, who were not likely to act against the line laid down by Marie. He must still fear that his father would outlive him and wreck all his plans—though we are told that Louis Auguste was now rather senile, caught more than once sidling off to bury a handful of gold coins in the garden. Paul himself was only forty-four, though aged by anxiety, bald, grey-skinned, with drooping-eyelids; a face lined with defeat. More and more he felt tied up with the Provençal earth, at ease only with 'compatriots.' With his usual fear of expenditure he mentions to Zola, 'The document is antedated, as the stamped paper was bought last year.' He intended to return to Paris before 1884. Zola's work he had been following only in *Le Figaro*, though recently he had also read 'a dull article about the valiant Desboutins' (a painter-engraver and rather weak dramatist, who made portraits of Manet and Zola). Paul thought highly of Zola's novel. 'As for me, I liked it a great deal, but my appreciation is not much literary.' When he wished, he was capable of sensitive criticism of literature. Was he not interested, or was he just too busy and confused about his own work and situation? or did the thought of the coming *L'Oeuvre* make him already throw up defences against Zola's novels?

On July 19th he wrote to Solari, whose daughter was marrying a M. Mourain, 'My wife joins me in my good wishes, and my frightful youngster [*gosse*].' Hortense was then with him at l'Estaque, as well as young Paul, now about eleven. On November 26th he told Zola that he had been back at l'Estaque (after a period at the Jas?) since early in the month, and now meant to stay till January. 'Maman has been here for some days.' Last week Rose had lost her child 'born in September or October, I think. The fact is that the poor little thing didn't last long. Otherwise all is as usual.' Once again he remembered Alexis.

This year Huysmans published his book on modern art. Pissarro reproached him for not giving enough weight to Cézanne. 'Why is it you don't say a word about Cézanne, whom all of us recognize as one of the most astounding and curious temperaments of our time and who has had a very great influence on modern art?' He thought Huysmans had let himself 'be carried away by literary theories which are applicable only to the school of Gérôme . . . modernized.' Huysmans replied:

Let's see. I find Cézanne's personality congenial, for I know through Zola of his efforts, his vexations, his defeats, when he tries to create a work. Yes, he has temperament; he is an artist; but in sum, with the exception of some still lifes, the rest is to my mind not likely to live. It is interesting, curious, suggestive in ideas, but certainly he is an eye-case, which I understand he himself realizes. . . In my humble view, the Cézannes typify the impressionists who didn't quite bring it off. You know that after so many years of struggle it's no longer a question of more or less manifest or visible intentions, but of works which are real childbirth, which aren't monsters, odd cases for a Dupuytren Museum of Painting [Dupuytren founded a medical museum of anatomy.]

We may note here the special force given by Paul and his contemporaries to the term *temperament*. In an artist, temperament meant creative force and personal sensibility. The

following passages from *Manette* bring out its scope of reference. 'He spoke of the temperament, the originality, the picturesque power of this draughtsman. Delacroix: a temperament all nerves, a sick man, a disturbed man, the passionate one of the impassioned. . . .'

Baudelaire had used the term. In a letter of 24 May 1865 he wrote of Manet, 'He will never be able to fill in the gaps in his temperament; but he does have a temperament and that is the important thing.' Gautier in 1849 called Gros 'more temperament than taste and a great gift for selection.' In 1856, discussing Peter Cornelius, he stated, 'These painters do not lack intellect, or knowledge, or talent, nor even genius, but they do lack temperament, a quality for which, in our opinion, there is no substitute and which one senses in the smallest brushstroke.' Temperament is thus something that the academics lack; it is the mark of a creative energy, which imprints on everything its personal signature, it reveals a fusion of life and art.

Zola himself was further clarifying his views. He did not agree with Huysmans in his judgments on Courbet and Degas. 'I'm not for throwing Courbet on the scrap-heap or for calling Degas the greatest modern artist.' Degas was only a costive man with the nicest talent. He summed up, 'The more I see and the more I detach myself from merely odd viewpoints, the more I feel love for the great and abundant creators who produce a world.' This position could not be reduced to one of 'the school of Gérôme modernized.' In its essence it acclaimed what were the aims of Paul, though he realized those aims only in part.

In December 1883 Monet and Renoir, coming from Genoa, went to see Paul at l'Estaque, but apart from such a rare visit and his walks with Monticelli he was alone.

1884 is badly documented apart from two letters to Zola. On January 23rd Paul wrote from Aix with thanks for *Joy of Living*, some parts of which he had already read in *Gil Blas*. The day before he had met the brave Valabrègue on a visit to Aix. 'We made a tour of the town together, recalling some of the people we'd known—but how far apart we are in sensation. My head was full of the ideas of this countryside, which seems to me very extraordinary.' He sent greetings to 'Alexis my compatriot, though I haven't heard from him for an infinite time.'

From Guillemet we learn that Paul submitted a portrait head to the Salon, which was rejected. On November 27th he thanked Zola for two new books, one of which may have been *Naïs Micoulin*, a collection of short stories. He had no news of 'the good town where I saw the light of day,' and adds a difficult sentence which reflects the struggle of new thoughts and lines of approach going on inside him. 'Only (but this without doubt shouldn't much affect you), art is being terribly transformed in its outer aspect and is assuming too much a slight and very paltry [*petite*, *mesquine*] form, while at the same time the unawareness [*inconscience*] of harmony is revealed more and more in the discordance of the very colours, and what is yet worse, in the deafness [insensitivity, *aphonie*] of the tones.' Presumably

'art' means 'my art.' He is changing his method at the root and feels that his grasp of form and colour is inadequate to the new realizations. Still, 'after moaning, let's cry Long live the Sun, which gives us such beautiful light.'

What of his art in these years? In 1880, the year when Zola wrote on the failure of impressionism to produce a great artist in his sense of the term, Paul seems to have felt restless. He tried a new way of laying on paint, in curling touches that have been called comma-like. He refined his rhythms and system of drawing, as in *The Turning Road* (about 1881); he went painting in Normandy with Choquet, returned to the use of parallel strokes, using them to define volume more effectively. In the south, he organized his masses with even greater solidity and also with fuller control over depth. He was exploring the new dimension he had discovered and created, stressing one aspect or another, but moving forward all the while. Then in 1885 came a check, connected with the emotional crisis we shall now consider.

In a letter of 14 January 1885 Gauguin presented a highly romanticized picture of Paul:

> Look at Cézanne, that misunderstood man, whose nature is essentially mystical and oriental (his face is like an old Levantine's), his form has all the mystery and oppressive tranquility of a man lying down to dream, his colour has the gravity of his oriental character; he is a man of the Midi and spends whole days on the tops of mountains reading Virgil and gazing at the sky; his horizons are lofty, his blues very intense, and his reds have an astonishing vibrancy.

There were a few constant admirers. Pissarro bought canvases and told his sons, 'If you want to learn to paint, look at Cézanne.' In November 1884 Gauguin, though now hard up, wrote to his wife, 'I am attached to my two Cézannes, which are rare of their kind, for he has completed few such, and one day they'll be very valuable indeed.' He didn't want them sold.

Meanwhile Paul was painting at l'Estaque, far from the oriental gravity imputed to him by Gauguin. He thanked Zola for *Germinal*. 'Rather severe neuralgic pains have left me lucid only at moments,' but now his head had eased and he could walk again 'on the hills, where I see fine panorama-views.' It is a great pity he did not write his ideas about *Germinal*, in view of his sympathy for writers like Vallès and Mirbeau; but in these years he appears almost numbed as he struggles along with his new approach.

However, in the spring he was galvanized by a desperate, though hardly existent, love-affair. He seems to have kissed a girl, Fanny, who worked at the Jas, a robust wench unafraid of hard work, capable of lifting up a cask filled with wine unaided. 'You see how good-looking the maid at the Jas is,' he is said to have remarked; 'she's just like a man.' The evidence for his action and his state of mind come mainly from a draft on the back of a drawing, which, in its tortured politeness, is surely the oddest letter ever written in such a situation:

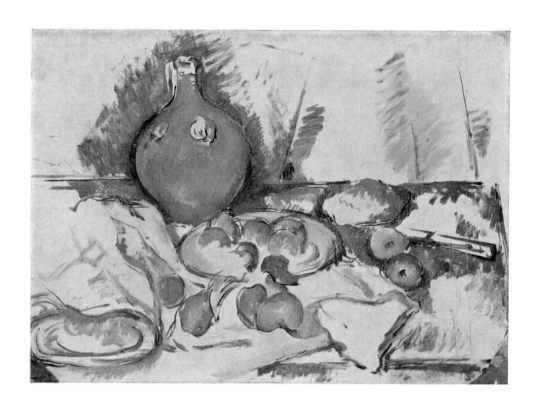

III Still Life with Water Jug, 1892–93 *The Tate Gallery, London*

I saw you and you permitted me to embrace you; from that moment a deep disturbance has continued to agitate me. You will excuse the liberty that a friend, tormented by anxiety, takes in writing to you. I do not know how to qualify this liberty which you may find a very great one, but how can I remain under the oppression that bears me down? Is it not better to express a feeling than to hide it away? Why, I've told myself, keep silence over what torments you? Is it not a relief to suffering to let it find utterance? And if physical pain seems to find some abatement in the cries of the sufferer, is it not natural, Madame, that moral griefs should see a consolation in the confession made to a worshipped being?

I know this letter—the hasty and premature sending of which may seem indiscreet—has nothing to recommend me to you but the goodness of. . .

The keenly observant Marie noted what was going on, and promptly sacked Fanny. We do not know if Paul ever gave the girl the letter which he had drafted, but he certainly went on hoping to make something lasting of the obscure and transitory affair.

Meanwhile, what of Hortense? For some fifteen years now, she had been kept in the background of his life, with a son to look after, on a fairly small allowance. As we have deduced from his art, it is likely that he had long since dropped all marital relationship with her. In him an extreme desire for women was linked with an extreme fear of succumbing. His oscillations between exalted confidence and abysmal conviction of failure, between a happy outpouring of himself in work and a reaction of totally dammed-up faculties, would in any event have made more than difficult the achievement of a normally extended harmony with a woman; and once a break had come, his awkward diffidence would set up strong barriers against a fresh start. Zola, with his acute nose for this sort of thing, depicts Claude in *L'Oeuvre* as turning away, after the first period of union, from sexual contacts with his Christine. The artist withdraws from his wife in his fierce effort to give himself up wholly to his art, and the woman in childbirth is opposed antithetically to the artist in his creative throes:

She knew too exactly how he had come to forsake her. It had begun by his refusing her when she nestled close to him in bed the night before he had important work to do; he said it tired him. Later, he pretended that when they made love, it took his brain three days to clear well enough for him to produce anything worth while. That was how they had gradually drifted apart; a week would go by while he was finishing off a picture, then a month while he was preparing and starting work on another, and soon, with postponements and neglected opportunities, abstinence had grown to be a habit and ended in complete estrangement.

Logically Zola shows the artist's suicide as the aftermath of a moment of return to sexual experience, of complete abandonment to his wife. He himself suffered from the conviction of a deep and inevitable conflict between childbirth and artistic creation. The Notes for *L'Oeuvre* state: 'Genesis of the works of art, nature embraced and never conquered. Struggle of the woman against the work, the childbirth of the work against the childbirth of real flesh.' And this kind of attitude, with its conception of mating as a loss of power, a waste and a pollution, derives largely from the shames of the onanistic orgasm. The evidence for the interpretation we have made of the bather with diagonal-arms becomes

overwhelming. Perhaps a wife of great tact and understanding might have drawn Paul out of his fantasies of loss and fear; but poor Hortense was hopelessly ill-equipped for such a purpose.

On May 14th he wrote to Zola from the Jas. Either he was in touch with Fanny, or (more likely) he hoped that letters of his would reach her and she would be drawn into replying. What he meant to do if she did reply, we can only guess. From the ardour with which he pursued her it seems that he had some hope of a permanent relationship. He asked Zola to grant him a favour, 'which I think is tiny for you, yet vast for me.' What he wanted was permission to use Zola as a postal address for Fanny. 'I'm either mad or in my senses. *Trahit sua quemque voluptas*! I appeal to you and implore your absolution; happy are the wise. Don't refuse me this service, or I don't know whom to turn to.' In a postscript he added, with his usual mixture of deprecatory humour and deep seriousness, 'I'm poor and can do you no service, but as I'll depart before you, I'll put in a word with the Almighty to get you a good place.'

At the Jas there must have been many recriminations and arguments. Paul's connexion with Hortense, however previously suspect, now had become the sole basis for any respectable arrangement. Paul fled to the north and took refuge with the Renoirs at La Roche-Guyon, Seine-et-Oise, but was not likely to have told them of his problems. To Zola alone could he open his heart. On June 15th he wrote to say he'd arrived that morning and asked to have any letters sent to the *poste restante*. 'Yesterday I was a bit too stuffed up with good things.' On June 27th he begged, 'When the time for your departure to Médan comes and you're installed there, please let me know. The need for change keeps me a bit on edge. Happy are faithful hearts.' He thanked Zola for 'obliging me about my letters from Aix'. Zola went to Médan but his wife was ill. On July 3rd Paul persisted: 'Owing to fortuitous circumstances, life here is getting rather difficult. Will you tell me if you can take me in?' Then three days later he wrote apologetically, 'I must ask you to forgive me. I'm a great arse. Just imagine, I forgot to go to the *poste restante* for your replies. That is what explains my insistent letter. Thanks a thousand times.' Now he asked for letters to be sent care of the Renoirs, adding in a postscript that this instruction did not refer to letters from Aix (i.e. from Fanny); these were still to go to *poste restante*, with a cross in a little corner of Zola's letter (presumably the envelope in which the Aix letter was enclosed). What use could the cross be except to inform an anxious Paul at once that the hoped-for letter had come? The difficult circumstances that had developed seem to have been caused by the Renoirs learning about Paul's love-hopes and arguing against his abandoning Hortense.

On July 11th he wrote to say he was leaving for the inn at Villennes. 'I'll go and see you for a moment as soon as I arrive; I want to ask you if you could lend me *Nana* to paint; I'll bring it back to its moorings after finishing my study.' He seems to want the boat to reach the island opposite the house, from which he had painted a view of the Château de Médan. 'Doing nothing, I'm getting more bored.' A postscript explained: 'See nothing

wrong in this decision. I'm obliged to make a change of place only. And then when you're free, I'll have only one step to take to your house.' Two days later at Vernon he declared, 'Impossible for this festival week to lodge at Villennes. Neither at the Sophora, nor at the Hôtel du Nord. I clasp your hand, I'm at Vernon, Hôtel de Paris. If my canvases are sent to you, please have them taken in and kept at your place.' Two days later he was still at Vernon. 'I can't manage my business in the conditions in which I find myself. I've decided to leave for Aix as soon as possible. I'll pass by Médan so as to clasp your hand there. I confided to your care some papers I'd like to have; if they're in Paris, could your servant fetch them one day when he goes to the Rue de Boulogne? Goodbye and thanks in advance. You'll forgive me once again for coming to you in the existent circumstances, but another seven or eight days to wait seems a very long time to me.'

On July 19th, still at Vernon, he wrote a typically vacillating letter. 'As you say, I'll go to Médan on Wednesday, I'll try to set out in the morning. I'd have liked to be able to carry on with painting, but I was in the utmost perplexity; for since I must go south, I concluded the sooner I went the better. On the other hand it would perhaps be better if I wait a little longer. I'm caught in indecision. Perhaps I'll get out of it.' At last he was invited for the 22nd. After some three years he and Zola met again, for the last time, for a couple of days. A letter of the 25th to Coste says that Alexis was there too. Zola was now getting fat; he weighed 15 stone and measured 44 inches round the waist. He was scared of diabetes, and had just gone with his wife to Mont-Dore for the cure. With each new novel he developed his estate. The garden widened into a park, an avenue of limes was planted, hothouses, pigeon-loft and model farm were built. But there is no sign that the last meeting between him and Paul was any less friendly than any previous one. It was to him that Paul had turned as his one sure stay in his predicament.

By August 20th Paul was back in the Jas, going daily to Gardanne, some eight miles from Aix, where old houses rose steeply along a narrow street to the mound on which stood a square bell-tower. 'I got the news you sent me about your address last Saturday. I'd have replied sooner, but the clods [*grumeleaux*], which are under my feet and are like mountains to me, have distracted me.' The clods or lumps in his way are now no longer his father but are Marie and his mother leagued with Hortense. Five days later he wrote to Zola in cryptic final despair. 'It's the beginning of the comedy. I wrote to La Roche-Guyon the same day as I sent you a line of thanks for thinking of me. Since then I've had no news at all; besides, for me, it's the most complete isolation. The brothel in town, or another, but nothing more. I pay, the word is dirty, but I've need of repose, and at that price I ought to get it. I beg you then not to reply, my letter must have come at the right moment. Thank you and please excuse me.' He adds, 'If only I had an indifferent family, everything would have been for the best.'

He definitely abandons all hope of further sexual relations. How far we are to take the remark about brothels seriously, it is hard to say. With so shy a character, who had now

developed a phobia about touch, the idea of brothel-frequentation is difficult to accept. But it is possible that, in his shattered condition, he really did bring himself to pay for the release he so badly needed. That certainly is the plain meaning of his words; and it may be that at Aix, or more likely at Marseille, he found the courage, the anguished strength, to force himself into a brothel. Indeed, for someone who, like himself, had reached the stage where a love-union was impossible, the whore may have been a genuine solution. It may be significant that about this time his series of stretching bathers lose their tense dislocations and achieve something like 'repose' in their bodies.

As for Fanny, we are told that though she made no effort to hold Paul, she cherished a painting he gave her of a corner of the Jas with outhouses. Only many years later, when lying ill in hospital, did she sell it—very cheaply, to a welfare-worker who seems to have had some idea of its value.

Apparently in 1885 there came a burst of erotic themes, of the kind that had died down since *The Struggle of Love*. Round this time we may put the sketches of a Carnival Scene, in which a Harlequin on the left impetuously embraces a woman; a man with bicorne hat sits behind a table; on the right sprawls a second embracing couple. A drawing of two wild dancers is probably of the same period. But the phase of excitement was too brief for these sketches to develop into paintings. The connexion of Harlequins with sexual release, however, seems to lead into the paintings, a few years later, of his son in harlequin costume. We shall see how, feeling himself decrepit, Paul became strongly conscious of the stirring sex-life of the lad.

We find also a vigorous drawing of Fauns attacking a Woman; but most important as a preparation for the attempt to recover love in life was his revival of the theme of the Judgment of Paris. The picture he now painted was unusual in composition. The three goddesses are grouped inconsequentially: one reaching vainly out; another crouching down with head against her hips, turned away from Paris though stretching out her arm with the reversed-hand gesture we saw in the second Temptation; and Aphrodite behind them taking an armful of apples from Paris. Behind Paris is a fourth woman (apparently Helen, his reward from Aphrodite), who lifts a veil in a variation of the diagonal-arms posture, that which expresses sexual release or acceptance. Paul-Paris was looking for someone to take the apple again. The Helen-figure is prophetic of Fanny. In an early *Satyrs and Nymphs*, we may note, a nymph has the Helen-pose.

We can relate with this phase also the *Leda and the Swan* with its sky-blue background, its intensely blue cushion with yellow tassel, its swan of blue-white (like the cloth and bed) with dark yellow beak, and its flesh of yellow-rose shaded with blue and green. The modelling of the body is defined almost wholly by colour. (We may recall the part played by the bird in one version of the *Rum-Grog* and in versions of the second *Temptation*.) Connected with the *Leda and the Swan* is the *Naked Woman*, where the same posture is used. Here the neck is blue-grey, the curtain blue, the flesh blue-rose, with yellow-green, green-white, and

yellow-red in table, cloth and pears. It has been suggested that the woman is Nana, and
Paul may indeed have had that character in mind, but there is no proof of it. What is of
interest is that the place of the swan is taken by the round table and two pears. This
fragment of still life is strongly uptilted to make it play much the same part in the design
as the swan in the other work—though it is even more florid and enveloping in its rhythms:
one might say, more alive. The huge pear with its stalk has a phallic-beak effect. This
transposition of the swan into a still life form brings out clearly what powerful emotional
significances underlay the 'cones and spheres' of the objects, especially those of fruit. One
may add that the way in which the two pears are put together has also a clear genital effect.

Zola had planned a visit to the south that would take him to Aix in early September. He
and his wife got as far as Mont-Dore, then gave up, hearing of a cholera outbreak at Mar-
seille. Zola thought Aix would be safe enough; but his wife, who had been ill, was afraid
of infection.

About this time, 1885, Maxime Conil bought a fine property called Montbriant, to the
southwest of Aix. Set on a fairly high hill, the house looked down the long Arc valley to
the distant Mont Ste Victoire. Paul often painted there, or in the neighbourhood, for instance
at Belleville with its farmyard and dovecote. His favourite site was a small wood from which
he had a valley-view of the mountain. He loved the deep hollow space into which he could
project himself, embracing the broad planes and masses, and enjoying the clear demarcation
lines (railway in foreground, viaduct further off). In his distracted state this year he probably
hardly noted that his once-hero Vallès had died of diabetes. At the funeral a vast crowd
accompanied the hearse, shouting *Vive la Commune*! The bands of Déroulède attacked the
procession with its red flags; and thus Vallès had a disorderly and challenging end to his
days of the kind that he would have approved.

On the morning of February 23rd Zola wrote the last pages of *L'Oeuvre*, the description
of Claude's funeral: the funeral of his own youth and also the funeral of his long friendship
with Paul. On April 4th Paul at Gardanne acknowledged receipt of the novel in the last
letter he wrote to Zola: 'I thank the author of the Rougon-Macquart series for this good
token of remembrance and ask him to allow me to clasp his hand while dreaming of bygone
days. All yours under the impulse of past times.' The dignified impersonal and elegiac tone
gives the farewell note. He says that he has not yet read the book; but he clearly knows its
drift. The work had been serialized in *Gil Blas*; and in February this year he had been at
a literary evening with Pissarro where some young poets rated the new novel as 'absolutely
bad'. Zola's special relation to the advanced artists ensured that they would have followed
the serial version with great interest. Guillemet wrote to him on 1 February 1886, 'I came
on a scene at Bennencourt which is so marvellously recorded, so moving, so true that I re-
lived there a little of my—of your—youth; and the small stream of Jenfosse and the islands

and all that came back to my memory—and I was deliciously moved. It's so good to become a little younger.' Paul knew that in the novel Zola had put down as fully as he could a deeply considered judgment of his character as a man and an artist, and that he was defined as impotent in the last resort to achieve his dreams—a neurotic of hopelessly vacillating moods whose logical end was suicide. To argue that Zola did not mean that his end was necessarily a suicidal one, would not in any way lessen the shock. Zola's method was, indeed, to take from life a character or characters with deep conflicts and then drive the conflicts to their limit. Thus he had shown Cézanne's father and mother in *The Conquest* as destroyed by antagonisms which remained largely latent in their actual lives. What mattered for Paul in *L'Oeuvre* was the thorough and detailed picture of his own inevitable frustrations and failure.

Zola had intended the work to be well documented and to depict a whole generation of painters; though Paul had inevitably been at the centre of his thoughts in working out the novel, he had not meant it to be obviously or simply a portrait of his struggles and defeat. With his usual industrious and systematic methods he had collected factual material. Guillemet told him how the Salon Jury functioned; Jourdain gave him information on architecture and Béliard on music. He gathered details about art dealers and collectors, studied afresh the Salon and its ramifications, went into all those aspects of the Paris scene that he felt relevant. For Lantier's suicide he had the precedent of an actual suicide by a young rejected artist in 1866, whose studio he had visited; he described this visit in *L'Evénement* as a preface to his attack on the Jury. Then, to disguise or adulterate the portrait of Paul, he deliberately mixed in elements from Manet, Monet and others, and while making his Claude a post-romantic he took care not to describe his technique and method too definitely in terms of impressionism. But with all his precautions and good intentions he could not help in gravitating essentially towards the artist he had known so well; whose hopes he had so passionately shared; and whose uncertainties, violences, and neuroses had finally convinced him of an inherent instability—an inability to carry his vision right through to the difficult and triumphant end:

In Claude Lantier I want to paint the artist's struggle against nature, the creative effort in the work of art, effort of blood and tears to give one's flesh, to create life always wrestling with the truth and always defeated, the struggle with the angel. In short, I'll relate my intimate life as creative artist, this perpetual and painful childbirth; but I'll enlarge the subject and dramatise it through Claude who is never satisfied, who is tormented by his inability to give birth to his own genius, and who, at the end, kills himself before his unfulfilled work. He won't be an impotent artist, but a creator with too great an ambition who wants to put all nature on a single canvas and dies in the attempt. I shall have him produce some superb things, fragmentary, unknown, and possibly ridiculed. Then I shall give him a dream of immense pages of modern decoration, of frescoes epitomising the whole epoch, and it is there he will destroy himself.

Thus, though Zola put himself directly into the novel as Sandoz, he embodied his own aspect as a poetic inventor in Claude as well as basing that character on Paul. But he could

do that only because of the many creative elements he shared with Paul: elements which we have already discussed. The novel's title, *L'Oeuvre*, does not mean *The Masterpiece*, as it is sometimes translated, but *Artwork, The Process of Art*. Other suggested titles that he jotted down were: *The Work of Art, Living Work, Living Flesh, Creating, Creation, Genius, Bearing* [enfanter], *Our Flesh, Our Works, The Anguish of Creating, of Bearing, The Bloody Couches, This is my Flesh, The Blood of my Work*. Zola said of his hero, 'I set him in the history of painting, after Ingres, Delacroix, Courbet.' His Claude rebels against art that is 'too dark and cooked-up' (*cuisiné*); 'he would like more of nature, more of open air, of light. Decomposition of light. Very clear painting. But that in immense canvases, in grand décor. And there's a romantic at basis, a constructor. Hence the struggle. He wants to embrace in one clasp the nature that escapes him.'

There is much insight into Paul's case in the idea of the conflict between the *plein-airiste* and impressionist on one side, and the romantic and constructor on the other: the desire to explore new fields of sensibility through colour and the urge to grasp the tumult of life in large significant patterns. As Zola rambles about in his Notes, he forgets that he is devising a Claude Lantier, and speaks as if he is simply analysing Paul.

Not to forget Paul's despair; he always thought he was discovering painting. Utter discouragement, once ready to drop everything: then a masterpiece, nothing but a sketch, quickly done, and which rescues him from his extreme discouragement. The question is to know what makes him powerless to satisfy himself: he himself, primarily, his physiognomy, his breeding, his eye-trouble; but I would like our modern art to play a role, our fever to want to do everything, our impatience in shaking traditions, in a word, our lack of equilibrium. What satisfies G[uillemet] does not satisfy him; he goes further ahead and spoils everything. It is incomplete genius, without full realization; he lacks very little, he is a bit here-and-there due to his physical make-up; and I add that he has produced some absolutely marvellous things, a Manet, a dramatised Cézanne, nearer to Cézanne.

The phrase about 'what satisfies G.' reminds us of the advice in the letters of 1860 to Paul.

The arguments by critics as to whether Claude Lantier is really an impressionist painter are quite beside the point. Claude is Paul in essence, and the art he seeks is the art that Paul sought. Why Paul in fact escaped the nemesis that fell on Claude is to be explained by factors outside the scope of the novel. Pissarro deflected Paul from the conflicts that Zola sketched out in his Notes and defined at length in the novel; he provided him with a haven in which he was able to turn in an orderly way to nature and to relax the grip of the romantic-constructor side of his artistic personality. Through Pissarro he found repose in a deep and loving study of nature, and then in due time was able to pick up afresh his romantic-constructor side on a new level and in a modified form, which did not disrupt his gains of loving study. He was unable to continue the struggle of the grand though imperfect forms of his earlier years, the forms which Zola defined in his novel. He escaped suicide or break-down by lessening his claims, by reassuming them in a way that harmonized with the lessons learned under Pissarro. The painters such as Pissarro, Monet and Renoir, who had

kept in fairly close contact with Paul's development, were able to see and sense the qualities which were to emerge stably in the later years; Zola, who had not been able to follow Paul's work in this way and who, in any event, lacked the trained eye of the painters, was unaware that Paul was making a crucial break with the course of his earlier years. He was able, therefore, in all innocence to see in Paul only those elements which seemed to make him a grandiose failure, a symbol of the impasse that Zola felt to be coming over art—brilliant exploitations of aspects of art-sensibility, with a collapse of the great integrating power to be found in an artist of overflowing abundance 'who produced a world'.

Paul enjoyed the early sections of the novel, which once more revived the magical years of his youth. All the worse, then, was the blow of the later sections, in which the weaker and anguished aspects of his life were remorselessly analysed and exposed. A man who suffered from so many self-doubts and anxieties could not but be cut to the heart by the powerful representation of himself as hopelessly self-divided and doomed to failure.

The impressionists were mostly dismayed. 'What a fine book he could have written,' Renoir remarked, 'not only as an historical record of a very original movement in art, but also as a "human" document . . . if, in *L'Oeuvre*, he'd taken the trouble to relate what he'd seen and heard in our gatherings and our studios, for here he happened to have actually lived the lives of his models. But, at root, Zola didn't care a damn about portraying his friends as they really were: that is, to their advantage.' A natural enough reaction, but irrelevant to Zola's aim. Tanguy was distressed: 'It's not right! I'd never have thought it of him. Zola, who is such a nice man and a friend of these gentlemen. He hasn't understood them. It's a great misfortune.' Pissarro told his son Lucien in March that he had dined with his fellow-impressionists and had a long chat with Huysmans, 'who is very conversant with the new art and keen to break a lance for us. We talked about *L'Oeuvre*.' Huysmans, it seemed, had quarrelled with Zola, who was very worried. However, when Pissarro got down to reading the book, he was unperturbed. To Monet, who feared it would do their cause much harm, he replied that he was now half through the work, and disagreed. 'It's a romantic book; I don't know the ending, it doesn't matter, that is not it! Claude isn't carefully studied; Sandoz is done better, one can see that he understood him.' He didn't think the book would do them harm. Monet held to his point. He wrote to Zola, 'I've been struggling a long time now and fear that at the very moment we're getting somewhere our enemies will use your book to confound us.' Neither he nor Pissarro seem to have felt that Claude was a portrait of Paul. He remarked, 'You were purposely careful not to have any of your characters resemble any one of us but, in spite of that, I'm afraid our enemies among the public and the press will identify Manet and ourselves with failures, which is not what you have in mind, I cannot believe it.' That he should fail to recognize the characters embodying Solari, Coste, Baille, Guillemet, Alexis, we can understand; but his inability to identify Claude with Paul is very odd. Many years later Zola, asked by a young student whom the characters represented, replied, 'They are failures of whom you would

scarcely know, I think.' Not for some time, and then only through a deliberate leak of information, was it suggested that Zola had given 'one of his chief characters the moral traits and artistic ideas of Cézanne.' Meanwhile, however, arguments went on among the artists who were naturally obsessed with what seemed to them the failure of Zola to do justice to the impressionists. Degas remarked coldly, at Morisot's, that Zola wrote the book only to prove the superiority of writer over painter. Moore tells us:

One evening, after a large dinner party given in honour of the publication of *L'Oeuvre*, when most of the guests had gone and the company consisted of *les intimes de la maison*, a discussion arose as to whether Claude Lantier was or was not a man of talent. Madame Charpentier, by dint of much provocative assertion that he was undistinguished by even any shred of the talent which made Manet a painter for painters, forced Emile Zola to take up the cudgels and defend his hero. Seeing that all were siding with Madame Charpentier, Zola plunged like a bull into the thick of the fray, and did not hesitate to affirm that he had gifted Claude Lantier with infinitely larger qualities than those which nature had bestowed upon Edouard Manet. This statement was received in mute anger by those present, all of whom had been personal friends and warm admirers of Manet's genius, and cared little to hear any word of disparagement spoken of their dead friend. It must be observed that Emile Zola intended no disparagement of Manet, but he was concerned to defend the theory of his book—namely that no painter working in the modern movement had achieved a result equivalent to that achieved by at least three or four writers working in the same movement, inspired by the same ideas, animated by the same aestheticism. And, in reply to one who was anxiously urging Degas' claim to the highest consideration, he said: 'I cannot accept a man who shuts himself up all his life to draw a ballet-girl as ranking co-equal in dignity and power with Flaubert, Daudet or Goncourt'.

More precisely what Zola had in mind was the question: Why couldn't Cézanne encompass in art the wide range of contemporary life that I have encompassed in novels? Why couldn't he release and apply in contemporary terms the romantic-constructor impulses of his poetic faculty as I did? And it is the measure of Paul's almost total absence from the minds of critics, writers and artists, that they were taken in by the linking of Claude and Manet's *Déjeuner sur l'Herbe*, so that they thought Manet played an important part in Claude's genesis and in the conception of the novel. Guillemet, himself at least in part one of the novel's least admirable characters (Fagerolles), could not see the connexion with Paul even when he mentioned him in a letter of protest.

A very gripping but a very depressing book, all in all. Everyone in it is discouraged, works badly, thinks badly. Persons endowed with genius or failures all end by doing poor work; you yourself, at the book's end, are completely frustrated and depressed; it is pessimism, as the word is fashionable. Reality is not so sad, fortunately. When I began to paint, I had the pleasure and honour of knowing the wonderful pleiad of modern geniuses: Daumier, Millet, Courbet, Daubigny, and Corot, the most human and pure of them all. They all died after producing their best work and all their lives they moved forward. You yourself, whose friend I am proud to be, do you not always progress and is not *Germinal* one of your finest works? In your latest book I find only sadness or impotence . . .
As for the friends who take up your Thursdays, do you consider they end as badly—I mean to say as courageously? Alas, no. Our good Paul is putting on weight in the lovely sunshine of the south, and Solari is scratching his gods; neither one thinks of hanging himself—very fortunately.

Let's hope, by God, that the little gang, as Mme Zola calls it, doesn't try to recognise themselves in your uninteresting heroes; for they're evil into the bargain.

Paul however was not deceived. For him it was the end of all relationship with Zola. The latter's daughter tells us that Mme Zola, asked long afterwards why the breach was never healed, replied, 'You did not know Cézanne; nothing could ever make him change his mind.' The inference is that Zola made overtures, but Paul ignored them. Unfortunately the various writers who purport to record Paul's comments in his old age are unreliable. Thus, Vollard cites Paul as saying, 'No harsh words ever passed between us. It was I who stopped going to see Zola. I was not at my ease there any longer, with the fine rugs on the floor, the servants, and Emile enthroned behind a carved wooden desk. It all gave me the feeling of paying a visit to a minister of state. He had become (excuse me, M. Vollard, I don't say it in bad part) a dirty bourgeois.' That is certainly false, though it may incorporate some sarcastic remarks by Paul about Médan. Vollard adds that Paul said, 'One day a servant told me that his master wasn't at home to anyone. I don't think the instructions were meant for me in particular; but I went there less frequently.' Again the episode may be true, but it can have gained significance only after 1886. The untrustworthy Gasquet elaborates with his usual inventiveness: 'A smile exchanged between a servant and Zola, at the head of a staircase, one day that Cézanne was late in arriving at the house, loaded down with packages, his hat awry, drove him away from Médan for ever.' However, his more sober account of the effects of *L'Oeuvre* may well reflect fairly truthfully what Paul said, doing his best, years later, to consider the matter objectively:

The early chapters of the novel always moved him profoundly; he felt in them an extraordinary truthfulness, almost unqualified and intimately touching to himself, who recaptured in those pages the happiest hours of his youth. When the book changed direction later on with the character of Lantier threatened with madness, he understood that this took place according to the necessity of the plan, that he himself was entirely out of Zola's mind, that Zola in short hadn't written his memoirs but a novel that formed part of an immense carefully worked-out whole. The character of Philippe Solari, set out in the guise of the sculptor Mahoudeau, was also very much altered to suit the plot, and Solari did not dream, any more than Cézanne did, of taking offence.

His admiration for Zola never faltered. And Zola, when I saw him in Paris fifteen years after *L'Oeuvre*, spoke to me of his two friends with the most profound affection. This was about 1900. He was still fond of Cézanne, in spite of his sulkiness, with all the warmth of a great brotherly heart, 'and I am even beginning', he told me, 'to have a better understanding of his painting, which I always liked, but which eluded me for a long time, for I believed it to be forced, whereas it is really incredibly sincere and true.

That rings all the more true when we bear in mind that Gasquet stood in a camp hostile to Zola and certainly did his best to turn Paul against his radical and anti-clerical friends. In contradiction we may take Vollard's statement that the very mention of *L'Oeuvre* made Paul tear a canvas to pieces.

Emile Bernard's account, supposed to record a talk of 1904, is at best a stupidly distorted version of remarks made by Paul on a bad day:

We were talking of Zola, whom the Dreyfus case had made the man of the hour. 'He had a very mediocre intelligence', Cézanne told me, 'and was a detestable friend; he could see nothing but himself. That is why *L'Oeuvre*, in which he claimed to describe me, is only a horrible distortion, a lie to increase his own glory . . . Then when I came to Paris, Zola, who had dedicated *The Confession of Claude* to me and Bail [*sic*], a comrade now dead, presented me to Manet. I was deeply impressed by that painter and by his cordial reception, but my natural timidity prevented me from going to his studio very often. Zola himself, as he established his reputation by degrees, grew unfriendly and seemed to admit me only as a favour: so much so that I became disgusted at the sight of him and let several years go by without looking him up. One fine day I received *L'Oeuvre*. It was a blow to me; in it I saw his real attitude towards us. In fact it is a bad book and completely false'.

Baille was not dead; he did not die till 1918.

No doubt Paul vacillated in his reactions in these later years, at moments of depression reviving all the old hurt, at others feeling no rancour to his old comrade. We seem to find the same variation in Zola's attitudes. His daughter recalled the joy he showed at finding some of Paul's works at Alexis' place; and Frank Harris (unfortunately an unreliable witness) declares that about 1900 he called Paul one of the greatest painters who ever lived. However G. Coquiot, recording an interview of about 1896, makes him speak in a bitter tone:

Ah yes, Cézanne. How I regret not having been able to push him. In my Claude Lantier I've drawn a likeness of him that is actually too mild; for if I'd wanted to tell everything . . . Ah, my dear Cézanne doesn't think enough of public opinion. He despises too much the most elementary things: hygiene, dress, language. And even all that, dress, self respect, is not very much, after all, if my dear great Cézanne had only had genius. You may guess how much it cost me to be forced to abandon him . . . Yes, to start out together in the same faith, in the same enthusiasm, and arrive alone, attain glory alone, it's a great pain that weighs you down. Yet it seems to me, in spite of all, that in *L'Oeuvre* I have noted with the most attentive scruples all the efforts of my dear Cézanne. But what would you? There were those successive failures, good starts and then sudden halts, a brain that no longer thought, a hand that fell, powerless. Never anything carried through to the end with magnificent tenacity and force. All in all, no realization whatever.

The smug and respectable idiom there is hardly that of Zola; at most Coquiot no doubt heard a general justification of *L'Oeuvre* as the picture of an artist unable to achieve his high aims. After 1886 Zola drew aside in general from the world of art and was not much concerned with what was happening in it.

We may pause here to consider some of the characteristics which Paul and Zola strongly shared, and which enabled Zola to enter sympathetically into Paul's struggles and sufferings. Both men looked back passionately to their youthful days together and drew an important source of moral and aesthetic strength from them. We have noted how Zola loves to describe and re-describe his years at Aix with Paul and Baille, and how the memories of that period underlie Paul's continual return to the theme of Bathers. 'Memory is today the only joy in which my heart finds rest,' Zola wrote in *Contes à Ninon*. Both men had a deep, almost obsessional fear of women and sexual experience. Dr. E. Toulouse analysed Zola's timidity

in this matter; and Zola, writing to a Russian who wanted to translate the doctor's book, declared, 'It's the truth and I accept it.' *The Confession* depicts already the inner division born from a tormented chastity linked with a possessiveness directed towards the mother. 'My soul is so exacting that it demands total possession of the creature it loves, in her childhood, in her sleep, in the whole of her life. It goes so far as to call into question her dreams, proclaiming that the beloved is defiled if in imagination she has partaken of the embraces of a vision.' He is afraid of the 'demon of her night' who has ravished her. Worse still if she has ever kissed anyone. 'She writhes in my arms, dreaming perhaps of former loves.' In such attitudes we see an extreme mother-fixation prolonged in onanistic fantasies, with fears of impotence brought to an extreme pitch of anxiety. As a result a full and confident union with any woman was more or less rendered impossible. Sandoz-Zola in *L'Oeuvre* sets out the notion of woman as destroyer of the artist. Elsewhere Zola wrote, 'The chaste writer can be at once recognized by the fierce virility of his touch. He is filled with desires as he writes, and these desires prompt the outbursts in his great masterpieces'—in *Le Voltaire*, 5 August 1879, chastising the self-indulgent Sainte-Beuve. With *A Page of Love* in 1878 he had begun his series that reveal a hidden dread of sex as a destructive force, a series that ran on through *Nana* and *Pot-Bouille*. *Nana* shows the corruption and demoralization of the upper levels of society by the prostitutes from below; *Pot-Bouille* shows the middle class destroying itself by pointless promiscuity; the general theme then carries on into *Au Bonheur des Dames* and *The Human Beast*. In both Paul and Zola the work-obsession had part of its root in an urge to escape from the sexual sphere, to prove masculinity by 'the fierce virility of touch' in art. Love and art are not seen as complementary spheres, each stimulating the other, but as ferocious rivals, each seeking to rob the other of its energies. These ideas were common to both Paul and Zola; but Zola, by his superior expansive force and adaptability, was able to control them better than Paul.

These distorted ideas in turn beget fantasies of sexual violence, which retorted on the woman the fears of strangulation and impotence that she aroused. Similar to Paul's paintings of rape or murder are the jealousy scenes in Zola, the scenes of terrible sex-guilt: *Nana* has Hugon driven to suicide, Muffat to religion; *Germinal* portrays the agony of Hennebeau; *The Human Beast* opens with violences; in *Travail* Delveau burns himself and his wife to death.

Linked with these positions is the continually asserted terror of sickness and death. Paul was dogged by this terror from early days, and especially after his father's death he lived in a blind conviction of impending doom. Zola was much affected by his highly-strung mother, who had been subject to nervous fits from her youth—though they slackened as she aged. She suffered from liver trouble and died of cardiac disease—the pains of Adelaide Fouqué in *The Fortune* were probably drawn from her. Zola in youth developed keen anxieties about his health, and the Goncourt Journal records many of his morbid fancies: 'the infirm sickly ultra-nervous side of him, which gives you at times the acute sensation of being in the

company of a melancholic impatient sufferer from heart disease.' Though worried by all sorts of symptoms, he was found after his accidental death to have all organs practically intact. His fingers trembled. He was afflicted by superstitions: agitated about numbers and given to counting (e.g. digits of cab-numbers, hairpins lying in the path) or touching a fixed number of lamp-posts. He was abjectly terrified of lightning, like Christine at the outset of *L'Oeuvre*. Edmond Goncourt tells of him seated heavily in his armchair in 1880, talking of 'kidney trouble, gravel, palpitations, then of his mother's death, of the gap it has left in his home—speaking with intense pathos'. He was obsessed by the window through which his mother's coffin had had to be lowered at Médan; after Flaubert's death he told friends how he and his wife lay awake at night, unable to sleep for fear of death, ashamed to speak to one another. He did not dare go to bed without a nightlight; and even so at times he leaped from bed 'in a state of unavoidable dread'. He put these fears in a story, *Death of Olivier Bécaille*, 1879; meditated a novel with a title like *Grief* on the theme of the loss of a loved one; finally wrote *Joy of Life* with its hypochondriac hero Lazare. And so he, like Paul, had his periods of acute depression. He told Coste, 'You wouldn't believe to what extent one suffers from sudden fits of depression in the hard trade I follow'. To Valabrègue in December 1866 he wrote, 'Nothing goes well.' To Roux on 8 June 1867 he wrote, 'I had atrocious insomnia last night, and as I couldn't sleep, I worked at our drama.'

It is necessary, then, to stress the extreme closeness of temperament in writer and artist; but at the same time we must note the differences. Zola had a stronger will than Paul. He drove on through his fears and fantasies; he dominated his situation. His art was expansive, while Paul's became one of intense concentration, the sort of art possible only to a man in lonely and obdurate dedication. Thus, despite many shared elements, the expression of each man took a different direction. They both used their women as shields against the world of tumultuous sexual experience they desired and dreaded; but Zola was able to come to some sort of rational companionship, while Paul retreated into a numbed separateness. Paul in a moment of distraction or sudden impulse kissed a housemaid, and did nothing about it. Soon afterwards Zola too kissed a housemaid, but he followed the relationship up and begot two children on the woman. (In the autumn and winter of 1888–9 he rented a Paris flat for Jeanne Rozerot who had been employed as seamstress by Mme Zola; she bore him a child in September 1889; the second child came two years later.)

We can now return to Paul in the Midi. Some three weeks after receiving *L'Oeuvre* he succumbed to the pressures from his mother and Marie, and married Hortense at the Aix Mairie. His witnesses were Maxime, a clerk, a ropemaker, and a minor official of Gardanne, Peyron. His son, now aged 14, was present. Paul took the witnesses out to lunch, while the family took Hortense to the Jas. The marriage deed had been signed by Louis Auguste and his wife. A religious ceremony followed next morning at the church of St Jean-Baptiste in the Cours Sextius. But the marriage did not mean any increased domesticity, with Hortense

warmly taken into the family bosom. On the contrary the break between Paul and Hortense was finalized, the family united in disliking Hortense, and in general she preferred to live on her own, with her son, in Paris. Paul went on living at the Jas, and the women who mattered in his life were his mother and Marie. The latter had established a thorough dominance over him, and his mother was jealous of Hortense.

A letter written to Choquet from Gardanne on May 11th shows the state of mind in which his marriage had left him. He was suffering from 'weak health and a spell of unseasonable weather'. His son was at school; and in his roundabout way he contrasts his withered hopes with Choquet's flourishing family life.

I don't want to weigh heavily on you, I mean morally, but since Delacroix served as intermediary between you and me, I'll allow myself to say this: that I'd have wished to own that intellectual equilibrium which characterizes you and permits you to attain with certainty the proposed end. Your good letter, added to that of Mme Choquet, witnesses to a great equilibrium of the vital faculties. So, as I'm struck by this need, I discuss it with you. Chance has not endowed me with a similar disposition, it's the only regret I have about things of this earth. As for the rest, I've nothing to complain of. Always the sky, the things without limits, attract me and give me the opportunity of looking with pleasure.
But as for the realisation of wishes for the simplest things, which seem as if they should come of their own accord, for instance, contrarious fate would apparently be involved so as to impair success; for I had some vines, but unseasonable frosts have come to cut my thread of hope. Whereas my wish would have been to see a fine sprouting, so I could wish that your plantations flourish and a vegetation finely develop: green being one of the gayest colours and doing the most good to the eyes. To conclude, I must tell I'm always busy painting and there'd be treasures to be gathered from this country here, which hasn't yet found an interpreter on the level of the richness it unfolds.

The failure of love's blossoming and of character-stabilization is linked with the fortunes of the frost-blighted earth and the yet-ungathered beauties of the Provençal scene; after all the despair, hope returns. Love may be destroyed but art may yet succeed. No doubt because Hortense was unwelcome at the Jas, he took a flat for her in the Boulevard de Forbin, a street with four rows of planes, at the foot of the old town; and at times he went in the evening to a café to meet the local doctor and Jules Peyron, the civil servant, who occasionally sat for him. A donkey, bought to carry his equipment, gave him a lot of bother, trotting ahead or refusing to budge; in the end he submitted to its will. He went off on expeditions of several days, eating with peasants and sleeping, if need be, in barns; he painted Gardanne and its environs, with Mont Ste Victoire in the distance. Now and then Marion, still an amateur painter, came on Sundays; his comments on the geological structure and the cataclysmic pressures that had produced it were useful to Cézanne, helping him to grasp the underlying patterns.

Monticelli, who had had a stroke in November 1885, died this year on June 29th. And about the same time Paul went to Paris for a brief visit. He called on Tanguy, whose walls were cluttered with the works of his unfashionable clients, to whom had now been added Gauguin and Van Gogh. Tanguy now and then sold a canvas cheaply. His Cézannes he

divided into big (100 francs) and small (40 francs); some canvases that held several studies he cut up and sold to poor art-lovers (says Vollard). When he was showing a picture, he went into his back shop, brought out the work in a parcel, slowly unwrapped it, and, his eyes misty with emotion, set it on a chair and waited in silence. Perhaps to those with whom he was familiar he might wave a finger and say, 'Look at that sky, that tree, it's come off, hasn't it?' He still fed young and hard-up artists, despite his poverty. The year before, on the point of being sold up by his landlord, he sent an appeal to Paul, whose bill was near 4,000 francs. A poor salesman, he put high prices on the works he particularly loved, so as to prevent their selling; and he refused to chat about his painters to men he didn't know well. Since his return after the Commune, he was afraid all the while of police spies, and he suspected that the government might throw the rebellious painters (those of the School, he called them) into jail.

We have already had examples of the way in which such painters were equated with the social revolutionaries. Here are some more examples. Gauguin wrote on 24 May 1885 about his Copenhagen show: 'All the base intrigues. All the old academic clan has trembled as if it were a question of a Rochefort in art; it's flattering, but in effect disastrous.' Duret remarks that it was just as well the police who arrested Tanguy as a communard didn't examine his home for the paintings there and show them to the judges. 'In that case he would certainly have been condemned and shot!' He also tells a tale of the dilemma of de Tschudi, director of the Berlin National Gallery, when the German Emperor paid a visit. He showed him the works by Manet and the impressionists; the Emperor disapproved and had them removed to a humbler place. But he didn't dare to show anything by Paul. Once when Duret was recounting this episode a connoisseur of eighteenth-century art 'said calmly that he understood very well M. de Tschudi's act, for *this anarchist's painting* could only cause the Emperor horror. I found this persistent judgment of Cézanne very typical; he was held always as an insurgent by the traditionalists and qualified now as *anarchist*, an epithet equivalent to that of *communard*, which had been applied at his appearance in 1874.' Millet, who in fact objected to revolutionary action and refused to accept his election to the Commune's Federation of Artists, had a portrait of himself taken in 1861 with his back to a wall, in which an admirer declared that he looked like a 'peasant leader about to be shot.'

Before returning to the Midi, Paul stayed a while with the Choquets at Hattenville in Normandy. Choquet was now released from his money worries by an unexpected legacy, but unhappy as a result of the death of his only daughter. Paul painted a portrait of him, then returned to Aix. Some time this summer Renoir, with his wife and son, came south to return the visit Paul had made last year. He rented Montbriand from Conil and stayed there some months.

On October 23rd Louis Auguste died at the age of 88. When his wealth was shared out

Paul got 400,000 francs. Now at last he could banish all money fears; but with the nemesis of such a situation as his, with its built-in anxieties, the liberation was also a disaster. The long death-wish he had directed at his father had finally recoiled on him. When we add the other crushing blows of 1885–6—the failure of his abortive love-affair, the humiliating way he was marched off to be married to a woman who had long meant nothing to him, and the anguish he had suffered over *L'Oeuvre*—we can understand why now, at the age of 47, he was already an old man, sure that death was only a few hours ahead, his health deteriorating all the while. But because the worst had now happened and he had nothing actually to fear except being crippled and unable to work, he applied himself to his art with an increased tenacity. The feeling that he had no time whatever to spare would have demoralized a less determined man; with him it had the effect of a ceaseless driving-force bidding him put all his remaining energies into the most concentrated study and expression. This sort of pressure had long operated on him, but now it had gained in its desperate intensity. Not only did he need to keep working, he needed also to exert all his forces in striving to deepen fully his sense of colour-form, of the modulation of colour-planes composing space.

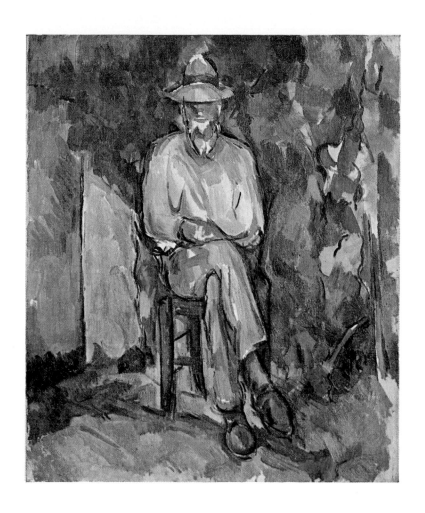

IV The Gardener, *c* 1906 *The Tate Gallery, London*

III *Forward Again (1887–9)*

THE year 1887 seems to have been spent working hard in the Midi. The *Self-portrait with a Palette* expresses his mood in this period. The absorption in work is expressed by the way in which the artist is controlled by the lines of palette and easel, almost as if they are a sort of hard imprisoning structure. The effect is strengthened, not weakened, by the free space above and on the left, and the force of the body's modelling. Paul himself grows up and out of the imprisoning structure, and yet is assimilated to it, a free and yet a fettered man.

Within the broadly rectangular face, the inner edge of the hair and beard is curved like the rounded corner of the palette; the indentation of the beard on the cheek corresponds to the outline of the thumb on the palette, and to the notch of the lapel. The most human element is bound to the non-human and both are stable and constrained. This bond reaches its most extreme in the surprising continuity of the vertical edge of the palette and the sleeve, which seem to form one body, parallel to the frame. (Schapiro)

The flat palette, without any foreshortening, is what especially cuts him off in his own world of concentration and solitude. The face, and particularly the eyes, are unfinished; but this perhaps increases the effect of haggard strength. The artist is too lost in what he contemplates to come alive in the ordinary sense; his life has become one with the act of creation. He is both cut off and powerfully present.

As a result of the deep emotional setbacks he suffered in 1885–6, his art received a check. The 1885–6 style had involved the use of parallel strokes to render 'patterns of sharply defined diagonal planes, sequences of tapering, wedge-like shapes which are among the most conclusive of all Cézanne's formulations. This style is a natural confusion of the development of the 'seventies and early 'eighties. Its very completeness, as well as Cézanne's changing frame of mind, perhaps forbade its development' (Gowing). The changing frame of mind cannot be considered apart from the emotional shocks to which he was being subjected. At first he seems to have been brought to a halt and for the first time in his art to have lacked a driving impulse; he held himself back and his work tended to be repetitive. He weakened in his definition of volume and concerned himself more with the picture-surface: the result was a dry linear style. He seems to have left more works unfinished at this period than ever before. 'He turned his back abruptly on the way which he had been following, and on the command which he had won so painfully over nature and himself' (Gasquet). A work in this linear style is *Chestnut-trees at Jas de Bouffan*, with its disconnected touch and its complicated set of verticals and branching lines drawn out from the

leafless trees which harmonizes with the buildings at the sides and the rather vaporous Mont Ste Victoire in the middle. These upward-tendrilling lines are held firmly in the horizontal bands of earth and wall, which heave gently up in the slopes towards the diagonals. (Fig. 74.)

For some time he continued with the dry diagonal style of 1886. The *Ste Victoire au Grand Pin*, which he gave to Gasquet, seems to have been painted in 1887 and well represents the phase of carefully constructed works. The trees of the foreground frame the receding planes of the distance, which have been worked out with a precise logic. To the preceding year probably belonged *The House in Provence* with its powerful horizontals counterpoised by the simple structure of the house, the upward lines of trees, and the clefts in the hills. Here is extreme simplicity and constructive order, with forms as bare as they can be without losing the flow and interplay of life; the foliage is as summarily treated as it can be without becoming mere lumps of colour. This was the sort of dry and drastic treatment that led on to subtler and more fluent, yet still severe, constructions—if we may use that word for these attempts to reduce a scene to its clear essentials without recourse to abstraction of any kind. Despite the reduction there is always the flow of life, checked, held at bay to a certain extent, yet finally reasserting itself. He felt that the bitterness of isolation which had come on him in 1885–6 could only thus be both expressed and overcome. He achieves peace in his self-identification with large-scale forms of space, treating them with a new objectivity and yet infusing them with a deep meditative acceptance. The bleak rocky world is cruelly apart in its separate existence, and yet is part of himself.

In still lifes of the time we see something of the same objective and directly analysed style, but in a milder vein.

Paul's niece tells us that, after Louis Auguste died, he gave up working in his studio and used the Salon on the ground floor, creating vast disorder there: 'flowers, fruits, white cloths, on the chimneypiece three skulls, an ivory Christ on an ebony Cross—grandmother's Christ, it still exists.'

In 1888, Paul, who had rather dropped out of the Paris milieu, decided to make another visit. No doubt he had been kept away by the exhaustion he felt after the (for him) strenuous events of 1885–6, as well as by a feeling that everyone in Paris would be thinking of him as Claude Lantier. He lodged in a gloomy old house, 15 Quai d'Anjou, on the north side of the Ile St-Louis, near to Guillaumin at no. 13. Oddly enough he chose to go to the very spot that Zola had selected as the residence of Claude in *L'Oeuvre*. Paul kept his lodging there for two years, often going alone to Chantilly or along the Marne. He may have made some visits to Aix during the period, but we do not know. Zola has described the location: 'little grey houses chequered on the ground floor by the wooden fronts of shops, while above, the wavering line of their roofs stood out against the sky.' The horizon was 'bounded by the blue slates of the roof of the Hôtel de Ville on the left, and the leaden dome of St Paul on the right. . . . Strange shapes crowded the water, a dormant flotilla of rowing boats

and gigs, a washboat and a dredger, moored to the quai; then, over by the other bank, lighters full of coal and barges full of stone, dominated by the gigantic arm of an iron crane.' No. 15 was built about 1645; no. 17 was the Hotel Lauzun where Baudelaire had lived for a time in his youth. The peaceful area had always attracted painters: Daumier occupied no. 9 for 17 years; and Philippe de Champaigne had lived on the Quai Bourbon, as did Meisonnier, who built a sham medieval watchtower there.

Paul, with his sense of failing health, felt little repose as he worked at home or in a studio leased in the Rue du Val-de-Grace. Choquet asked him to decorate his house in the Rue Monsigny; but after two sketches Paul lost heart. He persisted, however, with a Mardi-Gras subject, using his son as the model for Harlequin and the son of the cobbler Guillaume for Pierrot. As usual he wanted his models to keep on standing indefinitely, and one day the Pierrot fainted. (Fig. 69.)

In the afternoons he went to the Louvre, and sometimes he called on Tanguy with his collection that was variously considered a chamber of horrors or a museum of the future (Bernard).

On August 4th Huysmans wrote an article in *La Cravache* (reprinted next year in *Certains*), which dealt with Cézanne as an eccentric, bracketing him together with a second-rate painter C. Tisson and a Sunday-painter, the clown Wagner. He found in Paul an original but quite erratic expression:

Truths, so far left out, are perceived, strange, real truths, splashes of colour of remarkable veracity, shades in linen which are the vassals of the shadows cast by curving fruits here and there in credible charming blues, which make these canvases creative when referred to the usual still lifes hacked out of repulsive bituminous blocks against incomprehensible backgrounds. Then these open-sketches of landscapes, attempts which have remained in limbo; efforts whose freshness has been spoilt by touching-up; lastly childish barbaric beginnings, astonishing equilibria; houses tottering over as if intoxicated; distorted fruit in drunken bowls; nude women bathing, insanely outlined with the fervour of a Delacroix for the greater glory of the eye without refinement of vision or delicacy of touch, lashed to a fever of dashed-on screaming colour, standing out in relief on a canvas loaded to overbalancing point.

He summed up, in what was the first public notice of Paul since his exhibiting with the impressionists:

He is a revealing colourist, who has contributed more than the late Manet to the impressionist movement, but an artist with sick eyes, who, in the wild misconceptions of his vision, has discovered the premonitory symptoms of a new art.

He was trying to synthesize Zola's picture in *L'Oeuvre* with what Pissarro had said in his protest of 1883.

This was probably the year of Paul's meeting with Van Gogh, shortly before the latter's departure for Arles. Bernard tells us:

One afternoon when Cézanne came to Tanguy's, Vincent, who had lunched there, met him. They chatted together, and after having talked about art in general, they started on their own individual

ideas. Van Gogh thought he could not explain his theories better than by showing his pictures to Cézanne and asking his opinion of them. He brought out canvases of various kinds, portraits, still-lifes, landscapes. Cézanne, whose nature was timid but violent, said, after inspecting them all: 'Truly you paint like a madman.'

He was back in the Midi when Renoir passed through Provence in the winter. Renoir was amazed at the development that had been going on in his work. 'How does he do it? He can't put two touches of paint on a canvas without success.' Paul was still, however, at the mercy of his moods, ready to rip a canvas up or to leave it on the hills as he trudged home in misery. Once, when an old woman with knitting came near him as he painted, he shouted in fury, 'Look at the old cow coming,' and, despite Renoir's protests, he collected his equipment and dashed off as if pursued by the devil. (We may recall Vollard's anecdote in which he denounces women as calculating cows.) His increased instability appeared in his treatment of the unfortunate Renoir, his good friend. He asked him to dine at the Jas with its 'good fennel soups' (Vollard) concocted by his mother, who liked chattering and detailing her recipes. One day Renoir chanced to make a joke about bankers, and Paul turned fiercely on him, supported by his mother, 'Really, Paul, in your father's house!' When we recall how bitterly Paul himself had written in earlier letters about his family and how he had resisted banking and the law as something detestable, we see what a change had come over him after the events of 1886. He had sunk more and more into a position of servitude to his mother and his sister, and was accepting the family glorification of the dead father. Also, in his diabetic state his instability was increasing. As a result of this outburst, Renoir left the Jas in dismay and went to live at Montbriand, which he leased from Conil.

Gasquet tells us that Paul used to praise his father. 'Ah, there was a man who knew what he was about when he earned me an income. . . . Tell me, what should I have become without it? You see what they are doing to me, yes, yes, as I tell Henri, your father, when one has an artist son, one must earn him an income. One must love one's father. Ah, I shall never love the memory of mine enough . . . I didn't show it to him enough.' If it were not for Renoir's testimony, we should find it hard to believe that he could have falsified so thoroughly the facts of his long and harrowing struggle with his father for an allowance.

We do not know just when Paul returned to Paris, but we find him back on the Quai in 1889. This year he made his second appearance in a public gallery: at the Exposition Universelle. (It was the year the Eiffel Tower was opened.) How he got in is unclear, but it was certainly as the result of some backstairs deal. Vollard says, 'Here again he was accepted through favouritism, or, more accurately, by means of a bargain. The committee had importuned M. Choquet to send them a very precious piece of furniture, which they relied on as featuring in the show. He lent it as a matter of principle, but made a formal condition that a canvas by Cézanne should also be shown. Needless to say, the picture was

skied so that nobody save the owner and the painter ever noticed it.' All the same, no *objet d'art* is listed as loaned by Choquet. The picture was the *Maison du Pendu*, and in the catalogue Paul was described as of Paris. Three Monets were also hung, and two Pissarros, but nothing by Renoir, Sisley, Guillaumin or Morisot. On July 7th Paul wrote a note of thanks to Roger Marx (1859–1913), one of the first critics to champion his work.

In late 1889 he was invited to exhibit in Brussels. An independent group of artists had organized there in 1884 *Les Vingt*; for ten years they held yearly shows, in each of which twenty other artists, including foreigners, were also invited to contribute. (In 1894 the group disbanded and was followed by *La Libre Esthétique*, which survived till 1914). Already *Les Vingt* had called on Fantin-Latour, Gauguin, Bracquemond, Forain, Guillaumin, Monet, Morisot, Pissarro, Renoir, Rodin, Seurat, Signac and other French artists. With Cézanne in 1890 were Segantini, Sisley and Van Gogh. At first he had refused; then on November 27th he replied to Octave Maus:

May I be allowed to repel the accusation of disdain, with which you charge me in connection with my refusal to take part in painting exhibitions? I must mention in this relation that as the numerous studies to which I have devoted myself have given only negative results, and as I feared too well justified criticisms, I had resolved to work on in silence, till the day when I feel capable of theoretically defending the result of my attempts. But in view of the pleasure at finding myself in such good company, I do not hesitate to modify resolution . . .

One can feel in this statement a mixture of pride, resentment and genuine diffidence about his art. He sent three works. In one of his polite notes (December 18th) he asked Choquet to lend the *Maison du Pendu* (which he had got from Comte Doria in an exchange); and three days later he wrote again to Maus. Choquet was adding *A Cottage at Auvers*, and Paul himself was sending a study of a *baigneuse*. 'I applied to Tanguy to find which of my studies it was he sold to M. d. Bonnières; he was unable to give me any details. I am therefore asking you to catalogue this picture as Landscape Study.' He considered that none of his recent landscapes was worth sending.

When the show was held in January 1890 his works went unnoticed. The press was occupied with the violent reactions to Van Gogh, though one journalist referred to Paul's 'sincere daubing'. On February 15th he wrote to Maus with thanks for the catalogue with its *pittoresque* look.

Despite his worsened health he struggled to work for long hours at the easel—from five or six in the morning, with a break for early lunch, on to sundown. More and more he was driven in on himself. Bernard cites him as saying later, 'Isolation, that's what I'm worthy of. At least then nobody gets the *grappin* into me.' At fifty-one his hair had whitened. He had been put on a diet, which he didn't always follow. In his irritable state he was easily unbalanced. We are told that the mention of a member of the Institute or of a teacher at the Beaux-Arts was enough to arouse a fit of rage—as also did the least unpleasant noise, a squeaking waggon-wheel or a street cry. Under the stress of such nuisances he wanted to

move, and went to live in the Avenue d'Orléans. Choquet had died, and he felt the loss.

Hortense's father had also died. She wanted to attend to some family business in the Jura and took the chance to make a visit to Switzerland. Marie was not at hand to control her and Paul weakly gave in. On the way to or from Switzerland the party stayed at Besançon, where Paul painted three landscapes. He disliked the trip through the western Swiss cantons, with visits to Berne, Fribourg, Vevey, Lausanne and Geneva. Most of the time, he, Hortense and the boy were at the Hôtel du Soleil in Neuchâtel, where he seems to have felt more at home. Swiss scenery didn't move him much, though he did two unfinished paintings in Neuchâtel. These he left behind at the hotel and they were later painted over by another artist. He used to say of Switzerland, 'There's nothing but that'—pointing to the sky. At Fribourg, as he strolled with wife and son, he blundered on an anti-Catholic demonstration. Terrified, he disappeared. As he didn't return to the hotel that night, Hortense looked all over the town for him, but in vain. At last a letter came from Geneva, where she rejoined him four days later. What had upset him was not the cause of the demonstration, but the fact of a noisy crowd suggesting violence and jostling contact.

About this time he divided the family finances of nearly 25,000 francs into twelve monthly parts, and these each into three. His son had become eighteen in January, and Paul doted admiringly on him. 'Paul is my orient,' Vollard cites him as saying; and Alexis, 'Whatever stupidities you commit, I'll never forget that I'm your father.' He didn't want to repeat the errors of Louis Auguste, but the lad had no intellectual or artistic ambitions. Paul, however, was sufficiently astounded at finding that he could carry on the ordinary business of life; and the youth seems to have treated him with respect and courtesy, never taking hold of his arm without saying, 'Pardon, you'll allow me, Papa.'

Paul's niece, recounting the family tradition, says that Hortense was nicknamed *La Reine Hortense*. 'His wife is little mentioned, but she is not without qualities, she had an equanimity of humour and a patience proof against anything. When Cézanne isn't asleep, she lectures him at night, and that goes on, sometimes, for hours. Her mother-in-law, who feels no special tenderness for her, recognizes her patience; and then she has given him a son.' Paul, after the stress of work, was a great sleeper. An Aixois friend made a drawing of him snoozing on his back, with the legend: '*Chut!* Cézanne's asleep!'

The later 1880s saw various essays away from the dry works of 1885 onwards, in which, with their fine constructions, Paul's natural exuberance seems toned down and directed towards a more intellectual system. We find a strange intrusion from what we may call his Delacroix-derivations: the return to the theme of Bathsheba. In a much earlier version he had been drawing on Rembrandt's treatment of the subject, and later he approached the theme from the angle of Poussin's *Nurture of Bacchus* (also in the Louvre). The present version was in his later 1880s style, as well as having as its background the Mont Ste Victoire represented from memory (as viewed from Bellevue or the Château Noir). He

had not painted this motif till the 1880s. The nude, leaning back against a tree trunk, follows the lines of the mountain, and her woman attendant is repeated in the cloud-masses hovering over them. The version with the Poussin-nude has much the same composition, though in a less clear way, and the mountains are indeterminate. *The Great Pine tree*, done about 1889, was painted at Montbriand. Here, as in some pictures of deserted houses, we meet a powerful return of romantic ardour. *Provençal Underwood* shows rich prismatic colour, and brush-strokes in contrasting directions are used for the modelling.

Paul also made a determined effort to develop figure-painting. It has been mentioned that he painted his son as Harlequin and another boy as Pierrot. In the proud slouch of Harlequin he seems to have put all the envious admiration he felt for the lad because of his outward-turned character. What is happening in this picture, *Mardi-Gras*, is not clear: it has been suggested that the Pierrot, behind Harlequin, is trying to snatch the fool's-sword, his symbol of dignity and power; that the attacker represents Zola and the son is Paul himself, continuing his way unscathed. But it seems very unlikely that the events of 1886, which had struck so deep, could thus be expressed in a fairly light-hearted piece of symbolism, in which the tragic sufferings of Paul were reduced to a masquerade. Perhaps in a more general way, though, he may well be uttering a hope that the son will be able to take life easily, treat it as a masquerade, and be unaffected by mockeries that have hurt and paralysed his father. In this sense the work could be taken as an effort to heal the pangs of 1886.

In portraits of Hortense made during this period we see a fresh movement towards solidity of design. There are three works that seem to have been painted at the Quai d'Anjou, in a room with wainscot surmounted by a band. Here, too, we can place the three pictures of the boy in the red waistcoat. We see Paul searching again for fullness of volumes, though at times in a somewhat over-generalized way. He wants a simple grandeur of form; and in the red-waistcoated boy he gets a certain dreamy quality of adolescence that is quite missing from *Mardi-Gras*, with its cocky Harlequin and heavy-faced Pierrot.

PART FIVE

Last Years

I Flight from Giverny and Paris (1891–5)

IN February 1891 Alexis was in Aix. His letter of the 13th suggests that Zola had asked him to find out how Paul was getting on and to sound the situation.

This town is dismal, desolating, paralysing. Coste, the only person I see a little isn't amusing every day . . . Happily Cézanne, found again a while back, puts a little breath and life into my associations. He at least vibrates, is expansive and alive. He is furious against the Ball [*La Boule*, the nickname of the Zola-circle for the clogging Hortense], who, after a stay of a year in Paris, inflicted on him last year five months of Switzerland and *table d'hote* . . . where he met with little sympathy except from a Prussian. After Switzerland, the Ball, escorted by her bourgeois of a son, has marched back to Paris. But by cutting her allowance in half, Paul has brought her back to Aix . . .

In the day he paints at the Jas de Bouffan, where a worker serves him as model, and where I'll go one of these days to see what he does. Finally, to complete his psychology: he believes and practices.

Zola seems to have asked Coste also for information; for about this time the latter also wrote an account of Paul:

How explain that a rapacious and tough banker could produce a being like our poor friend Cézanne, whom I have recently seen? He is well and physically solid, but he has become timid and primitive and younger than ever. He lives at the Jas de Bouffan with his mother, who for that matter is on bad terms with the Ball, who in turn doesn't get on with her sister-in-law, nor they among themselves. So Paul lives on one side, his wife on the other. And it's one of the most touching things I know to see this good fellow retain his childlike naivety, forget the struggles, disappointments, and obstinately carry on, resigned and suffering, the pursuit of work he cannot produce.

Paul had thus, as part of his surrender to the maternal world, become a steady churchgoer. The fear of death, which the 1886 crisis had rendered so much more acute, had played a strong part in this collapse. We have seen that up to that point he had certainly shared the anti-clerical and radical views of Zola, Pissarro, Monet, Tanguy and others of his circle. Alexis' letter, in its whole tone, shows the surprise felt by his old associates at the new turn. He had told Alexis, 'It's fear. I don't feel I've four days left on earth. And after that, I believe that I'll survive and I don't want to risk roasting *in aeternum*.' Vollard tells us, 'If Cézanne avoided as much as possible the company of priests, he found some good in religion, that is, "an element of respectability," and "moral support." So he frequented churches and went to mass on Sunday.' Then he adds with his usual reckless inaccuracy in dealing with Cézanne's earlier years, 'From youth, besides, he had shown religious feelings. One day his father had said jokingly, to a friend, "We'll have to lunch a little late today. As it's Sunday the ladies have gone to eat the Good God." On which his son, usually so submissive,

had boldly raised himself against the author of his days: "Obviously, father, you read *Le Siècle* with its politics of wine-merchants." But if it happened that the sky was clear grey on a Sunday, the curé had to get along without him. Even at mass Cézanne didn't stop thinking of painting, unless he went to sleep in the church'. (The piety of Paul's comment to his father is not very striking; his words seem rather a rebuke of his father's ubiquitous commercial or banking attitudes.) Vollard adds a tale of a young artist who, hoping to see Paul, arrived at Aix on a Sunday; as the weather was bad, he went to St Sulpice with a friend as guide; the people were coming out of mass, and Paul, accosted, seemed like a man woken out of sleep. He dropped his mass-book; but when he was told that the newcomer was an artist, he said, 'Ah, you're of the party,' seized his button, and went on talking. (Again the piety of the situation is not very obvious). Vollard further tells us that 'Cézanne did not restrain himself from packing the Good God off to all the devils at the least mishap, at least when he didn't find a victim near at hand to let his anger loose on. I recall one day when fog had chased him out of the studio as he was doing a portrait, in the midst of profaning the holy name of God he recalled that he had Carrière as neighbour. So, with his fist raised towards the window of his colleague, miming a man in fury but already amused at what he was going to say, he cried, "That chap up there is happy, he has all the dreamed-of time to give himself up to his orgies of colour." '

He remained self-conscious and somewhat shamefaced about his churchgoing. He continued to dislike priests, called religion a 'moral hygiene' (Larguier) and his attitude 'taking my slice of the Middle Ages.' His niece says he often used the last phrase as he came out of mass. Indeed he gave a clownish note to the whole thing by saying ,'As I'm a weak character, I lean on my sister Marie, who leans on her confessor, who leans on Rome.' The niece tells us that Louis Auguste used to remark, 'Paul will let himself be devoured by painting, Marie by the Jesuits.' She comments, 'It wasn't so; Marie, very shrewd, gives at times alms for good works, but she knows how to keep her property. As for Paul . . .' Shortly before his end, cursing a 'cretinous abbé,' he stated caustically, 'I think that to be a Catholic one must be devoid of all sense of justice, but have a good eye for one's own interests.' When faced with difficulties in painting, he sometimes sang, to a tune of Vespers, 'Nom de Dieu de Nom de Dieu de Nom de Dieu . . .'

There is not one word of his which suggests that he felt any piety towards God, Christ, or the Virgin Mary; what he sought was simply what he said he sought—some external prop which would help him in his perpetual struggle with the fear of death (i.e. impotence) and enable him to keep at arm's length all the disquieting emotions of doubt, guilt, loss. His churchgoing, coupled with the element of strength he found in accepting the dominance of his sister Marie, certainly helped him in the terrible isolation that had settled on him since 1886. But to find in it some sort of metaphysical comprehension, which is to be linked with the peculiar penetration and balance of his post-1886 work, is to go quite outside all the evidence. It was the maternal church, not the idea of God, to which he had turned: the

maternal church, which he could now safely embrace, with his free-thinking mocking father dead and eliminated from the scene.

As part of his effort to simplify life and have it all under control, he brought Hortense to heel (probably at Marie's advice) by cutting the allowance which she was always trying to get enlarged; she was forced to leave her beloved Paris and come to Aix under the eyes of the Cézannes. Paul installed her in a flat on the Rue de la Monnaie, while himself staying at the Jas. He spoke of her with contempt. 'My wife likes nothing but Switzerland and lemonade.' If she ever tried to take part in the discussions he held with his friends, he rebuked her, 'Hortense, keep quiet, *mon amie*, you only say *bêtises*.' Alexis' letter describes the arrival of Hortense:

Yesterday evening, Thursday, at 7 o'clock, Paul left us to go and receive them at the railway station . . . and the furniture, brought from Paris for 400 francs, is going to arrive as well . . .

He himself doesn't mean to leave his mother and elder sister with whom he is installed in the suburbs, where he feels very comfortable and which he downright prefers to having his wife with him. Now, if as he hopes, the Ball and the brat [*mioche*] take root there, nothing will prevent him from going to Paris for six months from time to time. He cries: Long live the sun and liberty . . . Besides, no bother about money. Thanks to his begetter, whom he today venerates . . . he has enough to live on.

He goes on to tell of the division of income among Paul, Ball and Little Ball (*Boulet*). 'The Ball, not very delicate, it seems, has continual tendencies to encroach on his personal fraction. Today, buttressed by his mother and sister, who can't bear the lady, he feels himself big enough to resist.'

In the early 1890s he had continued with his return to the portrait or figure-composition from the model, increasing his grasp of mass and volume and achieving a sculptural and monumental quality without abating in the least his command over colour-movement. In *The Man with the Pipe* he used Père Alexandre, gardener at the Jas, who appeared also as the left-hand player in the three smaller versions of the *Cardplayers*. The sculptural aim is stressed by the relation of the drapes in fifteenth-century Florentine busts. *The Woman with Coffee-pot*, apparently based on a stalwart servant at the Jas, in a more complicated setting, shows the same aims. Furthermore, stimulated in part by the *Cardplayers* in the Aix Museum, he began on the theme of cardplayers in a café. He used peasants for models, and, apart from individual studies, did pictures with five figures, four, and then two (five versions in all). Attempts have been made to read a symbolical meaning into these works, as if Paul was recalling the comparison of Manet's *Olympia* to a flat card-design, so that the game is the art-struggle, with Paul the winner. This seems quite forced, as also the attempt to link the theme with the crude drawing of Ugolino in the early letter. No doubt Paul had watched players in cafés and noted their comparative immobility, which enabled him to study them at some length. Then, when he came to paint the motif, he could in turn get the models to keep still for an unusually long time. Beyond that we can only surmise a deeper

theme of chance and fate, of the money-game—a theme which from another angle was fascinating Mallarmé in his imaging of the poetic act as a dice-throw. What Paul achieved was a monumental pattern in the confrontation of the two men, who are lost in the absorptions of the game, dominated by the cards in which the secrets of fate are written, and yet in the last resort using those cards for their own ends. In this simple yet profound sense there is a richly realized symbolism, which is given a great force by the fact that the men, so grandly defined, are common working men. (Plate II.)

He probably began the first version in the autumn of 1890, and then went on working at the theme for several years. The composition with five figures shows an emphasis on curvilinear forms, which has been described as a touch of the baroque exuberance that kept on asserting itself in his work and linked with his interest in Puget's *Hercule Gaulois*. Indeed this baroque turn is brought openly out in *Still life with Plaster Cupid*, in which he inserted harmoniously among apples and sprouting onions the cast he thought to be after a work of Puget's in the Louvre. (He also brought in the lower half a painting of the so-called anatomy attributed to Michelangelo, but in a style that made it accord with the rest of the picture.) The curvilinear stress is found also in the portraits of Hortense in red; but was soon brought more under control and dominated by a concern for architectonic aspects as in the later *Cardplayers* and the *Woman with Coffee-pot*.

The *Plaster Cupid* provides a good example of the way that he organized his forms in space. The cast gives a strong vertical axis, turning on itself, from which the movement up along the diagonal is stimulated and controlled. The cast exerts this power because of its tilt that provides a view slightly from above—a view that so often delights Paul. (Fig. 16.)

By this means the major portions of the body and the base exist in differing relations to the upper and lower parts of the painting. The legs and base are the culminating function of the still-life on the table. The eye then passes upward and into the space of the room, through the torso to the canvas behind it, the latter relationship suggesting that the figure is represented in the canvas rather than being on the table. Cézanne has here revealed a profound visual truth: objects in space may be known separately, but when seen together they participate in each other's existence. (Hamilton)

From the aspect of symbolism, we may note that the head of the Love is balanced in the upper right corner by part of a version of the Flayed Man attributed to Michelangelo, which fascinated Paul and of which he made many studies. No doubt his interest was largely anatomical, plus the fact that he believed it was a work by Michelangelo, whom he greatly admired. (Such studies as he made in the Louvre of works with Christian themes were those dealing with suffering and death, not with resurrection and the like.) But we can probably pair off the Flayed Man with the Skull as an emblem with complex significances in his mind. Here the Flayed Man opposes the Love as Life against Death. But we can go further. In the *Fleurs du Mal* is a poem *The Labourer Skeleton* (dated 1860) which cannot but have sunk deep into Paul's thoughts; for it deals with anatomical drawings with 'Those mysterious horrors displayed, Digging away like labourers, Of Skeletons and Men Flayed.' These

figures, where an Old Artist has by his skill and knowledge (*savoir*) 'communicated Beauty,' are also simultaneously 'convicts snatcht from the charnelhouse' and workers carrying out 'what strange harvest'. They suggest a life-in-death: 'Perhaps still in some land unknown We there must flay the stubborn earth And push away with a heavy spade Under our naked bloody foot.' In a subtle set of correspondences the Flayed Man becomes the Labourer, the Earth itself, the Artist sweating in an unknown sphere: death-in-life and life-in-death. (Millet's *Man with the Hoe* is dated 1862–3; with his brutalized face and heavy almost-dead body hardly detached from the earth of toil it is a fine illustration of one aspect of the image. It was violently attacked as a foul slander. 'Is it impossible then to receive quite simply,' asked Millet, 'the ideas that occur to the mind on seeing a man doomed to earn his living in the sweat of his brow?') If I am right, then, Paul has added the Flayed Man here as a bitter comment on Love surrounded with his apples and sprouting onions (phallic like the pears in the *Nude* paired off with *Leda*). Love does not exist in its own airy space of enjoyment alone; the skull or the Flayed Man are *memento-moris*, but also emblems of the living pang, the inhumanity of the Ugolino-meal become a normal part of the bourgeois table and of the world where the labourer is the Flayed Man as well as *vice versa*.

In the final version of the *Cardplayers*, the main forms are disposed as symmetrically as possible, with the bottle between the two men placed as a striking expression of the central axis; but then a slight series of differences in balance (the tilted chair, the divisions of the wall, and so on) get to work in giving the monumentality its casual element. The hand-gestures, the faces with different expressions of concentration, bring a breathing quality to the immobility; but the movement of the planes, of the colour-transitions, is above all what reasserts the various presence of life.

In January 1892 Alexis tried to get Paul to show in the Exposition des Indépendants (founded in 1884 on the basis of no jury, no selection). 'At long intervals I see Cézanne,' he told Zola. Paul at last agreed, then changed his mind: the agitations and the rebuffs associated with public exhibitions were too frightening. His works were to be seen only at Tanguy's; then later at Vollard's rooms. As for Tanguy's place, Bernard tells us:

One went there as to a museum, to see the few sketches by the unknown artist who lived in Aix, dissatisfied with his work and with the world, who himself destroyed these studies, objects of admiration though they were. The magnificent qualities of this true painter appeared even more original because of their author's legendary character. Members of the Institute, influential and avant-garde critics, visited the modest shop in the Rue Clauzel, which thus became the fable of Paris and the conversation of the studios. Nothing seemed more disconcerting than these canvases, where the most outstanding gifts were coupled with a childlike naievety, the young felt the genius, the old the folly of the paradox; the jealous saw only impotence. Thus the opinions were divided and one passed from profound discussions to bitter jeers, from insults to exaggerated praise; Gauguin, confronted with their daubed appearance, exclaimed, 'Nothing looks more like a daub than a masterpiece!' Elimire Bourges cried out, 'It's the painting of a sewage-collector'! Alfred Stevens couldn't stop laughing.

The effect was aided by the oddities of Tanguy and his home, the mysterious smile on his thick lips as he brought out the packages. His comments helped innocently to strengthen the legends.

'Papa Cézanne', he would say, 'is never satisfied with what he does, he always gives up before having finished. When he moves, he is careful to forget his canvases in the house he's leaving; when he paints out of doors, he abandons them in the country. Cézanne works very slowly, the least thing costs him much effort, there is nothing accidental in what he does'. Naturally the curiosity of the visitors was aroused. Whereupon Tanguy would say with a rapt expression, 'Cézanne goes to the Louvre every morning'.

An American critic who visited the shop this year wrote:

Père Tanguy is a short, thickset, elderly man, with a grizzled beard and large, beaming, dark blue eyes. He has a curious way of first looking down at his picture with all the fond love of a mother, and then looking up at you over his glasses, as if begging you to admire his beloved children.

Among the visitors, apart from those already mentioned, were Maurice Denis, Paul Signac (who bought a Cézanne), Georges Seurat, J. E. Blanche, and Ambrose Vollard; Egisto Fabbri bought from Tanguy 16 canvases. Denis later declared that what attracted the young painters was Paul's reduction of nature to pictorial elements.

Slowly interest in Paul grew. Georges Lecomte wrote with sympathy about him in *L'Art Impressioniste* this year, and, invited by *Les Vingt*, lectured on him at Brussels. Bernard published a short biographical essay on him. Zola in an interview by the *Revue Illustré* was asked who were his favourite writers, composers, artists. He mentioned no names but spoke of 'those who see and define clearly'. In a discussion with Geffroy on Manet, Monet, Cézanne and the Impressionists, he denied that the last-named had the elements of composition which a work of art needed. Geffroy says:

I put up against him his own earlier arguments and the new ideas born from the evolution of artists and arts that he had upheld. He returned stubbornly to the need for composition, to his own manner of constructing a book; he saw among his old companions of art only bits and pieces, sketches.

A group who were specially interested in Cézanne, or at least in the rather confused idea they had of him, were the Nabis, ex-pupils of the Académie Julian, with strong symbolist tendencies. They were disciples of Gauguin (who used to say as he went to paint, 'let's do a Cézanne'), and took over his admiration of Paul. They included Denis, Vuillard, Sérusier. The actual vagueness of their knowledge of Paul's work is shown by the fact that when Sérusier suggested that Denis write an essay on it, Denis found the task difficult as he hadn't seen a single example. However Signac took him to see his collection. Denis was disappointed. Indeed one still life horrified him and he decided never to mention such a painter. But he was slowly won over into recognizing Cézanne's 'nobility and greatness.' None of the group had ever met him. Tanguy could give no clear account; Gauguin was in the South Seas. Some of the Nabis thought Cézanne was already dead; others thought

him a myth; others, the pseudonym of a famous artist who wanted to cover up his bold experimental work. A few said he was Zola's Claude.

They had got into their heads that Paul painted for painting's sake and sought to abstract pictorial elements from an actual scene, and so in some of their own senses was a symbolist painter. In fact they were inverting the reality; for what Paul sought was a full penetration into reality, a concentrated image that necessarily had its simplifications as well as its complexities, but not at all an abstraction of 'pictorial elements' in the name of some higher reality, moral or aesthetic. Thus Bernard in his essay on *Hommes d'Aujourd'hui* (no. 387) declared that Paul 'opens a surprising door to art; painting for its own sake.' He analysed the *Temptation of St Antony*: 'the power of originality and technique for which we are always searching and so seldom find in the work of the generation known today.' He recalled what Gauguin had said of daubs: 'an opinion that seems to me cruelly true in the present instance.' Lecomte was on safer ground by keeping to generalizations on the 'very sound and integrated art which a marvellously instinctive painter frequently achieved.' (Note that he speaks of Paul as if he were dead or had stopped painting.)

Perhaps these comments were read by Vollard, a dealer of Creole origin, hard up but shrewd and hopeful. At the moment he could manage only some small deals, and, anticipating difficult times ahead, had bought a barrel of ship's biscuits. Looking round, he realized that of all the impressionist group, only Paul had no proper dealer. However, things were made more complicated for him by the fact that Tanguy, moved by Bernard's essay, had decided to hold on to his remaining Cézannes.

Of 1893 we have practically no records. But early in 1894 Paul visited Paris again. Tanguy had died on February 6th of cancer of the stomach; and Caillebotte died fifteen days later— he had lived 18 years after his pessimistic will, retired at Gennevilliers, where he caught a chill while pruning his roses. Paul took a small lodging in the Bastille Quarter, Rue des Lions-St-Paul, near the Rue Beautrellis where he had stayed some thirty years before. He kept much to himself. Paul Signac tells how once he and Guillaumin were walking on the quais; they saw Paul coming towards them; but as they prepared to greet him friendlily, he made gestures begging them to pass on; bewildered, they went over to the opposite pavement. And once when in the Rue d'Amsterdam he came up against Monet, with whom he had always been on the best of terms, he 'lowered his head and dashed off through the crowd.' As a result of such events, when Renoir, who had a strong liking for him, went to Aix with Albert André, he hesitated at the last moment about calling, lost his nerve, and made no effort to visit him.

In Paris he drew at the Louvre. The town was too busy and noisy for him to work on the quais or elsewhere as he had once done. Rubens especially attracted him at the Louvre, and he drew ancient and modern sculpture both there and at the Trocadéro. In March Duret sold his collection. Experts had advised him not to include his Cézannes, as they

would discredit the other works; however three pictures by Paul brought in 680, 660, and 800 francs, while a Monet reached 12,000. But when a few weeks later Tanguy's collection was auctioned, six Cézannes brought in sums between 45 and 250 francs: 902 francs in all. Vollard bought five of the pictures. Geffroy took advantage of these events to publish in *Le Journal* a laudatory article on Paul on March 25th. He described him as the precursor of Gauguin, the symbolists, and Van Gogh, adding that he

does not approach nature with a theory of art or with the despotic intention of submitting it to some preconceived law, to some personal aesthetic formula. And yet, for all that, he is not without a plan, a convention, and an ideal. However they do not derive from art, but rather from his ardent curiosity and his desire to possess what he sees and admires. He is a man who looks closely around him, who is intoxicated by the spectacle before him, and wants to record that intoxication within the limited space of the canvas. He sets to work and searches for the means of accomplishing this transposition with the greatest possible truth.

Geffroy was now very interested in Cézanne and repeated his comments in the third volume of *La Vie Artistique* published this year. 'We could define him as a person at once unknown and famous, with only rare contacts with the public and seized on as an influence by the disturbed [*inquiets*] and the seekers in painting, known by only a few, living in wild isolation, disappearing, reappearing abruptly before the eyes of his intimates.' He spoke of his semi-secret production, the rarity of his seen works, a bizarre and already distant renown, an enveloping mystery.

It is an unforgettable sight, Renoir has told me, Cézanne installed at his easel, painting, looking at the countryside; he was truly alone in the world, ardent, concentrated, attentive, respectful. He used to return next day, and daily he accumulated his efforts. At times also he went off in despair, came back without the canvas that he'd abandoned on a stone or the grass as the prey of wind, rain, sun.

He found in his work 'a deep sensibility, a rare unity of existence. Surely he lived and lives a fine inner *roman*, and the demon of art dwells in him.' Geffroy, who belonged to the radical vanguard, contributed to Clemenceau's *La Justice*. A master of polemics, he championed the cause of the disinherited and unprivileged (whom he felt to include dissident and misunderstood artists); and drew from each event moral and social conclusions. His main work, *L'Enfermé*, which dealt with the life and ideas of the socialist L. Blanqui, was to appear in 1896; he was finishing it off at the time Paul painted his portrait.

On March 26th, at Alfort, Paul wrote briefly to thank Geffroy, whom he had not yet met. 'Monsieur, I read yesterday the long study that you devoted to throwing light on my efforts in painting. I wish to express my gratitude for the understanding I find in you.' He might well be grateful; for this was the first sustained and serious tribute paid to him.

This year he renewed his links with Oller, agreed to keep in his studio (Rue Bonaparte) some of the latter's canvases, advanced him some money, and settled his accounts with the Tanguy shop. Oller was now 62, 'old and shrivelled' (wrote Pissarro, March 23rd); he had

been some years abroad, had painted the Spanish king on horseback, and was now dazzled by the clear tones of the impressionists.

Paul spent some time at Giverny, near Vernon, where Monet had gone to live some eight years before. Paul both liked and admired Monet. Among his recorded comments are the words: 'The sky is blue, isn't it? And it was Monet who first noticed it,' and 'Monet is nothing but an eye, but my God, what an eye!' He put up at an inn, but went often to Monet's house, and there found the support, *appui*, which he often mentions in the letters of this time as his great need. Enthusiasm and despair alternated more sharply than ever, and he tended to be wild-eyed and excited in talk. Monet wrote in a letter of November 23rd, 'What a misfortune that this man did not have more *appui* in his existence; but he is a true artist and he's come to doubt himself as one too much. He feels the need to be set up again.' Mary Cassatt, a Philadelphia banker's daughter, who had close relations with Degas, depicted him at this time.

The circle has been increased by a celebrity in the person of the first impressionist, Monsieur Cézanne—*the inventor of impressionism*, as Madame D. calls him . . . Monsieur Cézanne is from Provence and is like the man from the Midi whom Daudet describes: 'When I first saw him I thought he looked like a cut-throat with large red eyeballs standing out from his head in a most ferocious manner, a rather fierce-looking pointed beard, quite grey, and an excited way of talking that positively made the plates rattle'. I found later on that I had misjudged his appearance, for far from being fierce or a cut-throat, he has the gentlest nature possible, *'comme un enfant'* as he would say. His manners at first rather startled me—he scrapes his soup plate, then lifts it and pours the remaining drops in the spoon; he even takes his chop in his fingers and pulls the meat from the bone. He eats with his knife and accompanies every gesture, every movement of his hand, with that implement, which he grasps firmly when he commences his meal and never puts down until he leaves the table. Yet in spite of the total disregard of the dictionary of manners, he shows a politeness towards us which no other man here would have shown. He will not allow Louise to serve him before us in the usual order of succession at the table; he is even deferential to that stupid maid, and he pulls off the old tam-o'-shanter, which he wears to protect his bald head, when he enters the room. I am gradually learning that appearances are not to be relied upon over here . . .

The conversation at lunch and at dinner is principally on art and cooking. Cézanne is one of the most liberal artists I have ever seen. He prefaces every remark with *'Pour moi'* it is so and so, but he grants that all may be as honest and as true to nature from their convictions; he doesn't believe that everyone should see alike.

Paul's courtesy to women, in comparison with his otherwise rough manners, was linked to some extent with his fear of them, his need to keep them at arm's length. He of the faecal language and erotic-dream canvas was excessively chaste of speech in women's presence.

Cézanne rarely went to the cellar-dinners. One day he was alone there with Vollard, who was telling him about a news-item in the paper. Cézanne stopped him with a gesture of the hand. When the maid had gone out, he said, 'I stopped you because it wasn't right to say what you were saying before a girl'. 'What girl?' 'Why, the maid.' 'But she knows all that well enough. You can even be sure she knows a great deal more about it than we do'. 'Possibly,' replied Cézanne, 'but we had better pretend that we don't know she does.'

Towards the end of November Monet invited several guests to meet Paul: Geffroy,

Clemenceau, Rodin, and the writer Octave Mirbeau whom Paul much admired. The date was November 28th; and in view of Paul's unpredictable moods Monet was somewhat apprehensive. He wrote to Geffroy, 'It's understood then for Wednesday. I hope Cézanne will still be here and be one of us, but he is so singular, so timid about seeing new faces that I'm afraid he'll keep away despite all the wish he has to know you.' And he added the remarks about Paul's need of *appui*: 'hence his strong response to your article.' However, Paul turned up and was unusually sociable, indeed too much so in his over-excitement. He roared with laughter at Clemenceau's jokes, and, taking Mirbeau and Geffroy aside, he remarked with tears in his eyes, 'Rodin is not at all proud, he shook my hand. A man who has been decorated!' Over lunch he grew even more hectically cheerful and confidential. He disowned the artists who claimed derivation from him and accused them of robbery. With sighs and groans he told Mirbeau, 'That M. Gauguin, just listen to this . . . O that M. Gauguin . . . I had a little sensation, a tiny little sensation. It was nothing in particular. No bigger than that. But it was my own little sensation. Well, one day that M. Gauguin took it from me. And he went off with it. He trailed the poor thing about in ships . . . across America . . . Britanny and Oceania, across fields of sugarcane and grapefruit . . . to the land of Negroes and I don't know what else. How do I know what he's done with it? And what can I do now? My poor little sensation.' After lunch, as the guests strolled in the garden, he was so overcome that he fell on his knees before Rodin 'to thank him again for having shaken his hand.'

Paul had a special suspicion of Gauguin. Monet used to warn people, 'Never mention Gauguin to Cézanne'—and, 'I can still hear him shout in his southern accent: That Gauguin, I'll wring his neck.' No doubt Gauguin's personality irritated him; but he also distrusted deeply the art-trends he was initiating. What he really objected to was not any 'theft' of sensation, but the failure to build on sensation and the flattening of forms. In all this he was close to Pissarro's views:

Gauguin is not a visionary. He is a cunning fellow who realized that the bourgeoisie were in retreat before the great notion of solidarity which is at last beginning to burgeon among the people. It's still half-conscious, that idea, but it's the right one, and it'll make its way . . .

I don't complain that Gauguin used a vermilion background [in *Jacob and the Angel*], or that he put his Breton peasant women in the foreground. I complain that he pinched all that from the Japanese, and from Byzantine painting, instead of applying his 'synthesis' to our philosophy of today, which is a social philosophy through and through, and an anti-authoritarian and anti-mystical philosophy.

We owe the account of the lunch scenes to Geffroy, and so may trust it. We see Paul in a state of overcharged emotion, in a highly unstable condition, deliberately acting the fool and yet unable to control himself, in a sort of ecstasy of self-humiliation, doubtless enhanced by wine. His phrase 'little sensation,' used as a self-depreciating term in his silly chatter about Gauguin and never used in any other context, has been taken up by critics to express his characteristic attitude before nature. In fact it was not a little sensation but a

large and comprehensive sensation that he sought; and he would never have used the term 'little sensation' except in a bad joke. He did not in fact consider Gauguin to have understood his art at all or to be in any real sense derived from it; what lies behind his diatribe is a certain sense of resentment at the way his name has been bandied about and misused by other artists for their own purposes.

Another luncheon party held by Monet was not so successful. This time Paul was in one of his abysmal moods. Renoir, Sisley and other close friends were present, and Monet thought that here was a chance to inspire him with some of the confidence he so sadly lacked—or perhaps he recognized the haggard face of Paul's misery. He tried to ease things by making a little speech. 'Here we find ourselves all gathered together, and we're all happy to seize the occasion and tell you how much we love you and how much we esteem and admire your art.' Paul stared at him in consternation and answered in a voice shaken with regrets and reproaches, 'You too are making fun of me!', snatched his overcoat, and rushed off. He left Giverny so abruptly that he forgot several unfinished canvases at the inn, which Monet collected and sent on to him at Aix.

It is of interest that while he laughed at Clemenceau's anti-clerical and anti-religious jests, he was scared by them. 'It's that I'm too feeble. And Clemenceau couldn't protect me. Only the Church can protect me.' Clemenceau with his bantering authoritative tone must have summoned up the ghost of Louis Auguste.

Late this year, probably in December, he wrote to Mirbeau, thanking him for this 'recent token of sympathy.' Mirbeau had written on Tanguy in *L'Echo de Paris* on February 13th and then on December 25th on the Caillebotte legacy, in which he mentioned Paul. Paul now asked him to put him in touch with an art dealer. Tanguy was dead and Paul needed someone to show his work in Paris; however, Pissarro was encouraging Vollard to take him up.

During this year there had been another incident that sharply brought up the question of the impressionists: the controversy that burst out over Caillebotte's bequest. The will insisted that all the works were to be accepted and shown in the Luxembourg, or none would go to the State. The director, after many wrigglings and attempts to impose restrictions, accepted as long as he could exclude certain works; and the executors finally agreed, though in so doing they were disobeying Caillebotte's express instructions. During the argument there was a spate of denunciations against the profaning of a Museum that had been previously kept safe for pure art and was now being polluted—so that young folk, studying there, could be 'turned away from serious work.' In the Institute, in the Senate, and in the press, there were attacks on 'a heap of ordure, the exhibition of which in a national museum dishonours French art.' Paul however was not singled out for abuse, and two of his works entered the Museum in 1895.

In April 1894 *Le Journal des Arts* had made an inquiry into the reactions of leading artists and others. Gérôme was furious. 'We are living in a century of decadence and imbecility.' He saw the new art as linked with political dissent. 'They are madmen and anarchists!

I tell you that people like that paint with their excrement at Dr Blanche's'—Blanche was an alienist. He saw the event as 'the end of France as a nation.' Benjamin Constant echoed him: the paintings were 'sheer anarchy'. The portraitist G. Ferrier simply wanted the painters kicked in their backsides. Some were milder, however. T. Rodert-Fleury saw serious experiments in the impressionist works. 'The day a man of robust genius and sound education makes it acceptable, we shall perhaps have a new art.' The writer Gyp said she loved the works. They were alive and in them 'you can breathe good sunny air.' *Le Moniteur* of March 24th defended them as showing up the sumptuous banality of Bouguereau and his fellows. 'I don't like canvases painted in cellars.' The vested interests that the new painters were up against can be suggested by a consideration of the prices paid for the canvases of the big academics. In 1886, a Bouguereau fetched 100,500 francs; next year Meissonier's *Fried-land*, 336,000 francs. The total gained by the Tanguy sale was 14,621 francs, with one Monet going for 3,000.

On 31 January 1895 Paul, now back in Paris, wrote another short note to Geffroy.

Monsieur, I have carried on reading the essays that make up your book, *Le Coeur et L'Esprit*, and in which you were kind enough to write a friendly inscription to me. But in carrying on with my reading I've learned to estimate the honour you did me. I am now asking you to preserve in the future this sympathy which is so precious to me.

The book in question consisted of fourteen tales, in one of which, *Le Viveur*, the hero talks in a way probably meant to represent Paul's viewpoint:

Nature provides on earth this extraordinary privilege for man. She opens our eyes, as with all beings, on the spectacle that is, and gives us senses to enjoy it. She supplies us, like all beings, with a brain that becomes the meeting place of our sensations. But we see indeed that man's cerebral activity can only connect up the facts and deduce from accidents the hypotheses of hope and the general laws. It's by this domination of ideas, which is our lot, that we are stronger than our fate, and we can survive ourselves. Man does not wholly die, and he has even resurrected his predecessors. History offers us the outline of the adventurous courses of separate spirits and men of action. But, at the same time, does it not also make us see by the succession of facts and by so many formid-able anonymous works, a lost track where we see something like the trampling of a crowd, we should mark our passage. If we wish to have lived, we must apply all our forces to marking it deeply . . .
 I have asked myself if this so brief time given us to get into contact with things were not better employed in trying to understand the whole or in assimilating all that's within our reach. The brain that thinks too much is a weight too heavy for the body . . . In me, youth regrets decreasing life, it commands the forces that remain, it wants to enjoy the last suns, enjoy all that it must quit, verdure, water, wind, morning, evening; it still wants to see, to love, before disappearing.

In the spring Paul asked Geffroy to pose for him. 'The days lengthen, the temperature grows milder. I'm unoccupied every morning till the hour when civilized man sits down at table. I intend to go up to Belleville, clasp your hand, and submit to you a project I've been cherishing one moment, then dropping, and which I again at times take up' (April 4th). He

signed, 'Paul Cézanne, painter by inclination.' For nearly three months he came almost daily to paint him in front of his bookshelves, seated at a big worktable with papers, flowers in vase, a plaster cast after Rodin. Since it was a lengthy task, he had paper-flowers put in the vase; and with his usual objection to the least change in arrangements, he had chalk-marks drawn round the chair-legs on the floor. However at last, after some eighty sittings, he suddenly sent for his easel, brushes, paints, writing that 'decidedly the enterprise was beyond his powers, that he had been wrong to undertake it, and that he asked pardon for giving it up.' Geffroy pleaded with him and he returned to work for a week or so; but now he lacked conviction, once more gave up, and set off for Aix. He left the portrait with Geffroy, and did not return.

The work was in fact one of his very finest portraits, both in its richness of details united in a clear grasp of space, and in the complex balances of its structure. Geffroy's unfinished head ('O, that comes at the end') lies at the converging point of the patterns of line and colour, but at the same time it is sensitively linked to the hands by the forward-movement of the pyramidal form built up by arms and body. If we add the parts played by the books on the table and on the shelves in constructing what one can call the intellectual space of the work, its design which everywhere leads to the head and hands of Geffroy as to a sort of thinking and informing presence, we can only feel admiration for the way in which Paul has defined the man. (Fig. 55.)

The equilibrium so consummately achieved results from the counterpoise of a great number of directions. One has only to imagine what would happen if the books behind the sitter's head were upright, like the others, to realize upon what delicate adjustments the solidity of this amazing structure depends. One cannot think of many designs where so complex a balance is so securely held. The mind of the spectator is held in a kind of thrilled suspense by the unsuspected correspondences of all these related elements. One is filled with wonder at an imagination capable of holding in so firm a grasp all these disparate objects, this crisscross of plastic movements and directions. Perhaps, however, in order to avoid exaggeration, one ought to admit that since Cézanne's day other constructions have been made as complex and as well poised, but this has I think been accomplished at too great a sacrifice of vital quality in the forms. And it is due entirely to Cézanne's influence that any such constructions have been attempted. He it was who first, among moderns at any event, conceived this method of organizing the infinite complexity of appearance by referring it to a geometrical scaffolding. Though it must always be remembered that there is no *a priori* scheme imposed upon the appearances, but rather an interpretation gradually distilled from them by prolonged contemplation. (Fry)

That is well said, but we must add that what Paul distilled from the objects before him was in turn conditioned by what he was feeling and what were the values embodied in the objects. The extreme of clarity and complexity in the system of the Geffroy portrait is also an expression of what he felt about the man whom he was defining.

Nothing but the most intense sympathy between him and Geffroy could have brought this result about: a sympathy kindled by his gratitude for Geffroy's writings. As he worked, he had talked. Monet: 'he is the greatest of us all. Monet, why, I add him to the Louvre.'

The new schools of precise divisionism and the like made him laugh. He expressed fear of Clemenceau and reacted against Geffroy's generalizing and large-scale viewpoints, which insisted on an ultimate relationship between impressionism, the latest atomic hypotheses and biological developments. Paul, with his existentialist concentration on the concrete moment, was afraid of such vistas, which seemed to rob his struggle of its autonomy, its immediate significances. Often he lunched with Geffroy, his mother and his sister; at times he even went with Geffroy to a tavern by the St Fargeau Lake and became expansive, 'I want to astound Paris with an apple.' It is necessary here to stress the complete harmony of Paul and Geffroy at this time, since later Paul, under Gasquet's influence, falsified the situation.

Royère in 1906 published a description of what Cézanne looked like about this time. Aged 56, he looked 64. 'He was tall for a Provençal, florid, with piercing eyes, his beard was almost white, his hair was thinning, his face was extremely mobile, rugged, and almost peasant-like. He was so nervous that he could not stay still, he would roar with laughter, then suddenly become moody. His twitchings betrayed exasperated sensitiveness. You knew immediately that the person before you was somebody.' Royère expressed enthusiasm before his pictures. 'He at once became very serious and even began to tremble. He took my hand and said, "I am a plain man, you must not pay me compliments and tell me polite lies." '

' "I say what I think," I replied. "If I say it badly, I cannot help it." Cézanne was convinced of my sincerity and wept.'

On July 6th he wrote to Monet from Aix. 'I'm with my mother, who is far gone in years, and I find her ill and alone.' Where, we may ask, was Marie, who should have been looking after her mother? She had taken a flat in Aix, unable to agree with her mother; but that does not excuse her absence if her mother was ill. Paul says that he was forced to give up 'for the time being the study I started of Geffroy, who had put himself so generously at my disposal, and I'm a bit upset at the meagre results obtained, especially after so many sittings and successive enthusiasms [*emballements*] and discouragements. So here I am again in the south, which I ought perhaps never have left, to throw myself once more into the chimerical pursuit of art. In conclusion may I tell you how happy I've been for the moral support, [*appui*], I've encountered beside you and which served as stimulus for painting. Till my return to Paris, where I must go to continue my task, for I promised Geffroy to do so. I am sorry for leaving without seeing you again.' It is clear then, that at this time he fully meant to carry on with the portrait.

The day before he had written a less amiable letter to his old friend Oller, who had come on a visit to Aix. 'Monsieur,' he began, crossing out 'Dear', 'the tone of authority you've taken towards me for some time, and the rather high-handed manner you permitted yourself to use at the moment of your departure, are not the sort of thing to please me. I'm determined not to receive you in my father's house.' (Note this odd way of referring to the Jas; Paul now assumes the mantle of Louis Auguste, as in the clash with Renoir.) 'The

lessons that you take the liberty of giving me will thus have borne their fruits. Adieu then.'

Pissarro gave Oller's account of the episode in a letter to Lucien. 'After numerous tokens of affection and southern warmth, Oller was confident he could follow his friend Cézanne to Aix; a rendezvous was made for next day, for the train—"Third class," said friend Cézanne. So next day Oller was on the platform, straining his eyes, looking in all directions. No Cézanne. The trains pass, no one!!! Finally Oller said to himself: He has gone . . . and decided to leave. Arrived at Lyon, he had 500 francs stolen from his purse at the hotel. Not knowing how to get back, he wired to Cézanne. The latter was at home, had gone first class.' Naturally Oller was annoyed; but when he at last got to Aix, he informed Paul. 'If that's the case,' Paul replied, 'come round at once; I'm expecting you.' Oller then found him violent, sardonic, arrogant: 'I'm the only one of them who knows how to use a red.' Pissarro was 'an old fool,' Monet merely 'sly' (a trickster). 'They've none of them got guts.' Then both men shouted recriminations. 'Oller received one of those letters that you have to read to form an idea of what they're like. He forbade him the house, asking if he took him for an imbecile, etc. In a word, a terrible letter. Indeed it's a variation of what happened to Renoir; it seems he's furious with us all.'

The arguments about money raged on, with an exchange of letters. On July 17th Paul wrote:

Monsieur, your somewhat buffoonish letter scarcely surprises me. But first, as I have some accounts to settle with you—you can't have forgotten certain accounts I had to settle at M. Tanguy's. Let's pass over in silence the attempt that didn't succeed at Mme Ch.'s. Finally I hardly understand in what way I can be responsible for the loss of money which you say occurred during your stay at Lyon. You can have your canvas fetched from the studio in the Rue Bonaparte between now and January 15th next. I release you from repaying the money I advanced you and everything else. I hope that, thanks to your change of attitude, you'll be able to prolong your stay with Dr Aguiard.

Aguiard was a Cuban, a boyhood friend of Pissarro and Oller, and an amateur painter; Paul had met him through these others. The affair dragged on a long time; for in January 1896 Pissarro wrote to his wife, 'I saw Oller yesterday.' Oller had doubtless asked him to intervene in some way. Paul, Pissarro said, 'was even worse than with Renoir.' He adds, 'Dr Aguiard has come to Paris for a few days. He has seen Cézanne; he is sure that he is sick. In short, poor Cézanne is incensed with all of us, even with Monet, who, after all, has been very nice to him.' Dr Aguiard assured him that Paul was not responsible for his behaviour when in his fits of rage.

On 21 September 1895 Paul sent a draft to a colour-merchant at Melun, whom he considered had overcharged him 1 franc 20 sous. 'I take it that you'll refund me this on my next journey to Melun.' His accession to wealth had not changed his penurious habits. But he was not always in a disagreeable mood. His friendly letter to Monet had been written the day after his haughty epistle to Oller; and in November he repeated some of his old

wanderings with early friends. Under November 8th, Emile, son of Philippe Solari, recorded:

Yesterday went on an excursion. My father, Cézanne, Emperaire, and I. We visited Bibémus, a country-house with wonderful outbuildings. Old stone quarries have left strange caves in the neighbourhood. Cézanne, tall with white hair, and Emperaire, small and deformed, made a weird combination. One might have imagined a dwarf Mephisto in company of an aged Faust. Further on, after crossing a considerable stretch of ground planted with small trees, we found ourselves suddenly facing an unforgettable landscape with Ste Victoire in the background, and on the right the receding planes of Montaiguet and the Marseille hills. It was huge and at the same time intimate. Down below, the dam of the Zola Canal with its greenish waters. We lunched at St Marc under a figtree on provisions got from a roadmenders' canteen. That night we dined at Tholonet after a walk over the stony hillsides. We returned in high spirits marred only by Emperaire's tumble; he was a little drunk and bruised himself painfully. We brought him home.

Philippe Solari, after working at Lyon, Blois, Reines, Tarascon, had returned to Aix, still dreaming of big works, in an old outbuilding in the Rue du Louvre. He and Emperaire were both very poor; and now and again Paul gave them a good meal. He and the two Solaris also went to climb Mont Ste Victoire itself: which, 'though not dangerous, is rather fatiguing and takes three hours.' Paul and Philippe had often climbed it in youth, but now didn't find it so easy. Still, they reached the top. The previous night they spent in the village of Vauvenargues near the base, sleeping in a room with smoked hams hanging from the rafters, and started off at daybreak. 'Cèzanne appeared surprised and almost chagrined when I innocently pointed out that the green bushes along the path looked blue in the morning light. "The rascal," he said, "he notices at a glance, when he's only twenty, what it's taken me thirty years to discover." ' On the top, 'we had lunch in the ruins of the chapel of Calmuldules, the site of an episode in Walter Scott's *Anne of Geierstein*. We didn't go down into the Gouffre du Garagaï [a bottomless pit near the summit], which is also mentioned in that novel. But Cézanne and my father spoke of it and recalled the memories of their youth. There was a terrific wind blowing up there that day.' On the way down Paul tried to prove himself as agile as ever by climbing a small roadside-pine; but he was tired and didn't succeed very well. 'And yet, Philippe, do you remember we used to be able to do that so easily?'

Vollard, in his astute way, with a pretence of ingenuous indolence, had been gauging the situation; he decided the time had come when it was possible to extend the reputation which Paul had won among artists. At his gallery at 39 Rue Lafitte (opened in 1893) he had held a show of Manet's drawings and another of Forain's work. Encouraged by Pissarro, as also by Renoir and Degas, he felt he could safely hold an exhibition of Paul's paintings: Seurat before his death in 1891 had also thought that such a show should be attempted. On the other hand, the uproar about the Caillebotte bequest had been so loud it might create a bad atmosphere. Of the total 65 pictures, 38 had been accepted; two of Paul's taken, two rejected. Renoir remarked that the only one of his own works accepted

with confidence was *Le Moulin de la Galette*, because an academic painter, Gervex, figured in it. 'But when it came to Cézanne. Those landscapes composed with the balance of a Poussin, those pictures of bathers in which the colours seem to have been despoiled from the old makers of faience, in fact all that supremely sapient art! . . . I can still hear Roujon saying: This one doesn't know what painting is.' Gérôme and some of the Beaux-Arts teachers threatened to resign.

Vollard decided to proceed, but first he had to find his man. Pissarro didn't know where Paul was. Vollard followed a trail through the forest of Fontainebleau, village to village. 'I learned that Cézanne had actually had a studio at Fontainebleau. I thought the quest ended, but no, the studio's owner told me the tenant had gone back to Paris and he couldn't recall the address. The only detail sticking in his memory was that the street where Cézanne lived bore the name of a saint coupled with an animal's.' By luck and guesswork, Vollard came on the Rue des Lions-St-Paul, but Paul had left for Aix. His son was at home and promised to write. Paul agreed to the show and supplied almost 150 canvases. He sent them rolled up, as wooden stretchers took up too much room and caused trouble in handling during his frequent moves. For some reason Pissarro withdrew his offer to lend canvases, but Vollard now had enough. Paul didn't show much interest in the whole affair; perhaps he had had so many disappointments that he had to build up a stoical apathy.

The show opened in November; admission was free. It drew much attention, often of a hostile nature. On December 1st *Le Journal des Artistes* spoke of 'the nightmarish vision of these atrocities in oil, surpassing today the measure of legally authorized practical jokes,' and expressed fear that the sight of such works might cause heart failure in its delicate female readers. Their defenders were accused of the partiality of friendship. We are told of a husband, angered at his wife, bringing her along as a punishment; she had once won a drawing prize. Quost, a famous flower-painter, was saddened. 'More than 3,000 studies of detail, sir, before I dare attack the smallest meadow-flower. And I don't sell.' Then with a smile, 'Those are paper flowers which served as model for your painter, I take it.' Vollard replied that Cézanne had indeed used paper flowers, since they faded less quickly than real flowers, but had finally been driven to copy his bouquet from an engraving, to get more certainty in the pose. Vollard's housekeeper said, 'I fear Monsieur will be much criticized by his customers for putting a picture of a naked gentleman in the window.'

/ But the show, which gave a panorama of all Paul's main developments, also had its admirers. His old artist friends had their faith in him strengthened. Pissarro wrote to Lucien, 'My enthusiasm is nothing compared with Renoir's. Even Degas has succumbed to the charm of this refined savage. Monet, all of us . . . are we wrong? I don't believe so. The only people who don't yield to Cézanne's charm are precisely those painters and collectors who have shown us by their errors that their sensibilities are defective./Monet bought three of the works; Degas one or two; Pissarro suggested an exchange. Some critics were friendly. T. Natanson in *La Revue Blanche* of December 1st spoke of Paul's single-mindedness as an

original creator; A. Alexandre in *Le Figaro* of December 9th, in a notice under the name of Claude Lantier, saw him rather as Zola's hero, 'inventive yet imperfect, wild and yet clever' —at the same time he attacked *L'Oeuvre* for exaggerating with 'lyrical romanticism' things 'that were quite simple.' A reply came from the Médan circle. Thiebault-Sisson, critic of *Le Temps*, wrote on December 22nd about Paul as if he *were* Claude Lantier. 'He remains today as he has always been, incapable of self judgment, unable to derive from a new conception all the profit that cleverer people would have derived from it: in a word, too incomplete to be able to realize what he himself had first seen, and to produce his full measure in definitive works.' Geffroy had seized the chance in *Le Journal* of November 16th to repeat his high opinion of Paul. He saw him 'on one side, a traditional painter enamoured with those he regards as his masters; on the other side, a scrupulous observer like a primitive anxious for truth. He knows art and wants to force it to reveal itself directly through objects.' He called him 'supremely sincere, ardent and ingenuous, harsh and subtle [*nuancé*]'; in due time he would be hung in the Louvre. 'All that is obscure and legendary in Cézanne's biography,' he said, 'will be dissipated and there will remain nothing but an austere though charming collection of works . . .' A hope which was hardly to become true.

Vollard has chosen his moment well. Pissarro says that many viewers were 'bewildered,' but new collectors were interested and bought works: Pellerin, the margarine-magnate, and the ex-king of Serbia, who said, 'Why don't you advise your Cézanne to paint pretty women?' This year Paul's old friend Leydet, now a senator, tried in vain to get him the Legion of Honour.

II *Joachim Gasquet (1896)*

IN 1896 Joachim Gasquet (1873–1922) came into Cézanne's life. A handsome, dashing and eloquent young man, he was the son of Paul's old friend Henri Gasquet, baker. Young Gasquet aspired to be a lyrical and pastoral poet; an enthusiastic follower of Mistral, he was a gifted improviser, whose backward-looking romanticism hardened in time into a sort of embryonic fascism. He was now living above the family bakery which his well-off father wouldn't relinquish. Henri was 'a neat little man of prosperous appearance with shaven lips and chin, his cheeks aristocratically ornamented with exactly symmetrical side-whiskers; he always wore white cravats, like a councillor of state.' So he is to be seen in Cézanne's portrait. His son had married, on January 23rd, Marie Girard, Queen of the Félibrige, the school of Provençal poets, the *Félibres*; and the school had turned the marriage into a festival. Gasquet, conceited and ambitious, was a most unreliable recorder of his relationship with Paul; but his account of their meeting must be quoted. It seems that he had realized something of the importance Paul was assuming among advanced artists and collectors in Paris, and decided to cultivate him. Indeed, among some of the Aixois circles, a puzzled feeling that after all Paul might not be such a joke, such a perpetrator of atrocities, had begun to percolate. A society of amateur painters, Friends of the Arts, had been formed at 2 Avenue Victor-Hugo, with Villevielle as president. Should they ask Paul to exhibit with them, or should they boycott him? They decided after all to ask him to send in two pictures. A pair of delegates called. Paul was surprised, flattered and delighted. He even offered each delegate one of his own works on the spot. One man accepted; the other demurred. 'My wife has a horror of modern art.' In the end Paul sent along a painting of a wheatfield and a *Ste Victoire au grand pin*. The embarrassed society hung them over the entrance-door in the hope that they would there escape notice; but even so they were laughed at. A local critic, who did his notices in verse, produced a quatrain:

> Across the boughs of giant pines you view
> The Mount Ste Victoire all outlined in blue.
> Were nature what this painter thinks, the work,
> Compendious, for her glory then would do.

Paul attended the closing banquet. One speaker declared, 'Gentlemen, our period will be that of Cabanel and Bouguereau,' and Paul shouted, 'Your Bouguereau is the greatest idiot of the lot!'

Joachim says that the first time he saw Cézanne he was seated at a table on the Cours outside the Café Oriental, with Solari, Coste and Henri Gasquet.

Night was falling under the great planes. The Sunday crowd was coming home from the band-concert. It was a serene provincial evening. His friends talked to one another, he himself listened and watched, with crossed arms. With his bald head, his long grey hair still abundant at the back, his short beard and thick moustaches, like those of an old colonel, which hid his sensual mouth, his freshly shaven cheeks and ruddy complexion, he might have been taken for an old retired soldier, were it not for his huge bulging forehead, the piercing eyes, which at once gripped you and never let you go again, brow of genius, remarkable for shape and size, and his reddened skin. That day a well-cut jacket covered his body, the robust body of a peasant and a master. A low-cut collar exposed his throat. His black cravat was neatly tied. Sometimes he neglected his appearance, going about in sabots and a ragged hat. When he thought about it, he was well-dressed. That Sunday he had probably spent the day with his sister.

I was a nobody, scarcely more than a child [in his 23rd year, and married]. In some haphazard exhibition at Aix I had seen two of his landscapes, and the whole of painting was made clear to me. Those two canvases had opened up the world of colour and line, and for a week I had been going about enraptured by this unknown universe.

As none of Gasquet's comments shows any penetration into the nature of Paul's art, we may doubt this statement.

My father had promised to introduce me to the painter, who was scoffed at by the whole town. I guessed it was he sitting there. I came up and murmured some words of admiration. He flushed, began to stammer. Then he pulled himself together, shot at me a terrible glance that made me blush in turn, a look that burned right through me. 'Don't you make fun of me, young man!'

The table shook under a terrific blow of his fist. The glasses rattled. Everything fell over. I don't think I've ever been more embarrassed. His eyes filled with tears. He took hold of me with both hands. 'Sit here—is this your son, Henri?' he asked my father. 'He's charming'. The anger had left his voice, which was now kind and gentle; he turned to me. 'You are young, you don't understand. I don't want to paint any more. I've given up everything. Listen to me. I'm an unhappy man, you mustn't hold it against me—how can I believe that you see something in my painting, in the two pictures you've seen, when all those fools who write nonsense about me have never been able to perceive anything? What a lot of harm they've done me. It's Ste Victoire in particular that has struck you, isn't it? That picture pleases you—tomorrow I'll send it to you—and I'll sign it too'.

Paul sent the picture to Gasquet. One of the finest of the Mont Ste Victoire series, it was painted about 1887, from the area of Bellevue. Now:

Cézanne turned back to the others. 'Go on talking, all of you. I want to chat with the youngster. I'm going to carry him off. Shall we dine together, Henri?' He emptied his glass and took me by the arm. We walked away into the darkness, along the boulevards at the town's edge. He was in a state of inconceivable exaltation. He opened his heart, told me of his discouragement, the loneliness of his old age, the martyrdom of his painting and his life, that 'profound feeling', that 'unity', of which Renan speaks, which I'd like to transmit, and of which that evening I had a sensation that was more than wonder; it was ecstasy. I was aware of his genius with my whole soul. I could feel it. I should never have believed that anyone could be so great and so unhappy; and when I left him I couldn't be sure whether I was possessed by the holiness of his human suffering or by the worship of his amazing talents.

Gasquet may well have struck him at one of his moments of self-intoxication, which accom-

panied his periods of anguish. An impulse to pour out his innermost thoughts was the complement of his depressed retreats into an inviolable solitude.

During the next week I saw him daily. He took me to the Jas de Bouffan; he showed me his pictures. We made long excursions together. He'd call in the morning; we wouldn't return till dark, wearied, dusty but enthusiastic, ready to start again the next day. It was an enchanted week, during the course of which Cézanne seemed to be reborn. He was like a drunken man. I think the same simplicity created a bond between my ignorant youth and his clear rich wisdom. All subjects of conversation were alike to us. He never spoke of himself, but said he'd like to give me the benefit of his experience, since I was just on the threshold of life. He regretted I wasn't a painter. The countryside thrilled us. He showed me, and explained at length, the beauty of all his conceptions of poetry and art. My enthusiasm refreshed him. All that I brought him was a breath of youth, a new faith that made him young again. But in that great soul, anything one added, however insignificant, was tremendously magnified. He wanted to paint portraits of myself and my wife. He started one of my father. He gave it up after the first sitting, lured from the studio by our expeditions to Le Tholonet, to the bridge over the Arc, or meals, washed down with old wine, in the open air. It was spring. He drank in the countryside with delighted eyes. The first pale leaves moved him deeply. Everything touched him. He'd stop to look at the white road or to watch a cloud float by overhead. He picked up a handful of moist earth and squeezed it to bring it closer to him, to mix it more intimately with his own re-invigorated blood. He drank from the shallow brooks.

'This is the first time I've really seen the spring', he said.

Certainly Paul, with his longing for a lost youth, seems in his last years to have responded strongly to the homage of young men. Gasquet with his powers of easy response, of a facile though shallow poeticality, and his enthusiasm for the Provençal past, may well have brought out all the excited happiness and self-confidence in Paul that he describes. 'That does me good, I'm glad to be able to bubble over,' Paul used to say (Le Bail). But the bubbling-over soon begot its opposite, the oscillation into despair and withdrawal.

All his self-confidence came back to him. At last he began to talk of his own genius. One evening he let himself go and declared, 'I am the only living painter'. Then he clenched his fists, relapsed into gloomy silence. He went home grimly as if some calamity had overtaken him. Next day he didn't come for me. He refused to see me at the Jas de Bouffan. For several days I called without result. Then I got this letter: 'Dear Sir, I am leaving tomorrow for Paris. Please accept my kind regards and sincere greetings'.

It was April 15th. The almond trees round the Jas, where I wandered about trying to conjure up the departed painter's image, had lost their blossoms. The friendly outline of the Pilon du Roi shimmered, pale against the evening sky. It was there, among these fields, these orchards and the walls, that Cézanne always painted. Suddenly on the 30th I met him coming back from the Jas with his knapsack on his shoulder, going towards Aix. He hadn't gone away after all. My first impulse was to run after him. He was walking as if crushed, sunk into himself, overcome, unseeing. I respected his solitude. An immense sorrowful wonder took hold of me. I bowed to him. He went on without seeing us, at any rate without returning my salute.

Paul liked Gasquet's Provençal patriotism. For him such patriotism was essentially a piety directed towards the days of his youth with Zola, towards the earth which he had then come to love. In a way the deepest aspects of his art represented a struggle to recover and define with full understanding the earth which he had then intuitively enjoyed. But Gasquet's

patriotism was merged with his literary ambitions and involved a mystical return to positions that were at root medieval: what Jaloux later defined as 'equilibrium, co-ordinated thought, living hierarchy not hardened into systems [*cadres*], of revolutionary [in fact, anti-revolutionary] movement and return to our truest tradition, to an emblem of purely national philosophy and manners.' Jaloux was there writing in defence of Vichy Fascism, in *Les Saisons Litteraires*, 1942. It would perhaps be going too far to call Gasquet, in the situation of the 1890s, a definite proto-fascist, but he strongly embodied the sort of attitudes which in a phase of sharpened social conflict and more advanced capitalism (i.e. monopoly) did in fact provide an important part of the ideology of Fascism. Indeed in 1917 he published a book, *The Benefits of War*. Paul's superficial religiosity in these later years was simply, as he himself stated, the expression of a blind terror of death, a prostration before the dead Father (who had now strangely become merged with the Good God), and a need to find some sort of enveloping protection, outside himself, which could make his sense of isolation at all tolerable. Gasquet's religiosity was quite different. It was an active creed, theatrically inflating God with Gasquet's own personal ambitions, and sharply opposed to all liberal and radical ways of thought. Before Gasquet appeared on the scene Paul was able, a trifle shamefacedly, to carry on with his role as a churchgoer, in the face of the anti-clerical views of men like Geffroy, Monet, Pissarro and Clemenceau. He could make his ironical self-abasing defences and leave it at that. Even in late 1895 he had felt unabated friendship with Geffroy, Monet and the others (though the strain of his break with Oller did bring out abuse and belittlement of his staunch friends, revealing a paranoiac touch); now, under the influence of Gasquet's mystical tirades, he began to come round to a position of genuine opposition to those old friends. He gradually turned against Geffroy, who had shown a real (if not a complete) understanding of his art, and allied himself with Gasquet, who had no understanding of it at all.

Vollard has one of his semi-garbled accounts. Paul said, 'You should read *The Heart and the Spirit*. There are some very fine things in this book, among others the tale entitled *The Sentiment of the Impossible*.' Vollard then asked why he no longer saw Geffroy. He replied, 'Understood, Geffroy is a *brave homme* and has a good deal of talent; but he kept talking all the time about Clemenceau, so I saved myself by leaving for Aix.' 'Clemenceau is then not your sort?' 'Listen, M. Vollard, he has temperament; but for a man like me, feeble in life, it's better to lean on Rome.' If Paul ever said anything like that, as in part he may have, he was inventing explanations to suit the positions he had built up after Gasquet turned him against Geffroy.

On April 30th, the day when the Gasquets met the crushed Paul, the latter felt ashamed and wrote to Joachim:

Dear M. Gasquet, I encountered you at the bottom of the Cours this evening. You were accompanied by Mme Gasquet. If I'm not mistaken, you seemed very angry with me. If you could see me as I am inside, the inner man, you wouldn't be so. Don't you then see the sad state to which I

am reduced? Not master of myself, a man who doesn't exist—and it is you who want to be a philosopher, who want to end by annihilating me? But I curse the Geffroys and the various clowns [*drôles*] who, to produce an article for 50 francs, have drawn the attention of the crowd to me. All my life I have worked so as to reach the point of earning my own living, but I thought one could produce well-done painting without drawing attention to one's private existence.

Certainly an artist desires to raise himself intellectually as much as possible, but the man should remain obscure. The pleasure should reside in the study. If it had been given me to realize, I should have stayed in my corner with a few studio-comrades with whom we used to go and booze a bit. I have still a brave friend of that time [probably Emperaire]; alas, he hasn't arrived anywhere, but that doesn't stop him from being a bugger of a lot better as a painter than all those messers [*galvaudeux*] with medals and decorations that make one sick. And you want me at my age to have faith in anything. Besides I'm as good as dead. You are young and I understand that you wish to succeed. But as for me, what remains for me to do in my solitude: to be all submission [give up the ghost, *filer doux*]; and were it not that I love enormously the configuration of my land, I wouldn't be here.

But I've bored you enough like this, and after I've explained my situation to you, I hope you'll no longer look on me as if I'd committed some violation of your security. I beg you, dear sir, on account of my great age, to accept all the good wishes I should like to make for you.

We cannot but be surprised at the envy with which Paul throughout his life regarded the vulgar signs of success; the medals 'that make one sick' he always wanted to gain. Also, it would be of interest to know how the fight of a man like Geffroy to gain his work serious attention had now become a cheap attempt to 'draw attention to his private existence'. He was ungratefully retorting his resentment at failure to gain serious attention on those who least deserved it. Gasquet's effusive homage, linked with attacks on the radicals, had brought him round definitely to this position. Zola's *L'Oeuvre* might have been described as an attempt 'to draw attention to his private existence'; but Geffroy had had no hand in it. It looks as if Paul were now retorting on the whole radical group the angers he nursed against Zola.

Gasquet goes on: 'I ran to the Jas. As soon as he saw me, he opened his arms. "Let's say no more about it. I'm an old fool [*bête*]. Put yourself there. I'm going to make your portrait."' However Paul soon lost interest in the work, which stopped after five or six sessions. Numa Coste bears witness to his miserable state of mind about this time, writing in April to Zola.

I have seen recently, and still often see, Cézanne and Solari, who have been here for some time . . . Cézanne is very depressed and often the prey of melancholy thoughts. He has some self-satisfaction, however, and his work is finding sales to which he hasn't been accustomed. But his wife must have made him do quite a lot of foolish things. He has to go to Paris or return thence according to her orders. To have peace, he has to give up all he has, and confidential remarks he has dropped reveal that he now has only a monthly income of about a hundred francs. He has rented a cabin at the quarry above the dam and spends the greater part of his time there.

Marie must have given up protecting him from Hortense, if the latter had indeed worn him so thoroughly down. He was using peasants and day-labourers at the Jas as models, as we saw in regard to his *Cardplayers*. A peasant woman was represented as a cook, while her

son appeared in a painting sitting at a table with a skull in front of him. When he had no model or no old studies, he used illustrations from his sister's magazines.

A note of May 21st runs, 'Dear M. Gasquet, Obliged to return early this evening to town, I can't get along to the Jas. I beg you to excuse this mishap. Last evening at 5 o'clock I hadn't received *Heart and Spirit* of Geffroy, nor the article in *Figaro*. I've telegraphed about it to Paris. Tomorrow then, Friday, if you agree, at the usual hour.' But we know that he had received a copy of Geffroy's book in 1895 and appreciatively acknowledged it. Why did he need another copy of a man he had denounced in the earlier letter to Gasquet? We can only assume that, while running Geffroy down to please Gasquet, he had pretended not to have seen the book. The copy of *Le Figaro* must have been the one of May 2nd in which Zola wrote what Geffroy called, 'a sort of victory-fanfare played as a funeral march.' Zola recalled the fight he had put up for Manet and the others. He said, 'I had grown up virtually in the same cradle as my friend, my brother Paul Cézanne; one is now only beginning to discover the touches of genius in this abortive great painter.' In reviewing at some length his associations with artists, he adds, 'Yesterday I still tramped with Cézanne the hard pavement of Paris in the fever of conquering it. Yesterday I went to the Salon of 1866 with Manet, Monet and Pissarro, whose paintings had been summarily rejected.' Now, he goes again, and what does he see? Everyone imitating Manet, Monet and Pissarro. The change is good and yet too simple a reversal. 'That was too dark, but this one is too white. Life is more varied, warmer, suppler.' A chalky insipidity has replaced the bituminous glooms, and the theories of reflected light have led to dogmatic extremes:

We maintained, very correctly, that the illumination of objects and figures is not simple; that under trees, for instance, nude flesh becomes green, that there is a continuous interchange of reflections which must be taken into account if one wants to imbue a work with lifelike light. Light ceaselessly decomposes, breaks up and scatters . . .

But as soon as it is dwelt upon, as soon as reason begins to play a role in it, caricature quickly results. And these are really disconcerting works, these multicoloured women, these violet landscapes and orange houses that are being given us with scientific explanations that they are like that as the result of a certain reflection or decomposition of the solar spectrum. O, the ladies who have one blue cheek in the moonlight and the other one vermilion under a lampshade. O, the horizons with blue trees, red water, and green skies.

He praises Monet and Pissarro for their truth, but insists that in time 'every movement is exaggerated, turned into a set system and into a lie, as soon as fashion takes it up. There is no truth, just and good at the outset and for which one would not theoretically give one's blood, that doesn't become by imitation the worst of errors, the encroaching darnel that it is necessary to cut ruthlessly down.' He asks, 'Truly, is it for this I fought?' and answers, 'Others will come by the new ways; but all those who have determined an epoch's evolution remain, on the ruins of their schools. And it is decidedly only the creators who triumph, the makers of men, the genius that gives birth, that produces life and truth.'

We can only assume that Gasquet has heard of Zola's essay and wants to make sure that

Paul reads it. He would know that the phrase 'this abortive great painter' would hit Paul to the heart. In fact Paul's opinion of the 'excesses' of impressionism was not so far from Zola's, and he too wanted the abundant genius who produces life and truth. He was struggling all the while towards the goal that Zola outlined, even if Zola did not know it (though, if we may trust Gasquet's later interview with Zola, the latter did near the end see some of Paul's mature works and begin to grasp what he was doing). At the same time Paul would have been the first to agree that the full free range he loved—that of a painter like Rubens or the great Venetians—continued to elude him.

His niece said that he attended on June 4th the first communion of Paule Conil at Les Religieuses de Sion at Marseille. If so, he must have left soon afterwards with Hortense and his son for Vichy, to undergo the cure. Here he received the first issue of a little revue founded by Gasquet, *Les Mois Dorés* (its title refers to the Golden Verses of Pythagoras). Gasquet wanted Paul to be associated with it, but Paul politely and firmly refused. 'You are young, you have vitality, you will imprint on your publication an impetus that only you and your friends with the future before you can give it.' (Gasquet had already edited the short-lived *La Syrinx*, to which Paul Valéry contributed. His friends and adherents included Joseph and Charles Maurras, Louis Bertrand, E. Jaloux, J. Royère, G. Dumesnil, José d'Arbaud, and others: some of these Paul met at his house.) However, he went on, 'it is not possible for the man who feels himself living and who has ascended, consciously or not, the summit of existence, to clog the march of those who are coming into life.' Meanwhile the rainy weather was ending in serene skies. 'I'll soon start making studies,' he wrote from the Hôtel Molière.

Late in June, still at Vichy, Paul got the second issue of the journal. Then, via Aix, he went to the Lac d'Annecy, where, on July 21st, he wrote, 'My family, in whose hands I find myself at this moment, has determined to fix me for the moment at the point where I find myself.' The lake, 'squeezed in at this place by two gorges, seems to lend itself to the linear exercises of young Misses. It is always nature, indeed, but a trifle like what we have learned to see in the albums of young girl-travellers.' He praised Gasquet, but found himself distant by reason of age and of the understandings he daily gained. 'Still, I come to recommend myself to you and to your good remembrance, so that the links that attach me to this old natal soil so vibrant, so hard and reverberating the light as to make the eyelids blink and to bewitch the receptacle of sensations, may not come to be broken and detach me so to say from the earth where I have come to experience, even without my knowing it.' He had heard with pleasure that the Gasquets were to preside over regional activities in the south: for example, a big fête of Félibres at Saintes-Maries-de-la-Mer on July 26th.

In the July issue Gasquet wrote an essay entitled *July*, which had a long verbose passage on Paul, without any precise grasp of his work:

The plain, the bluish hills, the horizons, the natural beauty of landscapes stretching round Aix, the gilded or green freshnesses where the river sleeps, revive in a hundred canvases, and the master

has also rendered, in his robust loyalty, the august and naive figure of the rustics cultivating these lands . . .

He compared Paul with Claudel. When he went on to say that he meant to write a book on Paul, the latter did not reply that he resented attempts to draw attention to him, as he had said of Geffroy.

On July 23rd, from the Hôtel de l'Abbaye, Talloires, he wrote to Solari: 'When I was at Aix, it seemed to me I'd be better somewhere else. Now that I'm here, I miss Aix. Life for me begins to be of a sepulchral monotony. I went to Aix three weeks ago, I saw Père Gasquet there, his son was at Nîmes. In June I spent a month at Vichy; the food is good there. The food's not bad here either.' His mind kept returning to the past. 'You will doubtless be soon at Aix. Tell him part of my memories, reminiscences of our walks to the Peirières, to Ste Victoire.' He was painting the lake: 'it's not up to our country, though without exaggeration it's fine. But when one was born down there, it's no use, nothing else seems to mean anything. What one needs is a good stomach and not give a damn for a bit of excess: "The Vine's the Mother of the Wine" as Pierre used to say, do you remember? And to think I'm going up to Paris at the end of August.'

He duly went from Talloires to Paris, and wrote on September 29th to thank Gasquet for the last two numbers of the revue. He'd been looking for a studio for the winter; was now in gunshot of Sacré Coeur, reading Flaubert and the revue: 'It embalms Provence,' he was repeating. 'I saw you again while reading and with calmer head I think of the brotherly sympathy you'd shown me. I can't say I envy you your youth, that's impossible, but your sap, your inexhaustible vitality.' He sent good wishes to 'the Queen who so magnificently presides over the rebirth of Art that's going on in Provence.' He had had difficulty in finding a suitable studio. He didn't care for the Rue des Dames in the Batignolles where he was staying; and near the end of December he went to 73 Rue St Lazare, where he was kept abed three or four weeks with influenza.

At some time this year, presumably during the summer while Paul was away, Zola came to Aix to see Numa Coste for several days. On his return to Paris he wrote, 'My brief journey to Aix seems to me already like a dream, but a charming dream in which a little of my youth came back to life and I saw you again, my old friend, you who were a part of that youth.' No doubt he had been ignorant of Paul's departure and hoped to encounter him. Vollard has a tale that is certainly untrue. Paul, he says, was working at a landscape and heard of Zola's arrival in Aix:

Without even taking time to pack up my things, I rushed to the hotel where he was stopping; but a friend I met on the way told me that someone had asked Zola the day before: 'Aren't you going to take a meal with Cézanne?' and Zola had answered, 'What good would it do to see that failure again?' So I went back to my landscape.

It is the measure of Vollard's unreliability that he gives a circumstantial account of Paul's visit to Amsterdam, citing his comments on the room where Rembrandt's *Nightwatch* was

hung—'I know nothing more shattering than the big crowd one sees pressing in with an air of ecstasy, but they'd vomit on the work if Rembrandt-prices began to fall . . .'—and yet in fact Paul was never in Holland. (Apparently the error arose through a landscape of *Auvers* being misprinted as *Anvers*, Antwerp).

This year Vollard had visited Aix in his quest for Cézanne canvases. On meeting Paul, he recognized him as one of the visitors to the Forain show a couple of years before: a man who had studied each picture, then, as he went out with his hand on the door-handle, remarked, 'Towards 1875 one day at the Louvre I saw a young man copying a Chardin; I went up and after a look at his work I thought: He'll arrive, for he sets himself to draw form [*dessiner la forme*]; it was your Forain' . . . Now he held out his hands, 'My son has often spoken of you. Excuse me a while, M. Vollard, I'm going to rest till dinner, I've just come back from the motif. Paul will show you the studio.' The first thing Vollard saw on entry was a large figure of a *Paysan* pierced with blows of a palette-knife. 'Thus when he saw his son looking a bit worn-out, he imagined the lad was staying out at night, and then bad luck for the canvas he found under his hand'. (The way Cézanne thus expressed sexual jealousy and fear by this attack on a painting is noteworthy.) Young Paul had in fact grown up an aimless loafer, frequenting brasseries where he seems to have picked up loose wenches. Deprived of an effective father for most of his life, and left to the care of the empty-headed Hortense, he had indeed become the little bourgeois. Cézanne, however, was pleased enough as long as the youth did not prove a burden and gave him some help in the management of his affairs—'The lad will work as soon as he wants to.'

On the floor of the studio was a portfolio of watercolours and a plate of rotting apples; on the walls, engravings and photographs of paintings: Poussin's *Shepherds of Arcadia*, Signorelli's *The Living Bearing the Dead*, works by Delacroix and Forain, Courbet's *Burial at Ornans*, Rubens' *Assumption*, a *Love* by Pugin, Prud'hon's *Psyche*, and even Couture's *Roman Orgy*. At dinner Paul was very gay, very polite; his favourite phrase, 'Excuse me a bit.' But Vollard was afraid all the while of upsetting him. Gustave Moreau was mentioned and Vollard ventured, 'He seems an excellent teacher.' Paul had raised his glass to his lips; still holding it there he cupped his other hand to his ear (he was slightly deaf)—'Teachers,' he exclaimed, setting his glass down so violently that he broke it, 'They are all stinkers [*salauds*], castrates, bugger-alls; they've got nothing in their guts.' After this outburst he was dumb-founded for a while, then burst into a nervous laugh and went on, 'If that distinguished aesthete does only out-of-date things, it's because his artistic fantasies are suggested, not by emotion before nature, but by what he has been able to see in museums, and still more, by a philosophic spirit that comes to him from an overplus of knowledge he has gained from admired masters. I'd like to have this fine chap under my thumb so as to inculcate in him the idea, so healthy, so fortifying and alone correct, of an enrichment of art through contact with nature. The great point, M. Vollard, is to come out of the School and all the schools. Pissarro wasn't wrong in that, and went only a little too far in saying we should

burn the graveyards of art.' (This scene is rather a synthetic composition by Vollard, using various elements from others' writings, than a genuine memory.)

A little later a young Aixois who had been awarded a B.Sc. in Paris was named, and Vollard said Aix should be proud of producing a future *savant*. Paul junior signed to him to be silent, and afterwards told him that his father had a horror of *savants* and thought them even worse than *professeurs* of art. The conversation about painting and literature continued. Paul was enthusiastic about Courbet, 'apart from a slight heaviness in expression.' Vollard spoke of Verlaine; Paul replied by citing Baudelaire's *Une Charogne*:

> Recall the thing that we, my soul, have seen
> This lovely morning of sweet summer.
> At a path's turn a ghastly carcass lay
> Upon a bed with pebbles scattered.
> Legs up in air, just like a wanton woman,
> Burning and sweating poisons,
> Opening in nonchalant and cynical fashion
> Its belly full of exhalations.

Vollard again tried to talk of Verlaine, but Paul interrupted, 'The one who is strong is Baudelaire. His *Art Romantique* is amazing, and he makes no mistakes about the artists he appreciates.' (Vollard quotes this from a later letter to young Paul.) He declared that he didn't like the work of Van Gogh and Gauguin. Vollard tried to say how Gauguin admired him, but Paul had wandered on, 'I have a little sensation, but I don't come to the point of expressing myself; I'm like a man with a golden piece who can't spend it.' (If Paul did here use the phrase *petite sensation*, it was because he was assuming a mock-humility as at Giverny; but it is fairly certain that Vollard is merely echoing Geffroy. Immediately after this passage he brings in the invented account of Paul before Rembrandt's *Nightwatch*.) Paul then goes on to say that grandiose art ends by wearying. 'It would *emmerder* me to have *The Raft of the Medusa* in my bedroom.' Then he broke off. 'Ah, when will I see a picture of mine in a Museum?' Vollard mentioned that the director of the Berlin National Gallery, de Tschudi, wanted a *Jas de Bouffan*, and then deplored the German Emperor's bias against the impressionists; but Paul said the Emperor was right and that 'what is needed is to do Poussin over again *sur nature*'. (We later shall discuss this phrase, which Vollard takes from Bernard, not from Paul himself.) 'All is there.' Then, leaning over, he spoke in the raised voice of a deaf man, 'William is very strong.'

Vollard then mentioned Kaulbach (of whom the Emperor used to say, 'We too have a Delaroche'), and Paul fulminated, 'I don't accept a eunuch's painting.' Corot came into the discussion and Paul remarked, 'Emile [Zola] said that he'd let himself go fully in enjoying him if instead of nymphs he'd peopled his woods with peasant-women.' Lifting his fists, he cried, 'Bugger of a cretin.' Then his emotion ebbed. 'Excuse me a bit, I love Zola so much.'

Next day Paul took Vollard to see a picture at Marie's house; but that devout spinster was out, probably at church: it was the hour of vespers. So they strolled round the garden. 'Rarely has a walk been so profitable to my soul,' says Vollard. 'Everywhere were posted prayers entitling one to indulgences, some valid for a few days, some for several months, and some indeed for whole years.' They also went for a walk along the Arc and Paul remarked how fine it would be to paint a nude at a certain spot. He also remarked, 'Look at that cloud. I'd like to be able to put it down. Monet could. He's got muscles.'

Vollard tells many tales about the pictures that Paul had given away in Aix. Some owners refused to look for such worthless daubs, which had been submerged in their junk-rooms. A Comtesse had stored her Cézannes in the granary; Vollard complained that they might be destroyed by rats. She replied, 'Well, let the rats eat them. I'm not a shopkeeper.' All the *amateurs* of the area rushed to sell him *their* works. But he did manage to get hold of some works by Paul. One man came along: 'I've got one of 'em, and since the Parisians are making such a fuss about 'em, I want to be in on it.' He asked 150 francs—'Cézanne thinks he's smart, but he was stupid to make me a gift of that.' He took Vollard to a house where the hall (commonly used in Aix as a storeroom) was heaped up with junk. There he knocked up a couple, who after a long conference asked 1000 francs for their Cézannes. Vollard accepted. Another long conference; then the owners said they couldn't hand over the works till Vollard's banknote was verified at the Credit Lyonnais. The wife told the husband to bring back gold if the note was all right ('Safer in case of fire'). She was so pleased when the gold appeared that she offered him a free piece of string. 'Very good string. We wouldn't give it to everyone.'

Vollard adds that one Aixois told him, 'I see what it all is: the Parisians buy his work to make a joke of us at Aix.' He says Paul had an admirer in Aix, a woman chemist who boasted of getting advice and encouragement from him. In her spare time she lovingly painted little sheep in stables. Paul told Vollard, 'Mme S. asked me to give her lessons. I told her: Follow my example, one must above all exert oneself to develop one's personality. She's a good worker, and if she keeps on she'll make in twenty years an excellent subordinate to Rosa Bonheur. If I'd been as clever as Mme S. I'd have got into the Salon long ago.' Vollard says he wasn't making fun of Mme S., as 'he had much esteem for anyone whatever who worked sincerely to develop his or her personality'. He didn't find this sincerity in academics like Signol or Dubufe, 'but he found more honesty in Bouguereau's art. Sometimes in the access of fury against himself at some difficulty in "realizing," he went so far as to cry out, "I'd like to be Bouguereau!" and at once explained himself, "That fellow has developed his personality!"' Vollard may be exaggerating, but Paul certainly did at times envy the cleverness which he lacked and scorned. And the overwhelming wish he had all his life to get into the official Salon must have stimulated this envy. Originally, of course, he had wanted to get into the Salon to confound his Aixois denigrators and to convince his father of his genuine talent as a painter, for only such a conventional success could have

established him at Aix and impressed Louis Auguste. But his lack of 'cleverness', his inability to work in any other way than that to which he felt driven by his emotions and sensations, effectively thwarted any impulses to sell out. So the division between the craving for official success and the deeper need to stake everything on 'realization' always remained to some extent in his mind.

The way in which the falsification of Paul's outlook was being carried on by the young painters was illustrated this year, 1896, by the comments of André Mellerio in a survey of what he called Idealist Painting. Mellerio was building on the ideas of Gauguin and Bernard, and he saw Paul's work as 'a synthesis of colours and forms in their intrinsic beauty'. Where such analyses went wrong was by abstracting Cézanne's method from the aim of penetration (via colour) into natural process in its fullness, and by thus presenting it as a synthesis imposed on the material in terms of some inner concept of 'intrinsic beauty', or order. Paul's whole notion of the dialectic of mind and nature in artistic process was thus distorted at the root. The end-product was abstracted and made a thing in itself: made an *a priori* structure imposed on the artistic process from the outset. In short, Paul's work was used in advocacy of views that he utterly detested. (Mellerio speaks of Paul as someone personally unknown: 'Still living, he is spoken of as a man vanished from sight.')

In 1896 he painted *The Old Woman with the Rosary*; for Gasquet mentioned it in his essay of that year. The dating 1900–04, which has commonly been accepted, is thus quite wrong; it also upsets any effort to see the way he developed in his last decade. Later, Gasquet wrote, 'For eighteen months at the Jas de Bouffan, Cézanne plugged away at *La Vieille au Chapelet*. When the canvas was finished, he threw it into a corner. It became thick with dust, rolled on the floor, trampled unconcernedly. One day I recognized it, I found it against the stove, under the coal scuttle, receiving from the zinc pipe a slow drop of steam vapour that every five minutes dripped down on it. I don't know what miracle kept it intact. I cleaned it.' The submissive yet stubborn patience of the old woman is finely grasped by the placing of bowed head and clutching hands in relation to the raised and forward-leaning mass of the body. But, in comparison with the other figure-works from the model of the last eight years, the form lacks clarity of volume. Also he could not get the left shoulder quite right, despite repainting and raising it. Hence his casting it aside.

The old woman was evidently by now sufficiently inanimate to have made an excellent model. She lent herself to a characteristic simplicity of statement. Her vivid old head in its absurdly frilled bluish white cap is a wonderful piece of carving in paint; and so are the gnarled hands, with their weight and their tension. Below the hands, in the blue skirt stuffed with petticoats, the form again is clear and strong, the colour and light sing together as they do in Cézanne's best still-lifes. It is on the upper part of the body, though the colour is rich, that there is a certain dullness and obscurity; and after all the effort to get that contour of the bowed shoulder in the right place, its relation both to figure and to background is still disturbing. Perhaps it was just this detail which made him think the picture a failure. If you cover this top contour and the wall behind there, there is an immediate increase in concentration. Most artists would just have covered up, somehow or other. That is what Cézanne could not do. (Hendy)

This picture could not have taken eighteen months to paint, for Gasquet wrote of it in mid-1896 as Paul's latest work, and from a letter of 1902 from Cézanne to Gasquet we learn that the woman was the ex-servant of Jean Marie Demolins, a notary of Aix who was a literary associate of Gasquet. We may assume, then, that Paul came across her after his meeting with Gasquet and his friends, and that he worked on the painting after his flight from Geffroy in Paris. If we compare the clear logical systems of the portrait of Geffroy with the failure to maintain structure and its colour-relations in the *Old Woman with Rosary*, we can well imagine why he threw it away in revulsion. Moreover, the contrast of the two pictures seems to reveal the emotional change which came over after his dropping of the Geffroy portrait and his meeting with Gasquet. Feeling defeated by the struggle for extreme rationality in the Geffroy work, he takes up a theme of extreme submission, a painful acceptance of pious old age; and again he feels defeated. (Fig. 27.)

Gasquet perhaps recognized in the work an attempt on Paul's part to renounce the world of Monet-Geffroy and to sink himself in Aixois piety, for in 1896 he described the picture: '. . . an old woman, a servant, with fervour and resignation presses between her old hands the beads of a rosary. A ray descends on her humble face.' And later he unscrupulously devised a long story—The woman was a nun who lost her faith and at the age of seventy scaled the walls of her convent with a ladder. Paul found her wandering about, weak in mind and body; he employed her as a maid and used her as model. She pilfered from him, but he nobly ignored it all. On days when she was too ill to come, he dressed himself in her clothes and posed for the painting. The whole story is made up to turn Paul into the sort of character Gasquet wanted him to be; and the touch of dressing-up, which completes the idea of Paul's self-identification with the woman, is obviously false. When we consider how Paul needed his model exactly in the same position for each sitting, what use would it have been for him to masquerade as the old woman?

But there was, indeed, another sense in which Paul could identify himself emotionally with the workers and peasants of Provence, even with the stingy Aixois couple who gave Vollard the piece of string, for at heart he belonged to Louis Auguste's world. We saw that in the 1860s, when he went to Paris, the drift from the land became noticeable; from 1870 the agricultural population went on decreasing, yet the land stayed generally self-sufficient in food-grains and other products suitable for the climate. Farms were reduced to small units starved of capital and technically inefficient; only a few areas saw attempts at modern methods. Octave Mirbeau, whom Paul much admired, was an admirable depictor of the small peasant with his mean world in which property rights and values dominated everything in the most callous way; in one of the tales of *Contes de la Chaumière*, 1894, he satirized a rich upstart landowner, calling himself a socialist, who tried to introduce modern methods in a ridiculous way, sowing rice, tea and sugarcane. The story is worth a few words, since it comes from an author with whom Paul felt much sympathy and gives us the peasant view of the new landowners. Meeting a poor woman gathering wood, the landowner beats her up,

then is scared when she speaks of the police, and gives her money. 'Today it is necessary to corrupt the people—and to beat them up.' The tale-teller remarks that this sort of rich agriculturist is the product of the social convulsions they've seen. 'And through the open bay of the dining-room, which framed like a picture the pleasant flight of lawns and the clumps of tall bluish trees, I seemed to see moving in from all points of the compass the cursed processions of miserable folk, the disinherited, who came to break their limbs and smash their skulls against the château walls.' (Mirbeau began as a conservative Catholic, then came round to a sharp sense of social injustice, which led to such plays as *The Evil Shepherds* (1897), directed against exploitation of the working-class by politicians, and *Business Is Business* (1903), directed against the financiers. His ruthless depiction of the reigning brutality and corruption veiled a certain sadism, which came out openly in *The Garden of Punishments*, written in 1898.)

There was scant surplus for the market, so that the peasantry could buy little with money; but they were seen by the ruling class as a barrier against revolution. By 1880 the pattern that persisted into the twentieth century was already clear: some areas of big estates producing for the market and employing labourers—with ownership growing concentrated where a cash crop (e.g. of the vine) was involved; elsewhere the small farm, whether held by peasant-owner, tenant, or metayer, using traditional methods with only a very slow influx, if any at all, of improvements. The small farmer felt himself more and more at the mercy of the market with its expanding controls; there was differentiation among the peasantry and a break-up of old ways, but at a slow and confused pace. After 1882 came a general depression which affected agriculture through its effects on industry; and the fall in prices was especially felt by the big commercialized holdings. The small-producers were cushioned in so far as they were outside the market-systems.

In many aspects Paul was, then, typical of the peasant of his world, with a grim distrust of all changes and controls, and seeing economic progress as a system aimed at crushing him out of existence; while as a *rentier* he clung to the passive basis of investment and guaranteed returns. In the 1860s and 1870s he felt close to the radical and even revolutionary forces since they opposed the State with which the forces of the cash-nexus, the market-systems, were allied. The 1882 depression ushered in his own personal crisis of 1885–6. I do not suggest there was any simple relation between the two events; but since it was not possible for him to achieve any coherent philosophy of social change, he could not but feel in the 1880s an increasing conflict between his own position, with its ultimate roots in peasant attitudes, and that of radicals like Clemenceau. This sort of strain, hardly at all understood, helped to bring about his *volteface* with regard to Geffroy, and his acceptance of Gasquet's views. All he was consciously aware of was a continual falling-away of his accustomed world and its values, which worsened his sense of personal isolation.

More importantly for his art, this social position intensified his sense of the concrete and made him unable to follow more middle-class artists such as Monet into an increasingly

abstracted use of the impressionist method. He clung to a need for the concrete object, a need which had strengthened Dutch art and certain lines of French art where there were close relations to a semi-peasant semi-craftsman middle class (Chardin, for example). The inner forces in Paul which drove him to transforming impressionism into an art of solidity, structure and planes of inter-related depths, were intimately connected with his obstinate peasant basis. Louis Auguste had manipulated money, and Paul had reacted against this sort of activity; but for Louis Auguste money was still a clear reflection of various concrete things (the securities which he knew each of his clients possessed, their actual skills and characters). Money in that sense was still far from the abstract quality it assumed at the level of pure finance; and in Paul's struggle with Louis Auguste the most fully concrete aspects of their world triumphed. The land, the handicraft tool and the skills accompanying it, the peasant and his farm still carrying on to a considerable extent without much need of money: all these elements in one sense underlay Cézanne's obstinate struggle to penetrate and regain a concrete universe, to define objects in their fullness, in their definite separate identity and their merging relationships. His desperate love of the earth, the natal earth of his youthful enjoyment, was linked at every point with a feeling that something alien and abstract was threatening the harmonious contact, the possession through joy as opposed to the possession by money-power. That money power was for him one with all authority and power-assertion, all that robbed and cut him away from the intuitive joy-possession which he wanted to express on a higher level in art's struggle to grasp and define. Louis Auguste as the money power, the source of authority, was the enemy whom he had to resist; he had to defy him as the money power in order to enter the concrete world which he manipulated and sought to dominate. (The fact that he also respected and even loved Louis Auguste complicated things, and was in part responsible for his oscillation of emotions, his swing from a secure sense of resistance to a guilty feeling of ingratitude, a fear of the final nemesis, the final loss, death.)

In a broader way we may link Paul's particular conflict with the whole situation that had been developing since the early eighteenth century, when the rise of money and market forces, with the accompanying expropriation of peasantries, had brought about a general feeling of the loss of the land, a nostalgic turn to folklore, folk ways, folksong, which lay at the very core of the Romantic Movement. England, where the process began in a big way, originated that Movement. For us, looking back, the extirpation of the peasants was a very slow and chequered business, and in France was only partially successful in the nineteenth century; but we can see how the cultural sphere kept on registering a series of intense shocks. The sense of a lost earth was an essential element in the rise of modern landscape painting, naturally coming first to a head in England, with Turner and Constable as the supreme expressions. With the full bourgeois triumph in England the true romantic tension slackened and broke, and the vanguard expression in art passed over to France, where it had been much involved in a direct political struggle centred on history-painting and finding

its forward-driving outlet in David, Gros, Géricault and the early Delacroix. The 1830 revolution broke this movement, and the full Romantic Movement expanded, with the later Delacroix at its head. Partly through him, and partly through the Barbizon school, the role of landscape painting became ever more important; but it was after the failure of the more radical and socialist elements of the 1848 revolutions that it came right to the fore as, in many ways, the key form in which the vanguard struggle was waged. Meanwhile, elements in David, Gros and Géricault had also developed into the Realist School of Courbet, which consciously opposed the academic art favoured by the *haute bourgeoisie*. Paul responded in his early days to both trends, that of Courbet—leading through Corot into Pissarro and the impressionists—while at the same time wanting to build on Delacroix in order to express his conviction of violent inner conflict and his sensuous aspirations.

The part he played in all this development was determined in the last resort by his quest for enduring structure, for the full identity of objects, and the inter-relations expressed by colour-modulations in depth. And we can securely link this quest with the stubborn peasant world from which he came and which he never ceased to reflect. We see that in the last resort he was the only artist aware of all the aesthetic issues of his age, the only one who tried to grapple with them all. Though he failed to create the full Rubensesque world that both he and Zola hypothesized, he managed to achieve a new concreteness, a new coherence of structure and relationships which was relevant at every point to the aesthetic issues, and thus to make possible a new birth of art on the grand scale. That no one followed him along the road he had opened was no fault of his. Why that happened, and what came about instead, we shall consider later.

Meanwhile there are some further points that come from Paul's sense of a living place among the labourers and handicraftsmen of his native region, and nowhere else. First, we have the fact that his most fully-achieved figure-work from the model was that dealing with the common people he knew, especially the labourers and gardeners of the Jas or Les Lauves. In his early years he used Uncle Dominique and his friends; as his art matured he achieved fine results from an old acquaintance like Boyer or a man with whom he felt at home like Choquet; Hortense sat in her dummy-like way for paintings at many phases of his work. But it was in the period opened by *Mardi-Gras* that he achieved his great triumphs. It was carried on through the Geffroy portrait and *The Old Woman with Rosary*, and then reached its climax in his paintings of workers. In the peasant-labourers of the *Cardplayers*, above all, he made his most powerful and subtle renderings of people. This was no accident. He could enter into these men—into their bodies and their habitual gestures, their way of standing and sitting, and so, ultimately, into their minds—as into nobody else. In one sense they were worlds apart from the lonely tormented painter; in another sense they inhabited the world in which he felt at home and at peace. They made no demands on him; they were simply and squarely themselves; they represented an essential part of him, symbols of the earth-rootedness that he struggled to achieve on a higher level. Through them he regained

his humanity. Borély quotes him as saying, 'I love above everything people who have grown old without doing violence to customs [*usages*], who've let themselves go along with the laws of time. Look at that old café-owner, what style! Look at that shopgirl, certainly she's pretty [*gentille*]. But in her hairstyle, in her clothes, what a banal lie!'

Secondly, his feeling for concrete things, linked with the handicraft world of the men who made those things, found its peculiarly complete expression in his still lifes. The feeling pervaded all his work; but here, because he was dealing with small familiar objects of daily use or consumption—above all, the fruits of the earth and common domestic objects, things that might have been factory-made but were in any event the kind of things still close to handicraft—he was able to concentrate all his energies on defining them with sensuous fullness. Because of the Hugoesque pantheism and the Baudelairean sense of correspondences which had entered deep into his sensibility, he was able to feel in his fruits, vegetables, bottles, vases and dishes a complex set of associations and symbolic significances. On the one hand there were the immediate aspects of form, of curvilinear volumes, which enabled him to get the same sort of satisfaction out of these objects as he did out of human figures, especially nudes. We saw that the apple above all had a deep meaning as the love-prize, the love-object, the surrogate of breasts and bottoms. In some of the later still lifes the little domestic cluster of things suggests the larger correlatives of mountains and valleys broken with the constructions of man, for example *Still Life with Teapot*, and *Apples and Oranges*. In the latter work, white and coloured cloths are drapes, and there is a plate, fruit-stand and jug besides the fruit. (*See* Plate III.)

The *compotier* grows out of the beautiful white cloth, and the decorated jug seems a fusion of that cloth with the apples and oranges and the ornamented drape behind it. The effect is dense, even crowded, like his landscapes with woods and rocks, and is enormously rich in unexpected shapes and chords of colour, almost to the point of engorgement . . . More than most of Cézanne's still lifes, it impresses us as orchestrated work, because of the wealth of distinct, articulated groups of elements carried across the entire field of the canvas. The white cloth is magnificent in its curving lines, its multiplicity of contrasted directions, its great rise and fall, and in the spectrum delicately toning its brilliant white surface. Against this complication of whiteness and the subdued chords of the mottled drapes (warmer and more angular in ornament at the left, cooler and with curved ornament at the right) play the rich pure notes of the fruit. These are grouped simply, in varying rhythms, and are so disposed as to form together a still life on a horizontal axis—a secret stabilizer among the many sloping shapes. A delightful metaphoric fancy is the decoration of the jug with red and yellow flowers like the nearby fruit; it is a bridge between the fruit and the ornamented drapes, of which the patterns, broken by the folds, are a rich flicker of less intense, contrasting tones. (Schapiro)

I cite this description by a sensitive critic to bring out the way in which any deep response inevitably brings up the sort of feeling felt before a highly complex and rich landscape. Indeed, the writer goes on to mention on the upper left 'a tall peaked fold' as if it were a mountain-top. And to drive home my point I may quote yet another critic, who remarks of the *Teapot :* 'The drapery sits across the wall almost exactly as the mountain does against the

sky in Cézanne's late landscapes. In the Jeu de Paume picture [*Apples and Oranges*] with its exuberant diagonals, drapery fills almost the whole background, except in the top right corner, where we get a glimpse of wall, and there, outlined against it, is the familiar shape of Sainte Victoire. . . . In these still lifes, painted in the studio, from nature, he is also painting his memories of landscape. He is projecting on to his intimate little indoors motif something of the vastness of the world outside' (Sylvester). But we must remember that this point cuts both ways; the still lifes helped him in turn to create the sensuous continuum of space in vast scenes, the ceaseless modulation of colour-planes making up his universe. Figure compositions, still lifes, landscapes, all have an ultimate intricately involved unity.

In a sense a still life of this sort involves a double set of activities, the decorative and suggestive arrangement of the material, then the re-creation of the objects in the imaginative unity of the painting. Le Bail describes Paul preparing a still life in 1898. 'No sooner was the cloth draped on the table with innate taste than Cézanne set out the peaches in such a way as to make the complementary colours vibrate, greys next to reds, yellows to blues, leaning, tilting, balancing the fruit at the angles he wanted, sometimes pushing a one-sou or two-sous piece under them. You could see from the care he took how much it delighted his eye.'

Paul could accept his still-life arrangement because it did not involve any distortion of objects, any sort of abstraction; it was still nature he was painting, but nature brought in a double way nearer to revealing the formative processes he sought to define. Likewise the artist entered in a double way into his material. So the pattern on the jug, reflecting or echoing in yet another way the natural forms, provides a sort of pun, expressing the manifold ways in which man enters into nature, and linking the natural and the man-made objects.

He was fascinated by still lifes not only for these reasons, but also because he was able to express in them a feeling of the harmony and happiness of the personal relations implicated in the home, which he so sadly lacked. Still lifes had been inevitably an important aspect of Dutch art in its great period, because of the persisting handicraft basis and the strong stable domestic life of the bourgeois at that time; Chardin expressed the same elements as they carried on in the French middle class of the eighteenth century. Paul carried on this tradition with a personal intensity that made his still lifes the most outstanding of all. In all this we see a survival of the original nature of the still life, though without the religious connexions; for the still life arose as an art form in Hellenistic and Roman times as an expression of piety towards the gods of hearth, home and storeroom. Still lifes were in a sense permanent dedications to those gods, votives expressing the peace-and-plenty which the householder desired and which those gods could provide. Cézanne's peculiar intensity in developing his still lifes brings his paintings back even closer to the originating impulses than the Dutch or Chardin ever got; his desperate desire for a happy and prospering home becomes in art the deeply-felt expression of a secure and abundant life.

In these last years Paul made much use of watercolour. This turn to the lighter and freer medium both expressed his mastery in handling and increased that mastery, reacting back on his oils.

Their decorative effect is, so to say, a by-product. Their intention is to record for his own satisfaction the nodal points in a composition, and by nodal points I mean those places where the junction of the planes is of the greatest importance. The direction of these planes he represents by touches of pure colour, pale blue, pink, sienna, and green, and his knowledge of their effect on one another is so sure that a very few of such transparent touches are sufficient to create an effect of great solidity. It is in his drawings and watercolours that one recognizes most clearly Cézanne's faculty of seeing both in depth and pattern at the same time. Sometimes the point he selects for notation is a piece of the background, sometimes an internal plane, yet all are related in space and subservient to a design. Out of a very complex subject he is able to select a few beautiful shapes and set them down with such certainty that we are not conscious of the white paper in between them, but only of their harmonious relation to each other. (Kenneth Clark)

We see that what obsessed him was not the analysis of planes as such, but that of planes in relationship, which meant planes in movement, in their changes from one to another. The direction of the plane is all important; and thus it is that in his vision the shadowpath defines both depth and pattern. In so doing it defines depth in a new way, by means of colour conceived as the inter-movement, fusion, separation and direction of planes. Pattern and depth are inseparable from a fullness of volume and plasticity, and these latter aspects are never seen in a static way. The plasticity of any single object is only one factor in the total plasticity of space. We can indeed speak of a 'plastic dynamism'. (Gleizes)

We may note in passing that the attempts to find some mystical value of nature-without-man in the landscapes are misdirected. The reason why figures are left out is that Paul's method, with its need of the model, could not introduce figures in a way that would have satisfied him. His continuing efforts to paint portraits and genre-pieces like the *Cardplayers*, and to carry on with the *Bathers* despite his lack of the full facilities that his art required, is proof enough that he deeply wanted to deal with people. The effort he made to show peasants at work in a landscape, *The Harvest*, may have pleased Van Gogh, but it certainly would not have given him any satisfaction.

III *The Matured Artist (1897-9)*

O N 13 January 1897 Paul wrote to Guillemet about his bout of influenza, which made him refuse an invitation. On the 30th he wrote to Solari saying he had missed a previous letter. He had been in bed since the last day of 1896. 'Paul arranged my removal from Montmartre. I've not yet been out, though I'm much better.' Gasquet seems to have suggested the gift of two pictures to his old professor at Aix, G. Dumesnil; Paul now asked Solari to take Gasquet to Marie and get her to let them into the Jas, so that the paintings might be collected. 'Apart from a slight *marasme* inherent in the situation, things don't get worse; but if I'd known how to organize my life for living down there, it would have suited me better. But a family forces one to a lot of concessions.' The same day he wrote to Gasquet, asking him to take charge of all the necessary 'circumlocutions'. 'I'd be very happy if the philosophy Professor of the Faculty of Aix deigns to accept my homage. As an argument of my value I can point out that in my land I am more a friend of art than a producer of painting, and that from another angle it would be an honour for me to know that two of my studies were accepted in a good place, etc.' He thanked Gasquet for the honour paid him. 'And long live Provençe!' This was the man who cursed all savants and art professors, and damned Geffroy for aid in a far more important sphere. The canvases that went to Dumesnil have not been identified.

If we were right in seeing in the *Old Woman with Rosary* a phase of depression following the flight from the Paris of Geffroy, Paul seems to have overcome that emotion in *Italian Girl Leaning on Her Elbow*, probably painted at his Montmartre studio about this time. She was said to be the daughter of an Italian who posed for him in 1893 (in a picture not now discoverable), and a close relation of the boy, Michelangelo Di Rosa, in a red waistcoat, of whom Paul made four portraits (his notebooks mention several Italian models). Here the bent figure fills its space nobly, and her head of reverie lacks the old woman's despair. The grave colour has its sombre as well as its rich elements, but there is no failure in definition of form. (Fig. 66.)

This spring the Caillebotte Room in the Luxembourg was opened, amid more howls, threats of resignation from Gérôme and others, and speeches in the Senate. For twelve more years Caillebotte's brother tried to get the whole collection in, but failed. Thiébault-Sisson noted that the spiteful would describe the protests as made by 'tradesmen exasperated by the progress of a rival business'. Paul was now at last hung in a Museum. He seems to have stayed in Paris till April, then to have spent a month at Marlotte and afterwards at Mennecy in the forest of Fontainebleau. From the Hôtel de la Belle Etoile, Mennecy, he

wrote to Emile Solari on May 24th saying he would leave for Paris on the 29th. He wanted Emile to call on him at 73 Rue St Lazare during his couple of days' stay at Paris before going on to Aix.

Back in the south, he rented an old stone farmhouse at Le Tholonet and worked there for the summer, seeing only Gasquet and Philippe Solari. On July 18th he wrote to Gasquet, excusing himself from an invitation as being 'at the end of his forces'. He added, 'I must be more sensible and realize that at my age [58] illusions are hardly permitted and they will always destroy me'. Near the end of August he invited Solari to lunch on Sunday at the restaurant Berne at Le Tholonet. 'You'll find me about 8 a.m. in the quarry where you made a study the last visit but one.' On September 2nd he wrote to Emile Solari about a review with some of the young man's poems in it, which he expected, and asked for 'an account of the festivities at Orange'. 'It's indeed very kindly of you amid your Parisian occupations and preoccupations to recall the few hours, too brief, that you spent in Provence; it's true the great magician, I mean the sun, was of the party. But your youth, your hopes, must have contributed not at all slightly to making you see our land in a favourable light.' He adds, 'Last Sunday your father came to spend the day with me. The unfortunate man, I saturated him with my theories on painting. He must have a good constitution to have withstood it.' On the 8th he wrote about getting the review, and mentioned that Philippe was coming 'to eat a duck with me next Sunday. It will be served with olives. A pity you can't be with us.'

On September 26th he again refused an invitation from Gasquet. 'I sup at my mother's, and the state of lassitude in which I find myself at the day's end doesn't permit me to present myself in a proper aspect before others. You must then excuse me. Art is a harmony parallel with nature: what do those imbeciles think who tell you that the artist is always inferior to nature?' The Gasquets were living in the Rue des Arts-et-Metiers; and it is possible that already Paul was feeling out of place in their world of display, as he certainly did later on. He was still unpopular in Aix. The successes he had had seem to have stirred rather than appeased rancour; he is said to have heard one day in the street, 'Such painters ought to be put up against a wall and shot.'

On October 25th his mother died at the Jas, aged 82. She had been growing very weak and querulous, but Paul always treated her with complete patience and gentleness. Gasquet says, 'He went driving with her, took her to the Jas to sit in the warm sunshine. He carried her, light and frail as a child, from the carriage to her chair in his own strong arms. He told her countless stories to amuse her.' Her death was a great blow to him, all the more because it involved him in property problems. Something had to be done about the Jas de Bouffan, to which he was deeply attached but which he was incapable of running on his own, even if his rather miserly attitude to money could have brought him to buy out his sisters' shares (each of the children inherited a third). As the house finally brought in only about the sum originally paid for it, he could easily have bought it. It was sold in 1899 to a M. Granel.

On November 2nd he wrote from it to Emile Solari to congratulate him on his forth-coming marriage and exhorted him to have courage in the struggle to get his plays on the stage. He mentioned the death of his 'poor mother', and added, 'It's some days since I had the pleasure of seeing your father who's promised to come to the Jas'. He seems to be drawing away from the Gasquets and relying more on his boyhood friend.

Meanwhile in Paris Zola was making his first protests in *Le Figaro* against the wrongful condemnation of the Jew Captain Dreyfus to Devil's Island. Monet and Pissarro, who could not but have been rather hurt by his recent comments on art, at once rallied to his side and sent him the strongest congratulations. The only members of the vanguard school who did not support him were the anti-semite Degas and the contrarious Renoir (who perhaps felt the 1866 art essay rankling)—and Paul, sunk in clerical backwaters, crushed by his mother's death, and thus even more dependent on Mother Church and his Louis Auguste God.

On 8 January 1899 Emperaire died, nearly seventy, without ever having seen the least spark of success. Till the last he did trapeze-exercises in the hope of making himself taller. Two or three of his pictures hung in a cheap eating-house in the Passage Asgard, and Paul went there now and then, just to have a look at them.

In the March-April issue of *Mois Dorés* Gasquet wrote again of Paul in a notice of a work on Provence by the local historian, Charles de Ribbe. Once again he poured out verbose platitudes about Provence and rustic virtues. 'The tormented or pensive attitudes of the rocks, the red blood that he makes flow in tumult under the lacerated earth, the gravity of the horizons, the flame of the sea, the reveries of water, the chastity of lines that entwine in his pictures with an austere tenderness . . .' One would think from his account that Paul was a Provençal Millet occupied with the life of the 'robust peasant, with a hue fed by the sun, with powerful shoulders, with hands made heavy by the holiest labours'. Paul, however, liked it and thought it far better than the intelligent comments of Geffroy; he now had ingrained in his mind that Geffroy represented the vile intrusive modern world and Gasquet the sacred ancient Provençal earth.

After having read the superb lines in which you exalt Provençal blood, I cannot resolve to keep silent, just as if I found myself in the presence of an unfortunate wretch like the vulgar Geffroy. There is only one thing to say, that the achieved work is unequal to the praise you give it. But you are in the habit of so doing and you see across such a prism that in thanking you every word becomes pale. Would you be kind enough to tell Paul what day I could see you again.

Gasquet had been in Paris, and Paul had done nothing about seeing him. But the rhapsodic verbiage of *Mois Dorés* restored his enthusiasm, and now, with contact re-established, they often met, especially visiting the Louvre together: Gasquet records their visits in imaginary dithyrambic conversations. No doubt Paul, who had been full of talk about art to Solari, did try to expound his views on these occasions; but Gasquet was incapable of grasping at all precisely what he was after. In May-June Vollard held another Cézanne show, but Paul

was not there. Though incapable now of directly resisting Vollard, he felt uneasy before his business acumen and the devotion he gave to an artist who was an important source of cash. 'He's up to something, something criminal.' He kept clearing from his studio the works he considered insufficiently realized, and burning them. So much the less for Vollard to grab and speculate on. When the Berlin National Gallery did buy two works, he remarked, 'Well, that won't make them accept me for the Salon'. He still, as indeed till the end, cherished the hope of getting into the Salon, with a medal or the ribbon of the Legion of Honour as a supreme glory. At Aix someone had stated publicly, 'Do you like Cézanne? I hate him, and I am speaking for posterity.' Henri Modeste Pontier had succeeded Gibert at the Museum in 1892, and had sworn that while he lived no canvas by Paul was going to hang near his own great work of sculpture (shown in 1877 at the Salon): *Ixion Tortured for Having Loved Juno*. Dying in 1926, he kept his word.

The young Paul was now the centre of his father's affections. The elder Paul admired his son's commonsense without fearing him. 'The boy is more competent than I am; I have no practical sense.' However he knew that the lad had no sense of art, but was a good business-intermediary, someone with whom to ward off the Vollards. The son in turn had now realized that there was money in his father's art, and worked with Vollard in the quest for buyers. Paul offered him 10 per cent commission and hoped that thanks to his pair of salesmen he would someday earn 6,000 francs a year with his brush—though as the son pointed out, he ought to paint more female nudes, as they were 'much more easily sold'.

Meanwhile the Dreyfus case was dividing the country. On 13 January 1898 Zola published an open letter to the president of the republic in *L'Aurore*, to which Clemenceau gave the title of *I Accuse*. In March his novel *Paris* appeared; but he had already been sent for trial and put under sentence. When he lost his case at the retrial in July, he slipped away to England. His expenses had been heavy and as the champion of an unpopular cause he had found his book-sales decline heavily. He steadily refused to make any profit out of his part in the struggle. Paul cut out Forain's anti-Dreyfusard cartoons from newspapers, merely saying, 'How beautifully drawn it all is'. And on Zola he is known only to have made one comment, mean and philistine, but not vicious, 'He has had his legs pulled'—or 'He's been sold a pup' [*On lui a monté un bateau*].

In the summer Paul went to Montgeroult, not far from Pontoise. A young painter, Louis Le Bail, living at Marines, heard from Pissarro of Paul's presence. He called on him several times and Paul felt flattered by his admiration. They painted together and Paul was often in an expansive mood, saying it did him good and answering Le Bail's questions. The key lay, he said, not in theories but in practice. 'We'll go and put our absurd theories into practice', he'd say. When asked what pictures he liked best, he replied that he'd prefer his own above all others if he could only realize in them what he sought. But he was easily upset. One day a young girl stopped and watched the two men at work. Pointing at Le Bail's canvas she said it was the better one. Paul was very disturbed—perhaps in part

because of the nearness of a girl; and next day he tried to avoid Le Bail. But after a while he grew warmer again and tried to explain, 'You should be sorry for me'—adding, 'Out of the mouths of babes and sucklings . . .' Then one day when they were at work, he was accosted by two men on horseback, who wanted to talk with him. He growled at them and they went off. Le Bail told him that the riders were Baron Denys Cochin, a collector who owned several Cézannes, and his son. Paul was in dismay and wrote later to Le Bail asking his help to put the matter right.

Then at Marines he fell foul of Le Bail himself. He had asked him to call daily at his room at 3 o'clock after he had had his nap. Le Bail took him at his word, knocked several times, and then entered the room. Paul was in a rage and must have been too confused at the time to express himself; for he wrote to Le Bail, 'Sir, the rather discourteous manner in which you took the liberty of entering my room is not calculated to please me. In the future please see you're announced. Please give the glass and the canvas left in your studio to the person who comes for them.' Perhaps Le Bail had touched Paul in order to wake him.

Paul does not seem to have seen Pissarro despite their nearness. This is the only period when, on account of Paul's attitude to Dreyfus, Pissarro felt a coolness between them.

On December 23rd Paul, back in Paris, wrote to Gasquet's father, thanking him for the 'good remembrance' he has sent. 'It's the evocation for me of more than forty past years. May I say that a providence has made me know you? If I were younger, I'd say that it's for me a point of *appui* and of strength.' He thanked him also for his son, whom he expected to see again soon on his return to Aix. He expressed full solidarity for the 'movement of art' being developed by Joachim and his friends. 'You have no idea how life-giving it is to find around one a youth that agrees not to bury one on the spot.' He asked to be remembered to Henri's mother, 'who, in the house, is the mother of the wisdom you represent. I know she wishes indeed to recall that Rue Suffren which was my cradle. It's impossible for emotion not to come on us in thinking of that time now flowed away, that atmosphere that has been breathed without one doubting it, and which is beyond doubt the cause of the existing spiritual state in which we find ourselves.' In these obscure phrases he is paying a tribute to his early days and to the elements that then nourished him and made him what he is. The stress on the mother is noteworthy.

In February 1899 he was still in Paris. On the 25th he wrote to Emile asking him to come on a Sunday afternoon visit. 'Two sittings a day of my models and I'm totally exhausted.' On May 16th he wrote to little Marthe Conil, his niece, who had invited him to her first communion at Marseille; he said he was tied to Paris by a lengthy piece of work (? the Vollard portrait), but hoped to come south in March. 'I ask you to pray for me, for once age has overtaken us, we find *appui* and consolation only in religion.' (Rose had two other girls, Paulette and Cécile.) However he didn't leave in March, for on May 31st he was still in Paris, writing to E. P. Fabbri, an Italian collector who already had 16 of his works and who had declared (May 28th), 'I understand their aristocratic and austere beauty; for

me they represent what is noblest in modern art'. He wanted to meet Paul, and Paul replied, 'I find myself unable to resist the so flattering wish you express to know me. The fear of appearing inferior to what is expected of someone presumed to live at the height of every situation is doubtless the excuse for needing to live in seclusion.'

Vollard had asked Paul to paint his portrait. The first sitting involved a calamity. The dais in the studio of the Rue Hégésippe-Moreau was made up of a chair set on a packing-case supported on four rickety legs. 'No danger of falling as long as you keep your balance; anyway a sitter mustn't move.' Vollard fell asleep through Paul's insistence on his remaining still; he swayed and crashed with the dais on to the floor. Paul was furious, 'Wretch, you've ruined the pose. I tell you, you must sit like an apple. Does an apple move?' After that, Vollard drank a cup of black coffee before posing. Even then he nodded now and then, but a look from Paul recalled him to his senses. He sat from 8 to 11.30; in the afternoons Paul still copied at the Louvre or Trocadéro, then went early to bed, but got up during the night to study the sky, concerned for a clear grey light next morning. Vollard says he worked with very flexible brushes of sable or polecat, which he washed after each stroke in a cup of turpentine. 'No matter how many brushes he started with, he used them all up in a sitting' and smeared himself all over. He was easily upset and put off his work—by movements, chatter, change of light or weather, sounds of hammering, the rattle of a nearby elevator which he called the pile-driver factory. Most of all he hated barking. He could not bear being watched and disliked the least change or tidying-up of the room. When a nondescript bit of dirty carpet was once taken out to be beaten, he was so enraged that he hacked a canvas to pieces and couldn't work for the rest of the day. 'When I'm working I need to be left in peace!' He was put off, too, if he was dissatisfied with his studies at the Louvre on the previous afternoon. When the portrait was well advanced, he said he wasn't pleased with the front of the shirt, and after 150 sittings he went back to Aix, asking Vollard to leave the clothes he had worn. They were soon eaten up by rats.

Paul had a special phobia about dogs. Vollard cites him as saying joyously: 'This Lépine [Prefect of Police] is a *brave homme!* He has given orders for the arrest of all dogs; it's in *La Croix*.' For some days there were no barks. Paul said once again, 'This Lépine is a *brave homme*', when a series of barks were heard; he dropped his palette and cried in despair, 'The bugger, he's escaped'. J. Royère says that he once went to the studio with young Paul. Cézanne 'seemed in a violent temper. "There's been a dog barking over there for the last hour", he cried as we came in. "I've had to stop work." ' The barking dog represented for him the viciously carping critic: so he said to explain the introduction of a dog in his *Apotheosis of Delacroix*. But it certainly also had a sexual significance. He brought a dog into the early fantasy based on the *Lunch on the Grass*, and put one again into his *The Struggle of Love*. Also, Zola noted him saying that the artist led a dog's life.

His works came up at sales this year. In April, at Monet's suggestion, a sale was held for the benefit of Sisley's children (Sisley had died in dire poverty on January 29th); a Cézanne

went for 2,300 francs. In May the Doria collection was sold, and Paul's *Snow melting in the Forest of Fontainebleau* brought in 6,750 francs. Onlookers shouted that it was a put-up job. A stout bearded man rose, 'I am the buyer and my name is Claude Monet'. In July Monet tried to raise a subscription for buying Manet's *Olympia* and presenting it to the State as a gift from the artist's widow. Although Paul was especially linked with this work through having painted versions of it, he does not seem to have been approached, nor does his name appear in the list of subscribers. His old friends still admired his work, as was shown by Monet's act at the Doria sale; but they clearly looked on him as hostile to their group and its outlook. Incidentally, Zola refused to subscribe on the grounds that the Manet should and would go to the Louvre, but through its own inner power; he disliked the 'roundabout form of a gift that will smack all the same of the coterie and of log-rolling'. He had now returned to France and was at Médan.

This year, while Paul was in Paris, Gasquet had his interview with Zola, together with M. Le Blond. He and Paul walked in the Louvre, then joined Le Blond for lunch. Gasquet and Le Blond did their best to persuade Paul into accompanying them, Paul kept on putting them off; and after lunch they tried to take hold of his arms and draw him along. He gave such piercing screams they had to let him go. Their grasp must have revived all his fear of *grappins*, and the thought of being forced to confront Zola must have further terrified him.

The Choquet collection was also sold this year, in July, by the widow; and seven Cézannes were sold for 17,600 francs. Paul wanted the Delacroix *Flowers*; so Vollard agreed to buy and give it in exchange for something of his. He looked up Delacroix's will and found the work described as of flowers placed at random against a grey background. 'Wretch', cried Paul, 'do you dare to tell me that Delacroix painted at random!' Vollard tried to calm him down. 'What do you expect?' Paul retorted, 'I love Delacroix.' Late in the year he agreed to send three works to the Salon des Indépendants. Vollard was grabbing all the Cézannes he could find. Late this year he wrote to Gauguin in Tahiti. 'I've bought the whole studio of Cézanne [at Fontainebleau]; I've made out of it already three or four shows; it starts to take with the public.'

On May 7th in the *Mémorial d'Aix* Gasquet had published an essay attacking F. Sarcy's statement that Aix was 'a dead town'. He declared that no city was so apt to 'develop the love of study, the cult of science, the passion of letters, the taste of meditation'. He cited, as examples of its products, Peiresc, Du Vair, Malherbe, Vauvenargues, Mirbeau, Mignet, Thiers, de Laprade, Mistral; but he ignored Zola and Paul. Yet, to refute Sarcy, he needed living examples, not men of the past. Zola he ignored because he was flatly opposed to his whole outlook, and especially to his courageous work on behalf of Dreyfus. In ignoring Paul he had no such political excuse; he had written strongly about him in *Mois Dorés*. But we touch here the opportunist element in the man. He was ready to gush about Paul in a coterie-monthly read only by a few intellectuals; he was not going to compromise himself by speaking up in his defence before a broad public. Paul read the effusion; for on June 3rd he wrote

from Paris to Henri Gasquet about the 'splendid article' which had stirred all the deep memories of youth he loved to talk about. 'In us has not ever slept the vibration of sensations reverberating from that good sun of Provençe, of our old memories of youth, of those horizons, of those landscapes, those unprecedented lines that leave in us such profound impressions.' But it was noteworthy that he wrote to Henri, not to Joachim, and what he stressed was the way in which his youthful memories were stirred. So suspicious a character could not but have noted the omission of any reference to himself, in the very place where it would have been apt, if Gasquet was indeed sincere in his admiration; and it is from this time that we see his resistances to Gasquet's somewhat bossy way of patronizing him, under the guise of homage, gathering in strength.

He had come to Aix in the autumn, we noticed. He had to face the problem of evacuating the Jas, with which his life was so closely entwined. In removing his things, he seems to have burned a large part of his studies. Various things he had been hoarding 'like relics' also went into a bonfire; but Marie seems to have been the destroyer here and proceeded to get rid of the past without consulting her brother. 'They didn't dare to sell them. They were poor things, dust-traps, so they burned them. The armchair in which Papa used to take a nap. The table at which he had done his accounts since he was a young man. They have burned all that remained to me of him.' He tried to buy the Château Noir (a farmhouse at Le Tholonet), but failed. So he turned to 23 Rue Boulegin at Aix, a handsome house in the street where Louis Auguste had once had his bank. He was on the second floor with a studio in the attic, facing north. Marie found him a housekeeper, Mme Brémond, some forty years of age, 'rather stout and good-natured in appearance' (Bernard); a good cook, she watched his diet, cleaned paint from his clothes, burned the thrown-out canvases. But, as Larguier remarks, 'The dining-room stove was not fed exclusively with broken stretchers and torn canvases'. The rooms were modest and meagre, with dull old wallpaper. Marie was living in the pious aristocratic quarter of Aix, near the church St Jean de Malte. Paul himself was now sixty and nearly decrepit. Gasquet says he would have liked 'to be a monk like Fra Angelico, so that his life might be ordered once and for all, and, freed from all cares and anxieties, he might paint from dawn to dusk, meditating in his cell, never to be interrupted in his meditations and distracted from his effort'. He forgets to add that he quite lacked the gift of submission and that orders coming from above would have maddened him.

He rose early to go to early mass. 'Mass and a douche are what keep me going.' Then he went to the studio, drew from plaster casts for an hour and then moved to the easel, breaking off to read his favourites: Apuleius, Virgil, Stendhal, Baudelaire. After lunch he often went to paint near the Château Noir, using a cabman with 'an ancient closed carriage upholstered in faded red velvet, drawn slowly by a pair of old and gentle white horses' (Larguier). At the steep places he got out and often forgot to get back into the four-wheeled carriage, plodding along and talking to the driver. 'The world doesn't understand me and I don't understand the world, that's why I've withdrawn from it.' Or suddenly, 'Look at those

blues, the blues under the pines'. He once gave the driver a canvas. 'The man seemed quite pleased. He said, "Thank you." But he left the canvas behind' (Gasquet).

Before he went to his apartment, while changes were being made there, he stayed with the Gasquets, and his disillusionment increased. We are told that Joachim lacked delicacy in his treatment of Paul, who felt himself 'exploited'. This feeling has usually been attributed to his dislike of Gasquet appropriating his work; he now had the *Ste Victoire*, *The Old Woman with Rosary*, and probably several other paintings. But more likely the emotion was of a subtler kind; he disliked the appropriation of his personality which he felt Gasquet had made—Paul as one more property in an ambitiously staged career.

Vollard noted that while working on his portrait Paul also had a large *Baigneuses* on the stocks. The latter's deep-rooted desire to paint female nudes did not decrease with the years. But even if he had had the physical stamina to deal as he wanted to with a very large canvas, he lacked the models which his method required. At the same time he was suffering from his touch-phobia and a worsening fear of any close contact with women, even of the simplest kind. He felt safest, even if uncomfortable, with old women. One day he told Vollard in 1899 that he'd hire a model. 'What, M. Cézanne, a naked woman!' 'O, I'll engage only a very old hag.' Vollard says he found the hag, used her for a nude study, and then made two portraits of her in clothes, 'which reminded one of these poor old women dependants met in Balzac's tales.' Paul declared according to Bernard:

As you know, I've often made sketches of male and female bathers which I'd have liked to execute on a large scale and from nature; the lack of models has forced me to limit myself to haphazard glances. There were obstacles in my way; for example, how to find the proper setting for my picture, a setting which wouldn't differ much from the one I visualized in my mind; how to gather the necessary number of people; how to find men and women willing to undress and stay unmoving in the positions I determined. More, there was the difficulty of carrying about a large canvas, and the thousand difficulties of favourable or unfavourable weather, of a suitable spot in which to place oneself, of the supplies needed for the execution of a work of considerable dimensions. So I was forced to abandon my project of doing over Poussin entirely from nature, and not made up piece-meal from notes, drawings, and fragments of studies; in short, of painting a living Poussin in the open air, with colour and light, instead of one of those works created in a studio, where everything has the brown colouring of feeble daylight without reflections from the sky.

No doubt (apart from the Poussin programme) Paul did talk like that; but if he had been determined, at least after 1886 when he was well off, he could have overcome the difficulties which further included Aixois prudishness. The fact that he gave up the ghost in this matter and did not try even to do small works based on a model in the open, shows that his fear of people, his extreme fear of naked women, was the decisive factor. Bernard tells us a tale of what happened a few years later, which brings out Paul's perturbed state in the presence of strange women. One day the gardener chanced to meet him near the studio and presented to him his two daughters, who were with him. Paul tried to slip away and take refuge in the house, but found to his horror that he had forgotten or mislaid the key. Trembling, he bade the man break the door down with an axe; and once he was safely

inside, he bolted himself in and stayed there for the rest of the day. Conil tells how he once employed a model for his studio in Paris. She, an experienced professional, began to undress without any self-consciousness. With each removed garment, Paul grew more uneasy. At last, naked, she sat by him and said, 'Monsieur, you seem upset.' That only made him worse. He tried to pull himself together and paint, but failed; dropping his brushes, he hurried the woman into her clothes and packed her off with instructions not to return. Gasquet says that Paul now declared he had passed the age for 'denuding a woman to paint her'. Women were calculators, who would put the *grappin* on him. Also, what a scandal in Aix if he shut himself up in his studio with a model. One day he said to d'Arbaud, 'Look here, you see women, bring me some photographs.' As he didn't explain what he meant, he confused the unfortunate fellow badly. He wanted to study the nude, but sheered off in fear from carrying out his wish. He had proposed to work with Le Bail in his Paris studio, where they could have female models; but nothing came of it. At Aix, besides old studies he had *The Nude in the Louvre* (1891), a collection of photos of paintings and sculptures, to look at.

However, if he felt properly protected by the family, he could enjoy the companionship of young girls. His niece records: 'In 1902 or 1903 his nieces have a great wish to see the 14th-July parade in the Cours Mirabeau. But in 1900 young girls do not go alone to attend a military review. So Uncle Paul is asked if he would be ready to act as a guide for four young girls: this year they're between 13 and 18 years old, and are, *ma foi*, very charming. Cézanne accepts, they walk proudly, two on each side of the master. During the march-past of the troops, he halts and says, "What a pretty frame you make for the old picture I am." '

It is perhaps of interest, both in connexion with Paul's views on the clergy and with his sex-life, to glance at *L'Abbé Jules* by his favourite author at the time, Octave Mirbeau. The abbé is shown as a mass of violent contradictions, wily, unscrupulous, ambitious, ruthless, self-torturing: the sort of person into whom Paul could read a great deal of himself, at least in his frustrated, anguished, bitter aspects. At the end Jules fools his bourgeois relations in his will, leaving his property to the first priest who defrocks himself after the hour of his death; and when a trunk, which he has zealously kept secret, is burned at his instructions, it bursts open and sends fluttering out in the wind of the flames a vast mass of pornographic engravings, drawings etc. The assumption is that in the periods when he locked himself in with his trunk he indulged in orgies of masturbation. That such work should fascinate Paul in these years is not without significance. Mirbeau was not a prolific writer, and the *Contes* and *L'Abbé Jules* must have been the works on which Paul built his enthusiasm for him. (Mirbeau's judgment of Paul, characteristic in phrase, is not without truth: 'It is easy to follow the dogmas of an art; the cruel joy of those who have nature for master is to know that they'll never attain her. Those who have transformed Cézanne's classicism into a school-wisdom have not divined that the incomparable joy that he found in painting, in painting all his life, was singularly close to the punishment of Tantalus.')

This reference to *L'Abbé Jules* reminds us that Paul was very literary-minded. His comments on 'literature' to Bernard in 1904 must not be got out of focus; he is protesting in all possible ways against the undue imposition of theory or of extraneous ideas on the processes of painting. But his whole practice, and his lifelong admiration of Delacroix, Rubens, and the Venetians, prove that his arguments against Bernard have no relevance to the question of an artist being influenced in his themes by the poetic, literary, and general cultural tradition to which he belongs. Because academic art was feebly illustrative, the serious artist was not forbidden to draw inspiration from any sphere of culture or life. In a period of vitally advancing culture all the forms of expression influence one another, and the artist draws on the poetic and mythological storehouse of his age without any sense of incongruity or of being false to the full demands of his own idiom; nor is he afraid of the social contexts of his art. Out of his links with other spheres he strengthens and extends the expressive range and spiritual depth of his art; and there is no opposition between art and literature. That arrives only when a culture is weakening, breaking up, drying out. Paul with his love of Wagner and Baudelaire belonged to the synthesizing school, a position in no way contrary to his need to resist any form of external demand from a society of deepening alienation. L. Werth, writing on Paul in 1914, put the matter simply but soundly: 'It's understood that art does not have for goal the expression of ideas. But it is certain that Rembrandt and Corot were not pure decorators. And not only did they tell about the persons they painted, they also told about themselves. Painting must not be literary: it's a very fine formula. But I fear that it means nothing. It must not be literary. But literature none the less, and all that, it's a matter of the aesthetic.' The sin of academiasm was not its illustrative nature, but its feebleness, its lack of any vital relation to natural process. In his arguments with Bernard, and in his suspicion of painters like Gauguin, what Paul was denouncing was any form of *abstraction*, whether it came from a premature imposition of motives and ideas on the artist's material, or from an intellectual or schematic concentration on one aspect of artistic process to the exclusion of the fullness of the phenomenon under consideration. Cézanne would personally have included Cubism, Expressionism, and so on, under the heading of literary art in the bad sense, because they abstracted one aspect of the art process, or overstressed one possible attitude of the artist.

Apart from the way in which he had been soaked in the poetry of Hugo, Musset and others in his youth, he continued all his life his enthusiasm for the Latin poets he had known at college—adding to them a prose-writer like Apuleius with his rich symbolizing definition of life. He probably knew Chénier as well as Zola did; and Baudelaire was so close to his heart that Gasquet says his copy was tattered and he knew *Les Fleurs du Mal* by heart. An exaggeration, no doubt, but it is clear that he absorbed Baudelaire deeply into his whole system. De Vigny also came to be one of his loves. Gasquet depicts him as saying, 'Do you want me at my age to believe in anything? Besides I am as dead.' Then he recited:

Mighty and solitary, Lord, you made me.
Then let me sleep now with the sleep of the earth.

A letter to Zola shows him familiar with Molière (whose *Tartuffe* he illustrated); he had read Kant and Schopenhauer; he loved Stendhal, and Baudelaire as a prose-writer on art. Vollard says he much admired the Goncourts, especially their *Manette*, at least until the 'widow' (in Barbey d'Aurevilly's phrase) was left to write alone. He knew Mirbeau's work well, indeed much of the work of the whole Médan group. He read also the work of Gasquet and his group. He read closely the work of Zola up to *L'Oeuvre*, and he was interested in Balzac, as his 1868 letter about a review of his that Alexis lent him reveals. The letters showed that he looked in the papers for the works of Zola being serialized and that he followed his journalism. He was an admirer of the writings of Jules Vallès, as we saw. A man who had such wide interests in literature must have read much of which we have no record. Thus, from his interest in the Temptation theme we may surmise that he read Flaubert apart from the fact that he mentioned him.

Clearly the works that most interested him were those that embodied his ideals, as Hugo and Musset had uttered and strengthened the vague but powerful aspirations of adolescence; or those in which he felt himself and his conflicts more or less directly reflected. In the latter category we may place Baudelaire's poems, Vallès' *Jean Vingtras*, the Goncourts' *Manette Salomon*, and (if I am right) Mirbeau's *L'Abbé Jules*. Another work which certainly belonged to this class was Balzac's *Unknown Masterpiece*, written in 1832, which more than any other book he felt to define his deepest artistic experience. Frenhofer, Balzac's artist, lived in a continued state of agitation and delusion about the degree to which he had realized his aims. His main problem was that of the plasticity of solids: what Leonardo called *sfumato* (the surrounding of things with a soft misty atmosphere). As an old man, after ten years' continuous struggle, he has brought all his gains and lores together, and at last, he believes, achieved his vision. But when he shows the work to two younger painters they see only 'colours placed together in chaotic confusion, held together by a mass of strange lines and forming an impenetrable wall of paint.' After a long scrutiny one man sees in a corner 'a piece of foot emerging from this chaos of colours, shades, undifferentiated hues, a kind of mist without shape.' He cries, 'There's a woman underneath!'

But it wasn't the climax of failure that made the story so fascinating for Paul—though that too certainly had its meaning for a painter so dogged by a sense of lagging behind his vision, of producing confusion instead of the subtle fullness of plasticity he desired. What struck him was the closeness of Frenhofer's ideas to his own. Frenhofer, we learn, 'is a man passionately devoted to art, who sees higher and further than other painters. He has thought profoundly about colour, about the absolute truth of line; but as a result of his researches he has begun to doubt even the object of his researches.' He comes to think that 'nature comprises a series of interlacing curves. Strictly speaking, drawing does not exist . . . Line is the means by which man renders the effect of light on objects; but there is no line in

nature where everything is full; it is in modelling that one draws—that is, detaches things from their environment; the distribution of light alone gives bodies their appearance . . . Perhaps it would be better not to draw a single line, but to attack an object by the centre, dealing first with the features that are most highly lit, and then go on to the darker parts. Is this not what the sun, the divine painter of the universe, does?'

Actually, at the time when Balzac wrote, Turner in England was developing his vortex-compositions of curves, in which nature is for the first time being treated as composed of force-fields, and was thinking more and more in terms of the light-centre as the determining factor, abandoning the age-old custom of building from darks into the light. But Balzac could have known nothing of his work. He was responding to a deep trend of his world, which, beginning with Turner, was to lead through Delacroix into the impressionists and (more fully) into Cézanne.

Burger-Thoré wrote in 1847: 'Lines or drawings serve no other purpose than that of holding colours together, enclosing their harmonies. One might even say that the line in painting is only an abstraction; it does not exist; one assumes it between two different colours as one assumes it between two solids in nature'. Gautier said: 'At the outset in painting there stands a lie, for in nature there are no lines. Contours dissolve into one another, the line does not exist'. Delacroix noted that lines do not occur in nature and exist only in the minds of men. Vasari too had made this last point. And all the impressionists denied the existence of the line in nature as seen by man. Baudelaire went deeper than all these when he said: 'In nature there is neither line nor colour. Both are abstractions, which owe their nobility to the same source. In both cases nature is only the stimulus'. (Badt)

This last statement tends to subjectivism and does not represent the more dialectical way in which Paul viewed the problem. But what is significant is the focussing of a new sort of attention on the passage between one object and another, and the way in which this passage is viewed in colour terms. Gautier also remarked, 'Even if one develops solids from the centre outwards' (in accordance with the procedure of Gros, Géricault, and Delacroix) and 'even if one avoids using any kind of line at all, one yet achieves a concealed drawing which is not any the less real.'

I have said the climax of Balzac's tale was not what made the thing so fascinating for Paul; but there was a sense in which that climax must have had a deep meaning for him. No one was (intuitively, immediately) more aware of the problem-teeming nature of his society and its art. Dealing with the choices that confronted the early nineteenth-century novelist (of concentrating on the specific character of modern life or attempting to formulate universal timeless laws), a critic has said:

The first way, the one Balzac among the modern artists followed with the greatest effect, the one Goethe also followed in his *Wilhelm Meister* and *Faust*, led to the theory of the modern novel, to the relentless expression of all the problematic elements and inartistic uglinesses of modern life, to the artistic overcoming of this problematic character by the very act of following it through to the end. Balzac distinctly felt and gave clear expression to the conviction that there still remains, none-theless, a deeply problematic aesthetic element. His artistic confession of faith, especially his story

Chef d'oeuvre inconnu, clearly shows how following this path consistently to the end, as prescribed by the specifically modern principles of art, must lead to self-dissolution, to a destruction of artistic form. (G. Lukacs)

The pressures of chaos and disorder which Paul felt all the time, and which he could resist only by his slow and obdurate analysis, are present in his work—but as the defeated enemy. (At times however they do unnerve and disorder him.) But if artists take over from him without that passionate discipline, the pressures of chaos must steadily assert themselves more and more. The alienation or fragmenting pressures grow stronger than the resistances; the integrative method splits up; in its place we find partial approaches along various expressionist, impressionist, futurist, constructivist, cubist lines. The senses explode in varying degrees of chaos masquerading as a new cosmos as the integrative systems weaken, or else harden into intellectual schemes and imposed forms of stylization. At most we see the mangled remains of humanity in the pounding hammers or cutting wheels. Thus Paul realized in Frenhofer both his own struggle to grasp process and the nemesis that lay ahead of any weakening in that struggle.

A poem by Baudelaire which certainly woke a strong echo in Paul was *Les Phares*, with its praise of Rubens, Leonardo, Rembrandt, Michelangelo, Watteau, Goya, Delacroix. He probably knew Champfleury's tale *La Fuentzès*, in which a picture, which brings death to all who own it, is of the Temptation of St Antony.

We may note here, in connexion with Paul's reaction to the *Unknown Masterpiece*, that the terms *réaliser* and *réalisation*, which became for him the most fully satisfying terms to express his aims, were of nineteenth-century origin. In fact they came into art criticism about the same time as the term *réalisme* and were clearly connected with it: that is, they raised like that term the question of reality in a new way and posed the question of the artist's relation to it. Delacroix did not generally use the verb *réaliser* for the carrying-through of painting to its desired and adequate conclusion; instead we find words like *exécuter*, *finir*, *rendre*, *achever*, *compléter* in his writings. He was acutely aware that there was a problem in deciding just when a work was finished in its most effective artistic form; but it was only after others had used *réaliser* that we find him also picking it up. Near the end of his life, on 21 October 1860, he remarked, of Rubens' 'wonderful plasticity,' that 'only the very greatest artists successfully achieved a realisation of the problem of mass [*épaisseur*] and of plasticity giving the effect of being alive.' He noted too that, like Rubens in paint, Puget in sculpture 'realises life through plasticity'. Writers such as Castagnary had been popularizing the word. Somewhat clumsily Castagnary strove to express through it something of a fusion between the artist's mind and the outward world. 'A *realised* work,' he wrote in his *Philosophie du Salon de 1857*, 'is, on the basis of the idea contained in it and its outward form, not a copy and also not a partial imitation of nature, but a quite extraordinarily subjective production, the outcome and the expression of a purely personal conception.' He added, 'The artist materializes and concretizes his personal conception of beauty to

correspond to the particular forms of his art.' This is a one-sided formulation, in which the artist is seen merely to seek for forms that correspond to a mental conception; but if we make the interconnexion more truly dynamic, we move towards the usage shown by Delacroix in 1860 and later by Zola when he criticized Manet for 'realising' nothing on account of hastiness, approximations, lack of passion in observing nature. *L'Oeuvre* was the novel on an 'unrealised' artist, and Paul himself went on seeking in ever fuller forms his *réalisation*.

Réaliser was thus connected with *Réalisme* because it meant the re-creation of reality by the artist. It implied a vision of the real world, but from a viewpoint that actively involved the artist with that world. Courbet's Realism was entangled with his vision of reality as something that could and must be changed—in the direction of a fuller harmony, a universal brotherhood, which was inseparable from a new sense of nature. Delacroix saw the realization of plasticity as a re-creation of life in all its vast energy and power of joy. Realism did not mean the inert reflection of the outward world, and neither did Naturalism in Zola's usage. It meant that the artist must drop idealization, must ruthlessly cut out everything which was dead, conventional, academic, flat, from his art and its techniques. He must see the world afresh, as if it had been newly created that very moment; and because he was discarding all set interpretations and formulae, he must throw himself powerfully into the picture. The act of seeing the world afresh was an act that stirred and evoked the full potentialities of his character, his being. Hence the way in which Zola's bringing into the novel of all sorts of new material was linked with his poetic sense of the inherent and symbolic correspondences alive in that material; and the way in which Paul strove to achieve the union of a purely personal and immediate vision with a definition of all that was most stable, structurally coherent, and eternal or universal in a scene.

This sort of attitude had been impossible before the nineteenth century; its first great exponent was Turner. It involved two new things: a deepened sense of artistic process, a new sort of self-consciousness in the artist, and also a feeling of nature as made up of processes, not merely of objects in mechanical relation to one another, in a world where the link of observer and observed was determined by rigid geometries of linear perspective.

The new self-consciousness of the artist was linked with a wide set of historical circumstances: the breakdown of the old systems of patronage, the shift of his social status to one hovering between bohemian outcast or social rebel and money-making gentleman, the advent of the industrial revolution and various democratic, radical and revolutionary ideas and movements. The common man or worker became important, and his background the new world of industrial processes. The crucial period of change was that of the French Revolution and the following years of its impact, with David in France and Turner in England as the exponents of the new situation, different as they were in their methods. Through David, Gros and Géricault a new attitude to people was born, while Turner, as we noted, embodied the deepened sense of process. Steadily it became clear that to express the new kind of

common man a new kind of art was needed, of which the romantic turmoil of Delacroix
and the direct vision of Courbet were both aspects. The transition from a handicraft world
to a machine world (also a world of new sorts of power processes) is reflected in the creative
artist's new awareness of technical issues. Increasingly he felt detached from a moribund
academic system, which carried on in an etiolated form the views and methods of a previous
age with quite different problems and social relationships. At the same time he was driven
to seek a personal way out, a method derived from his own sensibility. Delacroix, Courbet,
Corot, Daumier, Manet, showed the first stages of response to this situation; the decisive
point of break came with Pissarro, Monet and other impressionists, who carried on the
revolutionary outlook pioneered by Turner, with more precision but without his breadth
and scope. Cézanne emerged at this point as a significant artist, seeking to synthesize the
lines of Delacroix, Courbet and the impressionists. He proved unequal to the full and
gigantic task he set himself, but in the process he made important gains all along the front
he tackled: in the expression of deep change and turmoil, in the definition of the common
man, in the achievement of an artistic method deeply revelatory of natural process. Rilke
understood that the method of Paul was a method of process; he saw his main purpose as
'the production of something which carries conviction, the process of making a thing
"become" a thing, the reality which, by his own experience of an object, was intensified
until it became indestructible.'

Without attempting to compare the final values of the achievements of Zola and Paul, we
can note that the work of both men belongs to the second phase of Realism in the nineteenth
century. The massive confident form in David, Géricault, Courbet, or in Balzac, was no
longer possible. Its break-up was linked with the deepened strains and pressures on the
spirit, the new extensions of the cash-nexus, the State, the division of labour, and the whole
alienating mechanism. The writer or artist had to make a violent struggle to reassert his
grip on life. On the one side he was liable to lapse more and more into subjectivism, often
into romantic attitudes now running to decay, as he felt incapable of grappling with the
confused unnerving scene; or he was liable to sink under the weight of alien material,
unable to absorb it into a coherent artistic system. Flaubert shows the anxious conflict
between in-turned aestheticisms and notions of the artist as a God's-eye machine. He him-
self expressed the inner conflict thus: 'There are in me, literally speaking, two distinct *bons-
hommes*: one who is smitten with rodomontades, lyricism, great eagle-flights, and all the
sonorities of phrase and the crests of ideas, another who digs and excavates the true [*le vrai*]
as much as he can, who would like to make you feel almost materially the things that he
reproduces. *L'Education Sentimentale* has been, with my knowing it, an attempt at fusion
between the two tendencies of my spirit. I failed.' There was much of Paul in such a state-
ment. Zola, more sanguine, tried to overcome the split by mixing a fervid poetic power
of evocation and permeation with a journalistic gathering of factual details. There was a
hectic element in the resulting work, even if at its most successful a new sort of comprehensive

vision, a dynamic unity linking the writer more actively with life, was precariously achieved. In his own way Paul was waging the same sort of struggle, seeking a combination of Courbet and Delacroix, turning to impressionism with its schemes of scientific exactitude in reproducing a scene, and fighting to find how to achieve out of the various ingredients of his technique and vision a new realism or *réalisation*. At root the strains in both him and Zola are the same; the objective of realization is the same, despite the many differences in the working-out. The problem of both men was to convert the increased strains and disorders in society and in themselves into an expression grasping the character of order-disorder, symmetry-asymmetry in their world (personal, social, natural) and reasserting an over-all aesthetic control.

One price that the advanced and dissident artist had to pay was an increasing sense of isolation; he also had to be ready to meet vicious abuse and attack. Turner, though his early work carried him into the Academy, was abused through most of his career in what was quite an unprecedented way for a great artist. Delacroix, though gaining important official commissions, was often rejected by the Salon; the one-man show of his work held in 1860 was his effective breakthrough after a lifetime of mostly stupid and depreciating comment. In his diary for 14 May 1850, after someone had read out a sentence from Benjamin Constant's *Adolphe*, 'Independence has isolation for companion,' he recorded it as: 'The result of independence is isolation'—with the observation that such a condition was 'inevitable.' Courbet, a heartier character, felt the same pressure:

Beneath the laughing mask which you see me wear, I conceal grief, bitterness, and a sorrow sucking the blood from my innermost heart like a vampire. In the society where we live one does not need to make much of an effort to find emptiness. There are in truth so many stupid people that it makes one feel most discouraged and afraid to develop one's intelligence lest one should find oneself completely isolated. (Letter to A. Bruyas, November 1854.)

Daumier, imprisoned in 1832 for a cartoon, remained quite outside the art world, exhibiting nothing, and rescued in his blind old age by Corot. Charles Méryon lived with 'madness and wretched poverty seated side by side' (Goncourts, 10 October 1856). On December 25th they noted, 'Gavarni is living an even lonelier life than ever. He is no longer a human being, only a spirit. . . . He sees no one in his tiled attic.' Millet suffered great hardships: 'How shall I get my month's rent? After all the first thing is that the children must eat' (1856); poverty nearly drove him to suicide in 1857 (year of *The Gleaners*); 'we have wood only for two or three days and do not know how to get any more; my wife will be confined next month and I'll be without anything' (1859, year of *The Angelus*). In 1851 he cried, 'The joyful side never appears to me. I do not know what it is. *I have never seen it*. The most cheerful things I know are calm and silence.' His work was much attacked, and even Paul de St Victor, who had supported him, described *The Gleaners* as 'scarecrows' and saw only ugliness and unrelieved vulgarity. We have considered something of the long struggles of Pissarro and the impressionists, with years of dire poverty. Van Gogh never sold a picture, went

69 Mardi Gras, 1888

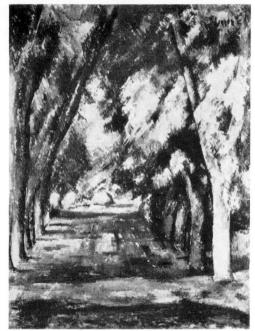

70 Avenue of chestnuts at Jas de Bouffan, 1888–90

71 Bather with raised arm, 1885–87

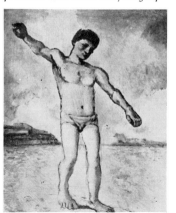

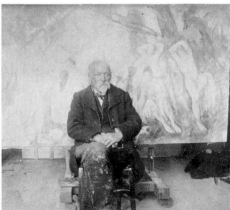

72 (left) Cézanne in his studio at Les Lauves, in front of his 'Bathers'. Taken by Emile Bernard in 1904.

73 (below) Bather with raised arm, 1875–76

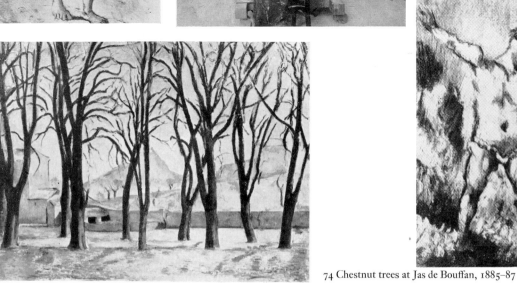

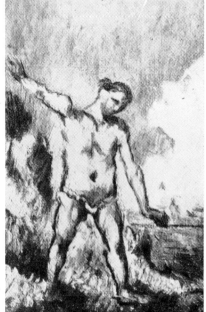

74 Chestnut trees at Jas de Bouffan, 1885–87

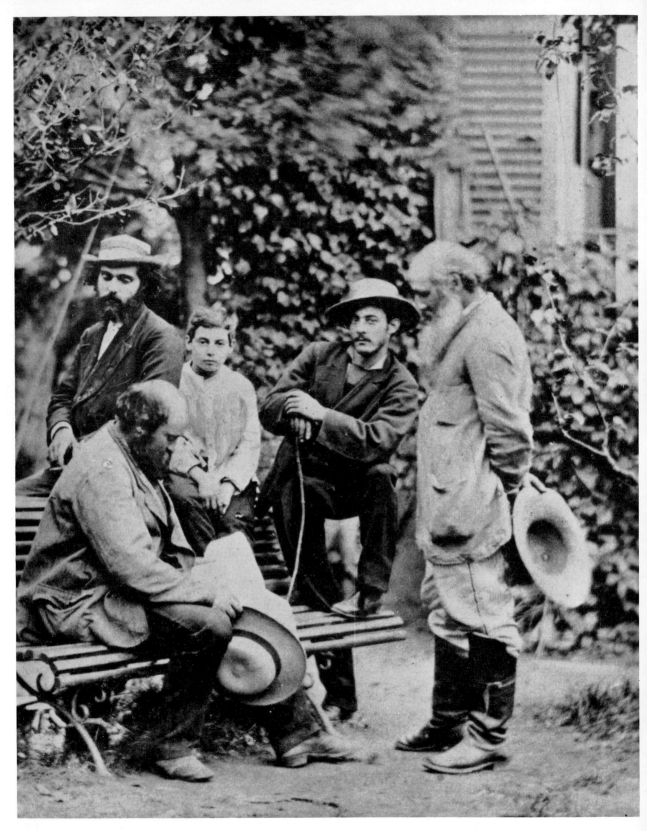

75 Photograph of Cézanne (seated) and Camille Pissarro (standing at right), taken in Pissarro's garden in Pontoise, *c* 1873

mad, and shot himself; Gauguin ended in poverty and disease, bitterly quarrelling with the authorities in the Marquesas.

In the last resort these artists were experiencing in an extreme form the sense of loss, isolation, division, which had been worsening ever since the effective growth of what Carlyle called the cash-nexus, what Hegel and Marx called alienation, what Ruskin saw as a fragmenting and dehumanizing system, what William Morris attacked as cutting men aridly off from the sources of creative labour. For Marx (as for Hegel) the core of the alienating process lay in the division of labour (with the State-mechanism and all bureaucracy, whether of the official or the commercial world, as the supreme expression of this division). The Romantic Poets had felt the deepened pressure of alienation as a sense of the loss of the earth and of all 'natural relationships.' With Baudelaire emerged the full awareness of a new desolation come upon man, the increased loneliness of the individual lost in the desert of the big crowded (industrial) city. There was an element in Paul that could have made him express directly the ugliness and desolation of the industrial scene. Werth remarked in 1914, 'In his first landscapes he uses the language of Courbet. In some less known works we see factory chimneys. With red and black is expressed a sort of industrial tragedy. Imagine, among the divergent routes where Cézanne at the start of his life makes a stop, that he may have followed that one and become a Verhaeren of painting.' (He is probably thinking of works like *Mont de Cengle* near Aix, about 1870. The industrial scene intrudes similarly in some l'Estaque works, for instance in a study in which the chimney helps in bringing about the staccato rhythm, the succession of vertical planes that draw the spectator in.) We may add that the extent to which Paul in his obsessed isolation was linked with strong trends in his world, is shown by the romanticized account of Corot as Crescent in *Manette*, published in 1867:

This absorption, this communion, this embracing of visions, of colours, of phantasmagoria of the countryside, had at length developed in him the sort of illumination of a seer of nature, the inspired religiosity of a priest of the earth in sabots. The shepherd's rumination of dreams, the artist's exaltation of perceptions, the peasant tenacity of meditation, the over-exciting work of isolation, the immense holy drunkenness of creation, all that, mixed in him, gave him a little of the ecstatic state of the ancient Solitaries. As with some great landscapists with a savage way of life, with congested ideas, one would have said that the sap of things had gone to the brain.

Paul was later to write to Gasquet in envy of his 'sap'.

No one experienced the new depth of the alienated condition of man with more unrelieved poignancy than Paul did. Scattered comments in his letters show that he was not unaware of the wider aspects of the problem; and his sense of standing apart, in opposition to the cash-nexus and the dominant trends of his society, must have been fed by the radical views he imbibed from Zola, Pissarro, Monet, and writers like Rochefort and Vallès. But he was never in any way a systematic thinker on the general issues; except in his art he had no stable basis of rebellion. Hence the way in which, after the shattering year of 1886,

he fell away from all radical politics and found his *appui* in Marie and the maternal church. But this change did not affect in the least the struggle to express his dissidence in his art, to oppose its integrative values to a world of ever-increased fragmentation. In one sense his determination to have no vaguenesses of form or relationship in his art was a reaction against the ever-worsening tendencies to falsification, loss of truth in social relationships, blurring of all realities, in the culture of his world.

In his earlier work an only partially controlled conflict keeps intruding, his powers of integration cannot dominate the aesthetic situation. But they steadily keep on asserting themselves. As his art matures, it is the resolution of the conflict that becomes the main thing, triumphant in his best landscapes and still lifes, and in the handful of figure-compositions where he overcame his anxieties and perturbations. But because of the immense struggle he had to put up all the while against overwhelming odds, his triumph did not yield an abundant world of Venetian or Rubensesque forms or a Rembrandt-dimension of suffering human beings grasped in the essence of their life-experience, in a penumbra of destroying-and-preserving time. The peculiar strains attending Paul's efforts, which involved the need for endurable and unmoving objects as his models, had the effect of giving his realized art images their remarkable quality of solid simplicity, stillness and breadth. (The interplay of light and shadow is as removed from impressionist time-precision, time-fleetingness, as is possible; the particular moment is rendered as much as a moment of eternity as it can be without losing its particularity.) Thus, while Rembrandt concentrated the time-essence of his figures, Paul expelled it in terms of an intense meditative calm or concentration. But that is only one aspect of what happened; by itself it suggests the sort of abstraction that Paul wanted at all costs to avoid. The conflict of time and permanence, driven out at one level, reappears at other levels: in the pulsation and drive of his brush-strokes, in the perilous struggle of stability and instability, in the inner movements that give life to every inflection and relationship of colour. Especially in his last works the full inner conflicts burst out.

The paintings of Cézanne's last years have an epic largeness. He sees nobly and builds with a few clear objects; but these are tremendously alive, throbbing with colour and the powerful rhythm of the brushstrokes. Each area approaches an ultimate of movement and depth, within the limits of simplicity and grandeur of form. The strokes have become larger and more impassioned, the silhouettes more flickering in their contention with neighbouring tones. In the impulse-charged rendering of great masses, the smallest inflections count, without appearing contrived. The pliant tree at the left [in *Le Château Noir*, 1904–6], the thin wavering lines of branches in the sky at the right are responding forms, which seem to flow from the rhythm of the surrounding strokes. The irregular and, in places, flamelike silhouette of the trees against the sky and building has no drawn outline, but owes its moving form to the life within the coloured mass. It is contrasted with the regular forms of the building—a stable ruin, in which we feel, however, through the patched, hot colouring and vibrant edges, the pulse and instability of life. It is an exalted, passionate meditation, in which the great constants of the forest, the building and the sky are suffused with the artist's deep fervour. (Schapiro)

The struggle of stability and instability, we have seen, was characteristic of his art at all phases; it continued in his finest and most mature work, in an intensified and deepened form. In some of the latest paintings the dynamic attack produces an extreme tension of bursting, chaotic energies and structural planes, in which the patterns and rhythms of the brushwork are one with the rich involvement of colour-volumes. The complex movement of forms in depth is one with the interflow of colour-harmonies and contrasts.

Instead of stiffening in a fixity which was not a stability, but an artifice of construction, instead of refusing to adapt itself to the pulsation of time, the work of art accepts mobility, and it is this mobility that becomes the condition of its spatial harmony. It is integrated in the universal rhythm, it is no longer a closed world, situated outside the time and space of nature, hardened in its autonomy, and as such all the more vulnerable to the blows of changes and evolutions, it is henceforth an integral part of this universe in movement of which it has become an element, in the same way as its concrete suggestion or its imaginary prolongation. (Guerry)

Among the contradictions which his art presents there is none, perhaps, more profound than that between the sense of the transience of life and of its permanence. In the *Still Life with Teapot*, even more, even much more, in the great paintings of Mont Ste Victoire, we experience these contradictory feelings separately, and each as poignantly as the other. There is a hopeless sadness in that all we see and rejoice in dies for us no sooner than it is seen; there is a serene affirmation that what we are now looking at will be there for ever. We are faced with our deepest concerns about life and our place in it, but exalted here by acceptance of the intolerable fact that mortality and immortality are only meaningful in relation to one another. (Sylvester)

The disintegration is pushed to such a point, the volumes are so decomposed into small indications of movement scattered over the surface, that at first sight we get the impression of some vaguely patterned carpet of embroidery. But the more one looks, the more do these dispersed indications begin to play together, to compose rhythmic phrases which articulate the apparent confusion, till at last all seems to come together to the eye into an austere and impressive architectural construction, which is all the more moving in that it emerges from apparent chaos. (Fry)

Let us look a little further at some aspects of his method that relate to these questions. Paul's line has been well described as one 'which encloses each individual solid with continuously changing degrees of intensity; which sometimes achieves perfect graphic expression; sometimes on the other hand is reduced to a vague incidental element in the deliberate contact of two areas of colour; sometimes at certain points disappears entirely' (Novotny). There is an 'outline which is not so much intended to define the object which it encloses but rather the two coloured parts between which it lies.' Further, 'in the formation of this outline the isolating effect of contours is restricted to a minimum and instead the opposite effect is achieved: each object is linked to every other one and the space represented on the picture is linked to the picture plane.' Edges are of supreme importance since through them one defines both the identity of an object and its relation to other objects in front or behind: that is, its situation in sensuous plastic space.

The same problem comes up in what has been termed the shadowpath between objects in Paul's work. Bernard tells us, 'He started with the shadow, in fact with one patch of colour. This he covered over with a second, larger one, and then with a third one, till all

the shades together formed a veil and modelled the object with their colourfulness.' The shadow-paths that separate objects also unite them, so that the whole picture is a modulation of colour-forms all ultimately parts or aspects of the sensuous continuum of space. The individual objects emerge out of the continuum. The shadow-paths provided 'the veins of the picture's design, often only faintly visible, though often on the contrary extremely plain, but in every case intensely effective.' (Novotny)

The colour blue played a special role in the definition of space, its curvilinear depths and its dynamic continuity. Paul learned much about the impressionist use of blue; but his mature use of it is far from any simple connection with impressionist atmospherics. Zola in *L'Oeuvre* remarked of Claude, 'The awful problem, the adventure in which he had engaged, had its origin in the dangerous theory of complementary colours . . . Thus science entered painting and a method of logical observation was created; one had got to take the dominant of a picture, then to find the complementary colour of one like it.' Paul chose blue as his dominant, a blue richer and more intense than the atmospheric blue. He wrote to Bernard, 'Blue gives other colours their vibration, so one must bring a certain amount of blue into a painting.' Bernard added, 'in fact, the atmosphere is this blue, in nature it's always found over and around objects and they merge into it the more they draw away towards the horizon. The way in which Cézanne used this blue is not at all analogous to the procedure of the impressionists; they rather spoil their palettes by exchanging the warm scale for the cold one; they practise an all too patent abuse of blue. Cézanne insists on letting objects keep their local colours, i.e. their own colours; he admits blue only as a stimulating element and in no way as a devouring agent.' Denis noted a number of watercolours 'constructed out of lively contrasts on top of a basic design of Prussian blue . . . They looked like old faiences'; Le Bail said Paul in his old age drew with a brush loaded with aquamarine, greatly diluted with turpentine; Rilke noted his 'dense padded blue'.

It has been remarked, 'This blue is not air, but something more, a sort of fluid made of matter, simultaneously solid and liquid, an element in which all substances are assimilated to one another' (K. von Tolnay). We may say that Paul used blue as a uniting element, linking the far and the near.

Whether the object were red, green or brown, yellow, pink or white, all parts in shadow were to Cézanne of a blue shade, based on blue. So he started to paint a motif by applying different blues along the path where he envisaged the shadows as falling, which formed the framework of the composition. Having applied these blues he went on to modulate them by contrasts as necessary, or led them into the colour of the thing itself. So he might take a deep crimson red, or brighter green, dark brown or light shades of ochre and apply them side by side with the blues. At the same time he added depths to the shadows by painting over the first light blues with more blue or with related colours, until gradually distinct forms began to detach themselves from the shadows. (Badt)

No doubt the strong blue of the shadows in the Midi helped him towards these procedures. His blue both linked and differentiated heaven and earth.

We may note how grid-systems (like that discussed in his *View of Médan*) and shadow-paths thus took over the part played by the black shadow-grid of his earlier works. In the process what had been a disarticulating and fettering pattern became a dynamic and uniting one.

There is another angle from which we can approach his conquest of space. The impressionists were averse to panoramic views, partly because of their associations with past art, which made them seem picturesque in themselves, but also because they were more recalcitrant to treatment in a unified sweep of reflected lights. Paul, however, had no such inhibitions. He liked to paint a massive object right before him, as with the quarry of Bibémus, but that was because he then had problems of structure, mass, and colour-modulation presented in an extreme form. But he was also unafraid of panoramic views, whether of the bay of Marseille from l'Estaque or of Mont Ste Victoire from various points around. Because of his need to banish all indefiniteness, he had to make all distances as clear as the foreground and yet to keep them as distances—to make the foreground keep its place and yet be no more detailed than anything else in the picture. In his paintings of the Gulf of Marseille from l'Estaque,

Cézanne in no. 411 begins to give more importance to the foreground (le premier plan) than to the sea, to Marseille, and the mountains at the back. Then he frees himself from the foreground, feels more the importance of the mass of the sea, and creates three masterpieces: 428, 429, 493 . . . He takes possession of the distant town and mountains without representing them as if they were near, but by making us feel their plastic essence. He abolishes *le premier plan* and excludes all details that differentiate what is far from what is near. To feel the mass of the sea, it is necessary to look down from on high; but the hill that dominates l'Estaque is too far off from the sea to enable us to feel the latter's plastic mass. As if he flew above the houses and chimneys, Cézanne sees the sea's surface lift itself up to show its mass; but he does not lose at all as a result the impression of a distant space. (Venturi)

But it does not therefore follow that the planes have an imaginary order in their relationships, something not in nature, only in art, as Venturi asserts. What is defined is in part a movement of the eye in grasping the totality of the scene, but it is also the symmetry-asymmetry tension that brings the whole thing alive as one moment in a changing, developing universe. The various masses, with their differing tilts and colour-planes, combine in a single image of realized space-time.

We feel that he could never have made his artistic statement as fully as he did without the Provençal earth, and we understand why he loved it. He did fine paintings in what we may call Pissarro-country; and in the later 1890s he could produce a work of massive forms out of the Fontainebleau Forest, such as *Rocks at Fontainebleau*, where, out of the heavy obstructing rocks in the foreground with the further barrier of tree-trunks and overhanging foliage, he yet creates an image of powerful movement up, over, on. Though it is doubtful that he was recalling the passage, he has remarkably recreated the description by Flaubert in *Sentimental Education* of the same forest:

The light . . . subdued in the foreground planes as if at sundown, cast in the distance violet vapours, a white luminosity . . . The rocks filled the entire landscape . . . cubic like houses, flat like slabs of cut stone, supporting each other, overhanging in confusion, like the unrecognizable and monstrous ruins of some vanished city. But the fury of their chaos makes one think rather of volcanoes, deluges, and great forgotten cataclysms. Frederic said that they were there since the beginning of the world and would be there until the end. Rosanette looked away, saying that it would make her mad.

He painted another heavily-obstructed forest interior near Aix, *Woods with Millstone*, where the quarry is going back to wild nature and there is no sky-exit, only the fierce struggle between order and disorder. And when all is said, it is the Provençal landscape that gave him full scope for what he most deeply wanted to express. The breadth and weight of its forms, with the contrasts between greenery and bare slopes, matched his need for big architectonic structures in strong clear light. And we must not forget the part played by its wind, the mistral, in sweeping across the forms, agitating both painter and scene, and stimulating the sense of movement, of change, of the struggle to reassert symmetry and order in a world trembling on the edge of disorder.

We should by now have some idea of what constituted Paul's achievement and why his highly ordered systems appeared an extreme disorder to his contemporaries, apart from a handful of advanced artists. And though it is no part of this book to examine his impact and influence from 1900 onwards, we need to get at least a rough notion of his relation to the art of the future. Few important schools of the first decades of the twentieth century, which proliferated with new movements ranging from Fauvism, Expressionism, Futurism and Cubism to Surrealism, did not see him as in some respect or other a precursor. Especially, his relation to Cubism is a crux for art-criticism, and needs to be clarified and explored if modern art (the art of the twentieth century) is to be understood. But at a glance we can see that all these movements, and especially Cubism, would have been disliked and denounced by him in varying degrees of anger and disgust; for what he stood for above all was an integrative art, based on the unceasing analysis of nature and seeking always to make its grasp more comprehensive. We thus have the paradox that he has been made the forerunner, and in some sense or other the founder, of movements which dealt with partial or abstracting attitudes that were not merely different from his own, but diametrically opposed to it. (As part of the falsification of his aims, his comment on spheres, cylinders and cones to Bernard in April 1904 was altered to take in cubes. Bernard made the change first in 1921, well after the advent of Cubism, to adapt Paul's art to the new school.)

This point has been noted, but not in any clarifying way. The conventional view of Paul as the precursor of abstraction is thus put:

There is no doubt that we can already perceive the natural experiences of the senses being made abstract in the 'pure' vision of the impressionists, which was so to speak distilled from the natural harmony of the senses. Here the artist's vision has already so thoroughly demolished the links with

the world of space and solids which are always implicit in 'natural vision' that the world of human senses has already been abandoned and there is already an overwhelming inclination to turn away from it, even though this may not yet have reached its extreme form. The way to total abstraction has been prepared and Cézanne is to bring it almost to fulfilment—at any rate to point the way thither. (W. de Boer)

It would indeed have been news to Pissarro, Renoir and Monet in the 1870s and 1880s that their art was distilled from the natural harmony of the senses, and not based on the prismatic analysis and so on, or that they were abandoning the natural world which they loved and exalted. But the statement has one element of truth: impressionism limited the vision of art to certain aspects of experience, and by carrying this vision to its extreme, as in the later work of Monet, it did begin to invert its attitudes, putting more emphasis on the mechanism of vision and less on the external world—though it never severed the link between them. The way was opened to abstract impressionism. But the situation was quite different with Paul, who broke with impressionism precisely because of its limitations, in his quest for a comprehensive art linked at every point with nature. Something of these facts has been seen by a few critics.

In the works of the impressionists there is no sign of 'the natural experiences of the senses being made abstract'. On the contrary, the impressionists live and enjoy 'the experiences of the senses' to the full and the world of the human senses is preserved whole in their pictures—if indeed without literary references, yet strongly marked by feeling, in particular the feeling of joy and of love for things. Cézanne in turn did not pursue the impressionist trend in his conception of the real world. Nevertheless, though he took a different turning, he did not move towards abstraction: instead he evolved a new kind of symbolism. (Badt)

Much of that is true; but the world of the human senses was not preserved 'whole' by the impressionists, or Paul would have no quarrel with them; and Badt shows the usual prejudices in using the term 'literary references' to cover the whole nexus of human culture and experience apart from the direct act of aesthetic analysis. And while it was true that Paul had his deep symbolizing element, we merely introduce abstraction from another angle unless we add that his symbolism could only be achieved by the total integration of man and nature.

Cézanne puts sensation at the base of all his work. All the rest is only the skeleton. He always draws his forms from nature; never in the geometry which is abstract. His style is the true one, that which consists of profound expression and does not depend on decorative means. It is as strong in pictures so-to-speak *pointillés* as in those where the object is surrounded with a contour. (Simon Lévy)

That is true but does not advance the problem far. Venturi comes closer:

There is then no *a priori* schema imposed on appearances, but an interpretation gradually distilled from appearances by means of a prolonged contemplation (Fry). In other terms the order that Cézanne proposes is nothing else than the very evidence of sensation. And his contour is not that of draughtsmen like Ingres; sometimes it disappears, sometimes it reappears; sometimes it is cut by brushstrokes, sometimes it is affirmed strong and thick, and harmonizes its firmness with the

effect of distance. There results a solidity imposing through its weight despite the atmospheric character of all the chromatic reflections, a surprising simplicity, despite the complexity of effects of each detail, finally a clear order vivified by a very lively sensibility . . . It is then necessary to read the phrase about cylinder and sphere in the light of Cézanne's 'sensations' if one does not want to falsify ridiculously his thought. To Bernard, who has sought an artistic order outside reality, in rhetorical abstraction, to all the cubists or pseudo-cubists who thought to found their abstractions on the so-called principles of Cézanne, Cézanne in person, in the last year of his life, at the moment when he was summing up all his experiences, opposes the teaching of Pissarro, that is, the impressionist principle of the natural sensation.

But still the comment is not altogether clarifying. We still do not see why Paul holds his peculiar position in the history of art, in his relation to both nineteenth-century and twentieth-century painting.

Another set of half-truths is present in the following formulation:

To him nature was nothing without design, and design was nothing without nature. And so, whatever the value of 20th-century art as it has so far developed, it is separated from Cézanne and the 19th century by its concentration upon utterly different values. Cézanne belongs to the great tradition of the past. In the context of the 20th century he is an 'Old Master'. (Hendy)

That makes him a dead-end and again we are left with no explanation as to the vast reverence for him by so many leading twentieth-century artists or the way in which he has been invoked to lend a halo to that art. The truth is that he is both the summation of the grand tradition as it led up to his day, and the re-creation of that tradition in terms that face into the future. If we disintegrate his art, break it up into its various components, we can indeed demonstrate a connexion between those components and different movements of the twentieth century that have concentrated on one aspect of creative experience to the exclusion of the others. He has thus indeed had his effective relation to those movements, but not a relation he would have approved of. The art he wanted to come out of his work would have been very different: one that had absorbed his concept of colour-form and that proceeded to apply it in all sorts of new directions, especially in the representation of a Rubensesque world of human activity, human life realized in all its variety and fullness of relationships.

But no artist can legislate as to the way in which his work is to affect other artists and what elements are to be drawn from it. There was a real relationship of Cubism to Paul's art; and the question that concerns us is why the abstracting instead of the integrative interpretation was chosen. To answer that, we must return to the question of the alienating process we discussed earlier. Paul's whole life, in and outside his art, was one conditioned by that process as it operated in his times; but while the process determined many of his emotions and attitudes, and in the last resort underlay his terrible sense of isolation and frustration, his art, in so far as it was successful, was its defeat. His integrations are the overcoming of alienation and the triumphant affirmation of joy, harmony and union. When critics have said that Paul exhausted the analysis of nature and thus left open to his successors only more partial, personal (in the narrow sense), and abstracting lines of attack, they

are really saying that: (a) no one with enough artistic energy and vision followed him; and (b) that the increased pressure of alienation forced artists into the more limited lines. Above all, abstraction expresses and reveals the alienating process, for it obeys its strongest pressure and aim: the reduction of human beings to fragmented things. In making this statement I am not saying that all post-Cézanne art of a significant kind is a passive reflection of alienation; for in its most important exponents a profound and often valuable struggle is waged against the alienating pressures as they intrude ever more deeply into the human being, physically and spiritually. But it is not my job here to go into that matter. The general point must be made, however, to explain how Paul simultaneously has a vital relation to movements like Cubism and is totally opposed to them. We may add that if art is ever to recover wholeness, it will still have to return to him in a new way and find how to carry forward his integrative vision.

When we re-read Paul's repeated insistences to Bernard on the need to base any artistic vision on nature, we feel that in thus addressing the first important distorter of his method and message, he was addressing the posterity of artists who were to carry on from him in ways that he would have disliked. The contrast of his work with Cubism is particularly to be stressed; for here are the root-levels from which the key-developments of modern art proceed. In his work he was grappling with the time-process because time is at the core of all growth, not as a passive thing measured like a line in space, but as the ceaseless assertion of the symmetry-asymmetry conflict we have discussed. Like Turner, he was grappling in all his mature work with space-time as process; and his particular system of perspective, of defining a sensuous space-continuum in all its complex arabesque and curvilinear subtleties, was derived from that struggle. In Cubism this problem was abstracted and the solution found in the mechanical combination of several views of an object all more or less superimposed—the Futurist notion of a simultaneity of various stages of an object in motion showed a similar sort of approach. But Cubism proved incapable of development except in the direction of ever increased abstraction. For the true and dynamic expression of timespace the artist must return to Cézanne and pick up the struggle from his work, even if he cannot but be aware, while so doing, of the way in which Cubism froze the problem, re-invoking mechanism to get rid of the vital issues. That is, he would have to include Cubism in some way, while dismissing and transcending it.

(The problem of Cézanne had been well posed by Werth in 1914: 'We do not know yet if the perspective of his painting is a human limit and closes all hope, or if it is on the contrary a stammering, a presentiment.)

IV Old Age and Youth (1900–2)

IN 1900 Cézanne gained a certain official recognition by having three works hung in the Centenniale of French Art at the Petit Palais, during the International Exhibition. He owed this appearance to Roger Marx, an inspector of the Beaux-Arts, who had been won over some years ago to the impressionists and to his work. Marx had much trouble, but at last managed to get Paul's works in. At the opening on May 1st, Gérôme, showing the President of the Republic round, hurried him through the room with impressionists. 'Don't stop. This is a disgrace to French art'. On July 10th Paul sent Marx information as to the year and place of his birth as requested.

He stayed on at Aix this year. One Sunday in August he wrote praising some poems on landscape painting that Gasquet had sent him. On the 11th: 'I'm ill and can't come to thank you as I'd like. I'll go and clasp your hand as soon as possible'. In the autumn he met at the Gasquets' a young poet Léo Larguier, who was starting his military service at Aix, à la caserne du 61. He also met Louis Aurenche, who arrived early in November to serve a term as probationer in the Bureau de l'Enregistrement and who had already founded a little review, *La Terre Nouvelle*, at Lyon. Through Aurenche he met a young law-student, Pierre Léris. He often asked these young folk to dine with him, but left Gasquet out. When he did not take them home, he dined with them at the Hotel de la Croix de Malte.

Aurenche tells how he himself first called on Gasquet. 'With his blond beard and hair, his white complexion—like a second Musset—his singing voice, his open arms, Gasquet welcomed me, as he knew how to receive young folk whom the love of letters sent to him'. He took Aurenche to the first floor and told him to call on Larguier; Jaloux and Paul, he said, were coming to lunch next day. 'Cézanne left Paris a short while ago', he explained, 'after meeting only mortification, misunderstood and treated with jealousy'. We see here the legend he had built up by playing on Paul's sense of defeat, a legend that ignored Monet, Renoir, Pissarro, Geffroy and other loyal friends. Gasquet's disregard of the truth further appears in the tale he told Aurenche about the gift of his *Ste Victoire* (we have seen how in his written account he states the painting was given to him immediately after his first meeting with Paul). 'He stayed in our house some months during the alterations' at Rue Boulegon, 'and he wanted, on leaving, to give us the landscape of the Ste Victoire Mountain that's in our dining-room, and that portrait which he painted during his stay with us, a masterpiece, though the hands are not finished'. One or other of the stories must be pure fiction. Another example of his inventions is the tale that old Cézanne was urged by the poet Gilbert de Voisins to illustrate Flaubert's *Tentation* with two drawings. The drawings

exist; but they were done before de Voisins was born, in 1877. The only apparent motive of such lies was to link Paul as much as possible with Gasquet's group.

Mme Gasquet came in, 'tall, slim, supple, with brown hair, her voice grave and contralto'. She 'said simply to her husband, "Aurenche will come to lunch with us to-morrow, isn't that so, Jo"'. That day Aurenche rented a room in the Rue Emeric-David; at four o'clock he called on Larguier, whom he found to be tall and thin in his uniform of trooper of barracks, with a small brown moustache and a ringing voice that rolled its rrrs, 'with the powerful mask of a Roman Emperor and a leonine mop of hair'.

Next day, well before noon, I arrived at the Gasquets' house. In the bright dining-room, with its Provençal furniture and tile-decorated walls, the table was set, dominated by the old oven-door of Gasquet's father, a baker, which his son, as a memorial of his trade, had proudly fitted into the wall like a noble iron coat-of-arms. And here in turn I saw enter Léo Larguier in full dress, with his képi pompon and his epaulette of red wool, then a thin brown young man with eyes full of flame and with a ready flow of speech, Pierre Léris, law student, with whom I became closely associated, a lawyer named Marie Demolins, big and strong and yet timid, Georges Dumesnil, professor of the Faculty of Letters of Grenoble, Edmond Jaloux, svelte, elegant, who, with his fair moustache, buttonhole-iris, and impeccable appearance, amused himself by imitating Georges Rodenbach.

At 12.30 the master of the house, whose warm voice dominated the noise of entangled conversations, suddenly announced, 'At last here's the master', and framed in the salon door I saw Cézanne for the first time.

Clad in a dark morning-coat, the end of a black silk cravat fastening the neck of his shirt, holding his Cronstadt hat in his hand, Cézanne appeared extremely unhappy. His face was red, his grey hair was ruffled all round his bald skull, his globular eyes regarded each of us anxiously in turn. He stayed fixed after his first step, silent, intimidated, almost nonplussed. But, with her natural delicacy, Mme Gasquet, leading each of us in turn before him, made the introductions. To each of us he bowed deeply, stammered some unintelligible words, then a long silence fell.

We passed to the table where Mme Gasquet, clad all in white, between the painter and her father-in-law, knew how to give each diner his due. The wines of the Var helping, conversation quickly became amicable. Cézanne responded above all to Mme Gasquet, and at times I saw him suddenly stop and flush; fancying that a somewhat crude word had shocked one of the diners, he remained dumb for quite a while. He left us before three, so as not to arrive late for vespers at St Sauveur, which he never missed attending, Mme Gasquet explained to us. When he passed by me, he said, 'As you love painting, M. Aurenche, you must come and see me'. I thanked him, not hoping for so speedy an invitation. But he in his turn, thanking me for accepting, bowed before me in my confusion.

From November 1900 to October 1901 Aurenche saw Paul often at the Gasquets, at the Café Clement on the Cours, or (most often) at his house. He stresses the simplicity of his nature, his readiness to give full confidence, his quick reaction to anything he considered 'the paltry tricks, nastinesses, hypocrisies of his pseudo-friends'. (Here Aurenche is innocently repeating the Gasquet-legend of the villainies of the Monet-Pissarro circle.) Paul impressed everyone with his churchgoing piety, and, deliberately or not, gave an effect of always having cherished religiosity. Aurenche says that the college at Aix had 'impregnated his soul with the divine ideal that never left him'. He 'gave willingly to the poor, who,

at least in Aix, knew him well; for I have often seen bands at his door; he loved children and watched them at play with gentle eyes; he spoke in a friendly way to animals'. At his dinners Mme Brémond served with dessert a bottle of old Médoc. (Larguier however remarked that this wine was 'no better than that in the canteen'.) Once, painting some artificial flowers, he became so angry at his failure that he kicked picture and easel over, swore, and went out, slamming the door.

Jaloux also described Cézanne's entry into the Gasquet salon.

Suddenly the door opened. Someone entered with an almost exaggerated air of prudence and discretion. He had the look of a petty-bourgeois or a farmer, comfortable, sly, ceremonious with all that. His back was a little rounded, his skin marked with brick-red hues, a naked brow, white hair escaping in long locks, small piercing ferrety eyes, a Bourbon nose, slightly red, short drooping moustaches, and a military goatee . . . I heard his manner of speaking, nasal, slow, meticulous, with a solicitous and caressing note.

Already he resented the smug cosy atmosphere of the Gasquet home. A little later he confided to Camoin, 'What do you want me to go and do in their salon? I say all the time Nom de Dieu'. Jaloux astutely noted that he was suspicious of praise, afraid that it held some 'interested stratagem'. Often he was moved to tears, then would roar with laughter.

He clearly enjoyed the company of the young men, but at the same time an unpleasant cantankerous note crept into his remarks more than ever before. He abused Geffroy, Zola, and even Monet; and had harsh words for the young painters or for older men like Gauguin who had praised him highly. While remaining friendly to Gasquet's face, he ran him down.

This year, 1900, he had three pictures in the Salon des Indépendants; and perhaps at this time Gasquet paid his visit to Zola at Médan, to which we have already referred. Zola spoke of Paul and Solari with admiring affection and said he loved Paul for all his sulks; he was even gaining a deeper insight into his art. This year too Marion and Valabrègue both died.

We may now consider some of Gasquet's accounts of what Paul said to him. A disciple of Mistral and Charles Maurras, Gasquet had a vague concept of art as the expression and revelation of the mysterious interpenetration of human and natural forces; art thus had the function of lifting men to a new awareness of nature. This concept, worked out in a concrete dialectic, could have been valuable; but with Gasquet it remained only a sort of incantatory principle. Paul, it is true, had his own notion of the interpenetration, harmony, and differentiation of art and nature, going back in part to the Hugoesque pantheism of his early days with Zola; but his application of such ideas or attitudes had nothing of the imprecise verbosity of Gasquet, who considered colours to be 'living ideas, beings of pure reason'. It is therefore wholly Gasquet whom we find in sentences cited as being uttered by Paul. 'Look how tenderly the light loves apricots, it takes them whole, enters into their very flesh, illuminates their every side. But it is miserly with peaches, of which it makes only one half luminous.' 'An artist you know must create his work as an almond tree its

blossom or a snail its slime'. (Paul then falls into a reverie, watching the 'play of light and shade' on his own closed fist.) 'People think a sugar basin has no physiognomy, no soul. But it changes every day. You have to know how to approach these chaps, how to coax them . . . Those plates and glasses talk among themselves, interminable secrets'. Here is a part of his description of the final large *Baigneuses*:

. . . The water is deep, the grass glistens. The clear French landscape is pure as a verse of Racine. It's the afternoon of a light summer . . . The women at first appear disproportionate, thick, square, the two running, as if cut in an Egyptian relief. We approach, we look for a long time. They are fine, elongated, divine, sisters of Jean Goujon's nymphs . . . One of them goes off, with the gesture of a giddy hussy that is pursued, her legs aren't visible, but her hand, the clenched fingers of a Cambodian dancer; we feel her leap, pubescent and ravished, through the green tips that brush her. Another, calm, olympian, leans on a tree, dreams with lost eyes. One, stretched out, content, appeased, has installed herself, with elbows in the grass, to contemplate her girlfriends in the water; and her opulent breasts, her massive and hard buttocks, her brown hair, take a bath of light, shiver, moistened with broken blue, like a dream taut in silken flesh. . . . And behind her, abandoned, a sleeping girl breathes the treachery and the charm of the grass where a flowered fever undulates.

And so on and on. His veracity is shown by the way in which, just as Vollard made Paul talk about Amsterdam, he makes him discuss the colours of a Titian at Milan, which he could never have seen, not to mention prehistoric paintings that were found only after his death. He states that 'the most part of what I put in the mouth of the old painter are fragments of letters that will be published after my death'. When the letters did turn up and were published in 1959, they gave a complete lie to this claim. However there must be a certain amount of factual material embedded in the accounts; but just what it is we can only guess at. Some parts sound genuine. Thus we are told that Paul swore at his easel and sang a bit of doggerel which, Jean Renoir says, used to be sung by his father far back in the days of Gleyre's studio:

> Painting with oil
> is a wearisome toil,
> but the work's finer and fuller
> than in watercolour.

'It's so good and so terrible to attack a blank canvas'. Gasquet described Paul painting:

One must have seen him at work, painfully tense, his whole face a prayer, to imagine how much of his soul he put into his task. His whole body trembled. He hesitated, his forehead was congested as if swollen with visible thought, his body strained, his head sunk between his shoulders, his hands quivered until they began to paint, when they became strong, determined and tender in their certainty of touch which was always from right to left. He would then step back a short distance and again direct his eyes on the objects. They would wander round the objects slowly, linking them together, penetrating them, making them their own. They were terrible as they fixed themselves on a point.

'I can't tear them away', he said to me one day. 'They are so stuck to the point I'm looking at that it seems as if they were going to bleed. Tell me, do you think I'm going mad? I sometimes wonder, you know'.

Paul's slowness indeed involved prolonged stares in which the analytic contemplation must often have passed over into a sort of trance; one day when at Auvers he was out with Pissarro, a peasant told the latter, 'Sir, you've got an assistant over there who isn't doing a stroke of work'. We can well believe that he may have woken up now and then from this self-hypnotizing intensity with a start of agonizing fear. He, who was so painfully aware of the remorseless and draining passage of time, was throwing time away, was the victim of the process he wanted to master. One aspect of the pressure-mechanism driving him creatively forward must in fact have arisen from the deep conflict between the struggle of concentration and the conviction of ebbing time; he needed above all to hurry, and yet he could gain his realizations only by fighting against the impulse. And the moments of rage or despair when the conflict became intolerable must have given him a sense of going mad.

Gasquet has a story of Paul's paroxysm. Knowing how prevalent were the tales of such seizures, he may have felt the need to invent one; or, in view of the common occurrence of the fits, he may well have witnessed one or more. He says that he and Xavier de Magallon once went to meet Paul in the Tholonet hills. When they reached the Bibémus quarry, they saw him with clenched fists and weeping eyes stamp up and down before a canvas that he'd slit in half. The mistral blew it over and carried it off. They ran to pick it up. 'Leave it, leave it', Paul cried. 'This time I was really going to express myself. It was there, the whole thing was there. But it just wouldn't come. No, no, leave it'. He trampled the canvas to shreds, sat down, and sobbed. Suddenly he shook his fist at the young men. 'Go away, go away, can't you!'

If we look at the portrait Paul painted of Gasquet, we find that he has given him an oddly unstable balance and made his eyes look furtive, with a sort of squint-effect. A photograph of the period shows him as much more rounded in features and self-assured in attitude. Perhaps Paul has introduced some of his own uncertainties into Gasquet in the painting, or has sensed elements of inner strain that he was not consciously aware of at the time.

In the spring of 1901 Paul exhibited with the Indépendants and the Libre Esthétique of Brussels; his prices were rising to 5–6,000 francs, and he even sold one picture for 7,000. Maurice Denis showed at the Salon de la Société Nationale des Beaux-Arts a large canvas *Hommage à Cézanne*, which depicted a group of painters (Redon, Sérusier, Bonnard, Vuillard, K. X. Roussel, Ransan, Mellerio, as well as Vollard and his wife) around a still life of Paul's. Denis could not put Paul in as they did not meet till 1904. Paul sent him a brief note of thanks on June 5th. Denis himself said later, 'What we sought in his works and his words was what seemed in opposition to impressionist realism, and the confirmation of our own ideas, those that were in the air. Cézanne was a thinker, but did not always think the same thing every day. All those who approached him made him say what they wanted to hear. They interpreted his thought'. That comment was all too true. Nothing cited as

Paul's words by the young men from Gasquet on can be trusted without independent confirmation; on careful investigation the words too often turn out to be the writer's own ideas which with varying degrees of probability he has put in Paul's mouth. And their understanding of his art was equally arbitrary and subjective.

His reputation was slowly growing. This year a critic wrote that though he was not known to the mass, 'for a number of years painters have been attentively following him. Many of them owe to him the revelation of what we might call the intrinsic beauty of painting. In Cézanne the interest of the subject does not lie in the story; rather it lies in the production of visual delight'. (Intrinsic beauty and visual delight are abstracted from the struggle for truth in its fullness, the struggle which is also participation in the subject, in natural process.)

On July 17th Paul wrote to Gasquet, 'I got your envoi, *The Tree and the Winds*. I'll read it at leisure, but already in glancing through it, some exquisite and strong perfumes have come out'. Probably in October, he wrote gaily to Aurenche from the Café Clément:

If I weren't under the poet Larguier's powerful pressure, I'd let fly a few heartfelt phrases. But I'm only a poor painter and doubtless the brush would be rather the means of expression put by heaven in my hands. Then, to have ideas and develop them is not my business. I want you to reach soon the close of your examinations; your liberation will let us clasp vigorously and friendlily your hand. He who precedes you in the course of life and wishes you the best chances.

On November 20th, apologizing for a bad pen, he said that he and Larguier had dined together the previous night, talked of everything, and not forgotten Aurenche. He had met Léris, and praised him for 'all the amiability of his age and the exquisite qualities with which a favouring nature has endowed him'. He praised also M. de Taxis of Aix, a man to be cultivated: 'reason, that light which allows us to see into the questions submitted to our scrutiny, appearing to me to be the guide of his life and his social studies'. He had heard that his 'rascal of a son who does himself well', was coming from Paris on the 30th; he asked when Aurenche was arriving, so that they could all dine with him. And he ended with the comment, 'The Jo [Gasquets] appear (*nescio cur*) to have a little bit quenched their pride which is a bit dangerous anyhow. To you very cordially. One who has preceded you in life and who—*cahin caha*—will withdraw from it *rather soon* probably'.

This month yet another young man joined his group, Charles Camoin, whom he introduced to Aurenche as a painter of great talent. 'Vollard sent him to me and praised him up; and he knows it all himself, the bugger.' He also had come to Aix to do his military service, and had seen Paul's pictures some years before in Vollard's gallery. Paul lived in so retired a way that Camoin could not for some time find any Aixois who knew where he lived. At last, finding the house, he called about 7 p.m. The table was laid, but Paul was still out. Camoin, too shy to wait, returned about 8.30. A man's head came out of an upper-storey window, 'Who's there?' Paul had gone to bed as usual after supper; but now went down with his shirt-tails sticking out of his trousers, invited the abashed Camoin into the

dining-room, and, himself doing most of the talking, had a short chat about painting. Camoin, invited to return when he wished, often saw Paul during his three-months' stay, and was impressed by his gentleness and old-fashioned courtesy (Maxime Conil once remarked, 'Paul was no savage; he was a solitary'). Camoin thought the tales of his persecution in Aix much exaggerated. Perhaps he had looked more eccentric about 1878 with his long reddish-brown hair and bushy beard; now he was iron grey and his beard was trimmed (Larguier says, 'He was better and more comfortably dressed than most of the people in Aix'). He too spent much time with Paul, who even let him accompany him to the motif and watch him painting. He noticed Paul's prodigality in the use of paint. 'I paint', said Paul, 'as if I were Rothschild'. Camoin assured him, 'A new era in art is on the way.'

In November this year Paul bought a piece of land on the Lauves road. (*Lauve* is Provençal for a flat stone.) The land lay above Aix on the north, with a fine view of the town and the mountains along the horizon. The area was about an acre, with olive trees, cherries, almonds, and a few old apple trees. He commissioned a local architect Mourgues to pull down the cabin there and build a studio; then, renting a room in the Château Noir for the time being, he went off to paint. The Château consisted of two old gothic-windowed stone buildings with pillars and ruined walls, overlooking a wide vista of olive trees in ochre-red soil, with Ste Victoire at the back. Meanwhile, unsupervised, Mourgues produced a Provençal villa in the worst possible taste with wooden balconies and glazed-tile ornaments. Paul, when at last he came to look, was enraged and had the house stripped of decorations. He had insisted that it be so placed that no trees need be cut down; the roots of an old olive near one corner were protected by a wall of stone and earth. It was this tree that Gasquet described as his special love.

In the hilly streets of Eguilles he instinctively went to help others, to push a peasant's overloaded cart, to take from some old woman's failing hands the water jug she carried. He loved animals. He loved trees. As his end approached, an olive tree became his friend in his need for tender solitude. When he had had a successful session in his Lauves studio, he stood before the door at nightfall and watched his days and his town falling asleep. The olive tree awaited him. He had noticed it at once, when first he had gone there before buying the land. He had had a low wall put up round it, to protect it from any possible bruising while building was in progress. And now the old tree in the twilight of its days had almost a look of fragrance and sap. He stroked it. He spoke to it. Sometimes as he left it at nightfall he kissed it. The blue hills in the background grew a little taller. The sea could be felt. The steeples of honey and salt, the profiles of the Clock Tower and that of the Holy Ghost sang of Italy upon the sky. A gentle murmur rose from the poorer streets. The auburn night spread Aix with its smoke, and autumn, over the countryside. Cézanne the recluse listened to the olive tree. The tree's wisdom entered his heart.

'It's a living thing,' he said to me one day. 'I love it like an old friend. It knows all my life and gives me wise counsel. I should like to be buried under it.'

No doubt, as usual, Gasquet is laying the colours on thickly; but we can accept the substantial truth of this picture of Paul in communion with the tree.

The house was two-storeyed with a gabled roof of tiles. On the ground floor was a little

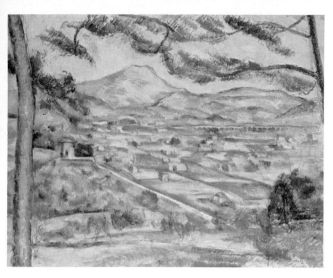

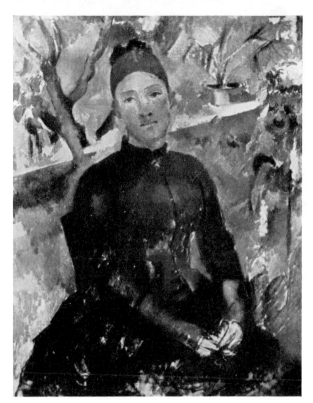

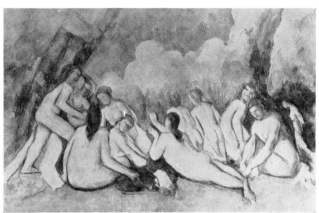

76 Madame Cézanne in the conservatory, 1890

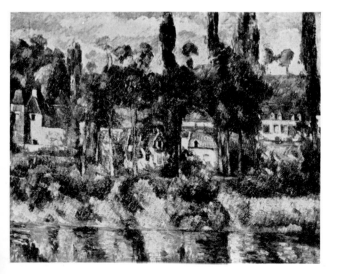

77 (top) Mont Sainte Victoire, 1885–87

78 (above) Bathers, c 1895

79 (below) View of Médan, 1879–81

80 Bather with raised arm, 1875–85

81 (left) Olympia, (?Nana), 1875–77

82 (above) The Eternal Feminine, 1875–77

83 Study for 'Afternoon at Naples', 1867–75

84 Undergrowth, 1900–04

86 Landscape, 1890–1900

85 The Wine-Grog, 1870–72

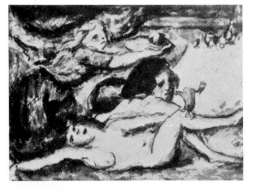

hall, a stairway, two rooms: one for resting in, the other for use as a dining-place when Mme Brémond served his midday meal; he always went back to Aix to sleep. Upstairs was a high studio. The steep slope of the hill meant that the studio-floor was almost level with the ground on the north side. The lower floor had windows only to the south; above were two south windows and a tall north light. Inner partitions were of plain grey-tinted plaster; and the studio had a long slit in the wall to allow the entry or exit of the big *Baigneuses*. He brought along his essential studio paraphernalia: the objects he liked for still lifes (ginger jar, rum bottle, cylindrical peppermint bottle surmounted by a sphere, skulls, plaster casts, faded blue fabrics and a table-cloth with red flowers on a green and violet ground) and his Museum, a cardboard box crammed with engravings, photographs and the like. The pictures in the box included a photograph of Courbet's *Bathers*, lithographs of Delacroix's *Boat of Dante*, Vernet's *Horses with Mamelukes* and two male nudes by Signorelli, and coloured engravings from the time of the second empire. With drawing-pins he stuck up on the stairway the anti-Dreyfusard cartoons of Forain that he'd cut out.

The garden was a tangle of brambles, flowering shrubs and fruit-trees, with winding paths between them. An old gardener, Vallier, attended to the place. Higher up the hill could be seen the wooded valleys in front of Ste Victoire, with an abrupt slope falling away in the foreground. Here Paul painted many oils and watercolours. From 1902 he worked almost wholly at or from Les Lauves.

On 4 January 1902 he wrote briefly to Gasquet. 'If isolation tempers the strong, it is the stumbling-block of the uncertain. I declare to you it's always sad to renounce living as long as we are on earth. Feeling myself morally with you, I'll resist till the end.' He was also resisting invitations to see Gasquet. His isolation did not stop him from seeing Aurenche and the other young men. Vollard visited him early this year, and on January 23rd Paul thanked him for a case of wine and promised to finish a still life of flowers by the 15th or 20th of the following month for despatch to Rue Lafitte. He sent thanks also for the flower-piece of 'the great Master,' Delacroix. Vollard was doing his best to please Paul, being worried by young Paul's sale of some Cézannes to the Bernheim firm.

On January 28th Paul wrote to Camoin with news. Aurenche had been appointed tax-collector at Pierrelatte in Dauphine; Larguier expected his release in 6–7 months, when he'd return to studying social and political sciences in Paris, without abandoning poetry. 'One says more and perhaps better things about painting when facing the motif than when discussing purely speculative theories, in which as often as not one loses oneself.' He was excited that Louis Leydet, son of his old friend, was now a painter in Paris with 'the same ideas as you and I. You say a new era in art is preparing; you sensed it coming; continue your studies without weakening. God will do the rest.'

On February 3rd he wrote two letters. He assured Aurenche that he regretted his departure. 'All the good memories that you evoke for me, come up into my head.' He said,

'I have not been able to associate myself in a heartfelt way with anyone here. Today when the sky is stretched with grey clouds, I see things still more in black.' He now seldom saw Léris. Larguier had passed as corporal and was coming to dine on Sunday evening. Paul had written to Camoin in a paternal way, 'as befits my age.' Indeed the letter to Camoin made a clear statement of his main tenets. Learn from the old masters, copy their works, but set direct study from nature at the heart of one's method:

As you are now in Paris and are drawn to the masters in the Louvre, make studies from the great decorative painters Veronese and Rubens, if you like, but make them as you would from nature: something I only partially succeeded in doing. But above all you'll do well to study from nature. From what I've been able to see, you're going ahead fast. I'm glad to hear you think highly of Vollard, who is sincere and at the same time serious. I felicitate you sincerely on being with your mother, who in times of sadness and discouragement will be the surest point of moral *appui* and the most vital source from which you can draw new courage to work at your art: which you must try to arrive at doing, not passively and feebly, but in a calm and steady manner: which cannot fail to bring about a state of clear-mindedness [*clairvoyance*] very useful to direct you stably in life.

An element of duplicity in Paul appears in the praise of Vollard to someone whom he knows to be in touch with him, while to Aurenche he called him a sharper, *roublard*.

On March 10th he again wrote to Aurenche. Larguier was suffering from conjunctivitis; he had been ill the week before the previous letter. 'The Gasquets of the one and the other sex haven't shown up to my eyes. They have acquired a Château at Eguilles, a hamlet some ten km. from Aix. The château's life will go on full blast; the Abbé Tardif will buy an auto, grand model, to get himself there. He is, I'm told, a distinguished preacher.' He asked Aurenche to delay his Aix visit till May, so that the room used by his son would be empty. 'As for me, I continue painfully my painting studies. If I'd been young, the result would have been oodles of money; but old age is a great enemy for man. I had the honour, walking on the Marseille highway, of being met by Mme de Taxis; I had the honour of greeting her, and the rest according to the formulas of usage.' He signed himself as 'obliged to recognize that he isn't one of the most unhappy on earth. A little confidence in yourself and work. Don't ever forget your art, *sic itur ad astra*.'

On March 11th he gave Camoin Leydet's address in Paris and mentioned that the Bernheims and another dealer had approached him, but he meant to stick to Vollard, 'a man of great flair, of good appearance, who knows how to behave'. (Knowing Camoin was friendly with Vollard, he was in effect here sending a roundabout message of assurance to that dealer). Sometime in March he wrote to Aurenche. 'I've much work on hand: which is what happens to every man who is somebody. I then won't be able to disturb myself [*me déranger*] this year. So I urge you keenly to work intellectually; it's the one serious counter-irritation we have on earth to distract us from the *ennuis* that press hard on us.'

Six days later he told Denis, who had asked him to exhibit with the Indépendants, that he has written to bid Vollard put at his disposal the works he thinks suitable. The letter to Vollard had a postscript: 'It seems to me difficult to separate myself from the young folk

who have shown themselves so sympathetic to me, and I don't think that by exhibiting I'll jeopardize [*compromettre*] the course of my studies'. On April 2nd he wrote again to Vollard; he has had to postpone despatch of his *Roses*; he would like to submit something this year to the Salon, but had better put the matter off as he was not satisfied with what he was doing. A draft letter of May 10th to Vollard announced: 'De Montigny, distinguished member of the Society of Arts of Aix, Chevalier of the Legion of Honour, has just invited me to exhibit something with them'. He asked Vollard to send along something that 'won't do too badly'.

Two days later he told Gasquet that Montigny wanted to hang *The Old Woman with Rosary*. This work he described as 'the head of the old woman, ex-servant of [Jean] Marie Demolins, a not *minime* contributor to your review'. Gasquet does not seem to have wanted to lend the work, and Paul was finally represented by two paintings doubtless sent by Vollard. Paul did not take offence, however. He wrote on May 17th to thank Gasquet for his good advice. Gasquet, he said, was wise to live in the country; and he, Paul, would visit him when he had got rid of these latest bothers.

On July 8th he told Gasquet about a call that Solari had made the day before while he was out. So far as he could gather from Mme Brémond, Gasquet could not understand his lack of reply to the invitation to stay at Font Laure. Paul said he would come as soon as he could. 'I pursue success by work. I despise [*mépris*] all living painters but Monet and Renoir, and I want to succeed by work'. On July 16th he told Aurenche that he'd be at Aix on the 24th–26th of the month, when he hoped to see him.

Paul's enjoyment of the companionship of the young is obvious. He often asked them to dinner; and apart from Solari, he seems to have asked no one else. They were surprised at the austerity of his furnishings: a round polished walnut table, six chairs, a sideboard with a bowl of fruit in the dining-room; no pictures on the walls. With the wine he quoted French or Latin poets; talked of Monticelli or Tanguy; at times made his malicious remarks about old friends. 'A thousand painters ought to be killed yearly', he said. Camoin asked, 'But who should be given the job of choosing them?' 'We of course, dammit'. Now and then he banged the table. 'Say what you like, I'm every inch a painter'. Then, turned serious, he would touch the objects on the table with delicate finger and point out how they reflected one another. 'Look at that'. Larguier noticed his hands thick as a house-painter's. At times, absorbed, he left the room and disappeared. They knew it was useless to try to get him back; he had forgotten his guests and gone to work.

On Sundays he sometimes went to the barrack-gates and waited. Dressed in képis, red trousers and white gaiters, the conscripts walked with him to mass at St Sauveur. Coming out, he was surrounded by a surge of beggars. He had small change ready, and, looking rather scared, distributed it as quickly as possible. One beggar particularly frightened him and was always given five francs. 'That's Germain Nouveau the poet', he once whispered to Larguier. This Nouveau had been a friend of Verlaine and Rimbaud; once he went mad

and was put in the Bicêtre; then he turned a religious vagabond, a pilgrim to Rennes, to Santiago de Compostela. In 1898 he came to Aix where he had spent his youth and where he believed the demons could not find a 'field of action' as in Marseille or Paris. Evidently the clergy were afraid and would have liked to get rid of him, as he went every morning to communion in every church in town.

> O my Lord Jesus, you sower of parables
> That hold the clear and living gold of symbols,
> Take then my copper poems as well as pennies . . .

Paul's niece also tells us that, after sitting through mass at the end of the vestrymen's bench on the left, Paul went out and always gave a five-franc piece to a beggar, who thanked him with a little smile. One day the nieces came out behind him and made fun of the beggar, comparing him with St Benoit-Labre. Paul rebuked them, 'But you don't know, it's Germain Nouveau, professor, poet, he was my fellow-pupil at the Collège Bourbon'.

Once Larguier as corporal was engaged in manoeuvres on the Tholonet road and asked permission of the officer to go to the Château Noir where he knew Paul was. He spotted the four-wheeler and saw Paul cleaning his palette. That evening in the barracks he was in charge of a squad doing arms drill, and as he saw the carriage coming down the road he gave the order to present arms. Paul took off his hat and stopped the carriage. Larguier told him that he'd given the order as a homage to a great painter. Paul made a despairing gesture. 'But you've done a most terrifying thing, most terrifying, M. Larguier'.

There were doubtless several reasons why Paul liked the company of these young men. His first turn to youth had been with Gasquet in 1896. Gasquet introduced him to other painters or poets, who treated him with deference; and he found that he could unbend with them, could drop the defences that he painfully wore against the world. Their company helped him to recapture the emotion of his early days with Zola, even if at the same time it forced on him a continual awareness of the loss, the difference. He found in it a powerful stimulus and a source of deep melancholy. 'You have no idea how life-giving it is to find around one a youth that agrees not to bury one on the spot'. He had always valued strength and energy. 'I am beginning to consider myself stronger than all those round me', he told his mother in 1874. In 1868 he had lamented in writing to Coste, 'it seems that one doesn't always vibrate, in Latin one would say *semper virens*'. And about 1876–8 he signed himself in a letter to Roux, '*Pictor semper virens* although not [word illegible]'. In 1896 he wrote to Gasquet about the envy he felt for his 'sap', his 'inexhaustible vitality'. Gasquet himself stated:

On the leaf of an album he wrote the following lines from *Emile*: 'The body must be vigorous if it is to obey the soul: a good servant must be strong. The weaker the body is, the more it takes command; the stronger it is, the better it obeys. A puny body weakens the soul.' And below in his big handwriting underlined: 'I am sturdy. My soul is strong.' On the wall of his studio he wrote in charcoal: 'Happiness lies in work.'

In a letter to Aurenche in 1902 Paul speaks of 'the Gods who protect Work [*Travail*] and Intelligence'. (It is not clear what passage from a Latin author he had in mind for *semper virens*: doubtless a mixture of many usages of *virere*, such as *virebatque integris sensibus*, Livy; *dum virent genua*, Virgil; *donec virenti canities abest*, Horace.)

His return to painting on the banks of the Arc, indeed all his *Bathers*, was an attempt to revive the spirit of his youth in terms of his matured perspective of life and nature. This point is brought out oddly by an attempt he made to write a poem for his son in the vein of his out-pourings to Zola. He seems to have had an ambivalent attitude to that lad's philanderings, envy or jealousy mixing with admiration and a hope to see him carrying out what his father had shrunk from. The poem is undated, scribbled at the end of a sketch-book, but its tone suggests sometime in the earlier 1890s. The bracketed lines have been crossed out.

> My son has bade me write a poem. I,
> Alas, much fear that I will rhyme awry.
> Phoebus Apollo, who won't help my rhymes,
> Removes the ladder for Parnassus-climbs.
> I scratch my brow. More hard than rocks, my Muse,
> Despite her labouring pangs, still won't produce.
> So if my child won't give an angry sigh,
> I'll break my pen and make him no reply.
> [Although still obstinate my infertile Muse]
>
> In an enchanting site of thick green branches
> Closed on all sides against importunate glances,
> Pure limpid water there of a clear spring
> Slid slowly with a gentle murmuring.
> [And there my child surprised the other day]
> Willow and poplar above the watery way
> Lift with their flexible boughs and softly sway
> [And so my amorous son]
> One day my dear son, seeking solitude.
> To study at ease and pleasantly to brood,
> A favourite book held neath his arms with care,
> By merest chance went wandering to this lair.
> Sudden he halts, and, checking the least noise,
> Enjoys a sight which his sole presence there,
> Suspected in that place, would have disturbed . . .
> That place unknown, forming like . . .

Clearly the lad was to surprise some nymphs or girls bathing naked; but probably Paul, when he came to the point, found his courage failing—just as he crossed out 'amorous son'. For a moment he enjoyed imagining himself as the youngster with a world of girls around him; then recoiled.

The exaltation of perpetually-renewed strength, expressed by his struggle to attain an increased freshness and vigour of expression as his body weakened, was linked with his cult

of Hercules, mainly expressed through his continual drawing of Pugin's *Hercule Gaulois* in the years 1880–90. Critics have assumed that he drew this statue simply through his interest in volumes, in continually receding surfaces. But he could have found countless other statues that would have provided an equally useful object to draw if that had been his only interest. We must recall his use of the Hercules theme in his early poems, and add that in his youth there was in the Aix Museum an antiquity incorrectly named the *Hercule Gaulois*. We must recall too that he was then imbued with Hugo's poetry (with Hercules, *Homme*, and Hugo linked together), in which Hercules was a symbol of struggling humanity and of the poet inspiring men to carry on the battle for freedom and a cleansed earth; from Michelet he would have learned of Hercules as the god of creative labour. Thus in turning to Puget's work in the 1880s he was picking up a thread of his early ideas, but with deepened understanding. He made 17 drawings of the statue, as well as of a small Putto which he doubtless thought to be Puget's but which was probably by Du Quesnoy. He had a plaster copy of this Putto in his studio and used it in his painting. His attraction to the *Hercule* must have been in large part through its theme, since the figure lacked 'the mistral which agitates the marble' (Gasquet) and which could be found in the Milo, the Perseus and Andromeda, and other works he copied. Denis was right in declaring after his 1906 visit, 'He loved exuberance of movement, the bulging of muscles, boldness of touch . . . he drew after Puget'.

If we look at the drawings we see that he first did the whole body, then drew the upper part or head; he preferred the back view with tensions, which at times he stressed to the verge of grotesqueness. (Contemporary reproductions also chose the back view.) What interested him above all was the relationship of the chest and other parts of the body. He used the enclosing arm, thigh, and so on, as a sort of frame for the powerful contractions of the muscles of the chest, with head turning in an opposite direction. In the *Hercule* he was, then, dealing with a similar set of tensions to those we discussed in the bather with diagonal arms; but what he was seeking here was to use the dynamic set of tensions, enclosed in a sort of framework of power, to express a resolution of the conflict between disarticulation and integrated purpose. The strong body is pulled in various directions and yet in the last resort defines a harmony of tension and repose, a gathering of forces for the liberating act.

The *Hercule Gaulois* thus stood for Paul as both the *pictor semper virens* and the whole world of creative labour. The figure was meant by Puget to represent the Greek Herakles, but contemporary thought saw it as a sort of symbolic Worker. E. Chesneau, who knew Paul, in his work on Puget (1882), declared that it 'is not the Greek Hercules, but in fact a Gallic one, what is today called a work of realism'; by *Gallic* was meant (Larousse tells us) 'uncultivated, barbarous, crude'. Lagrange in 1868 had considered the work to express in the highest degree, 'not the dignity of a son of Jupiter, but all the elements of physical force appropriate to a Herculean type'.

Though Paul did not make any direct use in his art of the *Hercule Gaulois*, he repeated

the pattern in various academic drawings and bather-compositions; and later had it in mind in choosing the angle from which he made copies of other baroque statues. In any event his obsession with the statue gives us much insight into his mind and his attitudes to work in these later years. He wanted to be the *Hercule Gaulois*, the artist with perpetually vigorous body, who was the supreme emblem of creative labour in all fields; he wanted to infuse the vigour of the Herculean artist into all he did, making every form, even that of a flower, express its tensions and triumphant harmony.

On September 1st he wrote to his niece Paule Conil, with thanks for remembering him. 'The thought touches me and reminds me at the same time that I am still of this world, which might not have been'. The day before he had been to dine with his sister Marie.

I recall perfectly well the Establon and the once so picturesque shore of l'Estaque. Unfortunately what we call progress is nothing but the invasion of bipeds who never pause till they have transformed everything into hideous quais with gas lamps—and what is yet worse—with electric light. What times we live in.

The sky which starts to be stormy has refreshed the air a bit, and I fear the water is no longer so warm that you'll take your bathes with as much pleasure, if indeed it allows you still this hygienic diversion.

Late in September he had a great shock. A labourer at Les Lauves had read in the newspaper of the death of Zola; he mentioned it to his master, whom he knew had been acquainted with the writer. Zola had been asphyxiated in his sleep by fumes from a coal stove (the matter is still obscure and he may possibly have been murdered by the reactionaries). Weeping, Paul shut himself in his studio for the rest of the day. 'He wept, suffered, and mourned a whole day' (M. Provence). In the evening he went to see old Solari. Next Sunday he attended his usual mass and on the way out he met Coste in the church doorway. They had not been friendly for years, as Coste ardently admired Zola and Paul had resented it (though Gasquet says that Coste was at the café table in 1896). The two men clasped hands in the square before the cathedral and murmured, 'Zola, Zola'.

Sometime in the autumn Paul went with his wife and son to stay with Larguier in the Cévennes. The Larguiers were simple countryfolk and Paul could relax among them. Larguier says he was gay and unconstrained, and his temper was not frayed even when the local notables were invited to a dinner in his honour. The clerk to the magistrate's court boasted that he had a chalk portrait of himself drawn by an itinerant artist at the Alais Fair —all done in three lines. 'And if M. and Mme Cézanne would take a glass of muscat with him tomorrow he'd be delighted to show it to them'. Paul merely smiled.

This year the Bernheims came to Aix and bought several canvases from Paul junior; and Octave Mirbeau tried to get Roujon, director of the Beaux-Arts, to give Paul the Legion of Honour. Vollard says the director was reaching for the drawer with the ribbons committed to his keeping, but when Cézanne was mentioned he drew back. 'Ah, M. Mirbeau, while I'm director here I must follow the taste of the public and not try to

anticipate it. Monet, if you wish. Monet doesn't want it? Let's say Sisley then. What, he's dead? How about Pissarro'. He mis-interpreted Mirbeau's silence. 'Is he dead too? Well then, choose anyone you like. I don't care who it is as long as you do me the favour of not mentioning Cézanne again.'

On 9 January 1903 Paul was feeling hopeful. 'I'm beginning to see the promised land', he told Vollard. 'Will I be like the great Hebrew chief or will I be able to enter?' But why had all this come about so late and so painfully? 'Is art really a priesthood that demands the pure in heart who belong to it wholly?' He wished he could draw closer to Vollard for moral support—'I live alone'. He cited some people, whom Vollard does not name, as unutterable. 'It's the clan of intellectuals, of what weight, good God.'

By February 22nd, writing to Camoin, he was tired. He asked Camoin to call on young Paul, who was 'rather shy [*ombrageux*], an *indifferent*, but a good lad. As intermediary he smoothes for me the difficulty I find in grasping life'. But the main question was work. 'All things, *above all in art*, are theory developed and applied in contact with nature'. He added in a postscript: 'When I see you, I'll speak more properly about art to you than to anyone else at all. I have nothing to hide *in art*. The initial force, *id est*, *temperament*, alone can bring anyone to the end he must attain.'

In March came the sale of the Zola art-collection, which included ten works of Paul's youth. They reached prices higher than works by Monet and Pissarro: 600 to 4,200 francs as against 2,805 for a Monet and 900 for a Pissarro. *Truth coming out of the Well* by the academic Debat-Ponsan fetched only 350. On March 9th Henri Rochefort in the *Intransigeant* made a violent attack on both Zola and Paul in an essay on 'The Love of the Ugly'; he wrote that ' "Young France", rivalling Zola, the smooth-haired intellectuals and the snobs of Dreyfusism . . . preferred not to expose themselves to the jokes that they, Jews or Judaizers, all freethinkers to the backbone, would not have failed to provoke in the midst of such a display of "godly junk" ' and 'modern paintings which the master had mixed with these rakings from the back of an antique shop' and which 'aroused the sheer hilarity of the crowd'. He saw Paul as an ultra-impressionist and said that even the most eccentric of the school, like Monet and Pissaro, were 'academics, almost members of the Institute, beside this strange Cézanne'. The crowd was especially amused by the head of a man 'whose cheeks were sculptured with a trowel and who seemed to be the prey of an eczema'. With an odd irony Rochefort damned Paul as the mere reflection of Dreyfusard Zola.

We have often declared that there were Dreyfusards long before the Dreyfus affair. All the sick brains, the crackbrained souls, the squinting and the maimed, were ripe for the coming of the Messiah of Treason. When we see nature as interpreted by Zola and his vulgar painters, it is quite simple that patriotism and honour appear to you in the form of an officer handing over to the enemy the defence-plans of the land. The love of physical and moral ugliness is a passion like any other.

In fact, if one went deep enough (as we have noted from time to time), there were many

close links between the work of Zola and that of Paul; but Rochefort was concerned only with crude polemics. Once again advanced art was identified with revolutionary politics.

The Aixois were delighted with the essay, which confirmed their view of Paul as a disreputable loafer who had sponged all his life on a respectable father. Gasquet says that 300 copies were ordered and slipped under the doors of anyone, near or far, who was thought to have shown any sympathy for Paul. 'All the wicked chatter that reached him overwhelmed him. Threatening letters, with scurrilous anonymous insults, were addressed to him at the Rue Boulegon. His family, his few friends, were calumniated. He was given orders to cease embarrassing with his presence the town he dishonoured'. Gasquet may have exaggerated, but we have a scrap of a letter from Paul to his son: 'Useless to send it to me, daily I find it under my door, without counting the copies of *l'Intransigeant* sent to me by post'. He hardly dared to leave his house. However, Geffroy continued to defend him. In the volume of *The Artistic Life* published this year he wrote:

If he is not scoffed at as in the past, he is still regarded with surprise by certain persons who do not make the effort to understand the decorative sense, the amplitude of form, the brightness of colour, which makes of this Aix painter a sort of Venetian, possessor of a new style, of a personal gravity.

On June 25th Paul wrote to Gasquet, who continued to send him his publications (this time, *Chants Séculaires*): 'March on and you'll continue to mark out for Art a new way leading to the Capitol'. Then on September 5th he made further excuses for his long-delayed visit. Gasquet had called at the Rue Boulegon and Paul had missed him. He declared that he must work for six months on a canvas for the Salon (which was rejected); after that he'd come. 'If I delay in visiting you, the cause lies in the inextricable situation from which I'm burning to escape. Ten thousand or nothing is what I need, or indeed I should, like Bourdelet [?] and the cretins with whom he has business, inspect the streets, know which wretched woman it is that produces a child before going through the *mairie*, and understand what a nice intellectual level'. Gasquet may have understood this letter, but we cannot. In any event Paul was evading the issue; he had found time to visit the Larguiers.

On September 13th he wrote to Camoin, who was now free to give himself up to his studies. Happily, though in a tortuous sentence, he writes of Monet as a good friend.

I thought I told you in talk that Monet lived at Giverny. I hope the artistic influence that this master cannot fail to exercise on the more or less direct entourage which surrounds him, will be felt in the strictly necessary measure it can and should have on an artist young and well disposed to work. Couture used to tell his pupils: Keep good company—that is, Go to the Louvre.

But after looking at the great masters resting there we must hurry out again and by contact with nature revive in ourselves the instincts, the sensations of art that reside in us. I'm sorry not to be able to be with you. Art wouldn't matter much if other considerations didn't stop me from leaving Aix. Still I hope soon for the pleasure of seeing you again. Larguier is in Paris. My son is at Fontainebleau with his mother.

What should I wish you, Good studies in nature's presence, that's the best thing. If you meet

the master [Monet] we both admire, remember me to him. He doesn't much like, I think, being bothered, but in view of your sincerity, perhaps he'll relax a bit.

The weakening of Gasquet's influence and the shock of Zola's death seem to have brought Paul back to something more like his pre-1896 attitudes.

On the 25th he congratulated Aurenche on the birth of a son. His own son was at Fontainebleau. 'I work obstinately, and if the Sun-of-Austerlitz of painting shines for me, we'll go in a band to clasp your hand'. Solari was now again his sole friend. They dined at Paul's home or at Mère Berne's eating-house at Le Tholonet. His niece tells us that Rosa Berne's establishment 'is not even a village-inn, but only a simple grocery-shop, but Rosa knows how to cook in the way that suited him. It's always *charcuterie de village*, an omelette with truffles or mushrooms, and the famous duck with olives and carrots, fruit in season, all watered with a good little white wine from the slopes of Ste Victoire'. Late one night there was a tremendous clamour from his flat and neighbours hurried to Mme Brémond. She reassured them: it was only the two old men arguing on art. Maybe this time they had drunk a whole bottle of brandy without noticing. Paul still had his bragging moments now and then. 'In France there are over a thousand politicians in every administration, but only one Cézanne every two centuries'. Often he came home from work so tired that he could hardly stand or speak; after a quick dinner he fell into bed; then was off again at dawn.

Marie kept a strict eye on him. Objecting to his generosity with alms after mass, she ordered Mme Brémond to see that he did not have more than 50 centimes in his pocket when he left home. She was doubtless responsible for the fact that one day, while he was out, the housekeeper took on herself to burn his sketches of *Baigneuses*. A woman who sold wine and liqueurs on the Place des Trois Ormeaux asked her, 'How is Monsieur?' 'Not very well'. 'Is Monsieur painting?' 'O, such horrors, I've just come down from burning a whole heap of naked women. I can't leave them for the family's sake. What would people say?' 'But some of them may be good'. 'They're horrors'.

This year, 1903, he showed seven paintings at the Vienna Secession, and later three others in Berlin. An Austrian critic was grieved at the increasing number of Paris collectors who 'call Cézanne the greatest of living artists and venerate him like God'. In November Pissarro died, and not long after Gauguin was to die in the Marquesas.

V The End (1903-6)

PAUL was showing the ravages of his diabetes; his eyes were swollen and red, his face puffy, his nose rather purple. It is clear that after his troubles of 1885-6 his fear of death, long active, gained a much intensified force; and if it hadn't been diabetes, it would have been some other ailment that thenceforward dogged him and brought him down. He must, indeed, have had a strong system to have lasted as long as he did in his anxiety-ridden state and his down-dragging conviction of impending death. With all his fears he does not seem to have kept to any strict regimen, though we hear of him refusing the richer dishes eaten by guests. On 25 January 1904 he told Aurenche that he hadn't seen Gasquet for a long time. On art he commented, 'I think that daily I come closer, though somewhat painfully. For if the strong experience of nature—and certainly I have it—is the necessary basis for all conception of art on which rests the grandeur and beauty of all future work, the knowledge of the means of expressing our emotion is not less essential and is only gained by a very long experience'. On the 29th, tired out after a day's struggle, he lacked the clarity at evening, he said, for letter-writing.

Some new friends were coming into his life. Especially important was Emile Bernard, who had wanted to meet him since the Tanguy days when he was an art student. In February he and his wife, with two children, landed at Marseille on their way back from Egypt and decided to go to Aix. Bernard found at the house an old gentleman wrapped up in a large cape and carrying a sort of game-bag. He introduced himself and Paul recalled the notice he had written as far back as 1890. 'I was just on my way to the motif. Let's go together'. Pleased with this cordial reception, Bernard took lodgings at Aix for a month and saw Paul almost every day. Visiting the Bernard's place, Paul noticed a still life. 'But you really are a painter!' As the lighting was bad, he put one of the lower Lauves rooms at Bernard's disposal. Bernard painted there and went with Paul to the motif, where he watched him work. Paul surprised him by saying that he used photographs. Once at Paul's house Bernard was taken into the bedroom to see a volume with a Van Ostade in it; he noticed a crucifix above the bed in the alcove (but had it been put there by Marie?) and the Delacroix *Flowers* turned with its face to the wall, to stop it from fading in sunlight.

Bernard liked theorizing about art and kept questioning Paul: On what do you base your perspective? What do you mean by the term nature? Are our senses perfect enough to be able to record without error what you call nature? (He was soon to become the champion of Neo-classicism and his bias coloured his whole approach to Paul's work and the way in which he reshaped Paul's comments.) The questioning irritated Paul. 'Believe me, none of

that is worth Cambronne's word [shit]'. (The euphuism 'Cambronne's word' is certainly the result of Bernard's polite editing of Paul's faecal way of talking.) 'These things are thought up by university professors . . . Be a painter, not a writer or a philosopher'. When Bernard persisted, Paul replied angrily, 'Do you know that I consider all theories ridiculous', and walked off, muttering 'The truth is in nature, and I shall prove it'. Bernard also found his letters disappointing. With Van Gogh he had been able to get down to definite elements of aesthetic theory, but Paul was more baffling. Bernard began to wonder if he had any clear idea of the problems he was tackling; indeed if he were at all intelligent. Still he records some of Paul's remarks:

> One had to return to classicism through nature, that is through sensation.
> One draws in the process of painting. The more the colour harmonizes, the more precise the drawing becomes. When the colour has reached its full richness, the form has reached completeness. The secret of drawing and modelling resides in the contrasts and relationships of tones.
> Work regardless of anyone and achieve mastery. That should be the artist's goal. The rest is not worth Cambronne's word.
> Begin lightly and with almost neutral tones. Then go on climbing the scale, intensifying the colours more and more.

The first sentence there is an example of how one has to read the remarks of Paul's that these later acquaintances quoted, in terms of the quoter's ideas. Probably there was an exchange of ideas on something like the following lines. Bernard was insisting on the need to return to classical bases and at last Paul, irritated, said something like, 'All right, if we have to return to classicism, it's got to be done through sensation, for that's where the real clues lie'. The same kind of basis lay behind the remark that 'what he [Paul] believes one can ask of the ancients, is their classic and serious way of logically organizing work'.

Bernard had begun in the Pont-Aven group round Gauguin with a liking for decorative refinement, naivety, hieratic purity of line. Then by 1895 he moved towards a sort of mystical neo-platonist aesthetic. In a poem composed in Egypt before his Aix visit, he wrote:

> Black, olive or brown the picture, what's it matter?
> Poussin, Carrache, Lebrun, we must love them all,
> We must learn to appreciate each powerful work.

He thus was identifying Poussin and the academic tradition; in fact before this 1904 visit he had been in Spain and Italy, spending much time in Venice; his work became in effect a pastiche of Venetian art in a darker key. But already in the 1880s attention was being paid to Poussin in the reaction against impressionist methods. Van Gogh noted in September 1806, 'People talk a great deal about Poussin. Bracquemond also speaks of him. The French call Poussin the very greatest painter among the old masters,' and in his next letter saw him as a symbolist. The 1890s saw a further reaction that denounced symbolism and *décadence* and wanted a return to Graeco-Roman order. Thus L. Anquetin, who began in

Seurat's circle then turned to Daumier and Courbet, came round about 1896 to Michelangelo and Rubens, and buried his former paintings in his garden. Though we cannot simply reduce this turn to the reactionary political development which accompanied it, there was clearly a strong connexion. The new evangel of classical order was strongly linked with attempts to bring about a Catholic revival, with notions of 'integral nationalism' such as we found in Gasquet, and with royalist politics. There was a conscious rejection of the radicalism and anarchism which were associated with the impressionist and symbolist movements. Not all artists were swept into the new current; for example, Vuillard, Bonnard, Lautrec and Matisse resisted it. But the poets and painters who surrounded Paul in the wake of Gasquet were largely exponents of the reactionary neo-classic viewpoints.

Denis, an Ingres classicist, was the one who linked Paul with Poussin. He called him, in reference to the Autumn Salon of 1905, 'the Poussin of still life and green landscape'; two years later he defined him as 'the Poussin of Impressionism'. As early as 1898 he had linked Poussin with the poets of discipline and order in *Le Spectateur Catholique*. In 1897 Poussin had come into his *Journal* and the following year he discovered Renascence art in Rome, with his friend Gide as guide—he then published his first essay on classicism, followed by a long study of Ingres' pupils, which exalted Raphael and Poussin. Bernard and others took over from him the connexion of Poussin and Paul. Bernard said nothing of Poussin in his first account of his visit, the only one which Paul saw, and he made no attack on the impressionists; on the contrary he cited Paul as calling Courbet, Manet, Monet, the best painters, and as adding, 'Pissarro has been close to nature'. But in 1907, after Paul's death, he coined the phrase, 'Imagine Poussin wholly redone after nature, there is the classicism I mean,' and put it into Paul's mouth. At most Paul might have said something like, 'If it's a question of returning to Poussin and the like, then it would have to be Poussin done all over again from the ground up'. He would certainly not have brought Poussin in at all of his own accord, and the programmatic tone that Bernard gives to the statement was quite foreign to his whole outlook.

This is an important matter; for Bernard's formulation fitted in with preconceptions of the time and has done a great deal to distort the understanding of Paul's real aims. Bernard himself was a religiously-minded dualist; his poems describe the world as a tormented conflict between gross sensuality and mysticism; he was essentially opposed to Paul's fundamental ideas—art as the re-creation of nature through sensations—and he finally recognized this fact. By 1926 he totally rejected the idea of 'becoming classic *par la nature*', which in 1904 had seemed 'the healthiest, the most misunderstood' attitude; and he denounced Paul's views as anti-classic, as 'bringing painting back into the slavery of appearances', which meant for him a return to academicism.

But meanwhile the damage had been done. The Poussin-thesis provided an easy way of evading the true nature of Paul's art and of fitting it into a climate of art expression and art criticism to which Paul would have been uncompromisingly hostile. Gasquet had written a

poem on Poussin (published 1903) as well as one on Descartes; he depicts Paul as a champion of the new order in the passage cited above about the *Baigneuses*, 'a Discourse on Method in action', and so on. He made his Paul declare, 'I'd like, as in *The Triumph of Flora*, to marry curves of women to shoulders of hills', and, 'as Poussin did, put reason in the grass and tears in the sky'. Vollard repeated Bernard's phrases, setting them in Paul's mouth. Larguier took up the theme, 'More than twenty years later it pleases me to conjure up the prayer he uttered without moving his lips: To bring Poussin to life according to nature . . . so be it'. And he turned the idea into a poem:

> To want to bring Poussin to life according to nature
> Should surely cause no offence.
> All is shadow, light, and colour.
> Line and Drawing are abstractions.

By 1914 L. Werth was confidently asserting, 'Cézanne recommended young painters to draw their stove pipes. He used to tell them also, or almost, "It's necessary to re-do Poussin according to nature"'. T. Duret in 1906 wrote that Paul knew the Old Masters well through the Louvre; in 1914 he added, 'Poussin in particular'. (Paul does seem to have told F. Jourdain that he advised a young artist to copy his stove-pipe. If so, he was recalling his own early painting of his studio stove, a subject treated by both Delacroix and Corot.)

 All this is not to say that Paul did not admire Poussin. He had a reproduction of Poussin's *Et in Arcadia Ego* in his studio. But he made only three copies after Poussin as against 56 of Puget figures, 27 after Rubens, 26 after Michelangelo; and it is clear from his own writings that Rubens and Tintoretto were the artists he supremely admired. The copies he did make from Poussin are of a shepherdess and a kneeling shepherd (*Et in Arcadia*) and a putto (*The Concert*). They seem of 1890–5, and deal with small points of interrelated forms, not with the over-all compositions. Rivière and Schnerb who visited Paul in 1905 give a reliable account. They stressed his admiration of Monet and Courbet, for sensitivity to light and colour, and for broad solid execution. Of Old Masters, 'Veronese was among those he thought most of at his life's end'. Also, 'he loved Poussin, with whom reason supplemented facility'.

 To return to Bernard at Aix in 1904. He saw Paul constantly at work on his large *Baigneuses*, which was 'in a state of utter confusion'; he saw him work at landscapes at Château Noir and at still lifes in the studio. He was astonished at his unceasing toil. He watched a still life of three skulls change colour and form almost daily. While working on the ground floor, he could hear Paul pacing in the studio above; often he saw him come down to sit in the garden deep in thought, then hurry upstairs again. Once Paul watched Bernard at a still life, found fault, and wanted to correct the painting; but when Bernard handed him his palette, he burst out, 'Where is your Naples yellow, and where's your peach-black? Where are your raw Siena, your cobalt, and your burnt lake? You can't paint without those colours'. Bernard noted Paul's palette at this time:

Cobalt blue, ultramarine, Prussian blue, emerald green, viridian, terre verte, vermilion, red ochre, burnt Siena, rose madder, carmine lake, burnt lake, brilliant yellow, Naples yellow, chrome yellow, yellow ochre, raw Siena, silver white, peach-black.

When not painting or worrying about his work, he was good-humoured and even gay. He dined with the Bernards at their flat in Rue du Théâtre, played with the children, and called himself Père Goriot. But soon he thought of work again and fell silent; the children were sent to bed. While dining, he often gazed at the fruit, dishes, glasses and plates, or studied his hosts' faces 'in the play of lamplight and shadow'.

One day he invited the Bernards to walk on the hills above the Château Noir, and surprised them by his agility; all the while, though panting, he chattered on. 'Rosa Bonheur was the hell of a woman', he remarked, scrambling on the rocks. 'She knew how to devote herself entirely to painting'. On the way he discussed his favourite poets and declaimed *La Charogne* (Vollard no doubt borrowed this detail from Bernard). He recalled with gratitude his days at Auvers with 'the humble and colossal Pissarro', who taught him how to see colour. 'He was a father to me'. Next moment he was waving his stick at a road-surveyor and his engineers, the maniacs who made everything ugly with straight lines. But he was too ill to remain vigorously angry. 'Don't let's talk of it any more. I'm too tired, too exhausted. I ought to be sensible, stay at home, and do nothing but work.'

One day Bernard and Paul, coming home from the motif, took a short cut on steep ground. Paul, ahead, caught his foot and almost fell; Bernard took hold of his arm to steady him. Paul exploded with rage, cursed furiously, pushed Bernard off, and dashed away, throwing wild terrified glances back over his shoulder. Bernard followed him to the studio and tried to explain; but Paul with 'his eyes starting out of his head', wouldn't listen. 'I allow no one to touch me. Nobody can put his *grappin* on me'. In bewilderment Bernard went to his rooms. That evening, as he was preparing for bed, there was a knock. Paul had come to inquire about an earache from which Bernard had been suffering; he was in an amiable mood, apparently having quite forgotten the episode. Next day Bernard told the story to Mme Brémond, who assured him it all meant nothing and that Paul had spent the evening in Bernard's praise. She herself had strict orders not to touch Paul, not even to let her skirts brush his chair while she served him. Finally, in explanation Paul told Bernard the story of a kick from behind on the school stairs, which we noted earlier. The story may have been quite true, but could not possibly explain such a deep-rooted phobia, in which we see elements of a paranoiac fear of attack from the rear, an emotion of sexual guilt which made him dread the nemesis of that attack, an anxiety-derangement of his senses that deeply affected his relations with women and was linked with his perpetual fear of artistic impotence. In a more diffused form we can trace the elements of this fear back to his youth; but they cohered in an intense form only in his later years, strengthened by the failure of his relations with Hortense in the 1870s and given a sharpened impetus by the events of 1885-6.

Despite the imperfect understanding between Paul and Bernard on matters of art, his letters to Bernard are the most important source of his opinions. We now have six of them in succession; in the first two he asks for the children to be given 'a good kiss from Père Goriot'.

(April 15th) Allow me to repeat what I was saying here: treat nature by the cylinder, the sphere, the cone, the whole put in perspective, so that each side of an object, of a plane, is directed towards a central point. The lines parallel to the horizon give the extension, whether it's a section of nature, or, if you prefer it, of the spectacle that the *Pater Omnipotens Aeterne Deus* spreads before our eyes. Perpendicular lines at that horizon give the depth. Now, for us men, nature is more in depth than in surface, whence the need to introduce into our vibrations of light, represented by reds and yellows, a sufficient amount of blues, to give the feeling of air.

Allow me to tell you I've had another look at your study on the studio's ground floor; it's good. You've only, I think, to carry on like this, you've the understanding of what must be done, and you'll soon reach the point of turning your back on the Gauguins and Van Goghs.

(May 12th) As I've told you, Redon's talent attracts me very much, and I am of accord with him in his feeling and admiration for Delacroix. I don't know if my precarious health will permit me ever to realize my dream of painting his Apotheosis. I proceed very slowly, since nature presents herself to me as very complex and the progresses to be made are unending. One must see one's model and feel it with extreme precision, and further express oneself with distinction and power. Taste is the best judge. It's rare. Art can address itself only to an excessively restricted number of persons. The artist should disdain an opinion which doesn't rest on the intelligent observation of character. He should shrink from the literary spirit which so often makes the painter turn aside from his true path, the concrete study of nature, to lose himself overlong in intangible speculations. The Louvre is a good book to consult, but it should still be only an intermediary. The real and prodigious study to undertake is the diversity of the picture of nature.

In the remark about cylinder, sphere and cone, Paul is not in any sense advocating abstraction; he is trying clumsily to explain how he sees structures in terms of depth and depth in terms of colour. As for the *Apotheosis of Delacroix*, he made several studies; one can be seen in a photograph taken in 1894. And on the back of a watercolour working out the theme, Bernard found six verses by Paul:

> Here's the young woman with plump bottom, see,
> In meadow-midst she stretches pleasantly
> Her supple body, splendidly expanded.
> Such sinuous curves in adders you'd not meet.
> The Sun obligingly beams down and sends
> Some golden rays upon this lovely meat.

The last word is *viande*. We are reminded of the cannibalistic vision of Ugolino with the skull being eaten at the parsimonious family-table; and of the way in which in *The Belly of Paris* Zola in a long passage of poetic virtuosity defines the fruit and flowers of the market in sexual terms, as aspects of femininity—with the comment by Claude, 'What I think is so exasperating, so unjust, is that these scoundrelly bourgeois should actually be in a position to eat all this'. For Paul the apple, orange, peach, we saw were from one angle love-fruit,

which were also symbols or images of the curved and rounded woman they evoked. Bernard was engaged in writing an essay on Paul for *Occident*. Paul wrote:

(May 26th) I always return to this: the painter should dedicate himself wholly to the study of nature and try to produce pictures that are an instruction [*enseignement*]. Talks on art are almost useless. The work that makes one realize progress in one's own trade is a sufficient compensation for not being understood by imbeciles. The writer uses abstractions for expression while the painter makes concrete, by means of drawing and colour, his sensations, his perceptions. One cannot be too scrupulous or too sincere or too submissive to nature; but one is master of one's model and above all of one's means of expression. Penetrate what is before you, and preserve it in expressing yourself as logically as possible.

(June 27th) The weather's fine and I take advantage of it to work. I ought to make ten good studies and sell them at a high price now that the collectors are speculating in them . . . It seems that Vollard some time ago gave a dancing party where there was quite a beanfeast. All the young school were there, it seems, M. Denis, Vuillard, etc. Paul met Joachim Gasquet there. I think the best thing is to work a lot. You are young, realize, and sell.

You recall the fine pastel by Chardin, equipped with a pair of specs, a vizor shading his eyes. He's a sharp one [*roublard*], that painter. Have you noticed that by placing a cross-plane like a ridge across the nose he brings out the values more clearly. Verify this fact and let me know if I'm mistaken.

He thought that Hortense and young Paul had rented rooms at Fontainebleau for a couple of months. He himself was having his lunches brought out into the country on account of the heat.

In the letter of May 26th he stated his belief in a dialectic of artist and nature. What the artist found in nature must be wholly respected, and yet as master of his method he was also master of the model, and thus in some sense transformed it. But just what happened in the moment of impact and fusion he could not explain. He knew what happened when the process was going on, but he could not find words for it. Hence his rages about theorizing and literary talk.

The misunderstanding on this point was crucial for the distortion of his art by the symbolists and then by the neo-classicists (often in the same persons). Denis tells us how Paul anticipated the symbolist aesthetic by substituting *reproduire* for *représenter*; but in fact he did nothing of the sort. What the symbolists meant by *reproduire* was something quite different from what he meant by *réaliser*. In the first there is a schism between the observer and the object; in the second there is a dynamic unity. In the first the artist imposes certain patterns or disposes of his material in some pre-concerted way, to gain an effect or a meaning that is in his mind rather than in nature; in the second there is a vital fusion of the processes of observation and reproduction with the processes of nature. What is painted is not in the last resort a thing; it is a process. And both artist and nature are dynamically implicated.

His sense of the dual aspects of the activity of painting, and his inability to explain how they came together, are illustrated by his remarks to Francis Jourdain, one of the young artists visiting him in his last years. In front of the *Baigneuses* he said that 'painting is in

here', tapping his brow; then insisted that his purpose had always been to convey the real distance between the eye and the object, and that true progress could only be based on nature.

On July 25th he thanked Bernard for his essay.

I regret we can't be together; for I want, not to be theoretically in the right, but right in terms of [*par*] nature. Ingres, in spite of his *estyle* (Aixois pronunciation) and his admirers, is only a very small master. The greatest ones, you know them better than I: the Venetians and the Spaniards.

For progresses towards realization there is only nature, and the eye is educated by contact with her. It becomes concentric by force of looking and working. I mean that, in an orange, an apple, a ball, a head, there is a focal point [*point culminant*], and this point is always the nearest to our eye— despite the shattering effect: light and shadow, colour-sensations. The edges of objects recede towards a centre located at our horizon. With a little temperament one can be very much of a painter. One can do fine things without being a great harmonist or colourist. It's enough to have a feeling for art, and no doubt it's a feeling that horrifies the bourgeois. So that institutes, pensions, and honours are meant only for the cretins, the humbugs, the rogues. Don't be an art critic. Paint. There lies salvation.

On July 27th he wrote at long last about arrangements to visit the Gasquets. 'Shaking off my torpor, I emerge from my shell and am going to make all efforts to follow up your invitations. I went to the Musical [? Circle] to get some information from my friend your father as to the voyage to be undertaken. Please tell him to give me some indications as to the time of train-departures and the point of rendezvous'. It appears as if he went; and it seems there were quarrels. Paul on a visit into which he had been forced was not likely to be amiable; and apparently all the resentments he had been harbouring against the Jo now burst out. Gasquet tells us nothing about the break, but it existed henceforth.

On September 24th he invited Solari to a Sunday lunch; he was sitting to the sculptor for a life-size bust. On October 11th he replied politely to a letter of homage from the dealer Bernheim-Jeune. Soon after he must have left for Paris. The Autumn Salon was making a special attempt to impress the public with his work, and he was showing several canvases. Paul's heart seems to have failed him. Jules Renard noted in his Journal for October 21st, 'Cézanne barbarian. One must have admired a great many famous daubs before liking this carpenter of colour'. Then he set down his version of the legend. 'The beautiful life of Cézanne, all passed in a village in the South. He didn't even come to his own show. He'd like to be decorated. That's what is wanted by all these poor old painters, who, after an admirable life, see at last, as they approach death, art dealers getting rich on their work'. The Salon was open from October 15th to November 15th; and there were still many attacks on his work. 'False, vulgar, and mad', *L'Univers*; 'might have been done by a Madagascan', *Le Monde Illustré*; 'Ah Cézanne, blessed are the poor in mind, for theirs is the kingdom of art', *La Revue Bleue*. *Le Petit Parisien* thought his work was like the patterns made by schoolboys folding paper over inkblots. One line of attack was to declare, 'Cézanne owes his reputation to Emile Zola', Jean Pascal in a pamphlet on the Salon.

Perhaps Paul was afraid of meeting the old friends from whom he had turned. He was staying at 16 Rue Duperré, not far from the Place Pigalle. People began calling on him, so he went to Fontainebleau.

On December 9th, back at Aix, he wrote to Camoin who was in Marseille, and bade him come whenever he liked.

I have lunch at eleven and then I set off for the motif unless it rains. I have a baggage depot 20 minutes away from my house. The reading of the model and its realization is sometimes very slow in coming for the artist. Whatever master you prefer, this must be only a directive [*orientation*] for you. Otherwise you'll never be more than an imitator [*pasticheur*]. With any sort of feeling for nature and some happy gifts—which you have—you should manage to disengage yourself; advice, the methods of another, shouldn't make you change your own way of feeling. Should you momentarily undergo the influence of someone older than yourself, believe me, as soon as you begin to feel yourself, your own emotion will always end by coming out and conquering its place in the sun,— *get the upper hand*, confidence—what you need to arrive at possessing is a good method of *construction*. Drawing is only the configuration of what you see. Michelangelo is a constructor, and Raphael, an *artist* who, great as he may be, is always constrained by the model. When he tries to become thoughtful, he falls below his great rival.

Bernard replied from Naples, and on December 23rd Paul wrote:

Yes, I share your admiration for the most valiant of the Venetians; we both bow to Tintoretto. Your need to find a point of moral, intellectual *appui* in works that will assuredly never be surpassed, puts you constantly on the *qui vive*, on an unceasing quest for the means, steadily grasped, that will lead you certainly to feel through nature what your means of expression are; and the day you've reached that point, you may be sure you'll find, without effort and through nature, the *means* used by the four or five great men of Venice.

This is incontestable—I am very positive—an optical sensation is produced in our visual organ which causes us to grade, in terms of light, halftone and quartertone, the planes represented by sensations of colour. (Light then doesn't exist for the painter.) As long as, inevitably, you go from black to white, the first of these abstractions being a point of support [*appui*] as much for the eye as for the brain, we flounder about, we don't succeed in gaining mastery, in possessing ourselves. During this period (I unavoidably repeat myself somewhat) we go to the admirable works that the ages have handed down to us, in which we find a strengthening, a stay, as the plank is for a swimmer.

The letter is difficult; but he seems to be saying that the problem is not to deal with light either in the impressionist or in the academic manner, but to grasp the colour-gradations in all their subtlety of movement. The artist will then define the variations of planes, which give both depth and form, out of his 'sensations of colour'. Truth to those sensations is dependent on the analytic precision by which the eye and the brush can define the modulations. What he seems to be opposing is the impressionist stress on reflected lights.

Sometime this year he wrote thanking Jean Royère for his *Poèmes Eurhythmiques*. 'Unfortunately the advanced age I've now reached makes the approach to new formulas of art hard for me'. He sent nine works to Brussels; and he wrote to Geffroy, contributing to the fund for Rodin's *Penseur*. He was said to have done so on hearing that Geffroy and Rodin had commented on the fact that the subscribers were all Dreyfusards.

He had been working now for ten years on the *Grandes Baigneuses*. Would he ever be able to complete it? He never did; and despite many fine qualities his attempts remained for him a failure. He wanted to achieve a composition as 'realized' as the great Rubens canvases, but realized in a different way: in terms of his colour-vision with its new treatment of volume and form, edges and planes, picture-surface and depth. What prevented him from achieving what he wanted was his increasing physical weakness plus the exacting treatment that his vision demanded for every inch in its colour-modulations over such a large area—a treatment that needed both its precise local definition and its harmonious control of the whole. If one looks at, say, the *Grandes Baigneuses* in the London National Gallery long enough and thoroughly enough, one can achieve something like his own trance-sight and suddenly get a glimpse of the unity in depth and surface-movement which he sought. The composition in these later versions, however, tends to be forced and schematic in comparison with the living rhythms of earlier and smaller works with the same sort of theme.

With his poor health he must have found it difficult to cope with the number of visitors he now attracted. On 5 January 1905 he wrote to Camoin about lodgings in Aix. Five days later he told Aurenche, 'I'll continue with my work, and that without paying any heed to criticism and critics, as a real artist should do. My work must prove I'm right. I've no news of Gasquet, who is, I think, in Paris at the moment'. (Aurenche must have inquired after Gasquet.) On January 17th he defined what he wished to all sympathizers of art: 'to succeed in formulating sufficiently the sensations we experience in contact with this beautiful nature—man, woman, still life—and to find favourable circumstances'. On the 23rd he thanked Roger Marx for two essays in the *Gazette des Beaux-Arts* on the Autumn Salon (December 1904), in which even one of his landscapes had been reproduced. 'My age and health will never allow me to realize the dream of art I've been pursuing all my life. But I'll always be grateful to the public of intelligent amateurs, who had, despite my own hestitations, the intuition of what I wanted to attempt for the renewal of my art. To my mind one does not substitute oneself for the past, one merely adds to it a new link. With a painter's temperament and an ideal of art—that is, a conception of nature—all that's needed are the means of expression sufficient to be intelligible to the wide public [*public moyen*] and to occupy a fitting place in the history of art'. It is noteworthy that here, in his last days, he shows a wish to reach the general public. No doubt this change derived from the fact that at long last he was widening his audience and could hope for this development to go steadily on; he no longer needed to console himself with remarks about fine art appealing only to a minority.

Bernard was again in Aix in March. At lunch Paul kept glancing affectionately at his son and repeating, 'Son, you're a man of genius'. On the 23rd he was indisposed and couldn't attend to the return of some cinnabar green that a colour-merchant had sent him; he asked for five Prussian blues and an urgently needed bottle of siccative.

This year he was visited by a caricaturist who wanted to paint, Hermann Paul, and his

future wife Pauline Ménard-Dorian, divorced wife of a grandson of Hugo and member of the republican aristocracy. Paul liked Hermann's head and asked him to sit. Hermann agreed; for though the sittings were rather frightening, he wanted a chance to observe Paul himself. As soon as he left the studio, he made drawings from memory, which he later used for a large expressive painting of Paul in slippers staring at his model. Paul used the sittings to draw Hermann out about Mirbeau, whom he pretended not to know; he wanted to find out just how much influence the writer had. The failure to get him the blue ribbon had rankled and he perhaps suspected that Mirbeau hadn't tried with all his might. He spoke scornfully of Gasquet, 'the rhymester who thinks himself Victor Hugo', in strong contrast with his earlier lavish praises. When Pauline, showing an interest in Paul's work, asked the price of a picture, he grew abruptly suspicious and replied rudely, 'I have no reason to offer you a present'. Now that his work was selling he behaved very differently from the days when he frequently gave works away. (Vollard mentions a friend, F. Champsaur, who some ten years previously had called at the Jas with greetings from Pissarro; Paul promptly pressed on him two flower-pieces he had praised; and Champsaur, who didn't want to be burdened with them, accepted the gift out of politeness.) Hermann and Pauline, offended at Paul's discourtesy, rose and left; but when they had returned to Paris, Paul apologized. In the earlier part of their stay at Aix, they had gone into a café with Paul. Hermann, very well dressed, was clearly prosperous; and some local notable came up, hoping to be introduced. 'So you have company today, M. Cézanne'. Paul replied, 'So today you recognize me'.

On July 6th he was at Fontainebleau. He wrote to a colour-merchant that he had received canvases and paints, but was impatiently waiting for his box and a palette with a hole for the thumb. He asked for burnt lake, cobalt, chrome yellow. He had gone once more to the north to escape the southern heat which he now found too fatiguing; but he could not face Paris. In August and September the *Mercure de France* published the results of an inquiry into 'the present tendencies of the plastic arts'. One question was wholly about Paul. 'Where do you place Cézanne?' The answers were very varied; some expressed admiration, others scorn and incomprehension: lasting value, 'genius', 'one of the great masters of French painting', and doomed to oblivion, 'a sour fruit', 'a drunken scavenger'. Sérusier's reply is worth citing; for it shows the penetrating enthusiasm as well as the ardent misconceptions which he and other young painters had brought to Paul's work, and which was to affect radically the influences it had.

Cézanne was able to clean away from pictorial art all the mould that time had deposited on it. He clearly showed that imitation is only a means, that the one goal is to arrange lines and colours on a given surface so as to charm the eye, speak to the mind, in fact create a language by purely plastic means or rather to rediscover the universal language. He is accused of harshness and aridity: these seeming defects are the external appearances of his power. His thought is so clear in his mind! his desire to express himself so imperious! If a tradition is born in our period—I dare hope it will be— it will be born of Cézanne. Others will then come, clever cooks who will stew up the remaining

scraps in more modern sauces. It is not a question of a new art, but a resurrection of all the sound pure classic arts.

Ten of his paintings had been hung in the Autumn Salon, but meanwhile Paul had returned to Aix. There to his surprise, in the *Mémorial*, a writer, citing Jean Puys, had praised him for having brought impressionism back 'to the traditional and logical path.' At Paris the critics, dealing with the Salon, now and then gave some praise, but mostly saw practical jokes, mud-painting, puerility, at best a Verlaine of painting, who 'by force of his isolation and tenacious gaucherie,' stumbled on some lucky strokes (*Art et Décoration*). Rochefort returned to the attack, calling Paul 'an irredeemable failure. So much the worse for the traders, who have believed, on Zola's word, that there was a fine *coup* to be made with his works.'

On a Friday of an undated month he wrote again to Bernard. Clearly Paul both liked Bernard and felt put on his mettle by their discussions. For all his scorn of theoretical talk he wanted to explain himself, but could do it very imperfectly away from the activity of painting.

It's sad to realize that such improvements as have taken place in my understanding of nature from a pictorial viewpoint, and in the development of my means of expression, coincide with increasing age and feebleness of body. If the official Salons are still so inferior, the reason is that they use only more or less perfunctory methods. It'd be better to introduce more personal emotion, more observation, and more character.

The Louvre is the book in which we learn to read. But we must not be content to memorize the beautiful formulas of our illustrious predecessors. Let us go out and study beautiful nature, let us try to discover her spirit, let us express ourselves according to our temperaments. Time and meditation tend to modify our vision little by little, and finally comprehension comes to us.

In this rainy weather it's impossible to put these theories, however reasonable they may be, into practice out of doors. But perseverance teaches us to understand interiors like the rest of nature. Only our old habits stifle our intelligence, which needs stimulation. You'll understand me better when we meet again. Observation modifies our vision to such an extent that the humble and colossal Pissarro finds his revolutionary theories justified.

Then on October 23rd he said how precious he found Bernard's letters, rescuing him from the intellectual exhaustion brought on by fatigue.

Now, being old, nearly seventy years, sensations of colour, which give light, are the cause of abstractions which don't allow me to cover my canvas or to follow out the delimitation of objects when the points of contact are tenuous [*ténus*], delicate; whence it comes about that my image or picture is incomplete. On the other hand the planes fall one on the other: whence comes the neo-impressionism that outlines the contour with a black line [*trait*], an error that should be fought with all one's strength, now nature, consulted, gives us the means of attaining this end.

I remembered quite well that you were at Tonnerre, but the difficulties of settling down in my own house make me set myself entirely at the disposal of my family, who take advantage of it for their own conveniences, while somewhat forgetting me. At my age I should have more experience and use it for the general good. I owe you the truth in painting and I'll tell it to you.

He added, 'Optics, developing in us through study, teach us to see.'

For some fifteen years Aix had been holding a Carnival. Solari was able to earn a little by

decorating the floats. While engaged on this work he caught pneumonia and died in hospital on January 17th. A few weeks earlier he had completed a bust of Zola for the town library; and Mme Zola had given Aix the manuscripts of the *Three Cities* series. So on May 27th the municipality organized the unveiling of the bust in the presence of the widow, Numa Coste, and Victor Leydet, who was now vice-president of the Senate. The Mayor was Cabassol, son of Louis Auguste's old partner. In his speech he recalled the large part that Aix, as Plassans, played in Zola's work, and mentioned the friendship of the Inseparables. He cited Zola's description of the Jas de Bouffan ('the mosque-like whiteness in the centre of the vast grounds') and told how in 1858 Zola parted from Cézanne, 'since become the great modern painter, as we know.' Numa Coste rose. Suffering from heart-trouble, he was at times breathless, and his voice shook with emotion.

We were then at the dawn of life, filled with vast hopes, desirous of rising above the social swamps in which impotent jealousies, spurious reputations, and unhealthy ambitions stagnate. We dreamed of the conquest of Paris, the possession of that intellectual home of the world, and out of doors, in the midst of arid and lonely spaces, by the shaded torrent or the summit of marmoreal escarpments, we forged the armour for the gigantic struggle . . . When Zola preceded the group to Paris, he sent his first literary efforts to his old friend, Paul Cézanne, at the same time letting all of us share his hopes. We read those letters amid the hills, in the shade of evergreen oaks, as one reads the communiqués of a campaign that is beginning.

Nothing could have been more calculated to strike home to the depths of Paul's heart. He wept. Through his tears he saw Mme Zola embrace Coste at the end of his speech in which he extolled 'the work that consoles and makes one forget one's sorrows.' There is no mention of a meeting of Paul with Mme Zola; it is not likely to have occurred.

This year the Friends of the Arts of Aix asked him to exhibit 'as of right,' but hung his works badly. In the catalogue Paul described himself as 'pupil of Pissarro.' He said to Denis, who, with Roussel, visited him, 'I am a landmark, others will come.' Another visitor was K. E. Osthaus, founder of the Folkwang Museum. The account has its oddities, such as the praise of Holbein; the alleged remark about Poussin is certainly the result of Bernard's writings, which had affected Osthaus by the time he wrote up his memories; the reference to the old invalid probably derives from Vollard's 'old hag.' We see how quickly the legends thickened round Paul.

When the door [in the Rue Boulegon] was opened, we entered an apartment that in no way revealed the exceptional qualities of its inmate. There were no pictures anywhere on the walls, Cézanne received us without formality. Standing, we told him we'd been glad to take the chance of a trip south to bring him the homage of our respect, and that we hoped very much to buy one of his works. Cézanne asked several questions about our collection. The names there represented gained us his esteem. Growing communicative, he began to expound his thoughts on painting.

He explained his ideas before several canvases and sketches that he fetched from all over the house. They showed masses of brush, rocks, and mountains all intermingled. The principal thing in painting, he said, was to find the distance. It was there one recognized the talent of a painter. And as he said this, his finger followed the limits of various planes on his canvas. He showed how

far he had succeeded in suggesting depth, and where the solution had not yet been found; here the colour had remained colour without becoming the expression of distance.

Then he talked of painting in general. Was it courtesy to his German interlocuters that made him set Holbein heading the list of all the masters? In any case he did so with such emphasis that it wasn't permissible to question his convictions. 'But one cannot equal Holbein,' he cried. 'That's why I took Poussin as an example.'

Of the moderns he spoke warmly of Courbet. He admired his boundless talent that overcame all difficulties. 'Great as Michelangelo,' he said, but with this qualification, 'He lacks the elevation.' He only glanced at Van Gogh, Gauguin, and the neo-impressionists. 'They make things a little too easy for themselves.' Finally he gave an enthusiastic eulogy of his comrades of former years. In the pose of a great orator, raising his finger in the air, he exclaimed, 'Monet and Pissarro, the two great masters, the only ones.'

The stress in the discussion on depth and the means of obtaining it by colour sounds true. Osthaus later visited Les Lauves and saw the big *Baigneuses*. He spoke of the painting of nudes. Cézanne then complained of a narrow provincial attitude which prevented him from having a female model. 'An old invalid poses for all these women,' he explained. Osthaus went on, 'I bought a Bibémus quarry picture and another canvas.' Paul promised to send some more works to Germany, but was unable to carry out his promise. Back in Paris, Osthaus was surprised to hear of him as a man impossible to approach.

There are 18 letters extant from Paul's last months, of which 16 are to his son, who was now managing things for him—hence a 'genius.' In the letters Paul sends good wishes to his son's *maman*. Perhaps his ill health was making him more tolerant, regretful at having got so little out of his marriage. On July 20th he wrote that on account of the hot days he had to start off at 4.30; by eight the heat was unbearable. 'The atmosphere is often dusty and of a lamentable tone.' He sent his regards to Mme Pissarro. 'How far away everything is already, and yet how close.' On the 24th: 'Yesterday the filthy Abbé Gustave Roux took a carriage and came to hunt me up at Jourdan's; he's a sticky fellow. I promised to go and see him at the Catholic College. I won't go.' On the 25th: 'Hortense was ill. Yesterday, Thursday, I should have gone to see the priest Roux. I didn't go and that's how it will be, up to the end, it's far the best thing to do. He's a sticky fellow. As for Marthe, I went to see your aunt Marie. There's another nuisance [séton]; at my age it's better to live isolated and to paint. Vallier[the gardener] massages me, my kidneys are a bit better. Mme Brémond says my foot improves. I follow Boissy's treatment; it's horrible.' Boissy has been described as a homoeopathist; but he seems to have been an ordinary apothecary of Aix. About this time however Paul did try a homoeopathic treatment, probably basing it on what he had learned from Dr Gachet; in any event it is likely that he acquired his respect for the method from that doctor. However, his disease was now at an advanced stage. Vallier, who was massaging him, was the subject of one of his last works, perhaps the finest of his portrayals of the common man, with whom he felt in his depths a complete sympathy. Setting him in profile against a dark background, he achieved a work which is strongly sculptural and yet defined in a diffused light; the richness of colour comes together in a subdued unity; every-

thing serves the effect of meditative calm. We see a man resting securely on his life-centre, battered by circumstances but unbroken, asking and expecting nothing, and somehow nobly intact; he has the enormous dignity of one who has reached an inner peace by shedding everything save the pure components of a man, who rests solidly on the earth of his labours, without regret or hope or fear. Paul has made of him the image of all he would have liked to be himself; by the integrity of his art he makes Vallier his own true image. (Fig. 48)

The ever-more-frequent use of watercolour shows its influence here despite the thickness of the chromatic impasto which recalls altogether the works of the first period. The image is luminous, as if it held an inner light: the hat and flesh are yellow-orange-red and the shirt green-brown clear in front of a dark green-brown garden wall. Throughout the shadows are blue. The solid and solemn old gardener is seen with a sorrowing sympathy that reveals the personality of Cézanne in the last years of his life better than his self portrait does. (Venturi)
For a similar conception of man one must turn to Titian and Rembrandt. It concerns an aristocracy which is founded not on power or accomplishment, but on inner strength. (Schapiro)

On August 3rd his brain was oppressed by the heat. 'I was forced to call in Dr Guillaumont, as I had a bad attack of bronchitis, and I gave up homoeopathy in favour of the mixed syrops of the old school. I coughed a hell of a lot, *Mère* Brémond applied some linen soaked in iodine, and it did me much good. I regret my advanced age in view of my colour-sensations.' He cried, 'Long live the Goncourts, Pissarro and all those who have the love of colour, representative of light and air.' He had been touched by the kind thoughts of Forain and Dierx, and remembered the meeting at Nina de Villars' place. 'Now I must ask you not to forget my slippers, those I have are almost in holes.' It is hard to understand why young Paul in Paris must deal with his slippers, when Mme Brémond and Marie were close at hand, even if he could not get some himself.

On August 12th he recurred to the irritation and dislike he felt of clerics; his savage comment was rather that of his old radical days.

The painful sensations exasperate me to the point of not being able to put up with them, and they make me live in retreat, which is best for me. At St Sauveur Cathedral a cretin of an abbé has succeeded Poncet; he works the organ and plays wrong notes. So badly that I can no longer go to hear mass, his way of playing music makes me absolutely sick. I think that to be a Catholic one must be deprived of every sentiment of rightness [*justesse*] but have a wide-open eye for one's own interests.
Two days ago the sieur Rolland visited me and made me talk about painting. He offered to pose for me as a bather on the banks of the Arc. That'd make me grin a bit, but I fear the gentleman would like to get his hands on my study. Still, I almost feel inclined to try something with him. I have demolished Gasquet and his Mardrus for him; he told me he'd read *The Thousand and One Nights* in Galand's translation.

Mardrus' version had appeared in 1900 and had a vogue in Gasquet's circle; Paul preferred (like Renoir) the old version of 1704. He was also pleased to get in a dig at Gasquet and his taste. Rolland, he went on, 'seems to understand that influence can help to insinuate us in, but in the long run the public sees all the same it's been fooled.' He thought Bernard not to

be 'overwhelmed with commissions. A good bohemian, born in Lyon, came to borrow a few sous from me; he has the look of being in a frightful mess.' He repeated, 'Remember the slippers.'

On August 14th he still complained of the heat. At 4 p.m. the carriage was to take him to the river by the bridge of the Trois Sautets, where he often worked in his last months, and where he, Zola and Baille used to bathe as lads. 'I was very comfortable there yesterday. I've begun a watercolour like those I used to do at Fontainebleau, it seems to be more harmonious, the whole thing is to put in as much of relationship as possible'. Yesterday he had gone to wish Marie a happy birthday. His foot was better; the slippers had come and they fitted. 'By the river a poor little child, very lively, who came up to me, in tatters, asked if I were rich; another, older, told him such questions weren't asked. When I got into the carriage to return to town, he followed me. When we reached the bridge, I threw him two sous. If you could have seen how he thanked me'.

August 26th: still hot, he was making river-visits in the carriage, much enfeebled. 'I'm quite bowled over at the cheek with which my compatriots try to compare themselves with me and to lay hands on my studies. One only needs to look at their dirty daubs.' Yesterday, 'I met the priest Roux, who disgusts me.' Paul had risen late, after 5 a.m. 'Sometimes the light is so dirty, nature seems ugly to me. Selection is necessary then.' On September 2nd: 4 p.m. and stifling, he waited for the carriage. 'I spend some pleasant hours there. There are some big trees, they form a vault over the water. I'm going to a place called the Gour de Martelly, it's on the little Chemin des Milles, which leads to Montbriant. Towards evening come cows, brought to pasture. There's material for study and for masses of pictures. Sheep also come to drink, but they disappear rather quickly. Some journeymen painters came up and told me they'd gladly paint as I do, but at the drawing-school they're not taught it. I told them that Pontier was a dirty brute and they seemed to approve.' He had met Demolins, an Aix notary, four or five days back, and thought him very artificial. 'Our judgments must draw a lot from our state of soul.'

On September 8th, again the heat:

This temperature must be favourable only to the expansion of metals, to help the sale of drinks, and fill the beer-merchants with joy: an industry that seems to assume respectable proportions in Aix—and [it expands] the pretensions of my land's intellectuals, a pack of ignoramuses, cretins, and fools. The exceptions, there must be some, don't make themselves known. Modesty is always unaware of itself. Finally, I must tell you that I became a painter more lucid before nature, but that with me the realization of my sensations is always painful. I cannot arrive [in art] at the intensity which is developed in my senses. I lack the magnificent richness of colour that animates nature. Here, on the river's verge, the motifs are plentiful, the same view seen under a different angle offers a subject for study of the highest interest and so varied that I believe I could be busy for months without changing my place, simply leaning a little more to right or left.

He repeated his faith in his son as the controller of his affairs, and noted that the President was going to visit the south. 'Jo, where will you be?' The thought of the important political

and social occasion made him think of Gasquet with his wish to take a prominent part in such things; and he went on with a reflection about variations in success. 'Is it the factitious and the conventional that most surely succeed on earth and in the course of life? or indeed is there a series of happy coincidences that bring our efforts to their ends?'

Five days later he sent on a letter from Bernard, whom he calls Emilio Bernandinos. He could scarcely read the letter, though he thought Bernard on the right track but unable to put his theory into practice. He wished he had him under his control so that he could infuse in him the sane, comforting, and solely-correct idea of art developing through contact with nature. His drawings were 'old-fashioned stuff, which shows the effects of his art-dreams suggested not by the emotion of nature, but by what he's been able to see in museums, and yet more by a philosophic spirit that derives from a too great knowledge of the masters he admires.' We also hear that Bernard had had some 'annoying accident.'

Paul decided that he could not go to Paris this year. He drove daily to the river, but through fatigue and constipation had given up going to the studio. That morning he had gone for a short walk. 'My research interests me greatly. Perhaps I could have turned Bernard into a convinced adept. Obviously one must [succeed] in feeling for oneself and in expressing oneself sufficiently. But I repeat the same thing over and over again; my life, arranged in this way, allows me to isolate myself from the lower sphere.' He adds that Baudelaire is 'one of the strong ones, his *Ars Romantique* magnificent, and he makes no mistakes in the artists he admires.'

On September 21st he wrote to Bernard himself, stressed his doctrine of nature, talked of the heat and the cerebral disturbances that had made him fear for his reason. Now the weather was growing milder. 'Will I ever attain the end for which I have striven so much and so long? I hope so, but until it's attained, a vague sense of malaise persists, which can be dissipated only after I've reached the port, that is, have realized something developed better than in the past and thus proving theories which themselves are always easy.' Bernard stood out in his mind as the most theoretical of the young artists and he badly wanted to bring him over to his way of thinking, seeing, painting. Somehow that would have made him feel safer, more sure that he was on the right track, more sure that he would reach the goal of realization which tantalized him. 'I study always after nature, and I seem to be slowly getting ahead. I'd have liked to have you by me, for solitude always weighs somewhat on me. But I am old, ill, and I have sworn to die painting rather than go down in the debasing corruption [*gâtisme*] that threatens old men who allow themselves to be dominated by passions brutalizing for their senses.' He signed himself: 'the obstinate old man who cordially clasps your hand.'

On September 22nd he wrote again to his son. He told in his letter to Bernard. 'I've come to the conclusion it's not really possible to help others. With Bernard it's true one can indefinitely develop theories; for he has a reasoner's temperament.' In a postscript he speaks of his brainstorms. 'I see the dark side of things and so feel more and more forced to

rely on you and look to you for guidance'. Four days later he wrote that he had been told eight works of his were to be hung in the Autumn Salon. Yesterday 'that valiant Marseillean Charles Camoin' had come. Paul thought his work good. They had agreed that Bernard was 'an intellectual congested by the museums.' So 'Pissarro was not mistaken, though he went too far, in saying the necropoles of art should be burned down. Certainly one could make a strange menagerie with all the art-professionals and their kindred spirits.' He was still working on the Arc, storing his paraphernalia with a man named Boissy. Two days later he wrote about pills and paints. He was still seeing Camoin and was reading Baudelaire on Delacroix. He made a furious outburst against the scoundrelly world which was cheating him. 'As for me, I must remain alone. The sharp practice [*roublardise*] of people is such that I'll never be able to cope with it, it's theft, complacency, infatuation, rape, the hands laid on your production, and yet nature is very beautiful. I still see Vallier, but I am so slow in my realization that I'm very sad. No one but you can console me in my sad situation'.

In these last days, as he felt his strength failing, he turned rather pitifully to his dull shrewd son. On October 8th he told him how he'd been at the Café des Deux Garçons from 4 to 7 o'clock with some friends who included Niolon, a local painter, who used at times to go on the drive with him to the Château Noir. Though the weather was fine, he felt nervous. 'This afternoon I'm going to my motif. Emery raised the price of the carriage to 3 francs return, when I used to go to the Château Noir for 5; I've fired him. I've got to know M. Roublard, who has married a fine dowry in the person of Mlle Fabry. You'll see when you're here what there is to do. He's a young man, well considered in the town; he has organized intelligent concerts of great artistic value.' Five days later there had been heavy rain and the time of heat seemed at an end. He discussed the sending of wine. As the river banks were now cooler he had left them for the quarter of Beauregard 'where the path is steep, very picturesque, but very exposed to the mistral. At the moment I go up on foot with only my bag of watercolours, postponing oils till I've found somewhere to put my baggage. Once on a time one could get that for 30 francs a year. I feel exploitation everywhere. I'm waiting to take a decision. The weather is stormy and very changeable. My nervous system much enfeebled, only work in oils can sustain me. I must carry on. I must then realize from nature sketches; canvases, if I did any, would be only constructions after [nature], based on the method, the sensations and developments suggested by the model, but always say the same thing. Could you get me a small amount of almond paste?' He had a letter from Bernard. 'I hope he'll come through, but I fear the contrary.'

Two days later he wrote his last letter to his son. There had been rain and a thunderstorm. He was eating well and wanted two dozen brushes like last year's; he had got the cocoa. 'I have difficulty in carrying on with my work, but in spite of that it's something. It's important, I believe. The sensation which composes the basis of my work [*affaire*] I believe to be impenetrable. I'll let the wretched fellow whom you know go on imitating me to his heart's content; it's hardly dangerous.' He sent good wishes to some friends of his

son. 'Everything passes with a terrifying rapidity, I'm not getting on too badly.' But, 'my dear Paul, for me to give you news as satisfying as you want, I'd have to be twenty years younger. I repeat, I'm eating well, and a little moral satisfaction—but nothing can give me that except work—would do me a lot of good. All my compatriots are arses next to me.' He signed the letter, 'I embrace you, you and maman, your old father.' But he couldn't stop writing. He added a postscript: 'I believe the young painters to be much more intelligent than the others, the old ones can see in me only a disastrous rival. Good wishes, your father.' Then he added a second postscript, 'I'll say it yet again. Emile Bernard seems to me worthy of deep compassion, since he has the care of souls.' By *charge d'âmes* he probably meant a family to keep and consider.

Two days later he wrote to a paint-dealer to ask why some burnt lake, urgently needed, hadn't come. By that time he was already in a bad way. The day he wrote his last letter to his son, he started off on foot for the motif. He had dismissed his driver in protest against the small rise in his fee, and now he had to carry his heavy equipment. This time he had his watercolour knapsack on his shoulder. While he was working, a heavy rainstorm blew up. For a while he stayed at his easel, hoping the weather would clear. Drenched and chilled, he at last went off; but the strain of plodding through the storm, hampered as he was, over rough hilly country was too much. He collapsed by the roadside and was found later by the driver of a laundry-cart, who recognized him and brought him back, half-conscious, to the Rue Boulegon. Mme Brémond sent for Marie and the doctor. Pneumonia set in, but not till five days afterwards did Marie write and tell his son, and even then it was only because she wanted him to help her. Her letter, we may note, does not refer to Hortense as Paul's wife.

(*October 20th*) My dear Paul, your father has been ill since Monday. Dr Guillaumont doesn't think his life is in danger, but Mme Brémond can't take care of him by herself. You'd better come as soon as you can. At times he's so weak a woman cannot lift him; with your help it could be done. The doctor has suggested hiring a male nurse; your father won't hear of such a thing. I think your presence is necessary so that he may be looked after as well as possible.

Last Monday he was out in the rain several hours; he was brought home in a laundry cart and it took two men to get him upstairs to bed; early next morning he went out to the garden [*Lauves*] to work at a portrait of Vallier under the lime-trees; he came home in a state of collapse. You know what your father is like; it would make a long story—I repeat that I believe your presence to be necessary.

Mme Brémond particularly wants me to tell you that your father has taken your mother's dressing-room for his studio and that he doesn't intend to move out of it for the present; she wants your mother to know this fact; and since the two of you were not expected back here for another month, your mother can stay in Paris for some time longer; by then perhaps your father will have moved his studio.

There, my dear boy, is what I think it my duty to tell you; it is for you to make your own decision. I hope to see you soon, I embrace you most affectionately, Your devoted aunt, M. Cézanne.

The letter arrived on October 22nd, followed by a telegram from Mme Brémond urging

both Hortense and her son to come at once. Paul was rapidly growing weaker. At one time he kept on calling, 'Pontier, Pontier,' the name of the director who had sworn to keep his picture out of the Aix Museum. He also called for his son, 'Paul, Paul.' But Paul did not arrive in time. It seems that Hortense, who was busy with fittings at a dressmaker's, hid the telegram in a drawer. On Monday the 22nd Marie left the room for a moment. Mme Brémond, alone with the stricken man, realized that she could no longer hear him breathing. She came closer and found that he was dead. He had already received the last sacraments. The funeral was held on the 24th; the date of death on the funeral announcement was given as 23rd, but this was a polite fiction to enable the funeral to be legally postponed a day. Hortense and her son were thus able to reach Aix and be present at the burial in the old cemetery.

Victor Leydet spoke a few words at the ceremony.

Notes

I have kept these to a minimum, except where any controversial point was involved, or where I felt an acknowledgment was needed. At the outset I must pay a special tribute to the books of John Rewald, in which ever since his *Cézanne et Zola* of 1936 a vast amount of reliable information has been collected. Anyone writing a biography of Cézanne cannot but feel a debt to him on almost every page where he is dealing with the events of the artist's life. The Correspondence remains a basic source, together with Rewald's *Cézanne, Geffroy et Gasquet*. Mack's book provides a solid frame from which to start; and many other writers such as Perruchot and de Beucken give some useful additions to Rewald's wide-reaching works. Badt's book I have found useful on many aspects of Cézanne's art, though I cannot accept many of his conclusions. A wide range of critics from Meier Graffe, Fry, Novotny, on to Schapiro and other more recent writers, have offered valuable insights; Venturi's collection is indispensable; and Reff's analysis of various psychological aspects of Cézanne's art I have found extremely illuminating, ramifying various conclusions I had already reached, and giving them greater force. Douglas Cooper and many others have helped recently in the very difficult problem of dating Cézanne's work—but I have found Lawrence Gowing's work in this matter most congenial and helpful. Without a reasonable amount of security in the dating, the problems of a biographer of Cézanne are indeed perplexing.

I should like to thank the Bibliothèque Municipale of Marseille for going to some trouble to check Marseille newspapers, etc., in response to queries of mine, and Dr D. Demarque (of Bordeaux) and Dr L. M. Blanc (of Aix) for inquiring about Boissy.

I, 1.

Rougon: The name came from a schoolfellow at the Aix Lycée, whose grandfather was mayor of Flassans (dept. Var) in 1920s, though in fact this family was legitimist. For some reason the names stuck in Zola's mind: Perruchot 20f.

I, 2.

Magasin Pittoresque: Bernard (2) 1925, 47.
Conquête, sketch MS 19. Coquiot; R(1) 18. *Les Incas*: Reff (7), Berthold 155-9.
There seems a confusion about the band. Gasquet says Zola played the cornet, Cézanne the clarinet; Rewald agrees (*Ordeal* 3); Mack reverses.
Courbet: his *Beggar's Alms*, dated 1868, returned to the theme. See Nochlin, on whom I draw; Schroeder 103, 263f., n22; Hofmann 238f.; Baudelaire, *Le Voyage* 1859; Pool 31.
Tata Rébory: M. Conil (niece).
Mother: illiterate (de Beucken); book, Reff (7); Rewald (1) 97 (information from young Paul and Maxime Conil).
Drawing-school: Nov. 1858 to Aug. 1859; Nov. 1859; Nov. 1860; he drew from casts and models.
Solari: born 1840, the one friend against whom 'the surliness of his disposition and his sudden fits of misanthropy were never directed' (Gasquet).

I, 3.

Pascal Antoine Marguery 1841-81, took up literature, published several vaudevilles.
Letter 29th?: *ce sont soupirs mentals ou mentaux, je ne sais.*
Hercules: Reff (4) for the whole of this analysis; Alpers 31-60. Texts: *Mem.* ii, 1, 21-34; *de offic.* i 115-21; Italicus xv 20-2; Xenophon, *Mag. pitt.* xii 1844, 49f. Zola and H.: Bibl. Nat. *E. Zola* 1952 no. 42; pitot, letter 5 May 1860. Mistral, *Breviari de l'istori de Prouvenço.*

I, 4.

Ugolino paintings: Yates. Dante known from version by L. Ratisbonne (secretary of de Vigny): see Delacroix 4 Aug. 1854; or that by Mesnard: see Sainte-Beuve, *Causeries* xi 198 (1854). See L. Gillet, *Dante* 1941. Badt ch. 2 for an unlikely hypothesis. How far is Zola reflecting romantic charnel-fancies or

building on Aix memories in the account of Aire Saint-Mittre in *La Fortune*, which had been a graveyard and where the youngsters, 'lamented the loss of the peartrees, played at bowls with the skulls'? This Aire is a scene of love-making, half-closed tombs serving as nuptial couches; Silvère picks up bits of skulls, 'and they loved to speak of the ancient burial ground.' For skulls: V. 61, 68, 751, 753, 758–9, 1129–31, 1366, 1567–8.

Zola: as orphan, Hemmings 6.

I give here for completeness the verses I have not thought worthwhile inserting in the text: (1) 30 Nov. 1859: '*La Provençe* soon will see within its columns/The insipid novel of flaccid Marguery;/You shudder, Provençe, at this new misfortune,/The cold of death has frozen all your blood.' Then 'Personages: Inspirational Spirits of Gaut; Gaut himself directing the sublime *Mémorial*' (the weekly: Gaut was director also of the Bibliothèque Méjanes). '*A Spirit*: Great Master, have you read the serial story/That now the *Provençe* has just started issuing? *Gaut*: It's bad to a degree. *A Second Spirit*: I say the same,/Master, the paper's never yet produced/A work that's so absurd. *Gaut*: What scamp is this,/Presumptuous so much he'll beard my fame/And follow me, the Press's Torch, parading/The misery of such a meagre novel? *A Spirit*: His name, till now whelmed in obscurity,/Wants to come forward . . . *Another Spirit*: What a mistake, just heaven! *Gaut*: What does he think to do, to be so bold/As wish to walk below here in our steps? to dare to claim that he has reached the heights/Above the vulgar where I reign supreme? *A Spirit*: No, Master, never, for his feeble pen/Is ignorant how novels are spun out,/how, by an involved intrigue, one brings the vapours/To all the readers who are reading you. *Another Spirit*: But firstly, he knows nothing of this art,/This art in which there's none so skilled as you,/ this art so precious, and so painful too,/ This art you've pursued and God has made your gift,/This art, in short this art that all admire/and which no word suffices to express. *Gaut*: That's right, I understand: Verbology,/its etymology is Graeco-Latin/beneath the azure skies with myriad fires,/Who is the *gunogene* that's bold enough/to claim that he's invented anything/More beautiful than the names my prose employs? My French *carmines* are far superior/to all a heap of rimers have produced/and most my novels, field where I am lord/And as the sun, on rising, bathes in light/The *excelse* heights of all the *virid* forests/I show myself to the world a shining prism. *A Spirit*: O sovran *Domine*, incomparable Spirit/Praise must be rendered to your estimable/Virtue. *A Choir of Spirits*: You, You Alone, Great Innovating Gaut/Sublime in the level heavens with your grandeur/The most brilliant *sideres*/At the fire of your eyes/lowering their brow confused,/dazzled before your glory,/Make no attempt to triumph/And wagging now his head/Ludovico comes to a halt/And cries: I'll write no more./Glory, O glory, Gaut the *Philonovostyle*,/To equal you, great Gaut, is a difficult task.'

The Charade in the late 1859 letter runs: 'My first is slender sly in looks deceitful/Dreaded destroyer of the gnawing tribe,/ It has always, full of tricks, with shameless force,/Levied its imposts on the tastiest grub./ My second gave our starving stomachs joy/At college when we had it served with sausage./For indigestion is my third much used: to help digestion. All the English Nation/Drink it, each evening, after a good supper./My whole is called a theologic virtue.' Answer is: *Chat-riz-thé=Charité*.

II, 1.

Scheffer: *Manette*, ch. iii.

Paintings: In Jas an 18th-c. draught-screen, no doubt left behind by previous owner, had its canvas panels on one side covered with distemper and decorated; on the other, in a framework imitating tapestry-borders, Paul painted a set landscape with trees, people, etc.; Zola was said to have helped: V. 1–3 (1858). Three girls: V. 24. *Kiss of Muse*, V. 11. *Girl with Parrot*, V. 8, cf. 99. Academic works, V. 9–11, 14 (after Lancret). Early landscapes, V. 26–8. Dates of Jas works: Cooper (1), Gowing (1), 186: 1860 or even earlier. The more developed *Pêcheurs* (recently uncovered), and a landscape into which a bather was later inserted (V. 83), seem a little later. Besides *Mag. Pitt.*, Marie seems to have taken the *Musée des Familles*, and Paul seems to have known C. Blanc's *Collections*, e.g. The Spanish School, from which he took Christ Descending to Limbo: Rewald (1) 45. Coquiot has an unconvincing tale that L.A. said, 'Look here, Paul, you have sisters, how could you paint a large nude figure on the wall?' Paul replied, 'Well, haven't my sisters got bottoms like you and me?' The tale seems about what was in fact the nude torso of a man.

Letter, 5 May 1860: 'You speak vaguely of a certain adventure with unpleasant results for Leclerc and Dr Julienne.'

II, 2.

Paris: Reff (3); S. Braun. Brothels in Guys: Baudelaire, *Le Peintre de la Vie Moderne*; d'Eugny, esp. 36–8, 137–40; *The Pearl from Plymouth*, 1950, W. H. Holden, with bibliog. 161–9. Vallès (2) 7.

Huot: became chief architect, Marseille: Raimbault. The poem in letter to him is more slipshod and rough than in earlier attempts.

Zola: he turned from poetry to prose in the 1860s in part because it seemed that verse then held no future. He wrote (8) on contemporary poets: 'Towards 1860, under the 2nd Empire, poetry was not in

great esteem. The vogue of informative periodicals, the success of topical and facile literature, seem to have dethroned verse for a long time. Only the *Revue des Deux Mondes* dared publish at wide intervals a short poem, and always chose the most colourless and mediocre poem possible. In a word, the poetic moment, after the superb outburst of 1830, seemed arrested.' He discusses the Parnassians and Coppée, makes a brief reference to Verlaine as a 'victim of Baudelaire,' and sees Mallarmé as so obsessed with 'rhythm and the arrangement of words as to end by losing awareness of the written language,' ready to 'give the sensation of ideas with sounds and images. In short there is there only the theory of the Parnassians, but pushed to the point where the brain cracks.' He thus saw no way of making verse an effective form of expression.

II, 3.

Couplet: variations, 'Cézanne the banker' and 'behind the counter born'.

Open air: much more could be said about this. The practice in the last resort links with that of country-walking already discussed. Even the neo-classics who inspired Corot, Michalon and Valenciennes, made studies out of doors. For Turner, see my *Turner*.

Salon: for an account, see *Manette*, ch. xlii; salon portraits, xliv. Also Zola, *L'Oeuvre* for Varnishing Day. Manet on Paul: J. E. Blanche, 234.

Zola: 'Fatally . . .' *Les Romanciers naturalistes*, 109.

Oller's 1865 address: may only be one of convenience, Paul seems to live at St Germain. Meets Courbet: Duret (3) 25.

Olympia: based on Reff (3), see later for other versions. Couture, with his famous *Romans of the Decadence* 1847, also painted *La Courtisane Moderne*. The name O. came originally from Donna Olimpia Maldachini under Innocent X and the Doll in Hoffmann's *L'Homme aux Sables*; popularized by A. Dumas' *La Dame aux Camélias* 1848; carried on e.g. by Augier, *Le Mariage d'Olympe* 1855; Varin and Biéville, *Ce que deviennent les roses*, 1887; Aigu, *Les Femmes sans Nom*, 1887. Manet and Paul: V. i, pp. 23, 34.

Paintings: *Virgin and B.*: V. 15 (*Père Zorobabel* above door, to show her ancestry). *Paris*: V. 16. *Interior Scene*: V. 24, where V. says, 'The brushstroke gives synthetic effects of light that give a presentiment of the post-impressionists and Matisse'. This seems to me much exaggerated.

'Hideous realism': Vaperau in *Lit. and Dram. Yearbook* 1866.

Zola photo: in coll. Assistance Publique, Médan. Paul's painting V. 22 may be of her; if so, it supports the idea that he first met her. But apart from the fact that Zola had it, there is no proof: see Laborde 29f. on Perruchot. Rewald lost his papers in 1940 and could produce no evidence for tale that Paul first met her, Laborde 24.

Roux: in *Mém. d'Aix*, 3 Dec. 1865.

Zola: in his articles he reproached Corot for cowardice and said Rousseau was severe; in reprint he omitted this section as containing inaccuracies. Letters of protest: Rewald (7) 43f. They called Manet a bungler, vulgar and grotesque; the articles insulted the painters most beloved of the people; Manet's dirty figures seemed 'emerge from a coalsack.' An artist asked for the articles to be 'entrusted to clean hands.'

II, 4.

Café Guerbois: also Degas and Stevens there, engravers Desboutin and Belot, poet and sculptor Z. Astruc, writers Vignaud, Babou, Burty: Duret (1). Meetings now and then in Manet's studio. Paul with dirty hands: M. Elder. Morisot influenced Manet from imp. side, but couldn't get him to join the group. *L'esprit emmerde*: Vollard, but we can accept the phrase as typical.

Grog au Vin: V. 112, with variants 223, 224 (negress), 820, 822 (negress), 1176–9, 1181, 1183; Schneiwind VI. He seems to have taken up the theme afresh round time of the *New Olympias*. For Salon: Rivière (2) 63.

Paris: based on Reff (4) 38f.; V. 16. Lucien P.: from Bensusan-Bull: *tu t'as fait roulé*.

Second father-portrait: V. 91 has on wall the early still-life V. 62 of strong impasto-style. Earlier portrait V. 25; a study of woman (V. 22) is signed 1864; *Tannh. Overture* (V. 90) has Manet's *Mme Manet at Piano* behind it—it has yellows, greys, browns: colours typical of Manet.

Madeleine Férat: In 1865–6 Zola hawked two plays in vain; one provided the basis for the novel.

Peaches: V. 12; cf. 607, 614 etc.

Picnic: Schapiro 34; V. 107 (1869–70). The very elongated figure (only parallel the *Seasons*) suggests an early date, but Paul is shown as very bald. Probably 1869 is date (Schapiro).

Paris theme: Reff points out relevance of Michelet's moralizings in *L'Amour*: 'Is it really certain that these beauties, with their bacchanalian revels, could bear comparison, in a true Judgment of Paris, with the woman who has always led a temperate life, discreet and pure?'

Zola's screens: in letter to Valabrègue (cited Badt 34–7, who brings in unnecessarily Alberti's window and veil, a drawing-device; Zola was more likely inspired by the image of the camera plate).

Fashions: E. Saunders, ch. 19.

Letter June 30th: Rewald suggests the work is V. 17, head of old man; if so, it is only part of the original.
Marion-Val. sketch: V. 96, and plate 10, Rewald (2).
Dominique: V. 72–7, 79–80, 82; Schapiro 32. Self-portrait, V. 81; V. 78, ? Marie: still-lifes 61–5. For Lacordaire: L. Rosenthal, 85f.
Delacroix: *Manette*, ch. xxxv—*en avance sur le mouvement*.

II, 5.

Bohemians: *Manette*, ch. lii, Café Fleurus near Luxembourg. For Paul, see also Duranty's story, *Le Peintre Louis Martin*. Venturi, i 29.
Salon 1867: rejected Renoir, Pissarro, Sisley, Bazille, Guillemet; even Monet's *Femmes au Jardin* (painted in open in his own garden under amused eyes of Courbet—Manet also was against *plein-air* painting). Alexis says Zola wrote a *Salon* for a journal belonging to the King of Hanover; no copies survive; elsewhere we are told the Salon was stopped almost at once through its violent tone.
Pigs-trotters: Salon of Rejected had a canvas with this title by one Graham.
Scipio: style related to that of *L'Enlèvement*: Gowing (1) 186f. Solari's letter to Zola is dated April 2nd, and may be of either 1867 or 1868.
Marion: to Zola, 2 Jan. 1869, 'Paul has seen me at work, I have perhaps wearied him with my naturalist's enthusiasm.' Marion became Prof. of Zoology at Univ. of Marseille and directed the Nat. Hist. Museum of the town.
Gauguin on Music: Gasquet 1926, 10.
Rewald on Marriage: (1) 67.
Hortense: V. 527, cf. 521; Schapiro 58. V. 569, has a tender charm in colour and setting, but in last resort the face is still closed, in reverie apart. Duret (3) 32.
Emperaire: V. 86, Gowing (1) 1868 rather than 1867. Son of inspector of weights and measures; in Paris he lived for a time on ten sous a day.
Still-lifes: V. 59–61; Gowing (1) 186.
Alexis and Zola: V. 117, cf. 118 (*Reading*). Guerry 29ff., citing Lhote. The late work at the Jas shows the changes that had gone on: the Lancret copy with feeling for greens, still keeps to blacks for shadows. Gowing (1) 186 says colour-considerations may lead us to link the Jas Christ and the Emperaire (1868): areas of red and blue embodied in schemes of black and white, cf. *La Douleur*, V. 84.
Bennecourt on right bank of Seine, opposite Bonnières. Zola and Paul found it in 1866 doubtless on the tracks of Daubigny. Zola went each year till 1871. (The inn of Père Faucheur in *L'Oeuvre* was in fact kept by L. Dumont and wife.) Vernon is a dozen km. below Bonnières; La Roche-Guyon, on right banks, above Bennecourt. Monet was at Vétheuil, then at Giverny; Renoir at La R.-G. These areas with Argenteuil and Auvers-sur-Oise beloved of the impressionists.
Zola in groups: of artists—two in 1870, Fantin-Latour, the Batignolles group (Monet, Renoir, Bazille etc. at Manet's easel); and Bazille, his studio in Rue de la Condomine (Zola chatting with Renoir; Manet, Monet, Basille, Maître at piano). Paul was too isolated to appear in such works.
Manet's relation to impressionism, 1869: A. de Leiris (*Sur le plage de Boulogne*).

III, 1.

Gabrielle scared; Letter to E. de Goncourt, 7 Sept. 1870.
Roux: 'Marchons! Ils sont jolis, les cocos.'
L'Estaque: Schapiro 38; Fry 23; V. 54, 57f. Roofs, v. 55. Zola, cited Rewald (7) 73–4.
Perspective: Novotny (1) 81; Badt 162. Also Badt 192f.
Temptation: V. 103 (later, V. 240f.). Venturi, 1867–9; Vollard, 1870. In general I follow Reff (4) who dates 1870; he compares Patinir, in whose Temptation the hermit is challenged by three fine ladies, one of whom holds out apple; also romantic version by Tassaert, which Paul may have seen, where ladies are blonde, brunette, red-headed, like the three whose hair are visible in Paul's work: Prost 39, 86. (A variant got medal, Salon 1867: not in catalogue, see Larousse, *Dict.* xiv 1616.) Paul painted no Fall but copied Titian's *Fall of Man* (known through copy by Rubens or a disciple in Louvre). I follow Reff as to the meditative figure.
Delacroix: Robaut no. 1184; de Tolnay (2); 1860s and prints, Reff (4); Lichtenstein 60 and 55 for list of reproductions of D.'s work owned by Paul. *Death of Sardanapalus*: V. 104. Robaut no. 198; Berthold no. 12.
Pastoral: also called *Don Quichotte sur les rives de Barbarie*: V. 104; Guerry 19f. Picnic seems to belong to *Pastoral* series.
Other *Temptations*: Isobey in Salon no. 1236, Leloir 1476, Vely 2325; Reff (4) 41; Badt 112. Gautier, *L'Illustration*, May–June 1869 reprinted 1880, *Tableaux à la Plume*. Zola: M. le Blond 128, 135f.; Lapp 127–33. Flaubert: Cigada and Guignebert. Complete text 1874; versions of revised first text, in *L'Artiste* 1857, ed. by Gautier. Flaubert, *Corr.* ii 73 (to Mme Colet); see 1908 ed. of *La Première Tentation de S.*

Antoine publiée par L. Bertrand. Zola-head: V. 19; Reff (5) 117; Baudelaire, *L'art romantique 415* (Bovary). Puppets: Lombard. Popular theme: Seznec (1), Prost nos. 64, 186, 403, etc.

Solari: he had to keep in touch with Paul as the Salon verdict would be sent to the Rue de Jussieu. (Millet, fleeing from Barbizon in 1870, had been arrested at Cherbourg as a German spy because he drew the harbour.)

Maison du Pendu: Schapiro 42; Gowing (2) no. 10 suggests Paul may have gone home 1873 and painted Bassin du Jas (V. 160, dated there 1875–6) where darker tones but fine touch show perhaps an earlier date than Maison. Other exs. of Bassin: V. 164, 166–7. *Maison du Père Lacroix* (V. 138) has date 1873. For 1872 also *Le Moulin à l'Huile*, V. 136 (there 1870–1): cf. Pissarro's farmyards of the time. Paul also did pastels at Auvers (of quarry behind Gachet's house) and *Around a Table* (an unintended effect of Last Supper—who is there?).

New Olympia: note hat in right lower corner as in *Picnic*. Still-lifes: V. i 18 oddly sees in this passage from *Le Ventre*, and the other descriptions, an 'objective precision'. Pissarro: Le Bail, cited Rewald, *Hist. Imp.* 356; Badt 260. Near views: V. 26ff. 1870: railway-cutting (Badt pl. 37; V. 50, who gives 1867–70). On camera: Badt, 262 and 326; Anon, *E. Delacroix, sa vie et ses oeuvres* 406f.; Pissarro: *Lettres* 501. Masses: note Daumier and Manet; Zola had summed up Manet's style, 'He sees bright [*blonde*] and he sees in masses'— was he using what Paul had said?

Science: see my Turner for Turner and Constable; Ruskin's use of geology etc. Degas made studies of different kinds of smoke and loaves. A quasi-scientific attitude appears in some of T. Rousseau's works (*Marshy Landscape* and *Valley of Tiffauge*); Paul probably learned to see something of geological structure from Marion. When Gautier edited *Revue de Paris*, 1851, he meant to keep to literary and artistic matters, but demand forced him to add science. The True began to supplant the Beautiful. Pool 10–6 for summary. Camera: Moholy, 107, 136, 57, 97, 80. Bazille seems used photos for works like *Réunion de Famille* 1867 and *Terrace de Méric*. Paul's *Melting Snow at Fontainebleau* was based in fact on a photo of the Rouart property at Melun.

III, 2.

Exhibition: made possible by Degas and H. Rouart, an engineer. Critics: Guichard, letter to B. Morisot's mother; Huysmans, *L'art moderne*; O'Squarr, *Courrier de France*, 6 April 1877.

Impression: Even Millet used it for direct impact as opposed to imposed stylizations: 'I should like to do nothing which was not the result of an impression received from the appearance of nature.' (Wheelwright.)

Taine: preface 2nd ed. *Essais de Critique et de l'Histoire*.

Auvers: before leaving he probably wrote the note (to the grocer Rondès) offering to sign a picture.

La Faute: i 17: ii 6 (roses); cf. ii 7 and ii 11 (trees).

Wolf: see Geffroy, *Monet*, ch. xiv.

Lanterne de Marseille: the municipal Library of Marseille could find only two issues of this periodical, but said that one could safely hold it to be of very advanced republican views. '*La Religion Laique* does not appear in our collections, however its title is very significant.'

Letter to Pissarro: sends good wishes to family, Gaullaumin, M. and Mme Estriel.

Works: *Strangled Woman*, V. 123: curtain violet-red, back yellow-green, man in blue blouse and green-yellow pantaloons, woman yellow-brown hair, cloth skyblue-white, cf. style of *Courtesans* V. 122; *Murder*, V. 121 is less violent in brushstrokes. *Autopsy*, V. 105, Guerry 21. Three studies for *Strangled Woman*: Schneiwind: IIIv, XXXIII (5 figures), XXXVIII. In this sketchbook the seated man, XLIIv, seems early, cf. V. 118, 1198, the latter a drawing for the *Reading with Zola*.

Olympia: V. 106, 225.

Woman: V. 247, 895, 1207.

Lutte d'Amour, V. 379f.; Schapiro 48 (1875–80); Gowing 188 (1879); Vollard 1886; cf. Badt. 112.

Venus and Love, V. 124, and *Temptation*, V. 240: prob. 1873, Gowing.

Orgy, V. 92, hard to date; too light for earlier phases, and it has a dry touch, but is not as well organized as *Olympia*; seems before it.

Bathers, e.g. V. 167 (1875–6); 265 (? 1875), 264 (soon after). *Alley*, V. 47; Gowing 187, both he and Cooper date 1875. *Au fond rose*: V. 286. Gasquet, V. 283. 1876: *L'Estaque* V. 168 (letter 2 July), 158, and prob. 413: Gowing 187.

Temptation: first version V. 240; Cooper (3) 346 (1874–5); later 241. Apart from 103 (1869–70) there were 880, 1214, see Reff (5) studies fig. 6; also V. i p. 350 on 2 drawings, which Reff says not of *Temptation*. Venturi (1 p. 36f., 22) sees conflict of romantic theme and impressionist technique; Reff rights says no, rather a new concept of personal significance in Paul's art. Human-headed bird: V. 1214 (Reff, 1875), 880 (fig. 7 Reff) and perhaps joined to tree, 240; also Chappuis (2) pl. 3 (study for *Punch au Grog*). Sheba episode: Guignebert, Dumesnil, Chastel, Pantke.

Devil: studies, Reff fig. 6. Poem: fig. 7 (V. 880). Caryatid: Reff fig. 10. Fry 85f. suggests 17c original;

Berthold, 35, tried to link with Millet drawing, which C. could not have seen. Note V. 1214 (fig. 5 Reff) done before he saw engraving. Molière: V. 1191 (Reff fig. 8), cf. 1186. Baroque exs., Reff n. 81. I base my whole analysis on Reff, and must stress my debt to him here and elsewhere, e.g. next section.

III, 3.

Goujet: cf. Zola's earlier tale, *Le Forgeron*: Lapp 24–7. Note that Goujet rhymes with Puget.

Tanguy: Bernard (3); Mack 219–26. Daudet, E. de Goncourt, and Zola were for years a close knit group; Daudet and Zola met in mid-1860s, both working for Villemessant; later D.'s ill-health soured him and he found Zola's energy irritating.

Huot had been at drawing school with him, had done well as architect, got hold medal 1865–6 at Salon; in Marseille was chief architectural inspector of the Compagnie Immobilière.

Monticelli was like 'a portrait of Titian that had come out of its frame,' L. Brès. After music: P. Gigou. Trituration: Taburant. Also Maglione and Gasquet.

Hermit: V. 1192, Reff (5) fig. 9, he dates c. 1877. Monet: Elder 49, cf. Fry 87f. Sheba-bather: V. 1288, Reff (5) 124, Schapiro 28f. 116. Reff notes that Paul here is closer to Millet and Daubigny than the later illustrators such as Ensor and Redon, 123–4. Henri Rivière gave *Temptation* as shadow-play in Chat Noir Café, setting it in Paris and using effects of steam and electricity: A. France, *La Vie litt.* ii 215–7.

Vallès: (3) 159, 170, 131, 117 and (1) 215. See (3) 94 for brief intrusion of Courbet, pronouncing words very broadly e.g. Peurruddhon. 'I alone knew him. We were the only two ready in 48.' Villemessant (3) 29, 51, 67. Note grappin is slang for hand, e.g. Vallès (3) 72; to put the grappin on someone is to arrest them.

Not to be touched: Lucien, via Bensusan-Bull. 'Orovida did know of Cézanne's untouchability and doubtless heard of this from her father.'

Series of *Bathers*: Reff (1) on whom all this is based. Millet: V. 248, 1218; Reff, fig. 11. Transition, V. 259. Two drawings: Reff, figs. 13–14, and Poussin's *Plague at Ashdod* (Louvre), fig. 15. See further V. 259, 271. Reff for refs. as to physical tensions in art-imagery: P. Schilder, S. Levy, K. Machower; E. Fuchs, *Gesch. d. erot. Kunst* i 1912 342 for raised arm as penis. Schapiro, 29, cf. Fry 87, 'perhaps all great Classics are made by the repression of a Romantic.'

Art: Gowing (1) 188. *L'Etang*, V. 174; *Tureen*, V. 494. Others of 1877: *Hortense*, V. 292; V. 194 (repeating motif of 3 years before); 170 (Pontoise). See Gowing on the two types of wallpaper shown in pictures (diaper-pattern enclosing X-shaped lozenge; leaf-spray): e.g. V. 374 (shoemaker's son).

Science: Whyte 29–34; Curie, *Oeuvres* 119 and *J. de Physique* iii 1894 407; F. M. Jaeger, *Lectures on the Principle of Symmetry* 1917. Hamilton (2) 22 and (3); Laporte.

Gowing thinks (diaper) V. 209–10, 212–14, 363–5 and (leaf) 337–8, 343–6, 348 are 1877; 356, 358, 339, 341–3, 374 are 1879.

Médan: Fry 67.

Apparently some time in 1870 he wrote the letter in reply to a wedding announcement (? M. Sauvan to Mlle le contesse Gilette de St Joseph) of which a very polite draft exists: Schneiwind, front cover and I, Iv. He did not know the bride. He writes as *nous*, presumably as the C. family. Same sketchbook has, II, list of meals and costs: Wed., beef and kidneys, morning, cutlets, evening; Thursday, cutlets, morning, and 6 sausages, evening; Friday, beef and kidneys again in morning. Prices on back cover, e.g. flowerpot 32 centimes.

IV, 1.

Nana: V. 882; Badt 326 n. 39.

Manet's reaction: letter to T. Duret, severely criticizing Zola, then in second: 'It seems I'm in the wrong, but I hadn't judged Zola's article from a personal viewpoint and thought it contained too much eclecticism. We have so much need of being defended that a little radicalism would have done no harm.'

Degas on imitators: 'they are flying with our wings,' adulterating works to a 'corrected impressionism, toned down, brought within the comprehension of the crowd.' 1880 Salon: pictures were hung in a new way, four categories: artists hors de concours, exempt from passing the jury, those not exempt, foreign contributors. But the result brought out the vast number and banality of the privileged.

Paul's coat: Duret tells the tale and says Zola used to explain to other guests that Paul was eccentric, but 'at heart was annoyed by his disregard of social conventions.' That is Duret's assumption. Busnach flight: Elder 47.

Gachet sent in to the Salon, but never succeeded. He was however a man without bitterness. E. Rod (1857–1910) was a Swiss novelist of the Médan group.

Duranty's novel: cited Rewald (1). Maille (Maillobert) means stitch or knot in netting, mesh; speck or web; obsolete copper coin.

Renoir: at l'Estaque, to Durand-Ruel, 'As it's very beautiful here, I'm staying another fortnight. It would really be a pity to leave this lovely country without bringing something back. And the weather. Spring

with a gentle sun and no wind, which is rare in Marseille. I ran into Cézanne and we are going to work together.'

IV, 2.

Marcellin Desboutins: 1823–1902, was a pupil, like Monet, of T. Couture.

Temperament: Badt 129 for Baudelaire and Gautier: *Etudes sur les Musées* and *L'Art moderne* 238; but Badt wrongly thinks Paul used the word in a different sense.

Gauguin: to Schuffenecker.

Fanny: De Beucken, Perruchot. The affair remains obscure. But we cannot imagine Paul clasping anyone except a servantgirl; he had no social contacts of an ordinary sort. Vollard says there was an old hag at the Jas, her face cut with billhook-blows, of whom Paul used to say with admiration to Zola, 'Look, isn't that handsome? You'd say she was a man.' But as Zola did not visit the Jas in any later years, the tale if true must refer to drawings. In any event Vollard is unreliable. Fanny's old age: de B. 66. Carnival: Chappuis (5) XIX verso and XXVIII verso; (2) no. 4; (3) XX; Rivière (1) 1.

L'Oeuvre: roughly, Choquet is Hue; Alexis, Jory; Guillemet, Fagerolles; Solari, Mahoudeau; Cabanel, Mazel; Baille, Dubuche; Manet, Bongrand; Chaillan, Chaîne. Café Baudequin is Café Guerbois. Claude has Paul's training: 'Musée de Plassans (Aix), Atelier Suisse, a master who tells Claude he will never accomplish anything, the Louvre.' Zola had been influenced by *Manette Salomon* with its panoramic picture of the art-generation between the romantics and the impressionists.

Gasquet quotes Paul as saying, 'Nothing is more dangerous for a painter than to let himself go to literature. I know something about it. The evil that Proudhon did to Courbet, Zola did to me. I like very much Flaubert's rigorous forbidding, in his letters, anyone to speak of an art of which he doesn't know the technique.' At least the first part of this smacks strongly of Gasquet. But note, as to Flaubert, Pissarro to Mirbeau, 9 Nov. 1881, 'How he loved art.' 'What a difference from Zola.' 'The generally unfavourable conditions of the capitalist age for the development of art has generated the widespread prejudice that only artists themselves are capable of saying anything correct about art,' Lukacs 68.

Gauguin: 1885 letter, for date of show, *Burl. Ma.* 1958 85. Tschudi: Duret (3) 31, 35; Rolland, 29f.

Show: If Signac's memory was correct, this year something of Paul's was in a small show at Muret's place. (E. Muret, pastrycook, became a painter and bought impressionist pictures.)

Self-portrait: Schapiro 64; V. 516 (1885–7).

Pictures: see Gowing (1) 189f. and (2) nos. 24–33.

Judgment of Paris: V. 537. Reff (5) thinks perhaps earlier than V.'s date 1883–5. I should think V. is here right. For use of classical themes, cf. the 3 preparatory drawings for *Paris*, with *Nereid and Tritons* (Rewald 1939 fig. 16); *Venus and Cupid*, V. 124. Studies for *Paris*: Chappuis (2) no. 7 and V. i p. 311; (5) p. xxxix, xxviii (no Helen); V. 537, 1309. *Satyrs and Nymphs*: V. 94 (1864–8); *Fauns Attacking*, Schneiwind xlvi (v) cf. V. 897. *Leda*: V. 550; *Naked Woman*, 551. V. dates 1886–90, but I feel sure they are c. 1885.

Note how Schneiwind IV, rivergod from Delacroix's Gallery of Apollo (1849–50) is used in *Bathers* V. 275. For *Bathers* of 1885–9(?) in NY he used photo of male model: Barr (3) 22 f.

IV, 3.

Pictures. Gowing (1) for dates and analysis. He says, 'I believe there to be a radical difference between the pictures painted before 1835 and those painted later.' For 1885: Gowing (2) no. 35, *Paysage*, V. 487 (1885–7). *Marroniers*: V. 476 (1885–7), Novotny (1) 1885–90; Rosenberg no. 13 (1887); Cooper no. 11 (1885–7); Gowing (2) 1884; Gowing (1) 190 (1885–6); Schapiro 72. *Vue sur l'Estaque*: V. 406; Gowing (i) 190; Novotny (1) 205 (1883); Wildenstein no. 32 (1885); Cooper no. 9 (1885). *Marroniers* prob. preceded by V. 441, 487. 1885–6 winter and spring: V. 314, 463, preceded by 409–10 and perhaps 459.

Ste V. au grand pin: Gowing (2) no. 39; V. 454; Novotny (1) 202; Malone no. 52; Cooper no. 12 (1886–8). *House in Provençe*: V. 451 (1885–7); Gowing (2) no. 37 (1886). *Paysage Rocheux*: V. 491; Cooper no. 10; Gowing (2) no. 38: among the first of the many paintings of small houses in Prov. landscape of late 1880s.

Still-life: V. 623 (1890–4); Cooper no. 13 (1888–90); Gowing (2) no. 40 (1887), cf. V. 599. V. 206 (1873–7); Gowing (2) no. 41 (1887)—supports under objects to tilt to picture surface.

1888: V. 633; Gowing (2) no. 42, cf. Chantilly works V. 626–8. *Bethsabée*: V. 252 (1875–7); Gowing (2) no. 43 (1888). Earlier V. 255 from Rembrandt; then V. 253, nude Poussin.

Renoir: Geffroy: *La Vie art.* iii.

Belgium and Holland: never visited; E. Faure and Gasquet made the error, Vollard builds it unscrupulously up. Seems occurring through misprint of Anvers for Auvers in catalogue.

Prices: 1890, imp. prices rise, some Pissarros fetched 2,000 fr.; 1889, Theo van Gogh sold a Monet to an American for 9,000. Paul is said to have declared, 'My father was a man of genius; he left me an income of 25,000 fr.'

Pictures seen: apart from Tanguy's place, Zola had a landscape, Duret and Huysmans a sketch each;

some of his works were known to be with Choquet, Gachet (at Auvers), Muret (Rouen), Rouart, Pissarro, Caillebotte, Schuffenecker. Since founding of Mercure de France, 1890, A. Aurier regularly mentioned anything by Paul shown at Tanguy's, especially praising 'a still-life [*Pears on Napkin*] which is simply an incomparable masterpiece.' He also admired the Emperaire portrait (later bought by Schuffenecker): Rewald (7) 142.

Paul asleep: GBA lvi 1960, 209.

Mardi Gras: 'The persons are above all posed for painting, without giving themselves up to particular actions,' so Duret (3) 31; M. C(onil) says it was painted in the salon of the Jas after his father's death; V. 552, studies 1473, 1622, 553–5, 1079, 1486, see Gowing (2) no. 44 for 553–5 as later than 552; Bart, esp. 107–9, for untenable thesis.

Bethsabée: V. 252 (1875–7), Gowing no. 43 (1888). V. 255 (with classical building); 253 close to 252 but less definite. *Grand Pin*: V. 669 (1892–6), Gowing no. 45 (1889), Vollard 1887; Rivière (1) 1887, Malone no. 100 (1892–6). *Underwood*, V. 446 (1885–6), Gowing no. 46 (1889), it seems related to group of Bellevue (V. 650–5) which seem 1889. *Hortense*, V. 570–2 and 680–3, Gowing no. 47, Schapiro 92. 1888: three Chantilly versions of tree-alley, cf. *Château de Marines*: Schapiro 84 for entangling of house-forms and tree-masses, with entry into and emergence out of depth in varying ways. See also Schapiro 78: *Mountains in Provençe*.

V, 1.

Cardplayers: Fry 72f.; Badt for the untenable symbolism. Valabrègue in his book on Le Nain ignores the Aix picture.

Geffroy: *Monet* 11 80. Tanguy had moved from 14 to 9 Rue Clauzel.

Giverny: Geffroy, *Monet*; Mirbeau (1) 9f. For Clemenceau: Geffroy iii 66. Gasquet (6), 'That man doesn't believe in God . . . I had the sharp sensation of it.' But this is said of a portrait Paul made of Clemenceau (? a confusion with that of Geffroy). Marie Gasquet for second party.

Le Viveur: cited Rewald (6) 15f. Perhaps we should put this year, 1895, the tale of hiding in street. Vollard has a tale of a passer once knocking into Paul in a crowd; Paul exclaimed, 'Don't people know I'm Cézanne?'

Religion: 'And sometimes Demolins would ask him: "Do you believe, sir?" he would reply as a fervent Catholic, "But, by God, if I didn't believe, I couldn't paint."' The niece repeats this tale, which may be true, though Paul had managed to paint much of his life without the appui of such a belief. (The end of the niece's account shows signs of departing from direct family-tradition to buttress the notion of Paul's religiosity.)

More remarks about himself: 'There's only one living painter, me.' 'Politicians, there are 2,000 of them in every legislature, but there's only a single Cézanne in a couple of centuries': Conil and young Paul: Rewald 1939 416.

Geffroy: also Director of Manufacture Nationale des Gobelins; in 1926 elected President.

Mirbeau: draft of letter in Chappuis (5) 2; given in *Correspondence* as 1904.

Pictures: *Man with Pipe*, V. 564 (1890–4), Cooper no. 15 (1892), Gowing (2) no. 5 (1893). Note studies V. 1327, 1346 after bust of F. Strozzi by B. da Maiano as type of Florentine portrait bust, 15 c., with similar pose and parallel drapery-folds. *Woman with Coffeepot*: V. 574, son dated 1887, study Gowing (2) no. 53 (1893). *Card-players*: V. 560, 559, 556–8; see Gowing (2) no. 52; studies, Cooper p. 88.

Still-life with Love: V. 706 (1897), Novotny (1) pl. 44 (1897), Rosenberg no. 19 (1895), Cooper no. 16 (1895), Gowing (2) no. 50 (1892) and (1) 190.

Hamilton (2) 22. See also Lhote (3) 18f. for similar analyses.

Boy with red waistcoat was Michelangelo di Rosa (V. 680–3) with two watercolours. Many Italian models: Venturi i pp. 310–13: Antonio Franchi, avenue du Maire 124; Tulio Pietro Paolo, rue du Chateau 64; Jean Antonucci, 872 rue Mouffetard; Mancini, 5 rue Fiermat; Corsi, 5 rue Saint-Médard.

V, 2.

Henri Gasquet: *Mém. d'Aix*, Dec. 1929. Aix show: M. Provence, Perruchot 263.

Pictures: *Ste V. au grand pin*: V. 454 (1885–7), Novotny (1) 202 (ditto), Cooper no. 12 (1886–8), Gowing (2) no. 39 (1887). Earlier version V. 455 where dry diagonal touch suggests 1886; watercolour V. 914, prob. 1887, not 1888 as son said. For antecedents of logical plane-recession: V. 410 of Estaque, close to Gardanne views of 1885–6, the most deliberate of C.'s constructions.

Still-life: *Teapot*, V. 734 (1900–5), Gowing (2) no. 58 (1899), Rosenberg no. 21 (1906). *Apples and Oranges*, V. 732; series V. 730–45. For V. 741–2 Sylvester (1), Schapiro 102.

Zola: Rewald (1) 151–4 and 1939 354–61. Hemmings (2).

Watercolours: Clark 137. Lemonnier in 1868 was writing, 'Courbet created a sensation: Life in all its materiality. He gave the impression of a certain rich existence which was merged into the development of things; in his work life was lived to the full,' 23, cf. 25. 'Courbet studied in particular the volume, the space content of things, their mass rather than the refinement of the contours behind layers of transparent air,

the force, the weight, rather than the lightness of the effect,' 53. He praised his plasticity, *formule plastique*. (Badt 324f.) This brings out the direction of Courbet's impact on the 1860s and the extent to which he permanently affected Paul.

Harvest: V. 249, cf. 251 of about the same time. See Bodelsen. Other work-scenes: V. 242, river with dredge, cf. 243, fishers and promenaders. Note Seurat's studies of the industrial suburbs.

Le Nu: noted by Jourdain (1), plus a litho, by Daumier. Other books in studio: *Les Incas* (noted elsewhere); *L'Art pour Tous* xxi, xv 1867; *La Musée des familles* xxxii-iii 1864-6; Sale Cat. Hôtel Druot 7 June 1899; A. Caillot, *Abrégé des voyages modernes, reduit aux traits les plus curieux* (2 vols. 1834; first ed. 1820-1) and Dr Sancerotte, *Avant d'Entrer dans le Monde* (1847)—these two prizes for Latin and Greek 1854; Abbé A. Pluche, *Beautés du Spectacle de la Nature* (revised L. F. Jehan 1844—first pub. 1732-50), prize for chemistry etc. 1857; Marc-Ange de T. (J. J. E. Roy) *Euphrase, ou l'Enfant abandonné* (1874, first pub. 1869) inscribed Cézanne 1882; and J. Fouquet, *La Rime riche—épitre à Paul Cézanne* (Menton n.d., prob. 1900), a satire of contemporary verses more concerned with rhyme than sense; nothing on Paul in it but the dedication to 'my old comrade Paul Cézanne.' Fouquet had lived at Aix and was friendly with Zola and Marion (see his *Nouvelle Orientation de la Pensée* 1904 4). At least he must have thought Paul would sympathize with his position. In general see: M. Provence (1) 820-2; Reff (7). There must have been many more books in the studio; these seem those kept back at Paul's death by Marie: Mack 19. Paul must have bought or acquired *Euphrase* for his own reading.

Methods of work: Vollard on Paul's rage at fading flowers: 'Only, "these *sacrées bougresses*, they change tone in the long run!" Then, at certain moments of exasperation against the malice of things, Cézanne came to limit himself to the images of the *Magasin Pittoresque*, of which he had some volumes at his place, or even to the fashion journals of his sister.' See V. 119-20; Reff (7) 309 n 46.

The Flayed Man attributed to Michelangelo he much copied. D'Arbaud in de Beucken (1) 259f; Schneiwind i 10; cf. Houdon, V. 1452, 1626. In his reproductions baroque and especially romantic works (above all those of Delacroix) predominate. Note that he used works like Michelangelo's *Bound Captive* and Signorelli's *Living Carrying the Dead* to make copies and adapt as bathers in compositions: Berthold, 61-4, 249-51; Reff (9).

Fear of Women: V. i p. 60 tries to argue that *Hortense in the Greenhouse* (569; Schapiro 82: painted perhaps c. 1890, cf. *H. in the Yellow Armchair*, V. 571; Gowing no. 47) disproves C.'s fear of women. And he oddly adds, 'The legend's origin is clear: those who knew him after 1900, when he lived alone at Aix, noted *chez lui* a certain preoccupation not to be exploited by a woman who extorted money from him.'

Jean Renoir in *Renoir, My Father*, 1962, is gossipy and expands anecdotes. On religion he says, 32, 'C. once happened to complain about a well-to-do-man in Aix-en-Provence. It seems that the fellow was not only guilty of adorning his parlour with a picture by Besnard—"that *pompier* who's always on fire"—but he had the nerve to stand next to C. at Vespers and sing off-key. Very much amused, Renoir reminded his friend that all Christians are brothers, and added, "Your 'brother' has a right to like Besnard, and to sing off-key at Vespers, too, if he chooses." "No," retorted C., and continued, half seriously and half jokingly, "Up in heaven they know very well I am Cézanne." It was not that he thought himself superior to the man in Aix, he simply knew he was different—"as a hare is different from a rabbit"—Then he said contritely, "I don't even know how to work out my problem of volumes as I should. . . . I'm nothing at all." ' For Renoir introducing him to Vollard, 172, 253; the meeting with Cabaner (an unlikely version) 107; his recipe for baked tomatoes, 247; his manners, 108f.

V, 3.

Italian Girl: V. 701 (1896), Gowing no. 56; said to be daughter of Italian who posed 1893 (for what?). Paul was in Paris late 1896, Jan. 1897. For pose, cf. 679, 681, 684, 686, 688. Schapiro. 104.

1898: Paris address 15 Rue Hégésippe-Moreau (curving south of Butte Montmarte, and Rue Ballu).

Baron: the son is said to have remarked, 'Look, father, there's Cézanne.' 'How do you know he's Cézanne?' 'But look, father, he's painting a Cézanne.' If they had known he was about, the son might have thus guessed who he was.

1899: Vollard says Paul worked at a *Baigneuses* at time of the Portrait. One day he said he'd hire a model. 'What, M. Cézanne, a naked woman.' 'O I'll engage only a few old hags.' But he complained no one now knew how to pose. 'Yet I pay dearly enough for a sitting. It costs 4 francs, 20 sous more than before 1870.'

Choquet sale: *Maison du Pendu*, 6,200 fr.; *Mardi Gras*, 4,400. Said to be 32 Cézannes in all, bringing in some 50,000.

Literary art: highly suspect references in Gasquet (2) 75, 144.

Writers: Mirbeau (1) 9f. Gasquet adds Racine, but that may be only to stress classicism. Whether Paul kept up his Greek we do not know. *Unknown Masterpiece*: Paul's illustration seems c. 1870, see Chappuis (3) nos. 77-8; Reff (6); Bernard, *Souv.* 41f., 125. Lukacs 85; Badt 216; Burger-Thoré, *Salon de 1847* 119; Gautier, *L'art mod.* 1856 140; Vasari, *della Pittura* cap. I; Baudelaire, *L'Oeuvre et vie d' E. Delacroix* 1863

in *L'art romantique* 17f. Gautier 143, Badt 228. Rilke, letter 9 Oct. 1907. Gasquet, 43, 'Frenhofer, it's me.'
 Réaliser: Badt ch. iv; Turner, my book. Zola on Manet, Notes *L'Oeuvre* 1879.
 Isolation: Badt 190, who cites earlier instances like Pontormo, but it is with the 19th c. the phenomenon
becomes widespread. Werth 43–4; *Manette* ch. lxxxix. Millet: R. Rolland, ch. i; A. Sensier, *Vie* etc. 1881;
Dumas defended him 1859 against Salon, and Mantz, GBA 15 June.
 Last paintings: Schapiro 122; Guerry 180; Fry 78f.; Sylvester (1). Line: Novotny (1) 73, 80, 76; Badt
51f.; cf. Rilke on the 'there-ness' of C.'s forms.
 Shadowpaths: Novotny (1) 87, he adds, 'sometimes they seem not to have any direct connexion with the
forms of the objects but often on the other hand they are actually covered over by contours.' Zola, *L'Oeuvre*
1909 331; Badt 57.
 Blue: von Tolnay (1); Badt 81, cited passage 80. Badt 58ff. deals with blue at length and has very good
things to say besides the mysticizing trend. See his quotations from Goethe 59. Oddly, blue was Millet's
favourite colour; he had innumerable shades of it 'from the crude indigo of the new blouse to the delicate
tone of garments that had grown almost white by washing. He revelled in them.' (Wheelwright.) But could
not use it to renovate colour like Cézanne. Sensier gives a list of the colours he used (from a letter): '3
burnt siena, 2 raw siena, 3 Naples yellow, 1 burnt ochre, 2 yellow ochre, 2 burnt umber.' The most common
earths. Virgil (with the Bible and Theocritos) was a favourite author as with Paul.
 Industry: Werth 43f.; Schneiwind V (v) and p. 19.
 Gulf of Marseille: V. i p. 53–4—dates prob. earlier 1880s.
 De Boer: *Merkur*, Jan. 1953 32; Badt 327. Cube: Bernard(5).
 Baudelaire: his favourite poems, Larguier (1) 147. Werth 50.
 Rocks at Fontainebleau: Schapiro 118 and 120; he cites Flaubert.

V, 4.

 Gasquet's ideas: Reff (2) 155, see preface *La Pléiade* (anthology of group) 1921; *La Rev. Universelle* vi
(1 Sept. 1921) 607–12, M. Laforgue. 'He loved poetry with a sort of sensual gourmandise. I'd like to eat it,
he used to say,' L. Vauxcelles. Gasquet doubtless distorts when he makes Paul say, 'I may perhaps have
come too early. I have been the painter of your generation rather than my own.' He may have said something
flattering about his young audience, but not in terms that suggested his art had affinities with theirs. De
Voisins: Gasquet (2) 29; Reff (5) 123.
 Virgil: Morice 97; Bernard, *Souv.* 23, adds Horace and Lucretius.
 Letter to Zola 20 May 1881 on his walking powers.
 Hercules: Reff (4) 41–4. I owe my analysis to Reff. Critics and *Herc. Gaul.*: Rewald (13) 1 16f.; Bertold
22; Denis, *Journal* 1957 1 157.
 Reff finds that big sheets with whole of the body are earlier than those in notebooks with upper half or
head alone. Other works by Puget: Gasquet 191f.; Bertold 96–107, 125–30. Aix Museum: *Mag. Pitt.* xii
1844 399; Merimée, *Notes d'un voyage dans le Midi* 1835 234.
 Denis, *Théories* 1920 256. Paul copied no other Hercules statue in Louvre and only one (a conventional
herm) in Trocadero: Berthold no. 278. But was *L'Orgie* (?1867) based on Delacroix's *Hercules and Centaurs*:
Lichtenstein 57f.
 Chesneau, *Puget* 1882 18; Larousse *Dict* viii 1081; L. Lagrange, *P. Puget* 1868 67, cf. G. Geffroy, *La
Sculpture au Louvre* 1903 129 and L. Gonze, *La Sculp. fr. depuis xiv s.* 1895 192 (refs. from Reff). Con-
temporary illustration: GBA 1867 67. Delacroix and Puget, *Journal* 1932 ii 283, iii 173 and 303: *Oeuvres
litt.* 1923 ii 113—Paul may have known the 1845 edition. Other baroque statues copied: Pigalle's *Mercury*,
Coysevox's *Crouching Venus*: V. 1171, 273, 276; Berthold nos. 147f. 154–7.
 1902: Paule Conil. 'Little Marie cleared my studio which is now ready and where I am going to move in
soon.' This can hardly be his sister-in-law Marie Conil.
 1903: Burning of pictures: Perruchot 296f., recollections of E. Décanis, the wine-merchant's daughter.
Vienna: Heilbut.
 Prices at Zola's sale surprised the Gazette of Hôtel Druot: *L'Enlèvement* 4,200 fr.; *Nature morte au
Coquillage* 3,000; *Coin d'Atelier* 2,050; *Lecture* 1,050; *Paysage de l'Estaque* 1,050; *Portrait* 950; *Nature morte*
900; *Etude* 720; *Nereid and Tritons* 680; *Portrait de femme* 1864 600.
 Max Nordau wrote, 'Cézanne, conqueror for a brief moment with Zola, is classed definitely among the
conquered,' Rewald 1939, 383.

V, 5.

 Classicism: Rivière first tried find classical trend 1877, connecting it with Greek art. See Reff (2) at
length for detailed study of the poets and artists building up C.'s name; also (ii) as to Poussin. Note V. i
54 for some doubts as to Poussin.
 Reproduire-représenter: Denis, *Théories* 253. Gasquet and Sales: J. de Beucken says he did some double-

dealing, tried 'to make a corner.' Jaloux in *Saisons Lit.* admits he 'never wished to explain his break with C.' For works that G. had: Rewald (6) 49.

Salon critics: Vollard, app. i and ii.

Baigneuses: Anderson; V. i 62.

Vallier: V. 716–18, Schapiro 126, V. i 63.

1906. Trois Sautets, near Palette: V. 978, 979, 1076; photo, de Beucken (2).

14 August: At Marie's 'I found Marthe; you know better than I what I ought to think of the situation, it's always up to you to direct our affairs.' Marthe Conil? what does Paul suspect? cf. 25 July letter.

Factice: used in letters 2 and 8 Sept.; in second seems thinking of Jo as *factice*.

Carriage: Looking at the clouds etc., 'he beamed in ecstasy and the man, who could see only trees and sky which seemed always the same to him, nevertheless felt, as he admitted to me, a weird force, an emotion, possess him, emanating from Cézanne, who had risen and was standing transfigured, his hands clasped on the cabby's shoulder, full of an evident truth which sanctified him. On another occasion the sun was shining. They had gone halfway up a killing hill. The horse and driver had gone to sleep, tired out under the broiling sun, Cézanne, without a word or a gesture which might have hurt them, awaited their awakening, naïvely rubbed his eyes, and it was he who seemed to have fallen asleep.' Gasquet overdoes things as usual, and says of Paul's relation to the driver and other workers, 'His generosity towards them was royal, it was not mere pride of purse, but above all the leaven of his heart and mind.' As we happen to know that Paul killed himself by his meanness in refusing to pay the driver what he asked, the rhetoric is hardly convincing. Yet no doubt he did have his moments of fine courtesy to the poor and toiling.

Nouveau: Vérane; M. C(onil).

Poem to son: Chappuis (5) and (6)20. There is also a name and address (Léon Robert) and 'Friday Saturday Sunday Monday Tuesday Wednesday Sarsaparilla Wednesday Sarsaparilla Sunday *Sy*.' A diet note? Also a pen-drawing of two male bathers (1884–7).

Monet in a 1905 interview stated that he considered C. one of the great painters of the epoch.

A few more details from Gasquet. For what they are worth his citations of Paul's opinions on artists: Venetians, 137–9, 166, 175, 204 (with Bernard 26): Le Nain 28; David 165, 169; Ingres 177 (also GBA 1936 no. 177; *Point* 1936 37); Delacroix 179–81; Cournet 181–5 (Bernard 59); Puvis de Chavannes 75, 144; Manet 75, 146 (also *L'Amour de l'art* 1936 196); Renoir 110, 145 (Bernard 1925 55); Rodin 159.

Canvases: 'He was utterly indifferent to it (work done). His finest canvases littered the floor, he walked on them. One, folded in four, was wedged under a cupboard. He left some in the field, he let others rot in the arbours where the peasants put them for shelter.'

Supposed remarks on classicism: 'One must return to classicism but through nature, that is to say, through sensation,' Bernard *Point* Aug. 1936 35. 'I have painted to make impressionism as solid and as durable as the art in the galleries,' Denis, see Rivière 1923 180. On Colour: 'Pure drawing is an abstraction. Drawing and colour are not distinct since everything is coloured.' 'Line and modelling do not exist. Drawing is a relationship between opposites or simply the relationship between two shades, white and black' (Larguier). 'One draws in process of painting. Precision of tone gives us at once the light and the shape of an object. The more the colour harmonizes, the more precise becomes the drawing' (Bernard 1925 37).

Bibliography

Supplement with the Bibliographies in Venturi (1) i and Rewald (5). Abbreviations: AA, *L'Amour de l'art*; AB, *Art Bulletin*; AD, *Arts Documents*; AV, *L'Art Vivant*; BM, *Burlington Magazine*; GBA, *Gazette des Beaux-Arts*; JWCI, *Journal of the Warburg and Courtauld Institute*; MA, *Mémorial d'Aix*; MF, *Mercure de France*; RR, *Romanic Review*; O, *L'Occident*; PC, Paul Cézanne; C., *Cézanne*.

Alexis, Paul, *Emile Zola, Notes d'un Ami*, 1882; Alpers, J., *Hercules in Bivia*, 1914; Anderson, W. V. (1) BM cviii 1966, 475 (Bathers) (2) BM civ 1926, 196; Aurenche, L. *Tablettes d'Avignon* (letter), Dec. 1932; Auzas, P. M., *Peintures de PC*, 1945.

Bacou, J., in Chappuis (5); Badt, K., *The Art of C.*, 1965; Baille, I., MA 5 Oct. 1924; Barazetti-Demoulin, S., *M. Denis*, 1945; Barnes, A. C., and V. de Mazia, *Art of C.*, 1939; Barr, A. H. (1) GBA (Marion and Morstatt) Jan. 1937 (2) *Mag. of Art* 1938 (3) *Masters of Modern Art*, 1954; Bell, Clive, *Since C.*, 1922; Berger, F., *C. und Hodler*, 1913; Berger, K., GBA (Poussin & 19c) xlv 1955, 161; Bernard, E. (1) O., July 1904 (2) MF (Souvenirs) lxix no. 247f., 1 & 16 Oct. 1907, 385 & 606 (2a) *Souvenirs*, 1912 (3) MF (Tanguy) lxxvi no. 276, 16 Dec. 1908 (4) MF (C.'s method) cxxxviii no. 521, 1 March 1920 (5) MF (conversation) no. 551, 1 June 1921 (6) AD (Letters) June 1953 (7) AD Nov. 1954 (8) AD no. 50, Nov. 1954 (9) MF clxxxvi, 1 May 1926, 513 (10) MF xciii, 16 Sept. 1911, 255 (11) *Les Hommes d'Aujourd'hui* viii no. 387 1891 (12) *Sur PC*, 1925 (13) AA Dec. 1920 (14) MF 1 June 1921 (15) MF 1 May 1926 (erreur de C.) (16) *Nation Belge*, 18 April 1929; Bernard, M., *Zola par lui-même*, 1952; Bernheim de Villers, G., *Little Tales of Great Artists*, 1949; Bernex, G. (1) *Méditerranée* (Solari), Sept. 1911 (2) *Cahiers d'Aix en Prov.* 1923, 49; Berthold, G., *C. und die alten Meister*, 1958; Bertram, A., *C.*, 1929; Beucken, J. de (1) *Un portrait de C.*, 1955 (2) *C., a Pictorial Biog.* 1962; Blanche, J. E. (1) *Les Arts Plastiques* (2) *Essais et portraits*, 1912 (3) *Rev. de Paris*, 15 Jan. 1915 (C. and Renoir in Midi), reprinted in (4) *Propos de Peintre, de David à Degas*, 1919; Bodelsen, M., BM civ 1962, 204; Boer, W. de, *Merkur*, 11 Jan. 1953; Borély, J. AV (Aix) 1 July 1926; Bouchot-Saupique, J., *Rev. des Arts* (sketches) Dec. 1951; Bowie, T., *The Painter in French Fiction*, 1950; Boye, M. P., *Beaux-Arts* (Valabrègue) 28 Aug. 1936; Brady, P., *Rev. de sciences hum.* (Lantier), Jan.–March 1961; Braun, S., *The Courtesan in French Theatre from Hugo to Becque*, 1947; Breeskin, A. D., *The Graphic Work of Mary Cassatt*, 1948; Brown, R. F., *Mag. of Art* xliii Jan. 1950, 12; Bulliett, J. C., *Apples and Madonnas*, 1930.

Camoin, C. (1) AA Jan. 1921 (2) *Les Soirées de Paris* (letters) no. 2 1904; Carpenter, J., AB xxxiii Sept. 1951, 174; Cassou, J., *C., les Baigneuses*, 1947; Castelnau, J., *Zola*, 1946; Ceard, H. (1) *Rev. illustrée* (Zola) iii 1887, 141 (2) Journal litt., 10 May 1924; Champfleury (1) *Contes*, 1852 (2) *Du Réalisme*, 1857; Chappuis, A. (1) GBA 1965, 306 (2) *Dessins de C.*, 1938 (2) *Ibid.* (Mus. de Bâle) 1962 (4) *Ibid.* 1957 (5) *Album*, 1966 (6) *XXe Siècle*, 1 May 1938; Charensol, G. (1) AV (Aix) 1 Dec. 1925 (2) AV 1 July 1926, 494; Chassé, C., *Gauguin et le groupe de Pont-Aven*, 1921; Chastel, A., RR xl 1949, 261; Cheosé, C., *L'art symboliste*, 1946; Cigada, S., *Studi Francesi* 1960, 83; Claretie, J., *Rev. de Fr.* (Zola's death) v 1922, 853; Clark, Kenneth, *Landscape into Painting*; Cogniat, R., *C.*, 1939; Combe, J., *La Renaissance* (C.'s infl.) May-June 1936; C(onil), M., GBA lvi 1960, 299; Cooper, D. (1) *L'Oeil* 11 Feb. 1955, 13 & 46 (2) *Cortauld Coll.*, 1954 (3) BM xcvi 1954, 344 & 378 (4)

Werk-Mythos, 1927; Pia, P., *L'Oeil*, 15 March 1955 (Vollard); Piédagnel, A., *J. F. Millet, Souvenirs de Barbizon*, 1876; Pissarro, C., *Lettres à son Fils*, 1950; Pissarro, L., and L. Venturi, *Camille Pissarro*, 1939; Prost, B., *O. Tassaert*, 1886; Proudhon, P. J., *On the Principles and Social Destination of Art*; Provençe, M. (1) *Le Cours Mirabeau*, 1953 (2) MF clxxvii no. 639, 1 Feb. 1925 (C. at College) (3) MF clxxxvii no. 667 1 April 1926 (Coste) (4) *Rev. des Lettres*, Dec. 1924 (C. and church) (5) *C. au Tholonet*, 1939 (Soc. P.C., Aix) (6) *L'Année Cézannienne 1933*, 1934.

Raimbault, *Provincia*, Bull. Soc. de Stat. et d'Archeol. de Marseille, fasc. 2 (Huot) 1937; Ramuz, C. F., *Lettre à Grasset* etc., 1941; Raphael, *M. de F.* clxvii 1923, 104 (Rougons); Raynal, M., *C.*, 1936; Reff, T. (1) GBA lix 1962, 173 (2) JWCI xxiii 1960, 150 (3) GBA lxiii 1964, 111 (Olympia) (4) AB 1966, 35 (5) AB 1962, 113 (6) BM cv 1963, 375 (7) GBA lvi 1960, 303 (studio) (8) AB 1960, 145 (9) BM cii 114 (10) BM ci 171 (11) *Art de France* iii 1963, 302; Rebatet, L., *La Rev. universelle*, 15 June 1936; Revon, M., *Octave Mirbeau*, 1934; Rewald, J. (1) *C. et Zola*, 1936 (2) *Correspondance*, 1937 (3) Engl. transl. 1941 (4) with Marschutz (Jas) *Forum* ix 1935 (5) *C., sa Vie* etc. 1939 with bibliog. (6) *C., Geffroy et Gasquet*, 1959 (7) *The Ordeal of PC*, 1950 (8) see C. Pissarro, *Lettres* (9) *P. Gauguin, Letters to A. Vollard and A. Fontainas* (10) *Gauguin*, 1938 (11) *Degas* (12) *C. Pissarro*, 1963 (13) *P.C., Carnets de Dessin*, 1951 (14) *Hist. of Impressionism*, 1946 (14a) 1961 (15) *La Renaissance*, March–April 1937, 53 (16) AA (C. at Louvre) xvi Oct. 1935, 283 (17) *Arts* 21–7 July 1954, 473 (18) AA (Château Noir) Jan. 1935 (19) AA, C. issue, May 1936 (20) *Point*, C. issue, August 1936; (21) AA, May 1938 (Emperaire) (22) BM, June 1938 (Pissarro) (23) *Post-Impressionism*, 1956; Riat, G., *G. Courbet, peintre*; Rich, D. C., *Art News* xxix 20 Dec. 1930, 67 (Poussin); Rinteln, F., *Reden und Aufsätze*, 1927; Rivière, G. (1) *Le Maître P.C.*, 1923 (2) *C., le Peintre solitaire*, 1936 (3) *Renoir et ses Amis*, 1921 (4) with Schnerb, *La Grande Revue*, 25 Dec. 1907, 811 (studio) (5) AV, 1 Aug. 1925 (early work) (6) *Etudes*, 1911 (7) AV 1928 (children) (8) AV, 1 Oct. 1926 (Imp.) (9) AV, 15 Dec. 1926; Robaut, *Delacroix*; Robert, G., *Rev. des sciences hum.* li 1948, 181–207; Roche, A. V., *Provençal Regionalism*, 1954; Rochon, V., *La Vie bruyante de J. Vallès*, 1937; Rodolphe, W., GBA lxi 1963, 358 (Bonneville); Roger-Marx, C., *Le Paysage Français*, 1952; Rolland, Romain, *Millet*; Rosenberg, C. Exhib. London, 1939; Rosenberg, M., *Von Paris von Troja bis zum König von Marcia*, 1930; Rosenthal, L. (1) *Du Romanticisme au Réalisme*, 1914 (2) *Le Tradition of le Cubisme*, 1920; Rousseau, T., *Art News* li, April 1952, 28; Roux, M., MA, 3 Dec. 1865; Royère, J. (1) *La Phalange*, 15 Nov. 1906 (expanded *Kunst u. K.*, x 1912, 477) (2) AA, Nov. 1925 (Leydet) (3) MA, 15 Nov. 1929 (Gasquet) (4) *Frontons*, 1932 (5) notes in *Dix-neuf lettres de S. Mallarmé à E. Zola* (intro. Deffoux) 1929; Russell, J. in *Pissarro in England* (Marlborough Fine Art) 1968.

Salmon, A. (1) *C.*, 1923 (2) *L'Art vivant*, 1920 (3) *Cahiers d'Art* 1926, 263 (4) AV, 1 July 1926, 487 (grappin); Sandblad, N. G., *Manet*, 1954; San Lazzaro, G. di, *PC*, 1938; Saunders, E., *The Age of Worth*, 1954; Schapiro, M. (1) *C.*, 1952 (2) JWCI iv 1941, 164 (Courbet and Pop. Imagery); Schmidt, G., *Aquarelles de PC*, 1952 (London 1954); Schneiwind, C., *Sketchbook*, 1951; Schroeder, M. Z., *Icarus: the Image of the Artist in Fr. Romanticism*, 1961; Sesnier, A. (1) *La Vie et l'Oeuvre de J. F. Millet*, 1881 (2) *Souvenirs sur T. Rousseau*, 1872; Severini, G. (1) *L'Esprit nouveau* (C. et le Cézannisme), Nov.–Dec. 1921 (2) in Italian, *Ragionamenti sulle arti figurative*, 1936, 197; Seznec, J., *Mag. of Art*, xl 1947, 91; Signac, P., *D'E. Delacroix au Néo-impressionisme*, 1899 (also in *La Rev. Blanche*, xvi 1898); Silvestre, A., *Au Pays des Souvenirs*, 1892; Souchon, P., *E. Signoret*, 1950; Sterling, C. (1) Cat. Mus. Orangerie, 1936 (2) *La Renaissance*, xix, May–June 1936, 7; Sylvester, D. (1) *Listener*, 18 Jan. 1962 (2) *Ibid.* 15 Feb. 1962.

Tabarant (1) *Bull. de la Vie art.* (Caillebotte) xv, 1 Aug. 1921 (2) *Ibid.* 1 March 1924 (3) *Manet*, 1947; Tabary, L., *Duranty*, 1954; Tancock, L. W., MLR (Zola, early articles) xlii 1947, 43; Tolnay, K. von (C. de) (1) *Deut. Viertel. f. Lit. u. Geistsgesch.*, ix (Halle) 1933 (2) GBA (Delacroix

and Michelangelo) 1962, 43; Toulouse, E., *Enquête medico-psychologique* . . . *E. Zola*, 1896; Tourette, J., *Les Lettres fr.*, 28 Aug. 1952; Toussaint, G., *Granet*, 1927.

Vallès, Jules (1) *J. Vingtras, L'Enfant* (2) *Le Bachelier* (3) *L'Insurgé*: all 1885. eds. (2) reprint 1951, with prefaces by Monmousseau, Jourdain, Cachin, with *Le Proscrit*, preface by L. Scheler; Van Gogh, V., *Lettres à E. Bernard* in MF 1893; Vaudoyer, J. L., *Les Peintres provençaux*, 1947; Vauvrecy, *L'ésprit nouveaux*, Nov. 1920; Vauxcelles, L. (1) *Beaux-Arts*, 28 April (Gasquet) 1939 (2) *Le Gil Blas* (PC) 18 March 1905 (3) *Beaux-Arts* (Vollard) 28 July 1939 (4) *Le Feu*, 1 July 1926; Venturi, L. (1) *C., son Art, son Oeuvre*, 1936 (2) *Les Archives de l'Imp.*, 1939 (3) *PC, Aquarelles*, 1943 (4) with L. R. Pissarro, *C. Pissarro Son Art, son Oeuvre*, 1939; Verane, L., *Humilis, Poète Errant* (Nouveau); Verhaeren, E., *Sensations*, 1927 (with essay, *L'Imp.*, from *J. de Bruxelles*, 15 June 1885); Vergnet-Ruiz, J., *La Renaissance*, May–June, 1936; Vicaire, G., *Rev. Deux Mondes* xxi (Zola's aesthetic) 1924, 810; Vives-Apy, C., MA, 16 Feb. 1911; Vollard, A. (1) *PC*, 1914 (2) transl. H. L. van Doren, 1924 (3) *Quelques Souvenirs*, 1929 (4) *En Ecoutant C., Degas, Renoir*, 1938 (5) *Souvenirs*, 1937.

Waldfogel, M. (1) GBA (Baigneurs) lxv 1965, 113 (2) BM civ 1962, 200; Wedderkop, H. von, *PC*, 1922; Wencker, T., *Kunst u. K.* (Château Noir) 1929, 227; Werth, L. (1) in Mirbeau (1) (2) *Quelques Peintres*, 1924; Wheelwright, E., *Atlantic Monthly* (Millet) Sept. 1876; Whyte, L. L., *Unitary Principle in Biology and Physics*, 1959; Wilderstein (1) *Homage to PC* (Cat. Rewald) 1939 (2) Loan Exhib. of C., NY 1947.

Yates, F. A., JWCI (Ugolino) 1951, 92.

Zola, E. (1) *Corr., Lettres de Jeunesse*, 1928 (2) *Lettres et les Arts*, 1929 (1908) (3) *L'Oeuvre* ed. 1928 (3a) see Daix (4) *Le Figaro*, 12 April 1867 (5) *Ibid.* (Peinture) May 1896 (6) *Mélanges* (7) *Nouvelles Contes à Ninon, Souvenirs* (8) *Docs. litt.*, 1881 etc.

ACKNOWLEDGEMENTS

In many cases it has not been possible to trace the present owners of works reproduced in this book; however, the author and publisher wish to acknowledge the sources of the following illustrations: *fig.* 2, Collection of Mr and Mrs Paul Mellon; *fig.* 3; Collection of Robert von Hirsch, Basel; *fig.* 13, Museum Folkwang, Essen; *figs.* 18–24, Bibliothèque Nationale, Paris; *figs.* 52, 77, courtesy of The Phillips Collection, Washington; *fig.* 53, courtesy of The National Gallery of Art, Washington DC, Chester Dale Collection; *fig.* 61, courtesy of The Brooklyn Museum, New York; *fig.* 75, courtesy of Mr Lucien Pissarro; *fig.* 83, Kunstmuseum, Basel.